HOGARTH
HIGH ART AND LOW

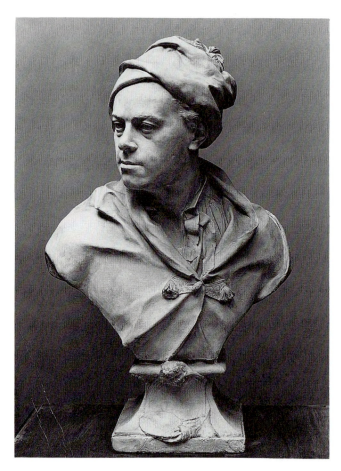

Frontispiece. Louis François Roubiliac, *William Hogarth;* bust, plaster modello; ca. 1740 (National Portrait Gallery, London).

HOGARTH

VOLUME 2
HIGH ART AND LOW

1732–1750

Painters and writers speak and writers never mention, in the historical way of any intermediate species of subjects for painting between the sublime and the grotesque.

—*Hogarth,* "AUTOBIOGRAPHICAL NOTES"

RONALD PAULSON

RUTGERS UNIVERSITY PRESS

NEW BRUNSWICK, NEW JERSEY

This publication has been supported, in part, by a grant from the National Endowment for the Humanities, an independent Federal agency.

Library of Congress Cataloging-in-Publication Data

Paulson, Ronald.
 Hogarth.

 Includes bibliographical references and indexes.
 Contents: v. 1. The "modern moral subject", 1697–
1732—v. 2. High art and low, 1732–1750.
 1. Hogarth, William, 1697–1764. 2. Artists—England
—Biography. I. Title.
N6797.H6P38 1991 760'.092 [B] 90-24569
ISBN 0-8135-1694-3 (v. 1)
ISBN 0-8135-1696-X (v. 2)
ISBN 0-8135-1697-8 (pbk. : v. 2)

British Cataloging-in-Publication information available

CONTENTS

ILLUSTRATIONS

Unless otherwise indicated, the illustration is an etching-engraving.

Frontispiece. Louis François Roubiliac, *William Hogarth*; bust, plaster modello; ca. 1740.

PREFACE

This volume covers Hogarth's peak years of experiment and success, from the age of thirty-five to fifty-three. Following his first great success with the general public in *A Harlot's Progress* (1732, ill. vol. 1), he made an almost, but not quite, successful attempt at securing royal patronage. This failure prompted him to extend the idea of public patronage he had demonstrated with his engravings to his paintings as well: which took the form of creating an exhibition space for them in public places—for example, pleasure gardens (Vauxhall) and charity hospitals (St. Bartholomew's and the Foundling). Hogarth's career corresponded to a time in which high art was being redefined by the decline of personal patronage and the consequent development of new cultural sites, no longer courtly but urban and public, and art works were being commercialized and treated as commodities. He was quick to see that one consequence was the breakdown of old aesthetic hierarchies and the development of new cultural forms—the ballad opera, the bourgeois tragedy, his own "modern moral subject," and the novel. As quickly he learned that a less-happy consequence was the rise of a body of professional cultural middlemen—the Heideggers and Overtons, the Cocks and Jonathan Richardsons—impressarios, print dealers, auctioneers, critics, and connoisseurs—with whom he contested the new market.

The new market of consumers was huge, potentially everyone between the landless peasants and the landed aristocracy, the London journeymen and the great merchants, the laboring poor and the patrician elite.[1] The work of art, the most obvious sign of class status, was now objectified as a commodity, consumable on an individual basis and not limited to a patron or collector. The aspect engaged by Hogarth, as early as the *Harlot's Progress,* was the connection between consumption, class, and imitation. The new consumers had as their only model the old patron or collector; this meant essentially access to his discourse of collecting, that is, a certain form of literacy (or

what we would call these days "theory"), which defines a canon of taste. Even Hogarth's subscription ticket for *A Harlot's Progress,* while it alerted the buyer that this series was about a low subject, an example of the imitation of "Nature" only, nevertheless, with its learned (Latin) inscriptions and allusions, made it quite clear that his maximal audience was the educated buyers, knowledgeable of classical texts, allusions, and notions. While there were many synonyms for *imitation* in this period, among them copying, emulation, and affectation, they all shared a common denominator of literacy. The discourse of collecting had to be *read,* even though it pertained to visual objects; and Hogarth's own pictures, with their learned and popular emblems, their visual and verbal puns, addressed—though by no means exclusively—an educated audience.

The new consumer was therefore tempted to climb (or appeared to climb) from one class to the next higher—to substitute a fashionable identity for his own. His plight opened up a new space for the enterprising artist, who produced copies—single or in the hundreds or thousands—of the original and privileged objects owned by the patron. An alternative space, at the same time, was opened by the even more enterprising artist like Hogarth who sought to develop a *new* product that corresponded to (and caught) the expanding audience on its own terms, especially those who wished to maintain their identity and *not* merely emulate their betters. From the days of his earliest professional training Hogarth had witnessed and participated in the employment of mechanical reproduction—printing and engraving—to create and extend cultural markets. Moreover, the exactly repeatable graphic image of the engraving extended the definition of "property" far beyond the collector's elite objects such as paintings. The prints could be seen in coffeehouses and shop windows by many more than actually purchased and owned them. The work of art was no longer limited to the simple status of personal possession; indeed it put in question the whole matter of property as it did of class.

If the upper social margin of society was distinguished by not having to earn a living, the line between the middle and lower orders was drawn at the possession of property.[2] The question for the artist was whether ownership is determined by mere purchase or use, or, in Locke's terms, by the labor of the creating. Hogarth thus became a property owner when he sold his own prints from his own copperplates. Later he would have other sorts of property (houses, a coach,

and so on), but the essential property, beginning with the *Harlot* in 1732, and consolidated with the *Rake* and the Engravers' Act in 1735, was the fruit of his "labor" in his prints.

Another formulation would say that the three fundamental orders of society were the landowners, the employers, and the laborers. Hogarth fell into the category of employer because he employed others to carry out certain aspects of his labor. But clearly he was himself a laborer—in this sense a nongentleman—even though self-employed. The woman laboring to hang out her laundry on the balcony in *Harlot* 1 was the only indication in that series of an alternative way of life in London. The Harlot *could* have been outside, with some space and fresh air around her, washing clothes and airing chamberpots; she prefers, however, to imitate the rich, wear gentlewomanly dresses, keep a servant woman, avoid physical labor, and be a piece of property herself. But the physical labor of the woman hanging out laundry also figures, for Hogarth and other engravers who read the art treatises, the mechanic labor of their humble craft, which was many steps beneath that of the painter. For the art treatises offered the artists their own equivalent of social climbing by urging them to emulate the Old Masters and affect gentlemanly behavior, including the collecting of pictures. The project of the *Harlot,* in short, places Hogarth himself within the process he depicts: he invents (*invenit,* the word that carries the prestige) an original, unique object *and* engraves (*sculpsit*) it. As artist he stands as a living rebuke to imitation, both in the sense that he does not copy the Old Masters but produces something new, and that he paints as well as engraves his product.

For Hogarth the artist, therefore, imitation meant copying—making and selling bad copies of Old Master paintings and often passing them off as originals, and copying his own prints. Most significant for him in the 1730s was piracy, the commercial sense of copying: as long as the artist's mass-market commodity could be copied, his property and profits were in jeopardy.

Thus he transferred the sense of the contemptableness of labor to the copying—pirating—by others of his own *original* engraving, giving, from his point of view, what had been traditionally regarded as the result of a mechanical reproductive process the status of an original in relation to piratical copies (copies by someone other than the originator). Significantly, Hogarth's Act (as the Engravers' Act was popularly known), while protecting the engraver who is also the

inventor of the original composition (Hogarth himself), did not protect engravers who copied Old Master paintings or sculptures.

Hogarth took imitation as the subject of his new product (the "modern moral subject"), projecting a scenario in which the new consumer and the old patron, the artist who originates and the hack who copies, join with the dealer and connoisseur in a struggle to the death around the art object (authentic or fake).

At the same time he revealed a conflict in his own practice between original and copy in the differences between his painting and his engraving: between a unique "aura" and the infinite repeatability of an image; between the antithetical intentions and qualities of paintbrush and burin, color and monochrome, and volume and linearity.

Earlier in this century the formalist critic Roger Fry pointed to the dichotomy of Hogarth's moralism and "his authentic gift . . . as a pure painter." He initiated the idea, subsequently taken up by Collins-Baker, Oppé, and Waterhouse, that Hogarth was "a born painter in the strict and limited sense of the word; he had the art of a vigorous direct statement and a feeling for the density and richness of his material. He had a painter's sensual feeling for the material texture." Fry commented too on "the fat, buttery quality of his pigment" that subsequent writers have observed.[3] While it is difficult to sympathize any longer with Fry's purely formalist assumptions, the dichotomy he indicates in Hogarth's work between moral illustration and pure painting is in fact crucial, though I hope to show that the interaction is far more complex than he supposed.

Graphic art is not, however, as was assumed by the school of Fry and Clive Bell (whose motto was "The representative element in a work of art may or may not be harmful; always it is irrelevant"), the making of forms but the making of images. And *image* is very different from *illustration,* which is the merely adequate correspondence to an abstract idea (as if Hogarth's *Stages of Cruelty* "illustrated" the admonition, "Don't be cruel to animals"). Form for its own sake is very different from significant or expressive form. Hogarth's paintings *and* prints, from their use of color down to their use of false perspective, are remarkable and instructive examples of image making.

Another issue in the foreground of the period covered by this volume is Hogarth's relationship to the emergent literary form that corresponded to his "modern moral subject"—the novel of Samuel Richardson and Henry Fielding. It is a curious fact that Hogarth gets

no mention in Ian Watt's *Rise of the Novel,* in Michael McKeon's *Origins of the Novel,* or in Nancy Armstrong's *Desire and Dramatic Fiction: A Political History of the Novel.* And yet he is the significant Other of the novel's rise in Richardson's *Pamela* and Fielding's *Joseph Andrews.*[4] Chronology alone tells us that without his graphic experiments in the 1730s both Richardson and Fielding would have written very differently in the 1740s.

A final issue is Hogarth's "ideology," religious, political, and social.[5] It would be foolhardy to claim that Hogarth's work does not reflect a hegemonic ideology, or that Hogarth himself is not in some degree a historically constructed subject. On the other hand, his paintings and prints do not fit into the Althusserian category of a work "held within ideology, but [which] also manages to distance itself from it, to the point where it permits us to 'feel' and 'perceive' the ideology from which it springs."[6] That description might fit a novel by Defoe or Richardson, the experiential lives of whose Crusoe and Pamela overflow and therefore define the bounds of the ideology they carry and inhabit. Hogarth's subject itself is ideology (as Blake's will be). He is constantly commenting on the general or dominant ideologies of his time, or what he took them to be, and showing how they warp the lives of his characters—if not of himself.

Enclosed within a society that managed to believe in itself, its mores, and its divinities, Hogarth remained socially a subversive apprentice, politically a skeptical member of the "opposition," and in religion a freethinker. The evidence of *A Harlot's Progress* pointed to Deist views on the clergy and biblical texts. In the years following, Hogarth's paintings and prints show the strand of critical Deism augmented by the beliefs and iconography of Freemasonry (of which he was an active brother). Both were substitute religions; Freemasonry accommodated the most heterodox beliefs. Also suggestive is the coincidence that both Freemasons and Deists placed great emphasis on the division of what the Masons called Lesser and Greater Mysteries, the Deists called exoteric and esoteric doctrines. They offered a much stronger version of the traditional poetic stance (articulated, for example, by Addison) of the "veil of allegory" used by the poet to distinguish the "ordinary reader" from the "men of greater penetration" (*Spectator* No. 315). The idea of a double address, to the great popular audience of the prints and at the same time to a small elite, whether this was the personal patron of the paintings or the Deist or Masonic insider, was plainly overdetermined for Hogarth,

who needed as an upwardly mobile artist to retain both audiences. He had announced this intention with the unveiling of Nature (*Diana multimammia*), itself both a Masonic and Deist image, in *Boys Peeping at Nature,* the *Harlot's* subscription ticket; and it will continue in various forms, including the variations distinguishing his prints from his paintings. This is not to say that the works themselves convey any sense of "secret" or "mystery." Were they to do so, Hogarth would have alienated his popular audience, the "ordinary reader." On the contrary, it is quite probable that Freemasonry and critical Deism helped to enable or authorize the frame of mind that led him to address in such an antielitist work as *Industry and Idleness* the Lesser Mystery to the masters and the Greater to the apprentices—a ratio quite the reverse of the Masonic though not of the Deist. At the same time, the notion of mystery does surface here and there, as for example when he includes the hieroglyphic Line of Beauty on the palette of his *Self-Portrait with Pug* (fig. 105).

The Masonic brotherhood may, however, confirm the suspicion that Hogarth, though he makes absolutely clear in his graphic works that his sympathy is outside the system, with the Nobodies (versus the Somebodies) of his society, nevertheless feels that he must have a secret handgrip or password. He enjoys and embodies the privilege of being outside and yet inside, using his dissident strategy to serve the social purpose of innoculation and enclosing it within the circumspect "career" of one who wants to be at once high and low.

HOGARTH
HIGH ART AND LOW

1.

PATRON AND PUBLIC (I)

Paintings and Prints, 1732–1733

A SCENE FROM "THE INDIAN EMPEROR"

A highlight of the social season in which *A Harlot's Progress* appeared was the children's production of Dryden's *Indian Emperor* at the Conduitts' town house in St. George Street, Hanover Square. John Conduitt, a gentleman who had begun his career in the army, married Sir Isaac Newton's niece, Katherine Barton; a genuinely learned man in monetary matters, he assisted Newton in his last years as Master of the Mint and succeeded him on his death in 1727. Mrs. Conduitt, admired in her youth by Swift and capable in later years of disturbing Pope, had good connections and no doubt arranged the party.[1] The center of attraction was the children's performance of Dryden's play, which had been successfully revived in 1731 at Drury Lane. The Conduitts' performance, in March 1731/32, was directed by Drury Lane's Theophilus Cibber; their daughter Kitty played Alibech, Lady Sophia Fermor played Almeria, Lord Lempster Cortez, and Lady Caroline Lennox (daughter of the duke of Richmond and later Henry Fox's wife) Cydaria: all the children were around ten years of age. The audience included the royal children, William, duke of Cumberland, and his sisters the princesses Mary and Louisa, and the daughters of their governess, the countess of Deloraine; among the adults present were the countess of Deloraine, Stephen Poyntz (the duke's governor), and the duke and duchess of Richmond.[2]

The performance must have pleased the duke of Cumberland, who ordered a repetition before his own family at St. James's Palace, which took place on 27 April. By the 22nd Conduitt had decided to

commemorate the occasion with "a conversation piece drawn by Hogarth of the young People of Quality that acted at his house, and"—the writer, Dr. Alured Clarke, adds—"If he isn't mistaken hopes to have the honour of the Royal part of the audience in the Picture; and I doubt not the painter's genius will find out a proper place for Miss C[onduitt]." Conduitt withdrew to his country seat at Cranbury Park, Hampshire, and his friend Thomas Hill kept him informed on the progress of the painting, telling him when Lady Caroline had agreed to sit for Hogarth and, on 29 June, commenting: "Hogarth has but in a manner made a sketch of Lady Caroline. Nothing appears yet to any advantage. The next sitting will, I hope, show something good. I think he has succeeded perfectly wel in Miss Kitty's face and air."[3]

Hogarth was in his thirty-fifth year; at the beginning of April he had delivered his *Harlot's Progress* to subscribers and at the end of May—in the wake of the *Harlot's* immense success—he and some friends had gone on a raucous "peregrination" to Kent. By the end of April he had accepted Conduitt's commission. Presumably he attended one of the performances, made a sketch, and then filled in those faces desired from separate sittings like the one recorded for Lady Caroline (figs. 1, 2).[4] George Vertue records the sitting of the duke of Cumberland, which led also to a full-length portrait (fig. 3) that virtually duplicates the figure in *A Scene from "The Indian Emperor."*[5] The canvas was larger than any Hogarth had hitherto attempted—51½ × 57¾ inches (*The Wollaston Family* had been 39 × 49, the *Assembly at Wanstead House* only 25 × 29). It was not finally delivered until 1735.

The children, the focus of attention whether on stage or in the audience, are all fairly visible; but only three of the adults have faces that show.[6] The woman in profile is probably the duchess of Richmond, and one of the men wearing an order must be the duke. The other figures merely fill in the composition, which is accordingly uncrowded and without the awkward rows of heads all facing the viewer with which Hogarth had filled some of his earlier conversation pictures. The host and hostess are discretely displaced to pictures hanging on the wall, near the mantlepiece bust of Sir Isaac.

The bust of Newton is homage to the Conduitt family patron.[7] But Newton was also the man who formulated the law of gravity being demonstrated in a small way by the fallen fan the little girl is being commanded by her mother to pick up, and in a more general

way by the natural, fatal attraction being dramatized on the stage. As Thomas Hobbes had shown, love is simply a matter of gravitational forces on moving bodies. Whenever a child does something in a Hogarth conversation, the action is associated with a law of nature such as that of gravity, and an adult, often a parent, attempts to countermand it.

The use in Hogarth's conversation pictures of paintings and architecture as an integral part of the composition—cognitive as well as formal—had been elaborately confirmed in *A Harlot's Progress* and suggests the continuing interrelation between his conversations and his "modern moral subjects." More portrait commissions followed that popular success, and Hogarth must have been busy with these for the remainder of the year. Indeed, in 1732–1733 he painted the most exalted sitters of his career and received a commission to paint a conversation of the royal family. Still, his reputation was primarily for such special subjects as children performing in a play. Conduitt's choice of artist may have owed something to the particular occasion, which would have recalled Hogarth's *Beggar's Opera* paintings (1728–1729): the scene he chose to paint was very similar. The promptbook shows the fourth scene of Act IV, a prison where Cortez is "discovered bound," and the rival princesses Cydaria and Almeria debate the captive conqueror in much the same manner that Lucy and Polly debated Macheath, who also wore fetters. But here Dryden's great Cortez and the two princesses, in one of the most heroic of English plays, are being played by children. An audience consisting of their parents and other children is watching these children acting the adult roles of Cortez and the two princesses, both of whom are in love with him. Hogarth is giving Dryden back his scene by way of Gay's parody of it (and of others—of Antony between Cleopatra and Octavia in *All for Love*, of Alexander between Statira and Roxana in Nathaniel Lee's *Rival Queens*) in *The Beggar's Opera*, but with his own parody, this time with the roles played by children rather than criminals. Fielding had produced *his* parody of the scene in *Tom Thumb* (1730), which Hogarth had illustrated in his frontispiece for the printed edition of 1731 (ill., vol. 1).

Also as in *The Beggar's Opera*, the audience is played off against the actors. The fathers are talking soberly among themselves, paying little attention to the performance; the mothers and nurses are addressing themselves to the play, except for the one who is ordering her small charge to pick up the fan she has dropped to the floor. The

small spot of disorder in the audience corresponds to the very large one in the moment of maximum tension that is taking place on the stage between Cortez and the two princesses—the same sort of disruption (in this case accidental) to be found in many of Hogarth's earlier conversations— *The Cholmondeley Family* of the same year, for example (ill., vol. 1).

The Cholmondeley children were also set off as if on a stage, and the "audience" was as oblivious as the fathers in the *Indian Emperor* performance. In one way or another the children are always cut off from the rest of the family, and Hogarth likes to show this by bringing together a stuffy audience, a theatrical presentation, and a prison cell: adult reality looks on (or carries on in its own adult way) while children act out their version of what the adults are doing in the context of a kind of incarceration, or—as with the Cholmondeley boys—try to break out. The situation is, of course, a repetition of the first scene of *A Harlot's Progress,* with its "actors" and "audiences," and although there was no longer any child in that adult performance, the young woman from the country retained the child's innocence; her doom was to live out the child's role in an adult world.

A Scene from "The Indian Emperor" ranks with Hogarth's best conversations. It depicts the psychological ties linking various orders of experience: people, social event, stage and scenery; adults, children, and carved putti; guests, players, busts, and painted portraits. In short, the real, feigned (acted), carved, and painted interact within a single painting. And the richness of literary content cannot be dissociated from the effect of the formal elements—the wedge-shaped audience balanced by the children on the stage, itself balanced (as the eye moves up) by the mantelpiece, the bust, and the two portraits, and finally (completing the zigzag path of the viewer's eye), the upper reaches of the stage set.

A MIDNIGHT MODERN CONVERSATION AND SARAH MALCOLM

Despite these painterly commissions, by the autumn of 1732 Hogarth had decided on another large print with which to follow up the

success of the *Harlot's Progress;* too busy to produce a new painting, he turned to a conversation picture he had done a year or so before of a drinking club (ill., vol. 1), titled it *A Midnight Modern Conversation,* added an inscription claiming disingenuously that no portraits were intended, and this time advertised his subscription in the newspapers—a distinct and bold step for a painter relying on a reputation for gentility (fig. 4).

The subscription was announced on 18 December. On 8 December the vintners of London had launched a full-scale attack on Sir Robert Walpole's proposed excise on wine and tobacco, which had become the most controversial issue in the career of the Great Man. The city of London was, to say the least, strongly against the Excise Bill. Hogarth must have dusted off and engraved this particular painting because it showed both tobacco and spirits being consumed with abandon.

In his advertisement of 18 December in the *Daily Advertiser* he emphasized the number of "characters" included (in the manner of his painted "conversations") and his worries about pirates:

> MR. Hogarth having engrav'd a large Copper Plate from a Picture of his own painting, representing a Midnight Modern Conversation, consisting of ten different Characters; in order to preserve his Property therein, and prevent the Printsellers from graving base Copies to his Prejudice, proposes to publish it by Subscription on the Terms following.
>
> The Price Five Shillings for each Print, to be paid at the Time of subscribing; for which the Author will give an etch'd Plate, with a Receipt to deliver the Print on the first of March next. But if the Number already printed be sooner subscrib'd for, then the Prints shall be sooner deliver'd, and Notice thereof given in the Papers.
>
> The Picture and Print to be seen next Door to the New Play-house in Covent Garden Piazza, where Subscriptions are taken in.

He not only advertised, he used his own name and gave his address (Rich's new playhouse had just opened). His advertisement was repeated in every issue of the *Daily Advertiser* through December and (with slight changes) January.

By 25 January he had come to another important decision: he deleted the last sentence of the second paragraph and replaced it with "after which Time they will be three Half Crowns each." He had

probably discovered that his method of engraving-etching produced impressions by no means exhausted after some fifteen hundred had been printed. By this time it had occurred to him that he could increase the take by keeping both the profits of his subscription and all subsequent profits; so instead of limiting the printing to those subscribed for, he raised the price after the subscription and sold to the general public.

The painting was a long horizontal canvas of 31 × 64 inches (as opposed to the standard 25 × 30-inch canvas of these years), but he engraved it in the light of *A Harlot's Progress,* compressing the horizontal shape, enlarging the figures in relation to the picture space, and rendering, for such a crowded plate, a relatively balanced composition. Men are leaning back on opposite sides, like supporters on a coat of arms; a clock is balanced by a fireplace; and the two men in the foreground, one leaning back, the other precipitately forward, also balance each other. The bewigged figure is in the center of the table and only slightly off the exact center of the wall paneling. The result is what Pope would have called "harmoniously confused."

Hogarth underlined the vocal aspect of the print in his subscription ticket (fig. 5), which showed a motley group of singers performing the oratorio of *Judith,* singing the words, mock-heroic in this context: "The World shall bow to the Assyrian Throne" (rather like calling a drunken revel a "conversation"). The reason for choosing this particular oratorio, which was scheduled to be performed on 16 February 1732/33 at Lincoln's Inn Fields, can be attributed to Hogarth's friendship with the author, William Huggins; to their shared love of music; perhaps to the more particular fact that Huggins had just purchased the *Beggar's Opera* and *House of Commons Committee* paintings left unclaimed by the ruined Sir Archibald Grant; and to the contrasting harmonies of music and drunken sounds in the ticket and the print.[8]

The great popularity of *A Midnight Modern Conversation*—stimulated in part at least by the Excise Bill—was underlined by the piracies that immediately appeared and the infinite variety of copies and adaptations that followed on everything from snuffboxes and punch bowls to fan mounts. The print was presumably delivered (as promised) on 1 March. By the 12th a piracy had been advertised (*Daily Post*). Salt glaze ware mugs with rough approximations of Hogarth's design were available before the end of March; fan mounts were advertised in the *Daily Journal* for 24 May as sold at Mr. Chenevix's

and other toy shops, with "a Description of each particular Person"
attached "for the Entertainment of the Ladies."[9]

Hogarth's interests extended straight down from the dukes and prin-
cesses of his conversation pictures to the lowest denizens of the Lon-
don underworld. While he was conducting the subscription for *A
Midnight Modern Conversation* the papers for 5 February 1732/33 pub-
lished the first accounts of a particularly grisly murder: two old
women and their maid were found in their beds with their throats
cut from ear to ear. Next day the *Daily Courant* noted that the coro-
ner's inquest had brought in a verdict of willful murder and that four
laundresses in the Temple were committed to Newgate for the crime,
one confessing and impeaching the other three. Sarah Malcolm,
"formerly a Servant to the old Gentlewoman," was named in the
Daily Journal of the same day, and on Sunday night she was sent to
the Compter on suspicion. On Monday she was examined by Sir
Richard Brocas, the magistrate, and sent to Newgate. She confessed
the murder, which she claimed she committed in conjunction with
two Irishmen. "A Silver Tankard, a bloody Apron and Shift were
found in a Close-Stool, and two Bundles of Cloaths, in her Master's
Chambers, where she had hid them, and 45 Guineas concealed in
her Hair."

On 6 February Malcolm was again examined by Brocas and this
time confessed that "she and Mary Tracy, together with James and
Thomas Alexander, both Brothers, had for some time contrived
to rob the Chambers of Mrs. Duncomb"—telling how they had
sneaked into the flat, accidentally awakened the maid, and had to
murder the women. Malcolm was "remanded to Newgate, with
strict Orders for the Keeper not to let any Person have access to her,
and to set a Watch over her Day and Night, lest she should make
away with herself, she having refused any Sustenance since she had
been there." Late Thursday night, the 8th, the coroner's inquest
brought in a verdict of willful murder against Malcolm only, refus-
ing to accept her word about accomplices. (She had apparently ex-
pected to turn state's evidence and get herself off.)[10]

On 21 February was published a pamphlet called *A Full and Par-
ticular Account of the barbarous Murders of Mrs. Lydia Duncomb. . . .
With a Narrative of the infamous Actions of Sarah Malcolm, now in New-
gate for the said Murders*, price 2d, and a second edition with an ac-

count of the trial was out on the 26th. On the 22nd Malcolm was arraigned; she pleaded not guilty, and on the next day she was tried:

> after a Trial of about five Hours, the Jury brought her in guilty. She behav'd in a very extraordinary Manner on her Trial, oftentimes requesting the Court for the Witnesses to speak louder, and spoke upwards of half an Hour in her Defence, but in a trifling Manner. She confessed she was guilty of the Robbery, but not of the Murder, only standing on the Stairs.

Her speaking "in a trifling Manner" refers to the most notable aspect of her defense, which was her argument that the blood found on her linen—present on both her inner and outer linen—was menstrual blood and not the blood of the murdered women.

> If it is supposed that I kill'd her (i.e., Ann Price) with my Cloaths on, my Apron indeed might be bloody, but how should the Blood come upon my Shift? If I did it in my Shift, how should my Apron be bloody, or the back part of my Shift? And whether I did it dress'd or undress'd, why was not the Neck and Sleeves of my Shift bloody as well as the lower Parts?[11]

Upon hearing the sentence "she fell into Fits, but being recovered she was a second Time brought to the Bar, and asked if she had any thing to say for herself, to which she answer'd, No."[12] Subsequently, she declared herself a Roman Catholic and, it was reported, "behaves very penitent and devout, but still denies the Murder; she is removed out of the old condemned Hold into a Room, but one or two Persons are always with her." On 4 March she attended chapel with the rest of the condemned,

> and behaved in a most bold and impudent Manner; she still persisting on her Innocence of being concerned in the Murder, and has given Orders for a Shroud and a Pair of Drawers, which are making, in which Habit she resolves to die; and the Sheriffs of the City of London have given Orders to the City Carpenters for erecting a Gibbet at the End of Fetter-Lane in Fleetstreet, facing Mitre-Court, for her Execution next Wednesday [the 7th].[13]

Besides the scandal of her defense, the most notable facts of her case were her Roman Catholicism and her refusal to confess to the

murder (the confession and penance with which the Ordinary of Newgate's narrative traditionally closed).[14] The contrast between her bloody crime and her youth (she was just twenty-two), sex, and cool behavior after the murders also must have attracted Hogarth. Accompanied by his father-in-law, Sir James Thornhill, he went to Malcolm's cell on the Monday (5 March) before her execution and sketched her portrait. The event was reported by the *Craftsman* (with mention of Thornhill's presence) and the *Daily Advertiser,* which follows its account of Malcolm with: "On Monday last the ingenious Mr. Hogarth made her a Visit, and took down with his Pencil, a very exact Likeness of her, that the Features of so remarkable a Woman may not be unknown to those who could not see her while alive."[15] It is evident that Hogarth's taking Malcolm's portrait was considered appropriate, this being his public role in the community, and (if the wording is precise) that he sketched her in oils—"pencil" at this time denoting a brush. If so, he may have carried with him to her cell the small canvas that now contains the finished portrait (fig. 6).

Thornhill had established the precedent for such a criminal portrait by a painter of more exalted subjects when (in 1724, perhaps accompanied by Hogarth) he had sketched Jack Sheppard in Newgate and published the portrait in mezzotint. But Sheppard was a robber and escape artist; Malcolm, the murderess, added a new dimension. Hogarth tapped into the growing public interest in murder. Heralded by George Lillo's popular play, *The London Merchant* of 1731, the crime of theft was rendered more dramatic and final by the act of murder. Unlike heresy, blasphemy, or treason, murder called for a treatment somewhere between the religious explanations of the seventeenth century and the psychological explanations of the nineteenth.[16] Hogarth omits reference to the theft, emphasizing Malcolm's bare muscular forearms resting heavily on a table—on which lie her rosary beads—and the prison cell. He balances her figure with the heavy bars of the cell door: the right half of the composition, to which Malcolm turns her gaze, is otherwise empty. According to one story, he supposedly said to Thornhill, "I see by this woman's features, that she is capable of any wickedness."[17] It is a powerful psychological portrait, and it demonstrates his remarkable fluency in the oil medium.

Malcolm's hanging on 7 March was marked by the same kind of melodrama that characterized Lillo's play, her trial, and her performance in prison. Dressed "in a black Gown, white Apron, Sarsenet

Hood and black Gloves," she "appeared very serious and devout, crying and wringing her Hands in an extraordinary manner." Several of the scaffolds constructed for the crowd collapsed, "and several Persons had their Legs and Arms broke, and others most terribly bruised."[18]

All of this contributed to the lively interest in Sarah Malcolm, and in the same newspapers of 8 March that described her death appeared Hogarth's advertisement:

> *On Saturday next* [10 March] *will be publish'd,*
> A Print of SARAH MALCOLM, engrav'd by Mr. Hogarth, from a Picture painted by him two Days before her Execution. Price 6d.

The strength of the painting is dissipated in the etched version (fig. 7). Hogarth emphasizes Malcolm's face, making her upper body fill the picture space, and omits her beads; the heavy arms are now delicate and rest lightly and rather elegantly on a table that is off to one side. The face is still interesting, but the body might as well have posed for a society portrait.

The advertisement was repeated on the 9th, with the added information that it was "To be sold at Mr. Regnier's, a Printseller in Newport-street, and at other Print-shops." Regnier appears to have bought Hogarth's copperplate. Apparently Hogarth still distinguished at this time between serious modern moral subjects, to be painted, subscribed, and sold at his house, and an ephemeral catch-penny print. The latter, at 6*d*, was almost as easily sold as a newspaper. Piracies immediately followed, as he must have anticipated. Whether or not he had intended it, the sale of the print was also boosted by the political parallel between Malcolm's crime, strictly for gain, and Walpole's Excise Bill: if Jonathan Wild and Walpole were analogous as low to high villains, so too were the murderess Malcolm and the Excise Bill, whose demise (withdrawal) in April was connected by Opposition propagandists with Malcolm's execution. (Sir James Thornhill had been one of the M.P.s, usually a Walpole supporter, who abstained on the vote of the 10th.)[19]

Thus was Hogarth poised uneasily between the world of high society and the lowest depths; at this time he frankly wished to span the two worlds, but whether his patrons would be as willing as the

general public to accept an artist who portrayed both kinds of life, let alone implied a connection between them, was another question.

THE PORTRAITS OF THE ROYAL FAMILY

In 1733 Hogarth was commissioned to paint a conversation picture of the royal family and made two compositions to this end, one indoors and the other outdoors.[20] The indoor version (14½ × 19¾ inches, fig. 8) is a modello; the larger outdoor version, 25 × 30 inches (incidentally, the size of the *Rake* and the other "progresses" of the 1730s), is possibly the beginning of the agreed-upon painting, blocked out in preparation for sittings (fig. 9). The portrait of the duke of Cumberland is closely related to the figure in *A Scene from "The Indian Emperor."* The Prince of Wales's portrait (in the modello) also appears to have been based on a sitting, perhaps related to the faces Hogarth contributed to one of John Wootton's equestrian group portraits.

Charles Jervas, Principal Painter to George II, had been commissioned to add the faces in the equestrian pictures of Wootton, a successful horse painter but a poor portraitist. When Jervas's incompetence had become apparent to the king and queen, Hogarth, known for his ability to catch likenesses, had been called in. It is possible that Lord Malpas (now earl of Cholmondeley), who appears in the group and for whom Hogarth had painted a family conversation in 1732 (above, 4), was the moving force. He is mentioned on the bill for Wootton's painting as its sponsor, perhaps only because payment was made through him as Master of the Horse; but it may be indicative that Hogarth used the same sitting as the basis for Malpas's face in both pictures.[21]

At this point, riding the crest of his fortune, Hogarth looked forward to the most impressive ceremonial that had yet come within his reach: the marriage of the princess royal and the prince of Orange, which was to take place that autumn. According to Vertue he "made application to some Lady about the Queen that he might have leave to make a draught of the ceremony & chappel & paint it & make a print of it for the public" (3: 68). He was still balancing one patron against the other, trying to have the best of both worlds: he would

make the painting another *Assembly at Wanstead House* (ill., vol. 1) or *Indian Emperor,* only grander, but he would engrave it as well for his popular audience.

Although Vertue specifically says a lady-in-waiting was Hogarth's go-between, one wonders if Lord Hervey was not somewhere involved. A good friend of the duke and duchess of Richmond, an intimate of the queen, Hervey was vice-chamberlain and effectively in charge of the ceremony; four years later he commissioned one of Hogarth's liveliest conversations (fig. 79). Moreover, Hervey, with his deep sense of irony, especially concerning this particular wedding, must instinctively have seen the marriage through Hogarth's eyes. It is hard to imagine what would have resulted if Hogarth had rendered the scene with the fat princess and the deformed prince described by Hervey. He comments that "the faults of [the princess royal's] person were that of being very ill made, though not crooked, and a great propensity to fat." As to the prince of Orange, he

> was a less shocking and less ridiculous figure in this pompous procession and at supper than one could naturally have expected such an Aesop, in such trappings and such eminence, to have appeared. He had a long peruke like hair that flowed all over his back, and hid the roundness of it; and as his countenance was not bad there was nothing very strikingly disagreeable but his stature.
>
> But when he was undressed, and came in his nightgown into the room to go to bed, the appearance he made was as indescribable as the astonished countenances of everybody who beheld him. From the make of his brocaded gown, and the make of his back, he looked behind as if he had no head, and before as if he had no neck and no legs.[22]

One can almost hear Hervey add the familiar refrain: "had I but the pencil of Hogarth . . ." The situation called for a Hogarth: the princess who, like Jane Austen's Charlotte Lucas, must marry this one or die a maid, and marries with stoic dignity; the prince, deformed but noble and delicate of bearing; the king, appallingly rude, reminding the prince that his sole importance is as son-in-law to the king of England; the Prince of Wales, hating his father and mother and equally despised by them; and all the courtiers fawning on one side or the other. The picture might have been a cross between *Marriage A-la-mode* 1 and the Harlot's wake; but it was doomed from the start.

Hogarth's plans, however bold, ignored one important factor—unless they were indeed based on this knowledge, intending to pre-

cipitate a test of some sort. For the master carpenter, in charge of decorating St. James's Chapel for the ceremony, was none other than William Kent, and the lord chamberlain was Charles Fitzroy, second duke of Grafton. Grafton had already distinguished himself in his office by conferring the laureateship on Colley Cibber: "And Grafton, tow'ring Atlas of the throne, / So well regards a genius like his own," as Tobias Smollett later put it. [23] Kent could claim that Hogarth was impinging upon his prerogative, exactly as Thornhill had done with Kent a few years before; and Grafton, Burlington's son-in-law and one of Kent's most prominent patrons, could claim that Hogarth had gone over his head and wrongfully secured the queen's permission, interfering with his prerogative. [24]

In October the newspapers were full of the preparations for the wedding. On the 17th it was revealed that "Her Royal Highness' Train is to be borne by four Ladies and two Pages of Honour, to and from the Altar." [25] On the 24th a scaffolding erected for the redecoration of the chapel fell down; one man fractured his skull, another broke a leg. The next day the prince of Orange arrived after some delay, and the newspapers followed his every move, though not recording the rudeness of the king and the Prince of Wales or the general awkwardness of the situation. On the 30th Philippe Mercier, now gentleman usher to the princess royal, was painting the pictures of the three eldest princesses, sittings being held every day. [26]

Newspaper reports, unfortunately, were as close as Hogarth got to the scene. Vertue fills in the details:

> when Hogarth came there to begin his draught. he was by Mr Kents interest ordered to desist. Hogarth alledgd the Queens orders. but Ld Chamberlain himself in person insisted upon his being turnd out, and not to persue any such design. at least was deprivd of the oppertunity of persuing it of which, when the Queen had notice. she answerd she had granted such a leave but not reflecting it might be of use or advantage to Mr Kent, which she woudnt interfear with, or any thing to his profitt. (3: 68)

This episode may have precipitated the announcement in papers of 6 November stating that the day before "Orders were given by his grace the Duke of Grafton, Lord Chamberlain of his Majesty's Household, for shutting up the Doors of the Chapel and Gallery, that is preparing for the Marriage of the Princess Royal, by reason of the

great Number of People who come there daily, and hinder the Workmen from their Business."[27]

Nor was this the end of Hogarth's distress: Vertue noted that "M^r Hogarth complains heavily. not only of this usage but of another, he had some time ago begun a picture of all the Royal family in one peice by order the Sketch being made. & the P. William the Duke had sat to him for one. this also has been stopt. so that he can't proceed." Vertue's conclusion should be reproduced in full:

> these are sad Mortifications to an Ingenious Man But its the effect of carricatures wch he has heretofore toucht M^r Kent. & diverted the Town. which now he is like to pay for, when he least thought on it. add to that there is some other causes relating to S^r James Thornhill. whose daughter is marryd to M^r Hogarth, and is blended with interest & spirit of opposition—
>
> Hogarth has so far lost the advantage of drawing portraitures from the life that he ownes he has no imployment that way. but has mostly encouragement from the subscriptions for those designs of inventions he does.—this prodigious genious of invention characters likeness. so ready is beyond all others. (3: 68)

The second paragraph, before the dash and Vertue's comment, must reflect Hogarth's own words, regarding this event as a turning point in his career. Beyond the simple matter of Kent's prerogative was the increasingly disturbing public reputation of Hogarth himself. One can imagine the duke of Grafton asking the queen: do you want to be immortalized by the author of *A Harlot's Progress* and the painter of *Sarah Malcolm?* Then one can visualize other commissions and potential commissions falling away: as the crown goes, so goes the court. Still, as Vertue suggests, Hogarth was again working on "those designs of inventions he does"—*A Rake's Progress* and *Southwark Fair* were under way and he had finished their subscription ticket, *The Laughing Audience.*

2.

PATRON AND PUBLIC (II)

A Rake's Progress and the Engravers' Act, 1733–1735

THE HUMOURS OF A FAIR (SOUTHWARK FAIR)

At the other extreme from the royal marriage procession in the Chapel Royal at St. James's Palace was the procession led by a beautiful but plebeian drummeress advertising a show booth, surrounded by riffraff, beneath the towering booths and signboards of Southwark Fair (fig. 10). An actor in ducal costume, perhaps borrowed from the marriage procession, is being arrested by a bailiff. Even a church is present, and kings played by actors are falling off their rickety stage.

Both the painting and the print were announced finished in early December when Hogarth launched his subscription for what he called *The Fair* (or *The Humours of a Fair*) and a new progress, *A Rake's Progress* (figs. 13–23); the engraving was delivered to subscribers on 1 January 1733/34.[1] Although the painting was obviously well under way by the time of the events in St. James's Chapel, it would have appeared significant at the time of the subscription that *The Fair* invokes the topos of *de casibus,* the fall of kings. Very possibly Hogarth was recalling the entries in Swift's parody of the astrologer Partridge's *Almanack* (in the *Bickerstaff Papers,* 1709) that juxtaposed the fall of a booth at Bartholomew Fair and the affairs of the kingdom of Poland. But also in his mind was the falling puppet stage in Coypel's *Don Quixote* illustration (ill., vol. 1) and perhaps also the falling scaffoldings during the execution of Sarah Malcolm. By the time the print was published he and his audience would also have made the association with the collapse of the scaffold in St. James's

Chapel in preparation for the royal wedding. If *The Fair* started as a low alternative to his royal painting, it ended as a bitter comment on it and the transience of human hopes, whether royal or Hogarthian. Much larger than his "modern moral subjects" (47½ × 59½ inches), it is a magisterial comment on the assemblies and entertainments of the aristocrats which he had been painting. The reverse of *A Scene from "The Indian Emperor"* (of a comparable size), the audience and performers are poor people, whose illusions are harassed and threatened by bailiffs and by the shoddy construction that allows their stage to collapse.

The scene divides into three distinct strata: at bottom moiling humanity, in the middle the dreams and illusions fostered by players and mountebanks, and at the top the church steeple and open sky and, through gaps between buildings, the countryside. The *de casibus* motif is supported by the rope dancers and the rope plunger from the tower of St. George the Martyr (itself destroyed in 1733, not rebuilt until 1734) who invoke a long history of aspiration, success, and failure, including the death in 1732 (28 Sept., *Grub-street Journal*) of one

> flying man [who] attempted to fly from Greenwich church; but the rope not being drawn taut enough, it waved with him, and occasioned his hitting his foot against a chimney, and threw him off the same . . . to the ground; whereby he broke his wrist and bruised his head and body in such a desperate manner 'tis thought he cannot recover.

And, as the *Grub-street Journal* (5 Oct. 1732) added, "On Saturday [the 3rd] he died."

St. George's tower is virtually indistinguishable from the theatrical structures of the stages with their gaudy signboards, and the flying figure shows that it has in fact been preempted as another theatrical locus. The Union Jack also graces the tower, recalling the negative associations of church and state in *Royalty, Episcopacy, and Law, The Punishment of Lemuel Gulliver,* and other satiric prints of the 1720s (see vol. 1).

At the left, over the collapsing stage with *The Fall of Bajazet,* is a show cloth Hogarth must have added to the painting in the summer of 1733. In the spring he would have watched with interest the metaphorical fall of Drury Lane Theatre: the old patentees, Cibber, Wilks, and Booth, who had figured in *A Just View of the British Stage,* gradu-

ally slipped out of the picture through death and retirement until a wealthy young man-about-town named John Highmore, who had distinguished himself as an amateur Lothario in *The Fair Penitent* with the Drury Lane company, was discovered to have bought up the patents and to be in control of the theater. His unprofessional and sometimes high-handed management annoyed Theophilus Cibber (also annoyed because his father had sold his share of the patent instead of passing it on to his son), who himself contributed to the unease of the season. One of the controversial pieces which Cibber brought forward, a great money-maker that tided the company over its hard times, was his version of *A Harlot's Progress*. A complete break came in May with Highmore's "occupation" of Drury Lane and Cibber's exodus with almost the whole company for the Little Theatre in the Haymarket.[2] Hogarth's feelings must have been mixed, but his closest friends were on the loyalists' side. John Ellys represented the widow Wilks's interests and was apparently a friend of Highmore's; Henry Fielding, out of a sense of loyalty to the original theater, continued to work with Highmore—he and the actress Kitty Clive being the only members of importance to do so.

A satiric print by John Laguerre showing both sides poised for battle (fig. 11) was published on 4 July, and by the 27th a play called *The Stage Mutineers* (by Edward Phillips) was being performed at Covent Garden by the gleeful Rich. Laguerre, described in his obituary (1748) as "a facetious companion, universally esteemed in every scene of life," could afford to satirize both sides of the quarrel: he was Rich's principal scenery painter at Covent Garden.[3] Hogarth copied Laguerre's print, with some changes, making it into a large show cloth to hang above Theophilus Cibber's booth. Hogarth's version of *The Stage Mutiny* underlines the Cibber parallel by adding "Pistol[s] alive" under Theophilus (noted for his bombastic portrayal of Ancient Pistol) and "Quiet & Snug" under Colley. For his own amusement perhaps, he added a paint pot and brushes near his friend, the painter Ellys. He does not take sides: the preposterous actors on the right are simply balanced by the amateurs—gentlemen and painters—on the left.

The mutiny remained in the air and no doubt contributed to Hogarth's subscriptions. In September and October the ejectment suit against Highmore was played out in Chancery; the affair came to a head in November when Highmore made the mistake of having Harper, one of the rival actors, committed to Bridewell as a vagrant.

Thereafter the papers attacked Highmore and Ellys, compared Harper to Prynne or Sacheverell (depending on their editorial politics), and made much of "liberty." Harper was freed on 6 December, and by February of the new year Cibber had taken possession of Drury Lane and Highmore sold his shares at a loss. On 1 January 1733/34 the print of *The Fair* had been delivered to subscribers, but it would be another year and a half before *A Rake's Progress* was delivered.[4]

Although Hogarth generalized the setting as *The Fair* in his advertisements, in his later price lists he stipulated *Southwark Fair* rather than Bartholomew Fair, with which he was so much more familiar.[5] His memories of the latter, and his stored visual impressions, went back to his early youth. At this time, however, two dramatizations of the *Harlot's Progress* (one "with the Diverting Humours of the Yorkshire Waggoner") were playing at both fairs throughout the season and were still on the boards when he announced his subscription.[6] It is possible that some particular episode occurred at Southwark Fair—perhaps the story of the drummeress that has come down in legend. Hogarth, who made a separate oil sketch of her, is supposed to have personally intervened between her and a ranting, insolent spectator.[7] But the most reasonable inference to be drawn from his choice of Southwark is that he was, as Nichols reported, spending his summer months on the Surrey side of the Thames, taking a good look at the Southwark equivalents of his old haunts in Smithfield.[8] Bartholomew Fair offered him everything that Southwark did, including a church, except for the prospect of countryside and the associations with his marriage (as opposed to his childhood). And this is his first, and virtually only, work that implies something in nature besides the human figure (the beautiful drummeress) as a norm against which the alternatives of hard day-to-day existence and the illusions of the fair are to be judged.

As a pendant, a kind of Vanity Fair, *Southwark Fair* meshes thematically with the conception of the *Rake's Progress* and acts as a prologue, announcing its juxtaposed themes of acting and nature, tightrope walking and falls of various sorts, and including such direct parallels as gambling, an arrest similar to that in Plate 4, and the broadsword fighter of Plate 2. But *Southwark Fair* is also making an assertion about genre that applies to Hogarth's own painting/print: that all of these acts—involving juggling, music, dancing, opera, pantomime, entr'acte, tragedy, comedy—are equally legitimate parts of theatrical representation.

THE LAUGHING (OR PLEASED) AUDIENCE

The subscription ticket, *The Laughing* (or *Pleased*) *Audience* (fig. 12), which is announced as ready in the initial advertisement of 9 October 1733, represents not a fair but a conventional theater at Drury Lane or Covent Garden, and not the stage but the audience: the pleased lower orders in the pit, the sour-faced critic in their midst, and the bored gentlemanly fops in the boxes. The orange girls indicate that the theater is also a place of sexual assignation and license; the lure of Venus gets Rakewell—who aspires to be one of those gentlemen—started on his "progress" from Sarah Young to prostitutes and finally a rich old woman.

The Laughing Audience presents a model for Hogarth's idea of his audience. *Boys Peeping at Nature,* the subscription ticket for *A Harlot's Progress,* had in fact focused primarily on the artist—imitating Nature (an adjunct to the subject of social imitation in the series)—and only secondarily on the two audiences implied by the lifting of the veil of allegory. *The Laughing Audience* implies both a wider spectrum and a specifically theatrical model. But it is significant for an understanding of Hogarth's attitudes at this time that he excludes the footmen and rabble who occupied the gallery, to whom he will specifically turn in the late 1740s. As early as his *Beggar's Opera* paintings he had represented actors and audience as interdependent entities drawing on the ancient metaphor of life as theater (*theatrum mundi*). Later in his "Autobiographical Notes" (ca. 1760) he writes that he conceived his characters as "actors who were by Means of certain actions and express[ions] to Exhibit a dumb shew" and constructed his compositions as if in a theater (AN, 209).[9] Indeed, the passage I have used as epigraph for this volume—"Painters and writers speak and writers never mention, in the historical way of any intermediate species of subjects for painting between the sublime and the grotesque"—is immediately followed in Hogarth's manuscript by: "We will therefore compare subject[s] for painting with those of the stage" (212). Perhaps recalling *The Laughing Audience,* Aaron Hill, in the *Prompter* of 27 February 1736, compared Hogarth's art with the stage in praising him as a reformer; unlike his "rival theatre-managers," Hogarth gives purpose and propriety to his "dramas."[10] While the ticket shows the audience (the subscribers), the *Rake's Progress* represents the stage itself. In *Rake* 3 the inscription *totus*

mundus on the map being set afire by one of the whores refers not only to the total conflagration of the world but to "All the world's a stage . . ."

A RAKE'S PROGRESS

If *Southwark Fair* was intended as a step forward in terms of size and scope, *A Rake's Progress* (figs. 13–23) was another, with eight plates, two more than the *Harlot's* six. A rake's progress was so obvious a sequel to a harlot's that a poem of that title had appeared a month following publication of the *Harlot;* it is not necessary to suppose that Hogarth was inspired by this poem, or that the poet had heard that Hogarth intended to follow his harlot with a rake.[11] Hogarth no doubt had read Mary Davys's popular narrative *The Accomplish'd Rake* (1727) in which the protagonist, Sir John Galliard, is left alone in London: "The first progress he made in modern gallantry was to get into the unimproved conversation of the women of the town, who often took care to drink him up to a pitch of stupidity, the better to qualify him for having his pockets picked." And Davys sums up Galliard's "progress," as she calls it: "His drinking made him sick, his gaming made him poor, his mistresses made him unsound, and his other faults gave him sometimes remorse. . . ."[12]

The rake was the male counterpart of the harlot in the popular picture stories: such series as *Lo Specchio al fin de la Putana* were complemented with *La Vita del Lascivo,* in which the rake was ruined by courtesans (as Tom Rakewell apparently is in Plate 3).[13] But Rakewell is specifically a middle-class youth who attempts to imitate—or in the *Rake's* governing metaphor, to "play"—the aristocrat. Hence the first plate establishes his social class and origins, as Hogarth's earlier series had begun with the Harlot's arrival from the country, and shows him already (his father hardly buried) being fitted with a fashionable suit. Like an aristocratic rake, he has gotten a young woman pregnant and now buys her off; he apes all the latest London fashions, especially wenching and gambling. He therefore assumes various roles, running from "rake" to Paris, Nero, and (in the final plate) a sentimental version of Christ.

But the Rakewell of Plates 2 and 3 recalls the *putana's* rakish keeper in *Lo Specchio al fin de la Putana* who claimed descent from the em-

perors Claudius and Nerva and was ordering his portrait to join theirs. Rakewell has broken the mirror in which his face is reflected, destroying his own identity, and has cut out the heads of all the Roman emperors along the wall except Nero. He has thus identified himself with (taken on the role of) Nero, the worst of the lot.[14] He is consciously copying those epitomes of aristocratic vice, the Roman emperors, self-styled "gods" portrayed (characteristically) in copies after Titian that hang on the brothel's walls.

According to Puritan doctrine we must scrub away our own image from the mirror and replace it with Christ's (an *imitatio Christi*): "We all with open face beholding, as in a glass, the glory of the Lord, are changed into the same image."[15] Rakewell is conceived in the terms of John Bunyan's *Grace Abounding* and the spiritual autobiography, where one proceeds in the world surrounded by alternative self-images. Bunyan is constantly aspiring to the role of Christ but also fears that he has assumed the roles of Judas, Peter, or Essau, or a contemporary renegade like Francis Spiro.[16] Hogarth shows his protagonist, far from finding Christ, completely losing himself in his theatrical roles. He recalls rather the masqueraders satirized by Mr. Spectator, the coquettes disguised (like the Harlot) as Quakers, whores as fine ladies, or "Rakes in the Habit of *Roman* Senators": "The Misfortune is, that People dress themselves in what they have a mind to be, and not what they are fit for" (*Spectator* Nos. 8, 14). The reverse of the spiritual autobiography, Hogarth's "progress" shows the closing off of awareness—or the replacement of rebirth—with mere mimicry, imitation, and masking.

The most blatant of Rakewell's "roles" is assumed in the final scene, where, stretched out in his death agony on the floor of Bedlam, he is made to recall Caius Gabriel Cibber's Bedlam figures *Melancholy* and *Raving Madness;* but the composition, including the surrounding figures, would have been recognized as a *Pietà* or a Deposition by anyone familiar with the sorts of pictures collected by Rakewell (figs. 24, 25). (As if he had carried the Christ allusion—Rakewell's Christ role—a little too far in the painting by showing Rakewell clothed only in a loincloth, Hogarth changed this in the engraving to dark breeches.)

The Rake's mad assumption of the Christ role is supported by two of the other madmen: one who thinks he is a king and another who thinks he is God. On the latter's walls are portraits (legible in the engraving) of Athanasius, the fanatical advocate of the Trinitarian

doctrine, and St. Lawrence, whose words "I'm done on this side, you can turn me over now," recall the gridiron the Rake brought with him to prison in the previous scene (and which, in the context of his two "wives," may have the same connotations as the gridiron with St. Lawrence over the bridegroom's head in *Marriage A-la-mode* 1 [below, figs. 90, 91]). These are specifically the mad men who, in Swift's "Digression on Madness" (in his *Tale of a Tub,* 1704), either succeed in founding new religions and philosophies or are locked up in Bedlam.

There is, however, an equally valid provenance for Rakewell in the new science of aesthetics and connoisseurship as in Puritan conversion doctrine. The second scene begins as another conversation picture—Rakewell with a gardener, musician, dancing master, and jockey (all perhaps portraits); he has already become a collector. The painting above his head is a Judgment of Paris, his personal version of the Judgment of Hercules that informed the consciousness of post-Shaftesburyian connoisseurs and the first plate of *A Harlot's Progress.* In this scene Rakewell's options are apparently so many as to make choice impossible; but the painting narrows them down to Minerva, Diana, and Venus, or Wisdom-Chastity versus Pleasure. The third scene shows that he has predictably, aping Paris, chosen Venus and settled into a house of Venuses. As Hogarth retells the story in *The Battle of the Pictures* (1745, fig. 99), Rakewell in the brothel is juxtaposed with a Feast of the Gods.

Shaftesburyian aesthetics posited a civic humanist Man of Taste, the Hercules of Shaftesbury's *Notion of the Historical Draught or Tablature of the Judgment of Hercules* (1713), the same person Jonathan Richardson proposed when he argued in his *Science of a Connoisseur* (1719) that the function of art in polite society is to be collected and hung on the wall and emulated, with the clear implication that such behavior will raise the individual's status as well as character.[17] For such a person, in society, Richardson showed, lives among and defines himself or herself in terms of art objects—by the choice of them and later by their proximity.[18] But Hogarth replaces the polite Man of Taste with the Mandevillean egoist, driven by powerful passions which are expressed in his choice of paintings. In practice, we have seen, this is the rake in *Lo Specchio al fin de la Putana* who claims descent from the emperors Claudius and Nerva and has himself painted accordingly. The truth under Shaftesburyian disinterested-

ness and impartiality is revealed to be acquisitiveness, sexual passion, and above all the desire to rise in society. The brutal egoism of Rakewell firms up the model adumbrated in the gentler Hackabout.

Hogarth never valorizes these paintings: the painting of Paris in 2 is as oppressive as the painting of Rakewell's father in 1, who recalls the "framed" portrait of the Harlot's model Colonel Charteris in the doorway of *Harlot* 1. These are contrasted with the unframed clergyman, who *should* be her model, and the similarly unframed Sarah Young in *Rake* 1, who in fact "breaks" the frame of the door behind her, which had "framed" Charteris: the difference is that the clergyman was too preoccupied with clerical preferment to help Hackabout while Sarah does succor Rakewell. God Himself is replaced in the Rake's world by "One G–d one Farinelli," inscribed on a sheet of paper to indicate society's equation of art with religion, Paris with Christ, and a fashionable castrato singer with God. In these terms, the sixth scene serves as a parodic Agony in the Garden and the second a Christ in the Temple, who, rather than surprising the learned men with his maturity, learns only how to enjoy himself.[19] Or rather than a Judgment of Paris, possibly in the light of the third scene it is a Temptation by the Things of This World (*totus mundus* again). One may then notice all the crosses suggested by window frames, even by the Rake's detached queue in the seventh scene, and certainly the juxtaposition of various heads and "glories" or halos: in particular the platter behind the posture woman's head in 3 and the IHS (*in hoc signo*) emblem behind the bride's head in 5.

Beneath the paintings are the Harlots and Rakes, capable of choice but limited by the socially accepted, fashionable models painted and affixed above them to the walls, which he or she internalizes. As in the *Harlot,* masking turns into self-enclosure. Rakewell never ventures out of doors except once, and then he has hidden himself inside a sedan chair to get unseen past creditors from his flat to St. James's Palace, where he hopes to curry a pension but is pulled out into the open air by a beadle. The walls get closer and thicker until in his Fleet Prison cell he is surrounded by prisoners whose attempts to escape extend from wings to alchemy to a proposal for paying the national debt. The Rake's only escape from his cell is into madness and the chains of that final prison, Bedlam.

Good actions appear only as a natural human (but more often animal) action unconnected with the works of art on the wall. Sarah

Young's charitable actions are such, but they are based on her love of Rakewell, a specific man. We are not shown her carrying out a disinterested act of charity.

SARAH YOUNG

Hogarth must have intended to stress the contrast between the Harlot and the Rake. The marginality of the outcast Hackabout is modified by the example of Rakewell, who, to begin with, is male. He has none of the vulnerabilities of the Harlot except for being in a mild way, like her, an outsider: he is an outsider merely in the sense that his father was a rich merchant while he wants to be a rich gentleman. In the attempt he exploits his father's wealth, a young woman who is in love with him, and an old woman also in love with him. The futility of his attempt to be a gentleman relates him to the Harlot and her futile attempt to be a lady; but the Rake does not stimulate the deep ambivalence felt in the presence of the Harlot largely because of the vulnerability of her position. On the other hand, in *A Rake's Progress,* where there is a male protagonist, there is also a vulnerable female figure, whom the Rake oppresses. The lower-class woman whom he has seduced and buys off in the first scene—whose name we learn is Sarah Young—is in one dimension the marginalized Harlot (as he is a foregrounded Charteris). But in another dimension she fills the secondary position of the servant woman who remained devoted to the Harlot even after death. In Sarah Hogarth is carrying the Harlot type—the marginal female—over into *A Rake's Progress* but without her centrality or her guilt.[20]

Looking back at the cast of Hogarth's *Beggar's Opera* paintings we notice that if emotionally the Harlot drew on the sympathetic figure of Polly, structurally she filled the role of Macheath, the parody Hercules, yet with the divided loyalties of both characters. While the Harlot had (in Plate 2) Macheath's problem of too many lovers, in general her loyalties were divided among the country, her past, and the church and the attractions of fashionable London. The main difference, however, was that while Macheath "chose," Polly mediated—rather than chose—between her father and her lover. Polly's mediating function was not, of course, emphasized in the Harlot.

Separate entirely from her was her syphilitic servant woman, whose function was to serve (literally) as a bunter between the Harlot and the external world that was viciously closing in on her.

In *A Rake's Progress,* however, something of Polly the mediator remains in Sarah Young—at least after Plate 1, as she doggedly continues to return. In 4 she mediates, indeed intercedes, between Rakewell and the law, in a pose reminiscent of Polly's but now with religious associations. The oil that overflows the lamplighter's can, which appears to be anointing the Rake's head, recalls such passages as the lines addressed to Doctor Faustus in Marlowe's play: "I see an angel hover o'er thy head, / And with a vial full of precious grace, / Offers to pour the same into thy soul. / Then call for mercy, and avoid despair." [21] The dripping oil is a metaphorical equivalent of the "angelic" intercession of Sarah—though like Faustus, Rakewell does not repent.

Sarah returns in the background of Rakewell's marriage to the wealthy old woman in 5, carrying his baby, and in 7 she has joined him in his prison cell (but has fainted away). In the final plate she again fulfills her function of intercession, this time specifically in the pose of Mary in a *Pietà*. Within a year of the *Rake's* publication, this figure with its biblical associations has moved to the center of the composition in Hogarth's painting of *The Pool of Bethesda* in St. Bartholomew's Hospital, and she remains central to many pictures that followed. But she was already at the center, contemporaneous with the *Rake,* in its pendant *Southwark Fair,* as the pretty drummeress who visually holds together the disparate elements of the fair.

However, as suggested by her failure to convert the Rake—her collapse in the prison cell, which turns her into yet another of his burdens—Sarah is inefficacious; one critic has remarked, "surely the girl, still faithful to her betrayer, is the maddest creature in Bedlam." [22] In the first scene two Rakewell escutcheons—a vice with the motto "Beware"—offer a warning to the world at large concerning both father and son, but they also warn young Rakewell of his own motto—to beware the consequences of his prodigality. The two escutcheons, hanging as they do above the heads of the two women, Sarah and her mother (emphasized by the vertical lines of the door connecting escutcheons with each figure), also warn Rakewell of the consequences of his treatment of the Youngs, who will indeed, like his vice, never let him go, even unto death. In the same way, in 4 the sign "Hodson Saddler" behind Rakewell indicates that he is to be

"saddled" with the results of his extravagance *and* with Sarah Young, who is interceding for him with the bailiffs. Hogarth shows Sarah to be a Good Samaritan in 4 and a ministering Mary in 8, but from Rakewell's point of view she is both angelic and a grim consequence.

A MARRIAGE CONTRACT

The oil sketch, the same size as the *Rake* canvases, usually called *A Marriage Contract* (fig. 26), must have been made as a first thought for Rakewell's marriage with the old woman, before Hogarth decided to represent the marriage itself (5).[23] Instead he used the room with its picture collection for Rakewell's levee (2), replacing the paintings with a Judgment of Paris and two portraits of gamecocks, retaining the crowd of clients in the next room and the jockey with his trophy of a victorious race in the right foreground. It is a scene he mined for later works. He resurrected the contract in *Marriage A-la-mode* 1 (adding a great many more pictures) and the painting of *Ganymede,* the objets d'art with auction lot numbers, and the black slave in 4. He expanded the romantic triangle of the mutilated busts (the younger pair exchanging amorous looks while the older man looks away) into full-length sculptures of Venus, Apollo, and Hercules in the first plate of *The Analysis of Beauty* (1753), and he transformed the unfaithful husband receiving a clandestine note into an unfaithful wife in the second plate.

What he never used were the paintings on the wall above the Rake and his bride: as an ironic comment on the transaction he shows Old Master paintings of the Virgin Mary and the Christ Child, a Holy Family, and (the largest, as if the consequence of the sequence) an allegory of the eucharist showing Mary dropping the Christ Child into a hopper that transubstantiates him into coins that are emptied into a priest's offering plate. (Under the Madonna and Child is a framed painting of a foot, presumably another antique fragment such as the broken heads below.)

The images of the Madonna survive only in the false halo inscribed "IHS" above the old woman's head in 5 and in the imagery of the live "Madonna," Sarah Young, in the last four scenes. The antipapist strain, which one sees nowhere else so bluntly expressed in English

art of the time, reappears in *Enthusiasm Delineated* (unpublished, 1759–1760) and, toned down, in *Credulity, Superstition, and Fanaticism* (1763, both ill., vol. 3). But the concern with the Virgin Mary, the Holy Family, and the Trinity (in the reference to Athanasius in 8) persists as a subtext of Hogarth's paintings.[24]

POLITICAL AND PERSONAL REFERENCE

Rakewell's choice in 2 and 3 recalls the *Beggar's Opera* paintings and the iconography of Sir Robert Walpole, who hovered between wife and mistress (Molly Skerrett) and has more recently had himself sculpted by Rysbrack to evoke the bust of a Roman emperor.[25] But in 1728 Macheath was pardoned; in 1735 Rakewell's choice of Venus, paralleling Paris's, leads to a universal conflagration. The blind harpist, Hogarth implies, is present at the burning of the world (*totus mundus*) by a prostitute, much as the blind Homer imagined himself present at Ilium, and as Nero—directly adjacent on the wall—sang the "Sack of Ilium" while Rome burned.[26] The fire is materialized in 6, where the gambling house burns, perhaps as the result of the careless handling of another candle, perhaps following the bolt of lightning in 4 (added in a later state); by 8 the fire has focused on Rakewell himself sinking into syphilitic oblivion, "burned out" in body and in brain—the sense of "burning" in *Harlot* 6 when Hackabout's death was given the same date as the Great Fire of London.

The figurehead on the blind harpist's instrument is of that other harpist, David. This effigy of the biblical harpist, warrior, and king is placed so as to overlap the frame of Nero's portrait and their relative size makes the one facing the other appear a David confronting a Goliath; the upward movement of the harp suggests that David is physically challenging the emperor, Hebraic against classical cultures, the musician-poets of the Old Testament against the imperial Roman world and its English simulacrum, political and aesthetic.

The fourth scene is set on St. David's Day, 1 March, Queen Caroline's birthday. David in 3 is back to back with the observant Welshman with a leek in his cap in 4. Since the bailiffs are also Welsh, it appears that the first Welshman, whose belligerent stance is echoed by his dog's, is probably the Rake's creditor. Here St. David and the

sturdy Welshman serve as context for the effete Englishman on their saint's day trying to celebrate not the birthday of a native saint but of a foreign (German) queen.

The overtones are subtly political, from the familiar anti-Hanoverian sentiment to the acknowledgment of Wales's claims to independence. But David may also carry a personal reference, as it seems to have done in *Harlot* 2 (and would later in *Industry and Idleness* 6, below, fig. 119). Hogarth seems to have associated himself with David, perhaps because of their shared relationships with a King Saul and a Michal. In the context of the *Rake* this association serves to distinguish the artist Hogarth from his protagonist Rakewell, as in 2 it pits David against the classical values of Paris, Homer, and Nero. One is associated with independence and integrity, the other with emulation and conformity, Walpolian imperialism and Shaftesburyian aesthetics. But Hogarth may also have intended a wry self-parallel with the Rakewell who unsuccessfully attempts to reach St. James's Palace, where he hopes for royal patronage. The personal allusions focus on 7, where he places Rakewell in the Fleet Prison with his father, Richard Hogarth, and his proposal for paying the national debt.[27]

THE PAINTING AND THE PRINT

The *Harlot* plates were almost friezelike, and only in the fourth plate did a deeply receding plane appear; most of the scenes of *A Rake's Progress* have deep recessions and give a greater sense of motion, with people restlessly surging from front to back. The compositions are more crowded, with blurred demarcations between planes and less reliance on the frontal plane. The Raphaelesque norm, clearest in the *Hudibras* illustrations, has disappeared. If the *Harlot* still invoked the canons of classical history painting, the *Rake* nods toward northern "merry company" scenes, and in Hogarth's own work descends from *A Midnight Modern Conversation*. (*Southwark Fair* recalls Netherlandish genre paintings of a crowd of small figures before a large architectural background and sky.)

The arrangement of the figures—the surging, in-and-out movement—is, however, clearly related to French rococo. The second scene in particular invokes French models (the French engraver, Louis Gérard Scotin, was hired to engrave it, but as usual Hogarth

was dissatisfied and finished it himself). The reason for the stylistic change may be related to Hogarth's friendship with Hubert François Gravelot, the charismatic advocate of the rococo who arrived in London around 1732, but it also shows his continuing adherence to decorum and suggests that the Rake's story is on a slightly lower level than the Harlot's. Not Carracci or Raphael now but Lancret, Pater, and Gravelot. The story of a merchant's son who aspires to be an aristocratic rake calls for busier, less-defined shapes than the story of a mad knight errant or even of that cathected young woman the Harlot.

Since the paintings of *A Harlot's Progress* were destroyed, only with *A Rake's Progress* is it possible to consider history painting as it appears on the one hand in engraved reproductions and on the other in the paintings themselves. Turning from the austere engravings of the *Rake* to the paintings, it comes as a shock to discover how small (25 × 30 inches) and colorful they are. One would expect an innovator in history painting to maintain the monumental size if not the subject matter. Pieter Aertsen and Frans Snyders, for example, drew attention to their modification of history painting into still life by the size of their canvases. Hogarth begins with very modest paintings (*Southwark Fair* is larger but the scale of the figures remains small) in which, contrary to the impression of the engravings, he produces something close to his conversation pictures but less finished and clearly delineated. While small in size, they are painted with flair, and the viewer's attention is drawn to their color and texture.[28]

The most telling difference between print and painting is that the relatively clear focus of the print is replaced in the painting by "broken" brushwork and a shifting focus (which critics associated with Rembrandt). Some facets, some costumes, some details are carefully finished and clarified, while other areas (sometimes as important for the story) are vaguely sketched in. On the small scale of *A Rake's Progress* the effect is a Hogarthian version of the rococo, just beginning to show the S and C curves with which he came to decorate his paintings. The clarity of the prints dissolves in the paintings, not only in color but in lack of uniform focus, from sharp features to vague recessions.

The second thing to note is that color functions over the eight canvases of the *Rake*. However they are arranged on a wall, whether in a row or two deep, the viewer is aware of the predominance of earth colors, a single wedge of blue sky appearing in 4, with strug-

gling people emergent from the dark background. The colors relate the Rake, full-length, fully clothed in 1 and the prone, unclothed figure in 8. (We recall the parallel or contrast of colors in the outdoor *Before* and *After* paintings, the pale, aristocratic shape of the young man in the one in contrast to the flushed, disheveled, and collapsed figure in the other [ill., vol. 1].) A certain continuity can be traced in the pale pinkish gray of his suit in 1, the pink of his dressing gown in 2, and the almost obscene flush of his bare skin in 8. More could be said about an individual painting like 8, where the raw pink of the Rake's body is balanced by the refined pink of the fine lady's dress (which recalls the pink of his dressing gown in 2) and is related to the deep red of his keeper's coat.

In general, however, the *Rake* paintings seem to move not by comparison and contrast of colors (let alone by any scheme that corresponds to a temporal or causal progression, from crime to punishment) but by degrees of color concentration. If we take as normative the neutral background color, the underpainting that is itself symbolic of ordinary "colorless" existence, then the emergent bright colors reach a peak of warmth—earth colors into intensely hot reds and yellows—in the brothel. The pinks and reds are building up to the left of it in 2, and in 4 Rakewell is pulled out of a red sedan chair, located at the left side of the canvas, almost as if it were an antechamber to the brothel in 3. Thereafter the scenes get cooler and darker, from the cold, gray-walled church in which the Rake takes his aged bride, to the darkness of the gambling house, prison, and madhouse. The colors locate the peak of pleasure and involvement with the colorful world, and then document the Rake's gradual isolation, until he is merely a spot of flesh or color, laid out almost like a piece of meat in a market, a cool pink that recalls by contrast the warm reds of the brothel (and is picked up, as we shall see, in the Pool of Bethesda painting that followed immediately after). Sarah Young, Rakewell's redemptress, wears a bonnet with a touch of pink and a pink rose in her bosom.

If the difference between color and monochrome is the first important fact about Hogarth as printmaker and painter, whose product was both the engraving and the modello for the engraving, the second is that, faced with the engraver's problem of reversal, he chose to paint his modello in reverse rather than painting it straight and then engraving it in a mirror. While often careless in the painting of such details of reversal as hands and buttons, he was careful to

reverse the general "reading" structure of the design so as to retain the primacy of the print. It seems likely that Hogarth and his print-oriented audience naturally approached visual structures through the conventions of linear-verbal structures, reading—as they wrote—from left to right.[29]

In the engraving of the first plate (fig. 14) one's eye moves from the objects in the lower left corner denoting miserliness up and into the picture, to the lawyer stealing and Rakewell squandering the miser's estate, and so to the pregnant Sarah Young whose silence the Rake is buying. The sequence in general moves from avarice to prodigality, as Pope moved from Old to Young Cotta in his "Epistle to Bathurst," but also, more particularly, from action to consequence. The movement stresses causality: A produces B produces C.

In the mirror image of the painting (fig. 13), however, one's attention is caught by the group of Rakewell, the pregnant Sarah, and her mother and, moving beyond this group (rather puzzling thus encountered), finds only emptiness at the right. Approaching the picture in this way, one sees everything from Sarah's point of view, which produces a sentimental effect that is quite absent from the print and seriously distorts the import of the whole series. Likewise, in 3 (figs. 17, 18), the print forces one to enter through the figure of the Rake into his story; in the painting the subject is blocked and deferred by the figure of the undressing posture woman: they become competing centers of interest.[30]

The matter of reversal suggests that Hogarth's prints are more expressive as narrative and didactic structures than his paintings.[31] But the colors and textures also alter the order of perception, breaking and diffusing the causal pattern into contrasts—between Rake and posture woman, between the Rake's world and the real world. The painting develops independently, more as a genre piece, a simple portrayal of manners, than as a morality.

One is also aware of the sheer exuberance in Hogarth's laying on of paint, as opposed to the outlining and mechanical cross-hatching of the print. In this sordid scene, as in the *Rake* paintings, a sort of romantic glow is conferred on the subject; there is none of the scruffiness of Ostade's paintings of drunken boors. The technique of Hogarth's paintings—his bravura brushwork, his rich and creamy colors—seems to remove the scene from the harsh newsprint reality of the engraving. Even in the grim world of the *Rake,* in scene after scene one is bewitched by the soft, lovely colors and textures and

distracted from the relentless message. In the brothel scene something of Hogarth's grim point is lost as the eye glides from the soft pale greenish coat of the Rake to the rose salmon dress, golden stole, and white gloves and bonnet of the whore next to him. The moral comment made by the color and texture is on the false gentility of these characters, contrasted with their gross actions. But this is a very general point, and in the fourth painting the green and russet of the chairman, the green, gold, and white of the Rake, and the crimson of his leggings and the sedan chair—with the white and russet of the girl—all stimulate a delight in color and form that preoccupies the viewer when (according to the moralist) he should be concerned with other matters.

Such an effect can only detract from a work's moral purpose. Perhaps there is something inherently satiric or moral about the linear, black-and-white medium of the print. (When two viewpoints are diametrically opposed, we describe the situation as black and white.) The vocabulary of printmaking corresponds to that of satire: cut, needle, acid, mordant (the name for etcher's acid), and bite ("the controlled corrosion of metal by acid which is the heart of the etching process").[32] Hogarth had not discovered how to *paint* a morality; he had not learned Goya's lesson, that a painting can be ugly. For Hogarth the lace or silk must charm, the female curls or complexion must allure. He had no convention in terms of paint and brushwork to correspond to the shapes of the black-and-white engraving, partly because the shapes themselves were purposely those of ordinary representational art, while Goya's bilious colors and agitated brushwork correspond to his expressionist forms. Hogarth, avoiding the quality he referred to under the general term "caricature," had no expressionist forms. Moreover, Goya tries to show a world gone completely awry, while Hogarth is still presupposing stability, order, and beauty—although sometimes he may question them.

It might be argued that the print presents a satire, a moral and rhetorical structure, and the painting then offers Hogarth the opportunity to flex his muscles as well as elucidate (within the limits of the general composition). He realized the difference that color made, as he realized the effect of reversal. He could have painted straight and reversed his engraving, but, perhaps recognizing that he could achieve greater fluency with the brush than with the burin, he chose to block out the picture backwards and paint it freely, con amore, and then draw it carefully on the copperplate. His attitude toward

the painting is therefore curiously ambivalent: it is an end in itself, and yet it is always painted with an eye on the print that will follow. It is seemingly painted to please the artist himself, and also to appeal to a collector-purchaser. Color may have been intended as a bonus, something to make the paintings a more deluxe item than the prints. But chiefly, I suspect, it was important for Hogarth to make this gesture in paint which was beyond and free of the engraving, because it designated him "painter" rather than merely "engraver."

Hogarth, I am sure, felt he was on the side of decorum. His clear demarcation of print and painting complies with the rule that demands sober colors for a sober scene, and with the Poussiniste ranking of drawing over color in history painting. John Elsum formulated the first in his *Art of Painting after the Italian Manner* (1703), when he said of the artist that "in Painting Men that are Old, Philosophers, Poor, Melancholy, and Brave, he must use such Colours as are sad, and deprived of vivacity." Hogarth's own palette is reflected in Elsum's advice: "Rose Colour, Light Green, and Light Yellow, appertain to Virgins, young Men, Harlots &c. Fine and glaring Colours to Buffoons, Scaramouches, Mimicks &c."[33] Of course the same applies to brushstrokes: a solemn subject should not draw attention to its painting with a light, lively touch; a Raphael subject should not be painted by a Venetian. One explanation for his procedure could be found in the precedent of such painters as Thornhill, whose St. Paul's panels are grisaille and figures stand out in full articulation, arranged planimetrically, evoking memories of the Raphael Cartoons. Like Hogarth's engravings, these paintings are black and white; one might say that Hogarth's prints approximate the monochrome of these, as his oil paintings supply the place of Thornhill's loosely painted modelli for the St. Paul series, in bright Venetian colors.

The academic (Poussiniste) view held that drawing was superior to color because its appeal was more purely intellectual, while color appealed to the eye alone. A work that appealed strictly to the mind—if that is accepted as painting's chief aim—would indeed have to avoid distracting colors. Color, John Dryden put it, is "*the Bawd of her Sister,* the Design or Drawing: she cloaths, she dresses her up, she paints her, she makes her appear more lovely than naturally she is; she procures for the Design, and makes Lovers for her: For the Design of it self is only so many naked lines."[34] Thus color can be distracting in history painting, like the fawns and satyrs of the oper-

atic style decried by Steele. Color is what Addison most clearly associ-
ated in his *Spectator* papers called "The Pleasures of the Imagination"
with his category of the "beautiful," as opposed to the "great,"
which consists of primary qualities. An advantage of the print over
the painting, as Jonathan Richardson noted, is that in the painting
"other qualities" such as color and texture "divert, and divide our
attention, and perhaps sometimes bias us in their favour through-
out," while the print lets us see the master's design and intention
"naked."[35] A background assumption which may have influenced
Hogarth, then, was that color is an additive, apart from the moral
being of Nature. In his prints he presented a world of primary quali-
ties where reason "might see light pure, not discolored, refracted, or
inflected."[36]

In one sense then color is a secondary, cosmetic quality, relying on
the senses but not inherent in nature itself. Color may be thought of
as a projection of the poet's mind, as self-expression or how he sees
qua artist, opposed to the black-and-white *real* world of primary
qualities in his engravings. In the print the artist is effaced, and form
as form is less evident because the print is reproductive to begin
with, a copy of a copy: the "idea" is all that remains. The execution,
the self-expression, is in the painting. These flourishes produce a pic-
ture that is about the print's subject *and* about the artist who shapes
and sees reality in this way.

Giampolo Lomazzo and Franciscus Junius, however, connected
color, as another tool of rhetoric, directly with the painter's function
as orator and poet to teach, delight, and move. Hogarth may, in the
early paintings, be reflecting the view that color and light could be
used to define reality *or* to move the passions. His flickering chiar-
oscuro, so much more evident in the paintings than in the prints, may
have been intended to bring out the painting's ability to move, as
opposed to the print's to be read.[37]

At bottom, however, the painting and the print expressed different
positions for Hogarth the artist. The painting was a graphic equiva-
lent of Pope's satire in which the poet metamorphoses the grossest,
lowest contemporary reality into something strangely beautiful, re-
flecting the genius of the artist who effects the transformation. And
the engraving was an equivalent of Swift's plain style which, coldly
recounting the most horrific human actions (babies sold for meat and
ladies flayed or dismembered), emphasized the horror.

As a final emphasis, Hogarth also added beneath his prints the moralizing verses of his friend (and son of the bishop) John Hoadly. These verses offer their separate, even personal comment on the graphic narrative: they were evidently inspired by the paintings and offered to Hogarth, who accepted them and cut them to fit under the designs. Some years later Hoadly was urging Robert Dodsley to print the complete verses in one of his *Miscellanies*. One reason for printing them, he says, is "that they will be ye only Copy of mine, of a grave Turn of Thought."[38] In effect, however, Hoadly's allegorizing and overt moralizing returned Hogarth's images to the operatic history against which he was reacting, and he never used verses again until he required a clearly moral embroidery for *Beer Street* and *Gin Lane* and *The Four Stages of Cruelty* (1750/51, ill., vol. 3).

In general Hoadly's poem simply draws out one aspect of the plate. In 3 it is the danger of women and wine; in 4 the consequences of rakish behavior in punishment and poverty, the Rake's only recourse being penitence (with a specific reference to Sarah: "Whom he hath wrong'd, & whom betray'd"); in 5 the "shame" of being reduced to marrying an old woman for her "gold"; in 6 the evil of gold; in 7 a *beatus ille* passage contrasting a past well spent with one ill spent leading to prison; and in 8 the terror of madness. Only the first two are of interest: in 2 Hoadly allegorizes the figures of the dancing, music, fencing masters as figures in the train of Prosperity. In 1 he emphasizes the father and his greed: the moral is for fathers to raise their sons in the right way. The verses in this case emphasize the moral, placing an emphasis that in the print itself is subordinate, though it is important in Hogarth's graphic vocabulary that Rakewell's father be embodied in a painting on the wall, the place for symbols of authority and emulation (and shown using the scales of justice to weigh money). It is possible that Hogarth told Hoadly to emphasize the father, but the emphasis could merely reflect Hoadly's own concerns with a powerful and dominant father.

THE ENGRAVERS' ACT

To return to 9 October 1733, the first announcement of Hogarth's new subscription read as follows:

> MR. HOGARTH being now engraving nine Copper Plates from Pictures of his own Painting, one of which represents the Humours of a Fair; the other eight, the Progress of a Rake; *and to prevent the Publick being imposed upon by base Copies, before he can reap the reasonable Advantage of his own Performance,* proposes to publish the Prints by Subscription on the following Terms . . . (emphasis added)

Although, having created his own market and replaced the middleman by a subscription, he was in a much stronger position than the ordinary engraver who was completely at the mercy of the printsellers' monopoly, Hogarth suffered the double annoyance of seeing large sums of money he felt rightly his still going to other parties, and of seeing wretched copies made of the works he had labored over with such care.

In 1733 a purchaser could go to Philip Overton and obtain prints of the *Harlot's Progress* at 15*s*, or to Giles King for the authorized copies at 4*s*; the originals, at a guinea, had been completely expended on subscribers, and Hogarth's contract with them stipulated that no more impressions would be pulled. A copy of *A Midnight Modern Conversation* was available for one shilling, as opposed to five for the original in Hogarth's shop.[39]

The idea of petitioning Parliament seems to have been Hogarth's—the Engravers' Act has always been called "Hogarth's Act." The evidence for his initiating it is circumstantial but strong. More than anyone else, Hogarth had proved the assumptions upon which the Engravers' Act was to stand, and the treatment he had received from the pirates of *A Harlot's Progress* was probably the immediate stimulus. Thornhill's experience in Commons and his practical advice may have seen Hogarth through the earliest stages of planning. He wrote, or had someone else write, a pamphlet that took the form of a petition to Parliament, and his friend William Huggins served as legal consultant.[40]

Three issues overshadowed the Engravers' Act: the evils of copying, the evils of the printseller, and the artist's right to his property. As early as *A Harlot's Progress* Hogarth had detected the analogy between the emulation of upper-class behavior and the copying of art: both are based on the assumption that the copy is as good as the original.[41] As he lobbied for the act, he thematized copying in *A Rake's Progress,* which is about genuine versus imitation, original ver-

sus copy in the story of the merchant's son who tries to be an aris-
tocratic rake. The vicious mediation of the printseller between artist
and consumer was also on his mind, and this may have been re-
called, for Hogarth at least, by the benevolent mediation in the
Rake of Sarah Young. Thus his attention moved from the pirated
copy to the original work of art, whose ownership (to follow
Locke's discussion of property in his *Second Treatise*) derives from
the artist's "labor," as opposed to the mere possession by the
collector or dealer of antique sculptures and Old Master paintings
and copies gathered (sold, bought).[42] Hogarth's art embodied the
Lockean valuation of labor as self-expression. The objects he makes
are, in short, *self*-expressive, virtually an extension of the self. But
at the same time these works are per se salable, transferable within
a market society. And so with the sense of ownership comes an
accompanying anxiety—and, in Hogarth's case, the need for extra
assertion.

For Hogarth property meant legal ownership and financial profit,
but also, and in some ways as important, the determination of its
meaning. The latter he sought to accomplish by creating his own
context for his product. This context he created by engraving his
paintings, selling the engravings himself, as time passed providing
explanations and arranging them according to his own plan in folio
collections—and, with the paintings themselves, establishing their
setting vis-à-vis a public audience, not a private collector. So long as
printsellers could have his designs copied and vended, he did not
control the meaning of his product.

The act Hogarth projected was based on the literary copyright act
of 1709 (*8 Anne,* cap. 19), "An Act for the Encouragement of Learn-
ing by vesting the Copies of printed Books in the Authors or Pur-
chasers of such Copies during the Times therein mentioned." The
main provisions were that the copyright of works already published
was secure to the present owners (whether authors or booksellers)
for twenty-one years; future authors had sole printing rights for
fourteen years, which they could assign to another (i.e., a bookseller)
for an amount that would appear fair. After the first fourteen years,
the copyright returned to the author (if still living) for a second four-
teen. Pirates were condemned to forfeit all the offending books and
were fined 5*s* a sheet for every copy found, half going to the Crown,
half to the injured author. Thus the author could sell his copyright

outright, or for a single edition, afterward bargaining for new con-
ditions, or he could keep it entirely to himself.[43]

As Hogarth (or his spokesman) presented the argument in the
pamphlet, *The Case of Designers, Engravers, Etchers, &c. stated. In a
Letter to a Member of Parliament* (undated, probably 1735), the art-
ists—the designers and original engravers—are "oppress'd by the
Tyranny of the Rich" (elsewhere referred to as "the Monopoly of the
Rich"): "not the Rich, who are above them; not the Rich of their
own Profession; but the Rich of that very Trade which cou'd not
subsist without them." These are the printsellers, who exploit the
original designer, his engraver, and the wretched hacks who engrave
their cheap copies—those "Men who have all gone through the same
Distress in some degree or other; and are now kept Night and Day
at Work at miserable Prices, whilst the overgrown Shopkeeper has
the main Profit of their Labour." Moreover, if an independent print-
seller "should dare to exceed the stated Price for any Print he should
think more valuable than ordinary; Copies are immediately procured
by the others, and sold at any Price, in order to suppress such a
Rebellion against the Monopoly of the Rich."

The pamphlet takes the side of the oppressed artist against the
monopolistic printsellers. Although never named, Hogarth seems to
be the chief example, included among the artists who, like the strug-
gling engraver of 1724, lack "Houses conveniently situated for ex-
posing their Prints to sale" and so must resort to printsellers, and
also among those who, like the prosperous entrepreneur of 1735,
"have much more advantageous Ways of spending their Time, than
in shewing their Prints to their Customers." Those needing protec-
tion are not only the inventive artists like Hogarth, but also "those
who take their Designs from Portraits, Paintings, Buildings, Gar-
dens, &c."—who prove that "the whole Profession is entirely in the
Power of the Shopkeeper."

The pamphlet's subject, however, is only partly the evil of the
exploitive printseller. More important is the "Improvement of the
Arts" in England, which can only be brought about if the English
artist can receive his just profits and spread his wares and his fame
through good engravings (not shabby copies). Then the purchaser
too will have a greater choice of prints at a lower price, "for when
every one is secure of the Fruits of his own Labour, the Number of
Artists will be every Day increasing." Even the printseller will in-
crease his profits, because he will have a greater range and better

quality of prints to offer as alternatives to the imports from the Continent.

The solution, as the pamphlet argues, is simply to pass a law against one artist's copying the designs of another. By "copying" is meant a shape-for-shape, distance-for-distance, part-for-part reproduction, with "so many Marks of its being a direct Copy, distinguishable by the most common Eye, that it will be impossible for it not to be discover'd when compared in Court with the Original." And, the writer states specifically, it is still an actionable copy if the engraver merely adds or subtracts a figure from it when all the others are obviously copied.

It is not certain when the idea of petitioning Parliament first occurred to Hogarth, but the *London Evening Journal,* 2 November 1734, carried the following announcement, which may suggest that the "several additional characters" were part of a tactic to delay publication until a copyright law could be legislated:

> MR. HOGARTH hereby gives Notice, that having found it necessary to introduce several additional Characters in his Paintings of the *Rake's Progress,* he could not get the Prints ready to deliver to his Subscribers at *Michaelmas* last (as he proposed.) But all the Pictures being now entirely finished, may be seen at his House, the *Golden-Head* in *Leicester Fields,* where Subscriptions are taken; and the Prints being in great forwardness, will be finished with all possible Speed, and the Time of Delivery advertised.

The petition presented to the House of Commons was dated 5 February 1734/35, signed by (besides Hogarth) George Vertue, George Lambert (who was now having his landscapes engraved), Isaac Ware, John Pine, Gerard Vandergucht, and Joseph Goupy (who carried with him the influence, such as it was, of the young Prince of Wales). "Artists and Designers of Paintings, Drawings, and Engravers of original Prints, in behalf of themselves, and others" presented the petition in the House

> alledging, That the Petitioners, and others, have with great Industry and Expence, severally invented, designed, or engraved, divers Sets of new Pictures and Prints, in Hopes to have reaped the Benefit of such their own Labour, and the Credit thereof; but that divers Printsellers, Printers, and other Persons, both here and abroad, have, of late, too frequently taken the Liberty of copying, printing, and publishing,

great Quantities of base, imperfect, and mean, Copies and Imitations thereof; to the great Detriment of the Petitioners, and such other Artists, and to the Discouragement of Arts and Sciences in this Kingdom: And therefore praying, That Leave may be given for a Bill to be brought into the House, for preventing such Frauds and Abuses for the future, and securing the properties of the Petitioners, as the Laws now in being have preserved the Properties of the Authors of Books; or in such other manner as by the House shall be thought fit.[44]

The petition was referred to a committee to examine and report on it, which met that afternoon in the speaker's chamber. Hogarth was not himself called by the petitioners as a witness, perhaps because he embodied all three parties—painter, engraver, and distributor. The engraver Bernard Baron testified that some hunting pieces he had engraved for Wootton had been "copied by another Person; and that the Copies were sold at a very Low Rate, which hindered the Sale of Mr. *Wooton*'s Originals." Henry Fletcher testified that he and two others designed and engraved a set of flower prints, which cost them £500; they sold them at two guineas a set, painted in color, but before long they were copied by another and sold for one guinea with color and half that without. Isaac Basire (father of the engraver who later worked for Hogarth) then produced these copies, which had been made by him, presumably at the instigation of a printseller. The committee concluded that the petitioners had proved their allegations and ordered that "Leave be given to bring in a Bill for the Encouragement of the Arts of designing, engraving, and etching, historical and other Prints, by vesting the Properties thereof in the Inventors and Engravers, during the Time therein to be mentioned." Their report, read by Sir Edmund Bacon, was presented on 14 February. Bacon, Edward Thompson of York, and John Plumptre of Nottingham were ordered to prepare the bill.

The first reading of the bill took place on 4 March, the second on the 13th, and it was assigned to a committee meeting the same afternoon at five in the speaker's chamber. On 2 April the bill returned from committee with report and amendments, which were read through first and then one by one, the question generally put, and the amendments agreed upon (with some amendments to them). The bill, with amendments, was ingrossed. On 11 April the bill was given its third reading, and the clause assigning Hogarth's friend John Pine a monopoly on the engraving of the House of Lords tapestries

(a project dear to Vertue's heart) was added at this time. It passed and was carried by Sir Edmund Bacon to Lords.[45] The bill had its first reading in Lords on 15 April, and was returned, approved, to Commons on the 25th.[46]

Sir Robert Walpole could most probably have either stopped or pushed through this bill, which made Hogarth financially independent. It would be dangerous to pursue the symmetry of the Engravers' Act and the Licensing Act of 1737, which we know had Walpole's strong support and effectually cut short Henry Fielding's career on the stage. The evidence of the Walpole Salver (see vol. 1) might suggest that Walpole had bought Hogarth's silence. After the commission of the salver in 1728 Hogarth did in fact cease making overt anti-Walpole satires. But *A Harlot's Progress* showed that by 1732 he was publishing at least indirect references to "Walpolism"—and perhaps in the first plates of *A Rake's Progress* as well.[47] But only with the passage of the Engravers' Act did he definitively turn his attention away from Walpole. It was following the publication of the *Rake,* one story has it, that the Opposition invited him to draw a "Statesman's Progress," but he refused.[48] What is certain is that the act could not have been passed without Walpole's approval and that two members of the Walpole family were on the committee that investigated the petition.[49] On the other hand, besides engraving the Walpole Salver, Hogarth had already assisted Thornhill in his House of Commons group portrait that featured Walpole, and he painted Walpole's daughter's family in *The Cholmondeley Family* (ill., vol. 1), his son Horace, in the mid-1730s Lord Hervey and other Walpole supporters, and later Sir Edward Walpole.

The act that was passed ensured against unauthorized copies for a period of fourteen years from the date inscribed on each print, and for every print discovered a 5-shilling fine was to be imposed. The effective date given, however, was 25 June, which Hogarth may not have anticipated; to his advertisement for the *Rake* of 3 May he added

N.B. Mr. Hogarth was, and is oblig'd to defer the Publication and Delivery of the abovesaid Prints till the 25th of June next, in order to secure his Property, pursuant to an Act lately passed both Houses of Parliament, now waiting for the Royal Assent, to secure all new invented Prints that shall be publish'd after the 24th of June next, from being copied without Consent of the proprietor, and thereby preventing a scandalous and unjust Custom (hitherto practised with Impunity)

of making and vending base Copies of original Prints, to the manifest
Injury of the Author, and the great Discouragement of the Arts of
Painting and Engraving.[50]

At this point a piratical printseller put into motion a strategy which
Hogarth had evidently not foreseen. A series of agents were em-
ployed to enter Hogarth's shop and, from observation of his paint-
ings or prints, produce pirated versions which could be published
before Hogarth's and before the act went into effect. These men re-
turned to their employers with a description of what they had seen.
The engraver or engravers (the style of the piracies suggests several)
then worked by hearsay, from garbled and probably contradictory
descriptions, as a police artist does in reconstructing the face of a
criminal from eyewitness reports (fig. 15).[51] The engravers must also
have been plagued by the necessity for haste. How completely Ho-
garth transformed the popular lives of the Rake can be seen by
comparing the work of the memorial plagiarists: whenever their
memories failed they reverted to precisely the traditional iconogra-
phy from which Hogarth had broken away, and in some cases to
motifs from his own *Harlot*.

On 15 May the Engravers' Act received the royal assent.[52] By the
beginning of June the plagiarist engraver had done his work, and the
Daily Advertiser for the third announced: "Now printing, and in a
few days will be publish'd, the Progress of a Rake, exemplified in
the Adventures of Ramble Gripe, Esq; Son and Heir of Sir Positive
Gripe; curiously design'd and engrav'd by some of the best Artists."
The ingenious publishers were the best-known London printsellers,
Henry Overton, Thomas and John Bowles, and John King. Hogarth
had by this time learned of the trick, and the same day published his
notice:

SEVERAL Printsellers who have of late made their chief Gain by
unjustly pyrating the Inventions and Designs of ingenious Artists,
whereby they have robb'd them of the Benefit of their Labours, being
now prohibited such scandalous Practices from the 24th Day of June
next, by an Act of Parliament pass'd the last Session, intitled, *An Act
for the Encouragement of the Arts of Designing, Engraving, Etching, &c.*
have resolv'd notwithstanding to continue their injurious Proceedings
at least till that Time, and have in a clandestine Manner procured
[mean and necessitous—*added on the 7th*] Persons to come to Mr. Wil-

liam Hogarth's House, under Pretence of seeing his RAKES PROGRESS, in order to pyrate the same, and publish base Prints thereof before the Act commences, and even before Mr. Hogarth himself can publish the true ones. This behaviour, and Men who are capable of a Practice so repugnant to Honesty and destructive of Property, are humbly submitted to the Judgment of the Publick, on whose Justice the Person injured relies.

N.B. The Prints of the RAKES PROGRESS, design'd and engrav'd by Mr. William Hogarth, will not be publish'd till after the 24th Day of this Inst. June: And all Prints thereof published before will be an Imposition on the Publick.

Only now did Hogarth decide to have cheap copies made (as he had with the *Harlot*): apparently he had not expected to. In the *London Evening Post,* 17–19 June, he added to his announcement:

Certain Printsellers intending not only to injure Mr. Hogarth in his Property, but also to impose their base Imitations of his RAKES PROGRESS on the Publick, he, in order to prevent such scandalous Practices, and shew the RAKES PROGRESS exactly (which the Imitators of Memory cannot pretend to) is oblig'd to permit his Original Prints to be closely copied, and the said Copies will be published in a few Days, and sold at 2s. 6d. each Set by Tho. Bakewell . . . all persons may safely sell the said Copies without incurring any Penalty for so doing.

The Bakewell copies at 2*s* 6*d* were aimed at those buyers who could not afford either the originals at 2 guineas or the piracies at 8*s*, and were smaller than either of these.

The next issue of the *London Evening Post* (21–24 June) carried only the advertisement; and on the 25th—as the act took effect—the genuine *Rake's Progress* was delivered to subscribers. But four days earlier the *Whitehall Evening Post* announced the Ramble Gripe piracy of the *Rake* as published. Having now seen it, Hogarth repeated his complaint in the *London Daily Post* for 27 June, with angry variations: the piracy is "executed most wretchedly both in Design and Drawing"; and he notes nervously that his own authorized copies will be ready "in a few days." There was, in fact, a delay of six weeks before his copies appeared on 16 August—again showing how late had been his decision to employ Bakewell. Finally, on 19 July (*Craftsman*) he opened the original *Rake's Progress* to the general public:

Pursuant to an Agreement with the Subscribers to the RAKE'S PROG-
RESS, not to sell them for less than two Guineas each Set after Publi-
cation thereof, the said original Prints are to be had at Mr. Hogarth's,
at the Golden Head in Leicester-fields, and at Tho. Bakewell's, Print-
seller, next Johnson's Court in Fleet-street, where all other Printsellers
may be suppli'd.
 Next Week will be published,
 Copies from the said Prints, with the Consent of Mr. Hogarth, ac-
cording to the Act of Parliament, which will be sold at 2s. 6d. each
Sett, with the usual Allowance to all dealers in Town and Country; and
that the Publick may not be impos'd on, at the Bottom of each Print
will be inserted these Words, viz. Publish'd with the Consent of Mr.
William Hogarth, by Tho. Bakewell, according to Act of Parliament.
 N.B. Any Person that shall sell any other Copies, or Imitations
of the said Prints, will incur the Penalties in the late Act of Parliament,
and be prosecuted for the same.

Hogarth has now established his practice: after the subscription, the
prints can be bought at a higher price; and they can also be had "with
the usual Allowance" by other print dealers.

Either the Engravers' Copyright Act worked better than the writ-
ers', or was easier to enforce, or many pirated prints have vanished.
The only ones that can be cited with any certainty are Dublin copies.
The exceptions were in the cheap "popular" prints such as the por-
traits of Lovat and Wilkes, when copies appeared everywhere—in
the *Gentleman's Magazine,* in newspapers, and as frontispieces to var-
ious pamphlets and books.[53]

The act, of course, presumed that a pirate would have little interest
in copying a fourteen-year-old print. This was to underestimate,
however, the continuing popularity of Hogarth's engravings, the
copyrights of which began to expire in 1750. He apparently made no
complaints in the 1750s, and indeed around 1754 he issued a print in
celebration of the act's success in advancing English arts and indus-
try, but at his death his widow noticed the damaging effect of piracies
on her sales, and in 1767 the act was revised to extend protection to
twenty-eight years from date of publication. For Jane Hogarth, pro-
tection was extended for another twenty years.[54]

Vertue's description of the engraver's sad lot, written long after the
Engravers' Act was passed, shows that in the long run only unusual
cases such as Hogarth's were materially benefited by the act; most

engravers were still weighed down by handicaps. Dealers may have been forced to offer more advantageous terms to artists, but the ordinary copyist engraver, who might be underbid by another copyist of the same unprotected subject, still had to rely on a patron who owned the work in question and allowed only him to engrave it—and even then his copy could be copied by other engravers, since it was technically not covered by the provisions of the act. In Vertue's own case the act left a bitter taste: it was he who suffered by John Pine's special permission to engrave the Armada tapestries in the House of Lords. If he blamed Hogarth it might explain something of the growing asperity of his remarks over the years, especially his emphasis on Hogarth the intriguer; he is silent on the subject of the act itself, as important as it was to the history he was writing. While Hogarth became increasingly independent as an engraver, Vertue continued to survive largely through personal patronage.

Hogarth's income at this time can be measured against a country parson's (Parson Adams's) of £23 a year with a wife and six children to support, or Joseph Andrews's as a footman, of £8 a year. Actors' top wages were £200 or £250 for a season. Whereas Hogarth's profits in 1731–1732 for the *Harlot* subscription were over £1500, almost all clear, plus the frontispieces and conversation pictures he was executing at the same time. In 1733–1734 his income from *A Midnight Modern Conversation, Sarah Malcolm,* and the *Rake* subscription must have been equal to that of 1732. And by 1735, with the Engravers' Act, he was secure and could live off the continuing sales of old prints as well as new subscriptions and topical prints.

As Hogarth's advertisements show, one way to replace personal patronage (a way that had been broached by Salvator Rosa and one or two other artists) was by reaching a more extended public through self-advertising, and, as Vertue's acid comments remind us, Hogarth had a genius for strategies of publicity.

As his rift with the aristocratic patrons grew, the broad permanent basis of his reputation was established. Mrs. Lidell, living in the north country, wrote in 1736: "We never had a duller season, ye Gunpowder Plot against Law and Equity has been ye only subject of late and all allow the scene of confusion amongst the Gentlemen of the Gown was droll. I could like to see it represented by Hogart." In December 1735 Robert Ellison remarked that his lodgings in Cannongate resembled the Harlot's, and a *Grub-street Journal* of 1735/36

remarked: "Fame, the Hogarth of every age, can paint it an image of human life; yet still the grotesque figures create us mirth, and the distant resemblance to truth an agreeable astonishment."[55] Hogarth would probably not have appreciated the *Journal's* condescension; however, it shows his name passing into common usage. The "celebrated" or "ingenious" Mr. Hogarth, unsurpassed "in his way" ("the first Painter in England, perhaps in the world, in his Way"),[56] to whom writers refer thereafter is essentially the Hogarth of the *Harlot* and the *Rake,* and of "Hogarth's Act." By 1740 the author of *Satirical and Panegyrical Instructions to Mr. William Hogarth, Painter, on Admiral Vernon's Taking Porto Bello* was calling upon Hogarth to paint a picture of this affair, and in the same year William Somerville dedicated his burlesque poem *Hobbinol, or the Rural Games* to Hogarth, "being the greatest Master in the Burlesque Way." Hogarth's province, Somerville writes, is the town, while his own will be the country, but they will agree "to make Vice and Folly the Object of our Ridicule; and we cannot fail to be of some service to Mankind." For the general audience of print buyers Hogarth's name was by now proverbial.

But in 1736 Hogarth received a compliment he must have cherished above all others. It was the madhouse as a metaphor for society in *Rake* 8 that led Jonathan Swift, Hogarth's original inspiration for the scene, to end his poem "The Legion Club," a tour of the Irish House of Commons as if it were a madhouse, with this invocation:

> How I want thee, humorous *Hogarth?*
> Thou I hear, a pleasant Rogue art;
> Were but you and I acquainted,
> Every Monster should be painted;
> You should try your graving Tools
> On this odious Group of Fools;
> Draw the Beasts as I describe 'em,
> Form their Features, while I gibe them;
> Draw them like, for I assure you,
> You will need no *Car'catura;*
> Draw them so that we may trace
> All the Soul in every Face. (ll. 219–30)

Plate 8 is Hogarth's most Swiftean image. When he began to collect his prints in folios, he sent Swift one, and in 1740 received a grateful

reply from Swift's publisher, George Faulkner (Swift by this time was unable to reply himself), saying: "I have often the Favour of drinking your Health with Dr Swift, who is a great Admirer of yours, . . . and desired me to thank you for your kind Present, and to accept of his Service."[57] It is pleasant to think of the two most powerful satirists of the age, one in words and the other in images, thus acknowledging each other.

3.

PUBLIC AND PRIVATE LIFE
IN THE 1730s

LEICESTER SQUARE

Although still a fashionable square, Covent Garden's reputation was no longer of the best. For drinkers and wenchers there were, within the purlieus itself, Tom King's "coffeehouse" and Mother Douglas's bawdy house; and for gamblers, Mr. Stacie, owner of the Bedford, could be found at all hours presiding over a game of whist while Tiger Roach, his one-eyed bruiser, lurked behind him in the shadows. After debauchery there was the Hummums, the oriental baths on the southwest corner of Russell Street. In 1732 the house next to the Hogarths' had been converted into the entrance to Rich's new Covent Garden Theatre. Charles Macklin, the actor, arriving in 1733, remarked on the number of actors living nearby: "I myself, Sir . . . lived always about James Street, or under the Piazzas; so that . . . we could all be mustered by beat of drum; could attend rehearsals without any inconvenience; and save coach hire."[1] It was a neighborhood for actors, writers, theatrical hangers-on, and artists. But the Hogarths, it seems, wished to move to a quieter, more fashionable area, which also symbolized independence from the Thornhills, with whom they still lived. (And Thornhill cannot have relished sharing his residence with a printshop; he passed much of his time at his estate in Dorset.) Already they spent summers in Islesworth, near Twickenham, where Hogarth began work on the *Rake's Progress*.[2]

The announcement on 9 October 1733 of his subscription for the *Rake's Progress* and *Southwark Fair* was also the announcement of his new address, the Golden Head in Leicester Fields, where he would live for the rest of his life (figs. 27, 28). The rate books show that he was in residence by 12 October at the latest, and that he might have

taken over the house as early as April; a letter from Jonathan Tyers is dated 1 May 1733 and addressed to him at Leicester Fields.[3] John Hoadly, some years later, wrote jokingly to him about the snobbish tendency to call it Leicester Square rather than Fields, but in all his advertisements Hogarth consistently inscribes his address as Leicester Fields.[4]

Leicester House had been built in the 1630s by Robert Sydney, second earl of Leicester; in Queen Anne's reign it served as the residence of the French ambassador, and in the first years of George I it housed the German representative. In 1718, after the break between the king and Prince of Wales, it was leased by the prince for £6,000; in 1743 his son, Prince Frederick, also took over the house as his anticourt residence.[5] The house itself dominated the north end of the square: two stories high, with tall windows facing on the square, implying the great reception rooms within. To the west, and forming one side of its courtyard abutting on the square, was Savile House, which was connected with Leicester House and served as the residence for the royal children and other relatives.

One visitor thought the royal apartments were furnished "with a greater Air of Grandeur than the Royal Palace at St. James's. And in the rest of the Square are several Houses of abundance of the first Quality. The Middle is planted with Trees, and railed round, which gives an agreeable Aspect to the Houses."[6] The square had been developed by the earls of Leicester, and most of the houses were built in the later seventeenth century; some of those on the east side where Hogarth lived dated back to 1673. It was one of the most fashionable and quietest of London squares in the 1730s, the noisy traffic of Coventry Street being cut off by the houses on its northwestern corner; the main entrance was at the southwest corner through Spur Street (now Panton Street). The garden with its walkways and grass plots had been enclosed in 1720, and from time to time in the 1730s the newspapers informed the public of the improvements being made in the square. "Leicester-Fields is going to be fitted up in a very elegant Manner, a new Wall and Rails to be erected all round, and a Bason in the Middle, after the Manner of Lincoln's-Inn-Fields, and to be done by a voluntary Subscription of the Inhabitants."[7] In 1743 the basin was replaced by a gilt equestrian statue of George I dressed in classical armor, which was acquired by the residents from the duke of Chandos's garden at Cannons when that mansion was dismantled. It is impossible now to imagine how it once looked. The quiet has

been replaced by noise and the dignified houses by commercial buildings. The only sign of the famed former residents is a few shabby busts—Newton, Hogarth, Dr. John Hunter, and Reynolds—and Hogarth's ironic memorial is in the cinemas that fill two sides of the square, producing, as a recent writer has wittily observed, "'serial pictures' of a kind not contemplated by Hogarth."[8] His self-portrait (fig. 105) also appears in mosaic on the entrance to the Leicester Square comfort station (men); his *Shrimp Girl* appears similarly on the ladies' side.

The five adjacent dwellings that included Hogarth's house were leased from the earl of Leicester's trustees to Thomas Cuthbert in March 1722/23 to run for fifty years, until midsummer 1772.[9] On 10 December 1732 Lady Mary Howard, who lived in the next-to-last house on the east side of the square (when numbered, No. 30), died, and her house went on the market.[10] Her relatives were still paying rates in April of 1733, and around that time Hogarth took up her sublease on the house. Its ratable value was £55; houses on the side streets went down to as little as £10, but on the east side of the square the lowest rate was £20, the highest £90. Though cut in half on the best-known print of Leicester Square (fig. 28), the house was three windows wide and contained a basement and four stories. It was a plain but handsome house, its front broken by band courses above the second and fourth stories, and the door fairly elaborate with flanking pilasters and a cornice hood on carved consoles.

Above the projecting hood Hogarth placed his sign, the "golden head." In this, his one essay in sculpture, "he, out of a mass of cork made up of several thicknesses compacted together, carved a bust of Vandyck, which he gilt, and placed over his door. It is," John Nichols wrote at the end of the century, "long since decayed, and was succeeded by a head in plaster," perhaps after Hogarth took it down in anger following his unsuccessful auction of *Marriage A-la-mode* in 1751; that plaster in turn was followed by another.[11] He must immediately have raised the gilt cork bust, since it already identifies the house in his earliest advertisement. It proclaimed the owner's profession of art, specifically the English tradition of portraiture with its northern antecedents (Rubens–Van Dyck–Lely–Kneller), rather than the so-called "foreign" schools of Italy and France.

He may, as Louise Lippincott writes, "have viewed his sign showing Van Dyck's head as a defiant emblem of his allegiance to the old

English tradition"[12] in another sense. Like advertising in the newspapers, putting up a sign—inviting any prospective consumer to come in—indicated a shopkeeper and not the gentleman artist advocated by Jonathan Richardson in his treatises. Arthur Pond never hung out a sign, nor did Joshua Reynolds in 1753 when he moved into Leicester Square.

It is also possible that with this sign Hogarth may have implied that he wished "to play a latter-day Van Dyck to Sir James Thornhill's Rubens."[13] The sign was a statement of lineage and paternity, but it also perhaps distinguished his métier from his father-in-law's (whose house in Covent Garden he had just departed). In *The Analysis of Beauty* manuscripts (ca. 1753) he relates Rubens and Van Dyck as the baroque master of the serpentine Line of Beauty and his more down-to-earth pupil:

> Vandike his scholar perhaps for fear of running into what he might think gross in his masters manner, Imitated Nature just as it chanc'd to present itself, and having an exact Eye produced excessive true imitations of it with great delicacy and Simplicity, but when Nature flag'd he was Tame not having principles which might have raised his Ideas, however grace often appears in his best works. (169)

He seems to see himself as a Van Dyck who *did* follow "principles which . . . raised his Ideas," but which he toned down from the example of his master, who he also notes was a bit exaggerated ("gross") in his employment of the Line.

In any case, the new house was a handsome residence a step up (in location at least) from the Thornhills' house in Covent Garden, but at the same time self-consciously stigmatized by a stop sign. Out of sight, behind the house, Hogarth built a painting room, necessary since the house faced east and west and he needed a north light for his painting and engraving.[14] (Reynolds did much the same with additions to the back of his house across the square in the 1750s.) Hogarth's maulstick and palette, the latter a shovel-shaped board now badly warped, are in the Royal Academy (the gift of J. M. W. Turner, opposite Reynolds's palette, the gift of John Constable). The palette, however, if genuine, was one of several: the one shown in his self-portraits, and on his own seals, is the more conventional shape, conforming to the serpentine Line of Beauty. His painting chair was said

to have been "a large affair running on wheels," still extant in 1867 when Alfred Dawson saw it.[15] From Jane Hogarth's sale catalogue of 1790, we learn that he had a large color cabinet with fifty-four drawers for colors, "a large press, with glazed doors and sliding shelves, painted mahogany," and a telescope (nos. 59, 60, 65). His lay figure is now in the Bath Academy, Corsham Court (donated by Walter Sickert).[16]

Some idea of the inside of the house may be had from the ground plan of its neighbor, No. 12 (later No. 28), inhabited in the 1770s by John Singleton Copley and in the 1780s by Dr. John Hunter. The hall and the main staircase were on the right as one entered, and the parlor and backstairs on the left; the house was bowed at the rear with two rooms shaped accordingly, which in Hunter's time served as a study and an afternoon bedroom.[17] Hogarth must have had a showroom on the ground floor where he hung his modelli and samples, at this time showing the paintings of *Southwark Fair* and *A Rake's Progress,* together with the engravings. The upper floors would have been living quarters for the Hogarths, with servants on the top floor and kitchen and other servants' quarters in the cellar.

When George II and Caroline lived in Leicester House the area had been a center of intellectual activity. Newton lived on the south side of the square and was often carried in his chair to Leicester House to participate in philosophical discussions; Samuel Clarke and Bishops Hoadly, Sherlock, and Berkeley met with Caroline there for this purpose. When Hogarth moved into the square, a scattering of high nobility remained, and some high-ranking army officers; for the rest, there was the magistrate Thomas De Veil, the painter Hans Hysing, and a few years later the writer Paul Whitehead. A fashionable tailor lived a few houses down from Hogarth. The Hogarth house, next to the last house on the bottom of the square, where the houses got smaller, was in fact almost into Green (now Irving) Street.

It is worth considering Hogarth living in this square, even then in one of the busiest parts of London, but cut off in a quiet, aristocratic haven; and just a block away from the long snake of St. Martin's Lane, the arts and crafts street of eighteenth-century London, where artists rubbed shoulders with musicians and writers, and booksellers with tavern and coffeehouse keepers. Slaughter's Coffee House, just south of Great Newport Street, was the social and recreational center of artists. Here was the sphere of Hogarth's activity: he was of it and yet withdrawn from it—around the corner, so to speak. By this bi-

furcation he presumably kept himself separate in his own mind from Tom Rakewell, who adopted an expensive equipage, took a fashionable and expensive house, collected Old Masters, and played up to the nobility.

Thornhill's death came in 1734, in the midst of the preparations for the *Rake's Progress*. Vertue records on 4 May that Thornhill had

> been much out of Order the last twelve month sometimes afflicted with the gout but one of his leggs swelling as if dropsy the last years of his life, but alwayes a man of high Spirit. but not long before he died he had a more violent Illness in London that had taken away his Voice. but recovering a little better. (being fully resolv'd or not inclin'd to be a member of parliament if he coud) he resolvd to go to his Country seat of Thornhill near Weymouth. w[h]ere being arrived. but fatigued with his journey he did not survive many dayes. (3: 70)

He died on 29 April, aged 57, as Vertue added, "setting in his chair." The *Daily Journal* for 11 May called him "the greatest history painter this kingdom has in any age produced" (which the *Grub-street Journal* reprinted without comment); and James Ralph's *Weekly Register,* No. 219, for 18 May, quotes the *Journal* with approval. On 6 July (No. 226) it praised his paintings in Greenwich Hospital. The *Gentleman's Magazine* printed an account of him, so sympathetic that a recent writer has thought it "reads like Hogarth's own composition." [18]

But Thornhill's day was past, and soon his name would signify the sad discrepancy between the quality of native English history painting and the Continental tradition. The surest signs of his reputation were not the respectful obituaries but the inactivity of his last years and the low prices brought by the auction of his own paintings from his collection early in 1734/35 (Cock's, 6 March). The set of small copies of the Raphael Cartoons went for 75 guineas; the large paintings went to the duke of Bedford for 200 guineas, with Vertue's comment: "he was for three years making these Coppies at Hampton—it was sold for less than cloth and colours cost" (3: 74).

A year later, in the second week of June 1735, while Hogarth was waiting outraged for the piracies of the *Rake* to appear, his mother suddenly and unexpectedly died. Not long after he moved to Leicester Fields, his mother and sisters had moved to a flat

on the north side of Cranbourn Street, in St. Anne's Parish. On the night of Monday, 9 June, shortly before midnight, fire broke out in Duke's Court, St. Martin's Lane, a few blocks away from the Hogarths. By 3 A.M. nearly twenty houses were on fire, and the fire was still burning when the *Daily Journal* went to press (11 June). When the smoke cleared, it was ascertained that the fire

> broke out between 11 and 12 o'clock, at a Brandy-Shop in Cecil-Court, St. Martin's Lane, and communicated itself into St. Martin's-Court, and continued with great Fury for the Space of two Hours, before Water could be got to supply the Engines. His Royal Highness the Prince of Wales, the Lord James Cavendish, Sir Thomas Hobby, and Mr. Cornwallis, were present; a Detachment of Foot Guards also assisted: His Royal Highness went on the Top of a House in St. Martin's-Court, to take a View of it, and then came down to direct the Engines, and animate the Firemen, &c. About 3 the Fire was got under, when about 15 Houses were destroyed, viz. 12 in St. Martin's-Court, and 3 in Cecil Court, besides a great many others much damaged: John Huggins, Esq; gave 20 Guineas to the Populace, to excite them to a Diligence suitable to the melancholy Occasion: His Royal Highness likewise gave a considerable Sum of Money to the Firemen and others.

John Huggins, it should be noticed, owned property in St. Martin's Lane; the *Old Whig* of 12 June observed that one of his houses was considerably damaged, adding that "the Thieves and Pickpockets were observed to be very industrious *in saving Things out of the Fire,* according to Custom."

The Hogarth women must have been living on the spur of Cranbourn Street which runs directly into St. Martin's Court, or else Mrs. Hogarth was visiting with a friend in St. Martin's Court. All that is known is that she died the next morning, "at her House in Cranbourn-alley, of a Fright, occasion'd by the Fire in St. Martin's court. She was in perfect Health when the unhappy Accident broke out, and died before it was extinguish'd." The account appeared in several papers; she is, in fact, the only person mentioned to have died as a result of the fire, although several others were seriously injured by falling debris.[19] An Irishwoman, Mrs. Kelloway, who lived in the brandy shop in Cecil Court, where the fire broke out, was apprehended on Thursday the 12th, taken before Justice De Veil on suspicion of willfully setting the house on fire, and committed to

Newgate, requiring protection from the angry mob assembled. The same night "was buried Mrs. Hogarth, Mother to the celebrated Mr. Hogarth," in the churchyard of St. Anne's, Soho.[20] All that survives is the portrait, inscribed "His best freind [sic]," signed with high-lighted initials, "W.H. ft" (as in the *Self-Portrait with Pug*) and dated 1735: perhaps painted from memory after her death (fig. 29).[21] Jack Lindsay's words sum up the impression of the portrait: "She sits there erect, ageing, hard, and unglamorous, with her slightly forbid-ding dignity, yet with nothing of the grand lady"—one might say a trial run, a female version of the *Captain Thomas Coram* of five years later (fig. 63).[22]

Exactly a year later, Hogarth and his sisters took out fire insurance policies on their respective properties with the Sun Insurance Com-pany. He insured "his household Goods and Goods in Trade and Copper plates Pictures [i.e., paintings]" for £500. It was characteris-tic of him to take out policies for his sisters as well as himself.[23]

CLUBS: FREEMASONRY

In view of Hogarth's multifold activities of the 1730s, his most fre-netically active years, it is not surprising to find him a compulsive joiner and a very sociable man. He frolics among his friends on the "peregrination" (see vol. 1) and drinks with Francis Hayman and is the subject of many anecdotes. Every relationship with a group proves to be aimed either at self-improvement or self-advancement. But at the same time, this aim incorporates a generalized desire for the advancement of the larger body of English engravers, of English artists, of all English men and women. Each enterprise, club, or friendship extends a personal position into a public one. Hogarth was naturally gregarious and translated thought into conversation and then into action. But he was also typical of the *vir bonus* of his time: the member of the Kit Kat or Scriblerus Club whose life was public, enacted in the context of the *polis*. Any personal action, to be mean-ingful, had to have a public significance or at least a public venue.

The groups to which Hogarth belonged constituted the public space we saw him defining at the end of Chapter 1, a space that was urban rather than courtly and with its own characteristic institutions: clubs, coffeehouses, taverns, and hospitals. In general these shared

certain assumptions, relatively new and local to London, in particular that of equality and a disregard for differences in social status among their members. The subjects of primary attention were politics, philosophy, and art—precisely those subjects previously controlled by, and associated with, the monarch and the church. In their varying forms from clubs to charitable hospitals, these groups embodied a revision and secularization of the "mysteries" of the old centers of power and patronage. And they defined their space in reaction to the oppressive a priori rule of state and church, which they replaced—as centers of conversation—with "reason," that is, a British, Whig, heterodox empiricism.

First in importance was Freemasonry: Hogarth was a Mason by 1725 and probably earlier. In 1731 he was a member of the lodge that met at the Bear and Harrow in Butcher Row (far east of the Tower), later called the "Corner Stone" Lodge.[24] The great names were the second duke of Montagu (who had been grand master in 1722), John Theophilus Desaguliers (a founder of English Masonry), the earl of Strathmore (master of the lodge), Lord Tynham, Lord Montjoy, and Charles Stanhope. More to the point were the members who formed the nucleus of Hogarth's intimate circle: the actors James Quin, Theophilus Cibber, William Milward, and Henry Giffard; the musician Richard Leveridge; the actor-artist John Laguerre; the artist and adviser on pictures to Sir Robert Walpole, John Ellys; and the lawyer-poet Ebenezer Forrest.

Beyond his particular lodge the circle included all the other brothers, known by a secret handshake and encountered at the Grand Lodge banquets once a year. Prominent Freemasons included Sir Robert Walpole, the duke of Newcastle, and the earl of Chesterfield. At the dinner held on Saturday 30 March 1734 at the house of the earl of Craufurd in Great Marlborough Street, according to the "Minutes," "mett a Splendid Appearance of Noblemen and Gentlemen of the first rank (being Masons) all clothed in White Aprons and Gloves." After the dinner the deputy grand master led a procession to take leave of the earl of Strathmore, the outgoing grand master and the master of Hogarth's lodge, then invested the new grand master and elected other officers. Among others, the twelve present grand stewards, carrying white rods as their staff of office, received thanks "from the Chair for the Care they had taken in providing such an elegant Entertainment for the Society and at the same time their Healths were drank and also desired to proceed for each Steward to

name his Successor for the ensuing year . . . " The grand stewards for the next year, one chosen from each lodge, included Charles Fleetwood, who had just bought Highmore's patent and now controlled Drury Lane Theatre, Dr. Meyer Schomberg, and Hogarth. "The general Healths being drank the Feast was concluded with great Harmony and Unanimity." At the dinner the next year, 17 April 1735—as the Engravers' Act and the *Rake's Progress* were moving toward mutual completion—Hogarth and the eleven other stewards were thanked for their service.[25]

To be chosen one of the grand stewards was a distinct honor; moreover, Hogarth's choice was timely. In 1735, as Henry Wilson Coil reports,

> By a vote of forty-five to forty-two, it was ordered that the twelve Stewards might form a lodge to be known as *Steward's Lodge*. It is to be noted that, from the Stewards only, were the Grand Masters to be chosen pursuant to a resolution in March 1735 [and "the *Steward's Lodge* nominated the Grand Officers"]. Several Masters of Lodges protested against the formation of *Steward's Lodge* and, on putting the reconsideration to a vote, there was so much confusion that the votes could not be collected or counted. The debate was dismissed and the Grand Lodge closed. This innovation of the *Steward's Lodge* created some friction until a much later date and its prerogatives were resisted by the Committee of Charity, a general committee somewhat like an executive committee to handle the affairs of Grand Lodge between meetings.

The steward's lodge (which consisted of all past stewards) met at the Shakespeare's Head, Covent Garden, four times a year (January, April, July, and October). One wonders if it is a coincidence that Hogarth's stewardship coincided with the controversial upgrading of the stewards. He is credited with the design of the "grand Jewel of the Grand Stewards (known as 'Hogarth's Jewel' and in use until just one hundred years later, being supplanted in 1835)."[26]

Freemasonry was important to Hogarth for several reasons. As a club it offered the conviviality of the lodge and the banquet; but as a social institution it stood for equality, and Hogarth would have been particularly drawn to the Masonic meritocracy: in theory at least (in the words of James Anderson's *Constitutions* of 1723) "All Preferment among *Masons* is grounded upon real Worth and personal Merit only" (51). There would have been something compelling for him in

the three degrees of Mason—apprentice, fellow craft, and master. And membership conferred social prestige. As a contemporary noted, it was of "no small advantage to a man who would rise in the world and one of the principle reasons why I would be a Mason."[27] Here Hogarth rubbed shoulders with the greatest aristocrats, who in some cases extended their patronage to their brothers. For example, the duke of Montagu, who had commissioned three paintings from Hogarth before 1731, may have been concerned with the commission of the *Scene from "The Conquest of Mexico"* of 1732, in which he prominently appears.[28]

Of equal importance, however, was Freemasonry's position on religious and political toleration. The first charge of the *Constitutions* said that Masons are only "oblig'd . . . to that Religion in which all Men agree, leaving their particular Opinions to themselves; that is, to the *good Men and true,* or Men of Honour and Honesty, by whatever Denominations or Persuasions thay may be distinguish'd" (50). The wording is Latitudinarian if not Deist.[29] One consequence was an orientation toward good works (charity was the topmost rung of the Masonic ladder); Masonry could be called Hogarth's first contact with the great charitable institutions of the period. But the lodge was also a gathering place where current and advanced ideas were openly discussed. As Margaret C. Jacob has written,

> For disillusioned Christians, Freemasonry had with it the potential of becoming nothing less than a new religion—and in the hands of philosophical radicals a natural religion based upon belief not in the power of providence but in the power of nature. It provided ceremonies and rituals . . . which were open to a variety of religious interpretations. Likewise its essentially social nature, reinforced by the trappings of secrecy, gave an extraordinary sense of community to men who were disaffected from church and chapel.[30]

And yet, as Dorothy Ann Lipson has added, this use of Freemasonry by some Masons as "a religious surrogate did not preclude other Masons from Christian denominational membership."[31] Far from being incompatible with Masonry, the Bible provided the basic Masonic myth of the construction of the Temple of Jerusalem. But as opposed to the Church of England, Freemasonry claimed to be (in the words of a contemporary) "the universal religion or the religion of nature," "discoverable to us by the light of reason *without the as-*

sistance of revelation." The last (emphasis added) marks the overlap with Deism.[32] Freemasonry, which offered a substitute religion without the authority or monolithic belief of the official church, helps to explain—if it did not authorize—the strain of critical Deism detectable in *A Harlot's Progress* (see vol. 1) and in Hogarth's works of the later 1730s.

Finally, there was the symbolism and esotericism, the dramatic and heightened language of the initiation rituals and the "secrets." The ritual brought with it a particular iconography and particular legends. For example, much attention was focused on the legend of the murder of Hiram, the master builder of the Temple, in defense of the Masonic secrets.[33] It is important to note that Hogarth, a Mason by the early 1720s, was one of those who would have seen the transition from operative to speculative Freemasonry from the viewpoint of the operative; he was an apprentice who in effect chose the more prestigious way of Freemasonry over membership in the old guilds. The secrets for which Hiram was murdered were initially about trade practices and signs of recognition. The trade secrets of the operatives became the esoteric secrets of the speculatives, and Hogarth retained traces of both. It is possible that in his satire, *The Mystery of Masonry,* of 1723 (ill., vol. 1) he was expressing his doubts about the takeover by the speculatives (led by Anderson and Desaguliers)—and a certain ambivalence always remains in his absorption of the Masonic imagery.[34] He was obviously attracted as well as repelled by such operatic stuff. But the story of Hiram, a paranoid narrative centered on the master artisan guarding his "secret," became more emphatic in his works over the years.

One part of him was drawn to mysteries, to the notion of truth veiled in an allegory and to a secret meaning concealed under an ordinary sign that could be read best by a kind of Freemasonry brotherhood (the readers of "greater penetration" to whom he had appealed in the subscription ticket for the *Harlot*). Freemasons and Deists shared this division into what the Masons called Lesser and Greater Mysteries, the Deists exoteric and esoteric doctrines.

Hogarth must also have found appealing the syncretic way Freemasonry treated legends, conflating in a single legend Egyptian, Hebrew, Roman, and Christian analogues. The Hiram legend, for example, was capacious enough to be read as a story of Christ or of Osiris, depending on one's orthodoxy or freethinking. A Freemason could presume that all religions are one—that no one religion is

privileged over another. And Hogarth could paint his English Harlot as if she were also Eve, a female Hercules, and a lapsed Mary; the Rake as if he were also Paris, David, Nero, and anti-Christ.[35]

There is no record of Hogarth's affiliation with the established church, though Jane Hogarth was a churchgoer and he was buried in sanctified ground. He may have taken the sacraments from time to time. But in religion he can best be called a Deist. Deist, however, was a general term of opprobrium. Of the big three Deists—Toland, Collins, and Tindal—only Tindal ever avowed Deism (in *Christianity as Old as the Creation*, 1730). Toland called himself a Pantheist and Collins a Freethinker. Thomas Woolston—the Deist to whom Hogarth alluded in *A Harlot's Progress*—thought of himself as an orthodox Anglican critic of ecclesiastical tyranny. Hogarth probably thought of himself similarly but called himself a Freemason.

Hogarth became part of quite a different club in 1735 when John Rich, with twenty-three of his cronies who included Ebenezer Forrest, George Lambert, Robert Scott, John Thornhill, William Huggins, William Tothall, and Gabriel Hunt, founded The Sublime Society of Beefsteaks. According to tradition, Lambert, working as a scene painter for Rich, having no time for a regular dinner, "contented himself with a beef steak broiled upon the fire in the painting-room"—the room behind the stage, near the Bow Street entrance. Sometimes he was joined by visitors, and by and by the Beefsteak Club was born; it assembled once a week in the painting room, and later in "a room in the play-house."[36]

Twenty-four was apparently the limited number of members. Hogarth was a member of the club from its inception, 6 December 1735. The two membership lists record the seats in the following order: (1) George Lambert, (2) William Hogarth, and (3) John Rich.[37] Hogarth remained a member until 31 March 1739/40, when he resigned and was replaced by John Frederick Holtzman, page to the Prince of Wales. He was reelected on 29 January 1742/43 and remained a member until 20 October 1744, when he was replaced by Paul Whitehead.[38] He is not listed as joining for a third time. Any member who felt unable to attend regularly was expected to resign. However, the rules say that members who have quitted the society (without being expelled) may be permitted to visit at any meeting, and one of the manuscript lists gives the names of some former members who were

now "Honorary." That it was a close-knit group is evident from an examination of members' wills. The names of beneficiaries, witnesses, and executors are frequently those of other members (though Hogarth's name does not so appear).[39]

They met every Saturday from October to June, wearing the ribbon and badge of the society shaped like a silver gridiron and dated 1735, with their motto "Beef and Liberty." Beefsteak was the only meat served, but in addition there were baked potatoes, Spanish onions, beets, chopped shallots, toasted cheese, porter, port wine, punch, and whisky toddy. The president of the day was under the "necessity of singing, whether he could or not, THE SONG OF THE DAY"; the newest member, the "Boots," served as "the fag of the brotherhood," bringing the steaks individually from the spit to each member and pouring wine. The bishop sang the grace and the anthem, and the recorder "had to rebuke everybody for offences, real or imaginary" and deliver "the charge" to each new member. There was an elaborate set of rules, ceremonies, and traditions, Masonic in its symbolism and complexity; but all was directed toward merriment and schoolboy pranks, reminiscent of Hogarth's "peregrination," from which the Beefsteaks drew three of its members.[40] One clause of the rules allowed for wagers, and toasts were to be as satiric as possible so long as they were not repeated outside the meeting.

In 1743, presumably as an exercise of this club, Hogarth and his friends played a trick on John Highmore, the theatrical amateur whose performance of Lothario on stage (which had led him to purchase control of the Drury Lane Theatre) was paralleled by his amorous boasting off. They rigged up an assignation with an attractive young woman who, between courting and bedding, disappeared and was replaced by a black prostitute, whom Highmore discovered when he climbed into bed. The jokers evidently emerged from hiding, ragged him, and commemorated the event by having Hogarth etch a plate showing Highmore's "discovery" and his tormentors' glee, complete with an appropriate Latin motto from Ovid. A few copies were printed for private distribution (fig. 30).

Although this hasty plate is the only surviving print Hogarth made for his friends, his sketches were said to have been circulated and posted in coffeehouses. This is evidently what happened with the drawing of Benjamin Read asleep (posted), and there are also accounts of a pencil sketch of "a celebrated young Engraver (long since dead) in a salivation," wrapped in blankets like the figure in

Election 3, and a drawing of a "corner of a street, with a man drinking under the spout of a pump, and heartily angry with the water, which, by issuing out too fast, and in too great quantities, had deluged his face." Contemporaries were not very sophisticated as to distinctions between drawings and prints, and the former often passed for the latter, as probably in John Wilkes's allusion in the 1760s (in *North Briton* No. 17) to a Hogarth caricature of Lord Hardwicke as a spider. Nichols recalls that in 1745 Hogarth made a caricature of one Launcelot Burton, a naval officer at Deal: "on a piece of paper previously impressed by a plain copperplate, [he] drew his figure with a pen, in imitation of a coarse etching." The "print" was sent to Burton in a letter, and his friends (who were in on the joke) claimed they had seen the print on sale in London shops.[41] Such hoaxes continued into the 1750s—the most notorious example being the forged Rembrandt that Hogarth and Benjamin Wilson foisted upon Thomas Hudson (see vol. 3).

Singing was another leading feature, and the official Song of the Day was one or another of the versions of "The Roast Beef of Old England." The title of Hogarth's autobiographical print, *The Gate of Calais, or O the Roast Beef of Old England* (1748, figs. 126, 127), may have signaled an allusion to the club.[42] For behind all the merriment was the assumption of xenophobia—half comic, more than half serious. Even at their most relaxed, Hogarth and his theatrical and artistic friends engaged in a kind of tendentiousness.

The standard of singing may not have been very high, but Hogarth clearly enjoyed a song with his friends, as the account of the "peregrination" shows. William Huggins was an enthusiastic member of the Academy of Ancient Music, which held its first meeting on 7 January 1726. The subscription lists include the names of London's leading musicians both professional and amateur, including a number of Italians (Agostino Steffani was elected president). Handel's is the only notable name that does not appear. The sixth subscription (ca. 1728) includes the name of "Mr. Huggins," and the seventh—each subscriber paying 10s 6d as usual, which began on 8 May and ran for six, or perhaps seven nights—gives as the sixty-ninth and last subscriber "Mr. Hogarth." The eighth subscription, begun 9 April 1730 has "Mr. Hogarth" as the sixty-sixth subscriber and "Mr. Huggins" "for the 7th and 8th subscriptions" as the seventy-second.[43]

Huggins was in these years writing libretti for oratorios, and in 1733 he collaborated with William Defesch on *Judith,* which Hogarth celebrated in both his subscription ticket for *A Midnight Modern Conversation* (fig. 4) and a frontispiece for the published edition.[44]

The significance of the academy for Hogarth lay partly perhaps in his love of music, but also in its program.[45] It was essentially a professional society for London's leading musicians (Maurice Greene, Bernard Gates, and William Croft), its members chiefly musicians in the Chapel Royal, St. Paul's Cathedral, and Westminster Abbey. The performances were mostly if not completely vocal, and thus its original title, the Academy of Vocal Music. It also took pains to include foreign musicians. Within a few years, however, dissension in the Academy for Vocal Music led to the reshaping of its affairs: while its repertory remained cosmopolitan, the active membership became almost wholly English, the aim was now the performance of old music, and (apparently at a meeting of 26 May 1731) its name was changed to the Academy of Ancient Music.

Hogarth was apparently a full-fledged member, since there seems to have been no distinction drawn between the professionals and the amateurs, and no one simply subscribed. He may have attended even more frequently after the change of name, when the leadership became more emphatically English. He was presumably nominated by a member: if this was not Huggins, who had joined the preceding year, another possibility was John Freke, evidently a friend (another Mason) and perhaps a connection between Hogarth's involvement in the Academy of Ancient Music and St. Bartholomew's Hospital. There is a well-known story, told by Dr. Belchier, an eminent surgeon:

> Hogarth being at dinner with the great Cheselden [whom he had known since the days of Vanderbank's academy], and some other company, was told that Mr. John Freke, Surgeon of St. Bartholomew's Hospital, a few evenings before, at Dick's Coffee-house, had asserted that [Maurice] Greene was as eminent in composition as Handel. 'That fellow Freke,' replied Hogarth, 'is always shooting his bolt absurdly one way or another! Handel is a giant in music; Greene only a light Florimel kind of a composer.' –'Ay,' says our Artist's informant, 'but at the same time Mr. Freke declared you were as good a Portrait-painter as Vandyck'–'There he was in the right,' adds Hogarth; 'and so by G– I am, give me my time, and let me choose my subject.'[46]

William Weber, who finds that the anecdote "rings true," comments that "it indicates nicely the kind of musically serious amateurs who frequented the Academy, which Greene helped found and where Handel's music was nonetheless performed."[47] The academy would have been to Hogarth's taste because the musicians respected ancients and moderns alike, not attempting to intimidate the former with the latter; they wanted to establish the credentials of the English musical tradition, but the best (and in fact only) way open to them was by framing its great works within the context of the Italian repertory. Theirs was an entirely new kind of canon, one closer to the literary cults of Shakespeare and Milton than to the cult of antiquity, even though its emphasis was not specifically nationalistic. There was a recognizable parallel between the aims of this group and of the artists who grouped around Hogarth at Slaughter's Coffee House.

SLAUGHTER'S COFFEE HOUSE

With the names of the Freemasons and Beefsteaks we may cautiously proceed to the center of Hogarth's social life as an artist. Old Slaughter's Coffee House, which Baron Bielfield in 1741 compared to Paris's Café Procope (another analogue would be London's Cafe Royal of the 1890s), was a center for artists: "The rendezvous of all the wits and the greatest part of the men of letters in town."[48] Thomas Slaughter had moved to this spot, on the west side of St. Martin's Lane (Nos. 74 and 75 when numbered), three doors from Newport Street, in 1692. A man in his late sixties at this time, he died in 1740 and the business was continued by Humphry Bailey until 1749, when John Barwood took over and added the bow front seen on most pictures of "Old Slaughter's."[49] The other names associated with Slaughter's—Gravelot, Roubiliac, Hudson, Lambert, Hayman, Pine, Jonathan Richardson—suggest the close connection between Slaughter's and the St. Martin's Lane Academy that was founded by Hogarth in 1735 a few houses away.[50]

Probably the most influential artist in the group was Hubert François Gravelot, a young Frenchman of thirty-three (two years Hogarth's junior), who had come to England around 1732 to help Claude Dubosc with his engravings of Bernard Picart's *Cérémonies et coutumes religeuses de tous les peuples*. He brought with him a brisk but

elegant decorative style which served as an easy access for the English artist to the fashionable French rococo. He was, as his apprentice Charles Grignion noted, "a designer but could not engrave. He etched a great deal in what is called the manner of Painters etchings, but did not know how to handle the graver."[51] It was as a designer (only a few oil paintings have survived) that he influenced the Slaughter's artists by introducing ways of using the rococo C and S curves as the basis for both decorative work and larger compositions. Jean André Rouquet (apparently a spokesman for Hogarth) wrote in the *State of the Arts in England* (1755):

> Mr. Gravelot, during the stay he made at London, greatly contributed to diffuse a taste of elegance among the English artists. His easy and fertile genius was a kind of oracle, to which even the most eminent occasionally applied. From him they learnt the importance of design; and till they can make themselves masters of this branch, they occasionally apply to some other artist who is capable of directing them.[52]

With his appearance on the scene, Hogarth moved somewhat to the left of the Raphaelesque classicism of his early *Hudibras* and *Harlot* plates to develop the sinuous, agitated compositions already evident in the *Rake's Progress* paintings. Nevertheless, one probably hears his voice in Rouquet's words: "even the *most eminent occasionally* applied" to this "oracle."

The earliest rococo pattern book was published in 1736 by an Italian, Gaetano Brunetti, full of shells, flowers, crooked scrolls, and fanciful cartouches; it was intended, he explains, for "painters, sculptors, stone carvers and silversmiths"—who were, in fact, the promulgators of the style in England. But already in 1735 Gravelot had made his illustrations of royal tombs in Pine's *Heads and Monuments of the Kings,* followed by decorative frames for Thomas Birch's *Heads of Illustrious Persons* (1738).[53] Almost at once he appears in collaboration with other artists of the Slaughter's circle. Besides the work with Pine, Vertue notes, he made designs for silver (it may also be significant that Paul de Lamerie began to experiment with rococo forms on his silverplate in the 1730s), and he is known to have worked with Hayman on the illustrations for Thomas Hanmer's edition of Shakespeare (1743–1744) and with both Hayman and Hogarth on the Vauxhall decorations. Most important, through Hayman his influence was passed on to Thomas Gainsborough. In October 1745 he

left London for Paris, not to return, presumably because of the war between England and France.[54]

Hayman, who seems to have been Hogarth's close friend, was apprenticed in 1718, at about fifteen, to Robert Browne, a history painter of the Painter-Stainers' Company, and worked as an interior decorator and scene painter at theaters. Judging by the anecdotes that have survived, he was a good eating and drinking companion, noted for his extraordinary appetite.[55] One story places him with Hogarth in a brothel in 1733 or 1734, where they observed two prostitutes quarreling: "one of them, who had taken a mouthful of wine or gin, squirted it in the other's face, which so delighted the artist [Hogarth], that he exclaimed, 'Frank, mind the b——'s mouth!'"[56] This story is supposed to have been the source of the detail in the third plate of the *Rake's Progress*. The anecdote is cited less for its veracity than to illustrate the contemporary view of Hayman and his relationship with Hogarth and others. As an artist, Hayman was Gravelot's closest student, or at least the one who most directly and literally took over his small decorative patterns and applied them to large, sometimes heroic compositions, especially at Vauxhall Gardens. After Hogarth he was the most various and experimental painter of the group—a fact sometimes obscured by the lively but crude product.

Perhaps the closest relationship of all was between Hogarth and George Lambert. Two years Hogarth's junior, Lambert is first mentioned by Vertue in September 1722 as a pupil of Warner Hassell, "a young hopefull Painter in Landskape, aged 22. much in Imitation of Wotton. manner of Gaspar Poussin." By 1726 he was painting sets for Rich, and continued to furnish Rich with sets for many years.[57] In 1727 he was prosperous or vain enough to have his portrait (painted by Vanderbank, 1725) published in a mezzotint by Faber. And around this time Hogarth made him a bookplate (fig. 31), which "was stuck in all his books; and . . . his library consisted of seven or eight hundred volumes."[58] Hogarth had some fun with the design. One supporter is Music holding a flute, leaning a heavy elbow on the escutcheon as she rubs her forehead for inspiration—apparently in vain, for the other hand holds a book of blank pages. She looks enviously at the other supporter, the more active muse of Painting daubing vigorously at the coat of arms with her brush. The irreverent grin on Painting's face and her activity on the coat of arms, together with the spelling of Lambert's name as "Lambart" (was Lambert claiming a connection with the Lambarts who

were earls of Cavan, whose arms were similar to those presented?), may suggest that Hogarth is joking about Lambert's pretensions. As Hogarth himself was a history painter who produced popular prints, Lambert was a landscapist who painted theater sets.

Like any judicious landscapist, aware of his position in the aesthetic hierarchy, Lambert heightened his scenes with figures "in order to give us Opportunity of employing our Reflections."[59] While Hogarth avoided landscapes, he painted figures for some of Lambert's landscapes in the 1730s. His figures may be recognized in Lambert's *Landscape with Farmworkers* (Mellon Collection, Yale), four views of *Westcombe House, Blackheath* (Wilton House), *Ruins of Leybourne Castle* (dated 1737, private collection), and the pendants, two views of Box Hill, Surrey (1733; figs. 32, 33; the second, Mellon Collection, Yale). Hogarth and Lambert apply paint in the same way and their foliage and architecture at times look so similar that it is difficult to say whether they share a style or Lambert helped Hogarth out with background as Hogarth helped him with foreground. Lambert's country views with haystacks and cornfields, farmhands and dairymaids, belong in his own canon, but with the ratio of landscape and figures slightly altered some would be rural versions of Hogarth's comic histories.[60]

By the 1740s Lambert's figures change, either to a cruder version of the Hogarthian figures or to the style of Hayman (whose pupil Samuel Wale is also known to have furnished Lambert with figures). But in the 1730s the Hogarth–Lambert collaboration had been fruitful, and in those years Hogarth may also have supplied figures for landscapes by Samuel Scott, another friend, one of the companions on the "peregrination" of June 1732.[61] Scott and Lambert themselves collaborated on the six views of East India ports, for which they received £94 10s on 1 November 1732; Scott painted the ships and seascape and Lambert the landmass and buildings.[62]

John Ellys (or Ellis) should also be mentioned. He had been apprenticed to Thornhill and may have assisted him at Greenwich. He and Hogarth first met, and their common attitudes were reinforced, in Vanderbank's academy.[63] They were Freemasons in the same lodge and fellow members of the Rose and Crown, another artists' club.[64] Ellys too was interested in the theater (he "had always been tampering with the Theatres," according to Benjamin Victor), and we have seen him acting in the early 1730s as deputy for Wilks's widow in the management of her shares of Drury Lane.[65] He was apparently a man

of independent means. As an entrepreneur, he had bought the senior Vanderbank's tapestry works and office of Tapestry Maker to the Crown when they were sold to free the young Vanderbank, and as a painter he made an easy living at portraiture, though he is also reported to have done some genre subjects. He was both Hogarth's staunch supporter in the original founding of the St. Martin's Lane Academy, perhaps contributing financial assistance, and Walpole's advisor on the acquisition of works for his great art collection at Houghton.[66]

Slaughter's is never mentioned by George Vertue, and none of his circle of friends appears to have frequented it. Vertue belonged to what he described as "the tip top Clubb of all, for men of the highest Character in Arts & Gentlemen Lovers of Art—called the Clubb of St. Luke" (3: 71, 120). This club, which traced itself back to Van Dyck (its founder), Lely, Riley, Verrio, Dahl, and Wren, included Hysing, Gibbs, Goupy, Bridgeman, Wootton, Rysbrack, Gawen Hamilton, and Kent. These virtuosi, according to Vertue, met at the King's Arms, New Bond Street, and were a very different group from those who met at Slaughter's. When Vertue raises his eyebrows at some sharp practice of Hogarth's he is probably reflecting the view of most of these vis-à-vis the decorators, craftsmen, scene painters, writers, actors, and physicians who gathered at Slaughter's.

The antipode of Slaughter's, however, was the Roman Club, founded in 1732 by Arthur Pond, George Knapton, and four other young men, all scions of prosperous City families. Celebrating classicism, Italy, and the Grand Tour, having close associations with the Dilettanti Society (founded 1734), the members of the Roman Club (in Louise Lippincott's words) "based their concept of the artist as a gentleman of learning, and the gentleman as a connoisseur and patron of the arts and literature on the theoretical writings and living example of their mentor Jonathan Richardson," whose art treatises were published by the Knaptons.[67]

Art was a subject that mingled professionals, amateurs, and connoisseurs in a single club. With the treatises of Shaftesbury, Hutcheson, and Richardson, such terms as the "pleasures of the imagination," the "fine arts," the "elegant arts," or "arts of taste" had charted out an area in which such unpolite, divisive subjects as politics and religion could be replaced. These treatises and terms dominated the story in which Hogarth participated in the 1730s and 1740s.

For they also polarized the "necessary," "mechanical," and "useful arts" by which Hogarth made his living, and which contributed to his unique product; these artists were set beyond the pale of something that was defining itself—by way of the Shaftesburian aesthetic, popularized in the *Spectator* and the periodical press—as "high" or "polite" art by the unconcealed aspect of their art as interested (as opposed to disinterested) and their works as commodities. We have already seen how these assumptions were refracted and rewritten in the fictions of Hogarth's *Harlot* and *Rake*.[68]

Richardson, in his *Essay on the Theory of Painting* (1715), followed in 1719 by *The Whole Art of Criticism in Relation to Painting* and *An Argument in Behalf of the Science of a Connoisseur,* had created the "connoisseur," who went to Italy equipped with the proper texts, looked at the proper pictures and statues, and returned a Roman. He was, of course, as eager to see an English school of painting in the grand manner develop and flourish as to see the English aristocracy develop into connoisseurs. But, as Pond saw to his advantage, the English aristocrats tended to take the second part of Richardson's challenge seriously, while ignoring the first part, and simply bought Old Masters or copies of Old Masters with greater assurance. Finally, Jonathan Richardson, Jr., went to Italy and published *An Account of the Statues, Bas-reliefs, Drawings and Pictures in Italy, etc.* (1722), which became a kind of Bible for the young Englishman who went abroad, telling him what he should see, what he should like and dislike. With this guide he bought pictures (usually copies, whether he knew it or not) and returned to England the champion of foreign art and willing to buy more copies on the London art market. This situation was the one Pond exploited in his trade as a copyist of paintings and engravings—first traveling to Italy himself to absorb the foreign tradition, then becoming an "expert" who advised the local gentry on their collecting.[69]

Richardson, by profession a conventional portrait painter, also frequented Slaughter's and mingled with Hogarth and his friends. (He had been a friend of Thornhill's.) We shall return to the night in 1734 or 1735 when he was present at Slaughter's and holding forth, according to one account, reading from his new work on Milton. In the preface to the published book he explains how he used his son, Jonathan, Jr., as "my Telescope" through which to see the Old Masters in Italy he had never seen himself.[70] Hogarth picked up the meta-

phor and, in a drawing labeled *The Complicated Richardson,* sketched him peering through a telescope inserted in his son's backside; the son's eyes are directed upward at a row of Old Master paintings, a copy of Virgil, and other items. Hogarth was specifically materializing the words of the preface to Richardson's book on Milton: "In what depends on the Knowledge of the Learned Languages my Son is my Telescope . . . T'is by the help of This I have seen That in *Milton* which to Me Otherwise had been invisible" (cxli). It is at this point that Richardson refers to himself as the "Complicated Richardson." The drawing, which Horace Walpole describes, survives only in a copy, possibly based on Walpole's description.[71] When Hogarth showed the drawing to Richardson, according to Samuel Ireland's story, the artist perceived the old man's uneasiness; so "he threw the paper into the fire and there ended the dissatisfaction." The drawing, however, was symbolic. Richardson represented to Hogarth and his friends the dilettantism that the ordinary Englishman was expected to consider the ultimate in good taste: the desire for a telescope when there was much to see (to use Hogarth's words in *The Analysis of Beauty*) "with his own eyes" and under his very nose. Nevertheless, Richardson was a serious portrait painter, a friend of Pope's, and an intelligent advocate of Milton, and as such he was a figure to be reckoned with in the 1730s.

VAUXHALL GARDENS

From all accounts, Hogarth appears to have been the first of the Slaughter's group to know Jonathan Tyers and grasp the potential of a public pleasure garden as a location for exhibiting contemporary art. Tradition has it that Hogarth met him shortly after he went to Lambeth with Jane in 1729, or during one of his early summers there. Tyers took a lease of Spring Gardens at Vauxhall in 1728 and re-opened the gardens in 1732. In a letter dated Vauxhall, 1 May 1733, he wrote to Hogarth (then in Leicester Fields):

My dear Friend,—Accept as a testimony of regard the accompanying gold medal, as a 'perpetuam beneficii memoriam' for your many past favours, also my likeness, done when in Paris. It was said to be very

like, but your correct eye will discover any defect, and easily recognize the Frenchman's hand. The bouquet, with best respects, to Mrs. Hogarth.—

<div align="right">

Believe me, ever yours faithfully,
Jona Tyers.[72]

</div>

The gold medallion, inscribed "IN PERPETUAM BENEFICII ME-MORIAM" with Hogarth's name on one side and allegorical figures on the other, admitted "a coachful" (six) persons. The most reliable account of the affair, though undoubtedly improved in the retelling, comes from John Phillips, who had the story from Mary Lewis (who would have had it from the Hogarths):

> On passing the tavern [i.e., at Vauxhall] one morning, which was then kept by Jonathan Tyers, and open, together with the gardens, as a place of recreation daily, Hogarth saw Tyers, and observing that he looked particularly melancholy said, "How now, master Tyers, why so sad this morning?" "Sad times, master Hogarth, and my reflections were on a subject not likely to brighten a man's countenance," said Tyers. "I was thinking, do you know, which would be likely to prove the easiest death—hanging or drowning." "Oh!" said Hogarth, "is it come to that," "very nearly, I assure you," said Tyers; "then," replied Hogarth, "the remedy you think of applying is not calculated to mend the mat-ter—don't hang or drown to day. I have a thought that may save the necessity of either, and will communicate it to you tomorrow morn-ing: call at my house in Leicester Fields." The interview took place, and the result was, the concocting and getting up the first "Ridotto al Fresco," under which denomination it was announced, and being then a novelty in England, proved a very successful hit; and from that time must be dated the commencement of that delightful and justly cele-brated place of public amusement. Hogarth was then in prosperity, and assisted Tyers, more essentially than by a few pieces he painted for the decorations; and Mr. Tyers presented him with the gold medal in question, as a ticket of admission for his family and friends.[73]

From this one may gather that, at the least, Hogarth gave Tyers ideas for ways of attracting the public. And in *A Sketch of the Spring-Gardens, Vaux-hall. In a Letter to a Noble Lord* (1752), Hogarth's friend John Lockman, after listing all the pictures, adds: "the hint of this rational and elegant *Entertainment* was given by a *Gentleman,* whose *Paintings* exhibit the most useful lessons of *Morality,* blended with

the happiest strokes of Humour"—the terms in which contemporaries identified Hogarth.[74] The debut of the newly decorated gardens was 7 June 1736: "On this occasion the Gardens were splendidly illuminated, and the entertainments consisted of a *Ridotto de Fresco* [sic], which was attended by about four hundred persons." An orchestra stand had been erected, and a number of pavilions and supper boxes "adorned with interesting paintings by F. Hayman and Hogarth"; or, according to another edition, "ornamented with paintings from the designs of Mr. Hayman and Mr. Hogarth, on subjects admirably adapted to the place; and each pavillion has a table in it that will hold six or eight persons." Ultimately there were fifty supper boxes surrounding the central quadrangle, called the Grove, and each contained contemporary English paintings, many of them eight feet wide.[75]

Hogarth's *Henry the Eighth and Anne Boleyn*—probably a copy of the engraving (ill., vol. 1)—hung in one supper box, and copies of *The Four Times of the Day* graced another pavilion. There may have been a few actually painted by Hogarth;[76] it would be surprising if he acted only in a supervisory capacity, though it must have been painfully evident to him that the life of a painting at Vauxhall was precarious, endangered by flying bottles or food.[77] But when engravings after eighteen of the Vauxhall pictures were published by Thomas Bowles in 1743–1744, the original paintings were all attributed to Hayman (who also painted portraits of Tyers and his family). The paintings from this period were scenes from plays, illustrations of romances and (after 1740) of novels, and romantic pictures of rural festivals and games.

Another member of the Hogarth circle was an older man, the sculptor Henry Cheere, who sometime around 1737 introduced François Roubiliac to Tyers.[78] The result was Roubiliac's statue of Handel (fig. 34), the most influential manifestation of the rococo in the Slaughter's group, unveiled at Vauxhall in 1738—the first great informal portrait in English sculpture, catching its subject with wig off, vest unbuttoned, and slippers askew. Perhaps significantly, the only musical score among those Handel has by him that bears a precise title is *Alexander's Feast,* which had been published earlier in the same year with an engraved design by Gravelot. Within three years Roubiliac had perpetuated Hogarth's face in the same naturalistic, informal style (frontispiece and fig. 35), with a separate ceramic of his pug, which again underlines the informality of the mode (fig. 36).

Roubiliac later added statues of Harmony and Genius to complement his *Handel* at Vauxhall, thence turning his attention (as Hogarth turned his to sublime history) to allegorical funerary sculpture and heroic compositions that rivaled the greatest work of his Continental peers.

Besides Hogarth, Hayman, and Gravelot, George Michael Moser decorated the Rotunda, Richard Yeo designed the medals used for admission, and it is likely that Lambert had a hand in some of the background landscapes. In 1737–1738 Hayman and Gravelot designed vignettes and decorations for the music sheets of the Vauxhall Songs (the words were by John Lockman, who later wrote a description of Vauxhall). Indeed, Vauxhall was a group project.

What these artists offered was a breath of fresh air in the stuffy world of English art in the 1730s. Gravelot supplied an elegant device for breaking sharply with the neat, orderly, and overschematized "official" art of the day. But more generally, the group was unified by a mutual impatience with the authority and idealism of Renaissance-derived, academic dogmas of the sort associated with the Roman Club, and a desire to return to nature: human nature and native English, empirical nature. In his manuscript notes Hogarth constantly reiterates the characteristic approach of the group: a conviction that artists should not filter their view of the world in the manner of Palladio or even Raphael, but should depict what they see with their own eyes. To "recover nature" the English rococo provided it with a shape and a subject: the present time, the ordinary place whether city or country, the ordinary person, and certainly the forthright approach. Hogarth had already dramatized one form of this development in his *Harlot's Progress* and another in his *Rake's Progress*. His artist friends, decorating houses or pleasure gardens and painting stage designs or landscapes, were reacting to the new mode by replacing cherubs and satyrs with squirrels and foxes, abstract designs with oak and laurel leaves, or assemblies of gods with Hayman's swinging, dancing rustics.

The questions of academic theory, rules, and stereotypes all came to focus for the Slaughter's group in the economic situation of the English artist. There was no dominating patron after Burlington: the artists who met at Slaughter's earned much of their living from book publishers and printsellers, gold- and silversmiths, manufacturers of pottery, cabinets, and furniture, and theater managers for whom they painted scenery. These outlets were adequate but hardly satis-

factory to ambitious artists. They were fully aware that only by displaying their original works *as works of art* could they hope to undermine the prejudices of powerful connoisseurs, and with facilities for display being meager at best, the native artist was, in effect, trapped in his role of craftsman.

THE ST. MARTIN'S LANE ACADEMY

The year that began with the introduction of the engravers' petition ended with the reestablishment of an artist's academy, which had been in abeyance since the early 1720s. Vertue noted that "this Winter 1735 an Academy for drawing from the Life sett up in Sr. Martins lane where several Artists go to Draw from the life. Mr Hogarth principally promotes or undertakes it" (3: 76). Elsewhere he says that Hogarth and Ellys were jointly the moving forces, and an English academy may be seen as a logical extension of the artists' circle at Slaughter's and of their attacks on the foreign artists. Vertue remarked that they established it "in the Same place St Martins lane" where Vanderbank's academy had been, and he adds that each subscriber paid two guineas for the winter season the first year, and the next year would have to pay only one guinea and a half (6: 170).

Hogarth's own account, written almost thirty years later when threats to his academy's continuance had risen in the form of a proposed state (or royal) academy, is more specific. But it also places its myth of origin in the death of Thornhill, which had taken place a year before. Hogarth wrote: "Sr James Thornhill dying I became proprietor of his neglected apparatus and began by subscription that in the same place in St martins lane which subsists to this day as it was founded."[79] He clearly saw it as a continuation of the principles of Thornhill's academy.

As he tells it, he secured "a room big enough [he has struck out "of a middling size"] for a naked figure to be drawn after by thirty or forty people." He then "proposed a subscription for hire of one in St. Martin's Lane and for the expenses attending," and his plan was soon accepted and subscribed to "by sufficient number of artists. He presented them with a proper table for the figure to stand on, a large lamp, an iron stove, and benches in a circular form"— Thornhill's equipment—but he himself remained (for him the crucial

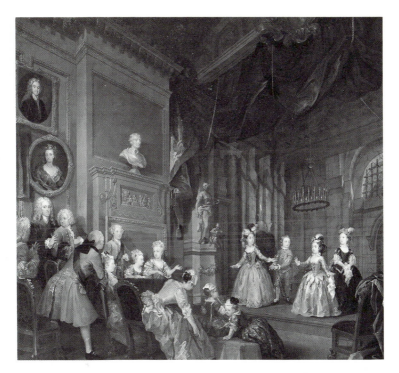

1. *A Scene from "The Indian Emperor"* (or "*The Conquest of Mexico*"); painting; 1732; 51½ × 57¾ in. (private collection).

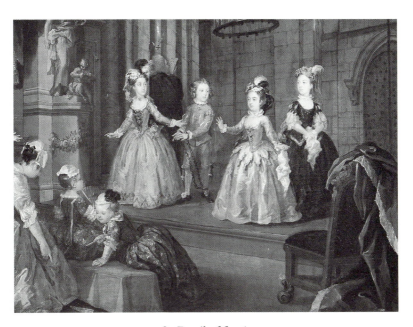

2. Detail of fig. 1.

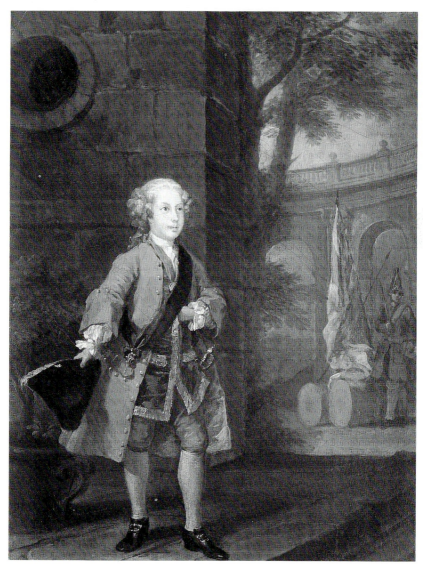

3. *The Duke of Cumberland;* painting; ca. 1732; 17½ × 13½ in. (Paul Mellon Collection, Yale Center for British Art).

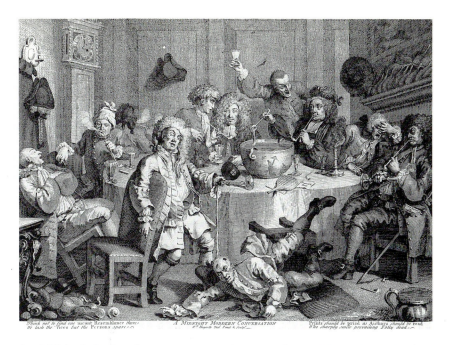

4. *A Midnight Modern Conversation;* engraving, second state; Mar. 1732/33; 12¹⁵⁄₁₆ × 18 in. (courtesy of the British Museum, London).

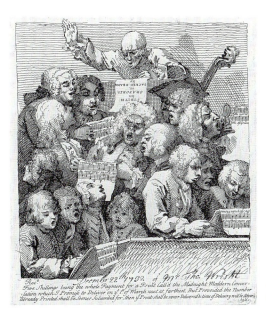

5. *A Chorus of Singers* (subscription ticket for *A Midnight Modern Conversation*); Dec. 1732; 6⁹⁄₁₆ × 6⅛ in. (courtesy of the British Museum, London).

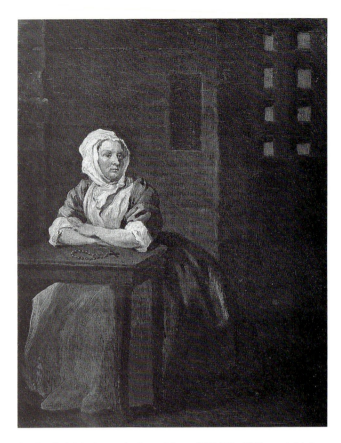

6. *Sarah Malcolm;* painting; Mar. 1732/33; 18½ × 14½ in. (National Gallery of Scotland, Edinburgh).

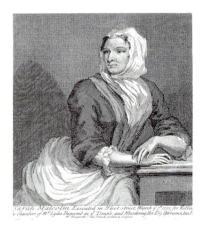

7. *Sarah Malcolm;* engraving; Mar. 1732/33; 6⅞ × 6½ in. (courtesy of the British Museum, London).

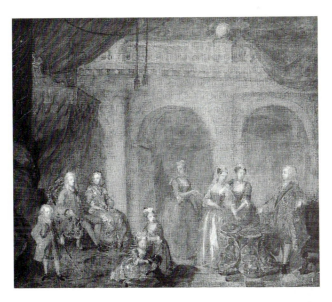

8. *The Royal Family,* modello; painting; 1732–1733; 14½ × 19¾ in. (National Gallery of Ireland, Dublin).

9. *The Royal Family;* painting; 1732–1733; 25 × 30 in. (Royal Collection, copyright reserved to Her Majesty Queen Elizabeth II).

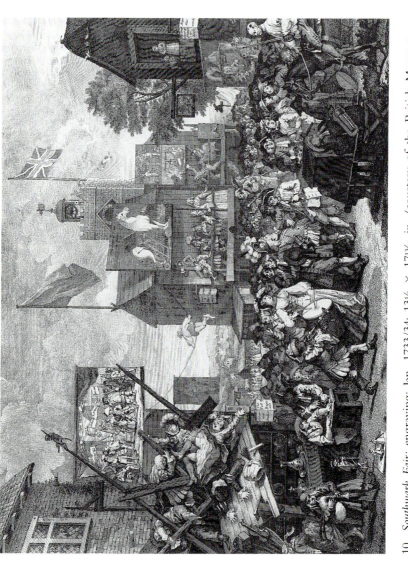

10. *Southwark Fair*; engraving; Jan. 1733/34; 13½ × 17¹³⁄₁₆ in. (courtesy of the British Museum, London).

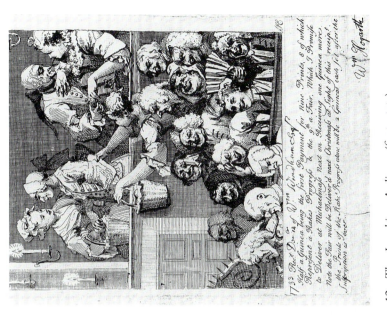

1733 Rec.ᵈ Dᵉ.ʳ 14 of Wᵐ Wincham Esq.ʳ
Half a Guinea being the first Payment for Nine Prints 8 of which
Represent a Rakes Progress & the 9.ᵗʰ a Fair. Which I Promise
to Deliver at Michaelmass next on Receiving one Guinea more,
Note the Fair will be Deliver'd next Christmass at Sight of this receipt
the Prints of the Rake's Progress about with a Guinea each set after the
Subscription is over

Wᵐ Hogarth

12. *The Laughing Audience* (first state); Dec. 1733; 7 × 6¼ in. (courtesy of the British Museum, London).

11. John Laguerre, *The Stage Mutiny*; 1733 (Royal Library, copyright reserved).

13. *A Rake's Progress,* Pl. 1; painting; 1735; 24½ × 29½ in. (courtesy of the Trustees of Sir John Soane's Museum, London).

14. *A Rake's Progress,* Pl. 1; engraving, second state; 12⅝ × 15¼ in. (courtesy of the British Museum, London).

15. Anononymous piracy, *A Rake's Progress,* Pl. 1; engraving; Mar. 1735 (courtesy of the British Museum, London).

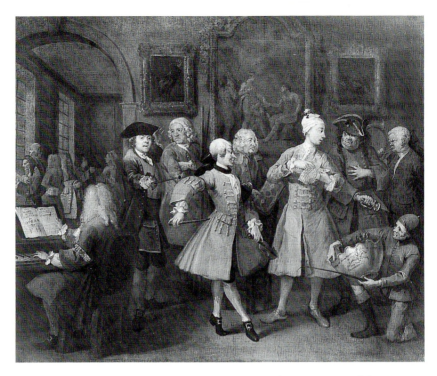

16. *A Rake's Progress,* Pl. 2; painting; 1735; 12 × 15¼ in. (courtesy of the Trustees of Sir John Soane's Museum).

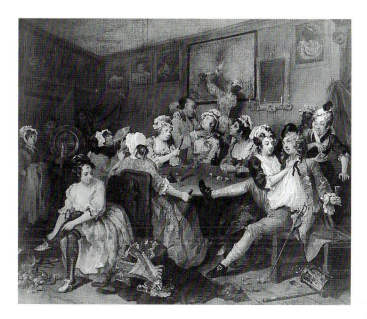

17. *A Rake's Progress*, Pl. 3; painting; 1735; 12⅝ × 15¼ in. (courtesy of the Trustees of Sir John Soane's Museum).

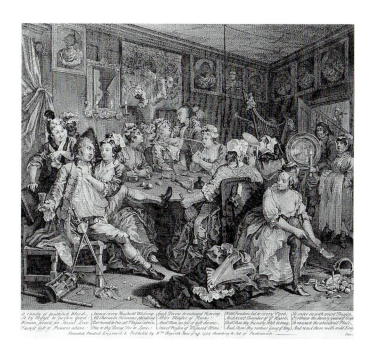

18. *A Rake's Progress*, Pl. 3; engraving, second state; 1735; 12½ × 15¼ in. (courtesy of the British Museum, London).

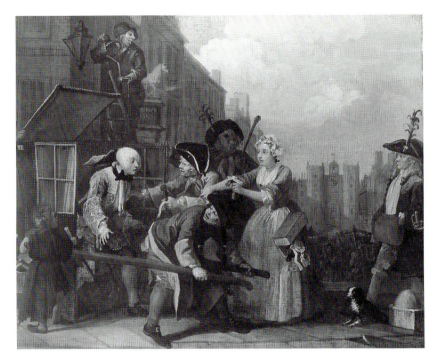

19. *A Rake's Progress*, Pl. 4; painting; 1735; 12⅝ × 15¼ in. (courtesy of the Trustees of Sir John Soane's Museum).

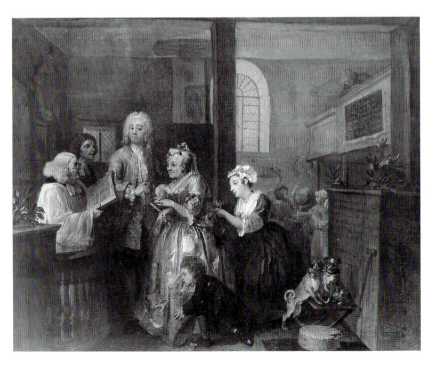

20. *A Rake's Progress*, Pl. 5; painting; 1735; 12⅝ × 15¼ in. (courtesy of the Trustees of Sir John Soane's Museum).

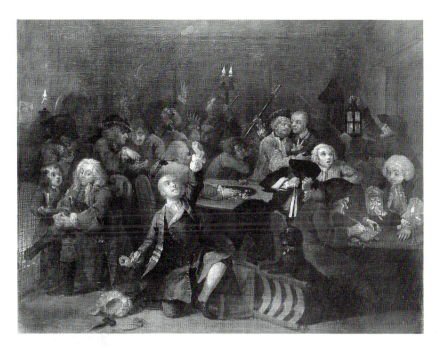

21. *A Rake's Progress,* Pl. 6; painting; 1735; 12⅝ × 15¼ in. (courtesy of the Trustees of Sir John Soane's Museum).

22. *A Rake's Progress,* Pl. 7; painting; 1735; 12⅝ × 15¼ in. (courtesy of the Trustees of Sir John Soane's Museum).

23. *A Rake's Progress,* Pl. 8; painting; 1735; 12⅝ × 15¼ in. (courtesy of the Trustees of Sir John Soane's Museum).

24. Annibale Carracci, *Pietà;* painting (National Gallery, London).

25. Caius Gabriel Cibber, *Melancholy* and *Raving Madness;* copied from the portal of Bedlam by Stothard, engraved by Sharp; 1783 (courtesy of the British Museum, London).

26. *A Marriage Contract* (Sketch for *A Rake's Progress*); painting; ca. 1733; 24¼ × 29¼ in. (Ashmolean Museum, Oxford).

27. J. Maurer, *Leicester Square;* 1750 (courtesy of the British Museum, London). The house at the far right (east side) with the golden head of Van Dyck over the door was Hogarth's from 1733 to his death. The fifth house on the left, with obelisk lampposts in front, was Reynolds's from 1760 to 1792.

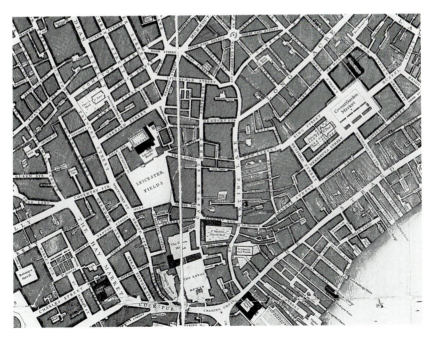

28. The Leicester Square area, detail of John Rocque's map of London; 1746 (courtesy of the British Museum, London).

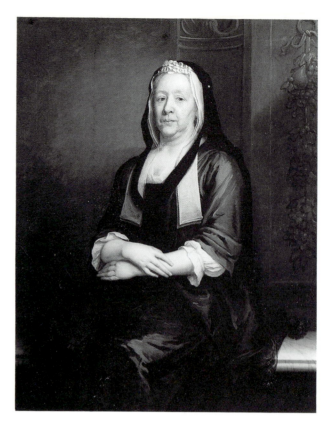

29. Portrait of Anne Hogarth; painting; ca. 1735; 50 × 40 in. (James D. Hamlin Collection, Panhandle-Plains Historical Museum, Canyon, Texas).

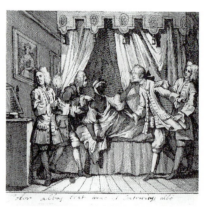

30. *The Discovery;* ca. 1743?; 6¼ × 7⅝ in. (courtesy of the British Museum, London).

31. Bookplate for George Lambert; ca. 1730? (courtesy of the British Museum, London).

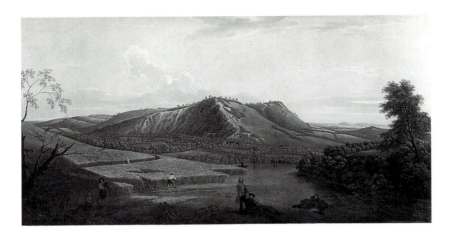

32. George Lambert and Hogarth, *A View of Box Hill, Surrey;* painting; 1730s (Tate Gallery, London).

33. Detail of fig. 32.

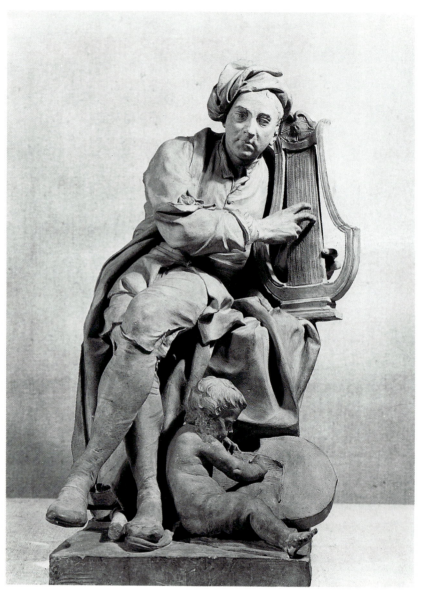

34. Louis François Roubiliac, *Handel;* terra-cotta sculpture; 1738 (Fitzwilliam Museum, Cambridge).

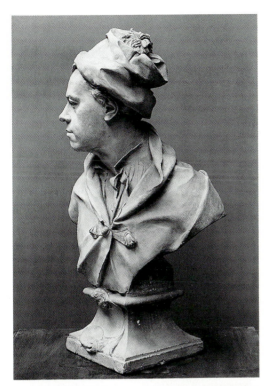

35. Roubiliac, *Hogarth;* terra-cotta sculpture; ca. 1740 (National Portrait Gallery, London).

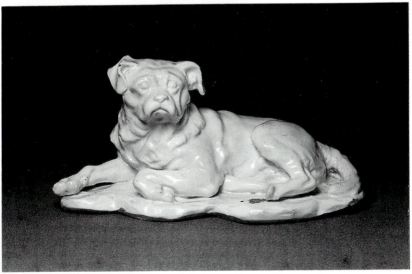

36. Roubiliac, *Hogarth's Pug;* ceramic; ca. 1740 (courtesy of the Board of Trustees of the Victoria and Albert Museum, London).

37. The Stairway, St. Bartholomew's Hospital (reproduced by permission of the governors of the Royal Hospital of St. Bartholomew).

38. *The Pool of Bethesda*; painting; 1736; 164 × 243 in. (reproduced by permission of the governors of the Royal Hospital of St. Bartholomew).

39. *The Good Samaritan;* painting; 1737; 164 × 243 in. (reproduced by permission of the governors of the Royal Hospital of St. Bartholomew).

point) "an equal subscriber with the rest signifying at the same time that superior and inferior among artists should be avoided especially in this country." Looking back from the time of crisis, he remembered stressing even then that it was the presence of directors and other hierarchical elements, in imitation of the French Academy, that had destroyed the earlier English academies—and he adds that his democratic plan did indeed work for thirty years.

The room was probably in Russell's Meeting House—a disused Presbyterian chapel which lay toward the west end of Peter's Court; it was evidently sublet, since there is no reference to it in the rate books.[80] Hogarth and Ellys were listed as the proprietors, and Vertue notes that before long Gravelot was teaching drawing and Hayman painting.[81] It was in this school that most of the artists of the period received their training. Here Hogarth's activism found its most important outlet in these years, in teaching, supervising, and advising young artists. He cannot have been a dogmatic teacher. Judging from his later writings, he would have urged the students to learn expression, movement, and the appearance of things from the model or from general observation—and to study commonplace objects as well as the classical casts. Only for some aspects of composition, such as arrangement of light and shade, would he have referred them to prints and casts. "While being forthright and sharp," Michael Kitson has speculated,

> he would not have spent his time 'telling as they do (in the French Academy) the younger ones when a leg or an arm was too long or too short'; nor would he have considered himself, as Reynolds did when President of the Royal Academy, to be above the day-to-day business of practical instruction. We can imagine Hogarth, rather, as being essentially concerned with the principles of artistic creation. What were 'the effects of nature on the eye'? How should perception of these effects be translated into art? By what visual means can movement or character be expressed?[82]

For Hogarth, however, the academy was also a means of consolidating the artists who had been loosely bound together by Slaughter's; it was in fact closer to guilds such as the Painter-Stainers' Company than to Continental academies (which were, of course, founded for the purpose of circumventing guilds), and was based on Hogarth's assumption that the future of English artists lay, not above with the aristocracy, but below, at Vauxhall, St. Bartholomew's Hos-

pital, and the Foundling Hospital. Thus he persistently stressed the democracy of the academy, as he also emphasized the great mass of buyers for whom he made his prints, and decried interference by the "great," the dilettantes who usually made themselves felt in such artists' academies. In the 1730s at least, Hogarth's idea of the academy's purpose must have been blurred: he saw it as a guild of artists, with mutual protection against patrons and picture dealers as its aim; yet it operated like the artists' academies, with a life class and theoretical discussions of art, toward enhancing the English artist's status. Insofar as it was an "academy," it descended not from the institutionalized royal academy of France but from the art academies of Italy, originally democratic and based on the radical Florentine political tradition.[83]

Above all the academy was another London club: it offered a space outside the control of institutions, with the tavern as its model. The club set itself off by its own myths, symbols, and laws at a parodic distance from the authority structures of church and state. The special, often secret laws gave the club members the maximum liberty to do what they willed (at length, in the Medmenham Monks, literally *Fay ce que voudras*). The Beefsteaks met symbolically behind the scenes of the *theatrum mundi,* to eat, drink, and joke. Appetite, rather than the fiats of God or the laws of the state, served as the basis for the club's society. The annual St. Luke's Day feasts were under way at the St. Martin's Lane Academy by the 1740s and probably from the beginning (one can imagine that Hogarth would have advocated, as in the Beefsteaks, a *native* dish). Conviviality and equality were the chief principles, designating a brotherhood rather than a patriarchy. It is easy to see how the academy served its founder as both "academy" and club.

4.

ST. BARTHOLOMEW'S HOSPITAL AND NEW TESTAMENT HISTORY PAINTING, 1734–1738

Early in 1734 when he was busy with the subscription for the *Rake's Progress,* Hogarth learned that the Venetian painter Jacopo Amigoni (or Amiconi) was negotiating with the governors of St. Bartholomew's Hospital (unofficially, since no word of this reached the minute books) for the decoration of the new hospital building's staircase and perhaps Great Hall. Since the elder Ricci's departure in 1716, Amigoni had been the first foreigner of note to assay England. By 1732 he had painted the ceiling of Rich's new Covent Garden Theatre with *The Muses Presenting Shakespeare to Apollo* and had decorated several stately homes; he had painted portraits of among others the three princesses; and he had been hired by Benjamin Styles to paint seven or eight panels at Moor Park to replace those by Thornhill for which Styles had been forced by law to pay.

In 1734 the plaster work was finished in the administrative or "ceremonial" block of St. Bartholomew's (the so-called first wing), which was more elaborately decorated than the rest of the hospital, and the surfaces were ready for painting. Amigoni had been approached by one or more of the governors and was receptive. But here he was treading on Hogarth's home territory.[1] The place was personally significant for him, but his primary reaction would have been artistic. Having unsuccessfully sought the patronage of the crown, he must have asked: what then of the Church? Remembering William Kent's fiasco at St. Clement Danes, he would not have been sanguine about ecclesiastical patronage; but the Church still represented one occasion for the great style of painting. Hogarth's solution, given the opportunity offered by St. Bartholomew's Hospital, was to paint religious paintings (New Testament, of course) in a

secular building, appropriately a hospital, where he could celebrate charity, the most secular and safe of religious virtues, for another aspect of the general public he had already won with his prints.

Hogarth seems to have known John Lloyd, the "Renter," or tax collector, of the hospital, and he certainly had connections through Thornhill with James Gibbs, the hospital's architect. Gibbs may have encouraged Hogarth (who later painted his portrait). The upshot was that Hogarth volunteered to decorate the stairway gratis, as an Englishman (echoing Thornhill's old xenophobic cry at the time of the St. Paul's commission), and Lloyd, on behalf of the governors, agreed. It appears that Lloyd exerted some influence for Hogarth since, in "acknowledgement for his services in connection with this work," Hogarth offered to paint his portrait and, in 1738, did paint his son John (Mellon Collection, Yale).[2]

On 20 February agreement was reached, and on the 23rd James Ralph crowed in his *Weekly Register* (No. 207): "We hear that the ingenious Mr. *Hogarth,* is to paint the Great Stair-Case in *St. Bartholomew's-Hospital,* with the histories of the *Pool of Bethesda* and the *Good Samaritan.*"[3] Although Hogarth can have done no more than sketches or perhaps the modello of *The Pool of Bethesda* (Manchester), on 27 April (No. 216) Ralph linked him with Thornhill and asserted that "sure no Body can say they have not found their Account in . . . [history painting] both in Interest and Reputation"; and in No. 222 (8 June) he reprinted his June 1732 essay on Hogarth in a new series on painting.

Ralph was a friend of John Ellys and must have known Hogarth as well; he was close to Fielding, later assisting him with *The Champion.*[4] Since January 1731 he had been editing the *Weekly Register,* a proministerial newspaper in which he set himself the task of reforming the taste of the age. As early as February 1731 he had included an "Essay on Taste in General" and on 3 June 1732 he had turned to painting, singling out for praise "the ingenious Mr. Hogarth" and his *Harlot's Progress,* which had just been published.[5] Then, beginning in mid–October 1733 and running till April 1734, he published a series of some twenty essays called "Critical Review of the Publick Buildings, Statues and Ornaments, in and about London and Westminster." In these he attacks the "gothicism" of Nicholas Hawksmoor and defends Palladianism, but he also ridicules the foreign painters who were decorating the buildings, in particular Amigoni.

Ralph's attack on Amigoni was part of a campaign in defense of

English painters such as Hogarth. On 20 April (No. 215) he began a discussion of history painting, in which he emphasized Steele's admonition of "the judicious Choice of a Subject," and in the issue for 4 May—the same day, as it happened, that Sir James Thornhill died—he launched into his attack on Amigoni. He begins by allowing that "when they neglect their own Countrymen in Favour of a Foreigner," the English should have "undeniable Evidence, that he has real Merit to deserve the Preference," and proceeds to parody Amigoni's paintings on the grounds that they are "only calculated to please at a Glance by the artful Mixture of a Variety of gay Colours, but have no Solidity in them," and they "will not bear an Examination." The three paintings on the Great Staircase at Powis House, for example, jumble stories of Judith holding Holofernes's head, Antony supping with Cleopatra, David and Abigail in the wilderness, and (on the ceiling) the "first Out-set of the Morning, attended by Hesperus, Zephyr, and the Hours." Old Testament figures are dressed in Roman togas in Venetian settings, and in the story of Antony and Cleopatra "Signor Amiconi seems to have copied the Gallantries of some fat rich Alderman, and his extravagant Spouse" (No. 217, 4 May). This was the standard criticism of the Venetian high style, as in Richardson's attack in his *Essay on the Theory of Painting* on Veronese's "Dog with a Bone, at a Banquet, where People of the highest Characters are at Table; a Boy making Water in the best Company, or the like."[6]

"Bavius" of the *Grub-street Journal* responded on 27 June, supporting Amigoni against his English competitors. Ralph and Ellys are identified and connected with an "eminent painter [who] was privy" to Ralph's attack on Amigoni: "they have more than once diverted themselves and others with the unmeaning manner" of Amigoni's histories. Both Hogarth and Ellys were included in the reference of 19 September to "those little painters, who were the *employers* of this admirable Critic [Ralph], and first *prescrib'd* to him this dirty work, or at least incouraged him in it"—which recalls Vertue's comment in 1732, singling out Hogarth, that he observed "the most elevated Men in Art here now, are the lowest of stature" (3: 61). Whoever wrote the *Gentleman's* obituary of Thornhill identified his surviving daughter Jane as "now the Wife of Mr. *Wm Hogarth,* admir'd for his curious Miniature Conversation Paintings." Such references to size may have rankled Hogarth. The paintings he was now planning to undertake at St. Bartholomew's Hospital contained figures seven feet

tall, and, looking back from the 1760s, he emphasized his sudden transition from small to huge compositions (AN, 202–3).

On 18 July he and John Jolliffe were nominated governors of the hospital by Sir Richard Brocas, the president (and ex-lord mayor). A presidential nomination was reserved for a few people of exceptional merit and was not, like other nominations, contingent upon a donation of £50 or £100. It is clear, however, that a donation of a sort—his paintings—was behind Hogarth's election. At the next meeting, 25 July, he and Jolliffe were duly elected "and Green staves are ordered to be sent to them according to antient Custom."[7] The staffs were carried by the governors in the procession preceding the annual dinner, which, as it happened, took place on this same day, and was no doubt attended by Hogarth with his staff.

The chronicler of St. Bartholomew's Hospital suggests that Hogarth's donation was "in memory of his birth near the hospital," and it is true that he had many sentimental associations with the hospital.[8] Another incentive was probably the desire to be a governor of the hospital—one of the two hundred who included such influential Londoners as the earls of Oxford and Orrery, the duke of Chandos, and members of the banking families of Hoare and Child. Hogarth would have wanted to bear the signs of prosperity that included governorship of a public institution. St. Bartholomew's was, in fact, the first of a series of such governorships that came his way. This is not to deny that he was sincerely motivated by charity. But then charity and self-interest were motives shared by most of the governors of the hospitals for the poor.[9]

Hogarth, it is clear, was clinically as well as charitably interested in what he saw in St. Bartholomew's. Considering his friendship with medical men he must also have shared their interest in more and better hospitals as a way toward improving English medicine and scientific knowledge. Only through a hospital did medical men have access to clinical material for their own studies or for the teaching of others. Education was always, in its various forms, one of Hogarth's abiding interests. Moreover, hospitals were regarded by the doctors as academies—the medical equivalents, from Hogarth's point of view, of the St. Martin's Lane Academy.

But chiefly he was determined to capture the commission and establish his credentials as a painter of sublime history. And while he had other good reasons for doing this, one satisfaction must have been to avenge his recently deceased father-in-law's humiliation at

the hands of Amigoni. Indeed, a principle of Hogarth's career emerges in the story of the St. Bartholomew's paintings: the stimulus of competition. The Venetian Amigoni's contract prompts Hogarth to paint his own alternative as a programmatic utterance about English art, society, and morality, correcting the foreign art of Venice. In later years he will respond in the same way to the overpriced painting of Sigismunda by "Correggio" and in a variety of ways to the work of Rembrandt. But it is equally possible that he regarded himself as a rival, as well as disciple, of Thornhill and wished to challenge his New Testament paintings in the cupola of St. Paul's.

In Ralph's second *Weekly Register* essay on history painting (No. 216, 27 Apr. 1734), in which he links Hogarth and Thornhill as "almost the only Persons who have lately made it their Study," he recognizes that the difficulty lies with English Protestantism: "All Reformations run into Excess, and while we abolish what is criminal, we are too apt to trespass upon what is useful." Churches ought to be encouraged to commission paintings: "'Tis my Opinion, that holy and devout Pictures are no Fault in themselves, and 'tis certain they have a very fine Effect in making the Face of Religion gay and beautiful," and he adds that "even Devotion itself might be made instrumental in the Encouragement of Taste and Politeness." The other possibility for commissions lies in public buildings, which he enumerates as "Hospitals, Courts of Justice, Theatres, City-Halls, &c." [10] In fact, this essay almost programmatically outlines the new areas of patronage being broached by Hogarth. [11]

His desire to attempt sublime history cannot be attributed only to the shadow of his father-in-law. However original, Hogarth was still deeply rooted in the tradition of academic doctrine; some part of him continued to believe what the art treatises had to say about history painting. But he had already made clear his contempt for histories portraying heathen gods and heroes, and a religious subject, even with a commission, was a dubious undertaking given the English Protestant distrust of Roman Catholic church decorations, images, and Counterreformation iconography. The difficulty of painting a church altarpiece in England was once again articulated in November 1735, when the *Daily Advertiser* referred to an "extraordinary altarpiece lately set up in Clerkenwell Church . . . wherein, to the Reproach of Protestantism, *the Virgin Mary is painted with Christ in her Arms in the front, with Moses and Aaron on each side as her proper Guard*." The congregation petitioned the bishop of London for its

removal, just as St. Clement's congregation had done with Kent's altarpiece. A sixpenny print of the altarpiece was advertised as sold along with "the late Bishop Fleetwood's Account of the Origin and Progress of setting up Pictures and Images in Churches, to the Scandal of Christianity, and the Promotion of Superstition and Idolatry."[12]

THE POOL OF BETHESDA AND THE GOOD SAMARITAN

Hogarth's account, written years later, was that before he devoted himself wholeheartedly (or so I interpret his ambiguous phrases) to "Engraving modern moral Subjects, a Field unbroke up in any Country or any age," he made an attempt at "the grand stile of History": "I then as a specimen without having done any thing of the kind before Painted the staire case at St Bartholomew Hospital gratis" (AN, 216). He adds that "the puffing in books about the grand stile of history painting put him upon trying how that might take so without haveing a stroke of this grand business before." If one emphasis is on the mystification of history painting by theorists such as Richardson, the other is on his having done nothing of the sort before: "immediately from [having painted only] family picture[s] in smal he painted a great stair case," he says again, with

> figures 7 foot high . . . this present to the charity he by the pother made about the grand stile thought might serve as a specimen to shew that were there any inclination in England for Historical painting such a first essay would Proove it more easily attainable than is imagined. (202–3)

His aim, he explains, was not solely to paint sublime history himself but to ensure that other English artists might also paint histories, that England might be decorated with English art, and that the English public might see it (figs. 37–39).

Although the agreement with St. Bartholomew's went back to early 1734, and Hogarth was elected a governor of the hospital that summer, the *General Evening Post* of 15–17 July 1735 could still announce blandly that he was going "to make a Present of the Painting

of a Stair-Case at St. Bartholomew's Hospital, of which he was lately chosen a Governor," but with no further information than the 1734 announcement in Ralph's *Weekly Register*. Presumably he had waited to begin the work until the *Rake's Progress* and the Engravers' Act were off his hands; and perhaps the July announcement followed from his having just set up his materials. The panel would appear, from the size of the canvas, to have been painted at the hospital.

The *London Evening Post* of 8–10 April 1736 announced the first part of the project as completed:

> The ingenious Mr. Hogarth, one of the Governors of St. Bartholo-mew's Hospital, has presented to the said Hospital a very fine Piece of Painting, representing the Miracle wrought by our Saviour at the Pool of Bethesda, which was hung up in their great Stair-case last Wednes-day [i.e., 7 April].
>
> The same Gentleman is preparing another Piece, representing the Story of the Good Samaritan, which he intends to present to the said Hospital.

Vertue, exceedingly annoyed, wrote in his notebook (3: 78) that "this advertisement is his own,"—by which he meant inserted in the paper by Hogarth as a news item. Judging by the consistently published news of St. Bartholomew's Hospital in the *London Evening Post,* it appears more probable that the hospital and not Hogarth secured the publicity. Vertue's general reaction, nevertheless, was positive. He admits Hogarth's "extraordinary Genius," which up to now

> has displayd it self in designing, graving painting of conversations charicatures. & now history painting—, joyn'd to a happy—natural talent a la mode.—a good Front and a Scheemist—but as to this great work of painting it is by every one judged to be more than coud be expected of him.

The first reaction to the completed *Pool of Bethesda* seems to have been incredulity mixed with grudging admiration.

Through 1735 and into 1736 Hogarth had worked almost exclu-sively on this enormous canvas, followed by *The Sleeping Congregation* in October of 1736 (fig. 40). Delays of one sort or another—perhaps the need to recoup the "gift" to the hospital by some more profitable engraving projects—prevented work on *The Good Samaritan* for a whole year, until finally in the issue for 14–17 May 1737, the *London*

Evening Post announced: "A few Days since a Frame was fix'd in the Staircase of St. Bartholomew's Hospital, in order for painting the History of the good Samaritan, by that celebrated Artist Mr. Hogarth." The same journal announced in the issue of 7–9 June:

> On Monday last the Masons began to lay the Stone-Work in the new additional Buildings in St. Bartholomew's Hospital, which is to contain twelve Wards; and on Tuesday [7 June] Mr. Hogarth began painting the History of the Good Samaritan, in the great Stair-Case in the said Hospital, and 'tis thought will be finish'd against the Governors' annual Meeting, which will be the last Week in July next.

The Good Samaritan was apparently painted in situ in order to sustain the tone of the finished work next to it. The *Grub-street Journal* of 14 July noted that "Yesterday the scaffolding was taken down from before the picture of the Good Samaritan, painted by Mr. Hogarth, on the stair-case in St. Bartholomew's hospital, which is esteem'd a very curious piece." On Thursday the 21st the General Court met as scheduled, with an "elegant Dinner" (Henry Overton the printseller was one steward), and it was "Resolved That the Thanks of this Court be given to Wm Hogarth Esqr one of the Governors of this Hospital for his generous free Gift of the Painting of the great Stair Case performed by his own Skilfull Hand in Characters taken from Sacred History) wch illustrate ye Charity extended to the Poor Sick and Lame of this Hospital." Hogarth was himself absent from the meeting, but the *London Evening Post* of 21–23 July reported that the paintings "were esteem'd the finest in England."

It is, as Hogarth claimed, startling to move from one of his 1735 paintings to this huge wall: the figures are larger than life-size, and they loom up as one ascends the staircase (fig. 37). From the top landing, outside the entrance to the great hall, lighted only by three windows and a chandelier, they are at eye level, but even at that distance the color and the brilliance of execution are impressive.

In general, Hogarth wishes to summon up with his centerpiece the large rectangular shape of the Raphael Cartoons, in particular *St. Peter and St. John Healing the Lame*. The cripple at the right, taken from Raphael's beggar, is his conscious allusion (as also the lame man who appears in the monochrome story of Rahere beneath) to Raphael's inclusion of figures less than ideally beautiful. But the emphasized recession, the Veronese arcade across the back, the focus on the

foreground group, the free brushwork, and the soft colors draw attention to the Venetian tradition, which still carried a certain authority in London and continued to influence Hogarth the painter as it had Thornhill. Indeed, given Hogarth's seizure of the commission from Amigoni, it seems appropriate that he joins the pictorial spaces of Raphael and the Ricci.[13]

And yet a contemporary would also have sensed a tension between the compositional echoes of Raphael and the particularity of the Dutch tradition. The paint surface shows Hogarth's relationship to the Kneller version of the Rembrandt tradition—but for him the decisive source was probably a verbal one: Jonathan Richardson's description of Rembrandt's *Christ Healing the Sick* (the Hundred Guilder Print), which is not itself a close visual equivalent. In his *Essay on the Theory of Painting,* Richardson discussed it as the model for the historical composition of a religious subject, insisting on "variety" in the delineation of different types of the diseased and crippled, and emphasizing Rembrandt's storytelling details: the Ethiopian, for instance, who shows how far Christ's fame had reached.

The Good Samaritan is seen only from the side as one ascends the stair toward *The Pool:* the visitor then has to stand on the far side of the landing and turn between the two scenes. They are not, as in *Before* and *After* (a version of which Hogarth published as engravings about this time), a contrast but a parallel between the uncovered victims and the ministering figures representing Charity in each. Both Christ (in the pose of Christ in Raphael's *Feed My Sheep*) and the Samaritan are dressed predominantly in red: color emphasizes the parallel between the divine and human acts of charity. Christ's upper (outer) garment is blue, his tunic red; the Samaritan's underrobe, the upper part of his attire, is ochre, the lower or overrobe is red, and his hat repeats the blue of Christ's robe.

The use of painted decoration to support the architectural structure is reminiscent of Thornhill's work with Gibbs at Wimpole House, except that Hogarth's brushwork is much freer, emphasizing the large rocaille forms. The decorative borders and scrollwork around the painting are said to have been executed by a Mr. Richards; if so, he captured Hogarth's brushwork perfectly. The extensive landscape, out of Salvator Rosa, has been, on the strength of Hogarth's known friendship with George Lambert, attributed to that artist.[14] Above the door to the Great Hall is a circular medallion profile of Galen,

probably added after the unveiling in July 1737; and over the other door, which opens into the hall, is a medallion of Hippocrates, in reddish paint simulating bas-relief. These are matched by the simulated bas-reliefs below the large pictures: under *The Pool of Bethesda*, a sick man carried on a stretcher into the hospital; under *The Good Samaritan*, the jongleur Rahere, founder of the hospital, asleep and dreaming his vision of the hospital, and again receiving gifts and beginning to build the hospital.

The St. Bartholomew's paintings represent a departure in Hogarth's career: to begin with, a shift from the prison to the hospital as a central symbol. The place was a hospital for the poor, the subject Hogarth chose was charity, and the pictures themselves, Hogarth's own gift to the hospital, were a charity. Charity was one of the most popular topics of preachers in the great middle area roughly designated as Latitudinarian. Clergymen such as Bishop Benjamin Hoadly (Hogarth's friend, of whom he painted at least two portraits) taught that an active charity was at once the condition of salvation for the individual soul and the keystone for the practical betterment of society. In St. Bartholomew's Hogarth might be illustrating a Hoadly sermon:

> Did Men but consider, that the great Branch of Christian Duty, is Love, and Good-nature, and Humanity; and the distinguishing Mark of a *Christian*, an universal Charity; they could not but own that *Jesus Christ* came to plant and propagate them in the world.[15]

It is fairly certain that Hogarth believed in this religion of social morality, in which faith was significant if at all only as a moral virtue that produces charity. For charity also represented the *test* of "faith," those verbal protestations of virtue, and of a corrupt clergy.

The minute book of the hospital says that the pictures illustrated "yᵉ Charity extended to the Poor Sick and Lame *of this Hospital*" (emphasis added). Besides the subject of charity, what caught Hogarth's interest, and drew upon his long knowledge of the hospital, was the matter of disease and injury. As if recalling Richardson's advice, he has chosen to represent the diseases cured by Christ (that act of "charity") in terms of the contemporary diseases treated at St. Bartholomew's Hospital. The patients are carefully observed: the in-

fant with the prominent forehead, curved spine, and enlarged joints is a classic case of rickets, as first described by the hospital's Dr. Francis Glisson in 1650.[16] Also painted with clinical accuracy are a woman with inflammation of the breast, a man whose gouty hand has received a painful knock from the blind man whose staff is near it, a girl unhealthily fat, and an emaciated old crone. The arms of the last two are bare to illustrate hypertrophy and atrophy, processes of abnormal growth and abnormal wasting.

But it is more significant perhaps that with the beautiful nude woman in the background not physical symptoms but the graphic context—of husband or more probably lover and servant, and also of those contemporary works of Hogarth's, the *Harlot* and *Rake*—makes it extremely likely that she is suffering from a venereal disease. Also evidence is the story, told by "an old acquaintance" of Hogarth's (probably Ebenezer Forrest) who informed John Nichols, that the lady was "a faithful Portrait of Nell Robinson, a celebrated courtesan, with whom, in early life, they had both been very intimately acquainted."[17]

As we have seen, Hogarth also painted the pictures to demonstrate something about his artistic aims, and so he chose *New* Testament subjects involving Christ and his parables. By placing these stories of illness and wounding in St. Bartholomew's Hospital (as by continuing to use identifiable contemporaries such as Nell Robinson), he was bringing the Bible story up to date, and so creating something that was a history painting but at the same time related to his "modern moral subject." It was the reverse of *A Harlot's Progress,* which showed the story of a contemporary prostitute in terms of the story of the New Testament Marys.

THE WOOLSTONIAN MODEL OF NEW TESTAMENT HISTORY

In *Harlot* 2 (see vol. 1, 288ff.) Hogarth placed a small portrait on the wall between the head of the Harlot's Jewish keeper (who steadies the table she is kicking over) and the Old Testament history painting of Uzzah steadying the Ark of the Covenant. The name "Mr. Woolston," prudently excised from the published print, was retained in the authorized set of cheap copies by Giles King.[18] One of the fea-

tures of Woolston's *Fourth Discourse on the Miracles of Our Saviour* (1728) and again his *Sixth* (1729) was that in order to ridicule the "miracle" of the Resurrection he assumed the mask of a Jewish rabbi. The Jew represented a safe position of exaggerated hostility from which to dissect the New Testament; at the same time the Jews, embodied in their priests and rabbis, had come to represent to the Deists the evils of clerical and textual authority, of elevating the law over the spirit.

Another reason for Woolston's presence between the Jew and the painting of Uzzah was that Bishop Edmund Gibson (alluded to in Plates 1 and 3) not only attacked Woolston's *Discourses* in his *Pastoral Letters* but pursued him into the courts and had him locked up in prison, where, because he could not pay the fine, he languished until he died. This is presumably the reference intended by the Anglican bishop shown in the painting (in place of Jehovah) stabbing poor Uzzah, who is only trying to save the tottering Ark of the Covenant from falling. Uzzah's attempt to save the Ark *equals* the argument for which Woolston was persecuted.

Woolston demonstrated with heavy ridicule that the "miracles" of Christ were improbable as history and therefore conceivable *only* as allegory. This served the overt function of saving or recovering the New Testament as a higher form of truth, by way of Church Fathers such as Origin. But covertly, by showing that the New Testament has no possible validity except as allegory, Woolston discredited the text's authority as the Word of God. Citing various Church Fathers, but with obvious irony, he offered his own allegory of this "history," which always proved to be an attack on the authority of the clergy. In the *First Discourse* (1727) he shows that the "miracle" of Christ's chasing the money changers from the Temple is in fact an allegory of the need to cleanse the Church of its mercenary clergymen ("Bishops, Priests, and Deacons"). This *Discourse* was dedicated to Gibson and set in motion his course of episcopal retaliation.

Hogarth followed the Woolstonian model in *A Harlot's Progress*. In Plate 1 he reduces the conventional representations of Mary, Elizabeth, and Zachariah in the Visitation to the girl from the country Moll Hackabout, the bawd Mother Needham, and her employer Colonel Charteris in contemporary London; in 3 he historicizes the Annunciation into Hackabout—in the conventional tester bed with her book in front of her (Gibson's *Pastoral Letter*)—and the magistrate

Sir John Gonson entering not to announce the birth of a son (though this does take place between plates 4 and 5) but to arrest her for prostitution (again, parallel to the arrests of Uzzah and Woolston); and in Plate 6 a Last Supper is historicized into the Harlot's wake, her coffin the Eucharist table, her twelve mourners the disciples, and her son the Christ figure: and if Woolston and his rabbi are still lingering in the memory, it is to recall their demystification of the Resurrection itself.

In each demystified scene Hogarth replaces the New Testament story with a story (in Woolston's terms an "allegory") of the corruption of the clergy: In 1 the clergyman turns his back on the girl to read the address of the bishop of London, the source of clerical patronage (Bishop Gibson himself); in 2 the bishop stabs Uzzah; and in 6 the clergyman, who should be officiating at the Harlot's funeral, is making tipsy advances to the whore next to him. However we wish to nuance the juxtapositions of scriptural allusions (compositional and in the paintings on the walls), they closely resemble Woolston's program.

In his *Defence* of the *Discourses* (1729) Woolston explains that he was only employing ridicule, not blasphemy, and justifies his method: "Ridicule will cut the Pate of an Ecclesiastical Numbskull, which calm and sedate Reasoning will make no Impression on."[19] But the characteristic Deist device was indirection or what I have referred to as Woolston's overt and covert meanings—or (to use Toland's terms) the exoteric-esoteric irony employed partly to avoid censorship, but more emphatically because, "Thinking that the priests and their preachings were fraudulent, they felt justified . . . in using fraud to fight fraud."[20] This interpretation of *A Harlot's Progress* finds support not only in the portrait of Woolston in Plate 2 but also in Hogarth's programmatic subscription ticket for the series, *Boys Peeping at Nature* (ill., vol. 1, and fig. 52), which shows the goddess Nature being unveiled, or demystified, by the satyr in order to show the reality under the veil.

It is worth noting that the Pool of Bethesda was one of the miracles Woolston subjected to destructive criticism based on reason and sense (the eighth, treated in the *Third Discourse on the Miracles of Our Saviour,* 1728). Regarding the story as a tissue of "Absurdities, Improbabilities and Incredibilities" (34), Woolston tests the New Testament "miracle" as if it took place in contemporary England—for

example, the pool brings to mind "the medicinal Waters of *Bath*" or some "Pool or Cistern of Water about this City of *London*" (39, 45). So unlikely are the facts in this context, he concludes, that one has no choice but to read the narrative as an allegory.

The story (John 5: 7) is about the periodic troubling of the water of the pool when an angel passes over it, after which the first person into the water is cured of whatever his or her disease. Woolston asks how, given the modus operandi of the pool, "the Disposal of the Angelical favour to this or that poor Man, according to his Necessities or Deserts," was in fact regulated: "Just as he who runs fastest obtains the Prize: So here the Diseased, who was most nimble and watchful of the Angel's Descent, and could first plunge himself into the Pool, carried off the Gift of Sanation. An odd and a merry way of conferring a divine Mercy" (42–43). He imagines the trouble "the poor and distressed," as opposed to "their betters," would have had getting into the water first. He also broaches the practical questions of the angel's landing ("whether . . . with his Head or his Heels foremost, or . . . like a Goose into a Horsepond") and the sight of "some hundreds perhaps, of poor Creatures . . . at once tumbled into the Waters to the diversion of the City Mob, as well as of God's Angels" (41, 44).

Hogarth, of course, would not have been so indiscreet as to make a Woolstonian New Testament painting, but the site *is* a hospital, not a church, and traces of Deist satire are discernible. He adds in the background the tableau centered on the unclothed woman (not in the biblical text) to explain why she gets into the water and why the lame man does not. The chain of action, connected through hands and arms, shows a woman and her ailing child being pushed aside by a burly attendant who accepts money to assist the more prosperous, more "respectable" group consisting of the servant offering the bribe, her master giving the orders, and his beautiful mistress. In short, Hogarth maintains religious decorum but introduces the problem of the poor's ever getting first into the pool ahead of the rich—as well as an image of a beautiful Titianesque Venus.

By his placement of the other diseased folk (and his allusion to Rembrandt's *Christ Healing the Sick*) he also answers Woolston's criticism that Christ would not have healed only one man, the so-called impotent man—"he cured all where-ever he came" (50). Woolston asks what specific diseases could be covered by the word "impo-

tence," and Hogarth responds with a clinical description of diseases treated in St. Bartholomew's Hospital.

Woolston's point was that the so-called miracle of the Pool of Bethesda made sense only if interpreted allegorically, and the baptismal allegory he (and many of the Church Fathers) educed was of the "ignorant, erroneous, and unstable in Faith and Principle," identified as those who "rest on the Letter of the Law, which throws them into various Errors, like diseases, of different Kinds, of which they can't be cured without the Descent of the Spirit, like an Angel . . . " (58–59). Hogarth's "allegory" similarly concerns the letter versus the spirit: the "Somebody" who exploits the letter of the law by bribing a place for his mistress is contrasted with Christ who, ignoring the pool altogether, simply cures the poor and helpless "Nobodies" himself.

Woolston recalled that the Jews were "mov'd with Indignation at the Cure of the infirm Man, saying to him, [John 5] ver. 10. *it is the Sabbath, it is not lawful for thee to carry thy Bed.*" Although he doubts this literally, he interprets it allegorically to mean "that the *Clergy,* who would be *Jews* inwardly," oppose Christ's mission to replace the Law with "the Spirit of Truth [which] will descend on Mankind" (62). The verses continue (John 5: 16): "And therefore did the Jews persecute Jesus, and sought to slay him, because he had done these things on the sabbath day." Since the miracle takes place on the Sabbath, both the "impotent" man by carrying his mat toward the curative waters of the pool and Christ by curing him are violating the Old Testament law. This is the part that doubtless led Hogarth to connect the story of the pool with the parable of the Good Samaritan, which he placed on the adjacent wall.

The parable of the Good Samaritan (Luke 10) is Christ's reply to the lawyer's question, "What shall I do to inherit eternal life?" The law forbade the Levite and Pharisee from touching bloody or possibly dead bodies, which would make them ritually unclean. The Samaritan, who is already unclean and can ignore the law, is a type of Christ. Christ's answer to the lawyer's question is: an act of charity, which transcends law, faith, and orthodoxy. For the positive subject of the Good Samaritan's and Christ's acts of charity evoke the negative (Wooston's allegorical) subject of the Pharisees' pursuance of the letter rather than the spirit of the Old Testament Law—and the clergy's legalistic persecution of Woolston. It should come as no surprise

that one of Bishop Hoadly's favorite (most repeated) sermons was on the parable of the Good Samaritan, and that it sets forth the particular emphasis Hogarth picks up:

> We may be . . . certain, That an honest *Heathen* is much more accept-able to [God], than a dishonest and deceitful *Christian;* and that a chari-table and good-natured *Pagan* has a better Title to his Favour, than a cruel and barbarous Christian; let him be never so orthodox in his Faith.[21]

This parable, referred to by Hoadly as inculcating "the Great Duty of universal Charity, and a most comprehensive Compassion," im-plicitly comments on those who are "never so orthodox in their faith."

The common elements in the two texts Hogarth chose to illustrate are the wounded or sick, a ministering figure of charity, and some Levites and Pharisees who, in the Good Samaritan parable, as Hoadly characteristically explains, are "in the Service of God, and devoted to the *external Offices of their Religion*" (320, emphasis added). Their holiness (or faith) makes us expect them to do the right thing, and they do not; the Samaritan, a member of an outcast group—a Turk or a heathen—does the right thing, and one result is to show up the Faithful, or the Chosen People (epitomized for Woolston by the Jews) with their exalted claims to a moral mission.

In *A Harlot's Progress,* the protagonist, however guilty, was essen-tially the poor robbed person ignored by all the Pharisees and Levites who pass by; pushed aside by the "great men" and their mistresses. Self-interest was the response to the Harlot in the first four plates, and in the last two the outside world had become almost totally un-concerned; so too with the Rake, where by the sixth plate all the others were ignoring him. The exception in both cases was a single Good Samaritan: the poor noseless servant woman of the *Harlot* and in the *Rake* the fallen woman, Sarah Young, who nevertheless faith-fully followed her seducer to his bitter end.

The difference is between a satiric and a heroic mode: in the one the Samaritan is peripheral, in the other central. In the heroic mode the Pharisees and Levites are peripheral, and in *The Pool of Bethesda* the sick at the left are beginning (in a spectrum of *l'expression des passions,* that crucial doctrine of the art treatises) to respond to Christ's gesture. It is dawning on them that he can help them. But it

is also a fact that the prominent figure in the foreground of each of the St. Bartholomew's pictures, the sick and wounded man being ministered to, is as unmistakably similar to the prone Tom Rakewell in Bedlam as are the background figures to the two young sightseers who giggle behind their fans. All of these derive visually from the figures of Raphael's Cartoon *St. Peter and the Lame Man*. But, although the art context is (we have seen) self-consciously present, the meaning of Christ and the Good Samaritan owes less to works of art in the great European tradition than to Hogarth's own recent *Rake's Progress*.

Christ's role goes back to the smiling host of the conversation picture, his hand outstretched in a gesture of connection and unification. With the documentable diseases and patients (and possible portraits), this is a conversation picture which, by its biblical subject and heroic size, the trappings of costume and the floating angel, has been vastly expanded into a history painting. Here the host's gracious gesture has become the single point of contact projected in a situation of isolation, pain, and self-regard—without, however, losing all of the genre's original intimacy and domesticity. This was Hogarth's basic conversation picture gesture—which in the "modern moral subjects" led into false unions: the bawd in *Harlot* 1, the Harlot's own in 2. In *Rake* 1 Rakewell's hand is outstretched to the pregnant Sarah Young he has just paid off. But by the fourth plate Sarah has assumed her true role and is interceding for Rakewell with the bailiffs who are arresting him.

The protagonist in *The Pool of Bethesda* has become quite literally Steele's "Christian Hero," Christ himself; but this male figure follows iconographically, visually, and thematically from the female figure of Sarah Young. She too is a ministering figure who represents not eros (the Titianesque nude) but caritas.

RAHERE

In the context of these history paintings, the references to pharasaic law make a comment on the rules of art as well as those of religion and society. The paintings say something in favor of the artist-Samaritan, the painter as well as his subject, who refuses to follow blindly the rules of the art treatises or of patrons, including the great-

est (and in England most niggardly) of patrons, the Church. One such rule is that a painter of drolls does not attempt the highest genre, history painting, as Hogarth is doing in these paintings.

After he had finished the two large panels, Hogarth added three small reddish monochrome panels beneath telling the story of Rahere, the founder of St. Bartholomew's Hospital, in this way connecting divine charity with an even more human and outcast Samaritan. For Rahere was a jongleur or public entertainer who recounted tales of comic heroes, sang, tumbled, and led dancing bears. But he rose by way of his comic gift from humble origins and little education to be the favorite entertainer of King Henry II, and with his wealth he endowed the church and hospital.

Hogarth, whose childhood had been spent in the shadow of the hospital, and who by this time was a successful engraver *and* a governor of the hospital, suggests the parallel to his own career of painting comic histories, which has now ascended to this large gift of charity in the form of the most exalted genre. And while he painted the public message of Charity—his own and his age's primary virtue—depicted larger than life above, he adds his personal message, in monochrome, below: the human version of the divine Charity in *The Pool of Bethesda.*

A dog is also present in both panels: the wounded man's wounded dog licks its bloody leg as the black dog in the other panel leans over the parapet of the painted frame and looks down at us, connecting the illusion of the painting with the reality of its spectators. He is leaning out of *The Pool of Bethesda* and sniffing at the monochrome panel of Rahere greeting a patient brought in on a stretcher to his hospital. In another of the panels below a dog is barking to awaken Rahere from his dream. These dogs evoke Ralph's criticism of Amigoni and Richardson's of the Venetians' tendency to mix classes by painting a "Dog with a Bone, at a Banquet, where People of the highest Characters are at Table." Hogarth's panels are themselves, of course, about the mixing of classes, of Pharisees and Samaritans, of rich and poor. But the dog has also by this time become a Hogarth trademark; he relates to the iconographical tradition in which dogs represent the natural self and recalls the prominent role of dogs in Hogarth's conversation pictures, where they introduced natural disorder into the very ordered party in progress.

The reference in the St. Bartholomew's paintings is, at a deep level, personal. After Christ's response to the Jews who accused him of

violating the Sabbath by curing at the pool of Bethesda, the Jews "sought the more to kill him, because he not only had broken the Sabbath, but said also that God was his Father, making himself equal with God" (John 5: 18). This is, to a large extent, the image Hogarth hypostatized of himself, beginning in the 1730s, of the figure outside the system whose "miracles" threaten the system and are retaliated against whenever possible. The growing list of self-surrogates includes the dog of the conversation pictures, little David the harper of the *Rake,* and Rahere the juggler, himself a low equivalent of Christ.

Hogarth remained a governor of the hospital. On 31 July 1735, when the second wing was begun, he subscribed £22 10*s*, but as a governor he appears to have been relatively inactive, attending few meetings and serving on no committees. The first meeting he attended was the General Court (which met five times a year) held on 25 March 1737, with a very large gathering of governors. Although not mentioned in the minutes, he may have been present to explain why he had not gotten on with the second painting. The next meetings he appeared at were the General Court of 1 December 1737, when Alderman Barber was chosen president, and a weekly Thursday meeting, 27 April 1738, to give his opinion on the painting by Mr. Richards of the benefactors' names on the tablets in the court room. As a result, it was "Ordered that the Ground Work of the Painting of the Benefactors Names in the Court Room be of a Darker Porphory Colour than that already laid and the Letters to be of Gold and Mr. Richardson [sic] to go about the same as soon as possible." On 19 December of the same year, although absent from the meeting, he was mentioned in a consultative faculty. He and James Gibbs, architect of the building, were "desired to see the large Picture [of Henry VIII]—properly framed and fixed with decent and respectful Ornaments"—moved from the counting house to the Great Hall:

> And Mr Gibbs and Mr Hogarth are also desired to give Orders for preparing a Busto of Rahere the first Founder of this Hospital to be taken from his Monument in Great St Bartholomew's Church to be fixed in the Great Court Room over the Middle Chimney.

In 1751 the staircase paintings were cleaned by one John Williams, at Hogarth's own expense. (He had also required that his canvases never

be varnished, but they were, repeatedly, after his death.) On 17 May
1754 it was "Ordered that an Inscription be set up in some part of
the Painted Staircase leading to the Court Room, Setting forth that
the two Capital Pieces of Painting were painted & given by Mr Wil-
liam Hogarth, & all the Ornamental Painting there was done at his
Expense." The inscription is over the door leading to the court
room, a single line: "The Historical Paintings of this Staircase were
painted and given by Mr. William Hogarth and the ornamental
paintings at his Expense, A.D. 1736."

Hogarth now had large sublime history paintings on permanent
public exhibition, as accessible as Thornhill's. They had little or no
influence on English painting, except as an example to such artists as
James Barry of the way an ambitious artist might attempt history and
do so by painting for a public building where his pictures would
remain on permanent exhibition. We do know, however, that the
paintings had some effect on the popular consciousness. Once they
were finished and in place, they were "esteem'd the finest in En-
gland" and, to judge by contemporary testimony, they became a
tourist attraction, one of the visual experiences sought out by Lon-
doners. One Sunday in April 1740 Mary Granville Pendarves, who
in 1731 had sat to Hogarth for her portrait, enjoyed a day on the
town with friends. They left Whitehall in two hackney coaches at
10 A.M.

> Our first show was the *wild beasts* in Covent Garden; from thence to
> St. Bartholomew's Hospital—the staircase painted by Hogarth, the
> two subjects the Good Samaritan and the Impotent Man; from thence
> to Faulkner's, the famous lapidary, where we saw abundance of fine
> things, and the manner of cutting and polishing pebbles, &c.; then to
> Surgeons' Hall to see the famous picture of Holbein's of Harry the
> Eighth, with above a dozen figures in it all portraits; then to the Tower
> and Mint . . . [22]

Hogarth's St. Bartholomew's pictures were one of the sights of Lon-
don, their theme and mode part of the baggage carried around by
writers and artists of the 1730s and 1740s.

The immediate reaction to Hogarth's paintings was a small resur-
gence of interest in history painting among London artists. Both
Hayman and Highmore followed with their own versions of *The
Good Samaritan* (Yale and Tate). Highmore's painting pilfers the in-

jured man from Hogarth's *Pool* and the Samaritan himself from the *Good Samaritan,* as well as the figures in the distance (reversed). Moreover, *The Good Samaritan* reappears a decade later as a Hogarthian picture-on-the-wall in Highmore's first painting for *Pamela.*

As to Hogarth himself, one or two private commissions may have followed for small history subjects, but from the great religious or state patrons there was no response. As he put it looking back from the 1760s, "religion the great promoter of this stile in other countries in this rejected it," that is, did not offer him any commissions. And, "this failing," he was "still unwilling to fall into the manufacture," presumably ordinary hackwork, so he "dropt all the old Ideas" of history and returned to his "modern moral subjects" and his "dealing with the public in general" (AN, 202–3, 216). In fact, appropriately, the Good Samaritan topos was to reappear six years later in Fielding's *Joseph Andrews* and ten years later parodied in Hogarth's own *March to Finchley.*

THE SLEEPING CONGREGATION

In 1736, in the middle of his work on the St. Bartholomew's Hospital paintings, Hogarth published a small print called *The Sleeping Congregation* (fig. 40), which explains why he had to place his New Testament paintings in a charity hospital rather than a church.[23] This church has been stripped of graven images; Roman Catholic idolatry has been expunged. The only trace of art is the disjointed angel (who recalls the angels of *Kent's Altarpiece*) who now serves as a supporter of the royal arms. Even the stained glass of the windows has been replaced with clear glass, but in the one remaining pane the cross has been transformed into the royal cross of St. George. In short, worship has only been displaced from images of God to the monarch—from the *Dieu* of the royal motto, now lost behind a pillar, to the *et mon droit* which is all that remains, along with the lion supporter of the royal arms.[24]

Whenever Hogarth represents an Old Master painting of a religious subject in one of his interiors, he either chooses a subject in which the deity does not appear or excises the deity. In *A Harlot's Progress* 2, in the painting of Uzzah being struck down by an angry Jehovah, he replaced Jehovah with an Anglican bishop who stabs Uz-

zah in the back. But the substitution raises a question: who is obliterating the deity, the Anglican bishop or the iconoclastic Protestant Hogarth? If the former, the strategy is part of Hogarth's satire on the time-serving clergymen which extends from the corrupt priests of *The South Sea Scheme* to *Harlot* 1 and 6. But in *The Sleeping Congregation* the name of God, apparently excised in favor of the king's, is in fact only concealed by a trick of Hogarth's composition: the *Dieu* may still exist if we could see through the church pillar that blocks it out. The satirist is pointing out something about this church: the general neglect is evident in the cracks in the walls. But it is *his* comment on the clergy. He is making a picture that is itself an act of iconoclasm, first in the sense that it directs its own destructive energy at the royal motto and the subservient, lax, and lecherous clergy, and second in the sense that it does itself, by an act of aesthetic framing, physically cancel the name of God.

It is well to remember that while an image of God can be broken by a Protestant iconoclast, the deity can be removed entirely by a Hobbesian materialist, a critical Deist, or a Pantheist, let alone an atheist. God could be called a *deus absconditus* in *Harlot* 2 where Hogarth reproduced paintings in which he has withdrawn and it is instead a bishop who is striking down Uzzah in one picture and in the other (the one next to which a portrait of Samuel Clarke hangs) Jonah who is cursing Nineveh after Jehovah has forgiven its people. More precisely, *A Harlot's Progress* evokes a society—or indeed a world—without God, in which God has been removed and displaced to human agents (see below, note, 450).

Sometime between 1747 and 1753 Hogarth added to *Rake* 4 the one manifestation of divine intervention in his engraved oeuvre—a lightning bolt descending on White's gambling house (ill., vol. 3).[25] The jagged streak of lightning could be a natural phenomenon in a pantheist universe or it could be another iconoclastic act—this one directed against White's—by Hogarth the artist. But it seems doubtful that Hogarth was an iconoclast in the strictly Protestant sense.

Consequences of the English tradition of iconoclasm included the physical destruction of medieval painting and sculpture, the virtual nonexistence of religious painting by English artists, and the radical curtailment of an English tradition of graphic art. The heritage of iconoclasm was a frame of mind suspicious of all the visual arts, and more particularly of the tradition of Continental popish art, as leading to worship of the Whore of Rome. This frame of mind contrib-

uted to the Puritan dissolution of Charles I's great art collection and explains the mere trickle of commissions of religious paintings in the eighteenth century, including the irony that Hogarth must represent the bare church and its disinterested heterogeneous congregation rather than the religious scenes painted by his Continental precursors.

What remained for English artists was to paint as compensation mere (from the point of view of contemporary theory) portraits, landscapes, still lifes, and local or contemporary history. As their spokesman, Hogarth represented only (in Calvin's words) "things which can be presented to the eye," commonplace objects and events, which served a useful, that is, a moral purpose.[26] *The Sleeping Congregation* accordingly replaces the canonical religious painting that has been iconoclasted from the walls of the church with a representation of its absence and the substitution of a contemporary, commonplace, living image. For if the iconoclastic displacement is (as it was historically) from *Dieu* to the royal *droit,* at a more popular level the displacement is from devotion to the image of the Virgin or any other icon (i.e., representation) to the exposed bosom of the sleeping woman. She, dozing with her prayer book open to the service of Matrimony, has displaced her own worship to thoughts of a husband. For the majority of the congregation spirituality has been simply replaced by sleep.

Idolatry could be construed as the theme of Hogarth's satires: either the idolatry of any object that is denied its physical reality (a harlot, for example) or the idol as a godless, that is, a lifeless work of art (the paintings shown in 2, the engraved copies in 3, for example). Therefore, the figure of the pretty young woman is being worshiped by the clergyman whose eyes should be on the Word of God before him. In this interpretation, Hogarth becomes the iconoclast. But the question is perhaps whether the devotion to a young woman in *The Sleeping Congregation* is idolatry or a proper humanizing of the idol. For one thing, the focus on her bosom evokes emblems of Charity—with children attached to her breasts—thus linking this print indirectly to the figures of Christ and the Good Samaritan but directly, and I think more significantly, once more to the *Diana multimammia* of *Boys Peeping at Nature* (see fig. 52).

As well as iconoclasm and Deism, there is a Masonic subtext in this print. The equilateral triangle on the wall, including the circle of rays symbolizing God's eternal glory (to which the malformed Ken-

tish angel is pointing), symbolized the Supreme Being for both
Christian and Freemason. But the triangle is upside down: for the
Masons the equilateral triangle pointing up "signifies that the Divine
or higher portion of our nature should increase in power, and control
our baser tendencies," and so faced down it means the opposite.[27]
Less abstractly, the royal lion who supports the royal motto displays
a prominent sexual organ, which may be *his* secular—or natu-
ral—response (complementing the clergyman's) to the pretty young
woman.[28] Hogarth follows the Swiftean assumption that there is al-
ways a subtext of desire beneath religious enthusiasm of whatever
sort, but he gives it a more positive charge than Swift. Deist or Ma-
sonic "Nature" in the sense of eros is in fact the *Droit* that replaces
Dieu in Hogarth's church.

The other Masonic symbol one would expect in this context is the
All-Seeing Eye (watchfulness), usually citing Proverbs 15:3, Psalms
34:15 and 121:4. The last of these reads: "Behold, he that keepeth
Israel shall neither slumber nor sleep." But here the eye is displaced
to the closed eyes—all but one—of the congregation. The one open
eye is the clerk's, directed at the sleeping female.

The Masonic reference is confirmed by the identification of the
officiant as a likeness of John Theophilus Desaguliers, holding a
magnifying glass as he does in a mezzotint portrait of 1725.[29] He *was*
a cleric; he had taken holy orders in the Church of England, preached
at court, and was chaplain to Frederick, Prince of Wales (another
Mason), but was notoriously more interested in Masonry. He ac-
cepted the Latitudinarian natural religion of Samuel Clarke; he did
not believe in revelation, though not because he was a Deist but
because revelation was not defensible against freethinkers. Thus it
is Desaguliers who would iconoclast this Anglican chapel, admit
Quakers (the pointed hats of Quaker women are visible), place a
triangle on the wall, and close all the eyes of his congregation. The
Deist Hogarth, always wary of texts and the clerical reader, shows
Desaguliers reading his text, assisted by his magnifying glass; the
clerk has put aside his reading glasses and is using his eyes instead
to peruse the woman's breast. The wry Freemason Hogarth has dis-
placed the one open eye to the bosom of Nature and substituted the
downward- for the upward-turned triangle. The unmistakable sug-
gestion is that Christian worship has been—perhaps *should* be—
displaced to the Isis cult of the Freemasons (appropriately to her
breasts).

Hogarth would have known the figure of Isis/Artemis or *Diana multimammia,* symbol of Universal Nature, both as a Freemason and a reader of Apuleius's *Metamorphoses, or The Golden Ass,* the best-known source for the Masonic mysteries of Isis. (He had also illustrated the 1724 edition of Charles Gildon's *New Metamorphosis,* a modernization of Apuleius.) At the end of his misadventures as an ass, Apuleius's hero Lucius is initiated into the mysteries of Isis and told by the goddess: "I am nature—the parent of all things, the sovereign of the elements, the primary progeny of time." Through her mediation he is returned from asinine to human form and prepared for the next stage of the initiation, the mysteries of Osiris. The Isis mysteries, followed by the mysteries of Osiris, her martyred and resurrected husband, played some part in the basic Masonic initiation ritual, usually figured as the testing, murder, and resurrection of Hiram, the master builder of the first Temple of Jerusalem. Freemasonry traced its origins to earliest times, which meant not just to the Temple of Jerusalem but to Egypt, Euclidean geometry, and the pyramids: symbols of which Hogarth made use throughout his career.[30]

In 1724, the same year as the illustrations for Gildon's Apuleius, Hogarth had published a print called *The Mystery of Masonry Brought to Light by the Gormogans* (ill., vol. 1) which parodied, or showed a perversion of, the Isis mysteries: an old woman is riding an ass hung with Masonic symbols and having her backside saluted by a worshiper. Hogarth may have been satirizing a Jacobite faction within the Grand Lodge that called itself (or was called, it is not clear which) the Gormogans; but he may have been using the Gormogans as a way of criticizing the excesses of the speculative Masons, led by Desaguliers and James Anderson.[31] (Of course, this satire could mean that he was *not* a Freemason until 1725 and that Thornhill, a prominent Mason, had won him over despite his doubts about Masonic ritual and symbolism.) At any rate, the print shows Masonic ritual centered on the figure of Isis. The ass carrying the mysteries of Isis (*asinus portans mysteria*) was a well-known image in emblem literature. In Geoffrey Whitney's version of Alciati's *Emblemata,* for example, it is given an anticlerical twist: with the motto *non tibi, sed religioni,* it connects the ass with the clergy, reminding the latter that they are merely vehicles for conveying the truth, not the truth itself.[32]

This is the icon Hogarth next figured in the unveiling of Isis/Artemis (or *Diana multimammia*) in his subscription ticket to the *Harlot,*

Boys Peeping at Nature (1731), and then naturalized in his story of the Harlot, as the real modern woman under the symbol. He would have been aware, joining the allusion of the subscription ticket with the New Testament allusions of the *Harlot,* how closely in Masonic terms Mary the Mother resembled Isis the Great Goddess. (Historically Masonic Isis-worship was a reaction to the cult of Mary, based on the leveling assumption that all religions are one.) Hogarth must also have recalled the inscription before the temple of Isis (reported by Plutarch): "I, Isis, am all that has been, that is, or shall be, and no mortal hath ever unveiled me."[33]

Virtually coinciding with *Boys Peeping* was one of the most popular eighteenth-century Masonic texts, the Abbé Jean Terrasson's *Séthos, histoire ou vie tirée des monumens anecdotes de l'ancienne Égypte* (Paris, 1731), which was immediately translated into English, German, and Italian. The English edition, translated by "Mr. Lediard," appeared in 1732 as *The Life of Sethos, Taken from Private Memoirs of the Ancient Egyptians* (Hogarth, in any case, read French).[34] Prince Sethos's initiation into the mysteries of Isis is recounted in great detail (based on Apuleius). Terrasson's account emphasizes the female figure and a sexual dimension absent from the Hiramite legend; it is less about Osiris than Isis's reassembling of his dismembered body with the exception of his missing sexual organ, which she produces out of herself by parthenogenesis (this is the god Horus): Sethos is instructed to worship a triple statue, a trinity, of Isis, Osiris, and Horus (1: 19–20, 164). It may have been as a witty play on the story of Isis's difficulties reassembling the body of Osiris that Hogarth hid the male genitalia in the English royal coat of arms.

In the context of this ritual, the fact that the *Rake's Progress* (following upon the *Harlot's*) is centered on a man's experience becomes more suggestive. That the Harlot was a failed Isis who could not reclaim men from their passions was one point made by *Boys Peeping at Nature.* Rakewell's "progress" is distinguished from Protestant spiritual autobiography by the mediation of a female. This is the woman whom the Freemasons, while physically excluding her from their lodges and ceremonies, employed symbolically.[35] Rakewell rids himself of the woman he seduced but finds her returning to him as a symbolic intercessor—finally in the implied death-rebirth of a mock *Pietà* in 8. Part of the joke in *The Sleeping Congregation* is that Isis is supposed to calm male passions and not, like the young sleeping woman (herself dreaming of men), raise them.

We might conclude that Hogarth the Woolstonian Deist is coolly rationalizing the myths of Freemasonry; but at the same time he internalizes one aspect of Masonic symbolism—the woman who is excluded as a member but celebrated and utilized as a symbol of intercession for men. Unfortunately, we do not know whether the Isis ritual (as opposed to the Hiram) was central, marginal, or heterodox in the London lodges; though in *The Sleeping Congregation* it is only one deviant member of the congregation who steals a glance at the Isiac breast. The fact that he is the only "initiate" is part of the joke.

If the Lesser Message of *The Sleeping Congregation* is that the orthodoxy of the Church of England (its iconoclasm) has made art in churches impossible, the Greater Message has to do with the cult of the woman: Hogarth's replacement of the deity with the Isis-Artemis-*Diana multimammia,* naturalized into a contemporary, plebeian English woman. The humanizing of Christ began with Woolston's satire but is turned by Hogarth into a feminizing, which in the late 1730s becomes the positive element of a fledgling aesthetics. The Christ of his St. Bartholomew's Hospital murals and the Sarah Young of his *Rake's Progress* lead together into the central woman of *The Distressed Poet* and *The Enraged Musician* who, at length, becomes the central symbol of Beauty in *The Analysis of Beauty.*

Hogarth's poetic/graphic "demystification" of Christ began in the *Harlot's Progress* with the safe subject of the classical Hercules (see vol. 1, 269–72). The *first* gestalt one recognizes in *Harlot* 1 is not the Mary-Elizabeth-Zachariah group but the clergyman-Harlot-bawd, who make a parodic Choice of Hercules that is a direct response to Shaftesbury's advice to history painters in his *Tablature of the Judgment of Hercules* (1713). One reason for Hogarth's conflation of Hercules and Mary is that Shaftesbury was a Deist who preferred pagan/classical to Christian iconography; Hogarth therefore shows, left to right, the Christian gestalt emerging out of the classical one and replacing it, only to be replaced itself by the living contemporaries who adopt these poses. Thus, in Woolstonian terms, after the classical myth is compromised by juxtaposition with the Christian, the Christian myth itself is submitted to reason. (It is also interesting to note, turning from Shaftesbury's *Judgment of Hercules,* that the headpiece to the first chapter of volume 3 of his *Characteristics* supplied Hogarth with a term of *Diana multimammia,* flanked by satyrs, for *Boys Peeping at Nature.*)[36]

5.

THE MEDIATING WOMAN

Literary History Paintings and Artist Satires, 1737–1741

Continuing his experiments in history painting, Hogarth turned to literary texts. A painting of Danaë was sold at his 1745 auction, in which, according to Horace Walpole, "the old nurse tried a coin of the golden shower with her teeth, to see if it is true gold. . . . It is a much more capital fault that Danaë herself is a meer nymph of Drury. He seems to have conceived no higher idea of beauty."[1] This judgment does not tell us whether Hogarth is burlesquing Ovid's story or Walpole is offended by an unidealized contemporary woman. Hogarth may have been suggesting the crudity inherent in the Greek myth and in the tradition of history painting based on such stories, possibly as a response to William Kent's *Danaë* painted on the ceiling of the king's Drawing Room, Kensington Palace. He might have seen Danaë as the other side of the Harlot's coin: one is the whore trying to talk like Danaë, the other Danaë showing herself to be nothing but a whore.[2]

He must have been pleased, however, when Dr. James Parsons singled out the *Danaë* in his important lectures on the muscular structures of physiognomy in 1746 as an example of passion delineated by expression:

> But if the Passion of Desire be prompted and accompanied by any more engaging Circumstances, then the *Elevator* of the Eye will act strongly, causing the *Pupil* to turn up, at the same time that the Action of the *Aperiens Palpebram* is more remitted, whereby all the *Pupil*, except a little of the lower Edge, will be hid, and the Lids come nearer each other; the Mouth being a little more open, the End of the Tongue

will lie carelessly to the Edge of the Teeth, and the Colour of the Lips and Cheeks be increased.

Thus yielded *Danaë* to the Golden Shower; and thus was her Passion painted by the ingenious Mr. *Hogarth.*

One aspect of Hogarth's humanizing of Danaë apparently ties in with his clinical interest, indulged in his association with St. Bartholomew's Hospital and the paintings there.[3]

A SCENE FROM "THE TEMPEST"

But Danaë may also have been another version of the Miranda of *A Scene from "The Tempest"* (fig. 41). Around the time of the large canvases of St. Bartholomew's Hospital Hogarth painted this Shakespearean scene which, like *The Pool of Bethesda,* had its formal point of origin in the early conversation pictures, but retains the smaller scale. Its subject draws on a nationalistic vein explored in *Falstaff Examining His Recruits* (1727, ill., vol. 1). In more ways than one, however, it is quite a different case of Shakespearean illustration from the *Falstaff.* There is no contemporary political reference, and Hogarth unmistakably draws upon Shakespeare's text rather than a contemporary production.[4] He has ignored the stage tradition of his time, which until 1746 was based on the operatic version of 1674 adapted by Thomas Shadwell from the stage adaptation by Sir William Davenant and John Dryden. In the opera there was not even a scene corresponding to the one Hogarth paints. But there were added sisters for both Caliban and Miranda and, to match Miranda the girl "that never saw man," there was a boy named Hippolito "that never saw woman." It is not surprising that Hogarth should avoid the operatic version, given his earlier satires (e.g., *Masquerades and Operas*), or that, since there was no native stage tradition for this play, he returned to the literary text itself.

Hogarth's Caliban, for instance, does not derive from stage tradition, which seems to have given him a bearskin and long shaggy hair, but from Trinculo's questioning images:

What have we here? a man or a fish? dead or alive? A fish: he smells like a fish. . . . Why, thou debosh'd fish. . . . Wilt thou tell a monstrous lie, being but half a fish and half a monster. (II.ii)

Hogarth shows him with web feet and scaly legs and a strange fishy protuberance that might correspond to Trinculo's remark that Caliban has "fins like arms"—in short something like the painting of a human "tapered off into a slimy, discolored fish" with which Horace introduced the *ut pictura poesis* theme in his *Ars poetica* ("turpiter atrum / desinat in piscem"), except that Horace's figure was a beautiful woman ("mulier formosa superne"): an appropriate allusion for a painting of a literary text.[5]

Even more interesting, Caliban does not appear in the scene Hogarth has chosen to illustrate: Act I, Scene ii, the first meeting of Ferdinand and Miranda, brought together by Prospero, who serves to introduce the two parties and to hover over the scene as playwright-magician. Hogarth paints Prospero in the role of the host figure in his conversation pictures, and though in a remote wild setting, the size, scale, and situation still recall the small conversations. Another parallel, however, is with the comic histories of 1730–1735 and their parodic echoes of High Renaissance art, in particular of biblical scenes.

Ferdinand's question to Miranda is about her virginity ("my prime request, / Which I do last pronounce, is, O you wonder! / If you be maid or no?" "No wonder, sir," she replies, "But certainly a maid"). Hogarth's focus is Miranda, the woman who has never seen a man, with her aged father Prospero behind her and a lamb nearby. And so he gives her the colors of the Virgin Mary and a pose roughly like that of Mary at the Annunciation—crossed with Mary in a Nativity scene. Ferdinand is not given the arms-crossed pose of the angel in Annunciation scenes but the prayerful hands of one of the Magi come to pay homage, in a scene of conventional mangerlike architecture. Ariel in this case becomes one of the heavenly angels floating overhead—and Caliban his diabolic opposite.[6] This was a scene Hogarth had used ironically to show the arrest by a magistrate of the Harlot—hardly any longer a maid—in her shabby quarters after a night of prostitution. The allusion in *Scene from "The Tempest"* serves not to problematize but to heighten.

If this painting does not carry a political subtext, it does carry a personal parallel in much the same way as the Rahere panels of St. Bartholomew's Hospital. The relationship between Hogarth, a sort of shipwrecked Ferdinand, and the great Thornhill, and the courageous act of Jane that brought about reconciliation—all serve as a

kind of subtext for the painting (see vol. 1, 200–202). Prospero will have none of Ferdinand as Miranda's suitor, forcing him to perform menial tasks such as gathering wood for the fire. It is possible that Hogarth may also have recalled (or sought to acknowledge) Thornhill's painting of the Nativity at Wimpole House—the only Nativity he would have known by an English artist.

The graphic source is Hogarth's *Beggar's Opera* paintings with their familiar triad, the daughter mediating between her father and her interloper lover, Polly trying to reconcile Macheath and Peachum, Lucy trying to reconcile Macheath and Lockit—which becomes in *The Tempest* Miranda trying to reconcile Ferdinand and Prospero (Jane-Hogarth-Thornhill). (There are of course obvious parallels between the stories of Gay's *Polly* and Shakespeare's *Tempest,* which may also have led Hogarth to his *Tempest* painting.) All we can say is that this was a scenario that interested Hogarth, or he would not have painted it so often. The scenario does not, however, appear in his progresses; rather he broaches this stigmatic subject in his more sober historical paintings, especially those based on literary texts.

In *A Scene from "The Tempest"* however, Miranda in the center, with her father Prospero hovering behind her, is flanked by Ferdinand and Caliban, who are both (in their different ways) suitors. Ferdinand *and* Prospero are placed on one side of Miranda, as if Prospero (the good host) is introducing them to each other. On the other side is the grotesque, plebeian Caliban, Prospero's slave (and Miranda's prospective rapist) as opposed to the genteel Ferdinand whom he tests with errands. As we have noticed, in Shakespeare's text Caliban is offstage at the moment gathering wood for a fire; Hogarth shows him bearing wood, carrying out the labor demanded of Ferdinand by his "father-in-law" Prospero. The suggestion now seems to be that there are two aspects of the "lover" who is being fended off by Prospero, one of which is embodied by Caliban—Hogarth's indication of another aspect of himself, noted by Thornhill, by Jane, or by himself: "desinat in piscem" (i.e., he is *socially* an amphibious creature). Caliban is shown crushing underfoot one of a pair of linked doves, Venus's doves.[7] It would seem that Hogarth is beginning to do himself what he accused Rakewell of doing when he assumed the roles of Paris, Nero, and Christ: thus, David, Rahere, and now Ferdinand.

SATAN, SIN, AND DEATH

It was probably about the same time that Hogarth painted a scene from Milton's *Paradise Lost* (fig. 42). He had already, in 1724, made two small engravings for *Paradise Lost,* one of the council of the fallen angels and the other of the council in heaven, the sort of contrast he later developed in his *Before* and *After* paintings (ill., vol. 1). In the second illustration the Father and the Son are having a private chat together, though surrounded by a circle of conventional angel heads (of the sort Hogarth ridiculed the same year in *Kent's Altarpiece*). But the scene he painted on canvas, with shockingly lurid colors and melodramatic gestures, was more significant for his own work and for the tradition of Milton illustration. It illustrates the encounter of Satan with Sin and Death in Book 2.

We recall that Jonathan Richardson read at Slaughter's Coffee House from his *Explanatory Notes and Remarks on Milton's "Paradise Lost"* (published in 1735). In this landmark critical work, Richardson claims Satan, Sin, and Death to be the "Allegory which contains the Main of the Poem," an epitome of the whole argument, and recommends this subject to the aspiring English history painter.[8] Richardson, as Peter Briggs has noted, was "among the first [critics] . . . to emphasize the visual side of *Paradise Lost*."[9] It is not surprising that Richardson, the voice of authority, had an effect on Hogarth. Within a year or so of the publication of the *Explanatory Notes* Hogarth had followed his recommendation, much as he had earlier followed Shaftesbury's recommendation to model history painting on the Judgment of Hercules.

Characteristically he focused on the psychological relationship of the triad: Sin holds apart her father-lover Satan from her murderous offspring-lover Death, as, once again in the *Beggar's Opera* paintings, Polly Peachum had stood between her father and her lover. His representation was originally and profoundly influential, to be followed by the "sublime" redactions of Barry, Fuseli, and Blake.[10] In retrospect, we may feel that Hogarth's *Satan, Sin, and Death* called for the Michelangelesque forms later conferred upon it by Fuseli and Barry; but this was not the effect Hogarth sought. In line with his previous work, from the *Harlot* onward, he represents the tension between heroic notions and contemporary reality, social and psychological.

The first graphic representation of the scene had been the 1688 illustration by Henry Aldrich (engraved by Michael Burghers [or Burgesse]), which placed Satan between Sin and Death. Louis Cheron's headpiece for the 1720 edition (fig. 43) balanced the three as a hieratic trio, with underneath them the lines describing the Satanic imitation of God's enthronement which served Dryden for his description of Flecknoe in *Mac Flecknoe* and Pope's of Cibber (a few years after Cheron's design) in *Dunciad* 3. Cheron's was the interpretation developed by Milton's earliest admirers among the poets, Dryden and Pope: Satan, Sin, and Death are an infernal parody, an unholy Trinity, the Father flanked by the Son and Holy Ghost who later set about their own parody-creation (imitating the creation by the Trinity in Book 5) in the construction of the bridge from hell to earth in Book 10. Satire and parody, in short, were the first uses to be made of Milton's scene. Hogarth's placement of his Harlot in a parody or imitation Life of the Virgin drew in part on this satiric tradition.

But if his version, based on his *Beggar's Opera* paintings, at first seems a radical alternative to Richardson's, upon closer examination it appears to be in Richardson's debt. For Richardson's primary contribution to the interpretation of *Paradise Lost* was the introduction of the term "mediator" for the Son and "mediation" as the central metaphor of the poem. The result was an original analysis of Milton's theology but more significantly a fiction of the Son mediating between the Father and his human creation.

To see the significance of this interpretation for Hogarth we need to look back at Addison's aesthetics of the Beautiful, Great, and Novel. In *Spectator* No. 417, on the "Pleasures of the Imagination," he had attempted to apply his categories to *Paradise Lost*: the Great (or Sublime), he decided, was embodied in the War in Heaven, the majesty of the Messiah, and Satan and his fallen angels; the Beautiful in Pandemonium, Paradise, Heaven, the angels, and Adam and Eve; and the Uncommon or Novel in the creation of the world, the metamorphoses of the fallen angels, and the "surprising Adventures" of Satan as he searches for Paradise.[11] In these terms, Richardson's interpretation served as a solution to the vexed question of whether *Paradise Lost* centered on the Beautiful or on the Sublime. As Leslie Moore has written, Richardson's interpretation showed the Son mediating "a new aesthetic between sublimity and beauty in *Paradise Lost*"—that is, between (in Addison's terms) the greatness of the Fa-

ther (and, in a different way, of Satan) and the beauty of Adam and Eve and Paradise.[12]

Describing the "Invocation" to Book 3, in order to define his visual sense of this mediator, Richardson uses the words "a *shape Divine, Presence Divine*, a *Bright Vision*," and describes the "Picture" that Milton draws of him: "Milton has Suppos'd Him Visible, though not as Cloath'd with Flesh (So he appear'd not in Heaven till after the Ascension) but as Mediator" (100). And, as Moore emphasizes, the primary characteristic of the mediator kept in view by Richardson is this visual quality. Glossing "Blaz'd forth unclouded Death" (10.65), he writes: "That Glory which in the Father was Invisible, is in the Son Express and Manifest. This is his Mediation" (443).

The most significant part is that Richardson the painter concludes with the wish that "*Rafaelle* had Attempted This and had Succeeded in it as when he painted Christ a Child" (100). This was the sort of challenge Hogarth insisted on taking up, and he has applied the metaphor of mediation to the "Allegory which contains the Main of the Poem," Satan, Sin, and Death (perhaps recalling the prior illustrations of them as a parody Trinity). Sin thus becomes the parody of the Son in the mediation between the Father and His creation. But she also makes an aesthetic statement for Hogarth: with her serpentine nether parts she is the beautiful woman who is half fish in Horace's *Ars poetica*: "Pictoribus atque poetis / quidlibet audendi semper fuit aequa potestas" ("But painters and poets have always been equally free to try anything," 9–10; she will appear again in *Strolling Actresses*, fig. 53).

Thus for his new excursion into history he chooses the aspect of the *Beggar's Opera* paintings that focused on Polly as mediator rather than Macheath as Hercules of the Choice. There he had shown one figure (Macheath) choosing and another (Polly), who was, through love, outside the choosing situation entirely, mediating between her lover and the outside world—in this case her father, but also between the fictional world of Macheath and the real one of the duke of Bolton, her offstage lover. Polly, as mediator, represented Nature—the nature that can be veiled by playwrights or artists—as a beautiful young woman. Carried over intact into *A Harlot's Progress*, she was displaced in *A Rake's Progress* to Sarah Young, Rakewell's ever-faithful mediator between himself and the world, between affectation and brute reality. Of course, the Harlot was, above all, with her

Marian allusions, the ironic mediator—an intercessor for concupiscent men. In *Satan, Sin, and Death* the mediating woman is now unambiguously the central figure.

But the context makes it clear that the father and lover/son are fighting for the daughter. They are not only held apart by her but are contending for her favors. By emphasizing the triangular psychological relationship Hogarth has turned a spotlight on the conflicting instincts at work in Milton's scene, hitherto unnoticed by illustrators. He has also revealed something about his *Beggar's Opera* and *Tempest* paintings: that under the daughter's mediation we may detect another gestalt that involves the rival father and son contending for the young woman, Peachum and Macheath separated by Polly, Lockit and Macheath separated by Lucy.

And the biographical question follows: did Hogarth, at the same time that he pursued the political analogy of Walpole-Hercules-Macheath, associate himself (as James Boswell later did) with the jaunty, disreputable pseudogentleman Macheath in relation to Polly and Mr. Peachum, that is, in relation to his wife Jane and his father-in-law Thornhill? If so, this would explain why he later used the same configuration to illustrate scenes that are closer to his own situation and why he was initially so intrigued by Polly: first demythologizing her in the *Harlot's Progress* into the heroine of the sequel *Polly* who does *not* escape the clutches of Trapes and Dukat, and then developing the loving-idealistic-faithful aspect of her in Sarah Young of the *Rake's Progress*—with implicitly in the background an *un*faithful Macheath ("One wife is too much for most husbands to bear, / But two at a time there's no mortal can bear").

There is yet another dimension to Richardson's metaphor of mediation. His words describing the Son as expressing a "Mediatorial Sweetness and Sublimity" (101) must have stuck in Hogarth's mind. After all, his figure of Sin derives from both Polly and Sarah Young, and partakes of their avatar in the Christ of *The Pool of Bethesda* of about the same time as *Satan, Sin, and Death,* as well as the Isis figure of the Masonic rituals: in other words, a reconciliation of God and man or—in Deist and Masonic terms—nature and man, which in Hogarth's fiction becomes a mediation by a young woman between forces of order and chaos or the ruling social order and unfettered plebeian energy. In aesthetic terms, this means a figure that Hogarth, following Richardson, can call Beauty mediating between the Sublime and the Novel or Uncommon. But the orthodox Protestant

Richardson replaced the Marian intercessor with Christ the Son, while Hogarth has more radically restored the female. We see him using interchangeably the Masonic, Christian, and classical names, and so mingling Isis, Artemis, Diana, and Venus with the two Marys.

It is time to recall that in *Rake* 8 Hogarth affixes the name of Athanasius to the wall of a madman's cell in Bedlam. William Whiston, whose name is also inscribed on the Bedlam wall, was known for his anti-Athanasian pamphlets.[13] Given the presence of Rakewell and Sarah in the pose of Christ and Mary, Hogarth may be recalling Rakewell Senior (a weighty presence in Plate 1, not surprisingly represented as a framed picture) to complete a parodic Trinity.

The argument concerning the Trinity was the most vexed of the religious controversies surrounding Deism. The heretical views filled a complicated spectrum labeled Arian, Socinian, anti-Trinitarian, semi-Arian, Tritheist, and so on. But in general the unorthodox view was that the Holy Spirit and the son were distinguished from the Supreme God and could not therefore be regarded as part of Him and His omnipotence—three distinct spirits or independent minds, three different essences. Freemasonry, as obsessed with triads as the Trinitarians, explained them as consisting of a creator, a preserver, and a generative principle (Osiris, Isis, and Horus). These became the type of the three governing officers who preside under various names in each Masonic degree: the master and the two wardens in the lodge thus give rise to the priest, the king, and the scribe in the Royal Arch, and so on.

It is also possible to see Hogarth, the son of a learned and controversialist father, with his own private agenda, as he moved from the *Rake's Progress* into sublime history painting, developing a story—one that relates closely to the story of Sir James Thornhill, himself, and his wife Jane: of an omnipotent father, a son of confused loyalties, and a spirit (female) that tries to join them; or, to take Richardson's thesis of Christ as mediator: a father, mediating daughter, and fallen, "low" (Rahere, pug, apprentice, Caliban) son; or a creator, preserver, and destroyer, with the creator and destroyer changing places according to the circumstances. This is a story about separateness *and* undifferentiation; about the power and threat of the father; about a second father (Thornhill) who *replaces,* obliterates in some guilty sense, the first and real father (the scholarly Richard Hogarth); and about a "trinity" of separate elements, two opposed and the third

attempting to mediate between them, different versions of the tension between division and union.[14]

Jonathan Richardson embodied his own theory of mediation not in an illustration of *Paradise Lost* but (since he was a professional portraitist) in a bizarre portrait group consisting of himself, his son Jonathan Jr., and—looking quite alive, though glancing away from the other two—John Milton. The image of poet, critic, and critic's son (Richardson's telescopic eye) represents his own allegory of genealogy as well as a Trinity that recalls his reference to "the complicated Richardson" (and Hogarth's visualization of it). Further pursuing the metaphor, Richardson also remarked, "I have from Infancy lov'd and Practic'd Painting and Poetry. One I possess'd as a Wife, the Other I kept Privately" (i.e., as a mistress).[15]

ARTIST SATIRES

Beginning in 1736, as he turned from *The Pool of Bethesda* to *The Good Samaritan,* Hogarth published a series of prints—all single sheets except for the pair called *Before* and *After* (December 1736)—having to do with men and women in a situation less satiric than comic, less moral than aesthetic. The prints are all in one way or another about the artist. Perhaps it is reasonable to suppose that when Hogarth worked on sublime histories, his art tended to focus (possibly in self-defense) on the theoretical aspect of making high art. The juggler Rahere had appeared in the St. Bartholomew's paintings. Hogarth now also had a large stake in (was the "proprietor" of) the new St. Martin's Lane Academy and was at the center of the artists in London. At this point he published *The Distressed Poet* of March 1736/37, followed by *The Enraged Musician* of November 1741 (figs. 44–49), and projected a "Distressed Painter" that was never completed.[16] (Seen in the context of these prints, the engravings of *Before* and *After* could be construed to be about the "art" of the seducer whose art is as futile as the painter's or musician's when it comes up against the natural passion it kindles in a woman.)

The image of the artist that emerges from these graphic fables is of a poet up in a garret, remote from reality, unable to pay for food, wearing inappropriate clothes, and writing poems about gold mines in Peru. A musician is seen enclosed by a window—in a dark inte-

rior, cut off by a heavy window sash and an iron fence—and venting his rage on a motley crowd of London's plebeian noisemakers in the street outside. He plays his violin inside his closed room, according to notes on a staff arranged according to regulated intervals and harmonic laws, while the scissors grinder, ballad singer, and chimney sweep emit their cacophonous sounds any old way. Worse, he tries to impose his sense of order by quieting them. To make art, Hogarth suggests (as he did in *Boys Peeping at Nature*), the artist must hear and take into consideration the hawkers and vendors, the noisy children and screaming ballad singers outside his window. It is precisely the "beggars" of *The Beggar's Opera* and the world of that opera that the musician is excluding (a poster indicates that it is being performed nearby).

Perhaps with the artist putti of *Boys Peeping* in mind, Hogarth is treating the maladjusted artist who is cut off from reality or from his proper function—the artist as another form of the Harlot or Rake. The Poet is a moral figure if the picture is read.causally (he brought this squalor upon himself and his family by his folly), but is merely a representative of art removed from reality, or of the unnatural, if the picture is read as a contrast between the Poet and the outside world. Though still following a left to right track, the eye now finds itself moving from the consequences of the Poet's folly—the dog eating his last chop and the milkmaid with her unpaid bill—back to his wife and child, the innocent victims, and finally to the Poet himself, the guilty victim and the cause.

In the painting of *The Distressed Poet* (fig. 44), of course, the order is reversed; first established is the nature of the Poet's folly and then its consequences: he has withdrawn from the real world, leaving a trail of chaos in his wake. In terms of causality, the print contrasts the harsh world and the Poet's withdrawal, the real world and the Poet's isolated dream world at the far right of the scene. He is virtually enclosed in his alcove, surrounded with the illusions of poetic inspiration.

Both painting and print draw the eye toward the Poet's wife, placed as she is slightly to right of center; but in the painting her blue green dress and the red dress of the milkmaid firmly anchor the viewer to that side of the scene; only later do we return to the Poet at the left side for causal explanations. Both women's rosy cheeks and complexions are contrasted with the pale, faded Poet. The colors support what is done formally by the heavy lines of the Poet's cu-

bicle: these cut him off from the room, which is itself closed from the outside world. If there is a readable structure in the painting, it is different from that in the print; the colors divert our attention from the Poet to his wife, whose function as mediator between the poet and the outside world becomes the chief subject. The eye probably still moves up and to the right, but the colors capture and hold it on the central figure of the wife—so central that, if the figures were a little closer together, she would remind one (observing her bluish dress) of a Madonna. The composition carries unmistakable overtones, more evident in the painting than in the print, of a Nativity: the stablelike garret, Mary at the center with the babe behind her, Joseph to one side scratching his head in puzzlement, and the parody of gift-bearing Magi to the other side in the dunning milkmaid (recalling the contemporary *Scene from "The Tempest"*). The painting could be titled "The Wife of the Distressed Poet." Even the cat nursing its kittens emphasizes her centrality: though present in both versions, in the print the cat seems to reflect on the Poet's responsibilities to his large family, while in the painting it refers, like everything else, to the wife, the beautiful mediator who tries to deal with (as she has herself a role in) the outside world of torn trousers, unpaid milkmaids, unfed babies, and hungry dogs.

In *The Enraged Musician* (fig. 48) the beautiful young woman is the milkmaid. Balancing a milk pail on her head, she delicately lifts her skirt to avoid the boy's urine stream. Her mouth is open, uttering sounds that we presume are natural but not gross like those of her companions. Her carriage, her expression, her function of distributing milk all imply the sweetness of her song as a harmonious yet vital alternative to both the artificiality of the Musician's music and the cacophony of the plebeians'. Her beauty and grace are surely intended to suggest that her voice, which among the sounds of nature is art, is more beautiful than the Musician's violin because less constricted by conventions, the impositions of treatises and connoisseurs. Thus the Musician, like the putto who turned away from Nature in *Boys Peeping,* by stopping his ears misses the song of the milkmaid as well as the harsher sounds.

There was a trial-proof state of *The Enraged Musician* (fig. 49) [17] in which an analogy between the little girl's playhouse and a bird catcher introduced a domestic theme. The wandering eye of the handsome boy-grenadier made him the third party in a potential triangle (with the girl gazing at the boy urinating), of the sort Hogarth

introduced into the seemingly animated sculptures in *A Marriage Contract*. Even the syphilitic dustman contributed to a theme concerning love along the line of the diseased mistress of *The Pool of Bethesda*. Hogarth then, in the published state, turned the boy's head away, removed the grenadier's cap, and gave him a plain face; he removed the doll and restored the dustman's nose. He retained only the girl's interested regard for the little boy's method of noisemaking and placed in her hand a rattle: strengthening the simple contrast (silence-sound) at the expense of the sexual subtext.

Hogarth had begun to explore this contrast between the irreconcilable forces of unity and heterogeneity, high culture and low, or society and its subculture, in his *Scene from "The Tempest"* with Ferdinand opposing Caliban (as well as, or instead of, Prospero). Here it sets him on a course to the undisguised opposites of Francis Goodchild and Tom Idle in *Industry and Idleness* (1747).

In *The Shrimp Girl*, probably from a few years later (fig. 50), the most famous and popular of all Hogarth's paintings, he has simply removed the surround and painted the girl's head and shoulders—outside of any context save the simplest identification of occupation. There is of course no reading structure in this painting, because denotation is rendered minimal and nothing distracts from the play of the brush and the paint, from their form, color, and texture. But Hogarth is still creating within the assumptions of his subject paintings. There is the smiling face, barely represented but with pleasantly plebeian features, a mouth open in a smile that may graduate to a fishmonger's cry; there is just enough characterization to go beyond the face of the woman in *The Enraged Musician* and show that this is joy *in nature*, unavailable (if we put it in the context of the moral works) to more sophisticated and artful women.

A type of Dutch genre picture in the seventeenth century, popularized by Frans Hals, showed a fishergirl with a basket of fish on her head. One by Hals, with contemporary copies, has a composition similar to Hogarth's, though extending to a half-length. And indeed a Hals laughing boy or girl is about the only graphic precedent one can think of for Hogarth's remarkable *Shrimp Girl*.[18] The fishergirl and fisherboy pictures may have been reminders of the "liberty" of the "natural life" over the servitude of city life; in Hogarth's own iconography this is at any rate the case. But there was also a verbal tradition that played on the incongruity of country freshness and

freedom in a city context, applicable also to the original conception of the Harlot.

The Sleeping Congregation fits into this sequence of artist fables. The beautiful young woman is present, dreaming of marriage but also mediating between the clergyman and the sleeping congregation, between the solipsistic preacher above and the lecherous natural man beneath him. The preacher is, in a sense, a relative (chronologically a precursor) of the Poet and Musician, so absorbed in himself that he not only ignores the young woman but puts his audience to sleep (an audience that is more likely to be aroused by the young woman than by his words).

The official message of these prints is that the central figure of affectation, the person who is one thing and wants to be another, has now been moved to the side and become the deluded artist, and the faithful Polly or Sarah has become an aesthetic norm which conveys Hogarth's ideas about the natural versus the "artistic," or low art versus high, and implicitly about the close relationship between nature and beauty. It was his way of saying that true art is nature and that the true artist imitates nature, not whatever sort of art happens to be fashionable at the moment. Nature is defined as not only sexuality but the life of the lower orders and true art as one that draws inspiration from the subculture.

If there is a Masonic mystery that informs Hogarth's story of the young woman, this is only another of the structures used to accommodate the personal fiction we have seen concerning himself, his wife, and his father-in-law. Given the biographical facts we know, it would seem that Hogarth presents a story—in his experiments in high art and in his prints about art and the artist—in which his wife Jane is the center of his world, the mediator between a poor foolish artist trying to find and impose order (trying to equal the Old Masters, trying to establish an "English" art) and the threats of intractable experience, or perhaps between the late father who imposed the ideal and the young interloping lover who violated it, or some such dichotomy. But is she the center in the real or in the Masonic sense—that is, excluded from fraternity with her husband and his friends but mythically and symbolically efficacious? Either Jane has become the center of Hogarth's imaginative world—or he has found a substitute for her (what he would have *wanted* her to be) in this figure.

This "wife" figure functions as an Other to the Harlot, Hogarth himself, and the rest of his dramatis personae; she is good, the Samaritan as opposed to the wounded man or his wounded dog. She is, of course, an example of good mediation, as opposed to the *bad* mediation of the printseller or bookseller who intervenes for his own profit between artist (whether William or Richard Hogarth) and consumer.[19] And for Hogarth mediation is distinct from imitation: the Harlot emulated fashionable ladies and so took lovers; but Miranda mediates between Ferdinand· and Prospero, her lover and her father—or, we are allowed to construe, between Ferdinand and Caliban (two aspects of her lover). While the father-son conflict emerges more uncompromisingly or undisguisedly in *Satan, Sin, and Death,* the dichotomy of Ferdinand and Caliban becomes the subject of the artist satires. The emphasis is no longer on the imitator (who might be Richard or even William himself) but on the mediator between generations, polarities, and incompatibles.

There is no sense that Ferdinand *desires* Miranda because he desires (or desires to be) Prospero.[20] But for Hogarth the myth of Miranda's mediation may have been a screen to cover his own imitation—guilty knowledge that in fact he desired Jane because she was Thornhill's daughter, because she represented a Thornhill surrogate, and because she was a way of possessing Thornhill or what he stood for. We have noticed that Thornhill died in May 1734; Hogarth probably wrote the obituary and certainly wrote the essay signed "Britophil" in 1737 defending Thornhill as a painter (see Chap. 6). But in 1732 Thornhill had resigned the Serjeant Paintership in favor of his son John—Hogarth's friend but certainly someone who on the face of it had less right to the position than Hogarth. These facts should be set against the paintings and the artist prints he was executing between Thornhill's death and the early 1740s, showing romantic or mediated triangles. We might speculate that in Ferdinand-Miranda-Prospero we have jealousy if seen from Prospero's point of view, mediation if seen from Miranda's, and imitation if seen from Ferdinand's: all are implicit in Hogarth's myth of himself, Jane, and Thornhill.

Hogarth mythologizes himself, his story, and in particular his marriage. It is quite possible to imagine him seeking out, selecting stories that in some sense validated or made public and respectable the important elements of his personal life. He finds public, accessible, ennobling (and enabling) equivalents in literature, history, and Masonic ritual which make these stories seem significant: first the

story of his childhood, his father's failure and imprisonment; second the story of his second father, that father's daughter, and their marriage. And these allow him ultimately to make the slide from the father down to the son through the mother-daughter, with his ambivalences expressed in the story of paternal opposition, rivalry, denial, and threat—and settle his attention on the daughter-wife.

HOGARTH AND POPE

On 16 March 1731/32, shortly before the *Harlot* was published, "Mr. Bavius" had made the promise (unfulfilled) that a collection of papers from the *Grub-street Journal* was forthcoming to be called *Select Memoirs of the Society of Grubstreet,* "adorned with Hogarthian frontispieces, representing to the life the Authors, Printers, Publishers, and Booksellers of Grub-street." This invocation (or invitation) suggests that the authors of the *Grub-street Journal* (which included Alexander Pope) saw Hogarth on their side, and I presume *The Distressed Poet* was to some extent made to answer the challenge.[21] He includes an issue of the "Grub Street Journal" on the floor near the Poet's foot; and Pope's *Dunciad* is cited under the first (1737) state of the print, and the scene illustrates one of Pope's points in the prefatory matter to the *Variorum Dunciad.*

In the painting (fig. 44) the Poet keeps on his wall a print of Pope himself. It is an anti-Pope caricature, "Pope Alexander," "His HOLINESS and his PRIME MINISTER," the latter being an ape (fig. 46). This is an image that could be the poor Poet's revenge on his denigrator, the author of *The Dunciad,* or it could be his simple-minded icon of the Great (successful) Poet. In either case the print designates Pope's Roman Catholicism, his self-regard, and his self-proclaimed role as Great Poet. Though the print is carefully detailed, as if for transfer from the painting to the engraving, in fact the published engraving of *The Distressed Poet* (fig. 45) replaces it with another (more timely) print, one referring to the scandalous business in 1735 of Pope and Edmund Curll over the publication of Pope's correspondence (fig. 47). This print (unlike "His HOLINESS") was apparently invented by Hogarth: it is not clear whether Curll is beating Pope or Pope is beating Curll. But the known fact was that Pope had tricked Curll into publishing his correspondence so that he could

himself bring out an "authorized" edition "without imputation of vanity." [22]

It is easy to see why the Poet has been identified as a likeness of Lewis Theobald (of whom unfortunately no portrait has survived). Theobald was the chief dunce of *The Dunciad,* the lines from which (referring to him) appear under the print, the Poet's face is individualized, and the poem he is writing is called "Poverty a Poem." [23] Theobald was the author of *The Cave of Poverty, A Poem, Written in Imitation of Shakespeare* (1714). In this sense, Hogarth has "illustrated" *The Dunciad* in much the same way he illustrated Swift's *Gulliver's Travels* in *The Punishment of Lemuel Gulliver* (ill., vol. 1), producing his own interpretations and commentaries on the two great literary satires of his time.

We also know that Hogarth illustrated Theobald's opera *Perseus and Andromeda* in 1730/31 and, more significantly, he was a subscriber to Theobald's edition of Shakespeare (published 1734, dated 1733). The crux of Pope's animus against Theobald had been his criticism of Pope's edition of Shakespeare in *Shakespeare Restored* and the subsequent edition of Shakespeare that embodied the corrections. Hogarth's subscribing to this edition would have been evidence of his feelings about Pope in the mid-1730s (we have already seen his feelings in the 1720s in *The South Sea Scheme*). On the other hand, when he republished *The Distressed Poet* in 1741 Hogarth changed "Poverty" to "Riches" and dropped the Pope caricature and the lines from *The Dunciad,* calling the print simply *The Distrest Poet* (the title it had been advertised by in 1737). [24]

He would have seen Pope in the 1720s as part of the Burlington-Kent circle, and so anti-Thornhill; he would have known of Fielding's attacks on Pope the man, defending his cousin Lady Mary Wortley Montagu. Pope was also a Roman Catholic whose allegiance was to Continental art and theory. Pope regarded the relationship between poet and patron as one of mutual flattery in a degraded public realm, and so refused to accept the great as patrons but utilized them as "friends": a view Hogarth would have regarded as sycophantic and hypocritical. Pope spoke for—withdrew into the circle of—those friends (Burlington, etc.) and railed against the poor Grub Street hacks, with whom Hogarth may have associated himself (and certainly his father). [25] In short, the Poet like the Harlot errs in trying to be like the great, in this case the "Great Poet" Alexander Pope. It

is well to remember also that there were an inordinate number of exemplary portraits of Pope in paintings and prints—many commissioned by Pope himself and quite a few the works of Jonathan Richardson (and none the work of Hogarth).[26] The portrait of Pope was almost a blazon for the subject of emulative iconography.

Critics had complained that Pope's ridicule in *The Dunciad* fell upon the unsuccessful, therefore poor and needy poets, and so in the second, *Variorum Dunciad* of 1729, he justified his satire on the poor poets. In a letter attributed to William Cleland several arguments are marshaled, but the climactic one asserts that the poor, incompetent, and deformed become justifiable objects of satire when they try to pass for the fashionable, talented, and beautiful: "Deformity becomes an object of Ridicule when a man sets up for being handsome; and so must Dulness when he sets up for a wit. . . . Accordingly we find that in all ages, all vain pretenders, were they ever so poor or ever so dull, have been constantly the topics of the most candid satirists, from the Codrus of Juvenal to the Damon of Boileau."[27] Behind the satirists Pope cites there is, of course, the figure of Aristotle, who postulated in his *Poetics* that the subject of comedy is the low—which could be interpreted as an inferior class, one aspect of which is its poverty.[28]

What is established in *The Dunciad*—that the poor poet is risible if he emulates, that is, desires and attempts to assume or presume to, the status of the real poet—was, in a general way, explored by Hogarth two years later in *A Harlot's Progress,* and then followed by his literal illustration in *The Distressed Poet.* The question Hogarth raised in *A Harlot's Progress,* however, was whether the object of the satire was the poor copyist or what she copies. Obviously the imitator is "comic" because of the incongruity between aspiration and reality; as in *The Beggar's Opera* one laughs at Macheath's gentlemanly diction, at Peachum's pose of the merchant and Polly's of the romance heroine. But the "villain" in both works is not the poor emulator but the figures emulated—the "great men," the lawyers, magistrates, and statesmen who, unlike these poor imitators, prosperously die in their beds. In the painting of *The Distressed Poet* this becomes the poet Pope, now formally in the place of Sacheverell and Macheath.

In this context, by making the Poet's wife a mediator between the incompetent poet and the hard world of London economics, Hogarth has corrected Pope's *Dunciad* and replaced his Goddess Dulness with a more benevolent goddess. Indeed, Pope's Dulness invoked in

many respects Hecate or the Queen of Night, the negative of the *Alma Mater,* and Hogarth has simply replaced her with her more benign aspect.[29]

CARICATURES AND THE "FOUR GROUPS OF HEADS"

The advertisement of 5 March 1736/37 announcing publication of *The Distressed Poet*[30] included a clause that carried implications for Hogarth's work on art and artists. Besides *The Distressed Poet* he announced "Also four Etchings of different Characters of Heads in Groups, viz. a Chorus of Singers, a pleas'd Audience at a Play, Scholars at a Lecture, and Quacks in Consultation. Price 6d. each." The first two were the subscription tickets for *A Midnight Modern Conversation* and *A Rake's Progress* with the receipts removed, the third had just been published in January (dated the 20th), and the last bore the same date as *The Distressed Poet* (3 Mar.). These made a group of faces that would be taken by contemporaries as Hogarth's "caricatures."

Arthur Pond's prints after Italian caricatures by the Carracci, Guercino (Francesco Barbieri), Pier Francesco Mola, and Pier Leone Ghezzi had begun to appear in 1736 and were all published by 1742 when Fielding alludes to them in his preface to *Joseph Andrews* and Hogarth draws public attention to them in *Characters and Caricaturas* (fig. 88). In that print Hogarth copies the Carracci *Due Filosofi* and a Ghezzi head from Pond's *Caricatures,* as well as a grotesque Leonardo head from the French *Têtes de Caractères* (published by Crozat, Caylus, and Mariette), contrasting them unfavorably with his own examples of "character" (which he supports with copies of three heads from the Raphael Cartoons).[31] But he had begun to draw this sort of head—presumably his own response to Italian caricatures—as early as *A Chorus of Singers* in 1733 (fig. 5). When he published these small prints together, "Four Groups of Heads," in 1737, he must have been placing them in competition with—and as a corrective to—Pond's series.

Caricature originated in the studio of the Carracci brothers in 1580s Bologna—brief sketches that reduced the subject to a few emphatic lines and one or two exaggerated features, a nose or a mouth.

Caricature required the sophistication of academic artists and aristocratic patronage to be recognized for wit rather than ineptitude. Portrait caricature was both an in-joke and an expression of draughtsmanly mastery. Until the early years of the eighteenth century it remained a private entertainment for acknowledged masters of high art and their patrons. With the age of the Grand Tour, however, caricature spread through Europe and especially Great Britain. Visitors to Rome and Florence brought back drawings and prints, and Pond's series of caricature portraits made the issue public—and to Hogarth opened his own position to misunderstanding. He was surely aware that "caricature" was applied to the work of any artist who ventured beyond the Raphael formulae; the earl of Chesterfield, not long after, wrote to his son: "I love la belle nature; Rembrandt paints caricaturas."[32]

Hogarth would also have responded adversely to the coterie aspect of caricatures. Behind their vogue was a sense that portraits, once an aristocratic preserve, were becoming all too common when every Captain Coram could have his portrait painted and come out looking like an aristocrat. The sophistication of the caricature offered the young nobleman something more daring and exclusive than a painted portrait, implying disdain for the indiscriminate products of the portraiture tradition, beyond the comprehension of captains and merchants. The sophisticated paradox of the portrait caricature was that while apparently denigrating, in fact it exalted—setting apart, acknowledging and reinforcing celebrity.[33] Moreover, the young noblemen produced their own caricatures—amateur products to be passed around among a circle that would recognize resemblance in the crudest scratches. Hogarth's "Heads," therefore, related the issue of caricature to his own serious undertaking in the late 1730s of portrait painting (see Chap. 7).

Published as a group, the "Heads" also represented another statement about art. In *A Chorus of Singers* Hogarth juxtaposes the singers with their words, in *The Laughing Audience* the audience with the play, and in *Scholars at a Lecture* the scholars with their vacuous text. But the darkest view of "art" is in *The Company of Undertakers* (or *Consultation of Quacks,* as advertised in the *Daily Gazetteer,* 5 Mar. 1736/37; fig. 51), published with *The Distressed Poet.* Here art kills rather than cures: the physician's pretensions are summed up in three murderous quacks (or "Quack-Heads") presented as mock-armorial bearings. In his "Britophil" essay, published in June, Hogarth ap-

plied the term "quack," thus contextualized, to critics and picture dealers (see Chap. 6).

It is worth noting that the prints concerned with physiognomy are concentrated during the time of Hogarth's painting at St. Bartholomew's: his fascination with the clinical was evidently as strong a force as the desire to paint sublime history. Some of the St. Bartholomew's physicians have been identified among the physicians portrayed below the wavy line of the escutcheon. But the three quacks posed as figures on the "chief" part of the shield are John Taylor, Sarah Mapp, and Joshua (Spot) Ward, who were associated as a sort of medical triumvirate, or mock-Trinity, in the journals (especially the *Grubstreet Journal*) during the autumn of 1736, following upon Hogarth's painting of Christ healing the sick:

> In this bright age Three Wonder-workers rise,
> Whose Operations puzzle all the Wize.
> To lame and blind, by dint of manual slight
> MAPP gives the use of limbs, and TAYLOR sight.
> But greater WARD, not only lame and blind
> Relieves; but all diseases of mankind
> By one sole *Remedy* removes, as sure
> As Death by *Arsenic* all disease can cure.[34]

Hogarth does not show the horrible consequences of their quackery, so clinically described in the *Journal* (and delineated in *Harlot* 5), but limits himself to a clinical examination of the quackery—that is, the self-presentation—in a comic juxtaposition of feigned skill and actual incompetence, revealed in each abysmal physiognomy.

Taylor, an oculist, was not, properly speaking a quack. The *Grubstreet Journal* carefully emphasized that he was a regular surgeon of talent, but one who subordinated his talent and profession to the demands of a commercial enterprise: defending him (on 2 Dec. 1736) as a physician but attacking him as a self-puffer and ridiculing his commercialism and lack of professional dignity. In an earlier issue, a correspondent signing himself "Fair Play" tells of a patient who lost the sight of both eyes a few days after one of Taylor's operations; this, he says, was not the fault of Taylor's work but of his ridiculous advertising and pompous progresses through the countryside, which led incurables (this patient was seventy) to believe they were curable. On 27 January 1736/37 both Taylor and Ward were described in the

Journal as members of "The Trumpeters Club or Society of Puffers," in which "the present honorary professor is the worshipped Dr. T——r, well known for his various puffs all over the kingdom."

Hogarth's presenting them on an escutcheon also introduces the subject of royal patronage. The arms (royally granted), showing both what they think of themselves and what the Crown thinks of them, become an imaginary projection of royal favor. Taylor, like Colonel Charteris and his wife, had been presented to Queen Caroline at Kensington "and had the Honour to kiss her Majesty's Hand, in consideration of his extraordinary Merit in the Sciences he professes." This was in September 1735, not too long after Hogarth had been snubbed by the royal family. In October John Faber's mezzotint portrait of Taylor appeared, and the oculist was again at Kensington, this time to show the queen some of his inventions. She promised to call on him in a few days to be present at one of his operations. More currently, in May 1736, Taylor had been appointed oculist to the king and had the honor of kissing the hands of both king and queen, and in August he conducted one of his triumphal progresses through the countryside with hundreds waiting for him and seeking his help.

Joshua Ward, the most famous quack of his time, was attacked by the *Grub-street Journal* for creating the reputation of being—like Taylor—a wonder-worker. But his claims were based only on a "Pill and Drop," made of antimony and arsenic, which had a powerful purgative effect and sometimes killed before curing. The *Journal* listed case after case that demonstrated the horrifying results of his "cure": blindness, paralysis, and death. The most dangerous of the three quacks, he was attacked as early as 1734 and remained one of the *Journal*'s main subjects until it expired itself at the end of 1737.[35] Attacks reached a peak of intensity in the middle of 1736. On 17 June, the news was printed that Ward and eight or ten of his cured patients had appeared before Queen Caroline and were examined, and Ward was congratulated and given money. Then the *Journal* set about investigating these cures and reported on 24 June that only seven had appeared and none could be called a real cure, either because it was not known what the patient had to begin with or because he still suffered from the same disease, only somewhat eased, after the treatment.

Sarah Mapp was simply a broadly comic figure—a female bone-setter. But in August 1736 she was performing her operations at Epsom and Kingston before persons of distinction, and was scheduled

to perform before the queen at Hampton Court. (At the same time the news was confirmed that her husband had deserted her, making off with 102 guineas.)[36] Mapp is another—this time clearly parodic—version of Hogarth's female mediator, amorously nuzzled by both Taylor and Ward. The three figures sum up the dark side of Hogarth's study of artist, art, and patronage in the 1730s—and its dark reflection of the Christian religion.

The advertisement of 5 March 1736/37 announcing publication of *The Distressed Poet,* besides announcing the "Four Groups of Heads," indicated a significant departure for Hogarth in his mode of distribution. The individual prints were now

> To be had either bound together with all Mr. Hogarth's late engraved Works, (except the Harlot's Progress) or singly, at the Golden Head in Leicester-Fields, and at Mr. Bakewell's, Printseller, next to the Horn-Tavern, Fleet-street.

Hogarth announces that his prints can be bought not only as "furniture," for framing, but in folios as a collection. The Hogarth folio will contain all of the works from the copperplates he owns: the point of departure is immediately following the *Harlot* plates, since he had pledged himself to his subscribers that there would be no more impressions taken after the subscription. He kept his word until 1744, when he announced that unless his subscribers objected he was printing a second edition—which then entered the folios.[37] With the folios he assured himself—or his works—of an elite audience, an authoritative canon, a permanent order, and the likelihood of continuing study and contemplation.

6.

Urban Pastoral

The Four Times of the Day, 1737–1738

Between April 1736 and May 1737, in the hiatus between the completion of the painting of Christ and the beginning of the Good Samaritan, Hogarth not only published six prints (*Sleeping Congregation, Before* and *After, Scholars at a Lecture, Distressed Poet,* and *Company of Undertakers*), he also embarked on the painting of four small upright panels he named *The Four Times of the Day* (figs. 54–58). According to tradition, they were originally intended for a Vauxhall supper box (copies were apparently used); modernizations of such topoi as the four ages of man and the four seasons, they were eminently suitable for the diners and strollers at Vauxhall.[1] This urban pastoral would have suggested the tension between Vauxhall's "garden" and the crowded city just up the river from which these pleasure seekers had come. Vauxhall represented the sort of transition between art and nature, between history painting and landscape, that Hogarth explored in these paintings.

Hogarth was also painting in his more familiar horizontal shape a group of actresses, *Strolling Actresses Dressing in a Barn* (fig. 53). When he decided to engrave the *Times of the Day* he added this subject as he had added *Southwark Fair* (a similarly theatrical subject) to the *Rake's Progress.* In May 1737 he began to advertise his subscription for the five engravings, and the subscription ticket was once again *Boys Peeping at Nature* (fig. 52). The reuse of the subscription ticket for the *Harlot's Progress* makes it clear that Hogarth intended this series as a similar departure. By January 1737/38 the plates were still unfinished when he launched a new series of advertisements. On 25 April he announced that the prints were finished and would be ready for delivery to subscribers the next Monday, 1 May, at the Golden Head.[2] There was a great deal of advertising for this series;

even after publication he continued to advertise, changing the opening to "Mr. HOGARTH HATH just publish'd, . . . ," and continuing through most of May.

STROLLING ACTRESSES AND FIELDING'S FARCES

In the advertisement of 10–12 May 1737 it was announced that the prints are "in great forwardness" (*St. James's Evening Post*). At the end of the month Walpole's Licensing Act was voted law by Parliament, closing all English theaters except the two patented theaters of Covent Garden and Drury Lane. Dissident plays such as Fielding's *Pasquin* and *The Historical Register* were in effect suppressed and Fielding's theatrical career brought to an end.[3] At this point Hogarth may have rethought his engraving of *Strolling Actresses;* he added the small paper labeled "The Act against Strolling Players" on the crown, being used as a tablecloth by the mother feeding her baby—recalling the ignominious use to which Bishop Gibson's *Pastoral Letter* was put in *Harlot 3*. The Licensing Act is a final *vanitas* symbol added to the sequence of the broken eggs, the crown as a stand for the baby's pap, the orb a plaything of kittens, the mitre a receptacle for promptbooks, and the hero's helmet a chamberpot for a monkey—and, on a larger scale, the theater itself a barn with a shattered roof. But the addition is appropriate considering that the design shows what is essentially a behind-the-scenes view corresponding to a Fielding rehearsal play of the type that precipitated the act.

In a single image *Strolling Actresses* summarizes Hogarth's comments on society up to this point, but in the particular idiom of Fielding's plays. In his farces and burlesques Fielding showed shabby mortals acting the roles of gods, goddesses, kings, queens, and personifications. Authors, critics, and actors, who are sometimes prevented by bailiffs or drink from assuming their roles, discuss the play and then watch and perform a rehearsal, continuing to comment on its absurdities. This conception reached its highest art in the plays of 1736 and 1737, *Pasquin* and *The Historical Register,* and then came to an abrupt end with the Licensing Act. Hogarth celebrates both the model and its termination in *Strolling Actresses,* beginning with an exaggeratedly baroque composition (recalling the final version of

The Beggar's Opera) and a subject reminiscent of an assembly of the gods. The gods, however, are theatrical poses and costumes assumed by contemporary women (not men), merely roles in a play, and seen backstage, in a state of exposure and discomposure. It is the situation Fielding mentions later in his *Champion* of 10 May 1740 (describing his own theatrical farces), "of a man behind the scenes at your play-houses," who "is not so agreeably deceived as those to whom the painted side of the canvas represents a beautiful grove or a palace." It is also the locus, though a milder version, of Swift's "Dressing Room" poems, where the beautiful idol is seen stripped of her paint to reveal flesh and excrement.

At the left, an emblem of the enterprise, is an actress playing a mermaid—a naturalization of Horace's "mulier formosa . . . desinat in piscem" (which Hogarth had also explored in *Satan, Sin, and Death*). She is ministering with gin to another actress dressed as Ganymede, but with trousers off and suffering from a toothache. Ganymede's eagle is a mother feeding her baby, who is frightened by her mother's costume. Chickens perch on the waves of the stage ocean, Apollo points to his stockings hung on a canvas cloud to dry, and a winged Cupid climbs a ladder to get them down for him. The composition is a simple pyramid structure with the Ganymede figure at one side and Juno trying to memorize her lines at the other (the Queen of Night patches a hole in her stocking).

The apex of the triangle, the center of attention, is an actress assuming the pose of Diana the Huntress (Louvre), with one hand up to pull an arrow from her quiver and the other holding her bow, here rendered absurd by lack of either quiver or bow (as was the case in versions of the sculpture surviving from antiquity). Thus both actress and art object manqué, she recalls that earlier Diana, the nature goddess of *Boys Peeping at Nature,* which introduced *A Harlot's Progress* and serves as subscription ticket for this series as well. *That* Diana was in fact an earth-mother (more closely related by her breasts to the Venus-cookmaid of *Noon*), and this Diana only acknowledges the goddess of chastity in the crescent on her head—and the male face peering down at her from a chink in the roof, who fills the role of Actaeon. Unlike the goddess of chastity, she lets her neckline plunge and drops her protective girdle around her ankles to reveal enough to endanger any Actaeon in the vicinity. She also smokes a pipe and drinks ale.

She is another of Hogarth's attractive young women but a disrepu-

table Diana. We do not blame her or the other actresses, however, because they are, as actresses, not guilty of the Harlot's or Rake's affectation. These roles have been assigned them by the manager, as they were by Divine Providence in the metaphor of Life as a Stage. As Addison put it: "All that we are concerned in is to excell in the Part which is given us. If it be an improper one the Fault is not in us, but in him who has cast our several Parts, and is the great Disposer of the Drama."[4] Being an actress sets her off from Miranda, Sin, and the Poet's wife; if she is a figure of mediation it is between the gods and the humans, connecting the illusion of the performance with the privileged spectators—the internal one on the roof and the external ones who purchase the print—who (in the terms of *Boys Peeping at Nature*) get this "peep" backstage where she is literally "unveiled." And in that sense, if theatrically she is a disreputable Diana, in terms of the subscription ticket she is another Diana of Ephesus, *Diana multimammia*.[5]

The Actaeon, shortly to be turned into a stag and devoured by his own hounds, may also be a humorous reminder of the "danger" perceived by the ministry and parliament in these theatrical performances. Corbyn Morris, in his *Essay on Wit* (1744, dedicated to Walpole), justified the censorship of plays on just this ground:

> For these profligate Attacks made Impressions more deep and venomous than Writings; As they were not fairly addressed to the Judgment, but immediately to the Sight and the Passions; nor were they capable of being answered again, but by erecting an opposite *Stage of Scurrility*.[6]

Hogarth's *Strolling Actresses* announces—to Fielding among others—that once the theater is closed to such plays as this, they will still survive in his prints and continue to be seen and to transform Actaeons.

With its emphasis upon the materiality of stage properties, one Fielding play in particular dominates the imagery of *Strolling Actresses*: in *Tumble-down Dick, or Phaeton in the Suds* (1736) the sun is a lantern, the Palace of the Sun a roundhouse; Aurora is delayed going out to meet the sunrise because her linen is not washed, she is accompanied on her walk by girls carrying farthing candles to represent the stars, and Neptune is a waterman. But Fielding's farce also introduces a rascally justice, once again (as in *Rape upon Rape*) apparently

based on the notorious Westminster magistrate, the "trading justice" Thomas De Veil, and in close proximity to him songs about gin and allusions to the Gin Act of 1736, which had reduced the number of gin shops; as a consequence of his imbibing, the justice ends the play as a merrily singing Harlequin, exposing his true personality. There are also a barber shop and a cuckolded cobbler quarreling with his wife. *The Four Times of the Day* could have been constructed from such hints.

THE FOUR TIMES OF THE DAY

Even here, in this most generalized of Hogarth's modern moral subjects, particular allusions were not lost on the public of 1738. The drunken Freemason in *Night* was recognized as De Veil, whom Hogarth had supposedly portrayed in *The Denunciation* (ill., vol. 1). A member of Hogarth's first lodge which met at the Vine, he had lived until recently nearby in Leicester Fields.[7] Indeed, De Veil, who took a major part in enforcing the Gin Act, but was known to many Londoners as a pleasure-loving man himself, appears appropriately drunk, a merrymaker with a gin seller pouring brew into a keg directly behind him, and a woman pouring a less savory liquid on his head from an upstairs window.

The scene was no doubt conceived when the first advertisement appeared in May 1737, but substantiation of various sorts followed, perhaps leading Hogarth to add details and reshape the composition. On 16 August a "comical Affair" was reported by the *London Evening Post* as happening near Bow Street, and the reference to De Veil was obvious:

> One who is known there by the Name of Michael, who sells things in a Barrow, being in Liquor, went to one Mrs. How, and desir'd her to let him have a Quartern of Gin, his Wife being sick, which he put into a Phial, and was carrying away with an Intent to inform against her; but being elated with the thoughts of the Reward, he could not keep the Secret, but told three or four of his Acquaintance, who met him by the Way, of his Design, and let them see the Liquor; they desir'd him to let them taste it, which he did; some of them amus'd him whilst the others drank it up, and one of them piss'd about the same Quantity

in the Bottle and return'd it him, which he carry'd to a noted Justice in Westminster, and told him he was come to inform against a Person who had just sold him a Quartern of Gin, which he had in his Pocket; whereupon the Justice order'd a Glass to be brought, and some of the Liquor to be pour'd into it, which he tasted, but soon finding what it was, he directly order'd him to be committed to Tothill-Fields Bridewell for the Affront put on him.[8]

The chamber pot is accordingly an even more appropriate punishment for the gin suppressor: the woman in the window is watching the effect of the action, which appears premeditated.

Throughout the autumn De Veil continued committing people for selling "spirituous Liquors," and more than once was in some danger from mobs. In January 1737/38 a crowd of a thousand people assembled before his door, threatening destruction if he would not turn his informers, with him at the time, over to them:

Whereupon the said Justice read the Proclamation [the Riot Act], which instead of dispersing the Mob encreased it greatly; but observing among the rest a profligate Fellow, who was the great Encourager of this Tumultuous Assembly, (one Roger Allen) and who encourag'd them to pull down the Justice's House and kill the Informers; had him seiz'd, and the said riotous Assembly remaining before the Justice's House above three Hours after he had read the Proclamation, his Worship sent for a strong Guard from the Commanding Officer at St. James's, and having sent away the Informers to Whitehall, under the Protection of part of the Guard, he took the Information of three Witnesses against the said Roger Allen, who is committed to Newgate.[9]

The trial of Roger Allen for inciting "a tumultuous Assembly of above 500 People to pull down Col. De Veil's House, in Frith-street, Soho, and to kill two Informers against Spirituous Liquors, which were then protected in the Colonel's House" took place on 25 January, the day Hogarth began to renew his advertising of *The Four Times of the Day*. It was demonstrated that Allen was feebleminded and he was found not guilty; nevertheless, the renown of the case is evident: "Westminster-Hall was so full one might have walk'd on the People's Heads; and the Mob on hearing of his being acquitted, were so insolent as to *Huzza* for a considerable time, whilst the Court was sitting."[10] It can be no coincidence that the new advertisement for

Hogarth's subscription appeared, after a year's silence, on the day of Roger Allen's trial.

The fire in the distance, which appears only in the print, may have been added as a reminder of the recent attacks on De Veil's house. But the print's details of disorder—the fire, the overthrown coach and sedan chair—originate in the plebeian crowd ritual's conflation of national and subversive holidays. De Veil is the Lord of Misrule, the upholder of the Gin Act who is drunk and the Hanoverian who wears oak leaves in his hat to celebrate Restoration Day (the oak leaves recall the tree in which Charles II hid after the battle of Worcester). In fact the contiguity of George I's birthday and the Jacobite anniversary of Charles II's restoration (as well as Charles I's martyrdom) allowed for the anti-Hanoverian crowd to celebrate in a subversive way. Jacobite symbolism was used in the 1720s and 1730s as a means of popular dissent, but its use was as theatrical as the chairings of members at elections and bonfire lightings at "Pope Burnings": it did not follow that the people who used them were more than play Jacobites. Some imagery of dissent was needed and the "lewd Jacobite gesture" was the image "most calculated to enrage and alarm the Hanoverian rulers." [11]

At the Reformation the medieval religious festivals, such as Corpus Christi, had been secularized into "national" celebrations, which by the end of the seventeenth century were politically partisan, Whig or Tory. [12] While utilized by the governing ministry to dissipate dissent and consolidate authority, they could and did get out of hand, as when Tories turned a Whig celebration into parody. But by Hogarth's time they were often uncontrollable and the Riot Act (known as a "Hanoverian proclamation") was frequently invoked. Insofar as the crowd was suppressed, the old and generally rebellious as well as the contemporary and partisan political feelings went underground or sought expression in the conventional forms that remained—the lord mayor's processions, "Tyburn Fair," the hustings of general elections, or Bartholomew (or Southwark) Fair, in other words precisely the areas, always liable to erupt in violence and develop into a riot, that Hogarth singled out for representation, beginning as early as *Hudibras and the Skimmington* and *Burning the Rumps at Temple Bar* (ill., vol. 1).

The specific riots of 1736–1737 explain the connection Hogarth makes between the Licensing Act of *Strolling Actresses* and the disorder of *Night*. One of the chief reasons for Parliament's passing the act

when it did (an unsuccessful attempt had been made in 1735) was the rioting in London theaters. Any riot was interpreted by the king and therefore by his ministers as Jacobite and anti-Hanoverian. Indeed, the king and queen more than Walpole resented the satiric representations of the plays, which often focused on the royal family and at this time in particular on the unseemly quarrels between George II and his son, Prince Frederick.[13]

A major riot in Edinburgh, named after Captain Porteous (who was lynched when it was learned that the crown had pardoned him), had erupted in September 1736. This was followed by riots in London later in the month when the Gin Act took effect. By Michaelmas (29 September) the streets were being patroled by horse guards, the signs of the liquor shops were draped with black, and there were mock funeral processions for "Madam Geneva" re-creating *The Deposing and Death of Queen Gin,* a farce that had been performed at the Little Theatre in the Haymarket (Covent Garden had played *The Funeral; or, Grief à la Mode*). The king was conducting one of his protracted and unpopular visits to Hanover, where he was reported to spend lavishly on his German mistresses. The mob cry was ominously "No gin, no King."

De Veil was involved in one of the theater disturbances, the "great Riot" that broke out on 21 February at Drury Lane. The footmen, following upon an earlier riot, were locked out of their free preserve, the gallery, and so proceeded

> to hew down the Door of the Passage which leads to the said Gallery; of which Colonel *De Veil,* (who was in the House) had immediate Notice, and thereupon came out where they were thus assembled, and notwithstanding they threatened to knock his Brains out, he read the Proclamation [the Riot Act] to them . . . and . . . they all went off in a few Minutes after the Proclamation was read.[14]

Two weeks later, on 5 March, with the Prince and Princess of Wales present, the footmen again broke down the door, and this time when De Veil attempted to read the Riot Act "the violence and Number of Footmen in this riotous Assembly" prevented him. After a struggle, De Veil took some of the ringleaders into custody, examining them (sending three to Newgate) while the injured were treated by a surgeon.[15] From 7 to 14 March armed soldiers guarded the playhouse during performances.

Antigovernment riots of the autumn and spring laid the scene for the performances of Fielding's *Historical Register, Eurydice,* and (following the violent riot that closed *Eurydice*) *Eurydice Hiss'd,* and finally in May Walpole's flourishing of the scurrilous play text called *The Golden Rump* which led immediately to the passage of the Licensing Act.[16] In any case, the Restoration Day trappings of *Night* refer to the Prince of Wales's rebellion against his father (for a decent allowance) as well as to the king's fears of Jacobite riots, the disorders of various sorts connected with both the Gin Act and the theaters, and the traditional bonfires and saturnalian celebration.

THE "TIMES OF THE DAY" TRADITION

The Four Times of the Day, in composition at least, are Hogarth's closest approximation to the Dutch style. The graphic tradition they draw upon is the northern European "Times of the Day." The basic design, as Sean Shesgreen has shown, presented an allegorical figure hovering above and a landscape or townscape with farmers, hunters, and shepherds filling the lower part of the picture.[17] The allegorical figures legitimated the landscape and the human activity that was being carried on beneath them. Among the works of Dirck Barendtsz (1534–1592), for example, there are several series of prints showing an allegorical figure dominating, or giving meaning to, a set of landscapes (figs. 59, 60).[18] In conjunction with landscape, the allegory was usually one of time, based on seasonal change. Though some scenes showed Arcadian retirement in a verdant spring landscape, many also represented the work done in woods and fields— sowing, hunting, and reaping; in other words, they made a georgic statement about agricultural experience. The "Times of the Day" were sometimes also structured by borrowings from the "Ages of Man," which added the dimension of history, usually a movement of decline, from the Age of Gold to the Iron Age.

Historically, as the landscape gained its own legitimation, growing more particularized and contemporary, the contrast between the figures in the landscape and the allegorical figure reclining on a cloud overlooking the scene became increasingly incongruous. Eventually the allegorical figure shrank in size and prominence until it disappeared, or reappeared in an inset scene within the landscape. By 1600

the secularization of the tradition was well under way. What survived was the landscape (or genre) scene alone. Well into the seventeenth century, however, random landscapes (by Nicolaes Berchem, even by Claude Lorrain) were linked as if they were still "Times of the Day," "Seasons," or "Ages of Man." All of these stages survived, jumbled together, in the printshops of London where Hogarth—and his audience—could have seen them.

The "Four Times of the Day" was the particular series Hogarth chose, with its divisions of morning, noon, evening, and night. It does not represent the "progress" of a day, as his other series had shown the progresses of a harlot and a rake; the division into four times produces contrasts, comparisons, and repetitions rather than a plot. In the paintings this scheme offered an opportunity to explore the peculiar light or atmosphere of the different times of day. The prints, in black and white, emphasized the moral overtones, the "wisdom" of the allegorical series. But the moral was less emphatic than the generic question—whether this was landscape, pastoral, or georgic—and how these modes related to allegory and the high art of history painting.

By introducing the *Times of the Day* with the same subscription ticket he had used for *A Harlot's Progress,* Hogarth indicated that this series was another aesthetic departure: the boys are once again trying to get behind the conventions of a veiled Truth. This ticket had set out his intention to correct the outmoded ideas of history painting by turning to contemporary London life. Here its message, as if ironically addressed to his friend George Lambert, is that cityscape is the form of landscape painting most appropriate to England in the 1730s.

THE "BRITOPHIL" ESSAY

In June 1737 Hogarth augmented the advertisements and subscription ticket of *The Four Times of the Day* with an essay signed "Britophil" in the same issue of the *St. James's Evening Post* that carried an early announcement of his proposals for the subscription (7–9 June). The reprint in the July *London Magazine* attributed the essay to "the finest Painter in England, perhaps in the world, in his Way." The

importance of the essay lies in its being Hogarth's first substantially authenticated piece of writing. He probably drafted or supervised *The Case of the Designers, Engravers, Etchers, &c.,* but the "Britophil" essay set the tone for all the writings, and many of the pictures, which were to follow. In it Hogarth reveals a flair for drama and an ability to use words forcefully in a posture of attack.

The immediate provocation for the "Britophil" essay was an account from Paris in the *Daily Post* of 2 June of François Lemoyne's suicide: "his Head was out of Order ever since the four Faults that were found by some rigid Criticks in that vast Work, which he had been four Years about." The reporter adds: "The Painter of the great Hall of Greenwich Hospital had much more Resolution; notwithstanding there are as many Faults as Figures in that Work he died a natural death, tho' an Englishman [i.e., a sufferer of melancholia]." The reference, of course, was to Thornhill.

Within a week Hogarth replied. English art, he says with sharp eloquence, is undervalued by the critics, who try to make reputations for themselves by denigrating English pictures and by criticizing details instead of wholes, and by the picture dealers, who try to make their fortunes by selling foreign pictures. As his pseudonym suggests, he speaks as a "Well-wisher to Arts in England," and a defender of Thornhill.[19] The background villain is the connoisseur, whose French name defines his exclusive approval of foreign art. His connoisseurship, exploited by the dealer, involves attaching an impressive name to an anonymous painting, drawing attention to the smallest stylistic detail, and suggesting that reasons are unnecessary in the face of the connoisseur's peculiar and unique perception.

Hogarth's greatest scorn in the essay is reserved for the picture dealers. "There is another set of Gentry more noxious," he says, than the critics (who, with the false connoisseurs, had been dealt with in Ralph's *Weekly Register* essays):

> and those are your *Picture-Jobbers from abroad,* who are always ready to raise a great Cry in the Prints, whenever they think their Craft is in Danger; and indeed it is their Interest to depreciate every *English* Work, as hurtful to their Trade, of continually importing Ship Loads of dead *Christs, Holy Families, Madona's,* and other dismal Dark Subjects, neither entertaining nor Ornamental; on which they scrawl the terrible cramp Names of some *Italian* Masters, and fix on us poor *Englishmen,* the Character of *Universal Dupes.*

Ralph had referred to "the Multitude of Venus's and Madona's that have been produc'd in the schools of Italy, and thence have wander'd all over Europe."[20] Hogarth may have remembered the sentence, but he has unerringly singled out the dealer, who had remained curiously free of attack. It took Hogarth to link critic and dealer (or "quack," as he terms the latter). He sees them as part of the paradigm of the *Harlot* and *Rake:* the false mediator who leads the ordinary man to buy, dress as, or imitate what the critic recommends. The critic and the dealer are examples of such mediation, as rakes, gamblers, "fine ladies," and the rest were for Hackabout and Rakewell in the print cycles. So also with Mr. Bubbleman in the "Britophil" essay, whose customer, "(tho' naturally a Judge of what is beautiful, yet ashamed to be out of the Fashion in judging for himself) with this Cant is struck dumb, gives a vast Sum for the Picture."

It is clear from *The Marriage Contract* of around 1733 (fig. 26), an oil sketch for one of the *Rake* paintings, that these issues had engaged Hogarth's attention before the need to defend Thornhill prompted the "Britophil" essay. Rakewell's chamber is crowded with "*Holy Familes, Madona's,* and other dismal Dark Subjects" the dealer has sold him. The suggestion in both painting and essay is that, as a poet of the time put it, "All his nicest pieces, [are] furnish'd by the hand / Of Angelo's, who studied in the Strand." The idea of art objects that were reassembled or copied (and recopied) and so lacked authenticity comes to rest in the dubiousness of the classical deities in *The Four Times of the Day.* In one passage of the "Britophil" essay Hogarth creates a dialogue between a dealer and a commonsense buyer. "Mr. Bubbleman," says the honest buyer,

> "That Grand *Venus* (as you are pleased to call it) has not Beauty enough for the Character of an *English* Cook-Maid."—Upon which the Quack answers with a confident Air, "O L——d, Sir, I find you are no *Connoisseur*. . . ."

This passage, which anticipates the more famous one in *The Analysis of Beauty* in which Hogarth prefers a living woman to a classical sculpture of Venus, draws our attention to the fact that the handsome cook-maid who appears in *Noon* is thus a "London Venus."

This Venus is accompanied, as she sometimes was in the "Times of the Day" series, by a Cupid, in this case a bawling child who has spilled his pie. What was traditionally a dining scene, with men and

women around a table, becomes a scene in which food flies out a window, a pie spills, and a little girl gorges in the gutter not far from the body of a dead cat; and this contrast with the abundance of food in the country is also set off against the "spiritual" nourishment dispensed by the Huguenot chapel on the other side of the street. The gutter that divides physical from spiritual hunger is a poor substitute for a country rivulet; the kite caught on the church roof recalls its more usual perch in a tree; and the cityscape evokes its absent opposite, the countryside.

The other three scenes operate in the same way. In the "Morning" of the graphic tradition, the figure of Aurora or Cephalus usually appeared above, accompanied below by human hunters and gardeners. Hogarth substitutes for the panoramic country scenes with vistas to the horizon a city square with buildings rising against the sky, as closed as the first scene of *A Harlot's Progress*. Only through a pun is a "garden" present: this is Covent Garden, London's greengrocery, with a few carrots and turnips scattered about. Not shepherds and shepherdesses at their labors but city beggars, market girls, hucksters, and whores are in evidence. Instead of the sun in the sky, there is only a clockface over the portal of St. Paul's church, and the icy old woman is all that remains in this setting of the young Aurora, the dawn, accompanied by Eosphoros the dawn bearer, here represented by a shivering page trailing behind rather than preceding his "goddess."

Diana or Hesperus ordinarily appeared on the upper level of "Evening," and in "Night," Proserpina, Nox, or Pluto himself. On the lower level, figures with shepherds' crooks appeared in "Evening" and with torches in "Night"; they were shepherding or walking around in the one and sleeping in the other. Hogarth shows, instead of lovers strolling across a landscape, a weary married couple: a tiny, cuckolded husband and a large, forbidding wife. She is a formidable Diana; the horns of her husband (the cow's horns are attached to his head by an optical illusion) recall the fate of Actaeon. Perhaps in eighteenth-century London Actaeon is merely a cuckold (as in *Marriage A-la-mode* 4), as in the country he is a bumpkin peering through a hole in a barn roof at a half-dressed Diana. The couple does attempt a stroll in the country, but they are frustrated by the heat and the encroaching London suburbs. There is no escape from the city because the countryside is now built over and the distant hills are remote and inaccessible (as they were in *Southwark Fair*). The stream

running beside the couple is wider than the gutter in *Noon,* but it is a constructed canal, the "New River" which brought to London its water supply from the country. The country itself remains a remote ideal, lost to contemporary Londoners.

Whereas in "Night" sleep was traditionally represented by a recumbent figure (Pluto) and by images of sleeping figures and Saturnalian revelers in a landscape, Hogarth shows Hesperus as a linkboy, indigent couples asleep on the street, and Proserpina's chariot overturned, out of which she herself gapes in bewilderment. In the center is Justice De Veil, a modern Pluto as lord of the London "underworld," familiar with criminals and a harsh enforcer of the Gin Act, but here transformed into an urban equivalent of the Saturnalian reveler in his drunken state and Masonic regalia.

So Hogarth disposes in two ways of the allegorical elements that in this context seemed as outmoded as the Hercules figure had in *A Harlot's Progress.* First he reduces the gods and goddesses in their rural ambience to a contemporary servant girl or a drunken magistrate in an urban setting; then he takes the gods and goddesses themselves, formerly suspended above scenes of contemporary or pastoral life, with their costumes and poses, and transposes them to the fifth plate where they are more appropriately shown as actresses playing these roles in their original country setting, inside a barn, in a backstage dressing room. The extra plate is, so to speak, made up of the supernatural detritus of the upper level of the "Times of the Day": Aurora, a black woman, kills lice on the Siren's costume; and Diana, the central figure, returns from "Evening" revealed as all too human beneath her costume. Other miscellaneous gods and godlings are present, from Apollo the sun god who hangs his/her socks on a stage cloud to dry to Ganymede, cupbearer to the gods, who is not dispensing but receiving, not nectar but gin. The only way the Arcadian past can enter art now, Hogarth implies, is through actresses "dressing in a barn"; for this is a country performance by town actresses, bringing together the antipastoral and antimythological strains of the "Times of the Day" in a country setting in which no country is visible—and (as the document referring to the Licensing Act shows) this is the final performance.

As in the *Harlot* Hogarth deposited the baroque allegory he found unsuitable to the narrative proper in the Old Master paintings on the walls, now he drops the gods and goddesses that no longer fit in a modern "Times of the Day" into an adjunct theatrical plate. But im-

mediately following his New Testament histories and in the midst of his artist satires, he makes another comment on the religious dimension of art, showing it removed and replaced. Here it is classical mythology and not the New Testament story; and yet the analogy is unavoidable with *The Sleeping Congregation* of just two years earlier, which was as "iconoclasted" of the Christian deity as the *Times of the Day* is of the classical deities.

The theme of art is represented in *Strolling Actresses* by the painter's materials, including a chamber pot for mixing paints, associated with scene painting—the best (Hogarth is suggesting) an English painter could hope for at the time if he wanted to paint either history or landscape. The monkey (relieving himself in a hero's helmet) appears in this context as an emblem of artistic imitation, but our eyes move from his cloaked and wigged figure up to the actresses, who also imitate the characters of superior beings. The satire reflects on the inappropriate ideals to which ordinary artists were obliged to aspire by connoisseurs like Mr. Bubbleman of the "Britophil" essay.

GAY'S *TRIVIA*

The greater part of Hogarth's audience, however, would have understood these prints in a literary context. The contrast between the true "Britophil" and the French who have infiltrated England ("the Common-shore, / Where *France* does all her Filth and Ordure pour," ll. 87–88) and the detail of "the emptied chamber-pots [that] come pouring down" (l. 398) directly echo Juvenal's third *Satire,* probably John Oldham's imitation which replaced Rome with London (Hogarth owned a copy of Oldham's *Works*). The collapse of buildings and vehicles, the raging fire, and the threats to pedestrians were mediated for Hogarth by Gay's *Trivia* (1716), a poem he must have read when he was nineteen or twenty and absorbed thoroughly.[21]

From the hints of the Harlot's story in Book 3 (ll. 267–84) or the milkmaid of *The Enraged Musician* (2.9–12) to the sixth plate of *Industry and Idleness* visualizing the lines, "Here Rows of Drummers stand in martial File, / And with their vellom-Thunder shake the Pile, / To greet the new-made Bride" (2.17–19), *Trivia* seems to have served as a source book for Hogarth—in poetry what the *Spectator* was in critical theory and social attitudes. But, as in the harlot nar-

rative, while Gay sees her from the point of view of her gulled victim (he has Theseus gulled by Ariadne), Hogarth—in this respect closer to Gay's Polly Peachum—sees from her own point of view. And the "draggled Damsel" who sells fish and "the sallow Milk-maid [who] chalks her Gains; Ah! how unlike the Milk-maid of the Plains!" are translated by Hogarth into the lovely girls who bring beauty into the city—ultimately his Shrimp Girl. "Unlike" is the operative work, projecting the requirement for Hogarth's sense of the beautiful as a living woman, the actress playing Diana, and not the antique sculpture, but nevertheless seen in terms of that classical figure. She is now set off, however, by the heavy wife of *Evening*.

Hogarth retains the classical parallel that in *Trivia* is between the plebeian activities of the street and the heroic acts of Theseus, Daedalus, Oedipus, Orpheus, and Regulus. Oedipus in particular, given the title of Gay's poem, is at its center,

> Where three Roads join'd, he met his Sire unknown;
> (Unhappy Sire, but more unhappy Son!)
> Each claim'd the Way, their Swords the Strife decide,
> The hoary Monarch fell, he groan'd and dy'd!
> Hence sprung the fatal Plague that thinn'd thy Reign,
> Thy cursed Incest! and thy Children slain!
> Hence wert thou doom'd in endless Night to stray
> Through *Theban* Streets, and cheerless groap thy Way. (3.217–24)

Violence of the disruptive boy (finally, at this point, acknowledged by Gay to be a son) to his father, however comically viewed, is the crime, and the consequence is to "cheerless groap" his way through the maze of London, as the boy who steals a gentleman's watch is pursued through winding streets, caught, and violently punished: a verbal model of the Hogarthian "progress."

Between Juvenal and Gay came Swift's "Description of the Morning" and "Description of a City Shower" (1709, 1710). Juvenal showed the last Roman retiring from the corrupt city to the country; Swift conflates pastoral/georgic and contemporary London. He situates the contemporary city in a moral and classical perspective, replacing Apollo's chariot of the sun with a hackney coach, shepherdesses with adulterous chambermaids. But for him this is the perspective of the poet. Poets—according to Swift—use their "art," their "poetry," to romanticize reality. Beneath the apparent beauty

and order of the pastoral or the georgic is conflagration and chaos; despite the artifice of the georgic poet (the utilization of weather forecasts), people are caught off guard by the Deluge and, as London's sewage is flushed out and pours down its streets, are forced out of their artful poses and hiding places.

In *Trivia* Gay accepted Swift's distrust of the efficacy of art but also implied (following his other model, Pope) that in certain ways nature can be amplified by art—by the poetic myth of hackney coaches as Apollonian chariots, or by regarding chambermaids *as if they were* pastoral heroines. Conflating Juvenal's third *Satire* and the Virgilian georgic, *Trivia* is a cheerful manual of the artifice required to survive the threats of the London streets—for example, of hackney coaches—which at the same time (reversing Juvenal) prefers the life of walking to that of riding. His insight is that the play of such artfulness against disorder is beautiful and endlessly fascinating. In Book 2, walking through London in the daytime, the poet finds his greatest pleasure in the details of disorder (the complexity of experience), validated by the kinds of order he sees people attempting to impose, often with incongruous effect. The copious confusion of morning is juxtaposed with sleep and stasis; the profusion of a fish stall ("Red-speckled Trouts, the salmon's silver Joul, / The jointed Lobster, and unscaly Soale") with the "rigid Zealots" who enjoy such lovely fish on their "delicious Fasts": "*Wednesdays* and *Fridays* you'll observe from hence, / Days, when our Sires were doom'd to abstinence" (2.413–20). In the spattering of black coats with white flour there is both a strange beauty and an energy of metamorphosis. The oxymoron "delicious Fasts" epitomizes Hogarth's position. He projected the graphic equivalent of these contrasts favoring transgressive, inclusive, and egalitarian sympathies in *The Enraged Musician,* but he explores them more subtly and extensively in *The Four Times of the Day.*

Hogarth's visual re-creation of *Trivia* begins in *Morning,* recalling Gay's morning, winter, snow, and frosts in Book 1:

> Where Covent-garden's famous Temple stands,
> That boasts the Work of Jones' immortal Hands;
> Columns, with plain Magnificence, appear,
> And graceful Porches lead along the Square:
> Here oft' my Course I bend, when lo! from far
> I spy the Furies of the Foot-ball War:

The 'Prentice quits his Shop, to join the Crew,
Encreasing Crouds the flying Game pursue. (2.343–50)

For Gay (the follower of Pope), however, the church of St. Paul's
Covent Garden is a moral and architectural ideal, recalling its archi-
tect, the father of British Palladianism. In a passage that follows in
lines 483–500 (an urban version of a country-house poem), Gay fo-
cuses on the great city houses of Arundel, Cecil, Bedford, and Vil-
liers, now only memories from the past. Inside, the high art with
which they were hung—paintings by Raphael and Titian—has been
replaced by prints from Overton's shop. As in Juvenal's third *Satire,*
the ideal in the past is now dilapidated or replaced by a poor substi-
tute. The one standing house—a recent construction—is Burlington
House, designed by Colen Campbell, where "Beauty within, with-
out Proportion reigns." Beneath Burlington's "Eye declining Art
revives," and the walls within "lives" with the "animated" art of
William Kent.

In *Masquerades and Operas* (ill., vol. 1) Hogarth had turned Gay's
image around and situated Burlington House as merely another op-
era house or pantomime theater. In *Morning* he retains St. Paul's
Covent Garden with, juxtaposed (reversed of course in the engrav-
ing), Lord Archer's imposing town house, the last grand titled house
to survive in a square which was rapidly declining in prestige (as
Hogarth's own departure from the square had shown). But, as in the
St. Paul's Cathedral of *The South Sea Scheme* and Burlington House
of *Masquerades and Operas,* both church and house are closed and dis-
tant, excluding the people they should be nourishing. Tom King's
tavern now intervenes, or replaces, the church; its door is open,
though only riot is visible within. Outside the purlieus of both
church and tavern, in the open square, people are engaged in amo-
rous dalliance and—a parallel activity—the attempt to keep warm
around a bonfire. The boy who carries the old woman's prayerbook
is trying to keep his hands warm.

Hogarth could be illustrating Gay's lines "You'll see the Coals in
brighter Flames aspire" and "at the Dearth of Coals the Poor repine,"
with their emphasis on seeking "the grateful Warmth" of a fire
(1.133–42). From Book 2 he takes the question raised by winter:
"Why do ye, Boys, the Kennel's Surface spread, / To tempt with
faithless Pass the Matron's Tread?" (331–32). Gay described the ap-

prentices who leave their work to make mischief in the shadow of the church (as Tom Idle will gamble during Sunday service), and these reappear in *Morning* with others, including the schoolboys out of Swift's "Description of the Morning" who "lag with satchels in their hands."

One distinctive motif in *Trivia* seems to have lodged in Hogarth's memory. In Book 2 we are shown the "thoughtless Wits" "who 'gainst the Centry's Box discharge their Tea" and are advised: "Do thou some Court, or secret Corner seek, / Nor flush with Shame the passing Virgin's Cheek" (298–300). This is followed only a couplet later by advice to "the Maid when Torrents pour, / Her Head to shelter from the sudden Show'r." In *Hudibras and the Skimmington, The Enraged Musician,* and *The March to Finchley* Hogarth shows a male relieving himself against a wall (in one case a soldier with gonorrhea), observed by a female. In *The March to Finchley* (fig. 134) the painful urination at the left of the picture expands into a dreamlike image of "Torrents pour" as liquids (gin, milk, water) flow toward the right into a large puddle, suggesting something about Jacobite release and revelry.

There is a great deal of play with vivifying liquids in *The Four Times of the Day:* the squeezing of the girl's breast in *Noon* causes her to tip and overflow a stream from the dish she is holding, and this finds a parallel in the pair of hands milking the prominent udder and the "New River" in *Evening,* and grows into the flow of gin, urine, and blood in *Night,* which may recall the purgation of the city at the end of Swift's "Description of a City Shower" (anticipated by the gutter with its dead cat in *Noon).*

But Hogarth's flow is not purgative; his dichotomy in the *Times of the Day* is between the self-enclosed and the overflowing. He is as firmly on the side of nature, and against the pious old maid who stands outside the drinking and lovemaking crowd, as he is in *Strolling Actresses.* In the same way, he contrasts the rickety, man-made hulk of Tom King's tavern and the fire around which the motley crowd warms itself with the cold, geometrical facade of the palladian church. In the second scene the street, divided down the middle by the gutter, juxtaposes eating, lusting, sloppy, and plebeian English folk with pious churchgoers and (equated by Hogarth) French fashions. The latter are summed up by the little boy, preceding the French couple: an exact sartorial reflection of his father, he worships

his reflection in a muddy puddle. The worship on the English side of the street, as in *The Sleeping Congregation,* is focused on a young woman and specifically on her breasts.

Morning started with the simple contrast of two women, one a *dévote* and the other a lusty wench; but in *Noon* there is the wench with the black man's hand in her bosom and there is the stiff, pious French matron with her fashionable husband and offspring. Between these two, at a little distance, is a third woman: the shop sign of the "Good Woman," a headless woman, one who has no tongue and is no longer the conventional "scolding woman" or shrew, the popular effigy of the Skimmington. This is a husband's sign of a wife, his fantasy of an ideal wife. But juxtaposed with the "Good Woman" is a "John the Baptist's Head" on a charger, inscribed (appropriately for a chophouse sign) "Good Eating." This is the woman's equivalent fantasy of a husband—or rather the husband's fantasy of the woman's fantasy. The man's head is directly above the London Venus and her black lover, suggesting a heraldic triangle of husband, wife, and lover. (The two signs may also recall the decapitation of Doll and Orpheus in *Trivia.*)

The two signs are of course related to the carnivalesque figures of Somebody and Nobody, now gendered. Nobody, the male severed head, is still privileged, but "Good Eating" now applies to being eaten rather than eating. The focus is on the wife's aggression against the husband in metaphorical decollation or, in the context of the figures below, real cuckolding. Indeed, whereas the trio we have seen in other works of the 1730s has had a woman between opposed males, this woman is cuckolding one man with the other—and while she can be seen as a single woman vis-à-vis the French couple, the gestalt changes when she and the black man are joined by John the Baptist and the little boy spilling his pie. In *Evening* the juxtaposition of the horns and the husband's head suggests cuckolding. The young Venus has been canceled, leaving only a later, less happy version of the French couple of *Noon,* or she has turned into a married Diana, large and threatening. The married couple is now doubled with two children reenacting and parodying their elders as the French boy doubled his father (and children and animals doubled their parents in Hogarth's conversation pictures).

The only alternative is, as in *Morning,* the boisterous tavern, a means of escape. Finally in *Night* the husband *has* escaped: there are only the two Freemasons with linked arms. De Veil, dressed as a

lodge master (or past master), is accompanied by the tyler of his lodge, still carrying his sword, who guarded the door and made sure that only members were admitted. The two may be coming from the Rummer, where a lodge met.[22] In the midst of nocturnal disorder they seem to be replacing the male-female couples of the earlier scenes with Masonic fraternity—though the facts that they are aproned and transvestite, drunken and bewildered, and that an arm (which is probably female) empties a chamber pot on their heads, give the image a satiric edge. (By their enemies the Freemasons were accused of being drunkards and sodomites.) De Veil in fact formally parallels the religious *dévote* of *Morning,* suggesting that in Freemasonry he has found an escape from orthodoxy and piety, law and order, as well as marriage. A pretty young woman is present, but huddled under a bulk, too poor to afford any other shelter: one of the poor and dispossessed of whom Juvenal spoke in his third *Satire.*

Masonic signs were evident in *Noon,* where the head of John the Baptist, the patron saint of Freemasons (their annual feasts were held on St. John's Day), hung above the head of the pretty female whose act of dripping from plate to plate over a corner post resembling an altar recalls the similar group in *Strolling Actresses.* There the Diana figure gestures over an altar, assisted by two altar boys borrowed from Raphael's *Sacrifice at Lystra.* As with the group in *Noon* the ritual involves an altar, officiants, and a libation. While the actress is Diana the Huntress, her breasts are emphasized by the décolletage of her gown as the breasts of the young woman in *Noon* are by the black man's hands, and the subscription ticket of course brings back *Diana multimammia* herself. (Also present in *Strolling Actresses* are other aspects of the Diana-Isis figure, Hecate—the Queen of Night—and Flora-Ceres-Demeter, all central to the Eleusinian Mysteries and their Masonic equivalent.)[23] The ticket now serves as an emblem of male relationships centered on a woman: on the icy self-enclosed lady, the warm buxom English girl (vs. the stiff French wife), the heavy oppressive English wife (with her young imitator), the mock-women of the Masonic aprons, and the real woman, sleeping under the bulk (what at first appears to be a child in her arms is only a bundle; the man sleeping behind her—his wig awry—appears to be merely sharing the shelter).

It is not easy to judge Hogarth's attitude in the *Times of the Day* to either Freemasonry or marriage. There are no more overtly Masonic references in his work after *Night,* though its influence persists, and

there are no references to him in the minute books of the Grand Lodge after 1735. *Night* may reflect either rifts within the London lodges or Hogarth's disaffection from Freemasonry or only friendly criticism.

But it is notable that the *Times of the Day* is the first of Hogarth's works to introduce cuckoldry—to replace daughter, lover, and father with wife, lover, and husband; and to replace woman as mediator with wife as temptress, on the way to the unfaithful wife of *Marriage A-la-mode* and the *Analysis of Beauty* plates. The *Times of the Day* offers alternatives of order and anarchy specifically in terms of wifely control or husbandly escape to a Freemason's lodge, drink, and Jacobite fantasies of Restoration Day. But then Hogarth is playing with contrasts—of single and married, hot and cold, dry and wet, youth and age, outdoors and indoors, and freedom and confinement. All of this adds up to the contrast, with which we are familiar in the works of Bruegel, between the worlds of Lent and Carnival, repression and Saturnalia, but couched by Hogarth in his own terms of a progress. If the problem of *Morning* is how children and young lovers can stave off the cold, in *Evening* it is how to escape the oppressive heat of the London afternoon, of marriage, of responsibility, perhaps of maturity (with the children now doubles of their parents). And in *Night* heat has become an outlet, a form of destructiveness (of the coach, and of houses in the distance) as well as a light to guide drunken Freemasons home once again from their lodge meeting.

Following the trajectory of *Trivia* and Swift's "Description of a City Shower," the *Times of the Day* ends in fire and chaos, including an overturned coach:

> Ere Night has half roll'd round her Ebon Throne;
> In the wide gulph the shatter'd coach o'erthrown;
> Sinks with the snorting steeds; the reins are broke,
> And from the crackling Axle flies the spoke. (*Trivia*, 3.341–44)

But as the Restoration Day decorations and the bonfires show in Hogarth's scene, it is spring, and the row of pans on the barber-surgeon's sill is a reminder that bloodletting was popular as a spring tonic. Hogarth has re-created what must have been a cathected image for him: restoration of the Merry Monarch and Burning of the Rumps at Temple Bar associated with Masonic revelry.[24]

THE PAINTINGS

By this time Hogarth had reached a point where he could no longer express all that he wanted to say in his prints. This was already evident in the painting of *The Distressed Poet,* which was unquestionably more expressive than the engraving (figs. 44, 45). The stripes of the Poet's dressing gown are pink and green, and the bed darker shades of the same color, though the effect is still of cool, pale, indeterminate colors on that side of the canvas as opposed to the bright warm reds and pinks that highlight the two women. The monochromatic earth shades of the garret and the pale greens of the Poet's dressing gown (against a pink-and-green bed, blending into the neutral ground of the room) are contrasted with the blue of his wife's dress and the one spot of bright red in the milkmaid. To the extent that the bright colors are associated with the outside world from which the poet has withdrawn, the meanings of painting and print are generally parallel. Unlike the case of the *Rake* paintings, the colors do not alter but only refine upon the print's meaning: the creamy complexion and rosy cheeks of the wife—in the print she is a faded, worn creature—emphasize her Proserpina role in the Poet's garret, as her bluish dress underlines the religious allusion.

The painting of *Strolling Actresses* no longer exists, but the remarkable paintings of *The Four Times of the Day* make the engravings seem mere copies. While the engraving had to be uniformly clear, an important characteristic of the painting is the different degrees of focus, defined by highlights and details, and varying, for example, in *Morning* from a soft, almost hazy quality to the fussy treatment of the "prude's" head. In the group to her left only the lovers, whose heads are above the others and in the light, are clear—the rest remain a brown indistinguishable mass. Equally important are the pale buildings in the wintry background, the salmon-colored houses, the drab brownish groups of people, the leaden sky, and the pale snow-covered roofs; these are opposed to the color and movement around the fire, especially the bright blue lining of one girl's hat. Most interesting, in the engraving the prude who is headed past all these people is simply a cold woman going to church; the painting adds another dimension by giving her an ermine muff and pale pink apron over a champagne yellow dress with delicate sea green trimmings, and

above all, scarlet ribbons on her cap which link her with the flames of the bonfire. The engraving emphasizes the alienation of the two worlds, their utter separateness, while the painting brings out the similarities as well—suggesting an acceptance of both extremes which is perhaps not permissible in the engraving.

At this time Hogarth felt the need for color even in his prints. He introduced a reddish ink in the third plate for the wife's flushed, hot face, and blue for her husband's ink-stained hands.[25] Black and white were no longer sufficient. But in the paintings he could convey sensuous qualities, parallels and contrasts, which could not be conveyed except by colors and brushwork and a shifting focus that sharpened and softened. The result was not just a genre scene but a more complex set of relationships and judgments than were possible in the engraving; at the same time the hand of the artist maintained something of the balance Gay celebrates in *Trivia* between nature and art, a painterly equivalent of his couplets and diction. The color and texture seem to embed experience—the heterogeneity and disorder of London—in amber. One result is to draw attention to the artist's ability to endow such materials with beauty, but another is to suggest that there is a beauty and vitality inherent in even the most sordid materials.

A final word about the size of Hogarth's canvases. Despite the innovative explorations of the history painting genre, the *Times of the Day* are still 30 × 25 inches (the *Rake* canvas turned to the vertical dimension). Jack Lindsay has asked "why Hogarth did not even attempt to paint a life-size picture in his own history style?"[26] When he did paint "modern history" on a relatively large scale, as in *Southwark Fair* or *The March to Finchley* (47½ × 59½ and 40 × 52½ respectively), the scene was panoramic and the figures small. The sublime histories of St. Bartholomew's Hospital were, of course, on a vast scale, and more modest sublime histories such as *A Scene from "The Tempest"* were nevertheless larger than the "progresses" of the 1730s.

Taste in High Life, dated 1742, marks the last of the 25 × 30 inch canvases; *Marriage A-la-mode* goes up to 27½ × 35½ inches, corresponding to its higher finish and pretensions, and this canvas serves Hogarth in the 1740s for his "Happy Marriage" paintings, for a conversation picture like *Lord George Graham in His Cabin,* and, turned vertically, for his *Self-Portrait with Pug. The Gate of Calais* creeps up

to 31 × 37 inches, but even the *Election* paintings of the early 1750s are only 40 × 50 inches.

As a matter of artistic decorum, the size of *The Pool of Bethesda* was not available to Hogarth in "his own history style." But if he emphasized (as he did) the intellectual dimension of his painting, he had the precedent of the medium-sized canvases of Poussin, on which André Félibien had commented: "They offered him enough space to realize his noble conceptions, and to display, in small formats, grand and learned compositions."[27] This rationale could have served for Hogarth.

It was not history but portrait painting that led him to paint contemporaries on the scale of life. When in 1740 he undertakes a showpiece portrait—equivalent to his sublime histories in St. Bartholomew's— he paints *Captain Thomas Coram* (94 × 58) on the model of full-length Van Dyck portraits; and when he then returns to group portraits he follows this model rather than the conversation picture: the *Grey Children* of 1740 (41 × 35¼; St. Louis) is followed by the *Graham Children* (63 × 61) and *Mackinen Children* (71 × 56) in the mid-1740s.

7.

PORTRAIT PAINTING, 1738–1745

From 1731 to 1738 was an intense period of painting and engraving in the modes of comic and sublime history. Then, except for a ticket for the opera *Alfred,* there were no prints between May 1738 and the autumn of 1741 when *The Enraged Musician* was engraved, based on a very rough monochrome oil sketch. The only major engraving before *Marriage A-la-mode* (published in 1745 but not engraved by Hogarth himself) was the portrait of Martin Folkes in 1742. The explanation for the absence of engravings and history compositions between 1738 and about 1743, when the paintings of *Marriage A-la-mode* were begun, is that Hogarth was now devoting himself to portrait painting as single-mindedly as to conversation pictures in the years from 1728 to 1731 and to historical compositions from 1731 to 1738. Moreover, aside from a few major conversation pictures, the period is dominated by single portraits, which were more readily commissioned, more remunerative, and easier and quicker to paint.

The symbolic impetus for this focused activity in portrait painting appears to have been the arrival in December 1737 of Jean-Baptiste Vanloo from Paris—a man in his late fifties, "tall well shaped and of good aspect" (by which Vertue indicates the courtliness that the English had come to expect of their portraitists since the time of Van Dyck). He had painted French royalty and nobility, but after the death of his patron the Regent, and a commission lost to his brother Carle, he headed for London without, as far as Vertue could discover, any invitations or connections at the English court. He set up a studio in Henrietta Street, Covent Garden, and, as Vertue noted, "soon after being less than 3 or four months [he] had a most surprising number of people of the first Quality sat to him for their pictures" (3: 82). Hogarth's own reaction can be sensed in his friend Rouquet's account, published in 1755:

Scarce had he finished the pictures of two of his friends [Colley Cibber and Owen MacSwiney], when all London wanted to see them, and to have theirs drawn. It is impossible to conceive what a rout they make about a new painter in that great town, if he has but any share of abilities. Crowds of coaches flock'd to Mr. Vanloo's door, for several weeks after his arrival, just as they crowd the playhouse. He soon reckoned the pictures he had in hand, by hundreds, and was obliged to take five sittings a day: the man who kept the list of these sittings, was very handsomely rewarded for putting your name down before it came to your turn, which was oftentimes six weeks after you had first presented yourself to have your picture drawn.[1]

The *London Evening Post* of 16–18 February 1737/38 noted that Vanloo was "now painting in the Portrait Way most of our English Nobility" and that Amigoni was decorating the additional buildings at Greenwich Hospital—both items of more than passing interest to Hogarth. On 4 March the Prince and Princess of Wales visited Vanloo's studio, looked at his paintings, were won over, and "afterwards order'd him to prepare the Cloths for the painting their Royal Highnesses and the Princess Augusta's Pictures."[2] By April and May Vanloo was granting five sittings a day, though his likenesses were said to be natural without flattery: "the great employment in six months from his first comeing exceeds any other painter that is come to England in the memory of any one living"; and Vertue adds: "but the English painters have had great uneasiness [that] it has much blemishd their reputation—and business—" (3: 84).[3] The *London Magazine* observed that "the ridiculous imitation of the French is now become the epidemical distemper of this Kingdom . . . and what seems, at first sight, only very silly, is in truth the great national peril . . ."[4]

The French tradition reintroduced by Vanloo offered a more mobile face, one with, as David Piper has said, "a waxier *chic*, and a more minute technique in the rendering of the features than any British painter then working," which pointed toward the "two-dimensional illusion of a wax tailor's dummy."[5] Vanloo's *General Dormer* (which is still at Rousham) merely shows, as Ellis Waterhouse has observed, "the style of Richardson seasoned with a little of the high French affectation. The pose is a little less placid and easy, hands and arms make a little for elegance: draperies and the tablecloth curl into a little more Frenchified folds—and that is about the whole differ-

ence."[6] But it was just this tinge of modishness—or foreignness—
that brought him his following and that he now injected into English
portraiture. One might say that Vanloo served portraiture as Grav-
elot had the more decorative arts.

When Hogarth signed a portrait "W. Hogarth Anglus pinxit"
(1741, see fig. 77) he was reacting not only against Vanloo but against
the two hundred years in which the British had seen themselves
through the eyes of foreign portrait painters, or of British artists who
imitated them; and against the aristocratic stereotype, the elongated
bodies and faces as regularized as masks. He would have remembered
the assertion of *Spectator* No. 555 that English faces offered the great-
est potential for portrait painters and that even foreigners (Van Dyck,
Lely, Kneller) painted better portraits when they came to England.
"So that instead of going to *Italy,* or elsewhere," Mr. Spectator said,
"one that designs for Portrait Painting ought to study in England"—
as one should go to Italy to study history painting, or Holland for
drolls.

England was not, however, overly graced with good portrait
painters. Of the older generation (the "old masters" as Vertue called
them), Michael Dahl still painted a little; Jonathan Richardson, at his
best, could produce small informal faces (usually profiles) that were
close transcriptions, but in his formal portraits the precision was lost.
Though sometimes with features of a Hanoverian heaviness, the por-
traits of this period retain the slender, long Kneller shape and the
Kneller mask, and the same poverty of poses: a stiff figure holds, if
an author, a book; if a gentleman, a snuffbox; if a sculptor, calipers;
if an intellectually inclined woman, a book by Locke or Newton.

Of the younger generation John Vanderbank, who had been the
most promising of the fashionable young portraitists after Kneller's
death, had (to use Vertue's words) "blasted" his chances with his
amiable dissipation. But after clearing himself of debt in 1730, he
picked up his fashionable portrait practice again and in 1736 finished
his large full-length of Queen Caroline (Goodwood House). This
was painted for the duke of Richmond, to whom Sir Thomas Pren-
dergast wrote in recommendation of Vanderbank: "I think there is
no other in London who comes *so near* deserving the name of a
painter."[7]

Portraits by Joseph Highmore, born two years before Vanderbank
and four before Hogarth, can be dated as early as the 1720s, and a
great many have survived from 1728 on. His study of law had en-

dowed him with manners and an education, and he cultivated an aristocratic clientele. After his success in 1723 with his portrait of David Le Marchand, and Kneller's death in the same year, John Bunce wrote (in 1726):

> No more let Britain for her Kneller grieve
> In Highmore see a rising Kneller live
> Whose happy pencil claims as high a name
> If equal merit challenge equal fame.[8]

Though Highmore never achieved Kneller's or even Vanderbank's popularity, he introduced a calm realism into English portraiture that anticipated both Hogarth and Allan Ramsay.

Arthur Pond had returned from Italy in 1727 and had gained some reputation as a pastelist of faces (mostly children) as well as a virtuoso, connoisseur, and dealer; George Knapton was beginning his career as a portraitist in both crayons and oils. Thomas Hudson, first mentioned by Vertue in 1733, was just emerging; like Hogarth, he was one of the Slaughter's–St. Martin's Lane group. His earliest surviving portraits, from the 1740s, display rococo elements, and, of greatest significance, in 1740 he became Joshua Reynolds's teacher.

Shaftesbury had simply dropped portraiture from the ranks of serious art, the only exception being small likenesses to serve as mementos of friends. Otherwise, portrait painting could not, like history painting, be considered a liberal art, "as requiring no liberal knowledge, genius, education, converse, manners, moral-science, mathematics, optics, but merely practical and vulgar." Therefore it did not deserve "honour, gentility, knighthood conferred," as on Kneller.[9]

Jonathan Richardson, a portraitist himself, had attempted to raise the genre's prestige. Citing history painting as the only genre in which a painter could rival a poet, Richardson had followed the Italian Renaissance theorists, and in particular Lomazzo, in arguing for a portraiture that would act as history painting and elevate the particular individual.

> Thus to raise the character: to divest an unbred person of his rusticity, and give him something at least of a gentleman. To make one of a moderate share of good sense appear to have a competency, a wise man to be more wise, and a brave man to be more so, a modest, discreet

woman to have an air something angelical, and so of the rest; and then to add that joy, or peace of mind at least, and in such a manner as is suitable to the several characters, is absolutely necessary to a good face-painter. . . .[10]

Richardson's theory supported the practice of painting an apothecary as if he were a baronet, and his wife as if she were a king's mistress posing as a Magdalen or a St. Catherine. Hogarth may have remembered how Charles II's mistress, the duchess of Cleveland, had been painted in the pose of an erotically stimulating but dubiously repentent Magdalen (etched and transmitted to the general public by William Faithorne) as well as in the pose of St. Catherine, St. Barbara, Minerva, and others.[11]

The first real break from the Kneller pattern came in sculpture. From the point of view of the English gentlemen brought up on Richardson's treatises, the portrait was augmented if not superseded by the bust, with its echoes of antiquity, which meant much to the Englishmen who—with help from the Burlington circle—liked to think of themselves as reincarnated Romans. The Italian sculptor Giovanni Battista Guelfi had been imported for this purpose by Burlington, who then employed Michael Rysbrack when he saw that he did the job better. Rysbrack made the busts of Inigo Jones and Palladio which flank the entrance to Chiswick House, of the great men in Queen Caroline's Grotto, and of the artistic and literary bulwarks of the Burlingtonian system, Kent and Pope. Sir Robert Walpole as a Roman senator made a flattering portrait, but Rysbrack also caught a good likeness, which the portrait painters then had to live up to. By 1730 Vertue was noting that the reputation of sculpture was higher than ever before; in 1732 Rysbrack, who did more than anyone else to introduce this kind of portrait, had some sixty sitters, and by 1738 Vertue believed sculpture had made "greater advances" than painting.[12] Scheemakers's statue of Shakespeare in Westminster Abbey (1741) introduced the long series of relaxed, cross-legged figures leaning on pedestals in painted portraits.

For Hogarth the significant breakthrough was Roubiliac's full-length statue of *Handel* (fig. 34), unveiled at Vauxhall Gardens in 1738. This was a more intimate and individual portrait than the Roman senators of Rysbrack, one depicting the person himself, not the person as if he were someone else. Roubiliac caught his sitter in a

particular, literally unbuttoned moment as Hogarth had done in his conversation pictures, but he showed how this effect could be achieved with a single figure, and it is to him that Hogarth owes the comfortable pose of George Arnold or Martin Folkes. Even the liveliness of his application of paint tends to recall the sculptor's fingers in Roubiliac's terra-cottas, which are more like Hogarth's canvases than the finished marbles. The advent of Vanloo may have been only the excuse for Hogarth's entry into portrait painting.

CAPTAIN THOMAS CORAM

It can be no coincidence that he began to rethink portraiture just after the unveiling of Roubiliac's *Handel,* which was on continuous public display at Vauxhall—and so served as both inspiration and context for his portrait of Captain Thomas Coram (figs. 63, 64), which is the same sort of portrait, given the difference in media and professions. It is, in the same sense as the *Handel,* sculptured, and quite a different object from those stiff painted icons of Vanderbank and other contemporary portraitists. The words Margaret Whinney applies to Handel—"at once novel, informal, and topical"[13]—explain the popularity of Hogarth's early work as well. Hogarth also contrived to have his *Coram* hung on permanent exhibition in a public building.

The influence of Roubiliac is striking if *Coram* is compared with Hogarth's earlier single portraits. As early as 1730/31 (as recorded in his list of work at that time unfinished) he was painting a full-length of Sir Robert Pye, but it is small and doll-like on the scale of the conversation pictures. The full-length portrait called *Gentleman in Blue* produces the same effect, as do the standing portraits of Harriet, Lady Byron, and Gustavus Hamilton, Viscount Boyne (fig. 61).[14] Only *The Duke of Cumberland* (fig. 3) of about 1732 begins to approximate the *Coram* in its use of the picture space. It represents the young duke as he extends his hat in salute during his favorite exercise in the garden of St. James's Palace; as contrast, a full-grown grenadier stands in the background. The effect is of a fragmentary conversation picture.[15] Hogarth's experimenting was confined to such genre pieces as *Sarah Malcolm* (fig. 6). Verses "To Mr. *Hogarth* on Miss F——'s Picture," published in *The Bee,* 18–25 May 1734, evoke a single por-

trait, which may be one of those said to be of Lavinia Fenton.[16] The transitional portraits are of friends: a seated full-length of Dr. Benjamin Hoadly in 1737 or 1738 (fig. 62) was followed by a pair of his father, Bishop Hoadly (fig. 67), and Mrs. Hoadly. The latter suggest a conversation picture divided into two panels. Hogarth was no doubt aware that his strength lay in relating two or more figures, and that single portraits gave no scope to his particular talents.

The portraits of his wife (35½ × 27½ inches, ill., vol. 1) and his mother (50 × 40 inches, fig. 29)—the latter must be dated before 1740—were growing in size, but it is understandable that he remembered Coram as his first substantial portrait.[17] Measuring 94 × 58 inches, it shows (indeed displays) a decidedly plebeian man raised by his own moral strength to authentic greatness. Hogarth has painted him almost of a size with the figures of the St. Bartholomew's paintings, and given him a beaming face, full of self-confidence and good nature—the "cheerfulness, frankness, warmth, affection and great simplicity of manners" noted by his friend Dr. John Brocklesby.[18] His body appears to be about to move vigorously forward, perhaps because of the fluttering motions made by his great red coat. The seal attached to the royal charter of the Foundling Hospital is firmly grasped in one hand, a symbol of his own accomplishment, as is the globe, turned to show England and New England linked by the Atlantic Ocean (he made his fortune by trading across that body of water), and the prospect of the sea studded with sailing ships. The viewer looks up at Coram—is forced to by the angle of vision—but there are no falsely aristocratic features, and instead of robes of state only a coarse coat.

While *Coram* is best understood as a painted version of Roubiliac's *Handel,* the relationship between figure and picture space, as well as the conventional pillar and draperies, may inevitably recall inflated French portraits such as Hyacinthe Rigaud's *Samuel Bernard* (engraved by Drevet, 1729, fig. 65). The French portrait, however, is recast in terms of a British, significantly by Sir James Thornhill: his *Sir Christopher Wren* (1707, designed by Verrio and carried out in collaboration with Kneller; Sheldonian Theatre), or—without the accessories—*Sir Isaac Newton* (1710, Trinity College, Cambridge). This would be another sign that the arrival of Vanloo, and its effect, and then Roubiliac's *Handel,* had caused Hogarth to begin painting in a more tendentious way—enlarging the scale, as he had his history paintings, and invoking an English predecessor (and kinsman).

In writing, looking back from the 1760s, he expressed a view of portrait painting as uncompromising as Shaftesbury's. He sees no difference between the majority of examples of this genre and still-life painting, to which he more than once compares it. He uses the example of the crucifix maker who all his life had made nothing but crucifixes and so, without genius, grew to make them tolerably well (AN, 214). This mediocrity he considers essential to success in portraiture, where either imagination or "nature" might alienate the artist from his public. Here was the situation he himself had come to distrust and avoid: the third man, the sitter, with his self-interest and pride, interposing between the artist and the ordinary viewer, and behind (almost coinciding with) the sitter the Richardsonian connoisseur or Man of Taste who determined his taste.

"Portrait Painting," he wrote, "tho a branch that depends chiefly on much practice and an exact Eye as is plain by men of very middling natural parts having been at the utmost heights of it, hath always been engrossed by a very few Monopolisers whilst many others in a superior way more deserving both as men and artists are everywhere neglected and some starving." Although he must include English artists as "Monopolisers," he makes clear who he intends in this instance: "Vanloo, a French portrait painter, being told by friends that the English are to be run away with, with his grandeur and puffing monopolised all the people of fashion in the kingdom. Down went at once —— & —— & —— men then in vogue, even into the utmost distress and poverty." At least one of the blank spaces can be filled in, with Vanderbank's name; Vanloo's popularity cut into his trade, and the last year or so of his life saw him paying his landlord with paintings of Don Quixote. When he died on 23 December 1739, at forty-five, he was again penniless, and everything in his studio was seized by his landlord.[19] Other portraitists probably suffered too. It was at this time that Mercier left London for York to seek a new clientele. One can imagine the indignation of the author of the "Britophil" essay as he goes on to write:

> This Monopoly was agravated by being by a foreigner. I exhorted the painters to bear up against this torrent and to oppose him with spirit—my studies being in another way. I spent my own in their behalf, which gave me enemies among his espousers, but I was answered by [the English painters] themselves: "You talk, why don't you do it yourself?" Provoked at this, I set about this mighty portrait, and found it no more difficult than I thought it. (AN, 217).

"This mighty portrait" sounds as if he means, or wants the reader to think, that he set to work at once on the major portrait he shortly discusses, *Captain Thomas Coram*. He recalls that

> upon one day at the academy in St. Martin's Lane I put this question, if any at this time was to paint a portrait as well as Van Dyck would it be seen and the person enjoy the benefit? They knew I had said I could. The answer made by Mr. [Allan] Ramsay was positively No, and confirmed by about twenty who were present. The reason then given very frankly by Mr. R: "Our opinions must be consulted and we will never allow it."
>
> Upon which I resolved if I did do the thing, I would affirm I had done it. I found my advantage in this way of doing myself justice, reconciling this violence to my own modesty by saying Vanity consists chiefly in fancying one doth better than one does. If a man think he does no more than he doth do, he must know it, and if he says it in this art as a watchmaker may say, "The watch I have made I'll warrant you is as good as any other man can make you," and if it really is so the watchmaker is not branded as infamous but on the contrary is esteemed as an honest man who is as good as his word. (AN, 217–18)

Earlier we cited the story in which Dr. Freke—whom Hogarth has just criticized for ranking the English composer Maurice Greene as high as Handel—is then quoted as declaring that Hogarth was "as good a Portrait-painter as Vandyck"; to which Hogarth responds that there he was in the right: "and so by G—I am, give me my time, and let me choose my subject" (above, 63). By his "subject" Hogarth meant someone like Coram. He emphasizes, in the "Autobiographical Notes," the primacy of the Coram portrait: that he did it first, as a test, and "without the practice of having done thousands, which every other face painter has before he arrives at doing as well" (AN, 218). While for propaganda purposes it was appropriate that the Coram portrait should be his first as well as most famous one, there is a certain poetic truth in the assertion. Vertue makes no mention of Hogarth's portraiture of these years until at the beginning of 1741 he comments on "a picture at whole length of Mr Coram. the old Gent that proposd, & projector first of the hospital for foundlings-this was done and presented to the hospital by Mr. Hogarth. and is thought to be very well. this," Vertue adds (3: 102), "is *another* of his efforts to raise his reputation in the portrait way from the life" (emphasis

added). It was his first public portrait, his first portrait on a large scale and with a monumental composition that consciously invited comparison with Van Dyck (and, it would seem, closer to home, Thornhill).

ALLAN RAMSAY

The "Mr. Ramsay" in Hogarth's account of how he came to paint *Coram* was Allan Ramsay, the young son of Hogarth's old Scottish friend Allan Ramsay the poet. It is not surprising that writing in the 1760s, when Ramsay held a monopoly on royal portraits, Hogarth should locate the beginning of his portrait of Coram in a conversation with him. Vanloo had arrived in December 1737; then in August the young Ramsay, just back from Italy, set up in the Great Piazza, Covent Garden, as a portrait painter, and by the 22nd his father was writing to a friend: "I hear from my son that he is going on well in his business; he gets eight guineas a head," which was 3 guineas more than Reynolds charged when he first arrived in London fifteen years later. (Kneller had 15 guineas for a head, 20 if one hand was shown, 30 for a half-length, and 60 for a whole-length.) [20] In short, he arrived, with Italian training, just when the fashion for portraits was at its peak, immediately established a successful practice, and joined the St. Martin's Lane Academy, where he and his father's friend clashed.

Ramsay, according to Alastair Smart, wished "to be considered a man of reason who knew how to exercise a rigid control over his emotions. His temperament is mirrored in his portraiture, which is serene, urbane, altogether charming, but lacking in much passion. His was the antithesis of the rugged, untutored genius of his father, the poet." [21] The antithesis could apply equally well to Hogarth's temperament, and Ramsay's puzzlement over the phenomenon of his father—"one of the extraordinary instances of the power of uncultivated genius" [22]—might also sum up his attitude toward Hogarth. Allan Ramsay Sr. was a small, round, dark man (his son inherited his dark complexion and hair), whose pride in his "uncultivated genius" was large and ingenuous—he called himself one of "the world's wonders." Allan Jr. (b. 1713) would have seen Hogarth's prints in his father's shop, and at the impressionable age of nineteen would have

encountered the *Harlot's Progress*. He never lost his admiration for
these works. At twenty he arrived in London (1734) and lodged in
the house of Mistress Ross in Orange Court, Leicester Fields, so
close to Hogarth that one wonders if Ramsay Sr. had written him
about a place for his son to rent. Young Ramsay studied under Hans
Hysing, but he is also thought to have attended the St. Martin's Lane
Academy, and certainly came into contact with that other "vain little
man" who was beginning to think himself one of "the world's
wonders."[23]

He was in London only a few months, and returned to Edinburgh.
In May 1736 he was back in London ready to make the Grand Tour,
and on 24 July he and Dr. Alexander Cunyngham left on the Dover
coach. In Italy he studied with Francesco Solimena and learned from
Benedetto Luti the method of first modeling the head in red, which
Vertue commented on with annoyance within a few months of Ram-
say's return, but which apparently attracted commissions. He built
up the head entirely of vermilion, then superimposed glazes and
body color, which lent transparency to the flesh tints and kept the
shadows soft and unobtrusive.[24] His first paintings on his return are
in the "licked" Italian style, and when he wrote to Cunyngham in
April 1740 that "I have put all your Vanloos and Soldis and Roscos
[i.e., Ruscas] to flight, and now play the first fiddle myself," it is
significant that he never thought to mention an English name.[25]
Not only did he apparently not consider other native artists as com-
petition, but his style was intended to invite comparison with the
Continentals, not with the English, for whom Vertue was speak-
ing when he accused Ramsay's portraits of being "rather lick't than
pencilled . . . neither broad, grand nor free."

But Ramsay was not just the Italianate opponent; his style con-
veyed an intimate realism, and he possessed a remarkable ability to
catch a likeness. Led by Ramsay, the new generation produced a kind
of portrait that allowed for a good likeness, which effectively broke
the Kneller mask but kept the aristocratic formality intact. After
completing the face, the painter sent the canvas to Joseph van Aken
to fill in the fashionable body, costume, and stage props.[26] Vertue
attributed much of Ramsay's success to his drapery painter, and, in-
deed, in much of his work before van Aken's death in 1749 (and this
included the great full-lengths of *Dr. Mead* (fig. 66) and *The Chief
of Macleod*), Ramsay painted only the head and worked out the com-

position, and van Aken filled in the rest—thus adding another desirable attribute to Ramsay's portraits, for van Aken was a genius at rendering silks and satins.[27] Added to Ramsay's Italianism, van Aken, and the red underpainting, was the assistance he received upon his arrival from the Scottish colony in London—always a cause for annoyance among the English, to reach crisis proportions under the Bute ministry.[28] Ramsay very soon had collected more fashionable sitters than Hogarth ever painted: the dukes of Argyle and Roxburghe, and the earls of Coventry, Stair, and Haddington.

Most of Vertue's derogatory opinions of Ramsay would have found an echo in Hogarth, who, whatever his feelings about Scotland, followed the "broken" brushwork of the Kneller tradition and refers to Ramsay in one of his notes as another "face painter from abroad" who succeeded "by some new strategem of painting a face all red or all blue or all purple at the first sitting" and by securing "one of the painter taylors" (drapery painters). Hogarth, Highmore, and a few others refused to turn out factory products, and as far as Hogarth was concerned a painter who did was not a true artist. The view of many contemporaries, however, was probably summed up by Northcote (no doubt echoing Reynolds): "The genius of Hogarth was too great, and his public employment too little, to require the assistance of a drapery painter, therefore he might safely point his satire at those who did."[29]

It is probable that, whether or not Hogarth remembers the sequence correctly, his boast did in fact receive the negative response he records from Ramsay—and the boast may have been directed at Ramsay in the first place. He saw Ramsay, at any rate, as a symbolic opponent. Hogarth's confidence in his performance, reflected in his own memory of his boast at the academy, must have spilled over into conversations; or perhaps the St. Martin's Lane artists had begun to make jokes about this "uncultivated genius."

It would be interesting to know whether this scene preceded or followed Hogarth's first connection with the Foundling Hospital, or whether having associated himself with Coram for philanthropic purposes it occurred to him that here was the place for a great English portrait to be publicly exhibited in perpetuity (see Chap. 13).

Whatever the exact chronology, on 17 October 1739 Hogarth appears on the *Charter for Incorporating the Society of the Foundling Hospital* as a governor, and on 14 May 1740, seven months after the

granting of the charter, at the Annual Court of Governors, Martin Folkes, a vice president of the hospital (whom Hogarth also painted), "acquainted the Governors That Mr. Hogarth had presented to them a whole length Picture of Mr Coram for this Corporation to keep in Memory of the said Mr Coram's having Solicited, and Obtained His Majesty's Royal Charter for this Charity." The corporation voted its thanks to Hogarth.[30]

After his *Captain Coram,* Hogarth received no flood of commissions for similar full-scale portraits. As with his sublime histories, his great portrait remained a gift to a public building, an impressive display, while commissions went to Ramsay, Hudson, and others. To understand the effect of his *Coram*—what Waterhouse has called his "heroic middle-class art"—we must compare it with Ramsay's full-length portraits of the period— *Viscount Deerhurst* and *The Hon. John Bulkeley Coventry*—which established his reputation, and his monumental *Dr. Richard Mead* of 1747 (fig. 66), which he presented to the Foundling Hospital.[31] It is evident from the dates and from the story Hogarth recalled that he and Ramsay considered each other rivals. Ramsay's *Mead* turns the rich physician into Rigaud's Louis XIV himself. It is not surprising to learn that Mead took a strong interest in the status of physicians, and wrote an essay demonstrating that in antiquity physicians were not, as was commonly thought, slaves but respected citizens held in high regard. Such sitters as Dr. Mead would have preferred the great Reynolds portraits of the 1750s and 1760s, which attempted to materialize Richardson's program by making the English sitter as far as possible into a Titian monarch or merchant prince or princess, or even a Juno or Jupiter out of the School of Bologna.

The alternative, Hogarth's way, was to paint a sprightly, cheerful rather than dignified likeness and juxtapose this with the trappings of a Juno or Jupiter, keeping them separate (most effectively carried out, of course, in a conversation picture). Coram is a man whose discontinuity with his costume and office designates his personal greatness, which transcends them and is so concentrated as to exist outside the need of a role. He stands out from his setting, and his clothing hangs about him with an independent life, part of the separating process that applies to almost every object in the painting. Too much may depend on these symbolic attributes (however probable), and the involved pattern of light and shade which worked so well in

the storytelling histories may distract in a portrait where a single effect is required.

Hogarth's evident need to fiddle with his pictures, his unwillingness to let them leave his studio, and his occasional requests for their return while he made further changes may also have deterred the more fashionable clientele. Further, the determined straightforwardness of his portraiture was reflected in his studio habits; later stories describe his impatience with long sittings and the baiting to which he sometimes treated his sitters. He stressed integrity in every aspect of his life. The Reverend William Cole provides a glimpse of the household in 1736 when he was sitting for the Western family group. "When I sat to him, near fifty years ago," Cole recalled for John Nichols,

> the custom of giving vails to servants was not discontinued. On my taking leave of our Painter at the door, and his servant's opening it or the coachdoor, I cannot tell which, I offered him a small gratuity; but the man very politely refused it, telling me it would be as much as the loss of his place if his master knew it. This was so uncommon, and so liberal in a man of Mr. Hogarth's profession at that time of day, that it much struck me, as nothing of the sort had happened to me before.[32]

Hogarth's prices have not survived from this period, but one may be sure (judging by his later prices as well as by his temperament) that they were at least 8 guineas a head, or equal to Ramsay's and his other competitors'. On 7 November 1741 Lady Anne Cust wrote her son Sir John, who had approached Hogarth about a portrait group of Lady Cust and all her sons and daughters: "As Mʳ Hogarth persists in his price I desire you will talk with Zeeman or some other painter."[33] Between 1740 and 1745 Hogarth produced some sixty single portraits, averaging ten portraits (or 80 guineas) a year—not many for a professional portraitist.

Aside from the portrait of Archbishop Herring a few years later, his commissions for relatively ambitious works came from friends like the Hugginses and Hoadlys. It is never really certain whether the painting or the friendship came first, but with these patrons both pertained: apparently the sort of man who liked Hogarth would like his paintings. They were an odd lot; only a few of them are relevant at this point, and the others will be described later. Some, like Hor-

ace Walpole, never deigned to seek a portrait of themselves, collecting only what they considered his drolls.[34]

THE HOADLYS

The family that received the greatest benefits from Hogarth as portraitist was the Hoadlys. Hogarth may have first known Sarah Curtis Hoadly (d. 1743), who had been a portrait painter of some reputation (a pupil of Mary Beale) before her marriage to the future bishop. Her collection of paintings and her own works may have encouraged the artistic inclinations of her sons. He knew young Benjamin (1706–1757) in the early 1730s when he painted the Betts family, into which Benjamin had married: a physician who wrote plays, a fat, jovial, and learned man who later polished Hogarth's prose in *The Analysis of Beauty*. The second brother, John (1711–1776), another dramatist and a poet to boot, was a friend by 1734 at the latest, when he composed the verses that accompanied the *Rake's Progress*. Something of their relationship can be seen from a letter John wrote to Hogarth, undated but probably from the late 1740s, from Old Alresford:

> Dear Billy
> You were so kind as to say you wou'd touch up the Doctor [Hogarth's portrait of John's brother Benjamin], if I wou'd send it to town. Lo! it is here.—I am at Alresford for a day or to, to sheer my Flock & to feed 'em (money you know is the sinews of War,) and having this Morning taken down all my Pictures, in Order to have my Room painted, I thought I might as well pack up Dr Benjamin, & send him packing to London. My love to him, & desire him, when his Wife says he looks charmingly, to drive immediately to Leicester Fields (Square, I mean, I beg your pardon) & sit an Hour or two, or three, in your Painting Room. Do not set it by, and forget it now, don't you. My humble Service waits upon Mrs Hogarth, & all good Wishes upon your Honour; and
>
> <div align="right">I am, dear Sir,
your oblig'd and affectionate
J. Hoadly.[35]</div>

The reference to "an Hour or two, or three" is presumably to Hogarth's reputation for long and arduous sittings. The head-and-

shoulders portrait of Dr. Benjamin, now in the collection of Lord Mackintosh of Halifax (rather than the National Gallery of Ireland version, fig. 69), was pendant to the one of John (fig. 70): both are in ovals and would have hung facing each other.

About 1738 Hogarth painted a full-length seated portrait of Dr. Benjamin (fig. 62), a small transitional work, shortly to be expanded into the life-size *Coram*. The accessory here is Rysbrack's bust of Newton. Given the fact that Hogarth owned a cast of this bust, we might infer that Benjamin is sitting in Hogarth's painting room or parlor.[36]

Bishop Hoadly (1676–1761), Deist-Latitudinarian in theology, Hanovernian Whig in politics, and sybarite in lifestyle, had risen from one bishopric to another: from Bangor to Hereford (ca. £1200, to which was added the rectory of Streatham); to Salisbury (£3000); in 1734, with the friendship of Lord Hervey (whose daughter he baptized in March)[37] and Queen Caroline, to Winchester (£5000); and in 1740, to the Chaplaincy of the Garter. He lived well, kept a good table, and treated his friends with pomp and generosity.[38] As a host he was the opposite of Pope's Timon: in Winchester House, Chelsea, as his chaplain Edmund Pyle commented, "Such easiness, such plenty, & treatment so liberal, was never my lot before. . . . The danger I apprehend most is from the table, which is both plentiful and elegant." He adds that for every two dishes to which he was accustomed, Hoadly served ten.[39] This was the man praised by Fielding in his poem "Of True Greatness" as blazing with true greatness "'mid divines," in *Joseph Andrews* as writing "with the Pen of an Angel," and in *Tom Jones* as having a "great Reputation" in divinity.[40]

On the other hand, he was notorious (at least according to Opposition pamphlets) as an absentee bishop, who because of his badly crippled legs could not carry on his duties, could hardly even preach a sermon, but continued to enjoy all the perquisites of profitable offices while residing comfortably in London. He lived by his pen, serving the monarch less as a propagandist of the Walpole ministry than (starting with his first great fame in the Bangorian Controversy of 1716) an advocate of royal power over ecclesiastical.

He took care of his sons as well as Huggins *père* (or Sir Robert Walpole) did his. For example, John, having finished his verses for the *Rake* and attempting some unsuccessful plays,[41] was appointed chancellor of the diocese of Winchester (of which his father had just become bishop) on 29 November 1735, and the bishop ordained him

deacon and priest on 7 and 21 December. On the 26th he was appointed chaplain in the household of the Prince of Wales. In 1737 he was made rector of Mitchelmersh, vicar of Wroughton, rector of Alresford, and a prebendary of Winchester. In 1743 he became rector of St. Mary's, near Southampton, and in 1746 vicar of Overton. All of these, except Wroughton, were obtained by the gift of the bishop his father, and he held all of them simultaneously, with a number of others added in the 1750s. As he wrote to Hogarth: "I am at Alresford for a Day or two, to sheer my Flock & to feed 'em."

Whether one views Bishop Hoadly as a typical place-hunting clergyman of his time or as an important and thoughtful Latitudinarian theologian who overcame crippling physical handicaps and saw that his contribution lay with his pen, one need not doubt that he was a good husband, father, and friend. Aside from his valuable connections with Lord Hervey and others, he seems to have represented to Hogarth a sympathetic position on religion. Hogarth had invoked Hoadly's mentor Samuel Clarke in one version of *Harlot* 2, and probably his theology as well.

In his first portrait of the bishop (ca. 1738, fig. 67, half of the pair of Bishop and Mrs. Hoadly—both paintings, Huntington Art Gallery), Hogarth is dealing with a figure of ecclesiastic importance, but he maintains a tension between the office and the man.[42] One hand rests lightly on the robe-covered arm of his chair, the other as lightly handles his mortarboard; on him hang his robes and his garter insignia, and in the distance is the tower of Windsor Castle, the authority in relation to which he bears these signs of office. There is no sense of pride in Hoadly; rather, he epitomizes the frail mortal in a position of power, whose authority derives from his robes and other accouterments. (Coram, by contrast, has the seal attached to the royal charter of the Foundling Hospital firmly grasped in one hand.)

Shortly after the portrait of Coram Hogarth undertook a similarly monumental portrait of Hoadly (fig. 68).[43] He cut down the earlier seated portrait to a large torso that almost fills the picture space; he raises the hand in a blessing and replaces Windsor Castle in the distance with, appearing behind a drawn curtain, a stained-glass window. Two figures appear in the stained glass: St. Paul indicates Hoadly's strongly Pauline theology, and a crowned angel holds the arms of the see of Winchester, below which is a shield with the royal coat of arms.

Hogarth evidently painted with an engraving as the end product:

Hoadly raises his *left* hand in blessing. This would suggest that Hogarth had intended to engrave it himself; in fact Bernard Baron engraved it and—being a professional reproductive engraver—without reversal, promulgating the left-handed blessing. This engraving, published in July 1743, was included in Hogarth's folios—a significant fact. Along with *Martin Folkes* (fig. 76) and *Garrick as Richard III* (fig. 103), it was the only nonsatiric portrait so honored.[44] Like the pug of the frontispiece self-portrait, these portraits indicated aspects of himself that Hogarth wanted authorized. Folkes symbolized the empiricism of the Royal Society and the fraternity of Freemasonry, Garrick the naturalism of his revolutionary acting style. Hoadly stood for a liberal, anticlerical (erastian) theology. The striking omission is the portrait of Coram (which was engraved in mezzotint by James McCardell, published in 1749).

The *Hoadly* painting is a masterpiece. Hoadly's body looms up, one hand raised, the face both hideous and moving, surrounded by billowing robes. It is a great and problematic ecclesiastical portrait—as if a Velásquez dwarf were dressed in the robes of his royal master; but it is hardly, as G. R. Cragg has called it, "perhaps the most savage indictment of the eighteenth-century Church. . . . 'The lust of the flesh, the lust of the eyes, and the pride of life' have seldom been depicted with such merciless candour."[45] Hogarth illustrates Hoadly's physical pain, his mortality, as much as his worldliness. The portrait's power derives from the conflict between the frail human being and the robes of state in as incongruous a juxtaposition as Hogarth employed in *Strolling Actresses* (fig. 53) and later in *The Bench* (ill., vol. 3): it could almost be said to dramatize Hoadly's own views about the absolute lack of authority in churchmen—his anticlericalism which it is clear he shared with Hogarth. (It is just possible that Hogarth intended the left-handed blessing as an ironic commentary.)[46]

Hogarth's most interesting, certainly haunting, portraits are those in which the unity of man-office-garb has broken down in a frail human being, a mere vessel of God surrounded with the robes of authority. Selfhood is feigned or borrowed, or the man and his office are discontinuous: the conversation gesture of connection and its tension of unity and fragmentation remain implicit in Hoadly's left-handed blessing. It was therefore James Quin or David Garrick the actors, or the Graham or Mackinen children who are feigning grown-up roles, whom Hogarth preferred to paint.

In 1740 Hogarth painted Benjamin's and in 1741 John Hoadly's heads (figs. 60, 70), and before he was done he had painted at least one more of each brother and of Benjamin's wife.[47] The brothers are shown in simple head-and-shoulder portraits, clearly though sympathetically drawn, and for the full effect they should be hung next to the Bishop Hoadly in the Tate: against that tough old man they have gone to a fat and delicate softness.

England was full of Hoadlys in the mid-eighteenth century, and it is a pity that so few of them went to Hogarth for portraits. One can see, however, why they did not: few could duplicate the Hugginses and the Hoadlys in their unique combination of a self-aware second generation and a strong-willed elder who in some sense saw himself whole, weakness and all, and was proud of what he had accomplished nevertheless.

The characteristic Hogarth portrait is not, however, the impressive *Coram* or the unnerving *Hoadly* but the pair of George and Frances Arnold (ca. 1740, figs. 71, 72).[48] Like none of the earlier paintings, these heads and shoulders completely fill and dominate the picture space with a unity and concentration Hogarth had consciously avoided in paintings whose subject was disunity and whose reading structure required multiple, often conflicting, gestalts. George Arnold is all of a piece, unitary and unfragmented and unambiguous, a person whose glance cannot be avoided nor broken once taken up. Like Coram, he is all himself and nothing else; whereas Frances, deprived of the pendant, is incomplete, undefined except in relation to this powerful father.

Something can perhaps be made of Hogarth's pendant portraits, usually father and son or daughter, which are in psychological effect two heads from a conversation picture. It is almost as if he required the two generations for his portraits to take on some of the life and significance his history paintings—or his earlier conversations—possessed. One of the developments of the later 1730s was the departure from the conversation to the set of portraits in which Hogarth explores the family relationships that interested him but would have been impossible or dangerous to depict in a conversation.

Young Huggins, who already owned two of his most important paintings, commissioned (some dozen years apart) two circular heads, father and son, which are utterly truthful: the tough old father and the weak-jawed, flabby son, recipient of his father's ill-gotten

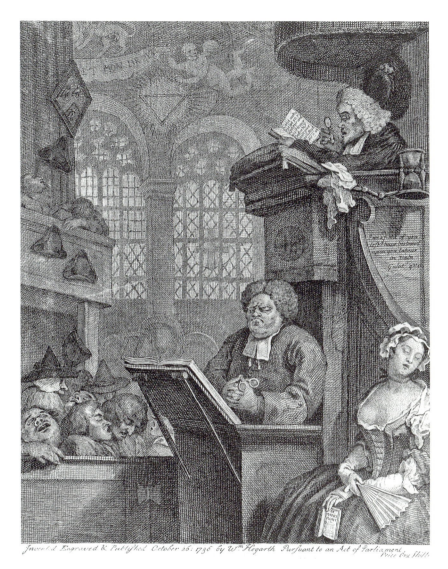

40. *The Sleeping Congregation* (third state); 1736; 10 × 7⅞ in. (courtesy of the British Museum, London).

41. *A Scene from "The Tempest"*; painting; ca. 1735–1738?; 31½ × 40 in. (The St. Oswald Collection, Nostell Priory).

42. *Satan, Sin, and Death;* painting; ca. 1735–1738?; 24⅜ × 29⅜ in. (Tate Gallery, London).

43. Louis Cheron, *Satan, Sin, and Death;* engraving, illustrating Milton, *Poetical Works*, 1718.

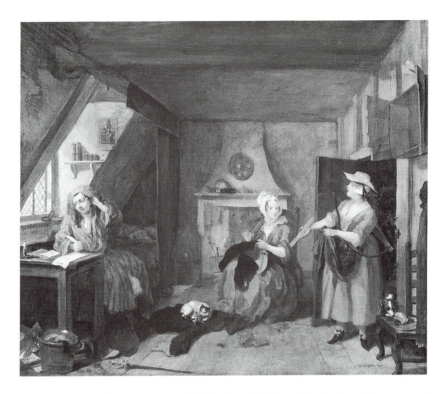

44. *The Distressed Poet;* painting; 1736; 25 × 30⅞ in. (Birmingham Museum and Art Gallery).

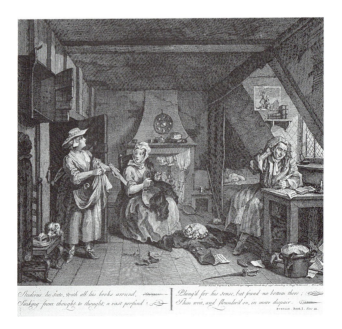

45. *The Distressed Poet;* engraving, second state; Mar. 1736/37; 12⅞ × 15⁵⁄₁₆ in. (courtesy of the British Museum, London).

46. Anonymous artist, *Pope Alexander;* engraving (courtesy of the British Museum, London).

47. Detail of fig. 45 (Pope thrashing Curll).

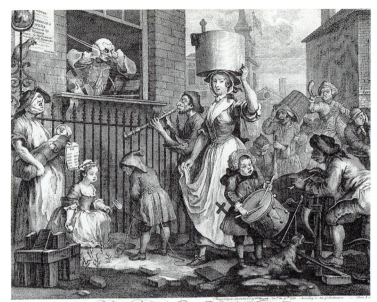

THE ENRAGED MUSICIAN.

48. *The Enraged Musician* (third state); Nov. 1741; 13¹⁄₁₆ × 15¹¹⁄₁₆ in. (courtesy of the British Museum, London).

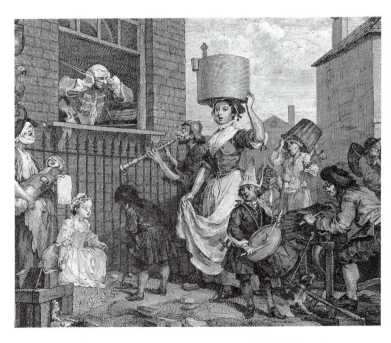

49. *The Enraged Musician;* trial proof (Chiswick Public Library).

50. *The Shrimp Girl*; painting; 1740s?; 25 × 20¾ in. (National Gallery, London).

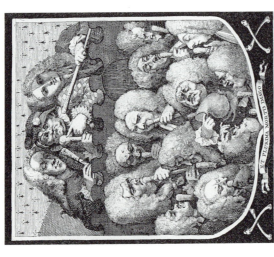

52. *Boys Peeping at Nature* (third state); 1737; 3½ × 4¾ in. (5¹⁵⁄₁₆ × 5 in.); (courtesy of the British Museum, London).

51. *The Company of Undertakers* (second state); Mar. 1736/37; 8⅝ × 7 in. (courtesy of the British Museum, London).

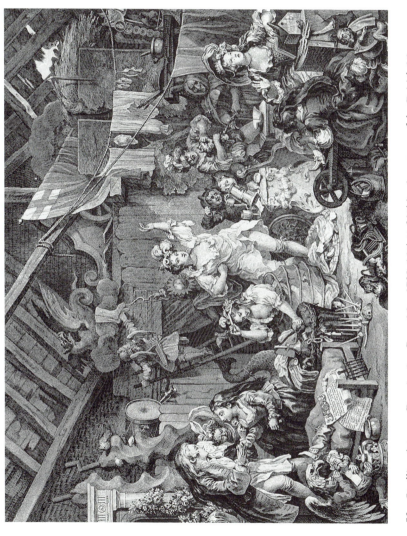

53. *Strolling Actresses Dressing in a Barn*; May 1738; 16¾ × 21¼ in. (courtesy of the British Museum, London).

MORNING

54. *The Four Times of the Day: Morning;* May 1738; 17⅞ × 14¹⁵⁄₁₆ in. (courtesy of the British Museum, London).

55. *The Four Times of the Day: Noon;* 17¾ × 15 in. (courtesy of the British Museum, London).

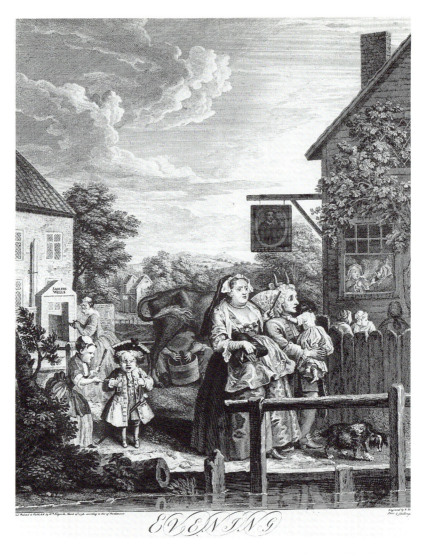

56. *The Four Times of the Day: Evening* (second state); 17⅞ × 14¾ in. (courtesy of the British Museum, London).

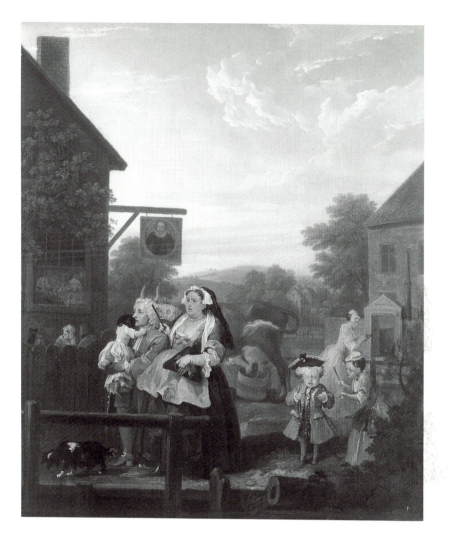

57. *The Four Times of the Day: Evening;* painting; 29½ × 24½ in. (the Right Hon. the Earl of Ancaster).

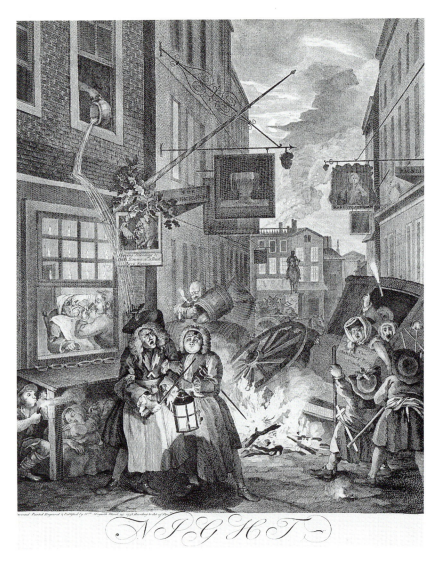

58. *The Four Times of the Day: Night;* 17⅝ × 14½ in. (courtesy of the British Museum, London).

59. Dirck Barendtsz, *Times of the Day: Morning;* engraving by Jan Sadeler; 1582 (courtesy of the British Museum, London).

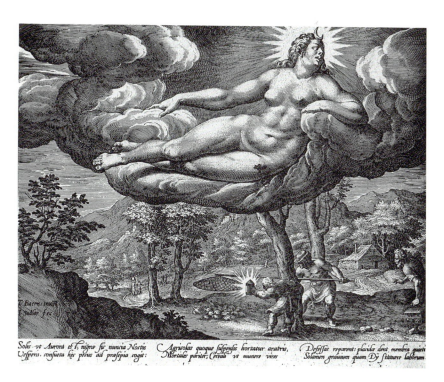

60. Barendtsz, *Times of the Day: Evening;* engraving by Jan Sadeler (courtesy of the British Museum, London).

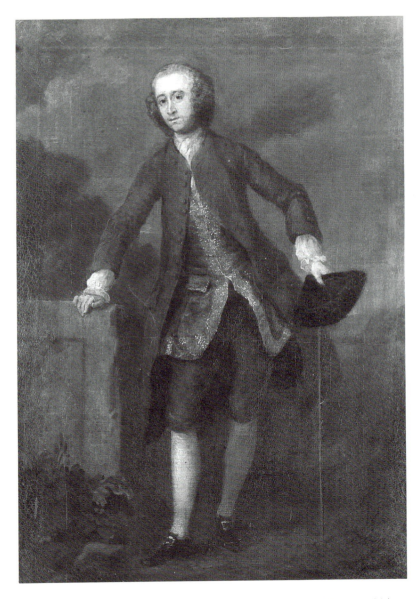

61. *Gustavus Hamilton, second Viscount Boyne;* painting; ca. 1735; 22 × 16 in.
(from the collection of Lord Boyne).

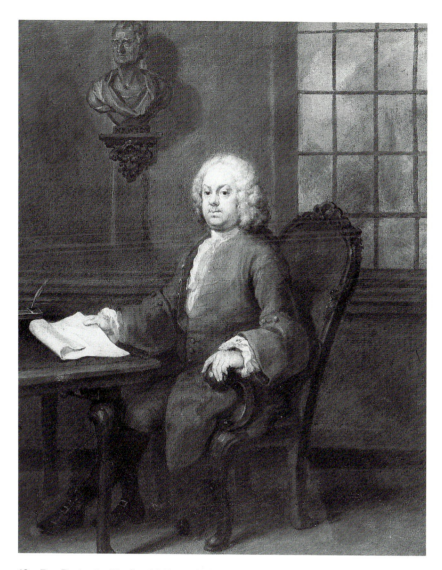

62. *Dr. Benjamin Hoadly, M.D.;* painting; ca. 1738; 22¾ × 18¼ in. (Fitzwilliam Museum, Cambridge).

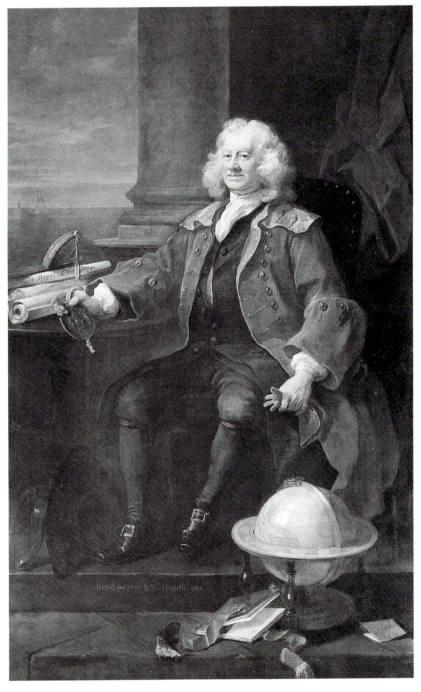

63. *Captain Thomas Coram;* painting; 1740; 94 × 58 in. (from the collection of the Thomas Coram Foundation, London).

64. Detail of fig. 63.

65. Hyacinthe Rigaud, *Samuel Bernard* (engraving by P. Drevet); 1729 (courtesy of the British Museum, London).

66. Allan Ramsay, *Dr. Richard Mead;*
painting; 1747 (from the collection
of the Thomas Coram Foundation,
London).

67. *Benjamin Hoadly, Bish-
op of Winchester;* painting;
ca. 1738; 24 × 19 in.
(The Henry E. Huntington
Library and Art Gallery).

68. *Benjamin Hoadly, Bishop of Winchester;* painting; 1741; 49½ × 39½ in. (Tate Gallery, London).

69. *Dr. Benjamin Hoadly;*
painting; 1740; 29 × 25 in.
(National Gallery of Ireland,
Dublin).

70. *The Rev. John Hoadly,
Chancellor of Winchester;* paint-
ing; 1741; 29⅞ × 25 in. (Smith
College Museum of Art,
Northampton, Mass.).

71. *George Arnold;* painting; ca. 1740; 35 × 27 in.
(Fitzwilliam Museum, Cambridge).

72. *Miss Frances Arnold;* painting; ca. 1740; 35 ×
27 in. (Fitzwilliam Museum, Cambridge).

73. *Mary Hogarth;* painting; late 1730s; 18¾ × 16¼ in. (Columbus Museum of Art, Ohio, Museum Purchase: Howald Fund).

74. *Anne Hogarth;* painting; late 1730s; 18¼ × 16 in. (Columbus Museum of Art, Ohio, Museum Purchase: Howald Fund).

be varnished, but they were, repeatedly, after his death.) On 17 May 1754 it was "Ordered that an Inscription be set up in some part of the Painted Staircase leading to the Court Room, Setting forth that the two Capital Pieces of Painting were painted & given by Mr William Hogarth, & all the Ornamental Painting there was done at his Expense." The inscription is over the door leading to the court room, a single line: "The Historical Paintings of this Staircase were painted and given by Mr. William Hogarth and the ornamental paintings at his Expense, A.D. 1736."

Hogarth now had large sublime history paintings on permanent public exhibition, as accessible as Thornhill's. They had little or no influence on English painting, except as an example to such artists as James Barry of the way an ambitious artist might attempt history and do so by painting for a public building where his pictures would remain on permanent exhibition. We do know, however, that the paintings had some effect on the popular consciousness. Once they were finished and in place, they were "esteem'd the finest in England" and, to judge by contemporary testimony, they became a tourist attraction, one of the visual experiences sought out by Londoners. One Sunday in April 1740 Mary Granville Pendarves, who in 1731 had sat to Hogarth for her portrait, enjoyed a day on the town with friends. They left Whitehall in two hackney coaches at 10 A.M.

> Our first show was the *wild beasts* in Covent Garden; from thence to St. Bartholomew's Hospital—the staircase painted by Hogarth, the two subjects the Good Samaritan and the Impotent Man; from thence to Faulkner's, the famous lapidary, where we saw abundance of fine things, and the manner of cutting and polishing pebbles, &c.; then to Surgeons' Hall to see the famous picture of Holbein's of Harry the Eighth, with above a dozen figures in it all portraits; then to the Tower and Mint . . . [22]

Hogarth's St. Bartholomew's pictures were one of the sights of London, their theme and mode part of the baggage carried around by writers and artists of the 1730s and 1740s.

The immediate reaction to Hogarth's paintings was a small resurgence of interest in history painting among London artists. Both Hayman and Highmore followed with their own versions of *The Good Samaritan* (Yale and Tate). Highmore's painting pilfers the in-

violating the Sabbath by curing at the pool of Bethesda, the Jews "sought the more to kill him, because he not only had broken the Sabbath, but said also that God was his Father, making himself equal with God" (John 5: 18). This is, to a large extent, the image Hogarth hypostatized of himself, beginning in the 1730s, of the figure outside the system whose "miracles" threaten the system and are retaliated against whenever possible. The growing list of self-surrogates includes the dog of the conversation pictures, little David the harper of the *Rake,* and Rahere the juggler, himself a low equivalent of Christ.

Hogarth remained a governor of the hospital. On 31 July 1735, when the second wing was begun, he subscribed £22 10*s,* but as a governor he appears to have been relatively inactive, attending few meetings and serving on no committees. The first meeting he attended was the General Court (which met five times a year) held on 25 March 1737, with a very large gathering of governors. Although not mentioned in the minutes, he may have been present to explain why he had not gotten on with the second painting. The next meetings he appeared at were the General Court of 1 December 1737, when Alderman Barber was chosen president, and a weekly Thursday meeting, 27 April 1738, to give his opinion on the painting by Mr. Richards of the benefactors' names on the tablets in the court room. As a result, it was "Ordered that the Ground Work of the Painting of the Benefactors Names in the Court Room be of a Darker Porphory Colour than that already laid and the Letters to be of Gold and Mr. Richardson [sic] to go about the same as soon as possible." On 19 December of the same year, although absent from the meeting, he was mentioned in a consultative faculty. He and James Gibbs, architect of the building, were "desired to see the large Picture [of Henry VIII]—properly framed and fixed with decent and respectful Ornaments"—moved from the counting house to the Great Hall:

> And Mr Gibbs and Mr Hogarth are also desired to give Orders for preparing a Busto of Rahere the first Founder of this Hospital to be taken from his Monument in Great St Bartholomew's Church to be fixed in the Great Court Room over the Middle Chimney.

In 1751 the staircase paintings were cleaned by one John Williams, at Hogarth's own expense. (He had also required that his canvases never

gains, a parallel to the father and son in the first plate of the *Rake's Progress.*[49]

Over the years he filled in the portraits of his own family and servants. If his mother and Jane receive full treatments, his sisters Mary and Anne are a pair of simple profiles on coarse canvas, with the Hogarth features prominent: the question is how they were hung, facing each other or looking away (figs. 73, 74). The servants appeared in a group of faces on a single canvas—one of his most remarkable paintings (ill., vol. 3).

In general, his portraits either center on the idea of disguise or present middling sitters who have no aristocratic pretensions, and to whom he gives a comfortable solidity instead. It is a kind of straightforward portrayal that would not serve as a society portrait and would seem out of place as a full-length work. The eloquently heavy torso that fills a large part of the picture space is the appropriate form. But the main reason that society did not beat a path to Hogarth's door may have been that, more blatantly than Ramsay, he shattered the Kneller mask, the standardized oval, with the long nose and narrow eyes. He replaced this with a round, beaming face whose mood was most often cheerfulness and a kind of positively unaristocratic busyness and vitality that makes them appear to be anxiously awaiting the end of the sitting. *The Shrimp Girl* is the greatest and most characteristic of his female portraits (fig. 50). Mr. Arnold (fig. 71) will stand for the male: David Piper notices how, as opposed to the Kneller oval, Hogarth's faces "tend to accumulate more roundly in an interplay of plump convexities, cheek, and chin, and chin again, and popping eyes," with full and fleshy mouths.[50] Many potential clients may have felt that while his portraits were appropriate for his particular sitters, the same approach would hardly suit them.

His most aristocratic sitters were the marquis of Hartington (fig. 75, later duke of Devonshire) in 1741 and the Grey children for the fourth earl of Stamford in 1740 (St. Louis Art Museum). The Hartington portrait is a stunning painting but conveys no sense of dignity or elevation. The marquis looks hardly older than the duke of Cumberland in *his* portrait. Hogarth never acquired more than a scattering of noble sitters, his clientele remaining clergymen, physicians, lawyers, dons, actors, soldiers, sailors, and merchants. And even with

most of these, the commission was not for a formal full-length por-
trait but for an aide-mémoire. The largest and most interesting single
group of sitters was scientific: from the surgeon Caesar Hawkins
to Thomas Pellett, president of the College of Physicians, and to
the biologist Edwin Sandys and the mathematician Thomas Jones.
Among the many unidentified portraits, one can only say that judg-
ing by appearances they are professional men, with an occasional
member of the landed gentry thrown in.

These then were the sitters who ordered portraits that challenged
Hogarth's abilities. The best of the head-and-shoulder portraits was
another personal friend, Martin Folkes (Royal Society; engraving,
1742, fig. 76). A scientist and president of both the Society of Anti-
quaries and the Royal Society, he was another Freemason brother, a
devotee of the stage, and frequenter of Slaughter's. The broken col-
umn, shown behind him (which gets much more emphasis in the print
than in the painting), was a Masonic symbol of the lodge secretary,
which sat on his desk (apparently associated with the secretary's col-
lections for charity). But the column also carries a joking sense of
"broken off," and the most familiar use of a broken column was as a
funerary monument. In Hogarth's composition Folkes rises up like a
mountain, the broken column rhyming with his large brutal shape.[51]
If in a public sense Folkes represented the Royal Society, in a private
sense he may recall Pyle's remark that he was "the most vicious
man, and the most foolishly and beastly vicious in the wenching way
of any body I ever heard of.—a good deal beyond Dr. Mead."[52]

The great majority of simple head-and-shoulder portraits offered
Hogarth no chance for his literary approach to painting. He was
aware of how difficult it is to show only a face. On the one hand, he
wrote, there was the problem that faces may "hide a foolish or a
wicked mind till they betray themselves by their actions or their
words," and though a fool may eventually reveal some traces of folly
in his countenance, "the character of an hypocrite is entirely out of
the power of the pencil, without some adjoining circumstances to
discover him, as smiling and stabbing at the same time, or the like."
On the other hand, there is the problem that the portraitist by defi-
nition portrays the good and exemplary. He remarks how strange
it is

> that nature hath afforded us so many lines and shapes to indicate the
> deficiencies and blemishes of the mind, whilst there are none at all that

point out the perfections of it beyond the appearance of common sense and placidity. Deportment, words, and actions, must speak the good, the wise, the witty, the humane, the generous, the merciful, and the brave. (*Analysis,* 137, 141)

With a few exceptions like the actor Quin, with his head thrown back, pleasantly posing (Tate), Hogarth added nothing in pure face painting to the compositions of Kneller and Richardson; his contribution was in the direction of humanizing, rather than particularizing, the sitter. For the most part, he does not emphasize the sitters' social lives: they are good, competent, professional people, whether doctors or soldiers. A marquis of Hartington has a bit more grace in his air, but that is all. If there is little social life, there is also nothing of that inner life Rembrandt gives his sitters—only good health and spirits, rosy cheeks and lips. In a sense they are mostly beautifully painted but perfunctory—and finally, if mentioned in the same breath with Rembrandt, must be judged repetitious and facile.

Nevertheless the head-and-shoulders portraits (e.g., fig. 77) reveal a debt to Rembrandt through Kneller. For, while he put Van Dyck's head over his door, attempted in *Captain Coram* to recapture the Van Dyck formula for his own time, and broke the fashionable mask of the Kneller portrait, he still continued to paint in Kneller's way. The meaty flesh, the corporeality of Hogarth's faces, and above all the unconcealed brushwork, are Kneller's bequest. Kneller's brushwork is closer to the heavy, impasto effects of Rembrandt's portraits than to the brilliant light touch of Van Dyck or the glazes of the Italians. And this technique Hogarth acquired, so that in his last years when he actually produced some consciously Rembrandtesque portraits, he was in a sense fulfilling his heritage. It was the broken color, however, and not the chiaroscuro, that accorded with his temperament.[53]

It is possible that Thornhill, in some ways Kneller's rival and a remarkably baroque portraitist himself, once more served Hogarth as a buffer or as a direct contact with the painting of Lely. Certainly there are Lelys with a thinner pigment than Kneller often used (e.g., the *Prince Rupert* in the Queen's House, Greenwich) that anticipate the Hogarthian technique at its best. Kneller's paint is often simply laid on every which way, while Lely's (and Hogarth's) creates a beauty in its own terms, even if sometimes reducing the sitter's individuality.

If most portraits offered Hogarth no chance for his literary

method, and little elaboration or character analysis, they did provide him with an opportunity for pure painting. In this sense his five years of face painting follow from the growing joy of applying paint to canvas that is evident in the modern history paintings of 1735–1738. The histories end and the portraits begin; to be enjoyed, the majority of those heads he painted after 1738, many of them in feigned ovals intended primarily as decorative devices for closets and overmantels, must be regarded as exercises in playing with paint. As such they are delightful, the color and brushwork exciting, and exude the sense of liberation Hogarth must have felt as he painted them.

GROUP PORTRAITS

The single portraits were an interval, and a necessary transition, between the last few conversations painted between 1735 and 1738 and the group portraits of the early 1740s, which combine the best of Hogarth's histories with all that he has learned about portrait painting. *The Strode Family* and *The Western Family,* both of 1738 (fig. 78 and National Gallery, Dublin), for example, contain somewhat larger figures; Hogarth seems to exceed the scale of a typical conversation picture. As in the modern moral subjects, the people now bear about the same relationship to their rooms as do the Harlot and the Rake.

The finale of the small conversation pictures (though no longer very small) was the group painted for John, Lord Hervey around 1738 or 1739 (*Lord Hervey and His Friends,* fig. 79), clearly an important commission. A precise date would be helpful, since the watershed of Hervey's power coincided with the death of Queen Caroline in 1737. Still, a staunch supporter of Walpole, he remained within the corridors of power beyond her death. He was, in any case, a significant patron, perhaps (as I suggested earlier) a contact made through Bishop Hoadly, one that brought Hogarth within arm's length of painting the royal family in 1733.[54]

The wittiest, not to say fantastic, of his conversation pictures, the Hervey group sets up the same play between the spirit and the flesh explored in the *Times of the Day* and *A Scene from "The Tempest"* (fig. 41, a picture that in many ways resembles the Hervey conversation, though smaller around by ten inches). The Reverend P. L. Wilman (or Villemain) is standing on a chair, looking so intently

through a spyglass at a church steeple that he fails to notice that his chair is in the act of toppling with him backwards into a pond. The rest of the company is concerned with the plan of a secular structure. From *this* ambiance Wilman needs a telescope to spy a church: a comment on the group's secularity. Indeed, the lone clergyman's black is contrasted with the bright colors of the other gentlemen (the violet of Hervey's coat and the bright red of Thomas Winnington's); his elevation and disinterestedness with the heaping platter of fruit and the wine cask; and his status as Christian, anchoring the left side of the picture, with the classical sculpture of Minerva which anchors the right side. It is presumably significant that both, figuring religious and secular Wisdom, are directing their gaze *away* from the gentlemen at hand.

The simplest way to assess this group of gentlemen is to recall Hogarth's earlier conversations of families in which the toppling chairs and pranks were the work of the children and dogs and the wit was contributed by the painter. Here the dog sits sedately next to Stephen Fox. But, by another of Hogarth's false perspectives, his straight back—or, we notice a second possibility, Fox's walking stick—seems to be the cause of the chair's toppling. The children of *The Cholmondeley Family* have now moved front center and the paternal clergyman is having a trick played on him. This is clearly a group of "friends," as the title traditionally assigned the painting indicates, and the wit is shown to be in the subjects themselves.

As context we have to recall (as Hervey would have) the anti-Walpole propaganda of these years, and in particular Pope's verse portrait of Hervey as "Sporus," as homosexual or bisexual, which had been published in the "Epistle to Dr. Arbuthnot" (1735). There was, of course, a Lady Hervey and children; but, in Hervey's friend Lady Mary Wortley Montagu's words, "There are three sexes: men and women and Herveys." The popular image of Hervey and his group of male friends was projected in William Pulteney's *A Proper Reply to a Late Scurrilous Libel* (1731), where Pulteney argues that British government centered on a (royal) family was being replaced by one dominated by a prime minister and his male minions.[55] Walpole's relationship to Hervey is described as analogous to "a certain, unnatural, reigning Vice (indecent and almost shocking to mention)." While the role assigned Walpole is only metaphorical, the group Hogarth portrays was, in part if not altogether, connected by homoerotic bonding. Although Hogarth shows the gold key at

Hervey's waist which was the badge of vice-chamberlain to the royal household, this is an intimate portrait group which is seen from the point of view of the witty Hervey, not the public diatribes of Pulteney and Pope.[56]

Instead of a family we have the pleasant familiarity of this male group. A parody husband and wife of the sort Hogarth represented in his family groups appears in Stephen Fox, seated at the table, and Hervey, holding forth the architect's plan. If an occasion is being celebrated, and it is designated by the precarious position of the Rev. Mr. Wilman, it may be the proforma marriage of Stephen Fox (then thirty-two) to a thirteen-year-old heiress, which had been carried out by Wilman. Fox's actual "marriage" was with Hervey.[57] To formally underline the theme, Hogarth gives two of the men phallic walking sticks and places behind them a wall adorned with phallic gateposts.

It goes without saying that the generic instability of this group portrait links it with a work like the *Scene from "The Tempest"* and other mixed conversation-history-romances Hogarth is painting as well. The integration has not quite been accomplished, however. The lines defining Wilman's profile are too emphatic, and the other faces (and figures too), though each is beautifully and delicately painted, are finished as separate portraits that do not seem integrated with each other. Some parts are in a much broader style than the rest and this effect corresponds to the shifting focus of the modern history paintings.

One final conversation picture—and another group of male friends—was *Captain Lord George Graham in His Cabin* (fig. 80), painted in 1745 for the youngest son of the first duke of Montrose. Graham was captain of the *Nottingham* and M.P. from Sterlingshire, and the portrait group was probably commissioned to celebrate his successful action off Ostend in June 1745.[58] In command of the frigate *Bridgewater* (24 guns), he had pursued and attacked a squadron of French privateers with a convoy of valuable prizes. He was congratulated for this successful action by the admiralty and appointed to command the large frigate *Nottingham* (60 guns). Hogarth's picture is far removed from the heroism of the battle: it is probably set aboard the *Nottingham,* which in the autumn of 1745 was in the Downs, and shows Graham smoking in his cabin before dinner. His chaplain and clerk are singing a catch to the music of a drum and fife played by his black servant. His (and Hogarth's) dogs join in, one wearing his wig, with the music supported by a wine glass. The

steward bringing in a roast duck upsets the gravy down the chaplain's back. It is *Lord Hervey and His Friends* all over again, but in a naval setting, with the implicit contrast between this happy crew (Graham wears his mobcap askew) and the battle that made its captain a hero: and in that sense, a "comic history" which in time followed *Marriage A-la-mode* (see below, Chap. 9).

Graham is dressed in gray with a red furred cap; the tablecloth is blue gray, and the room is dominated by cool grays and blues and reds. The chaplain is in brown but with a bluish vest and lilac coat collar; the wall behind is brownish but with the blue of the sky appearing through the windows. The foolish play of a "Merry Company" picture is necessary, and some sort of contrast, if only between this fun and the heroic battle, must remain.

A totally different sort of conversation, painted in the early 1740s in the wake of *Captain Coram,* were *The Graham Children* and *The Mackinen Children* (figs. 81, 82). These are essentially the size, monumentality, and broad rendering of the *Coram* composition extended to two or more full-length figures. In Reynolds's hands this will be an heroic conversation piece, making clear its descent from the portraiture of Titian and Van Dyck. Hogarth invites the memory of no forerunner other than his own *Captain Coram.*

The Graham Children was not commissioned by a great nobleman, for whom such scale would be dictated by decorum, but by the apothecary at the Royal Hospital, Chelsea. Daniel Graham (1695–1778) had been apothecary to George I and II (preparing, for example, the annointing oils for their coronations) and retained that position until 1741; from 1739 to 1747 he was apothecary to the Chelsea Hospital, a position that brought large profits from the sale of medicines. He came of a family that kept an apothecary's shop in Pall Mall, and one story has it that he owed his place to the duke of Newcastle in order "to get rid of a long apothecary's bill." He prospered, in the 1740s replacing the old shop and houses on either side with a grand house and shop, which is the site of the portrait. The room and its furnishing are suitably lavish. I see no reason, however, to believe (as has been suggested) that the picture's monumentality "delicately satirizes the family's luxurious standard of living"; it simply serves to elevate the painter and his painting.[59]

The Graham Children is a monumental version of the much earlier

House of Cards and *Children's Tea Party* (ill., vol. 1). The boy, Richard Graham, turns a bird organ or *serinette,* which has a picture of Orpheus charming the beasts painted on its side. He smiles, thinking he is "charming" the goldfinch that seems to be accompanying him but is in fact responding in terror to the threatening figure of a cat. The predatory cat and, opposite at left, a tiny figure of Cupid with a scythe like Father Time's atop the clock, flank the happy, smiling children and constitute an admonitory allegory. In this context, the boy's *serinette* is a childish illusion that will eventually be destroyed by the real world, where birds are devoured by beasts who cannot be charmed by their singing.

The Mackinen Children marks the climax of Hogarth's portrait groups in scale, monumentality, and beauty of execution. The Mackinen family, who traced itself back to the chiefs of the Highland clan of the Mackinnons of Skye, descended from the ancient Celtic kings of Scotland, had become rich in the West Indies. Daniel Mackinen (1658–1720), who made his fortune in sugar, was one of the greatest landowners on Antigua and a member of the legislative council.[60] His son William (ca. 1697–1767) commissioned the portrait while his two children, Elizabeth (1730–1780) and William (1733–1809), were at school in England. Tradition dates the sittings in 1747, but the children's ages would suggest a slightly earlier date, probably no later than 1745. The painting was sent back to their parents in Antigua.

The brother and sister are focused on a sunflower, atop which is a butterfly (their alert dog is also turned toward the sunflower). As Richard Wendorf has argued, sunflowers were associated with devotion and in this case the sunflower dramatizes "the devotion this young brother and sister share for each other, or the devotion their parents share for the children whose portraits they have comissioned." The butterfly is a "means by which the particular vitality and beauty of this young couple can best be shown."[61]

But the symbolism of the butterfly also has to do with the children's future—with fleeting time, lost beauty, and lost innocence. The girl has been collecting fallen petals in her apron and the boy is reaching out for the butterfly poised on the sunflower, which appears in many Dutch flower pictures as an emblem of transient beauty. And the potted sunflower in the foreground, big as a tree and flanked by the two children (its russet color matching the hue of the boy's coat) with their attention on the butterfly, endows the picture with

ironic overtones of Adam and Eve, their Tree of Knowledge (unpotted), and their lost Garden of Eden. Another sunflower appears to the right behind the boy, whose relation to knowledge is established by the book he holds in his left hand, as he reaches for the butterfly with his right.

The color scheme, like the symbolism, is more subdued than that of *The Graham Children*. The pale violet of the sky is repeated in the girl's dress, rendered less noticeable by her large white apron. The buildings in the background, in Hogarth's characteristic olive drab, are related to the green of the sunflower stalk, and to the pot of the plant, in his particular shade of brown gold. The boy's coat and trousers are brown and his vest a paler, grayer green than the leaves of the plant. Uniting the two figures, with their pale violets and brown-green-olive tints, is the pale gold of the huge sunflower.

In 1741 Vanloo's health gave out, and suffering from dropsy, gout, and rheumatism, perhaps aggravated by the London climate, he stopped accepting new commissions. Finally, having finished all his work, including the portraits of the Prince and Princess of Wales and Sir Robert Walpole, he departed England for his native Provence on 15 October 1742.[62] The week after he left, Vertue noticed a piece (he had originally written "of news," but he struck these words out) printed in the newspaper "with a sting in the tail" (3: 111). He refers to the *London Evening Post, 21–23 October 1742:*

> We hear his Majesty has conferr'd the Honour of Knighthood on Mr. Stephen Slaughter, Painter, in Rathbone Place, on account of an excellent Performance lately begun for his Royal Highness the Prince of Wales, which, by all Judges, is allow'd to be an extraordinary and uncommon Imitation of Nature; and may justly be said to excel the famous french Painter (lately gone abroad for the Recovery of his Health) as far as he did the English Painters in general. It is farther to be observ'd, that Mr. Slaughter is always happy in his Designs, and finishes the Whole with his own Hands—not common.

Vertue remarks that "this peece of Wit or sarcasm. being stuffd with falsity. is sd to be the [work] of Ho. . . a man whose high conceit of himself & all his operations, puts all the painters at defiance not excepting the late famous Sr Godf. Kneller—& Vandyke amongst

them." That "Ho. . ." stands for Hogarth becomes evident if one compares this account with Vertue's description of him a few pages later, using almost identical language (3: 124).

Slaughter had returned from years abroad in Paris and Flanders in early 1736, and made portraits in the late 1730s. The context of the news item suggests that Hogarth takes him to be a bad painter, a proper successor to Vanloo (with perhaps as little connection with England), but one who is receiving patronage above his desserts. One can only speculate, regarding the king's knighting Slaughter for a portrait of his despised son, that the portrait must have been so bungled as to depict the prince as his father saw him. But the reference to Slaughter's virtue of painting his whole portrait himself is used to berate the painters such as Ramsay and Hudson who employed van Aken.

The *London Evening Post* often ran such facetious notices as this; and if Hogarth was responsible for this one, he might also have been responsible for others with art references.[63] In 1741 he had published his *Enraged Musician,* which commented on the kind of artist who tried to cut himself off from nature, and had projected a parallel satire about a painter. He may have been accompanying his portrait painting with comments on the works of his contemporaries.

Vertue's summary of the effect of Vanloo's departure is dated 1743 and was probably written between June and July: "since mr Vanlo, painter left England the most promiseing young Painters make most advances possible to be distinguisht in the first class—of those that make the best figure Hymore. Hudson Pond Knapton Ramsey Dandridge Hussey Hogarth"—to which he added, with a caret, the name of Wills. He goes on, however, to single out Hudson, whose portraits are "true fair and Easy, his draperys well disposed and his actions natural, his flesh colours well immitated & his manner agreeable without affected manner of painting" (3: 117). This is a fair appraisal of Hudson's success and the reasons for it.

In May 1743 Hogarth set out for Paris, "to cultivate knowledge or improve his Stock of Ass[urance]," as Vertue put it. Although an important portrait resulted from the trip, he had in effect by this time returned to history painting. He must still have had some portraits going in the fall of 1743, but in February or March 1743/44 Vertue gives the palm to Hudson as the most sought-after and prosperous of the English portraitists (3: 118, 121). It would thus appear that, while Hogarth did his best and could be grouped with the portraitists

who "make the best figure," he did not achieve the success that he wished for, and this may have decided him to return to comic history painting and *Marriage A-la-mode* in 1743.

Looking back, Hogarth saw himself staking his reputation as a portraitist on *Captain Coram:*

> and it has been left to the Judgment of the public these twenty years whether if the efforts are equal or not. . . . Yet as the current ran, it was not my talent, and I was forced to drop the going on, the only way by which a fortune is to be got, as the whole nest of phizmongers were upon my back, every one of whom has his friends, and all were taught to run down my women as harlots and my men as caricatures.

And so, he adds, "My graving and new compositions were called in again for employ, that being always in my power" (AN, 218). "Harlot" and "caricature" were the words a competitor might have applied to Hogarth's healthy, blooming, but undignified portraits. On another occasion, remembering those years in a slightly different way, he wrote:

> He painted Portraits occasionally but as they require constant practice to be ready at taking a likeness and as the life must not be strictly followed [i.e., the figure must be idealized], they met with the like approbation rembrandt's did, they were said at the same time by some Nature itself by others execrable. so that time only can show whether he was the worst or best portrait painter living.

This paradox, he concludes, "can no other way be accounted for but by the prejudices or fashion of the times in which he lived" (AN, 212).

Hogarth—unless painting a friend—was intimidated by the presence of the sitter, and above all by a single sitter. He refers himself at one point (AN, 213) to Gay's *Fable* 18 (first series), "The Painter Who Pleased Nobody and Everybody," about a painter who (like himself) has the gift of catching likenesses. He paints truthfully and loses all his trade; nobody wants truth, and "In dusty piles his pictures lay, / For no one sent the second pay." Then he starts copying busts of Venus and Apollo for all his sitters, and for added effect, he

> talk'd of *Greece,*
> of *Titian's* tints, of *Guido's* air;

> Those eyes, my lord, the spirit there
> Might well a *Raphael's* hand require
> To give them all the native fire . . .

His trade grows, he raises his prices, and he becomes a successful painter.

Nevertheless, he did not abandon portraits. In 1744 he reached the most exalted of his clergyman sitters, Thomas Herring, archbishop of York (soon to be of Canterbury). His connection with Herring is unknown, though he also painted his nephew John Herring. That the archbishop knew, or knew of, Hogarth as early as 1739 is shown by a reference in a letter of that year to William Duncombe: "We had our music too, for there came in a Harper, who soon drew about us a group of figures that Hogarth would give any price for."[64] The portrait (fig. 83) was originally dated 1744, the year when Hogarth promised his subscribers he would be working on nothing else until *Marriage A-la-mode* was finished; but he could hardly turn down a commission from the archbishop of York. He exerted all his abilities and tact on this portrait and may even have traveled to York for sittings.

During one of these Hogarth is supposed to have said to Herring: "Your Grace, perhaps, does not know that some of our chief dignitaries in the church have had the best luck in their portraits. The most excellent heads painted by Vandyck and Kneller, were those of Laud and Tillotston. The crown of my works will be the representation of your Grace."[65] Hogarth never painted another portrait so grand or so French. As if consciously avoiding the idiom of *Coram* and *Hoadly,* he reduces his colors to the black and white of Herring's garments and the olive of the curtain; he avoids the busy detail that had enlivened his *Hoadly,* focusing on the simple gesture of Herring's left hand. Indeed, before he finished he painted out the one conventional background prop he had assayed, a classical pedimented column filling the left margin of the picture, onto which his signature originally fitted, leaving the signature, "W. Hogarth pinxt 1744," hanging in the air.

It was the first painting that allowed exploration of ideas he had acquired in France, especially the pastel work of Quentin de La Tour, which he admired and later recommended to Philip Yorke and perhaps to Allan Ramsay.[66] The La Tour portrait that probably most directly influenced him was *Le Président des Rieux* (1741, private

collection), which had been shown at the Salon of 1741.[67] Hogarth's *Herring* is strongly indebted to this or a similar La Tour pastel, the effect of which he turns into a broad and free handling of paint unprecedented for him or for other English artists before Gainsborough.

However, on 2 November 1745, Herring wrote from Bishopsthorpe to his friend William Duncombe in London, who was evidently urging an engraver's suit:

> I observed your postscript about Mr. Burford [an engraver]. You may, if you please, tell him, that I will talk with him, when I come down, but none of my friends can bear Hogarth's picture. This puts me in mind to tell you, that the true reason why I have broke my promise with you is, that I have been put out of temper with sitting, and I will not sit for you, till I can bear it with the best humour in the world.[68]

The final words may refer to Hogarth's pomposity or his demands on his sitters, but the mention of his friends' dislike was significant. The criticisms, together with Herring's accession to the archbishopric of Canterbury (and the hope that the painting would hang in Lambeth Palace), seem to have led Hogarth to take back the canvas and subject it to extensive repainting, resigning it "Hogarth pinx. 1747."[69] He lowered the hands and the armrests (adding a book in one hand), dropped the shoulders, and reduced the areas of the white lawn sleeves by covering them with the black gown—all of this "presumably to reduce the width of the figure"; he evidently wished to correct the criticism later recalled by Duncombe's son John that

> This picture indeed (as appears by the print, engraved by Baron, in 1750) exhibits rather a caricature than a likeness, the figure being gigantic, the features all aggravated and *outrés,* and, on the whole, so far from conveying an idea of that *os placidum, moresque benigni* (as Dr. Jortin expresses it) that engaging sweetness and benevolence, which were characteristic of this prelate, that they seem rather expressive of a Bonner, who could burn a heretic.

> Lovat's hard features Hogarth might command;
> A Herring's sweetness asks a Reynolds' hand.[70]

Hogarth completely repainted the face, the finish of which contrasts strikingly with the fluid brushwork in the rest of the painting. In

any event, the painting was not hung in Lambeth Palace (Hudson's portrait of 1748 was used), and it was not engraved until 1750 (by Baron).

The reference to Lovat, however, should be glossed: in September 1745, as the pretender's son, Prince Charles Edward, moved south with his army, Herring had mobilized the loyalist forces of Yorkshire and become a national hero. A portrait head, attributed to Hogarth, was engraved by Charles Mosely to decorate a speech in which the archbishop called the clergy and congregations of the north country to arms against the pretender.[71] But Hogarth's greatest fame in the wake of the Forty-Five was his brutally straightforward full-length etching of Simon Lord Lovat, one of the Jacobite rebels (fig. 110).

8.

Richardson, Fielding, "Comic History-Painting," and the Rise of the Novel

Hogarth's primary contribution to the "rise of the novel" (Ian Watt's term) was to "raise" popular and ephemeral prints and "novels" by connecting them with the highest-ranking and most ancient of genres, history painting. Then with his polemicizing subscription tickets and advertisements he attempted to validate the idea of a "new" genre, assimilating it to the established canon of Western art. His references in the *Harlot's Progress* and its subscription ticket to biblical and classical history painting, to Hercules, Mary, Eve, and Isis, were (whatever other local purposes they served) intended to elevate a contemporary subject. This was the project that he set out to fulfill in the 1730s; and this was the project that distinguished Richardson and Fielding from all the other fiction writers of the 1740s.[1]

Hogarth showed that an Other was needed against which to define the new genre. His Other was Renaissance history painting now antiquated and degenerate, practiced by seventeenth-century imitators and by eighteenth-century copyists. Richardson and Fielding validated their modes by repudiating, correcting, and elevating the popular "novel"—the sensational erotic romances of Manley and Haywood, the journalistic narratives of Defoe and Gildon. Hogarth taught them that by challenging the cultural legitimacy of "novels" one could appear to be "the first" legitimate novelist; and that this was accomplished by polemicizing the subject in advertisements, prefaces, public letters, critical essays, as well as the work itself. They ultimately succeeded where Hogarth failed by establishing a master genre of the nineteenth century. Hogarth's genre remained a maver-

ick, outside the main tradition. And this may be because his genre was more viable to assimilation by writers than by painters.

RICHARDSON'S *PAMELA*

If Hogarth's Harlot was the great mythic figure in the English popular imagination of the 1730s, Samuel Richardson's Pamela was the equivalent of the 1740s. The case of the many piracies and adaptations of the *Harlot* and the episode of the memorial plagiarists who copied the *Rake* before publication indicate a popular interest corresponding to the stories of eager readers waiting for the next installment of *Pamela*.

Richardson developed, in both *Pamela* (1740) and *Clarissa* (1747–1748), in the most graphic, indeed voyeuristic terms, the image of feminine beauty and innocence threatened and (in the case of Clarissa) destroyed by figures of authority. But he rejected, while sublimating, the other aspect of the Harlot—the ambiguity of her status as commodity and victim, free yet exploitable, powerful yet vulnerable. He created an alternative myth, and the difference goes some way toward characterizing the different tempers of the two decades as well as of the two artists. For while Richardson began with the Hogarthian narrative of the seductive yet helpless young woman, he corrected it. And then *his* narrative was corrected by Fielding in *Shamela* (1741) and *Joseph Andrews* (1742).

Hogarth and Richardson were both apprentices, tradesmen, successful printers and employers. Richardson, ten years Hogarth's senior, had also been put out to be an apprentice (1705)–his father "having been able to give me only common School-Learning," as he put it himself. Told to select a business, he chose printing, which he thought would "gratify my Thirst after Reading"; following his apprenticeship he married his master's daughter, as Hogarth married the daughter of his metaphorical "master," Thornhill. In 1721, at about the time Hogarth set up as an engraver, Richardson launched a modest printing business. By the 1730s he was very successful, and in 1738, before he had published any fiction, he set the seal on his tradesman's prosperity by leasing the Grange, North End, Fulham, as a country house.[2] Hogarth did the same a decade later, not far away in Chiswick. They had in common the economic security of

the merchant, never obtained by Fielding or even, in spite of his large income, by Smollett. To accomplish this, the artist had to be his own employer and publisher, as both Hogarth and Richardson were. They were as unlike in temperament as any two men could be: Richardson nervous, retiring, a listener, utterly closed in upon himself; Hogarth talkative and exuberant. Yet in important ways they were cut from the same cloth.

Shortly after the publication of *Pamela* Richardson asked Hogarth to make a frontispiece for the second edition. This was to have been Pamela by the pond, and then Pamela and her bundles (one of the subjects subsequently illustrated by Joseph Highmore: see fig. 100). Although Richardson blamed the failure of this illustration on the engraver, Gerard Vandergucht, it seems likely (no design has survived) that he found Hogarth's illustration insufficiently spiritual in its representation of his heroine. His account in the preface to the second edition (1741) is that

> it was intended to prefix two neat *Frontispieces* to this Edition, (and to present them to the Purchasers of the first) and one was actually finished for that purpose; but there not being Time for the other, and from the demand for the new Impression; and the Engraving Part of that which was done (tho' no Expence was spared) having fallen very short of the Spirit of the Passages they were intended to represent, the Proprietors were advised to lay them aside.[3]

On 29 November 1740 Aaron Hill had written to Richardson: "The designs you have taken for frontispieces seem to have been very judiciously chosen; upon pre-supposition that Mr. Hogarth is able (and if any-body is, it is he), to teach pictures to speak and to think." But on 9 February 1740/41 (now referring to the artist only as "your designer") Hill wrote:

> I am glad your designer falls to work on the *bundles;* because there is something too intensely reflective in the passions, at the *pond,* that would make such significant calls for expression and attitude, as not to allow the due pardon, for those negligent *shadows of form,* which we commonly find, in a frontispiece. Nay, I am so jealous, in behalf of our inward idea of *Pamela*'s person, that I dread *any* figur'd pretence to resemblance. For it will be pity, to look at an *air,* and imagine it *hers,* that does not carry some such elegant Reflection of amiableness, as will be sure to find place, in the fancy.[4]

Hill could be describing dissatisfaction with the application of Hogarthian forms and a recognizable likeness to the ineffable Pamela.

But why had Richardson asked such an unlikely illustrator as Hogarth to represent Pamela? Perhaps because he knew the St. Bartholomew's paintings as well as the *Harlot* and *Rake;* perhaps also because in *Pamela* he had rewritten the *Harlot's Progress* to correct its low and satiric tendencies, turning it into the story of a less exploitable, more enterprising young woman, one with God on her side— or (seen from the point of view of Fielding's subsequent rewriting of *Pamela* in *Shamela*) a woman more in control of the men who try to exploit her. Richardson's Pamela survives the same tempting and threatening situations to which Hogarth's Harlot succumbed. Instead of Hogarth's fallible young woman, Richardson supposed a "virtuous" young woman who triumphs over her oppressors, proving, as in a self-help manual (such as his *Apprentice's Vade Mecum* of 1734) that it *can* be done—a young woman who, when she gets her man, gives up her liberty and becomes a respectable member of upper-class English society.

Both show what it is like to dream of being a fine lady—and what happens to those who dream. Only in Richardson's version the dream comes true. The formulation gives some sense, however, of the parallel concealed by Richardson's rewriting: both Hogarth and Richardson agree that it is the social context of masters, magistrates, and clergymen which is culpable, not the individual dreamer, who either (in one scenario) suffers or (in the other) is victorious.

The crucial echo is the scene in which Pamela dresses down into the rustic clothes she wore before she came to B. Hall. Richardson makes her resemble Hogarth's Harlot of Plate 1, before she dresses *up* to the status of kept woman in Plate 2: "when I was quite equipped, I took my straw hat in my hand, with its two green strings, and looked about me in the glass, as proud as anything. To say truth, I never liked myself so well in my life."[5] This is the way the Harlot is seen in Plate 1, fresh from the country, with special emphasis on her straw hat, and this scene offers a gloss on the pathetic reminder of the hat on the wall above her coffin in the last plate. It is precisely this "rustic" dress that makes Pamela appear a new and exciting sexual object to Mr. B., as it presumably recommended Moll Hackabout to Colonel Charteris. The unfortunate consequence of Pamela's trial return to her former status is that it appears to be a "masquerade" in front of Mr. B., who takes the opportunity

to caress this "sister" of Pamela when he could not, by that time, have done so with impunity to the real Pamela. Pamela's sad conclusion is that "it was not fit for me to pretend to be any body else for my own sake, nor with regard to my Master" (65). She has accidentally turned herself into the innocent but self-absorbed young woman of *Harlot,* Plate 1, and she has suffered for the same kind of masquerade that defined and ruined that figure.

In this scene Richardson places Pamela in her rustic costume first before Mrs. Jervis and then before Mr. B., replicating the triangular relationship in *Harlot* 1 in which Hackabout is scrutinized by the bawd Mother Needham and by her master Colonel Charteris, who lurks in the doorway. But Richardson has given Pamela an alternative, *good* Mother Needham in Mrs. Jervis, and only later—in a more threatening situation—a real Needham in Mrs. Jewkes, who, when they first meet, re-creates the Needham of Plate 1:

> The naughty Woman came up to me with an Air of Confidence, and kiss'd me, See, Sister, said she, here's a charming Creature! would not she tempt the best Lord in the Land to run away with her! . . . So I find I am got into the Hands of a wicked Procuress [says Pamela], . . . in the Hands of a Woman that seems to delight in Filthiness. (101–2)

These words are a memory of Mother Needham. On the Lincolnshire estate Needham–Jewkes is in charge, and Pamela goes through experiences with Mr. B.'s grotesque minions and the "respectable" neighbors, including a clergyman, that re-create the nightmare experience of Moll Hackabout in London. Her words about Jewkes are preceded, in the editor's commentary between Pamela's letters and her Lincolnshire diary, by words that gloss the *Harlot's Progress* from Richardson's point of view:

> And the whole will shew the base Arts of designing Men to gain their wicked Ends; and how much it behoves the Fair Sex to stand upon their Guard against their artful Contrivances, especially when Riches and Power conspire against Innocence and a low Estate. (90)

This is not to say that *Pamela* lacked sources: the Pamela–Mr. B. situation may also rewrite the story of Moll Flanders and her first love, Robin, just as Hogarth can be said in some ways to modernize the heroines of Nicholas Rowe's "She-Tragedies." But the Rowe

heroine is *simply* victimized, pathetic, defenseless, and moreover chaste (except for Shore); whereas the Harlot, while certainly helpless in a male-dominated society, makes her mistake by imitating the fashionable models of London life. The key pattern in Richardson's novel is also of imitation and repetition, as Pamela writes to her parents:

> Forgive me, that I repeat in my Letter Part of my hourly Prayer. I owe everything, next to God's Goodness, to your Piety and good Examples, my dear Parents; my dear *poor* Parents, I will say, because your *Poverty* is my *Pride,* as your Integrity shall be my Imitation. (59)

But there was more to Richardson's debt to Hogarth than the rewriting of a plot. The first thing one notices looking at *A Harlot's Progress* or reading *Pamela* is the divisions, demarcations, "scenes," and closures (as in Fielding's novels, the "chapters"). Defoe's narratives simply ran on and on without stopping to shape, develop, and close his scenes; they represented how experiences are felt as they are recalled, without division or closure, without the claustrophobic immediacy (or unvarnished "truth") of the diary/letter. Hogarth's progresses of the 1730s were built on separate but closely interrelated scenes involving an emblematic, visualized interpersonal relationship. The situation is one of temptation, focusing on the choice between virtue and vice—specifically the choice between a paternal authority (Hackabout's clergyman, who turns his back; Pamela's father, embodied in his admonitory letter) that is summed up as industry and figured by the washerwoman hanging out clothes on a balcony in *Harlot* 1—and the idleness embodied in ladylike keeping by the lascivious and fashionable gentleman waiting in the doorway. The Harlot acts as she does in imitation of this figure of fashion, embodied in the pictures she (or her keeper) hang on their walls; her action is based on the principle (first explored by Hogarth in his conversation pictures of the 1720s) of milieu as constitutive of character. There is a marked disproportion between the apparent banality of this essentially descriptive mode—a mode in which the descriptive detail in effect subordinates if it does not replace the narrative—and the emblematic significance of the details.[6] Based on Puritan belief in the crucial significance for salvation of the most trivial contingency, Hogarth's scene shows the way in which every random detail is absorbed into a commanding structure of significance.

Richardson takes from Hogarth's progresses the graphic version of a play, with big scenes, symbolic gestures, and emblematic objects. In *Clarissa* he even acknowledges specific Hogarth scenes (as in the death of Mother Sinclair, he echoes *Harlot* 5 and 6). He adapts these from Hogarth rather than from the stage itself because Hogarth's prints freeze a moment in the continuing narrative action of the stage play, permitting him an almost unlimited exfoliation of detail in Pamela's elaborate descriptions, repetitions, and reflections. Prints offered a clarity of visual structure that lent itself to close analysis: they invited intimate reading, not unlike that of the novel that was to emerge. Moreover, Hogarth represented not only a "scene" but a series of spaces, most often domestic rooms: not the palace, temple, or battle-field, but a Jewish merchant's parlor, a whore's bedroom, the quarters of a nouveau riche merchant's son; or public spaces such as a brothel, Bridewell Prison, the Fleet Prison, and Bedlam Hospital.

Both *Pamela* and *Clarissa* utilize the Hogarthian "closed room"; both could be said to be about entrapment in, and attempts to escape from, carceral spaces. It is difficult to imagine any other immediate source than the rooms in the *Harlot* and *Rake,* which become literal prison cells or the cells of a madhouse. It is even possible to see a translation of the Harlot's coffin, her last and most confining room, rewritten in Clarissa's obsessive trying on of her coffin. Richardson develops Hogarth's central graphic metaphor into a spatial equivalent of the social metaphors of distance, hierarchy, and intimacy—as Pamela must protect herself in ever narrowing and more intimate spaces, ending in her closet and the dress in which she hides her letters.

But if Richardson corrected Hogarth's story, he also corrected Hogarth's form by adding a privileged first-person narrator—returning to their mutual source in Bunyan's *Grace Abounding*—in order to compensate for the detachment (or the irony) of the theatrical mode. The most important difference between Richardson's and Hogarth's art was between the eyewitness Pamela ("writing to the moment") and the spectator at a play or before a Hogarth print.

FIELDING'S *SHAMELA* AND *JOSEPH ANDREWS*

Fielding started with a kind of political play that owed much to Hogarth's prints and to common sources such as *The Beggar's Opera;*

and when in 1737 he was deprived of this outlet by the Licensing Act, the only model he had still before him for the sort of emblematic farce he had written was Hogarth's stagelike scenes. For Fielding the freezing of the narrative action (which he had sought in his own emblematic farces) permitted an elaboration, distancing, and contemplation of the scene which was closer to Hogarth's effect than Richardson's.

His immediate response to the *Harlot* had been in *The Lottery* (itself a Hogarthian subject). Lovemore's speech about Chloe, which draws upon *Harlot* 1 ("Ha! by all that's infamous, she is in keeping already; some bawd has made prize of her as she alighted from the stage-coach.————While she has been flying from my arms, she has fallen into the colonel's") is preceded by Whisk's account of Chloe, which Hogarth applied to his Rakewell, only changing the gender:

> I followed her to the door; where, in a very few minutes, came out such a procession of milliners, mantua-makers, dancing-masters, fiddlers, and the devil knows what; as I once remember at the equipping a parliament man's country lady to pay her first visit.[7]

In short, Fielding picks up a reference to a Hogarth print, and then Hogarth picks up that reference and uses it in his next print series: This will be the story of their relationship.

Within a few months of *Pamela's* publication Fielding, for whom Pamela *was* in reality a Harlot, rewrote Richardson's novel from the ironic point of view of Hogarth's *Harlot's Progress:* thus Pamela becomes Shamela posing as Pamela, Mrs. Jervis becomes a bawd, Parson Williams Pamela's surreptitious lover, and so on. A typical scene has Shamela discovered by Mr. Booby in bed with Parson Williams, rather as in the unveiling of the goddess in *Boys Peeping at Nature.* As Pamela's "Virtue" becomes Shamela's "Vartue," the stripping away of the veil of the virtuous Pamela reveals the bawdy Shamela, Fielding's equivalent of Hogarth's Harlot, beneath her ladylike pretensions.

In the context of Fielding's satiric plays and journalism of 1736–1739, it is clear that he reads Pamela in the Walpolian context of progressive individualism as the *successful* Harlot, who poses as a virtuous woman.[8] The basis of Fielding's rewriting of *Pamela* is still

the problem of the Great Man, the Walpolian upstart vis-à-vis the crown, the royal family, and the English nation—the bad model and its adulation and emulation. Richardson's Pamela, in this sense, is on a continuum with Fielding's Robin the butler, Tom Thumb, and Jonathan Wild, who are fulfilled in the "true" Pamela, Shamela, as types of Walpolian "greatness." The novel *Pamela* has replaced, in a more pernicious because less overt way, the prominiterial propaganda of the 1730s, and so Fielding's *Shamela* replaces and updates his own antiministerial satire.

But the replacement is of a particular sort. Hogarth showed Fielding how to socialize the political—to reencode politics as social and gender conflict, thereby producing a new fictional mode. He showed (in Nancy Armstrong's words, which she applies to Richardson and Fielding) "how a critique of the state could prove all the more effective when the political nature of that critique was concealed," though of course it is also possible (as was probably the case with Richardson) to use "the sexual contract to *cancel out* the political one," thus moving away from, replacing or sublimating politics. And this may also have been the actual effect of both Hogarth's progresses and Fielding's "novel" on their more timid epigones.[9]

But Shamela, the real Pamela, shares with the Harlot the quality of being herself merely a lusty Mandevillean woman who emulates but whose passion disastrously shows through the emulation. In her case, she follows the instruction and model of her mother and Parson Williams (Methodism, faith over works, the place-hunting clergyman), but she cannot stay out of the parson's bed and so is exposed and cast out by Mr. Booby.

In Fielding's second response to *Pamela, Joseph Andrews,* Joseph is a male Pamela, but also a male Harlot in the Harlot's precarious situation—as if to say: if we are going to rewrite the *Harlot's Progress* (as Richardson has done) and give her agency, then we have to change her gender back to male, back to the original Hercules of which she was a feminine parody in Plate 1. But the Harlot at least *chose* to come down to London; Joseph, a servant, did not even have that choice. Once in London, however, they are both without clergyman, family, or any external support; they are sought after by lustful members of the opposite sex. But unlike the Harlot, alone and unprotected in the hostile city, Joseph does have the letters of his sister Pamela and the sermons of Parson Adams; and when he is

expelled he returns to the country whence he came, seeking his beloved Fanny and his lost clergyman Adams (though running a gauntlet of *bad* clergymen).

On 10 June 1740 Fielding devoted an essay in his periodical *The Champion* to the subject of satire, making two generalizations: the first (essentially that of Steele in his *Spectators* on history painting) is that "the force of example is infinitely stronger, as well as quicker, than precept; for which Horace assigns this reason, that our eyes convey the idea more briskly to the understanding than our ears"; and second, "that we are much better and easier taught by the examples of what we are to shun, than by those which would instruct us what to pursue." The obvious instance of these two generalizations is "the ingenious Mr. Hogarth," whom Fielding says he esteems

> as one of the most useful Satyrists any Age hath produced. In his excellent Works you see the delusive Scene exposed with all the Force of Humour, and, on casting your Eyes on another Picture, you behold the dreadful and fatal consequence. I almost dare affirm that those two Works of his, which he calls the *Rake's* and the *Harlot's Progress,* are calculated more to serve the Cause of Virtue, and for the Preservation of Mankind, than all the *Folios* of Morality which have been ever written; and a sober family should no more be without them, than without the *Whole Duty of Man* in their House.

The second sentence shows that Fielding understood very well the operation of Hogarth's progresses within the genre of satire.

His next invocation of Hogarth was in his preface to *Joseph Andrews,* where he defines the "comic epic in prose" he projects in terms of Hogarth's "comic history-painting."[10] He intends to avoid the extremes of romance and burlesque, two different ways in which reality can be distorted, to glamorize and to vilify. He is, of course, reacting against *Pamela,* which he equates with the romances of *Jack the Giant Killer* and *Guy of Warwick,* but he is also steering clear of his own burlesque plays. By "burlesque" he means "the Exhibition of what is monstrous and unnatural": a Shamela, a Pistol in his own *Author's Farce,* or a Queen Ignorance in *Pasquin.* Burlesque, he argues (perhaps responding to William Somerville's reference to Hogarth as "the greatest Master in the Burlesque Way"),[11] is the literary equivalent of caricature. In order to make his point clear, he uses Hogarth's

works as an analogy. "Let us examine the Works of a Comic History-Painter," he begins, "with those Performances which the *Italians* call *Caricatura*." The one involves "the exactest copying of Nature; insomuch, that a judicious Eye instantly rejects any thing *outré;* any Liberty which the Painter hath taken with the Features of that *Alma Mater*" (he probably remembers *Boys Peeping at Nature*). But the aim of caricature is "to exhibit Monsters, not men, and all Distortions and Exaggerations whatever are within its proper Province."

> Now what *Caricatura* is in Painting, Burlesque is in Writing: and in the same manner the Comic Writer and Painter correlate to each other. And here I shall observe, that as in the former, the Painter seems to have the Advantage; so it is in the latter infinitely on the side of the Writer: for the *Monstrous* is much easier to paint than describe, and the *Ridiculous* to describe than paint. . . . He who should call the Ingenious *Hogarth* a Burlesque Painter [as Somerville had done], would, in my Opnion, do him very little Honour: for sure it is much easier, much less the Subject of Admiration, to paint a Man with a Nose, or any other Feature of a preposterous Size, or to expose him in some absurd or monstrous Attitude, than to express the Affections of Men on canvas. It hath been thought a vast Commendation of a Painter to say his Figures *seem to breathe;* but surely, it is a much greater and nobler Applause, *that they appear to think.*

By calling Hogarth's productions "comic history-paintings," and his own a "comic epic in prose," Fielding is trying, as Hogarth had done since *Boys Peeping at Nature,* to secure a place in the classical (and contemporary) hierarchy of genres higher than satire, the grotesque, or the comic. Hogarth had replaced the exaggeration of traditional history painting with a more restrainted delineation, closer to experience, and reliant on "character" rather than "caricature," on the variety rather than the exaggeration of expression; and he had displaced the grotesque elements to Old Master paintings above and to animals below.

Fielding's famous definition, "The only Source of the true Ridiculous (as it appears to me) is Affectation" (referring to that middle area between the behavior of paragon and evil which he says will be his subject), corresponds to the subject of Hogarth's progresses, but the example is now *The Distressed Poet:*

> were we to enter a poor House, and behold a wretched Family shivering with Cold and languishing with Hunger, it would not incline us

to Laughter, (at least we must have very diabolical Natures, if it would:) but should we discover there a Grate, instead of Coals, adorned with Flowers, empty Plate or China Dishes on the Sideboard, or any other Affectation of Riches and Finery either on their Persons or in their Furniture; we might then indeed be excused, for ridiculing so fantastical an Appearance. (9)

Both men are concerned with those ordinary people who act according to inappropriate ideas of themselves.

From Hogarth's theme of emulation/copying came the insight that the subject of "modern" fiction is the imitators of the great and not the great themselves. Fielding and Hogarth of course shared an admiration for *Don Quixote,* which taught them both that not romance but the reader of romance was their subject. And so in the preface to *Joseph Andrews* Fielding defines his mode as neither burlesque nor epic tragedy but a middle area, the "ridiculous"; and "affectation," the "only Source of the True Ridiculous," refers to the low affecting the manners of the high. In his first chapter he lays out his subject as the emulation by the foolish reader of Pamela (or of Colley Cibber or of Richardson himself), but behind this evocation of a false example is Pamela's own imitation ("appropriating the Manners of the highest to the lowest") of gentlewomanly manners. In the first extended comic exchange, Joseph is seen emulating the chastity of the biblical Joseph and his sister Pamela, while Lady Booby (in Joseph's biblical terms, Potiphar's wife) emulates the ranting heroine of the "She-Tragedies" (she "talked exactly as a Lady does to her Sweetheart in a stage-Play"). But the central and continuing example of affectation in *Joseph Andrews* is Mrs. Slipslop, the curate's daughter who interlards her speech with "hard words" that are beyond her comprehension and class.

Hogarth never seems to have used the term "comic history-painting" himself. Putting his thoughts on paper in the 1760s, he frequently called attention to the uniqueness of the form he had invented ("this uncommon way of Painting," "a Field unbroke up in any Country or any age"), which echoes Fielding's similar claims for his form; he called his works "modern moral subjects," but he recalls Fielding when he emphasizes that painters and writers "never mention, in the historical way of any intermediate species of subjects for painting between the sublime and the grotesque," whereas he believes that the "subject[s] of most consequence are those that most

entertain and Improve the mind and are of public utility," and that "true comedy" is a more economical and difficult genre, closer to reality, than high-flown tragedy, which he tends to associate with sublime history painting (AN, 208, 212, 215–16).

But Fielding's distinction between the ridiculous (affectation) and detestation is an important departure from Hogarth. He will include figures like Hogarth's Gonson, Charteris, and the Bridewell warder but only if they are incidental, peripheral, unable to carry through their wicked intentions, and are punished. Fielding's three terms for the Hogarth print in his *Champion* essay were (1) "the *delusive* scene (2) *exposed* with all the Force of Humour," followed by (3) "another Picture [in which] you behold the dreadful and fatal Consequence." Fielding carries out the first two but omits the third, or (as with Joseph's or Tom's incest) promises and then withdraws it. In short, he writes less from the experience of *A Harlot's Progress* than of *The Distressed Poet* and the single or juxtaposed prints of 1737–1741, which correspond to his own brighter, more comic vision. The most important difference between Fielding and Hogarth is in the matter of rigorous consequences: Hogarth's Tom Jones would have died of tertiary syphilis or at the very least suffered a clap. Hogarth's works are "comic" in another sense, one also evident in Fielding's novels but not part of his definition: comedy lies in the wit of the telling, in the *how* of the narrating of events; and this is the element Hogarth shares with—indeed we might say he offers a graphic precedent for—Fielding's major prose fiction.

In *Joseph Andrews* Fielding begins the complimentary allusions to Hogarth that continue through the remainder of his fiction (and were echoed by other novelists). Explaining the impossibility of describing Lady Booby's appearance after Joseph proclaims his love of virtue, he adds, "no, not from the inimitable Pencil of my Friend *Hogarth,* could you receive such an Idea of Surprize," and Mrs. Towwouse is so striking "that *Hogarth* himself never gave more Expression to a Picture" (1.14, 61).

In the sixth chapter of Book 3 he has Joseph link Hogarth's name with homophones of Italian "masters": "Ammyconni" for Amigoni, whose success may have led Hogarth to turn to sublime history, carries overtones of "cony," and perhaps less presentable puns; "Paul Varnish" for Veronese, with the suggestion that his paintings were

valued by English collectors primarily because of their varnishing; and "Hannibal Scratchi" for Annibale Carracci, which probably alludes to his caricatures. (Such corruptions were apparent every day in the auction lists in the papers that advertised works by Hannibal Carrots, and indeed Paul Varnish.) And in this dubious company Joseph puts the Italianate form of Hogarth's name, "Hogarthi." Fielding is having his little joke, giving them names that indicate Hogarth's reservations about the Old Masters.[12]

In fact, Joseph is talking about charity, the opposite of which, he says, is the man who chooses instead "to build fine houses, to purchase fine furniture, pictures, and clothes, and other things, at a great expense." We reverence the man who does a charitable deed

> infinitely more than the Possessor of all those other things; which, when we so admire, we rather praise the Builder, the Workman, the Painter, the Laceman, the Taylor, and the rest, by whose Ingenuity they are produced, than the Person who by his Money makes them his own. For my own part, when I have waited behind my Lady in a Room hung with fine Pictures, while I have been looking at them I have never once thought of their Owner, nor hath any one else, as I ever observed; for when it has been asked whose Picture that was, it was never once answered, the Master's of the House; but *Ammyconni, Paul Varnish, Hannibal Scratchi,* or *Hogarthi,* which I suppose were the Names of the Painters . . . (234)

In this passage Fielding shows that he not only has understood Hogarth's program in the *Harlot's* and *Rake's Progress,* and probably read the "Britophil" essay, but is pointing to the Hogarthian (Lockean) theory of property as regards art works: they belong to the maker, not the patron or purchaser. The passage—were it not prefigured already in Hogarth's graphic works—could be a proposal for *Marriage A-la-Mode.*

JOSEPH ANDREWS AND HOGARTH'S *GOOD SAMARITAN*

As the central paradigm of charity in *Joseph Andrews* Fielding used Hogarth's *Good Samaritan* painting. When Joseph encounters the robbers on the highway, we recall the Good Samaritan because the story

and setting are similar, but also because before Joseph leaves London he has already been associated with the biblical Joseph, as Parson Abraham Adams is with the biblical Abraham. After Joseph is left for dead by the robbers and responded to by the coach load of Pharisees and Levites with its one Good Samaritan (a poor postilion), he is carried to the Tow-wouses' inn and submitted to another Good Samaritan scenario, the one charitable person being a promiscuous chambermaid. The parable remains a kind of armature supporting behavior patterns during the rest of the journey to Booby Hall.

The graphic is valorized in *Joseph Andrews*. By bad "examples" Fielding means the literary models of Richardson's Pamela and Colley Cibber's "Colley Cibber"—both as characters and as written narratives that allegorize and theatricalize existential experience. He follows Locke's emphasis on the corporeality, the immediate sensory quality, essential to a good example. The good man is thus preferable to "a good Book," but it is possible for a writer "to present amiable Pictures to those who have not the Happiness of knowing the Originals" (17). Books, by contrast, are "written in obsolete, and as they are generally thought, unintelligible languages"; and even in "our own language," the chapbooks, popular nursery tales of Jack the Giant Killer and others have only led to Cibber's *Apology* and Richardson's *Pamela*. The biblical "Joseph" does not fit the real Joseph Andrews any more than the models of Pamela's letters and Parson Adams's sermons, to which Joseph at the moment gives credit for saving him from the arms of Lady Booby. In fact it was his love of Fanny Goodwill. Even Adams's sermons fall short of Joseph's immediate human contact with Fanny.

It is for this unmediated experience that Fielding turns to Hogarth, because there is more immediacy in pictures than even in his own writing. Therefore, at those moments when words fail, he must invoke "the inimitable pencil of my friend Hogarth." And therefore Hogarth's paintings of Charity in St. Bartholomew's Hospital—visible and public images, part of the London landscape and the popular consciousness—are more immediate than the words of the New Testament parable.

If Fielding agrees with Hogarth on the primacy of the visual image, it is not certain whether at this time they also agreed on the subject of Deism. In *The Champion* (1740) Fielding condemned ethical Deism but avoided the subject of critical Deism. There are traces of the former in his work prior to his marriage and of the latter prior

to his becoming a public spokesman of orthodoxy in 1748–1749. He plainly distrusts the authority of biblical (indeed, all) texts, names clergymen Puzzletext, Murdertext, and Tickletext, and attacks the textual basis of *Pamela* as if it were Scripture and he were Woolston or the Hogarth of *A Harlot's Progress*. The third volume of Thomas Morgan's widely discussed Deist tract, *The Moral Philosopher* (1740), had treated Joseph and Abraham much as Woolston had treated Christ. In the same way, Fielding corrects the implausibilities of the biblical story and "unveils" the real contemporary Joseph and Abraham under the biblical paragons.[13]

Fielding, however, has an order of priority: Joseph and Fanny's embrace supersedes Adams's beloved *Aeschylus,* as the Good Samaritan supersedes Joseph and Potiphar's Wife. The New Testament—left unquestioned in *Joseph Andrews*—is to be preferred to pagan classics and the Old Testament. Thus the model of Abraham causes Parson Abraham Adams to defend the father's sacrifice of his son, which is corrected by his human (NT) reaction when he hears his son has drowned. The paradigmatic OT story was Abraham's sacrifice of Isaac, which Hogarth affixed to his Harlot's wall; it summed up the patriarchal family, filial obedience, and arbitrary justice, while the NT story was Christ's attempt to bring man back to the undefiled source of religion in love—this in opposition to a clergy that exalts the OT law. Like Hogarth at St. Bartholomew's, Fielding stresses the Samaritan's alienation from the law: the postilion is later transported for robbing a hen roost, as Betty is discharged for being found in bed with her master. Betty, in fact, recalls Hogarth's Sarah Young, whose caritas was a development out of a frustrated eros. The problematization of the motivations for a charitable act (perhaps already overdetermined by the precedent of Pamela) derives from the conflation of the St. Bartholomew's pictures with the *Rake's Progress,* and it suggests that for Fielding, as for Hogarth, the context of the St. Bartholomew's images included the *Rake's Progress*.[14]

For another graphic model that is privileged in *Joseph Andrews* is the "Rake's Progress," recited by Mr. Wilson and employed as a normative element in the novel. The narrative of Mr. Wilson is Fielding's central edifying narrative presented as a sequence plainly modeled on Hogarth's series. Wilson goes through the phases, from overturning the wishes of his dead father to spending his inheritance on "Dancing, fencing, Riding the great Horse, and Music," pursuing women, suffering one clap after another, and debauching a Sarah

Young-like girl—pausing along the way to evoke *Harlot* 2 when he finds his mistress "at my Chambers in too familiar Conversation with a young Fellow, who was drest like an Officer, but was indeed a City Apprentice." He attends upon the great at their levees, gambles, loses his money, is arrested for debt, and goes to prison, "crowded in with a great Number of miserable Wretches." Along the way he tries to survive by writing plays (as the Rake does in Plate 7). He is finally saved by another Sarah Young, though (characteristically for Fielding) not the young woman he debauched but a pure and untouched woman who can (unlike Sarah) perform a disinterested act of charity. Of course, many of the details apply as well to Fielding himself—from gambling to playwriting to the providential appearance of Charlotte Cradock. Perhaps he has used Hogarth's *Rake* to distance and structure his personal experiences.

It is a curious fact—which will have consequences—that Fielding has misread Hogarth's sense of "affectation." This is partly because he cites *The Distressed Poet* rather than the progresses. The former involves literary affectation, and Fielding's training was in the literary satire of Pope and in the classical canon he exalted. In discussing comedy he begins with its subject (as defined by Aristotle): the poor, ugly, and deformed. He seems unusually concerned, however, with the first of these and is at pains to explain how the poor could be the subject of comedy. His example recalls *The Distressed Poet* but elides the crucial fact that it represented a *poet's* chamber: for him the poor become risible when they fill their cold grate with flowers and decorate their empty sideboard with china dishes.

In the narrative of *Joseph Andrews* poverty is an important subject (Adams and Joseph are always short of money). Affectation, however, follows the example of Pope's dunces and Hogarth's poet: the fishwife trying to speak like and indeed read Dido, the exemplary Dido, when only genteel Didos are capable of reading, understanding, and reproducing the diction of Dido.[15] Recalling his starting point in Pope's *poor* poet in the *Dunciad,* we see that in his theory the poor can become comic only when they are connected with literacy, or poverty with the writing of poetry. Fielding's immediate emphasis, of course, coming from his reaction to *Pamela,* is on the poor servant who imitates gentility in order to rise above her station, specifically by writing.[16]

Fielding's misreading of Hogarth is evident if we recall the distinction in the *Harlot's Progress* between the Jew, who has money and power, and the Harlot who is poor and powerless. Both are "affected," but the Jew could be comic (cuckolds were traditionally comic butts); the Harlot was not comic, not finally (in Fielding's sense) "ridiculous." Hogarth must, after the fact of *Joseph Andrews* and its preface, have realized this.

Once Fielding argued in effect that affectation of literacy is the way to make the poor a subject of comedy, Hogarth responded in two ways: first by looking up to his betters and creating a comedy of the rich in *Marriage A-la-mode* (1745), and then by looking down to the poor but without affectation, vanity, or pretension (let alone hypocrisy) and basing the structure of *Industry and Idleness* (1747) on the contrast of those qualities, of Francis Goodchild and Tom Idle, who are opposites, not one emulating the other, and whose comedy—if it is comedy—is in the way they cancel each other out.

9.

MARRIAGE A-LA-MODE,
1742–1745

TASTE IN HIGH LIFE AND MARY EDWARDS

In 1742 Hogarth carried out a commission for Mary Edwards of Kensington, the wealthy heiress who seems to have been his most staunch patron. She asked him to paint a satire on contemporary fashions of dress and furnishings (fig. 85). The story goes that friends had made fun of her old-fashioned dress, perhaps in general her strong-minded eccentricities (which numbered among them her patronage of Hogarth); so she paid him 60 guineas to portray the fashion, largely transplanted from France, of the year 1742. The central male figure, whom she must have designated, has been identified as the second Lord Portmore (who at the queen's birthday party in 1731 "was said to have the richest Dress, though an *Italian* Count had 24 Diamonds instead of Buttons").[1] But if the design originated with Mary Edwards, it was based on assumptions she had learned from Hogarth.

Taste in High Life (sometimes called *Taste à la Mode*) is a transitional work, anticipating much that was to occupy Hogarth over the next decade in both *Marriage A-la-mode* and *The Analysis of Beauty.* More plainly than in *Morning* or *Strolling Actresses,* he concerns himself with the constricting and finally mutilating effect of imitation, and he links fashion to art objects (specifically paintings). Although on the old 25 × 30 inch canvas used in the 1730s, the themes are laid out that will be elaborated in *Marriage A-la-mode,* which followed immediately: (1) The inscription on the pedestal of the statue (in the painting on the wall) indicates "*the Mode 1742.*" (2) A monkey on the floor, who resembles the beau (as he had in *Harlot* 2), wearing a similar costume and reading a menu, indicates *Imitatio.* (3) The imi-

tation is French: he reads, with a monocle, *"Pour Dinner Cox combs / Ducks Tongues / Rabbits Ears / Fricasey / of Snails / Grande / d'oeufs / Beurre."* (4) A black slave boy, dressed according to the current fashion and holding a statue of a Chinese mandarin (the rage for chinoiserie), is having his chin chucked by a lady. (5) She seems to have lost to him at cards: on the floor is a bill, *"Lady Basto / Dr to In Pip / / for Cards . . . Total 300,"* which would indicate that he has won at cards with his owner. Cards, dominoes (at left foreground), and the tiny creature on a handkerchief and a cushion, perhaps a baby squirrel (at right), are the company's diversion. (6) There are more pictures on the walls than ever before; for the first time they occupy more space than the people, seemingly forcing the central lady and beau to bend their heads.

A picture on the left shows Philippe Desnoyer, the fashionable dancer (cf. Hogarth's *Charmers of the Age, HGW,* no. 153 [159]), surrounded by butterflies, wasps, and a dragonfly, classified as *"Insects"*; one on the right shows caps, hoops, solitaires, wigs, muffs, and high French-heeled shoes, labeled *"Exoticks."* The large central painting shows the Venus de Medici in a hoop petticoat, cut away to expose the contrast between this stylish article and her own body; her legs are deformed by wearing high-heeled shoes. At the left a cupid is fanning a fire kindled by a hoop, muff, and bagwigs and queues. In the distance another cupid pares down the contour of a young woman to make her figure conform to the mode. The flanking rondels have a blind man and a woman in a huge hoop skirt which puts her in much the same hazard concerning her surroundings as the blind man. On a fire screen is a woman being carried in a sedan chair, her hoop (much too large for the enclosure) rising crushingly on either side of her (Hogarth used her later in *Beer Street,* ill., vol. 3). In *Marriage A-la-mode "the Mode 1742"* will become the situation of the young couple forced into a contracted marriage, and the power of fashion will be reflected in the costumes and art objects crowding their rooms, dominating both rooms and owners.

One wonders, in fact, if Mary Edwards was not seeing something of her own relationship to fashionable London society in the oppressive character Hogarth gives it in his painting. She may even have urged upon him the subject of *Marriage A-la-mode,* the story of a young heiress courted by a handsome, profligate young lord and his title-heavy but purse-light family, and their subsequent unhappy marriage. There are overtones of her own unhappy marriage in the

first plate—but the final conception (which she did not live to see) showed the degeneration of both husband and wife.

In 1728 Mary Edwards inherited from her father, Francis Edwards of Welham, an enormous fortune completely unencumbered and at her own disposal (her mother, wealthy in her own right, renounced all claims). At twenty-four she became the greatest heiress in England, said to enjoy an annual income of between £50,000 and £100,000, with extensive properties. She naturally attracted fortune hunters, and was dazzled by a young Scot five years her junior, resplendent in guardsman's uniform, with the fine name Lord Anne Hamilton (after his godmother, Queen Anne) and the fourth duke of Hamilton for his father.[2] She was a country girl who had seen little of London or the great world. She fell under the dashing nobleman's spell and their romance led to a hasty Fleet wedding in 1731.[3]

On 4 March 1732/33 a son, Gerard Anne, named after Lord Anne and his mother's family, was born, and within the year Mary commissioned Hogarth to paint the child in his cradle (fig. 86).[4] In 1733 Mary Edwards commissioned a conversation of her family. They are posing on the terrace of the Edwardses' house in Kensington, and Mary holds a copy of the *Spectator* open at a passage on the virtuous rearing of children (private collection).

The catastrophe of her marriage was by this time apparent to Mary Edwards. Lord Anne was spending her money like water; on 15 August 1733 he secured the arms and crest of Mary Edwards to himself and "the heirs of his body"; this grant had been ratified on 2 July under Mary Edwards's own hand and seal, giving, granting, assigning, and transferring her coat and crest to her husband. By 22 September he had taken the name of Edwards in addition to his own, as seen in the £1,200 of bank stock inscribed in the name of the "Right Honourable Edwards Hamilton" which he transferred from his wife's account to his own. Mary must have seen what was happening. There were the child's interests to safeguard, and she had no apparent recourse: no married woman's property act, and of course no marriage settlement.

One thinks of Hogarth, harried at about the same time by pirates and seeking a way out of an equally hopeless situation. Both, by ingenuity and perseverance, succeeded. While he turned to the law, however, she made use of the fact that her marriage had been clandestine. There had been no contract, and she simply effaced all record of the transaction, from the registers of the Fleet Chaplains to those of the

church where the child was baptized. She replaced the latter with a notice in the register of the church of St. Mary Abbots, Kensington, on 28 March 1734, describing herself as a single woman and making her child a bastard. She was willing to assume this equivocal reputation to save her fortune for herself and her child. On 22 May 1734 Lord Anne signed a deed executed by "Mary Edwards, spinster, and the Honorable Anne Hamilton alias Anne Edwards Hamilton," which declared all the property returned to Miss Edwards. On 20 June the £1,200 of bank stock was transferred back to her account.

Having recovered her property, she carried on her own financial affairs, assisted by legal advisors—as is attested by the great mass of deeds, leases, and agreements that survived in the family. In 1734 or 1735, she bought from Hogarth the completed painting of *Southwark Fair.* This was a remarkable act for a woman and a spinster. She may have bought other works as well which, like *Southwark Fair,* were not retained in the family after her death.[5]

Sometime in 1740 Hogarth painted a portrait of Mary Edwards in a flagrantly red dress—one of his strongest portraits (fig. 87)—holding lines on English liberty ("Do thou great Liberty inspire their Souls") which are very much in line with the ideal behind *Taste à la Mode.*[6] She made her will on 13 April 1742, leaving everything to her son, and characteristically ordering that her funeral be "without plumes or escutcheons on my hearse, and in all respects as private as is consistent with decency."[7] She died on 23 August 1743, as Hogarth was still working on the paintings of *Marriage A-la-mode.* She was thirty-eight years old.

Coming from the country and falling under the spell of "seducers," she may have associated herself ironically with Hogarth's Harlot. Her bold decision to declare herself one and her son a bastard, as well as the apparent sense of humor that led her to patronize Hogarth, may support the supposition. Whether or not she had a hand in *Marriage A-la-mode,* she had encouraged Hogarth to return to his modern history mode and specifically to the subject of fashion in high life.[8]

CHARACTERS AND CARICATURAS

A letter to Caleb D'Anvers in the *Craftsman,* 12 January 1742/43, misrepresented Fielding's contrast between caricature and character

as one between caricature and the beautiful: "The *outré,* or Extravagant, requires but a very little Portion of Genius to hit. Any Dauber, almost may make a shift to portray a *Saracen's* Head; but a Master, only, can express the delicate, dimpled Softness of Infancy, the opening Bloom of Beauty, or the happy Negligence of Graceful Gentility." This reference may have been the specific goad that led Hogarth to produce in the next month or so the etching *Characters and Caricaturas* (fig. 88) as subscription ticket for his new series, *Marriage A-la-mode.* He replies to Fielding's complimentary reference to him in the preface to *Joseph Andrews,* follows Fielding's terminology, and makes the connection explicit at the bottom of the print: "See yᵉ Preface to Joʰ. Andrews." At the bottom center of the cloud of faces representing "character" are, grinning at each other, likenesses of Hogarth the "comic history-painter" and Fielding the "comic epic in prose" writer. Hogarth's face anticipates the self-portrait profile of 1748 but with the mobcap of *Self-Portrait with Pug* (figs. 127, 105); Fielding's has the long nose for which he was famous (cf. the posthumous profile by Hogarth, the only authentic portrait, of 1762, ill., vol. 3).[9]

They represent "character." Underneath, Hogarth portrays idealized heads ("beautiful" in the *Craftsman's* terms) of St. John and St. Paul and places between them what would ordinarily have been considered a grotesque or "caricatured" head of a beggar. But all three are copied from the Raphael Cartoons, the generally accepted example of great history painting. With these he contrasts caricatures by Ghezzi, the Carracci, and Leonardo. Above them rises a mass of different, individualized faces that express the variety of character—like Raphael's beggar rather than either the caricatures *or* the idealized faces.[10] His point is to demonstrate that *Marriage A-la-mode* and his other series are not descended from caricature but are in fact part of the great genre of history painting. *Marriage A-la-mode,* as the subscription ticket announces, will be about "character," and in his advertisements Hogarth emphasizes that while French engravers are going to provide the required elegance of the engraving of the plates, *he* will do the faces himself, the "character."

But "caricature," from the Italian *caricare* (the French *charger*) to Hogarth includes a sense of compulsion—the effect of monstrously distorted stereotypes, including those of the past and of parents. These "caricatures" within *Marriage A-la-mode* shape and distort the "characters" of their children into "caricatures," as, for example, the

alderman's daughter becomes an adulteress, a murderess, and a suicide.

There is a detail that has not been explained in *Characters and Caricaturas*. Fielding and Hogarth are grinning at each other, as if sharing a good joke. But Hogarth's head is attached to another, growing out of the back of his head, clearly indicated by the shading of the neck that joins the two faces into a Janus. No other face in the print is attached to another. This gently smiling (vs. grinning) face, the only female face shown, I take to be Jane's—nor do I doubt that Hogarth was playing on the words Jane-Janus (Jane-us). He is showing the other, gentler aspect of himself, but he is also introducing with this ticket *Marriage A-la-mode,* a series about a bad marriage, with an allusion to his own happy marriage. And he is implying yet another of his Trinities—this time, at this moment, the fraternal Fielding and himself with Jane. For corroboration there are only the two surviving portraits of Jane—one with the mouth of the face in *Characters and Caricaturas* (fig. 89).[11]

MARRIAGE A-LA-MODE

In the *London Daily Post and General Advertiser* of 2 April 1743 appeared an advertisement:

> MR. HOGARTH intends to publish by Subscription, SIX PRINTS from Copper-Plates, engrav'd by the best Masters in Paris, after his own Paintings; representing a Variety of *Modern Occurrences* in *High-Life,* and call'd MARRIAGE A-LA-MODE.
>
> Particular care will be taken, that there may not be the least Objection to the Decency or Elegancy of the whole Work, and that none of the Characters represented shall be personal.
>
> The Subscription will be One Guinea, Half to be paid on Subscribing, and the other half on the Delivery of the Prints, which will be with all possible Speed, the Author being determin'd to engage in no other Work till this is compleated.
>
> N.B. The Price will be One Guinea and an Half, after the Subscription is over, and no *Copies* will be made of them.

When the advertisement next appeared, in the issue of 4 April, a parenthesis was added after "his own Paintings": "(the Heads for the

better Preservation of the Characters and Expressions to be done by the Author:)." These notices were repeated in the *London Daily Post* and the *London Evening Post* off and on until the end of July. Hogarth lived up to his word, except for "with all possible Speed": the other precautions listed seem to have canceled out any idea of haste in the project.

As he grew older he put more of himself into his advertisements. In the one for *Marriage A-la-mode* he is careful to note that he is going to use French engravers, though he will do the heads himself "for the better Preservation of the Characters and Expressions" (a reference to his subscription ticket, *Characters and Caricaturas*); that there can be no objection to "the Decency or Elegancy of the Whole Work"; and that no particular contemporaries will be portrayed. Finally, he emphasizes that (appropriately, considering what has gone before) it will deal with "a Variety of modern Occurrences in High Life."

"Elegancy" and high life were evidently intended by Hogarth as the keynotes of the new series. The subscription was announced in April, and by the first of May he was on his way to Paris—"to cultivate or improve his Stock of Ass[urance]," according to Vertue (3: 116). It is strange that nothing is known of this trip, Hogarth's first visit to Paris and direct contact with Continental art, save for its possible influence on his works: in the LeSueur version (based on Titian) of *The Martyrdom of St. Lawrence,* and perhaps the other pictures shown in the first plate of *Marriage A-la-mode,* and in the style of the portrait of Archbishop Herring, which may have been revised in the light of his French experience. It seems likely that he had not finished, or more than begun, the paintings of *Marriage A-la-mode* before he left for France: from the evidence of the finished paintings, he picked up a new lightness and fluency of touch, in the French manner.

His primary purpose for visiting France, however, was to secure French engravers for his project. It was not long before Vertue was noting that "M^r Hogarth I am told has got over a young Engraver from Paris to assist him in his plates or to work for him—this according to custom was told to me—not to comfort me—so much as to shew (their malicious) envy" (3: 20). Vertue's words strongly imply that he has felt all along that if Hogarth is using other engravers on his works they should include him; but he completely misses Hogarth's point. Whenever he had used engravers before—and one can

only guess at the extent—he minimized (and perhaps even concealed) their share in the work. With *Marriage A-la-mode,* with its Frenchified title and fashionable scenes, he advertised the fact and attached the engravers' French names to each print.

As usual, he had trouble with his engravers. Vertue remarked on the large amount of money he was forced to pay them, but in this case Hogarth apparently thought it was worth paying. According to George Steevens, he struck "a hard bargain" with Simon François Ravenet, who had come to England to work for him, and "the price proved far inadequate to the labour" of the two plates he engraved. "He remonstrated, but could obtain no augmentation." Years later when he had a large English clientele, he was asked by Hogarth to engrave *Sigismunda* and indignantly refused—though another report says he was under contract to Boydell at the time and this was his excuse. It is true that Ravenet did no more engraving directly for Hogarth (he engraved various of Hogarth's designs for third parties).[12]

The *General Advertiser* of 24 April 1744 announced that the plates "are now Engraving" and "will be finish'd with all convenient Speed." Subscriptions would continue to be taken until the first of May, and the subscription did close on that day, the maximum number having been accepted, a year before the plates were finally completed.

It was at this time, as *Marriage A-la-mode* was being prepared for publication, that war broke out with France; early in 1744 an invasion was feared. Hogarth had apparently intended, and arranged, to send his paintings to Paris to be engraved—evidently he had only finally finished them to his satisfaction around the time the war began. The long advertisement he printed in the *Daily Advertiser* for 8 November 1744 tells the rest. It begins with a stopgap, an announcement of the republication of the *Harlot's Progress*—the public's first opportunity to obtain the original work since its publication twelve years before; also perhaps a preparation for the eventual auction of the paintings. It goes on to explain the delay in the appearance of his new series.

> Note, the six Prints, call'd *Marriage A-la-Mode,* are in great Forwardness, and will be ready (unless some unforeseen Accident should intervene) before Lady-Day next; Notice of which will be given in the Papers.

In the Month of June 1743, the following French Masters, Mess. Baron, Ravenet, Scotin, Le Bas, Dupré, and Suberan, had entered in an Agreement with the Author, (who took a Journey to Paris for that sole Purpose) to engrave the above Work in their best Manner, each of them being to take one Plate for the Sake of Expedition; but the War with France breaking out soon after, it was judged neither safe nor proper on any Account, to trust the original Paintings out of England, much less to be engrav'd at Paris: And the three latter Gentlemen not being able, on Account of their Families, to come over hither, the Author was necessitated to agree with the three former to finish the Work here, each undertaking two Plates.

The Author thinks it needless to make any other Apology for the Engravings being done in England, than this true State of the Case, none being so weak as to imagine these very Masters, (who stood in the first Rank of their Profession when at Paris) will perform worse here in London; but more probably on the contrary, as the Work will be carried on immediately under the Author's own Inspection.

And he begs Leave to assure the Publick, that this Work will not in the least be retarded by the Publication of the *Harlot's Progress,* those Plates being ready for printing off immediately, and not at all the worse for the Number formerly published: Neither has there been, or will there be any Time lost with regard to the present Work, the Gentlemen having agreed to engage in no other Business till this shall be finished.

At this time, then, Hogarth himself was adding the cross at the bottom of the *Harlot* plates and making a few revisions to distinguish the second from the first edition.

His advertisement, of a record length, did not go unnoticed. Orator Henley, always anxious to be topical and ridicule the ridiculous, published an advertisement for an oration on the subject, and Vertue noted both in his notebook:

an Extraordinary Advertisement in the news paper. Nov. 1744. from Mr Hogarth about

6 Engravers at Paris he had Engaged to work for him, to graven his plates of Marriage a la Mode—

the Warrs prevented their comeing to London—3 only here—came

the Orator Henley—seeing this Puff. proposed at his assembly a Moral Consideration of the little Game Cock of Covent Garden—against. 4 Shakebaggs—meaning four print sellers of London—2. Mr

Bowles. & 2 Mr Overtons. who had sold & publisht. coppys always of Hogarths plates—now he defyes them—haveing an Act of Parliament on his side. (6: 134)

This oration (delivered in Henley's chapel at the corner of Lincoln's Inn Fields, near Clare Market, at 6 in the evening) was announced in Henley's advertisement in the *Daily Advertiser,* 10 November, and repeated 17 November.[13]

In short, Hogarth seemed to be giving this ambitious series a great deal of fanfare. Joshua Reynolds, who was in London at this time, recalled that Hogarth had told him, "I shall very soon be able to gratify the world with such a sight as they have never seen equalled!"[14] He evidently wished to think of himself as a painter— the "comic history-painter" of Fielding's designation—rather than as an engraver; and this explains his emphasis on the "French Masters" who were going to engrave his paintings, as well as the careful painting of the pictures, and the announcement that accompanied the last stages of the subscription that all his paintings of this sort would soon be auctioned.

The paintings were made once again in reverse—which might mean that he had originally planned to engrave them himself; ordinarily a professional copy-engraver produced a direct image of the original, and must have been instructed in this case to reverse the series. The difference is clear in 2 (figs. 92, 93): the engraving carries the eye from left to right, from husband to wife, from the disharmonious couple to the consequence of their way of life—their estate steward throwing up his hands in despair. In the painting, the steward is on the left, ushering us into the picture, as if presenting us with another genre scene.

Plate 1 (fig. 91) directs the viewer's eye from the earl to the merchant to the children. The figure of the earl is dominant; the men at the table appear to be paying him homage. Although we learn from "reading" that a bargain has been struck, the formal relationships emphasize social hierarchy. In the painting (fig. 90), however, this pattern is disrupted by the large red area of the merchant's coat in the center of the canvas.[15] The painting does not lead the reader in through the figure of the earl but instead balances the two groups, whereas in the print they are causally related, from left to right: the parents' greed *produced* the manacled children.

But the priority of shape, texture, and color draws attention to a

pattern that is invisible in the print. The manacled dogs and the young couple begin a long undulating curve that runs across the entire picture from left to right, interrupted by the upright figure of the usurer. The soft curves of the people, though hardening in the stiff posture of the earl and the jutting discontinuity of the usurer, are played against the geometrical angles of the picture frames. But taken altogether the pictures also make a gentle curve over the heads of the humans, their hard edges floating above the soft curves of bodies. They no longer weigh down on these people, as in the engraving.

One is initially aware of pinks, greens, and golds, and these colors and the texture of the paint hold the attention, producing an independent pattern, making it much more difficult to get to the details and inscriptions. The colors may have cognitive importance of their own, as with the salmon red of the large, confident area of the merchant's coat, which is contrasted with the faded pinkish attire of the decadent earl; but mainly they fix our attention on these two shapes in relation to the large area of green velvet wall with gold picture frames. The paintings, themselves part of a pattern of color and texture, resist the intense scrutiny they invite in the print. We are held by simpler, more expressive structures than are allowed to emerge in the print.

Moreover, the style of Hogarth's painting has changed. He now fills in (or finishes) every space; the neutral background has become a series of distinct areas in solid color and the canvas a complete mosaic of different but related planes and colors. Robert Wark has argued that the lack of "compelling focus" depends "on such factors as color, light and shadow, and paint application. There is no broad massing of light and shadow to direct one's attention. The colors, fairly high in intensity and value, often meet one another abruptly, with little gradation of tone to soften the transition." [16] This effect should, however, be contrasted with the opposite effect in the earlier paintings, in which there is indeed a "broad massing of light and shadow to direct one's attention." *Marriage A-la-mode* is Hogarth's half-way house between the shimmering tones and strong contrasts of the earlier paintings and the large flat areas of color in *The Election* (1754).

His intention in this case was presumably (following the example of *The Four Times of the Day*) to make the paintings primary, the engravings secondary; to make a salable object, which the connois-

seur would want to buy; and at the same time, with the relatively clear demarcations, offer a precise cartoon for the foreign engravers to work from. Indeed, the paintings are so detailed that there are segments (e.g., Pl. 6, the emblems on either side of the gallows on Silvertongues's last speech) that do not get into the engraving, which the engravers could not render as clearly as Hogarth's brush. The hiring of French engravers represented not only the importance of the project but the need for a particular elegance of style that was precisely *un*-English. The French, indeed "rococo" style suggests both a story about aristocratic love and a foreign, aristocratic decadence that is confirmed by the content.

A "COMIC HISTORY-PAINTING"

The title, though it merely refers to a "fashionable" marriage or a *mariage de convenance,* may have come from Dryden's old comedy, *Marriage à la Mode* (1673), and Cibber's adaptation of it, *Marriage à la Mode; or, The Comical Lovers* (1707); Tonson's reprint of Dryden's play in 1735 may have brought it to Hogarth's attention if he did not already know it.[17] The plot concerns a son ordered by his rich old father to marry the unseen daughter of another rich old man; marriages, based on a cash nexus, involve couples whose affections are directed elsewhere; a masquerade assignation leads to a challenge to a duel.[18]

The forced marriage, however, had long been a theatrical convention.[19] Moreover, the *Spectator* habitually argued that marriage can only be based on love (e.g., No. 268), that disaster follows upon a marriage arranged by parents (Nos. 220, 533), and that a marriage between a man of money without class and a lady of quality without money is bound to end in unhappiness (No. 299).[20] A contrary example to that of the young couple in *Marriage A-la-mode* was presented in early 1744, just as Hogarth's subscription closed: Henry Fox eloped with Lady Caroline Lennox, the daughter of the duke of Richmond (see above, *A Scene from "The Indian Emperor"* and *Lord Hervey and His Friends,* figs. 1, 79). Fox, who later fought the Marriage Act (1753) which attempted to prevent such evasions of family control over marriages, may already have seen Hogarth's paintings for the series; he collected Hogarth's prints. The subject and the mo-

tifs, in short, were both commonplaces and at the same time carried contemporary relevance. Pamela, writing in her journal about marriage, its "misunderstandings, quarrels, appeals, ineffectual reconciliations, separations, elopements; or, at best, indifference; perhaps, aversion," had added: "Memorandum: *A good image of unhappy Wedlock, in the Words* YAWNING HUSBAND, *and* VAPOURISH WIFE, *when together:—But* separate, *both quite alive.*"[21] In Plate 2 Hogarth has reversed the husband and wife—she is yawning—but otherwise the description is wonderfully apt and may have been in his mind.

The obvious sources for *Marriage A-la-mode* are dramatic—as of course they were to some extent for Fielding's novels. But it also seems reasonable to suppose that the immediate effect of Fielding's *Joseph Andrews* was to encourage Hogarth to produce a series that demonstrated the claims made for him in the preface. Seeing how much *Joseph Andrews* owed to his progresses of the 1730s, he may have decided to see how far he could carry the new form in the graphic medium. In some ways Hogarth makes *Marriage A-la-mode* more "novelistic" than *Joseph Andrews*—more in line with *Pamela*—by closer social observation, denser relationships centered on a family, and outward-extending references into family history of the sort Maurice Morgann was to argue Shakespeare projected in his characters.[22]

The reading structure is the most complex, the most literary and "novelistic," ever attempted by Hogarth. The visual mode focuses on a detail, whose significance acts both as the projector of a narrative—a sequence of events in time—and as a "character" or moral emblem.[23] In the second scene we see a lady's bonnet protruding from the husband's pocket, and Hogarth makes its meaning unmistakable by having (as usual) a dog sniff at it suspiciously and by showing the wife wearing *her* bonnet. This small detail implies a story of an encounter earlier that night with another woman, of perfume, carelessness, and infidelity—and it projects into the next scene, where the wearer of the bonnet appears. But it also creates an emblem of the *Unfaithful* Husband. The broken sword lying at his feet tells a story of a skirmish with the night watch and creates an emblem of the *Inadequate* Husband.

And these, combined with the literally "distant" wife, the gaping fireplace between them (suggesting the "emptiness" of their marriage as well as the "gap" between them), and the jumbled bric-a-brac on the mantel, become both narrative and emblem of a dissolving marriage. The Cupid, sitting amid ruined pieces of masonry,

who should be playing a lyre, plays a bagpipe, with the associations of cacophany and (especially in Watteau's *fêtes*) of the male sexual organ.[24] This image of disharmony and intrusive sexuality is supported by all the other details, including the bonnet and the sword.

But the reference in 2 is dense in another way: we simply learn a great deal about the countess. Two violins, an overturned chair, and an open music score are evidence of a duet followed by a hasty departure and project a story of an interloping musician. The husband sits on the twin of the overturned chair (which itself recalls the significance of the overturned furniture in 5 and in *After*). These and other references to music suggest that the interloper is the lawyer whose name proves (in 6) to be Silvertongue and who shares the countess's enjoyment of concerts (4). The book labeled "Hoyle on Whist" shows that she has been playing the fashionable card game popularized by Edmund Hoyle in his *Short Treatise on the Game of Whist* (1742), but the name "Whist" came from the sound urging silence and secrecy: something is being concealed.

The reference and innuendo can be extended almost indefinitely in *Marriage A-la-mode* (as Robert Cowley has fully demonstrated).[25] But the mode is still based on—still returns to—the mock-heroic structure Hogarth inherited from Pope and shared with Fielding. The heroic is still embodied in the biblical pictures on the walls (to which we shall return). There is no biblical or classical echo in the composition of Plate 1, however, only the memory of a conversation picture (such as Hogarth's own *Assembly at Wanstead House* or *Cholmondeley Family*) in which one expects to see familial harmony but in fact finds parents selling their children amid the signs of total fragmentation. What is revealed instead of the apparent conversation picture is a Dutch droll, a marriage contract with the exchange of money. Of course, it is also a final summation of the genre Hogarth had explored, thematized, and problematized in his earliest paintings.

In this "conversation picture" two families are being mingled and yet kept distinctly separate: the two young people are on one side of the picture and the two fathers, roughly speaking, on the other; but the grouping is neither by family nor by marriage bonds, for the father and son are as far as possible from each other and from everyone else, and the father and daughter are as closely linked with other figures: she, in fact, "mediates"—but of course in fact *chooses*—between the young lawyer who leans close, whispering in her ear, and her prospective husband. Parallel in shape and position to her is

the emaciated old usurer who mediates between the two fathers. It is also instructive to see who is noticeably absent. The dominant father is not accompanied by, or checked by a mother who, in terms of the Hogarthian myth, should have been interceding between the father and the children.

Every detail in the scene contributes to define "character" and interpersonal relations; at the same time every detail is symbolic. The bride's father, an alderman (probably a City banker or merchant), wears glasses that indicate both his physical and moral shortsightedness; focusing on the marriage contract, he overlooks the physically and morally "damaged goods" he is buying—the groom's lackadaisical slouch, the patch on his neck and, closer to hand, the broken branch on the family tree. The chain he wears shows him to be an alderman of the City of London—and so on.

He is not named, because his name does not matter; but the old nobleman, who seems to be sitting under a thronelike canopy (topped with a coronet) which is in fact his bed, is Earl Squander, his son (by courtesy title) Viscount Squanderfield. The denotation is even more specific than the words *Earl* and *Squanderfield* (on the marriage contract). As the subsequent plates show, while there is passion to spare in the young wife, the nobleman named Squander "squanders" his passion on prostitutes, much as his father squandered his money on Palladian building schemes and "dark master" paintings.

The earl's bandaged leg, which signifies "gout," serves to project a history, a moral judgment, and a series of relationships. "Gout" connotes a life of eating and drinking associated with the aristocracy. But the bandaged leg is related to the beauty patch on his son's neck, serving to hide a sore which (in this context) is venereal. The gouty connotation of sickness relates them, balancing formally the earl's flannel-wrapped foot on one side with his son's patched neck on the other. Sickness connects them as father and son, with proverbial overtones of "the sins of the fathers visited upon the children," which will run through the six plates, concluding in the sad shape of the grandchild with its own beauty patch in 6. The metaphor of disease permeates the series. Through its connotations of unsoundness, the bandaged leg and the patched neck relate to the building going on outside the window, half finished and in ruins, and to the merchant who is buying the son as a property but is getting an unsound piece of merchandise (as does the son with the whore in 3).

The patch as inherited disease also connects with the stamp of the

earl's coronet, which designates property, on every object in the room from footstool to chairs, bed, pictures, crutches, and is even stamped (in the engraving) on the flanks of his dogs. His son carries in his black patch the stamp not of the coronet but of his disease, and the stamp of property is confirmed by the "manacles" just beneath him that bind together the pair of stamped dogs. The pair of young people above the dogs are metaphorically manacled in the same way and from the same source, as are all of these people "manacled" together by their avarice and pride.

The milieu is once again—as in the *Harlot* and *Rake*—prison-like. A sense of openness is proffered by the extensiveness of large and luxurious houses, with windows and entrances to further, inner rooms, but these are false hopes of exit, each in its own way closed. In the first scene the window opens onto a Palladian building scheme of the earl's, but it has stopped for lack of funds: a project that confines and constricts the protagonists as effectively as walls. In the fifth scene the lawyer actually appears to be making his escape out of the window of one room—his symbolic exit from the stifling situation in which his attraction to the neglected bride has trapped him, which has led him to murder—but in the next scene a broadside celebrates his capture and execution. And in this last scene there are two exits from the room: one a door being taken by the physician, who has given up his patient, and the other a window with a view of London Bridge, which simply locates the merchant's house and reminds us, as we look back over the six scenes, of exactly how little egress there was for the young woman, now dead by her own hand.

THE THEME OF ART

The pictures on the walls are false windows that do not look out onto the natural world but rather reveal a world of art that constrains the people in the room. They are portraits or history paintings (the earl's), Dutch low-life scenes (the merchant's), but always closed, framed images of cruel or foolish actions in the past, a fantasy paragon, upon which the person in the room, cut off from the natural world outside, builds his or her own life and actions.

As the parodic finale to his conversation pictures *Marriage A-la-*

mode is Hogarth's homage to Watteau's *L'Enseigne de Gersaint* (Schloss Charlottenberg, Berlin). Hogarth turns Gersaint's shop into Earl Squander's chamber—or the earl's chamber into a dealer's salesroom. Traditional iconography has been totally displaced to its contemporary repository, the earl's picture collection which covers the walls and, given exaggerated prominence by the expressive use of false perspective, nearly crowds out the people. The largest and nearest picture to Earl Squander is a portrait of himself in the French style as Jupiter *Furens,* whose inflated pose he is imitating as he points down to his family tree. The earl would, of course, have his portrait painted by one of the French artists such as Vanloo who were the rage in London in the late 1730s and early 1740s; he would demand—and be given—a *fiat lux* gesture and the order of the *Saint-Esprit,* a French order that had never been awarded to an Englishman.[26] So too he would collect history paintings depicting scenes of murder and martyrdom. The man who imitates the pose of Jupiter in his portrait will also imitate the morality of these bloody fables.

The earl's paintings have in common images of violence, torture, and martyrdom—words that come to our lips as we correlate their subjects. We connect these images metaphorically with the behavior of the parents toward their children in the scene below.[27] A painting of St. Sebastian shot full of arrows hangs just above the shoulder of the young lawyer, who is making advances to the bride. Their poses are parallel, and the lawyer holds his quill pen pointed like an arrow toward his heart. The image recalls popular emblems of Cupid shooting arrows into lovers strung up in this way, and, in conjunction with the quill pointing to the lawyer's heart, it tells us that he is smitten and will be "martyred" by his love, both in the romantic and the literal sense when he is hanged for the murder he commits for love.

Directly above the nearly joined heads of the lawyer and the young bride-to-be are two more paintings. The upper one, of the vulture gnawing at Prometheus's vitals, conveys a general metaphor of lust which in its context refers to the flirtation below.[28] Immediately above the lawyer's head is a picture of Cain killing Abel, and the other pictures above the lawyer—one of David and Goliath and one of Judith and Holofernes—are similar images of murder, whether with reference to the lawyer killing the young husband or the young wife herself metaphorically taking her husband's head.

On a popular level these paintings do not require an iconographi-

cal or learned reading. Directly above the self-engrossed husband-to-be staring into a mirror is the *Martyrdom of St. Lawrence,* which carries a suggestive parallel to the viscount's prospective marriage bed. The physical resemblance between gridiron (with recumbent St. Lawrence) and bed, and the metaphorical relationship of heat and passion, make a visual pun, which will signify to the least learned of Hogarth's viewers.[29] But of course Hogarth has not forgotten his readers "of greater penetration," who would have recognized these paintings as "dark masters," probably copies—the David–Goliath, St. Sebastian, Prometheus, and Cain–Abel by Titian (and the ceiling painting of Pharaoh's host from the woodcut by de la Grecche after Titian), the Judith by Guido Reni, the St. Agnes by Domenichino, the St. Lawrence by Le Sueur (but out of Titian), and the Medusa by Caravaggio.

The Domenichino *Martyrdom of St. Agnes* (Pinacoteca, Bologna) is the most recondite. Legend describes her as a beautiful young woman who rejected her noble suitors because she was a Christian. The Roman governor of the province punished her by sending her to a brothel, but even there she remained pure: those who came to her were either struck by awe or, if they looked upon her lustfully, blinded—only regaining their sight by her prayers. The governor accordingly, as Domenichino's picture shows, ordered her throat cut and her body burned on a pyre: her arms are outstretched in prayer and a lamb is at her feet.

This painting of a young woman on her bed-shaped pyre is directly above the one of St. Lawrence on his gridiron—and the resemblance to a bed seems to be the common element. It is the only picture except *Judith and Holofernes* that refers to the bride, and it proves to be about a woman who is receiving an immortal crown from Christ for her refusal to have either marriage with a noble lover *or* intercourse with low-born men in a brothel. We recall that the alderman's daughter is proposed to by a nobleman and accepts, and (following the masquerade at which she has rendezvoused with the lawyer) goes to a brothel and does have intercourse, but her punishment too is death, though without any hint of a heavenly crown.

Indeed, the upper quarter of Domenichino's picture, the heavenly part, is omitted; as usual, Hogarth has left out the deity. But in the narrative context, the elimination of Domenichino's God reflects the patron, Earl Squander, who chose (probably commissioned) the copy of the original which hangs on his wall: he thus sees *himself* as

replacing the deity in the painting. In a more general sense, the omission reflects this high society, which has dispensed with God.

Cain killing Abel, the archetypal murder, projects a sense of "brothers" (groom and lawyer) sacrificing in their different ways to a single god (the bride), the result being jealousy and murder. The biblical story involves two offerings to the Old Testament god, two professions (shepherd and farmer) or perhaps we should say classes, and finally, in the implied relationship of these two brothers to Adam, the repetition of the sin of the father, the curse of the generations: in other words, an emblem for the scene and the series.

The story of Cain and Abel was read in two ways by the biblical commentators. Before the Civil War the story was used by preachers as an exemplum of God's inscrutability and of predestination. After the Civil War it was more often used as an example of the upper classes (Cain) opposed to the lower (Abel). As readers meditated (or, as was the common practice, conversed) on the pictures' stories, they would have noticed that on the religious level they share a confrontation between champions who represent opposing groups, whether the Israelites and their enemies or the Christians and their Roman persecutors. David and Goliath and Judith and Holofernes are champions of their respective people, the smaller or apparently weaker defeating the stronger. On the ceiling Pharaoh leads the Egyptians against the Israelites, only to be swept away by the natural force of the ocean. St. Lawrence and St. Agnes die for their faith against the might of Rome. St. Sebastian, the typical martyr as convert, is a soldier of the Praetorian Guard who becomes a convert to Christianity, a "traitor to his class," so to speak, and is strung up and shot full of arrows by his former colleagues. Prometheus also betrays his "class" by stealing fire from Olympus and giving it to men.

All of this is connected with the one broken branch on Earl Squander's family tree, designating a marriage with a commoner. The six plates are about the relationship between merchant and aristocrat, emphasized throughout by the running contrast between the vulgarity of the bride and the languorous decadence of the groom. In these terms, the Old Testament conflicts are all victories for the Israelites, for the weaker-seeming champion. (It is likely, considering Hogarth's comments on Jews elsewhere in his work, that he connects the victorious Israelite with the alderman.) In the New Testament conflicts the martyr dies, a defeat *and* a victory, and in both spiritual and physical senses the Christian cause wins in the long run. The

idea of a victor is less easy to formulate in the Cain–Abel and Prometheus–Zeus stories. The result in Hogarth's series is, of course, defeat for both classes, though the hardy alderman (with his feeble grandchild) is still around at the end, removing his daughter's ring from her finger before rigor mortis sets in. The allusion then extends to the conflict between merchant and aristocrat, with one member of each group as "champion" and a sense of somebody "betraying his class" (or "interest" or "order").

Each room in the subsequent scenes is filled with the pictures collected by its particular inhabitant, and as the series rolls on these people act out the roles and assume the poses dictated by their art objects, until in the last two plates the young earl, his countess, and the lawyer are indeed in the poses of murderer and martyred. The quack's room with his mummies and nostrums is followed by the countess's boudoir with her paintings of the Loves of the Gods and the bric-a-brac she bought at an auction, including Giuilio Romano's erotic drawings and a statue of Actaeon in horns (referring to the young earl).[30] The bagnio (to which we shall return) attempts gentility with a tapestry and paintings, and the alderman's house is hung with vulgar Dutch genre pictures. Here art has become an integral part of Hogarth's subject matter: it is here for itself, a comment on itself, and also on its owners and on the actions that go on below it. In no other series is the note so insistent: it permeates to a degree *Harlot* 2 or *Rake* 2, but here it dominates every room, every scene. The Old Masters have come to represent the evil that is the subject of the series—not aspiration but the constriction of old, dead customs embodied in both classical and Christian myths.

Art as theme is further underlined by the importance of viewing. In 1 the Medusa looks down in horror on the scene: an emblem of response of the sort that began with the screaming face made by the bed curtain in *Harlot* 3. But it also serves as an emblem of the way the pictures on the walls function. Like the Medusa they freeze the people who choose, own, and look at them into the poses and actions of those pictures. The earl, by looking at the Medusa, is frozen into the tyrant who destroys his children—and at the same time into the Medusa he looks at, thus having the same freezing effect on his children when they are in his presence.[31]

In 2 the Methodist steward (he carries a copy of Whitefield's sermon "Repentance") turns away, and his disdainful face is repeated in the Roman bust on the mantel, even to the broken nose of the one

and the pug nose of the other. One is turning away from the scene with pious horror, the other is regarding it. The steward's gesture makes the full-length saints on the wall of the dining room appear to be averting their gaze in the same way from the naked foot protruding from a curtain drawn over the picture. (St. Paul's sword, however, is pointed at the steward's back, suggesting the animus of the patron of the Anglican church against a heretic.) In 3 the skeleton whispers a comment to a stuffed specimen that is its companion, in 4 Silvertongue himself looks helplessly down from his canvas on the way events are developing, in 5 St. Luke and the shepherdess watch. St. Luke is painting the scene (according to such authorities as Theodorus Lector's *Ecclesiastical History,* he was noted for having painted the Virgin, who descended from heaven to sit to him). Only in 6, when it is all over, are the pictures unconcerned—the Dutchman turns his back on the scene to relieve himself as the physician walks away, having given up the case.

In the fifth scene (fig. 96) the Old Master compositions of the first two and fourth scenes, some religious and some mythological, finally step down from the painting and impose themselves on the actors themselves. The adulterous countess has been caught with her lover, and her husband the earl has fought a duel with him and been stabbed. In this theatrical setting (stage and painting join at this point) the pose of the dying earl is so curiously awkward as to call for explanation.[32] It can only be an echo of a Descent from the Cross, a Deposition or Burial, with the countess in the pose of a mourning Magdalen. To emphasize the point, Hogarth has outlined a cross on the door—a shadow thrown by the constable's lantern (which is much too close to the door to cast such a shadow). The biblical allusion is further supported by the picture of St. Luke and the tapestry of the Judgment of Solomon on the walls. Hogarth must have taken the earl's pose straight from a painting, probably Flemish, seen in France on his 1743 tour, not even adjusting for the absence of the man supporting Christ's body under the arms.[33] In paintings and blockprints of the Crucifixion and Descent from the Cross, the female figure who, like the countess, "stood near" Christ wringing her hands, or spreading her arms wide, or kissing his feet, was Mary Magdalen; while Mary the Mother was some distance away silently watching or being supported by an apostle.[34]

It is appropriate, of course, that in this context Hogarth produces a Magdalen—a prostitute—mourning Christ, who died for her sins. The traditional story of the Magdalen was actually rather close to the countess's: she was born of a good family, but after her marriage her husband deserted her and she turned to a life of sin and was possessed by seven devils.[35]

Hogarth makes his point by showing a painting of a whore in shepherdess's costume with hefty male legs protruding under the frame (from one of the soldiers in the overlapping Judgment of Solomon tapestry). The legs emphasize the incongruity of the sort of portrait Pope describes in his "Epistle to a Lady" (1735): ladies who have themselves painted as shepherdesses, Ledas, or Magdalens. With the countess, the Magdalen pose follows directly from her pictures of Io and Lot's Daughters on the walls of her boudoir. The implication is that she sees herself as a penitent Magdalen, or even (with her child, Luke, and his painting of the "Virgin") as the Mother. In the same way the earl sees himself as Christ martyred, revealing his self-pity and lack of self-awareness, in a scene of comic demystification.

The tapestry on the back wall (fig. 97), once again an Old Testament subject, is appropriately the story of two prostitutes who claimed the same baby.[36] Prostitutes would be interested in stories of other prostitutes, especially sanctified by a biblical subject and the treatment of the Old Masters. But the tapestry also serves as emblem or paradigm for the whole six plates, for it exposes the truth that has been hitherto plastered over by the protagonists and their friends and relatives. The master of the bagnio literally throws open the door, casting light on the scene. In this context of dramatic disclosure, only when Solomon makes the theatrical gesture of calling for the baby to be divided is true emotion to be distinguished from hypocrisy.

As the Deposition poses emphasize the element of sacrifice, the tapestry of Solomon and the "mothers" emphasizes the element of judgment that has now moved to the fore. This is a judgment, a magistrate's "choice," between a true and a false mother, as Hercules's choice was between Virtue and Vice. If seen from the point of view of the central figure—the child—it becomes a passive situation, a nonchoice. In the last scene a child is materialized, sickly and claimed by neither parent nor relative, for her mother is dead, self-poisoned, and the remaining parent figure turns his attention to the ring on his dead daughter's finger. But in 5 the bloodied sword

in the foreground divides the wishbone-shaped shadow of the fire tongs, emblem of the marriage: the marriage is cloven. The tapestry says that two competing parents are destroying a child: the choice is on the part of the parent (the mother in the biblical story), the one who will give up the child rather than see it halved, and is therefore the true mother. But Hogarth's series is about two false parents who are willing to see their children destroyed. In 5 then the emblem applies not only in a general way to the fathers but more directly to the countess's Solomonic judgment that kills both of her men. Although in appearance one is alive and one is dead, in fact both are doomed and by the next plate dead. The countess is shown with the dead one, thinking she has the live one safe, which in fact Justice is going to cut off as well. One message, consonant with the emblem of the Judgment of Solomon, is that authority, justly or unjustly, will destroy all who are under its power.

Looking back, we recall that the Judgment of Solomon was the motif that dominated the greatest of all English decorative painting schemes, Rubens's ceiling of the Whitehall Banqueting House (see vol. 1, 125–26).[37] When Hogarth uses the Judgment of Solomon, consciously replacing the Judgment of Hercules and its overtones of active choice, it is the harsh Old Testament *judgment* that he invokes, not, as with Rubens, Solomon's *wisdom*. Solomon is another version of, and parallel to, the murderous images of the paintings in the first scene. Nor does Hogarth elide (as Rubens does) the fact that the women who plead before Solomon are prostitutes.[38]

The child who had appeared peripherally in the conversation pictures and the earlier series is moving to the center, and now appears as two protagonists, a boy and a girl, who are contrasted—from different classes and backgrounds. The central child prepares us for the next phase in which Hogarth paints the child Moses before Pharaoh's daughter, and the pair points to the apprentices of *Industry and Idleness* and the boys of *The Four Stages of Cruelty*. Here the children range from the young viscount and his bride to his childish mistress to the malformed child in the last plate.

Children began for Hogarth in a context of parents, specifically fathers. A father may be implied in *Harlot* 1 and is certainly present in *Rake* 1, but only as something the protagonist reacts against.[39] It is the hero's choice to disobey the father which sets the series going. The father may be as passive and unconcerned as the clergyman or as beastly as old Rakewell the miser, but neither one has exerted any

pressure on the child, or if so has been defied (as Robinson Crusoe's father was defied). It is rather the society of London, the fashionable beau monde, that exerts the deadly fascination and the pressure. The protagonist does act: he or she chooses a role and carries it out to the crack of doom—even though it is a role that has been borrowed, imitated, and learned by rote. But in *Marriage A-la-mode* the protagonists are really "children," not just because they have parents but because they seem helpless and young—the parents make the decisions for them; and the story is about their natural premarital selves breaking out of the mold that has been imposed on them. Her passion, curbed by the arranged marriage and the cold husband (who needs little girls), bursts into an illicit affair; but she is enough her father's daughter to imitate her father-in-law, collecting art and dallying with the opposite sex. Her husband's jaded tastes go off into perversions and disease but he is still enough governed by his father's code to duel with the wife's lover and get himself killed. In short, Hogarth has changed his paradigm from the Choice of Hercules to the Judgment of Solomon—from the heavy weight of art and art objects of the past in Plate 1 to the emblem of Solomon in 5; and so to the magistrates and lawyers and parents on the one hand, and to the children, helpless without funds of their own, at the mercy of their parents, on the other: essentially the scenario that Hogarth develops over the next decade (and that William Blake will mythologize forty-five years later).

THE BLACK

Closely related to the contract-governed "child" is the black slave. There was one in *Taste à la Mode* who had won at cards with his mistress. In the *Marriage Contract* oil sketch (fig. 26) there was a black boy holding up for his master a painting of Jupiter's eagle carrying away Ganymede. In *Marriage A-la-mode* 4 this mocking boy points to Actaeon's horns in the collection of art objects the countess and her lover have brought back from an auction—and the castrato soprano sits beneath the same *Jupiter and Ganymede*. There is probably a pun intended in the juxtaposition of the black boy and the "dark master" painting of the sort Hogarth ridiculed, but the main point of the tableau is the contrast of art (or high culture) and nature, the danger-

ously close relationship between the two in the world of London, and the idea that art itself is merely a piece of property like the black slave who holds it up.

Two blacks appear in *Marriage A-la-mode* 4, one actively satirizing the married couple, or rather the husband Earl Squander, who has by this time been cuckolded by the lawyer who is enjoying the countess's company at her levee. The second black is in the same conventional pose as the black boy in *Harlot* 2: he is serving coffee, but he is also looking and laughing at the ultimate in civilized Europeans, the castrato soprano, over whom society women swooned and impresarios fought. The black face and the sharp eyes and smile directed at the castrato sum up the theme of savagery and civilization, which is at the bottom of the story of parents who destroy their children in order to control their estates. It is hard to think of a better example (at least from the English–Hogarthian perspective) of apparent civilization concealing savagery than the child who is emasculated in order to perfect his singing voice for the delectation of his elders, and this is set off by the supposed savage, the African black who serves these civilized people in a context of art collecting, marriage contracts, and coronets—forms that conceal the savagery of the private lives of earl and countess, of parents and children, which will erupt in murder, execution by hanging, suicide, and extinction of the family line.[40]

In *Harlot* 4 a pregnant black woman was seen among the prostitutes beating hemp. In the context of the white prostitutes she was an emblem of property—the Harlot being the "property" of her keeper, later of any man who can pay her fee and of the law once it apprehends her. The same is indicated by the black slaves in *Marriage A-la-mode* of the children who are the chattels of their respective parents. And I suspect that all of these find their associations with Hogarth himself as someone who does not enjoy "the fruits of his own labor" (the phrase used about blacks in eighteenth-century antislavery writings), which of course also sums up Hogarth's sentiments about the artist's (his own) exploitation by print dealers, connoisseurs, and collectors.

The black boy then is a metaphor, which emphasizes a quality less apparent in the white protagonist, and he is also an indication of the natural that is being suppressed or repressed by the sophisticated English men and women. In the same way in *Noon,* the second of *The Four Times of the Day,* the black man, in the role of Mars to a young

white Venus, was contrasted with the effeminate Frenchmen who are standing on the other side of the pavement.

These black slaves (or harlots or children or dogs) are of course safe, relatively harmless (because xenophobic English) images with which to express a critique of society, especially foreign influences, in the mid-eighteenth century. They also support the Hogarthian idea of "English" art as a virile, energetic outsider commenting on effete Continental art and culture. Every story Hogarth tells, every parable of art he unfolds, is seen from the point of view of the alien Other in the story—in this case the black boy.

The presence of the black boy therefore emphasizes the aspect of the art objects as property, and the fashionable clothes he has been dressed in emphasize the aspect of imitation. He is the one person who does not himself imitate. *Marriage A-la-mode* is Hogarth's climactic, final work in the thematization of imitation. It presents the imitation of classes, a rich plebeian marrying his daughter to a nobleman. Though he remains his boorish mean self, she changes into a lady with a lady's ways. But old Squander's choices are equally predetermined: he buys his pictures because they are fashionable and then internalizes them, becoming their "slave," his actions determined by their presence. He chooses portraits and history paintings to elevate himself, support his self-importance, pander to his megalomania; but the very paintings that portray his godhead dictate the tyranny, torture, and murder that godhead carries with it in the tradition of Western art (whether the religion is classical or Christian), and thus brings down his family, escutcheon, fortune, and estate.

Having shown the middle class emulating the aristocracy (as in the case of the Rake), in *Marriage A-la-mode* Hogarth shows that the aristocracy itself is no different: Earl Squander also defines himself by emulation and upward aspiration or self-glorification—upward toward the monarch and toward God. This is perhaps the rock-bottom message of *Marriage A-la-mode*: the aristocracy is no different from the middle and the lower orders.

Hogarth might appear to be taking revenge once and for all, without surrogates, on the "High Life" (as he called it in his advertisement) that defines itself by its fashionable foreign portraits, its Old Masters, its family trees, its "connoisseurship," and its fashionable diversions. In this sense, the advertisement with its talk of "Decency and Elegancy" was profoundly ironic. But it was also typical of Hogarth that he should be clearly aiming—with his advertisements, his

engravings, and his paintings themselves—at an audience approaching the aristocratic; yet the content of his series was decidedly anti-aristocratic, above and beyond the focus on contracted marriages. He was seeking the support of high society, but at the same time revealing what he thought of it. It is perhaps not surprising that though the project was immensely successful, it was not as successful as Hogarth expected; and the success could be parsed into the renown of the prints and the relative coolness with which the paintings were received.

The two audiences to which Hogarth has customarily addressed himself are moving further apart. The sophisticated audience is given something quite distinct from the general reader, no longer merely deeper, though perhaps still complementary. It is too easy to say that his readers divided into groups analogous to the alderman and the earl, because the earl is clearly a false connoisseur and the alderman so vulgar as not to be a reader of Hogarth in the first place. Nevertheless, the two audiences are roughly represented by these two classes, and one wonders how either could have been altogether reassured by Hogarth's picture, unless he was focusing on the other.

THE BATTLE OF THE PICTURES

At the first of the new year, 1745, the second impression of the *Harlot's Progress* was announced as published, and the *Marriage A-la-mode* plates were "in great Forwardness, and will be ready to deliver to the Subscribers on or near Lady-Day next," i.e. 25 March. On 25 January Hogarth issued a set of proposals for an auction of his "comic history-paintings" and distributed them among his friends and visitors to the Golden Head.[41] In the *London Evening Post* for 31 January–2 February he began to advertise the auction. It seems likely that Fielding's preface to *Joseph Andrews* with its talk of "comic history-painting," which emphasized the painting rather than the print, contributed to, if it did not inspire, the idea of the sale of the paintings from which the engravings were made. Hitherto, most paintings of this sort that Hogarth sold had been unconnected with the engraved product. *The Christening* and *The Denunciation* had been engraved, but not by Hogarth, and possibly after the paintings were sold; special commissions like those in Lord Boyne's and Mary Edwards's

collections were not intended to be engraved. But now, not long after the completion of the *Marriage A-la-mode* paintings, themselves the most elaborately, elegantly, and colorfully executed of his works, Hogarth announced that he would sell at auction the paintings that preceded his prints of the 1730s.

The first set of proposals, dated 25 January (BM), begins:

> Mr. HOGARTH's / PROPOSALS / For Selling, to the Highest Bidder, the Six Pictures call'd / The HARLOTS PROGRESS: / The Eight Pictures call'd / The RAKES PROGRESS: / The Four Pictures representing / MORNING, NOON, EVENING, *and* NIGHT: / AND / That of a Company of STROLING ACTRESSES Dressing in a Barn. / *All of them his Original Paintings, from which no other Copies than the Prints have ever been taken; in the following manner; viz.*
>
> A BOOK will be open'd on the First Day of *February* next, and will be closed on the last Day of the same Month, at his House the *Golden-Head* in *Leicester-Fields;* in which, over the Name of each Picture, will be entered the Name of the Bidder, the Sums bid, and the Time when those Sums were so bid; so that it may evidently be seen at one View how much is at any time bid for any particular Picture; and whoever shall appear, at the time of closing the Book, to be the highest Bidder, shall, on Payment of the Sum bid, immediately receive the Picture.
>
> N.B. The Six Pictures call'd *Marriage A-la-mode,* will be sold in the same manner, but the Book for that Purpose cannot be closed till about a Week after the Plates now Engraving from them are finish'd, of which public Notice will be given.
>
> CONDITIONS of SALE.
>
> I. That every Bidder shall have an entire Leaf, number'd, in the Book [of Sale,] on the Top of which will be entred his Name and Place of Abode, the Sum bid by him, the Time when, and for which Picture.
>
> II. That on the last Day of Sale, a Clock (striking the Quarters) shall be placed in the Room, and, when it hath struck a Quarter after Ten, the first Picture mention'd in the Sale-Book will be deem'd as sold; the second Picture when the Clock hath struck the next Quarter after Ten; and so on, successively, till the whole Nineteen Pictures are sold.
>
> III. That none advance less than Gold at each Bidding.
>
> IV. No Person to bid, on the last Day, except those whose Names were before entred in the Book.

Then follows the list of the paintings, and a postscript: "*As Mr. Hogarth's Room is but small, he begs the Favour that no Persons, except those*

whose Names are entred in the Book, would come to view his Pictures on the last Day of Sale."

A revised sheet of proposals was dated 11 February:[42] Hogarth has now decided that he should offer the possibility of breaking up the sets of pictures. After "For Selling, to the Highest Bidder," he adds: "Singly (each Picture being an entire Subject of itself) or in Sets." It was originally intended that the sale would begin at 10 o'clock: as the clock struck the hour, bidders were given one last chance to bid, and when the quarter hour struck the first picture listed in the sale book would be deemed sold to the highest bidder. This is changed in the new proposals to 12 o'clock and to five-minute intervals. Hogarth also adds a final condition of sale: "V. If any Dispute arise between the Bidders, such Picture shall be put up again." At some point he also decided to include in the auction a few other paintings, not included in the list (*Sarah Malcolm* and *Danaë*).

Advertisements continued to appear in the *London Evening Post* intermittently until the 19–21 February issue when the subscription ticket, *The Battle of the Pictures,* was announced (fig. 99), and another stipulation is added:

> Gentlemen and Ladies are desir'd to take Notice, that in order to prevent Confusion, or any indirect Practices frequently made Use of at Publick Auctions, None will be admitted on the last Day of Sale, but those who are possess'd of engrav'd Tickets, which will only be deliver'd to such as before that Day shall have enter'd a Bidding in the Book, which is now open for that Purpose.

Having dealt in his ticket for *Marriage A-la-mode* with the first point of Fielding's preface, the relationship between character and caricature, or comedy and burlesque, Hogarth turned in his next polemical etching—the ticket for the auction—to the second point, the term "comic history-painter," which he seems to apply (judging by his images, for he uses no words) to *modern* history.

No balanced choice is offered the spectator; the old history paintings are not eminent works (no Raphael here), but rather the aggressors trying to destroy his own modern histories. They are also, by implication, only copies of old themes and pictures, copies of copies, and the chief advocate for their side is not an Old Master but the picture dealer. The reference of the "weathercock" finial of the auction house is to Christopher Cock, an auctioneer well known (at least

in the early part of his career) for uncertain attributions and shady deals. The four winds that determine his "taste" spell "PUFF." If on the one hand Hogarth is explaining what modern history painting meant, he is also attacking the man he takes to be the real culprit for the downgrading of modern art, and so drawing attention to the purpose of his own auction: to circumvent the dealer as his independent subscriptions had circumvented the printseller. By avoiding the dealer who set values on pictures and controlled public auctions, he thought he could encourage competitive prices and an open market.

But, of course, the real project is to argue that Hogarth's paintings were not merely modelli for his enormously popular engravings but art objects in themselves, fit to stand up against Old Master paintings. For his auction ticket he picks up on the collections of paintings in *Marriage A-la-mode,* especially the Old Master collections of 1 and 4. There the Old Masters were metaphorically preying on the humans, their collectors; in *The Battle of the Pictures* they are literally preying on Hogarth's own paintings, their rivals, including *Marriage A-la-mode* 2. Hogarth adapts Swift's *Battle of the Books* (1704) in which the moderns, materialized in their books, attack and are repulsed by the folios of the ancients. But he has reversed Swift's scenario: the ancients are the aggressors, invading Hogarth's peaceful studio. Two baroque religious subjects and one antique Roman painting (a *St. Francis,* a *Penitent Magdalen,* and the *Aldobrandini Marriage*) are penetrating modern canvases by Hogarth, and only two of his paintings are besting the Old Masters. Moreover, innumerable Old Master reserves are advancing on Hogarth's studio from the direction of Cock's auction house: for, being merely copies, they are infinitely reinforceable. Like Swift's books, confident in their numerical superiority, these copies declare war on Hogarth's unique paintings. (He elides the fact, however, that his paintings have been multiplied by engraving into many more copies than these canvases can muster.)

The *Penitent Magdalen* slashing *Harlot* 3 is directly above a saint cutting into the pious old woman of *Morning* (the first of the *Times of the Day*). The saint is in a very similar pose, with similar altar, skull, and crucifix, perhaps merely at his devotions but, parallel to the Magdalen, he appears penitential. The first refers to the Harlot, a Magdalen who does *not* repent, and the second to the cold exclusive piety of the old woman, a contemporary version of

a holy hermit. The two penitent canvases are placed below two scenes of revelry: a Feast of the Gods versus a brothel scene and a bacchanal versus a drinking scene. They are scenes of revelry and penance, two and two, with the exception of the one pair of paintings that appear within the cutaway of Hogarth's house, where the painting of *Marriage A-la-mode* 2 is shown still on his easel (this series was not included in the sale). The opponent in this case is the *Aldobrandini Marriage,* sharing the subject of matrimony—one representing ideal marriage, the other a modern degeneration of that ideal. The other paintings could also be said to represent a moral decline as well as candid realism, if, that is, Hogarth takes the classical gods and the Christian saints to be ideals, which he probably does not.

While these old paintings are no longer worth copying, they do remain the only models in terms of which the world of eighteenth-century London can be properly understood. Modern English art can only be defined in relation to past art, even if in reaction against it—or desiring (as Hogarth implies) to live in peaceful coexistence. A London prostitute is a Magdalen-of-today, reduced to a smaller figure, one among others in a closed and detailed setting. The baroque sentiments and forms, Hogarth is telling his audience, are part of the negative context of his paintings: the *Harlot's Progress* only signifies as a part of this ancient-modern agon.

Off to the left, among the reserves, are columns of copies of other Old Master paintings led by a *Flaying of Marsyas* (with, behind it, a row of St. Andrews and his crosses) and a *Rape of Europa.* These—like the black boy or the row of objets d'art in *Marriage A-la-mode* 4—are peripheral emblems that inform the central action, the scene of combat. One *Marsyas* and one *Rape of Europa* are shown flying toward the fray. The story of Marsyas evokes the underclass modern, Hogarth himself, who challenges Apollo and is flayed for his impertinence (an emphasis the exact opposite of Pope's in his "Epistle to Dr. Arbuthnot" of 1735). In this paranoid context, the crucified St. Andrew offers a Christian version of the classical martyrdom.

Europa is more problematic: does she represent the Continental tradition of art, the Old Masters, being carried away by Hogarth the bull, who is "raping" the ancients of their Venuses?—as seen by the unsympathetic dealers and connoisseurs? Is the bull a larger version of the aggressive pug, who stood for Hogarth in his early conversa-

tion pictures and his self-portrait of circa 1745 (fig. 105)? Or is Hogarth perhaps pairing himself and his wife Jane (as he did in *Characters and Caricaturas*)? If Europa is Jane, then the bull is once again the impatient William carrying her away from her father.

It may be significant that paintings of most of the subjects on Earl Squander's walls were in Thornhill's collection: a Medusa's head after Caravaggio, a *Judith and Holofernes, St. Sebastian, David with the Head of Goliath,* and a *Prometheus* by Thornhill himself.[43] Thornhill also had his own version of *Lot and His Two Daughters* (in the countess's boudoir). Of the paintings in *The Battle of the Pictures* he had an *Apollo and Marsyas* ("a large sketch"), a "Bacchus &c." by Philippo Lauro, and an *Assembly of the Gods* by himself.[44] Although the compositions Hogarth used were all available in prints, it is not impossible that he was recalling pictures he had studied—or been impressed or oppressed by—in Thornhill's academy/home. There is no telling how much his subsequent attitude toward these works reflects their association with Thornhill. While there was, of course, the positive, Raphaelesque Thornhill, there was also the Rubensian Thornhill of *The Allegory of the Protestant Succession,* the mythological scenes at Stoke Edith, and his baroque picture collection; as there was the Thornhill who served as Hogarth's career model and the other Thornhill who was a probably overbearing father-in-law, indeed Father.

All we can conclude about *The Battle of the Pictures* is that Hogarth uses the figures of Marsyas and Europa and the bull to express his beleaguered Hiramite view of himself as he felt others saw him; but also to say something—on some level—about his painting *and* his marriage, both art *and* Jane, and perhaps also about revelry and guilt accompanied by penance. And it is being said in a representation that is ostensibly only about art.

The advertisement noted by Vertue and Orator Henley, the elaborate auction, and the subscription ticket—these public acts seem to have augmented certain private remarks such as the one recorded by Reynolds, made at the St. Martin's Lane Academy and probably Slaughter's and elsewhere, and served not so much to support the idea of a new art form as to underline a kind of "gamecock" arrogance in Hogarth. At just this time Vertue wrote his first long and fairly passionate meditation on Hogarth as one whose success had gone to his head. This passage, written directly after the auction, on 1 March, is remarkable:

as all things have their spring from nature. time and cultivation—so Arts have their bloom & Fruite &, as well in other places in this Kingdom. on this observation at present a true English Genius in the Art of Painting—has sprung and by natural strength of himself chiefly, begun with little & low-shrubb instructions, rose, to a surprizing hight in the publick esteem & opinion. as this remarkable circumstance is of Mʳ Hogarth whose first practice was as an aprentice to a mean sort of Engraver of coats of arms, wch he left & applying to painting & study drew and painted humorous conversations. in time with wonderful succes.—& small also portraits & family-peces &c. from thence to portrait painting at large, ⟨& attempted History⟩ thro' all which with strong and powerfull pursuits & studyes by the boldness of his Genious—in opposition to all other professors of Painting, got into great Reputation & esteem of the Lovers of Art, Nobles of the greatest consideration in the Nation. & by his undaunted spirit, dispisd undervalud all other present. & preceedent painters. such as Kneller—Lilly Vandyke—those English painters of the highest Reputation—such reasonings or envious detractions he not only often or at all times—made the subject of his conversations & Observations to Gentlemen and Lovers of Art But such like invidiuous reflections he woud argue & maintain with all sorts of Artists painters sculptors &c—

But to carry a point higher. he proposd to sell his paintings 6. of the *Harlots progress* . . . those of the *Rakes progress* . . . and others of the Morning or 4 Times of the day . . . these alltogether. & the Strolling Actreses . . . ⟨Danae. golden shower⟩ by a new manner of sale, which was by Engravd printed tickets his own doing—& deliverd to Gentlemen Noblemen & Lovers of Arts—only—bidders, (no painters nor Artists to be admitted to his sale) and by his Letter and a day affixd to meet at his house. there the pictures were put up to sale, to bid Gold only by a Clock. set purposely by the minute hand—5 minutes each lott. so that by this means he could raise them to the most value & no barr of Criticks Judgment nor—cost of Auctioneers. and by this suble means. he sold about 20 pictures of his own paintings for near 450 pounds in an hour ⟨March 1. 1744–5⟩

admit the Temper of the people loves humourous spritely diverting subjects in painting. yet surely. *the Foxes tale*—was of great use to him. as Hudibrass expresseth

> yet He! that hath but Impudence,
> to all things, has a Fair pretence. (3: 123–24)

Vertue's stories probably go back to the arguments about portraiture, in and outside the academy; none of the names adduced would have

entered Hogarth's conversation about his modern historical subjects. But *The Battle of the Pictures,* and the auction itself, implicitly extended his quarrel to the Old Masters as history painters. To contemporaries, the first plate of *Marriage A-la-mode,* and perhaps its general tone, would have served the same purpose.

The auction took place at noon on the last day of February. One of those present was a young man named Horace Walpole, who had just returned to England from his Grand Tour in 1741. He went immediately into Parliament, and during the next few years he divided his time, until his father Sir Robert Walpole's death in March 1745, between Houghton Hall and a house in Arlington Street next to his father's. In August 1743 he had completed his first work of art history, *Aedes Walpolianae,* a catalogue of Sir Robert's art collection at Houghton, and in the introduction he discusses the merits of the various schools of painting, ending with the characteristic sentence: "In short, in my opinion, all the qualities of a perfect Painter, never met but in RAPHAEL, GUIDO, and ANNIBAL CARACCI." It was this young man, already set up for life by sinecures his father had secured him, who attended Hogarth's auction and purchased the small portrait of Sarah Malcolm for 5 guineas. He may already have begun collecting Hogarth's prints—he gathered one of the first great Hogarth print collections. He did not let Hogarth in any way interfere with his admiration for Guido and Annibale Carracci: he was interested only in Hogarth's modern moral subjects, and the only paintings he collected were his small informal sketches such as the *Sarah Malcolm.* He never asked Hogarth to paint his portrait, but in 1750 he commissioned him to go to the King's Bench Prison and paint King Theodore of Corsica, who was imprisoned there for debt. It is difficult to imagine them on any other than business terms, but Walpole claimed in later years to have been Hogarth's friend, and is said to have arranged a notable meeting at his house of Hogarth and Thomas Gray. The drawing room of his house at No. 5 Arlington Street is supposed to have been the model for the room in Plate 2 of *Marriage A-la-mode.*[45] In one sense, Walpole is, like the young viscount, another of that series of sons of wicked, grasping, spectacular fathers, by whom they were completely overshadowed and provided for, who were Hogarth's friends and contacts with the classes above him. In another, he was an acute, narrow, critical intelligence who, coming into contact with Hogarth in the 1740s, may have reinforced his intention to devote himself to modern moral subjects instead of

portraits or sublime histories, while at the same time offering him a challenge he could not refuse to prove again his competence at sublime history.

Horace Walpole provides the only glimpse of that auction; he tells of the "poor old cripple that I saw formerly at Hogarth's auction," who "bid for the *Rake's Progress,* saying, 'I *will* buy my own progress,' though he looked as if he had no more title to it than I have but by limping and sitting up." Walpole identifies this man in his MS. *Commonplace Book* as Mr. Wood, possibly the same Wood who had commissioned portraits of his family, his daughter, and his dog Vulcan around 1730. William Beckford, another young man like Walpole with great parental funds and political ambitions, was the successful bidder for the *Rake's Progress.* Wood bought *Strolling Actresses* for 26 guineas after one Francis Beckford had decided against taking it.[46] (Francis may be a mistake for William, who already had fourteen paintings from this auction.) The purchases of both the *Harlot* and the *Rake* by Beckford for £273 (£88 4s for the one, £184 16s for the other) does not mean that Hogarth's paintings were being bought by merchants or men of the City.[47] Beckford was as yet neither. He had inherited large holdings in Jamaica, but he was as much a gentleman-about-town (educated at Westminster, Oxford, and Leyden) as Horace Walpole. In two years he would take a seat in Parliament, for Shaftesbury, as a Tory supporter of the fourth earl of Shaftesbury and the Prince of Wales. Only in the 1750s did he begin to connect himself to the City, and he did not break with the Tories until he attached himself to William Pitt late in that decade. Beckford seems to have shown no further interest in Hogarth: he appears in no subscription lists, and did not even notify the artist that the *Rake's Progress* had survived the Fonthill fire in 1755 that destroyed the *Harlot.* He probably bought them as Walpole did, as Dutch genre subjects.

Wood and the other buyers too were great landowners or, at the least, country gentry—the same people who bought pseudo-Correggios and Guidos and had their portraits done by fashionable foreigners or their English equivalents (not by Hogarth). The duke of Ancaster, who had connections with the Slaughter's circle, employing some of them to decorate his country seat, Grimsthorpe, bought the paintings of *Noon* and *Evening* and also the one sublime history on sale, *Danaë.*[48] Hogarth evidently also sold twenty-five heads from the Raphael Cartoons, either by Thornhill or by Hogarth

and Thornhill; these too went to Beckford, but since the purchase does not appear on the receipt he made out to Hogarth, it may have involved a separate payment to Lady Thornhill.

Although Hogarth never sounded satisfied with the proceeds from this sale, it was a respectable amount, especially considering that the majority were sets and were not separated. And this sale probably represents the peak of his popularity as a painter of modern history. The *Harlot* and *Rake* brought him £273, *The Four Times of the Day* altogether £127 1s (*Morning* and *Night* went, for 10 or so pounds less than their compeers, to the banker Sir William Heathcote), *Strolling Actresses* 26 guineas, *Danaë* 60 guineas, and *Sarah Malcolm* 5. The total proceeds were nearly £500. These were not contemptible prices if one considers what Sir Robert Walpole, one of the foremost collectors of his time, paid for Old Masters in the years preceding Hogarth's sale: in August 1735 he paid £320 for Poussin's *Holy Family,* the highest price paid up to that time for a Poussin; £315 for four small paintings by Murillo; £500 for a Salvator Rosa *Prodigal Son;* £700 for Guido's *Consultation of the Fathers;* £500 for his *Child in the Manger;* and £300 for Palma Vecchio's *Adoration.* Michael Dahl's collection of Italian, French, and Dutch paintings, sold at Cock's 9–10 February 1743/44, just a year before Hogarth's sale, brought in only £700, partly because at the moment the market was low. Hogarth would appear to have been paid well in relation to the Old Masters; but of course, he would not be satisfied until his prices equaled theirs, an utterly chimeric ambition in those days.

One "comic history" missing from the auction was *Southwark Fair,* which had been bought by Mary Edwards, presumably soon after it was completed. At her death, near the end of 1743, it was sold (it is not clear by what means) for a mere £19 8s 6d—as opposed to the 60 guineas she had paid Hogarth for *Taste à la Mode,* and the probably greater price for *Southwark Fair* itself.[49] This was an ominous sign of the price range Hogarth could expect from the sale of whole series of such paintings. Considering its size and scope, it should have brought more than any of the pictures in the auction, yet it brought less. At least one can see how comparatively successful Hogarth's method of selling was. If Mary Edwards had lived, the bids at the auction would probably have been higher.

The auction for the *Marriage A-la-mode* paintings (one had even been included in *The Battle of the Pictures*) does not seem to have taken place. Could Hogarth, unhappy with the amounts he had received

from the other pictures, have withdrawn this set? What happened is not known, but the set was not actually sold until another auction—described in grim detail by Vertue and others—was held five years later.

Meanwhile, Lady Day passed, and at the end of April Hogarth announced that the prints of *Marriage A-la-mode* would be ready for subscribers on the last day of May; and at that time they presumably reached the subscribers.[50]

RICHARDSON'S *CLARISSA*, HIGHMORE'S *PAMELA*

At the same time that Hogarth was painting *Marriage A-la-mode*, Richardson was writing *Clarissa* (published 1747–1748) and attacking the "property marriage," the economic pressures on young women, the "system" in which matrimony was a matter of money rather than affection, with overtones of chaining, martyrdom, and the perverting of nature. His literary sources were probably Rowe's *Fair Penitent* and Charles Johnson's *Caelia* for the character and intrigue of Lovelace; but his original contributions to the story were: the reversal in which Clarissa rises above her rapist by refusing to marry him; and the paternalistic family and the forced marriage—that "marriage a-la-mode" with Solmes.

The second deserves scrutiny. Hogarth's prints were announced for subscription on 2 April 1743, prior to his trip to Paris to secure French engravers. The paintings would have been available at the Golden Head, if not completely finished, at that time. The subject was the tyranny of the father, a forced marriage, and the consequences to both generations. Richardson's novel then, engaging in a kind of cross-pollenation, corrects or rewrites *Marriage A-la-mode*. Richardson takes the bad family, the wicked parents—including the gouty father and absent mother—and adds uncles, brothers, and sisters. Emphasizing Hogarth's absent mother (who, in Hogarth's terms, should have been mediating between father and children), he makes her a mediator between husband and child, but, confused as to whether she should be mediator for the husband or for the child, she is a failure in both cases. Characteristically, as he had done with Hogarth's Harlot, Richardson adds the *good* daughter, who behaves

properly, and thus corrects Hogarth's young woman who accepts the contracted marriage and merely conducts love affairs. He also adds some virtuous friends for Clarissa, the Howes. As in Hogarth's world (not Fielding's), the young woman is destroyed. But she conquers, redeems by her example, doing all of the things that the countess of *Marriage A-la-mode* did not do: indeed, he copies for us not the young woman in Plate 1 but the female martyr, St. Agnes, from the picture on the wall.

On 22 July 1745, not long after the appearance of *Marriage A-la-mode,* a set of twelve plates by Joseph Highmore illustrating Richardson's *Pamela* was published.[51] Highmore, who seems to have been a friend of Hogarth's, was a portraitist who also tried his hand at sublime history by painting a *Good Samaritan* (1744, Tate) that adapts forms and motifs from Hogarth's St. Bartholomew's Hospital painting. With Hogarth and his serial prints as his model, Highmore saw possibilities in *Pamela* that amounted to a retranslation back into visual terms. As he wrote a few years later (describing what Richardson called "writing to the moment"):

> where the principal incidents are crowded into a moment, and are, as it were instantaneous, there is room for the display of the painter's skill . . . such a story is better and more emphatically told in picture than in words, because the circumstances that happen at the same time, must, in narration, be successive.[52]

He was, in effect, going to improve upon Richardson's *Pamela*. And the result, an independent series of paintings intended for reproduction as engravings, constituted the first English attempt to base paintings on a contemporary novel. It also invited comparison with Hogarth's progresses.

Highmore's project was initiated in 1743/44, a year after *Marriage A-la-mode*'s subscription had been announced. The *Daily Advertiser* of 18 February announced his proposal to publish by subscription "TWELVE PRINTS, by the best French Engravers, after his own Paintings, representing the most remarkable ADVENTURES of PAMELA: In which he has endeavour'd to comprehend her whole Story, as well as to preserve a Connection between the several Pictures, which follow each other as Parts successive and dependent, so as to complete the Subject." He accompanied his prints with a written account, "wherein all the twelve Pictures are described, and their

respective Connexions shewn." The plates, 12 × 15 inches, were to have a short explanation under each, in both English and French (reflecting Pamela's great popularity on the Continent). The subscription price was 2 guineas, exactly the same price per plate as Hogarth's; ten of the paintings, already finished, were on display at Highmore's house, the Two Lions, in Lincoln's Inn Fields. Also, following Hogarth, the price was to go up to 2½ guineas after the subscription.

Perhaps thinking to offer a purified version of Hogarth's comic histories, one more in line with the Richardsonian narrative, Highmore produced paintings much simpler in composition, less crowded with incident, with less to read and little to distract the viewer from the central figures of Richardson's story. They were much closer to the contemporary French compositions of Chardin. The engravings after Chardin by François Bernard Lépicié, executed between 1739 and 1742, would have demonstrated Richardson's thesis that a maidservant could serve as the principal figure in a work of art. Perhaps Highmore noticed, as Hogarth must have when he was in France, that Chardin too issued engravings of his genre paintings (some with descriptive or moralizing verses). Highmore used two French engravers, Antoine Benoist and Louis Truchy, who worked in a loose, informal style in imitation of Lépicié or the engravings after Watteau.

Acting, as I presume he did, as a Richardsonian spokesman for *Pamela,* Highmore had to illustrate *against* the Fielding–Hogarth version of *Pamela,* which included Hogarth's *Harlot.* The most obviously revisionist Hogarthian of Highmore's *Pamela* illustrations is "Pamela Preparing to Leave the House of the Squire" (fig. 100). Pamela, having by this time lost any doubts she might have had as to the intentions of her employer, Mr. B., is preparing to leave his house and return home to her parents. She appears with the kindly housekeeper Mrs. Jervis, assembling her meager possessions, but through the window at the rear, watching her, appears the threatening face of Mr. B. In short, a picture of servants à la Chardin, with a sinister aristocrat added in the background.

It is easily seen as an anti-*Harlot* Plate 1. Both present a pretty, innocent girl of the lower classes, and an aristocratic threat to her virtue. The Chardinesque simplicity of Highmore's composition suggests the difference: Highmore shows this and no more. He illustrates sentimental goodness—a large part of Pamela herself, but

more precisely the part Richardson was conscious of, emphasized on his title page ("Virtue Rewarded") and in his correspondence. It is remarkable how much space is taken up by Pamela and Mrs. Jervis in Highmore's composition, as opposed to the small spot given Mr. B.; whereas in Hogarth's *Harlot* 1 relatively little space is given to the young woman among the threats and temptations that surround her. Hogarth's print is full of complicating detail that establishes a complex pattern of guilt, and the girl herself is less a study of innocence than of eager gullibility. She is crowded about by different forms and degrees of passive and active evil, including Colonel Charteris, who fills a doorway. Pamela and the relatively good Mrs. Jervis are alone, dominating a large space, with the single small indication of evil framed by only one window pane and the diagonal of a lifted curtain. Highmore's solution is to employ—in contrast to Hogarth's satiric model—larger figures, larger spaces around them (empty spaces), and simpler compositions.

What Highmore cannot or does not illustrate, and what was absolutely central to Richardson's novel, is Pamela's mind or, better, her consciousness—an aspect that is not visual, that depends on description *from a point of view*. In this illustration of virtue we do not get the sense of Pamela's point of view but in fact Richardson's, precisely because Mr. B. is marginalized: he is never marginalized in Pamela's consciousness. The sentimental goodness is only one aspect of Pamela, as "badness" is only one aspect of Mr. B.

Consciousness (and aspects of personality) are suggested by Hogarth in the pictures his characters hang on their walls. In one scene only, the first, Highmore employs a Hogarthian painting but without its function as a delineator of consciousness (fig. 101). It simply admonishes Mr. B. to be a Good Samaritan. Highmore positions Mr. B. in relation to Pamela so that they are parallel respectively to the Good Samaritan and the wounded man. This must be Highmore's rewriting of the Good Samaritan in Fielding's *Joseph Andrews* and in their common source, Hogarth's St. Bartholomew's painting. In *Marriage A-la-mode* the painting of *The Good Samaritan* would have been chosen by the late Lady B. and so serve as a sign of her goodness and piety, but also, bequeathed to her son, carrying the admonition: "Be a Good Samaritan to the helpless charge I leave with you." But now, with Lady B. dead and Mr. B. present in the room—taking over its space, making his first advance to Pamela—it

becomes an ironic comment on Mr. B., who should be, but is obviously the opposite of, a Good Samaritan.

Only the notion of the picture recalls Hogarth, and even here Highmore (and Richardson, who must have been cognizant of the strategy) may have regarded the model as Dutch and pre-Hogarth, appropriate for a domestic scene like this one. Highmore does not repeat the device. He does not want (nor does Richardson) a Hogarthian scene. He begins to suggest Hogarth's metaphoric use of interior spaces in the dividing-of-the-clothes scene, but he neglects to indicate the closure lines of a perspective box. He could have replaced both stylistic and emblematic elements with purely spatial ones, exploiting, as Richardson himself did in his innovative novel, the opportunities offered by the suite of rooms (and the exterior spaces) of a house, materializing the metaphor of spatial-social distances, as well as liberty, closure, and imprisonment. But virtue is all he wishes to represent, which stylistically took the form of French rococo elegance and well-bred decorum—precisely the qualities that Richardson himself sought in his genteel revisions of *Pamela*.[53]

Highmore's paintings (and perhaps Richardson's texts) did, however, have an effect on Hogarth. Friends had probably been urging him to try a more positive line: people seem always to have been suggesting this or that subject to him. The belief that he could paint only the low and sordid was beginning to be expressed, partly due to his association with the more controversial writings of Fielding. Hogarth was perhaps aroused by the possibilities—and the popularity—of Highmore's *Pamela* series to think in terms of more positive expression, smaller, simpler compositions with less incident, and more attention to painting. George Steevens in his account of Hogarth's "Happy Marriage" paintings (he seems to have seen only *The Wedding Banquet*) claimed that Hogarth, having been "often reproached for his inability to impart grace and dignity to his Heroines," vowed that this "happy" bride was "meant to vindicate his pencil from so degrading an imputation." Steevens then proceeds in similar language to show that Hogarth was so limited by class and experience that he could not paint a graceful, dignified heroine. But he ends his anecdote by recounting that Hogarth had "succeeded so well, at least in his own opinion, that he carried the canvas . . . in triumph to Mr. Garrick, whose private strictures on it" coincided with Steevens's. Garrick, as it happened, acquired *The Wedding Ban-*

quet, the painting in question; one which greatly interested George III, who in 1776 borrowed it from Garrick and detected a strong resemblance to his queen in the bride.[54]

The six or seven paintings appear to be a series and in some sense parallel to *Marriage A-la-mode.* The canvases are the same size as the *Marriage A-la-mode* canvases (27–28 × 35–36 inches).[55] While this may only mean that Hogarth was employing this size canvas in the mid-1740s, it is at least as likely that these pictures, which share a domestic subject, were part of a series—in the loose sense, based on relationship, including a relationship to *Marriage A-la-mode.*[56] Although "happy" is the operative word, he may have conceived a "Country Marriage" to contrast with his "City Marriage" in *Marriage A-la-mode,* recalling Abraham Bosse's contrasting series of those names. *Marriage A-la-mode* 1 draws upon Bosse, and one might see this as parallel to *The Wedding Banquet* in the second series, where the father of the bridegroom passes the loving cup to the happy bride (fig. 102).[57] Ironic parallels may also appear between the self-indulgence of 2 and *Relieving the Indigent,* the levee of 4 and *The Garden Party,* and the masquerade behind 5 and *The Country [or Wedding] Dance* (ill., vol. 3). But if the "Happy Marriage" series began, as appears from Samuel Ireland's etched copies, with pictures of courtship and the marriage procession, there are no plate-for-plate parallels. Moreover, if (as seems likely) the so-called *Staymaker* (Tate) belongs to this series (perhaps the fitting of the bridal gown), there were seven paintings. Hogarth had probably not decided on an exact number or progression when he discontinued the project.

From the high quality of the painting and the lack of incident it is easy to see why they were not engraved. Hogarth faced in the "Happy Marriage" paintings the same problem he faced in most of his portraits: there was no drama, there were no gestures and expressions, hardly even symbolic objects, with which to convey the emotions of joy and happiness. And so he ended by performing exercises in pure painting and never finished the canvases.

These canvases lead one to feel that as paintings Hogarth's oil sketches are more satisfactory than the finished works. Exactly what is lost is hard to define: spontaneity certainly, but this would be true of most finished paintings. Rather, the rudimentary sketch does not display the more constricting conventions of contemporary paintings—from the "licked" finish and the tricks of "drapery painting" (analogous to the finishing by a professional engraver, who per-

fectly rendered textures and tones, of one of Hogarth's etchings) to the static, fixed quality deemed appropriate for formal history paintings. What sets the sketches apart is Hogarth's tendency to reduce a subject to its most basic skeletal composition, subordinating realistic to formal, psychological to purely expressive considerations. Successive washes of semitransparent pigment, ribbons of color, build up the forms, emphasizing their rudimentary shapes and relationships. In paintings such as *The Staymaker* and *The Country Dance,* Hogarth achieves an effect not unlike the one Turner was to achieve in his Petworth interiors or Daumier in his *Don Quixote* canvases.

But if these paintings are reductions to a formal pattern, they are also significantly unfinished. If in the nineteenth century Daumier's difficulty in finishing a painting was a sign of a subconscious insight into the way pictorial substance was changing, Hogarth had no such insight: he pushed most of his works through to completion. He was unable to reconcile his facility in this style with his belief in a closed, stable, understandable world. The lack of finish—as realized a generation later in Fragonard's oils and Rowlandson's watercolors—was the vehicle for a fragmentary conception of the world quite alien to his, at least in his moral persona.

It is more likely that Highmore's series gave Hogarth the idea for his "Happy Marriage" than that its success convinced him that "the market for such a subject had been saturated."[58] These paintings would simply have lost their charm by being fleshed out into engravings: they demand color and freedom of brushwork. Hogarth turned instead to a combination of the two series, incorporating the happy scenes as the life of Francis Goodchild into *Industry and Idleness* (see Chap. 12): that amalgamation suggests how elaborate and ironic the parallels would probably have been between *Marriage A-la-mode* and the "Happy Marriage."[59] One step beyond the bifurcation of painting and print in the *Marriage A-la-mode* project was for Hogarth to think of himself as pure painter—or, we shall see, alternatively as pure printmaker.

10.

GARRICK AND THE THEATER

Public and Private Life
in the 1740s

GARRICK AS RICHARD III

An unauthorized poetic description of *Marriage A-la-mode,* published in February 1745/46, began with the problem of genre, concluding that "dramatic painter" was a more apt designation for Hogarth than history painter:

> If the Comic Poet who draws the Characters of the Age he lives in,
> by keeping strictly up to their Manners in their Speeches and Expres-
> sion; if satirizing Vice and encouraging Virtue in Dialogue, to render it
> familiar, is always reckon'd amongst the liberal Arts. And the Authors,
> when dead, dignified with Busts and Monuments sacred to their
> memory; sure the Masters of the Pencil, whose *Traits* carry, not only
> a lively Image of the Persons and Manners, but whose happy Genius
> has found the Secret of so disposing the several Parts, as to convey a
> pleasing and instructive Moral thro' the History he represents, may
> claim a Rank in the foremost Class, and acquire, if the Term is allow-
> able, the Appellation of the *Dramatic* PAINTER.[1]

Hogarth had himself drawn attention to this aspect of his art with his portrait—one of his most ambitious—of David Garrick as Richard III, the role that made him famous in 1741 and reportedly introduced his new style of acting to London. This was a myth Hogarth helped to propagate by his painting, which was finished in the fall of 1745; shortly thereafter he gave it his seal of approval by engraving and publishing it by subscription (July 1746).

If in one way this new phase of Hogarth's career begins with the

turn toward formalism and reduced complexity suggested by both the Line of Beauty and the "Happy Marriage" paintings, in another it begins with his sublime history portrait *Garrick as Richard III*. This painting commemorates a performance as important as *The Beggar's Opera* of twenty years before. That one ushered in his comic history paintings, while this opened a new phase in which he produced simpler, more unified and formalized histories in the sublime manner.

Garrick's success would have appeared to Hogarth as a hopeful sign, recalling the troubles of the theaters in the 1720s which made a play like *The Beggar's Opera* necessary—as the analogous situation of history painting had made *A Harlot's Progress* necessary. Now in the 1740s the preeminence of Shakespeare and the classic tradition of English drama is reestablished—as by implication the classic tradition of English art is again flourishing. With *Garrick as Richard III* this complicated and troubled period of Hogarth's career opens on a note of hope: the failure to leave a mark as a portraitist had been followed by the successful subscription for *Marriage A-la-mode;* the less successful auction of comic history paintings was followed by a payment of £200 for the *Garrick;* and this sublime history would shortly be followed by two others, with opportunities for histories by Hogarth's friends as well.

The subscription ticket for the engraved version (fig. 104) shows joined on one rope a manuscript hung with bays (Shakespeare), a palette (Hogarth), and a mask (a good likeness of Garrick's face), associating the three names in a history painting. Hogarth was always very circumspect about his public associations with his contemporaries: he had linked himself with Fielding in fiction, and now with Garrick in the theater. They were strong personal friends, and Garrick, in the days of his greatest prosperity, collected Hogarth's paintings, dedicated a play to him, and tried to smooth over his quarrels. Beyond friendship, they shared a common theory of the ideal mode of presentation on a stage and in a painting. Fielding, who also liked to link himself with congenial contemporaries, gets across the main point about Garrick's acting style when he has Partridge, at the theater with Tom Jones to see Garrick's Hamlet, comment that the king was clearly the best actor in the play: "he speaks all his words distinctly, half as loud again as the others.—Anybody may see *he* is an actor." As to Garrick's Hamlet: "why, *I* could act as well as he myself," says Partridge. "I'm sure, if I had seen a ghost, I should have looked in the very same manner, and done just as he did. And then, to be sure, in that scene, as you called it, between him and his

mother, where you told me he acted so fine, why, Lord help me, any man, that is, any good man, that had such a mother, would have done exactly the same."[2] Thus Garrick transformed Richard III from the bloodthirsty stock villain of the old productions into a complex tragic character. Nature here is the avoidance of bombast, or exaggerated gestures, and the reliance on the informal, everyday, and transient.

That the association was maintained is evidenced by the many contemporary references that connect Hogarth with Fielding, and a few that connect him with Garrick, such as Christopher Smart's couplet in his *Hilliad* (1752):

> While thinking figures from the canvas start,
> And Hogarth is the Garrick of his art—

Smart observes in his gloss that the compliment "is reciprocal, and reflects a lustre on Mr. Garrick; both of them having similar talents, equally capable of the highest elevation, and of representing the ordinary scenes of life with the most exquisite humour."

To see what Garrick's acting was, and to what extent the parallel with Hogarth was apt, one must consider the historical situation of the theater. Acting, like history painting, goes through cycles: Betterton acted with restraint, using few gestures and never raising his arms above his waist, relying heavily (in the small theater of the time with its apron stage) on facial expression. With the operatic effects of the more grandiose theater of the 1720s, and with opera as a competitor, the Wilks-Cibber-Booth school overacted and either spoke in cadence or ranted, modulating from the declamatory monotone to the vocal claptrap. James Quin, who sat to Hogarth for his portrait (though from the painting, only the raised head and proud stance would suggest that he was an actor), was recalled by Richard Cumberland in his *Memoirs:* "With very little variation of cadence, and in a deep full tone, accompanied by a sawing kind of action, which had more of the senate than the stage in it, he rolled out his heroics with an air of dignified indifference."[3]

The counterreaction began with Charles Macklin, almost an exact contemporary of Hogarth's (Garrick was twenty years, almost a generation, younger), a roistering actor who made his way through the 1720s and 1730s trying to develop a new style that was in some sense a return to Betterton. As early as 1730 he had been criticized by man-

agers for his overly familiar delivery, and the style he developed was based on "natural speaking" to replace the practice of "adding vehemence to words where there was no passion, or inflaming a real passion into fustian."[4] His naturalism was based on period costume, on a general toning down of bombastic declamation through underplaying, and, when passion was called for, on what contemporaries described as "break[ing] the tones of utterance"—modifications of the standard speech patterns of "acting" ("the recitative of the old tragedy").[5] The first great triumph of Macklin's reaction against the old bombastic style was his Shylock in February 1741. Then just eight months later, on 19 October, as if to snatch the fruits of Macklin's victory, the young Garrick made his indelible impression upon London as Richard III. Garrick had been acting in London semi-professionally for some time, and an old story has it that he first met Hogarth at a performance of *The Mock Doctor* given in the *Gentleman's Magazine* office in St. John's Gate, with Samuel Johnson as a bystander.[6] It seems likely that if Hogarth did not catch the first night of Garrick's *Richard III,* he must, as a confirmed theatergoer, have seen the play after the *Daily Post*'s glowing account the next day.

In William Cooke's words, Garrick's manner changed "an elevated tone of voice, a mechanical depression of its tones, and a formal measured step in traversing the stage, into a *familiar* manner of speaking and acting."[7] He seems to have gone well beyond Macklin in his ability to particularize characters. His technique of observing and committing to memory regional accents, gestures, and phrases as he "sauntered" about London recalls the mnemonic technique Hogarth claimed to have utilized for his graphic compositions. But Garrick's most distinctive contribution seems to have been the blending of comic and tragic modes in a single character (vs. the introduction of comic business into a tragedy, as in the porter's scene in *Macbeth*)—a strategy analogous to Hogarth's and Fielding's mingling of high and low. And like them he was accused by some critics of having vulgarized the classic roles. Aaron Hill criticized the "undignity" of his portrayals, remarking that his Lear looked "as like a mad anything else, as a mad king."[8] More to the point was Quin's malicious observation on Garrick's Othello that "There was a little black boy, like Pompey, attending with a tea-kettle, fretting and fuming about the stage, but I saw no Othello."[9] The allusion of course was to Hogarth's second plate of *A Harlot's Progress*. But one reason for Garrick's success and for his reputation as the founder of the school that

Macklin actually originated, was, as Alan S. Downer has put it, his "erring on the side of too much, rather than too little, fire," and thus avoiding the criticism of underplaying aimed at Macklin: "From Macklin he took the natural speech and the broken tones of utterance, from the older school he took the fire of romantic acting and the careful attention to grace in posture and gesture."[10]

Accounts of Garrick's acting indicate that facial expression accomplished as much for him as body movement or voice. After he took over the management of Drury Lane in 1745, he cleared the spectators off the stage and replaced the chandeliers with footlights, which focused the light on the actor's face and expression. If Hogarth tended to make his painting look like a play, Garrick made his play look like a painting. The instant he entered on the stage as Richard III "the character he assumed was visible in his countenance; the power of his imagination was such, that he *transformed himself into the very man;* the passions rose in rapid succession, and before he uttered a word, were *legible in every feature of that various face*—his look, his voice, his attitude, changed with every sentiment" (emphasis added).[11]

Clearly he also illustrated the concept of "character," and in the engraving that followed from the painting of Garrick, Hogarth had the work done by Charles Grignion except for the face, which he did himself, designating this in the publication line. Later, Grignion related that Hogarth attempted the face several times, each time without satisfaction, rubbing it out until he finally got it right.[12] In fact, however, it was the painting itself, not the engraving. As in his later portrait of Garrick (with his wife, ill., vol. 3), Hogarth had trouble catching Garrick's face with its constant and complete mobility. He finally gave up and tried out faces on another canvas until he had a likeness that satisfied him, which he then cut out and sewed into the *Richard III* canvas.

By 1745 Garrick's victory was complete and his position on the London stage unassailable to a degree that eluded both Hogarth and Fielding in their different media. In the spring of that year Garrick's version of *King John* at Drury Lane—with Garrick as King John, Susannah Cibber as Constance, and Macklin as Pandulph, the last played "as if the papal legate were a parish clerk," wiped out the old style *King John* of Colley Cibber at Covent Garden, played "in the good old old manner of singing and quavering out their tragic

notes."[13] The audience preferred the naturalistic style over the formalistic: Cibber's *King John* closed after ten performances. Garrick and his friends must have taken this as the defeat of the seesaw tones and the tragic gait, and the opening of a period in which nature would predominate over art in acting. It was of course at just this time that Hogarth, finishing *Marriage A-la-mode,* and with his portrait of Herring behind him, began thinking about his portrait of Garrick in his first great role.

Hogarth no doubt had Garrick's encouragement for both painting and print: Garrick cultivated people of other professions, especially artists and writers. Besides Hogarth, those who eventually painted him included Reynolds, Gainsborough, Hayman, Dance, Cotes, Hone, and Zoffany, as well as Angelica Kauffmann, Pompeo Batoni, and other Continental artists. Garrick shrewdly used their works to spread his fame.[14]

He was different from Hogarth, perhaps a useful complement, in that he very quickly achieved a social position never approached by the artist; he possessed an ability to rise and pass in the society of Lord Burlington, the marquis of Hartington, and others—not only because the eighteenth century was receptive to dramatic talent, but also because Garrick (his profession notwithstanding) was himself a gentleman, his father a captain in the army with entrée to the best military society, and his mother from a clerical family of Litchfield with connections in ecclesiastical society. To some extent this set Garrick apart from Macklin and Hogarth, if not from Fielding. But Garrick's ability to don the social mask does not seem to have caused friction between the actor and the painter, who remained friends—with occasional bouts of suspicion on Hogarth's part, perhaps for this same reason—until the end.

Fairly exact dating of the portrait is possible: Hogarth must have been busy with *Marriage A-la-mode* and his auction until March or April. Garrick was acting at Drury Lane during this season, and it was at the end of the 1744–1745 season that James Lacy bought the Drury Lane patent and approached Garrick about sharing it. During part of the summer he was away from London, presumably with Peg Woffington. Sittings for the portrait were completed by the end of the summer. By 10 October Garrick was in Litchfield, on his way to Dublin for the winter season. Hayman too was painting a portrait of Garrick at this time, back in London. "Have You finish'd My Picture

Yet?" Garrick asks him, prodding him as always to be on with his Garrick portraits: this may have been the other *Garrick as Richard III,* displayed at the Society of Arts exhibition in 1760.[15]

Garrick's close friend William Windham the elder, father of the statesman, who had championed Garrick in his quarrel with Macklin, was with him in Litchfield at this time, but becoming ill he left for London on the 10th or 11th.[16] He had dispatched back news of London by the 23rd, when Garrick wrote to Somerset Draper: "Mr Wyndham sends me a great account of *Hogarth's* Picture; have you seen it lately?"—which could mean either that it was still unfinished or that it was to be seen earlier, perhaps by Garrick himself. But the letter of 1 December to Draper, written in Dublin where Garrick spent the winter season that year, seems to indicate that the portrait was not yet finished: "Pray, does *Hogarth* go on with my picture, and does he intend a print from it?" He adds, "Pray, when you see him, give my services.—where is Hayman? he has used me ill, and never answered my letter."[17]

There was no correspondence to speak of between Hogarth and Garrick; nor does Garrick mention Hogarth much in his letters (the above rare instances support doubts as to how much Garrick is interested in his friends Hogarth and Hayman or in their portraits of him). This does not necessarily mean that the report of their intimate friendship from the earliest years was exaggerated,[18] but rather that they moved in different circles—certainly Draper, Garrick's main correspondent at this time, had little contact with Hogarth except to buy his prints.

If in terms of social acceptance Macklin corresponded to Garrick much as Hogarth did to Reynolds, it is more useful to see Macklin as a true dramatic equivalent of Hogarth's comic histories of the 1730s and Garrick as a somewhat more "dramatic" actor, analogous to Hogarth's style in the histories that began with *Garrick as Richard III.* The difference between this painting and *The Beggar's Opera,* which began the earlier phase, tells the story. The latter was a small picture with small figures, plainly actors, on an unmistakable stage, with members of the audience nearby. *Garrick as Richard III* is a huge (75 × 98½ inches) life-size scene, nearly of a scale with the sublime histories Hogarth painted in St. Bartholomew's Hospital. The audience has been not only moved off the stage but completely eliminated, achieving the illusion of a stage like Garrick's. The criticism advanced by later writers that Hogarth's portrait did not re-

semble Garrick (the face should be compared with the likeness of the mask on the subscription ticket) misses the point. In *The Beggar's Opera* Miss Fenton and Walker were clearly themselves, dressed as a maiden and a highwayman—an impression Hogarth does not wish to convey in *Garrick as Richard III.* Garrick has indeed "transformed himself into the very man"; he has *become* Richard III.[19]

The surprising change that has taken place between *Marriage A-la-mode* and *Garrick as Richard III* is based on the assumption that Garrick is not acting but *is* Richard III. Hogarth now relies more heavily on the figure's expression—on face and bodily movement—than on external attributes; he has turned from the emblematic-allusive mode he had perfected, perhaps to excess in *Marriage A-la-mode,* which he now reduces to one large emblem. The difference was formulated by the author of Hogarth's obituary in the *Public Advertiser* of 8 December 1764 (Morell perhaps, or Townley), who distinguished between sublime histories and "life paintings"(the "modern moral subjects" or "comic history paintings") as lying in the use of "furniture": "as in sublime subjects and history pieces, the fewer little circumstances there are to divide the spectator's attention from the principal figures, is reckoned a merit; so in life-painting, the greater variety there is of those little domestic images, to give the whole a greater degree of force and resemblance."

Hogarth shows Richard waking terrified from his dream of retribution, staring at the ghost, invisible between him and the viewer. There is only a slight suggestion of the old choice pattern in the cross on one side of him and his armor on the other; objects are held to a minimum. Everything that would have been important in the earlier paintings is subordinated to form and color and texture. The static, stylized, almost hieratic pose of Richard reveals less about the actor's style than about the kind of sublime history Hogarth would be developing in *Moses Brought to Pharaoh's Daughter* and *Paul before Felix* (figs. 129, 132), paintings of a comparable scale and formality. It is also significant that while there were some Lines of Beauty in *Marriage A-la-mode,* Richard's whole posture is a serpentine line, emphasized by the long sweep of his robes and the curtain of his tent.

Hogarth may have come to appreciate the power of a single gestalt from Garrick's new acting style. But there were other factors such as his trip to France. Although he presumably shows the scene as Garrick staged it, with the properties he used, Hogarth takes his composition from Le Brun's *Tent of Darius,* well known as an engraving

and perhaps seen in the original on his trip to Paris if he visited Versailles (included in the ordinary Englishman's tour). The colors and textures, as in the portrait of Archbishop Herring, also show signs of the trip to France. But the remarkable subordination of detail to broad design, so different from the equally large-scale but crowded group in *The Pool of Bethesda,* may be the most important evidence of his contact with French painting.

Hogarth may also have been preparing himself for this new development in his portraits, which of course required the single unified impression. As he was painting *Marriage A-la-mode* he was also painting *Thomas Herring* and the two monumental conversations of the Mackinen and Graham children.

In another sense this painting represented a departure in history painting. By deemphasizing Garrick the actor, Hogarth makes his picture a portrayal of national history, aimed at the Englishman's interest in his past as well as in Shakespeare (one glory of that past), and a suitable substitute for those discredited subjects from mythology and—for England, at least, largely suspect—the Bible.[20] His *Henry the Eighth and Anne Boleyn,* though its original intention seems to have been political satire, contributed to the idea of national history in the painted version that hung in one of Tyers's pavilions; and he had painted another Shakespearean history in *Falstaff Examining His Recruits* (both ill., vol. 1). At the time Hogarth was working on *Garrick as Richard III,* Hayman was also producing paintings from Shakespeare's plays, and in 1760 he exhibited Garrick as Richard III standing up and crying "A Horse, a Horse . . ." (National Theatre); and Tyers's Rotunda was being graced by images of Shakespeare and Milton as well as Locke and Handel.

In 1743 William Collins had published a poem addressed to Sir Thomas Hanmer "On his Edition of Shakespear's Works."[21] This is a subject that would have attracted Hogarth, Hayman was the illustrator, and the gist of Collins's argument would also have pleased him: that Shakespeare's vigor has been lost by too much art, as for example in such successors as Ben Jonson ("Nature in him was almost lost in Art"). This edition, Collins says, will make available to poets and painters Shakespeare and his native British power. Among his examples of Shakespeare's "picturesqueness" is the one that Hogarth illustrated a couple of years later in his first Shakespeare painting to be engraved:

> The Time shall come, when *Glo'ster's* Heart shall bleed
> In Life's last Hours, with Horror of the Deed:
> When dreary Visions shall at last present
> Thy vengeful Image, in the midnight Tent. . . .
> O might some Verse with happiest Skill persuade
> Expressive Picture to adopt thine Aid!
> What wond'rous Draughts might rise from ev'ry Page!
> What other *Raphaels* Charm a distant Age! (ll. 87–90, 107–10)

This was the sort of call (invoking Raphael and, in line 134, "The Sister Arts") which Hogarth answered, not least because it ushers in a complete change of emphasis in his work. The size and simplicity of this single figure confronting the viewer, in the context of the crowded *Marriage A-la-mode* canvases, suggest that he is fulfilling a call; equally striking is the anticipation in Richard III's expression of Collins's own "Ode to Fear" (published in his *Odes* of 1746). Richard is responding to the ghosts as Collins's personification of Fear responds, thus (Collins argues) producing the same response in the spectator.

Of course, the inspiration of Collins too was accompanied by— perhaps mediated by—Garrick: first as a celebration of his triumphant, career-establishing performance as Richard III; second as a representation of the particular style of acting associated with Garrick, who was famous for his "start" when Hamlet sees the ghost. In fact, Garrick's success in that role in 1741 may have led Collins a year later to use the particular example of *Richard III*, perhaps *because* of Garrick's "start" in the ghost scene; and this in turn may have contributed to the "Ode to Fear," which focuses on precisely that response. The representation of Garrick's *response* to the ghost—of fear—ties together the new acting style and the new poetics.[22] This was, incidentally, the one Hogarth painting singled out for praise by Joseph Warton in his manifesto of the new poetics in *An Essay on the Genius and Writings of Pope* (1756). It was also the painting upon which were based the scale and one of the composition types of the Boydell Shakespeare paintings; it opened the way, in terms of subject and treatment, to the academic Shakespeare paintings of the 1760s onward. It might even be argued that it laid down the pattern for the heroic portraits of Reynolds in which contemporary Englishmen are made to seem gods, heroes, or Shakespearean protagonists.

As Garrick's letters show, he was eager for an engraving, even before Hogarth had mentioned the possibility. For him it was an advertisement, for Hogarth it was to some extent another propaganda piece showing how acting conformed to the dicta he set forth on history painting and how the stage related to his histories. More important, the engraving broke ground and tested the possibility of engraving his own sublime histories. By 1751 and 1752 Knighton and Dodsley had also begun to publish prints of English history designed by Hayman and the French-trained Nicholas Blakey: *The Landing of Julius Caesar in Britain, Caractacus before Claudius, The Conversion of the Britons to Christianity, The Settlement of the Saxons in England, Alfred Receiving News of the Victory over the Danes,* and *The Battle of Hastings.*

Vertue was impressed by Hogarth's *Garrick,* especially complimenting the engraving, largely by Grignion, which, he thought, "may stand as a peece of reputation being the Invention painting & Engraving of Natives of England. this and many other products of Engravings are come to an equal perfection in most particulars to any foreign works of Italy france or Dutchlanders" (3: 130). He is speaking of reproductive engraving; but he qualifies his compliment by excepting portrait engraving, which of course was Hogarth's particular contribution in this case, as Vertue would have known from the publication line.

Hogarth presumably made the painting and then simply waited for a buyer; certainly he did not make it for Garrick, and it would seem a remarkable coincidence had it been commissioned just at that time. There is no record of an auction, or of any other disposal. Nevertheless, it was sold—perhaps at least partly through its subject matter—to a Mr. Duncombe of Duncombe Hall, Yorkshire, for £200, which, as Hogarth himself noted with pride, "was more than any portrait painter was ever known to receive for a portrait" (AN, 213). I cannot determine whether this man was related to William Duncombe, the friend of Archbishop Herring who seems to have been interested in getting his portrait by Hogarth engraved. Thomas Duncombe of Duncombe Park was the representative of the line of the family through which the portrait descended; his grandson became first earl of Feversham in the next century, and the portrait remained with the earls of Feversham until it was given to the Walker Gallery in Liverpool.

The painting had its buyer by 21 October 1746 when Hogarth

replied to a letter of inquiry about his *Garrick as Richard III* from a member of a literary society called the Argonauts which met in Norwich ("To J.H. to be left at the Post-office at Norwich"):

> Sr
>
> If the exact Figure of Mr. Quin, were to be reduc'd to the size of the print of Mr. Garrick it would seem to be the shortest man of the two, because Mr. Garrick is of a taller proportion. examples.
>
> [Sketches of "Quin, a very short Proportion" and "Garrick, a very tall proportion"]
>
> Let these figures be doubled down so as to be seen but one at once, then let it be ask'd which represents the tallest man.
>
> Yours, W. H.
>
> The Picture from which the Print in question was taken, was painted from Mr. Garrick big as the life, & was sold for two Hundred pounds on account of its Likeness, which was the reason it *was call'd Mr. Garrick in the Character of Richard the 3d* and not any body else.

This letter is another indication that Hogarth was beginning to theorize about problems like proportion as well as "character," and that he wanted people to know how much he had been paid for his portrait.[23]

The engraving was out in July 1746, and in the same month Hogarth accompanied Garrick to Old Alresford to visit their friend John Hoadly.[24] Hoadly's latest living was the rectory of St. Mary's, near Southampton, to which he was instituted 9 June 1743. At the time of the gathering he lived in Old Alresford in a house considered "as spacious and elegant a parsonage as any in the kingdom, (his predecessor, Archdeacon Brideoke, in whose time it was burnt down, having expended 4000l. on it, besides 500l. on the church) . . . embellished with the remains of his mother's pictures, and the best of her own paintings."[25] "Your Invitation to old Alresford I most cordially Accept of," wrote Garrick,

> & the little-ingenious *Garrick* with the ingenious little *Hogarth,* will take the Opportunity of the *plump Doctor's* being with You, to get upon a Horse-block, mount a pair of Quadrupeds (or one if it carries double) & hie away to the Rev'd Rigdum Funnidos at ye aforesaid Old

Alresford, there to be as Merry, facetious Mad & Nonsensical, as Liberty, Property & Old October [i.e. ale] can make "Em! huzza! I shall Settle the whole Affair with yr Brother tomorrow & shall wait his Motions: I am, in raptures at the Party! huzza again Boys! shan't I come with my Doctor? Yes; he gives me the potions & the Motions? Shall I loose my Priest? my Sir John? no, he gives me the proverbs & the No verbs. My cares are over, & I must laugh with You: Your French Cook is safe & sound & shall come with Me; but pray let us have no Kickshaws: Nothing but laugh & plumb pudding.[26]

As the reference to the "plump Doctor" suggests, Messenger Monsey, the physician and wit, a familiar figure in London social circles about whom many anecdotes have survived, was already present. Noted for his dirty linen, snuff-covered exterior, sharp tongue, and especially his buffoonery, which won him invitations to the tables of the great, he was a friend of Garrick's for many years. He made such fun of Garrick's social pretensions, however, that they eventually broke off relations. As a nonresident physician at Chelsea Hospital, Monsey may have been a contact or connection between Hogarth and Daniel Graham.[27] Hoadly's "Brother," Benjamin, at this time physician to George II, appears also to have been of the party that accompanied Garrick and Hogarth as they traveled south that July.

In the Old Alresford parsonage this group of congenial spirits—very much like the groups that went on the "peregrination" and assembled to eat beefsteaks together—engaged, among frivolities, in amateur theatricals. The Hoadlys, of course, were devoted to the theater, as both playwrights and amateur actors. One play performed has survived in manuscript, all or most of it composed by Garrick. A materialization of their particular kind of high spirits and the Hogarth-Garrick approach to "nature" through the travesty of heroic conventions, it is a bawdy parody of the quarrel scene between Brutus and Cassius in *Julius Caesar*. The manuscript dedication to Garrick's friend William Windham (in whose family the manuscript has descended) is dated 20 July 1746. It was called *Ragandjaw,* and it transformed the Roman generals into an English sergeant and corporal, lamenting the loss not of Brutus's noble wife but of his mastiff bitch Brindle, who had been after sheep. Scene: "A Tent; a Table, Pot of Beer, Pipes & Tobacco &c." Brutus became Brutarse, played by John Hoadly, Cassius became Cassiarse, played by Garrick, and

the servant Lucius became Loosearse. Caesar's ghost was replaced by the Devil's Cook, and this figure was played by Hogarth.[28]

There is an old anecdote, one of the most persistent about Hogarth, that "so unretentive was his memory, that, although his speech consisted only of two lines, he was unable to get them by heart. At last they hit on the following expedient in his favour. The verses he was to deliver were written in such large letters, on the outside of a illuminated paper-lanthorn, that he could read them when he entered with it in his hand on the stage."[29] This revelation is, unfortunately, somewhat exaggerated. Hogarth, as Grilliardo the Devil's Cook, had twenty-three lines to remember—and considering Hogarth's own remarks on his verbal, as opposed to visual memory, it is not surprising if he needed prompting. Also given what we know of Hogarth's piety, the casting was appropriate.[30]

Thunder and Lightning. Enter
Grilliardo the Devil's Cook

Brutarse. How ill this farthing Candle burns, and blue!
 I'll top the Glim—(*snuffs it with his Fingers*)—
 What's here?—Zounds who are you?
 That puts my Heart in Pickle and in Stew?
Grilliardo. I am Old Nick's Cook—& hither am I come
 To slice some Steaks from off thy Brawny Bum,
 Make Sausage of thy Guts, & Candles of thy Fat,
 And cut thy Cock off, to regale his Cat.
Brutarse. Art thou, in Hell, a Ruler of the Roast?
 I wou'd not care a—(*snaps his Fingers*)—for such a
 Ghost.
Grilliardo. And dost thou think to hide thy Crimes from me?
 Tho' thou blind'st Cassiarse, yet thou can'st not *We*.
 Your Wife you Murther'd—Shall I say for What?
 Because she leak'd beside the Chamber-Pot:
 Your Sisters you Debauch'd in Anger sudden,
 Because they put no Plumbs into your Pudding.
 You, Nero like, rip'd up your Mother's Belly,
 And boil'd your Father to make Calvesfoot Jelly.
 Adieu; to Hell I'm going to prepare
 This redhot Gridiron against you come there:
 Pack up your Duds and meet me at Rag-Fair.

Brutarse.	My Trull keeps Shop in Porridge Row—I'll meet thee
	there.
Grilliardo.	But first to Westminster I'll take my Way,
	And with a Gang of Lawyers load my Dray;
	Next to fam'd Warwick Lane away I'll Whiz,
	My Master Satan wants a Household Phiz:
	Last to where Convocation sits I'll fly,
	For I've a fatars'd Chaplain in my Eye.
	But ha! I'm call'd—Hell gapes! I'm on the Brink!
	Brutarse, prepare—for now I feel, I sink.

Walks off

Hogarth also participated, more characteristically, by painting the set, which represented "a sutling booth, with the *Duck of Cumberland's* head by way of sign"—the head of the hero of Culloden that was gracing signs everywhere in England at this time. "He also prepared the Playbill with the characteristic ornaments," George Steevens adds, remarking that the original drawing survived at that time.[31]

We do not know the exact dates of this visit, but 20 July on the manuscript of *Ragandjaw* is one clue, and Garrick was gone by 9 August when he wrote to Peter Garrick saying that he has one of Hogarth's prints (presumably *Lord Lovat,* which had just appeared) for William Vyse, the treasurer of Litchfield Cathedral. Hogarth's reaction to this outing was not recorded, but Garrick thanked Hoadly enthusiastically, stressing the amateur theatricals, on 19 August, and again on 14 September: "I was never in better Spirits or more nonsensical in my Life," he wrote about a recent experience, "allways excepting those never to be forgotten or parall<eled> Days that were Spent at O. Alresford in the Reign of *Ragandjaw* in the Month of July Anno Dom 1746."[32]

SELF-PORTRAIT WITH PUG

Having been celebrated in the preface to *Joseph Andrews* as a "comic history-painter," having published *Marriage A-la-mode* and sold his "comic history-paintings," Hogarth painted an official self-portrait (fig. 105), which not only was to hang in his house (presumably in his showroom) but, engraved, was to grace the bound sets of his

prints, to convey a likeness and to project an emblematic image of the "comic history-painter." He was now forty-eight years old, a mature artist, whose career had essentially evolved to a successful climax.

He used the *Marriage A-la-mode* canvas turned on its side (27½ × 35½ inches). His usual head-and-shoulders portraits were 30 × 25 (the size of the *Rake* and *Times of the Day* canvases); very special portraits, such as of Archbishop Herring or Mary Edwards, were closer to 50 × 40. But 35½ × 27½ inches was also the size of his portrait of Jane Hogarth (ill., vol. 1), for which his self-portrait may have been intended as a pendant. X-rays (fig. 106) show that he originally painted a conventional wigged portrait, with a white cravat and a coat and waistcoat with gold buttons, suitable to hang next to the portrait of elegantly dressed Jane. All that designated him a painter was the palette at the bottom, with some long brushes inserted in the thumbhole.[33] This new version—which in some ways seems to be a larger version of the self-portrait at Yale (21 × 21 in.; ill., vol. 1)—hung on his wall long enough for an enamel miniature to be made from it, probably by his friend Jean André Rouquet (fig. 107).[34]

In the revision he has replaced his coat with a painter's smock, his wig with a fur cap; his bust appears to be painted on an oval canvas resting upon a pile of books, the works of Swift, Shakespeare, and Milton; these are flanked by his alter ego, the bluff, honest-faced pug. All that remains from the first version is his painter's palette, now without the brushes. The dog and the other symbolic objects are painted with reversal and engraving in mind; one is to read up through the pug to Hogarth (both looking to the right), and then examine the palette and books.

The scar on his forehead, however, is correctly placed on his right in both painting and engraving. The scar, said to have been received in childhood, is also prominent in Roubiliac's bust (fig. 35). John Ireland records stories of his wearing his hat cocked back so that the scar was visible (1: 120). Either he received the scar not in childhood but in the 1730s, or he had chosen to conceal it in his first (the Yale) self-portrait and reveal it now. It seems to have been as important to him, in its way, perhaps as a sign of toughness and durability, as his dog.

In the art treatises, Old Masters were characterized by animals—Michelangelo by a dragon, Leonardo by a lion, Titian by an ox—and Hogarth draws on that tradition.[35] The pug, who appeared as a kind

of trademark in several of his works prior to the self-portrait, is also a satiric mask representing the artist's watchdog function and his moral toughness, reminiscent of Fielding's Captain Hercules Vinegar of *The Champion*. Hogarth owned a pug named Pugg in 1730, and by 1740 he had replaced him with one called Trump, who was sculpted to accompany Roubiliac's bust of his master (figs. 35, 36). The dog in the self-portrait is taken directly from the artist's pug in *The Strode Family* (fig. 78) who joins that family at breakfast, sitting opposite their own dog who enjoys his own breakfast while Hogarth's pug has none.[36] In the fifth plate of the *Rake's Progress* it may be he who woos a one-eyed bitch of another breed; the pair shows what the marriage of the rake and his superannuated heiress really amounts to (fig. 19).

By juxtaposing his own face and his pug's he suggests the resemblance, punning on his pugnaciousness or doggedness. There are other puns: the "fidelity" of the dog would be identified with Hogarth's own "fidelity of presentation"; his graphic work "literally rests (as does his palette) upon the English literary tradition."[37] Trump added a Hogarthian comment, and the self-portrait put the seal on Hogarth as "Painter Pugg," as he was later called by his detractors; but he was still willing to accept the pug as his persona in *The Bruiser* of 1763 (ill., vol. 3).

Dogs also had Masonic associations traced back to the Egyptian dog-headed Anubis who taught Isis the way to find the dismembered body of Osiris; and so the dog was associated with the higher secrets and the higher degrees of Masonry, sometimes appearing among the symbols on Masonic diplomas. Hogarth may have had these associations in mind when he juxtaposed the dog with the hieroglyphic Line of Beauty. A pug had itself been employed as an emblem of secrecy among the Jacobite faction of Freemasons, but if this emblem still carried any currency a self-portrait with a Jacobite pug would have been a rash gesture in the year of the Forty-Five.[38]

The books on which Hogarth's portrait rests represent the literary basis of history painting. Milton and Shakespeare were Jonathan Richardson's examples of the sublime in literature, and Hogarth adds Swift.[39] He had illustrated scenes from the works of all three. These particular names are important because they announce that he is tapping into the literary tradition in England—England's greatest strength—rather than the graphic, in which England competed less successfully with the Continent. He sets out the sequence, as many

of his contemporaries also did, as Shakespeare, Milton, Swift, *and* Hogarth.

If the books are equivalent to the literary dimension of his work, the palette stands for his "painting." And to the palette he adds the year "1745" and the strange S-curve line labeled "The LINE of BEAUTY And GRACE" ("And GRACE" was painted out but now shows through again) to demonstrate that the comic history painter—specifically the artist of *Marriage A-la-mode*—is also concerned with beauty and to tantalize the uninitiated, which included many of the artists at the St. Martin's Lane Academy, thus prompting discussion.

It is usual in such baroque frontispiece portraits as Hogarth creates here for the figure to appear more real than its architectural frame. Its attributes—the symbolic objects that define it—are part of the frame, and sometimes the artist is painted leaning out beyond the frame to impart a sense of corporeality vis-à-vis this artifact, which now appears to be a window. But Hogarth has made the painter's portrait the artifact, and the symbols of his moral-aesthetic function—the dog, palette, burin, and books—are real. In light of the direction he takes in both portraits and comic histories, Hogarth should be defined in his natural setting by the objects around him, including perhaps painted pictures on the walls. Instead, *he* is the painted picture. He has painted himself as the simplest head-and-shoulders portrait, in the familiar oval he used for his run-of-the-mill sitters in those years; and this portrait is just another object in a still life. The private man seems to be separated from the mask, the symbols, the aims of the moralist-artist. The usual orders of real and fictional are reversed, and the symbolic world of Hogarth's engravings that will follow (from the engraved frontispiece) in the folio volume is the real world. This frontispiece is an exceptionally sound indication of where Hogarth placed himself, at this time, in relation to his work.

Roubiliac's bust, based as it must have been on long and personal contact rather than a few sittings, is one of the primary sources of information on Hogarth's character. Here he is as he appeared in life, caught in movement, with his head sharply turned, jutting assertively, with incredibly sharp and observant eyes. Pugnacious is the only word to describe the face and its movement. Hogarth flattens and idealizes the terrier face and lengthens and enlarges the pug (which accompanied Roubiliac's bust), strengthening the resemblance.[40]

It is not certain when Hogarth engraved the painting (ill., vol. 3). At the beginning of *The Analysis of Beauty,* explaining the origin of the Line of Beauty, he writes that he "published" the "frontispiece to my engraved works" in 1745; but in March 1748/49 Vertue took note of the self-portrait as if it had just appeared (6: 200), and an early state that has survived has 1749 penciled in (BM). Under the design Hogarth engraved *Gulielmus Hogarth,* a puzzlingly pretentious title unless one recalls Richard Hogarth's signature as *Richardus*—and perhaps Vincent Bourne's verse epistle "Ad Gulielmum Hogarth" of 1734, and Bourne's treatment of everyday English subjects in classical Latin, another version of the "modern history" expounded by Hogarth. In the engraving he also omitted the particular names of the authors, perhaps in order to show that he referred to literature in general (the pug embodying the Swiftean or satiric aspect).

All the themes of 1745–1746 are present in the self-portrait: the continuation of portrait painting, the self-publicity that would soon be augmented by Rouquet's *Lettres de M. * *,* the expanding definition of "history painting," the increasing concern about the formal principles of art suggested by the Line of Beauty, and a similar concern about his own relationship to his work in the bifurcation of self-images or self-aspects (which will become critical in *Industry and Idleness*).

FOLIOS AND COMMENTARIES

The mid-1740s, the years around the publication of *Marriage A-la-mode,* were boom years for the print trade. Vertue wrote in December 1744: "this year or this time the most remarkable for works done or doing in engraving—in England—" (6: 199); and he singles out Pond for his "sketches of drawings—graved then Landskips Pousin and others" and Hogarth for *Marriage A-la-mode,* Highmore for his *Pamela,* and a few others.

Louise Lippincott argues that Hogarth and Pond were the two foremost creators of the new print market in England—Pond with his own version of Hogarth's "progresses" and other series, his *Prints in Imitation of Drawings* (1736–1737) followed by the more successful *Caricatures* (1736–1742), *Italian Landscapes* (1741–1746), to be followed in the later 1740s and 1750s by *Roman Antiquities* and *Large*

Dutch and *Large Italian Landscapes.* [41] These were, of course, all copies and represented the alternative to the Hogarth prints that were original, topical, contemporary, and so on; and to Highmore's illustrations of the contemporary novel *Pamela.*

In terms of the print market of the 1740s Hogarth shared (probably established) the aims of other printmaker-sellers such as Pond. In Pond's case, his *Prints in Imitation of Drawings,* sold by subscription, had been bought by connoisseurs, antiquaries, and artists—and did not succeed financially. The customers for his later series—numbering between forty and sixty prints a year—included schoolmasters, physicians, and a calico printer as well as the elite market. Hogarth too knew that he had to retain the top audience, the educated, but could count on a broader one as well that included calico printers and the like. Whether this audience really extended to the lower middle class is unlikely. But he did appeal to the lower orders and maintained the pose of reaching them; they served as a symbolic audience that was assumed by the elite audience as part of its enjoyment of the prints (see below, Chap. 12). Hogarth's scheme was a conscious alternative to the modus employed by Pond, the servant of the connoisseurs.

In this market context, Hogarth can be said to have reached out in one direction in *Marriage A-la-mode* and then looked around in the following years for another way to extend his market. But, as the sale of his paintings attests, it was also a time of consolidation. Folios of his prints were being sold; he painted his emblematic self-portrait, intended as frontispiece; and he augmented the folios with a commentary. The latter took the form of Hogarth's employing or stimulating his friend Jean André Rouquet to put together an explanation of his prints in French for his Continental purchasers, *Lettres de M. * *.*

Rouquet, if we may believe the title page of his *State of the Arts in England* (1755), was residing in England by 1725; he was certainly three by 1729. In the fall of that year, Vertue remarked of the enameler Zincke, then so well employed that he charged from 10 to 15 or 20 guineas for a small head, that "others have endeavourd to immitate and follow him close, particularly . . . Roquet Enameller has best succeeded. and now is much imployd—he is a Swisse born. of french extraction. and at this present has 10 guineas a head—" (3: 96). He was one of the best enamelers in England, though he seems only then to have attained the eminence of the miniaturists Zincke, Lens, and Richter, who had monopolized the trade in London. Many of his

portraits have no doubt passed for Zincke's, but the rendering is softer in effect, a bit closer to what one might expect of a friend of Hogarth: a similar delicacy of brushwork, eyes slightly protuberant, and moisture showing on the lower lips. Rouquet's growing success may be partly attributed to the deaths of Richter and Lens and to Zincke's failing eyesight. He was also no doubt the unknown "Riquet" who is mentioned as doing the chinoiserie decoration for the central Chinese pavilion at Vauxhall.[42] Born in Geneva around 1701, he spent much of his time in England, though occasionally returning to France. From the one surviving letter he wrote to Hogarth (of 1753), it is clear that he was a close friend and, evidently, a fervent admirer and disciple.

The immediate impetus for his commentary seems to have come not from Hogarth but from Charles-Louis-Auguste Fouquet, Marshal Belle-Isle. *Marriage A-la-mode* had been delayed, as mentioned, by the outbreak of war with France in 1743. The head of the party in France that had instigated the war was Marshal Belle-Isle. At the end of 1744 Belle-Isle, passing through neutral Franconia, blundered into Hanover long enough to be recognized, taken prisoner, and sent to England. In February 1744/45 he and his brother, the Chevalier de Belle-Isle, who had been with him, landed at Greenwich, and next morning set out for Windsor attended by a troop of General Wade's horse. In spite of French ransom offers, he remained in England until August of 1745. By March he was residing "at a House some small Distance from Windsor, on his Parole of Honour, where he is to be at his own Expence, and be allowed to go ten Miles round it, except on the London side, where he is to come no more than five." His confinement seems to have been light: in April he and his brother dined at the earl of Harrington's at Petersham, "where the Duke of Newcastle, and several of the Nobility were present." And in July they visited the physic garden at Chelsea and Sir Hans Sloane's curiosities, "at both which Places they were treated with the utmost Elegancy and Politeness; at which they both express'd the highest Satisfaction."[43]

It is evident that Hogarth's prints were popular in France—no doubt part of the Anglomania launched by Voltaire's *Lettres sur les Anglais* (1733–1734) and the growing admiration for Shakespeare (despite Voltaire's reservations). Hogarth must have recognized this popularity on his trip to France two years before. Marshal Belle-Isle and his brother, having bought the whole set of Hogarth's engraved

works to date, including *Marriage A-la-mode,* which appeared while they were in captivity, asked their fellow countryman Rouquet, "having then been in England many years and well acquainted with the manners and characters of yᵉ English," to while away the hours of their captivity with an explanation. He did this first "verbally" and subsequently in writing, and, as Hogarth told it, "afterwards at my request he changed [it] into familiar letters as to a friend in Paris," and this was published in April 1746 as *Lettres de Monsieur * * à un de ses Amis à Paris, Pour lui expliquer les Estampes de Monsieur Hogarth.* Hogarth always included a copy of Rouquet's pamphlet with the sets of his prints he sent abroad.[44] Around 1750 Rouquet added an explication of *The March to Finchley,* which was subsequently bound up with the earlier pamphlet.

Hogarth can have had little or nothing to do with the writing of Rouquet's pamphlet. If he had written it, he would probably have started with some generalizations about comic history painting, but Rouquet was writing to a French audience, and like the French interpreters of Fielding's novels, he felt that he must first explain Hogarth's concern with low life. This he explains with the conventional example of the Lacedaemonian (out of Horace, but used more than once by Fielding): "Vous verrez dans la suite, qu'il cherche moins à plaisanter du vice qu'à le rendre odieux; c'est un Lacédémonien qui veut en inspirer de l'éloignement en le montrant de plus près."[45] The accounts of the prints are general and, though they must have had Hogarth's sanction, do not reveal too much: they offer the details a Frenchman would need to see Hogarth's gist, but they leave him extensive freedom of interpretation within these factual limits.

Rouquet was apparently still in England in 1749, when Vertue says "News papers Journal—mentions the reputation & character of Mʳ Roquet Enameller. works" (3: 152). He must still have been there in early 1750 when he wrote the addendum on *The March to Finchley,* which describes the painting before the print was made. Perhaps he described the painting because he could not wait for the print. Around that time, no doubt with the support and patronage of Belle-Isle, he departed for Paris for an extended stay. By special command of Louis XV he was made a member of the Academy of Painting and occupied apartments in the Louvre, a particular honor since he was a Huguenot in religion.

In September 1749 Hogarth took the final step of buying a villa in the country. It is likely that he had rented one—possibly the one he

now bought—for some years, going back (if one can believe his friend Morell) to within a few years of his marriage, perhaps becoming more permanent after Anne moved in and could be counted on to handle business while her brother was away. The Hogarths had lived in Leicester Fields now fifteen years, growing more prosperous and better known; a country house was clearly called for.

Chiswick, the location they chose, was one of the loveliest of the Thames-side towns. John Bowack, in 1706, described it as Hogarth would have known it:

> The pleasant village of Chiswick, tho' but small, is so very pleasantly situated out of the road and free from noise, dust and hurry that it has for many years past boasted of more illustrious and noble persons than any of its neighbours, nor is it at present without a good number of persons of great quality and worth. The Thames, taking an oblique course from Fulham and Hammersmith, but gently salutes this place, and the several little islands, or eights, so pleasantly scattered in it, considerably weaken its force. The greatest number of houses are stretched along the Waterside from the Lyme Kiln, near Hammersmith, to the Church, in which dwell several small traders, but for the most part fishermen and watermen, who make up a considerable part of the inhabitants of this town.[46]

The town derived its name from Old English *cese* or *ciese* and *wic,* the cheese farm, and a cheese fair was supposed to have been held there within Hogarth's lifetime.[47]

The house he settled in, assessed at £10 and rated 5*s,* was a very modest version of Thornhill Hall.[48] A brick structure, it is of an irregular, almost wedgelike shape; its bare back wall is continued in a high wall that surrounds the whole garden and cuts it off completely from the outside world. Except for a couple of small windows in the servants' quarters, all the windows look inward to the garden. On the ground floor is an entrance passage, from which one turns to the left into a parlor (or dining room) and right to the stone-flagged kitchen. On the first floor is a small hall where the stairway rises; from the stairs one turns right into a bedroom, left into the best parlor with a large hanging bay window above the entrance door, and beyond that a second bedroom. All the rooms are paneled. On the upper floor were the servants' quarters (by the 1750s there were at least six rooms divided between the two residences).

A lane, now called Hogarth Lane and Church Street, ran past the

house, past the parish church and down to the Thames. It is now cruelly split by one of the most violent of English roundabouts and the main road from London to Richmond, Staines, and parts west. On the hill overlooking the river is St. Nicolas Church; though largely rebuilt, it retains its old tower of Kentish stone and chalk, built in the time of Henry VI (who had a residence in Chiswick in his early years). Hogarth's tea-caddy-shaped tomb also remains, though all design is worn away and the inscriptions have been restored. The Feathers Tavern still exists but probably not in its original location; the Burlington Arms still stands in Church Street.

Hogarth's house is largely as it was, the sole alteration being the demolition of his stable and studio and the addition of a room, possibly where the studio once was (fig. 108). A visitor in the mid-nineteenth century said he saw the studio over the stable. It had a large window and a very narrow stairway, and so "his paintings, I presume, would be let down through this window, for transmission, in his carriage, to town."[49] On one side of the house and walled garden is now the Hogarth Laundry with its sign an adaptation of *Hogarth Painting the Comic Muse* (now abandoned and in derelict condition); on the other is the Reckitt and Colman Axis Centre. But inside Hogarth's garden one feels much as he must have felt two hundred years ago—as though the torrent of traffic outside did not exist. All is still and green here, and the mulberry tree, from which the Hogarths are supposed to have given the village children fruit every year, still produces fruit.

The inside of the house was described by John Ireland in the 1780s, when it was still unchanged. None of Hogarth's own prints were on the walls, but there were engravings of Thornhill's St. Paul paintings around the parlor, and the Houbraken heads of Shakespeare, Spenser, and Dryden. In the garden, over the gate, was "a cast of George the Second's mask, in lead," and in one corner "a rude and shapeless stone, placed upright against the wall," the marker for a pet bullfinch:

<div align="center">

ALAS, POOR DICK!
OB. 1760
AGED ELEVEN.

</div>

Underneath were two bird crossbones surmounted by a heart and a death's head scratched with a nail, and at the bottom were Hogarth's initials.[50]

In Hogarth's time the house stood alone, and fields stretched beyond, across which he sketched and etched his friend Dr. John Ranby's house on what is now Corney Road (*HGW,* no. 182). He also painted portraits of Ranby and his natural son and daughter and sold (or presented) him his portrait of John Pine. Ranby, who was a principal sergeant-surgeon to the king, was also a friend of Fielding's and at Fielding's death in 1754 moved into his house not far away at Fordhook. Thomas Morell also lived nearby in Turnham Green, Arthur Murphy in Hammersmith Terrace, William Rose in Bradmore House in Chiswick Lane (where for thirty years he kept an academy), Ralph Griffiths of the *Monthly Review* in Linden House, and James Ralph in various houses in the neighborhood. The only house other than Hogarth's which has survived from the period is Chiswick House, the prototypical Palladian villa which Lord Burlington built and lived in, where he entertained William Kent and others, including Pope and Hogarth's own friend Garrick. Indeed, in the summer of 1749 Garrick had visited Lord and Lady Burlington and sent current prints from London out to the latter.[51]

Very little is known about Hogarth's private life during these middle years, aside from minutiae such as the fact Samuel Ireland discloses, that he could not distinguish fresh from salt butter till he had taken a bit of cheese at breakfast. And there are anecdotes about his forgetfulness or absentmindedness, traits often attributed to artists, but in his case perhaps a by-product of his remarkable visual memory. One need only imagine him deeply immersed in some problem of his latest painting or print: "At table he would sometimes turn round his chair as if he had finished eating, and as suddenly would re-turn it, and fall to his meal again." Nichols, who tells this story, adds that he once addressed a letter to Benjamin Hoadly simply "To the Doctor at Chelsea," which did however reach its addressee and was preserved by Hoadly "as a pleasant memorial of his Friend's extraordinary inattention."

Another remarkable instance of Hogarth's absence was related to Mr. Steevens, in 1781, by one of his intimate friends. Soon after he set up his carriage, he had occasion to pay a visit to the Lord Mayor. When he went, the weather was fine; but business detained him till a violent shower of rain came on. He was let out of the Mansion-house by a different door from that at which he entered; and, seeing the rain,

began immediately to call for a hackney-coach. Not one was to be met with on any of the neighbouring stands; and our Artist sallied forth to brave the storm, and actually reached Leicester-fields without bestowing a thought on his own carriage, till Mrs. Hogarth (surprized to see him so wet and splashed) asked where he had left it.[52]

Hogarth's absentmindedness or his being not yet used to a carriage could be equally at issue here. In 1776 George III, in the course of a conversation with Benjamin Wilson, Hogarth's old friend,

observed that he supposed that Hogarth told a story very well. Wilson answered, 'Pretty well, but he was apt sometimes to tell the *wrong story.*' 'How is that?' said the King. 'Sir,' he answered, 'Mr. Hogarth was one day dining with Sir George Hay, Mr. Garrick and others, when he said he had an excellent story to tell which would make them all laugh. Everybody being so prepared he told his story, but instead of laughing all looked grave, and Hogarth himself seemed a little uncomfortable. After a short time, however, he struck his hand very suddenly upon the table and said that he had told the wrong story. This caused no small amusement, and when he told the right one at last it was so good in its way that all the company laughed exceedingly.'[53]

As the first of these stories suggests, by this time he had set himself up with an equipage and was very conscious—as the self-portrait too might indicate—of his dress. Nichols talked with a barber who claimed often to have shaved Hogarth, and commented that he persisted in wearing a scarlet roquelaure or "rockelo," the loosely fitting many-buttoned cloak popularized by the duc de Roquelaure in the reign of Louis XIV, even after the fashion died away. Benjamin West recollected him as "a strutting, consequential little man"; James Barry saw him strolling about in a sky blue coat, and others remembered "his hat cocked and stuck on one side, much in the manner of the great Frederick of Prussia." John Ireland noted that he always wore his hat in such a way as to show off the deep scar in his forehead.[54]

We have seen him in the company of the Hoadlys and Garrick, of Fielding and Richardson. Another friend was the Reverend Arnold King, who became rector of St. Michael, Cornhill, in 1749; he chose the verses for *Industry and Idleness,* many passages of which are marked in Hogarth's family Bible. It was to King that Hogarth addressed his punning invitation to dinner at the Mitre Tavern by

drawing a circle for a dish with knife and fork as supporters; within the dish he placed a pie with a mitre on top of it, and around it wrote his invitation: "Mr Hogarth's Compts to Mr King and desires the Honnor of his Company at dinner on thursday next to Eta Beta PY" (fig. 109).[55] With these people he was obviously at ease. But unlike Garrick, for example, he was evidently not comfortable with the upper classes. There is the story of Horace Walpole's inviting him to dinner with the poet Thomas Gray, very likely in order to observe the confrontation of these two diametrically opposite characters. "What with the reserve of the one and the want of colloquial talent in the other, Walpole never passed a duller time than between these representatives of *Tragedy* and *Comedy*."[56]

Among the artists, he was most at ease with the most convivial—Hayman, Lambert, and Ellys. With Lambert and Ellys, the mutual attachment to the stage and scene painting probably contributed to the friendship. He seems to have liked people who were something besides artists. This was especially true of the younger generation, where he increasingly found his best friends. Benjamin Wilson, to whom I have referred more than once for anecdotes of Hogarth, was as much a scientist as a painter and published books on electricity. Allan Ramsay wrote as well as painted, and Samuel Scott was interested in music.

Hogarth's early life had been one of powerful relationships, with his family and with Thornhill, indicating an obvious personal need for security and for models. Once he was married, however, with his father, mother, and Thornhill dead, and the success and security he desired a reality, the remaining relationships are more difficult to assess as to importance and purpose. The majority were either convivial or professional, that is public, associations. For example, it is very difficult to document the personal relationship between Hogarth and Fielding, though much can be said about the public one. It is discernible in terms of their works, not of themselves: Fielding refers to "my friend Hogarth" in *Tom Jones*. And the Reverend James Townley, who assisted Hogarth with verses for his *Stages of Cruelty* and was to help correct *The Analysis of Beauty*, wrote him (28 February 1750): "I wish I were as intimate with you . . . as your Friend Fielding."[57] There are signs of affection but no very clear indication of what kind of friendship it was or what Hogarth put into it or got out of it.

Closer to home, his sister Anne and he remained in the same house for over twenty years, but nothing is known of their relationship save that she served him well and faithfully. His business situation was changing in the 1740s, most notably with the addition of his trade with the Continent and the increasing sale of bound volumes of his prints. The sisters, who were living close to William by 1736, appear as ratable tenants in Cranbourn Passage from 1739 to 1742. On Friday, 20 November 1741, Mary died and was buried three days later near her mother in the churchyard of St. Anne, Soho.[58] Anne remained in Cranbourn Passage into 1742, but by the end of that year she had given up the shop and moved in with William in Leicester Fields, and thereafter her signature begins to appear on receipts, bills, and the like, and she remained with her brother's family until her death in 1771. William may even have put money into Anne's shop before she came to live with him; certainly he supported her thereafter. In his will he stipulates that "I do hereby release, and acquit, and discharge my sister Ann Hogarth, of and from all claims and demands which I have on her at the time of my decease."[59] He left her £80 a year for life out of the profits of his engravings; and if Jane had remarried, the *Harlot,* the *Rake,* and *Marriage A-la-mode,* evidently the most popular of the prints, would have gone to Anne.

The only letter to Jane that has survived was written on 6 June 1749: Hogarth was in London, probably working on *The March to Finchley,* his most ambitious "comic history-painting" since *Marriage A-la-mode,* and she was in the country:

> Dear Jenny
> I write to you now, not because I think you may expect it only, but because I find a pleasure in it, which is more than I can say of writing to any body else, and I insist on it you don't take it for a mere complement, your last letter pleased more than I'll say, but this I will own if the postman should knock at the door in a weeks time after the receipt of this, I shall think there is more musick in't than the beat of a Kettle Drum, & if the words to the tune are made by you, (to carry on metafor) and brings news of your all coming so soon to town I shall think the words much better than the musick, but dont hasten out of a scene of Pleasure to make me one [I wish I could contribute to it—s.t.] you'l see by the Enclosed that I shall be glad to be a small contributor to it. I dont know whether or no you knew that Garrick was going to be married to the Violette when you went away. I supt with him last night

and had a deal of talk about her. I can't write any more than what this side will contain, you know I wont turn over a new leaf I am so obstinate, but then I am no less obstinate in being your affectionate Husband

Wm Hogarth[60]

Up the side he has written, "Complement as usual," referring to Lady Thornhill, who would have been with Jane in the country. He sends some money but makes no comment on business or on the project that engages his attention at the moment. He gossips about their close friend Garrick, who was about to marry Eva Maria Veigel, an Austrian dancer whose stage name was Violette: the marriage took place on the 22nd, when the *London Evening Post* (of 20–22 June) described her as "a beautiful Lady, with a Fortune of 10,000l." The tone of Hogarth's letter combines good-natured gallantry with affection, how much real and how much an automatic gesture it is impossible to say.

Responding to a typically ungenerous and vague description by Steevens of Hogarth's childless marriage, Thomas Morell, who knew the Hogarths well, wrote to Nichols:

> I knew little of Mr. Hogarth before he came to Chiswick, not long after his marriage; but from that time was intimate with him to his death, and very happy in his acquaintance. His excellencies, as well as his foibles, are so universally known, that I cannot add to the former, nor shall I attempt to palliate the latter. To assert, however, that he had little nor no acquaintance with domestic happiness, is unjust. I cannot say, I have seen much fondling between *Jenny* and *Billy* (the common appellation of each other); but I have been almost a daily witness of sufficient endearments to conclude them a happy couple.[61]

Hogarth was also "Billy" to John Hoadly (above, 166). Signing the letter to "Jenny" "Wm Hogarth" need not be taken as formal or authoritarian (Hoadly signed himself in the letter to "Billy" "J. Hoadly").

But if Hogarth's symbolic revisions of his self-portrait showed where he placed himself at this time in relation to his work (above, 263), they rendered the portrait no longer suitable as a pendant to his portrait of Jane. He did not paint another, in effect effacing the husband with the comic history-painter, a private with a public image (cf. Rakewell's parallel act in *Rake* 3). Whether he returned the portrait to its place or left the space empty we do not know.

11.

POPULAR PRINTS (I)

Lord Lovat and *The Stage Coach*, 1746–1747

SIMON LORD LOVAT

In May 1745 Hogarth published *Marriage-A-la-mode;* on 10 September news reached London that the Jacobite Pretender, Prince Charles Edward, had landed in Scotland. On 8 October a train of artillery started for Finchley Common, on its way to intercept the Pretender's army. The rebellion, known as the Forty-Five, dragged on until its bloody conclusion with total defeat of the rebels at the battle of Culloden on 16 April 1746.

Hogarth's first print after *Marriage A-la-mode* and *Garrick as Richard III* was a full-length portrait—etched in what Vertue would have called "a slight poor strong manner" (3: 136)—of Simon Lord Lovat, one of the most notorious rebels of the Forty-Five. Lovat had been captured in July 1746 by the British Navy as it searched the western coast of Scotland. Brought south, he reached St. Albans on 12 August and rested there at the White Hart Inn for two or three days "under the immediate care of Dr. Webster; who seemed to think his patient's illness was more feigned than real and arose principally from the apprehension of danger on reaching London."[1] In fact, Lovat was an old man of seventy and in poor health.

Hogarth had spent part of July with Garrick at the Hoadlys' in the south of England, but he was back in London by the end of the month. According to the Reverend James Harris, in a letter written on 28 August, Hogarth made a trip to St. Albans to get "a fair view of his Lordship before he was locked up."[2] Dr. Webster told Samuel Ireland that he had invited Hogarth to come up and meet Lovat during his layover; there would be no further chance once Lovat was in

the Tower. Webster may have been another case of a Hogarth ad-
mirer who invited him to portray some particularly striking figure.
One story, however, first recounted by "Peter Pindar," has Hogarth
coming into the White Hart just as Lovat was being shaved; the old
man leaped up and saluted him with a "kiss fraternal" in the French
manner "which left much of the lather on his face." Early accounts
claim that the two knew each other, but in his final edition Nichols
is careful to state that Hogarth "had never seen him before," denying
the Scottish connection for which there is considerable evidence.[3]

Harris, writing within a month of the event, said "the old Lord is
represented in the very attitude he was in while telling Hogarth and
the company some of his adventures," and he adds that "it is really
an exact resemblance of the person it was done for—Lord Lovat—as
those who are well acquainted with him assure me." Hogarth is said
to have told his friends that Lovat was counting out the "numbers of
the rebel forces" (in another account, the clans) on his fingers: "Such
a general had so many men, &c." Hogarth "remarked, that the mus-
cles of Lovat's neck appeared of unusual strength, more so than he
had ever seen." Something of his reputation for being a wily turncoat
is conveyed by the eyes, the turn of the head, and the wicked leer.
The only objects included are the pen and book labeled "Memoirs"
and the coronet behind his head on the chairback.

Hogarth returned to London with his drawing, made a simple but
powerful etching, and published it on 25 August (fig. 110). Lovat
had reached the Tower on the 15th, Lords Kilmarnock and Balmer-
ino and others had been executed and other indictments lodged on
the 18th, and more rebels arrived in London on the 20th, with three
more rebel officers executed two days later.[4] The moment was op-
portune, and although the presses worked through the night for a
whole week, not enough impressions could be made to meet the
demand. For several weeks thereafter the etchings were said to have
brought Hogarth £12 a day; and the story circulated that when the
plate was finished he was offered its weight in gold by a rival print-
seller. At a shilling a sheet, many of which must have been sold
wholesale to other print dealers, he would have sold something like
ten thousand impressions and earned upward of £300.

Vertue commented on the print's popularity: "etchd by him from
the life in his drole nature & manner. [it] was thought to be surpris-
ingly like. and from his humorous Character, was greatly cryd up &

sold every where at pr. 1sh many many hundreds. <nay thou-sands>." But he adds, with sudden acerbity:

> this is according to the old saying of a Man that has the Vilest char-acter. and the hatred of all partyes. & besides that a barefaced Rebel. if some persons had Engravd and publisht his picture, it had been highly Criminal—but as some are winkt at that steal a horse, whilst another is hangd for looking over a hedge.—but in this case Art overcomes Malice—(3: 131)

Vertue is raising the issue of decorum that hounded Hogarth through-out his career: how vile to portray vile men! Moreover, the portrait of this "Vilest character" is dignified and achieves by its composition a monumentality within the limited space of 13 × 8 inches that, except for the crafty look, could have graced a Captain Coram.

The financial success of a shilling print, quickly etched and yet supporting some thousands of impressions, may have convinced Ho-garth that he should undertake more of the same. Deep and repeated biting produced lines strong enough to approximate the durability of an engraving, with much less time expended and no assistance needed. But the effect of the heavy lines and the large white spaces was a powerful simplification that ushered in a new phase of print-making for Hogarth. Prior to this he had employed the purely etched style only in his subscription tickets. Now he began to apply the style to a subject matter popularly regarded, like the Lovat, as the vile and low.

While the next few months were devoted to the painting of a sub-lime history, *Moses Brought to Pharaoh's Daughter,* at the same time Hogarth must have been mulling over the twelve designs of *Industry and Idleness,* making the many drawings that have survived for that series, and beginning to etch some of them. *Moses* was finished by February 1746/47, followed at the end of the year by a commission for another history painting by the benchers of Lincoln's Inn (*Paul before Felix;* see below, Chap. 13). It was between these two ambi-tious paintings that he undertook a low and plebeian subject, perhaps to compensate for the unpaid outlay on *Moses* (which was a gift to the Foundling Hospital).

Hogarth seems to have been disappointed with the results of his elaborate campaign (focused on *Marriage A-la-mode*) to paint, en-

grave, and sell the paintings of his "comic histories," and perhaps for this reason he sought a polar opposite in subject if not audience. Watching him turn from the progress of an earl and countess to that of two apprentices, one cannot overlook the difference. He began by replacing the painting with a drawing, the reproductive engraving with a "popular" print, and high life, in which "Particular Care" was taken "that there may not be the least Objection to the decency or Elegancy of the whole Work," with the lower classes and extreme inelegancy. Since he had already shown that he was capable of portraying the lowest as well as the highest, he was apparently abandoning the connoisseurs in favor of a less habit-bound audience, a more honest and useful art. Economically, as Vertue noticed, he saved the money spent on engravers (especially those of *Marriage A-la-mode*) and reached the larger public that had been able to afford only the cheap copies of his earlier prints. Morally, he intended to correct some of the abuses he observed through his connection with the hospitals and the poor. Aesthetically, he sought a new source of inspiration in order to broaden his conception of modern history but also to allow more freedom than the elaborate rococo designs that corresponded to the decorum of high life. Formally, these prints were an equivalent to the simplicity of the "Happy Marriage" sketches in oil.

THE STAGE COACH; OR A COUNTRY INN YARD AT ELECTION TIME

A year after its first publication, in March and April 1747 with the trial and execution of Lovat, Hogarth's print had again become a best seller.[5] Then on 18 June Henry Pelham, the prime minister, unexpectedly announced a General Election to be held at the end of the month, and by the 26th Hogarth had published a small election satire, a shilling etching with no title but called, in the advertisements, "A Country Inn Yard at Election Time" (in Hogarth's price lists for his prints it was called simply *Country Inn Yard;* fig. 111).[6] Given the size of the design, it could have been originally intended for the *Industry and Idleness* series, which must have been well under way; it may have been a plate on which Hogarth was already working.[7]

The advertised title introduced a topical dimension to a print that simply represents the humors of a country inn. The crowd of elec-

tion campaigners were probably added, with the image of a baby ("No Old Baby") and the paper protruding from the pocket of a man who grudgingly pays his inn reckoning ("An Act . . . ," probably for preventing election bribery).

But the most prominent features are formal: the central shape of a coach and its door, and the backside of a large woman who is being crammed into the coach. Another largish woman is visible inside. A fat man standing in profile beside the coach door is next in line, and the man settling his inn reckoning is presumably the other prospective occupant of the coach: we can estimate how little space there is to hold them all. The coach itself fills the gateway of the innyard, a space which though outdoors is completely enclosed, with no trace of sky showing. Within the innyard there are many more doorway-like apertures. A dog is in its kennel, only its head and shoulders protruding; a pair of lovers embrace inside a doorway, and another between two columns of the balcony at the right of the scene; a couple of inebriated revelers lean out of a window space on the second floor of the inn, one smoking a pipe and the other blowing a horn; and a fat refreshment seller stands enclosed within her booth, the counter protruding to accommodate her girth.

All of these details, juxtaposing rectangular openings and the people who fill them, retail a comedy of space which is very different from the grim spatial relations of the *Harlot, Rake,* and *Marriage A-la-mode.* If we tilt the emphasis in the direction of satire the message is the incompatibility of human bodies and man-made structures such as coaches, doorways, or windows, even dog kennels—or the threat of human containment within these containers. The situation may have its origin in the first plate of *A Harlot's Progress,* in the innyard with only one small patch of sky. This innyard is far less threatening and claustrophobic, but everyone in it is nevertheless part of the central relationship of container to contained. The fussy Enraged Musician was another forerunner, showing rage at the disorder of plebeian noisemakers outside his window. Totally within his window, he withdrew from the disorder; here the hornblower, quite obviously uncontained by his window, extends the disorder outward.

As rectangles that cannot contain exuberant humanity *The Stage Coach* looks directly toward Thomas Rowlandson's bulging coaches, never able to hold the enormous people who are stuffed (or try to stuff themselves) in: a situation for which nobody is to blame. In one sense, then, Hogarth's print opens up a new line of development of

his art away from satire and toward a comic mode in which contrast
and formal play matter more than judgment, referential details, and
allusions to particular literary or graphic texts, particular events or
people. The central shape of the woman's backside is generalized and
geometrized (or rhymed) by the coach's wheel to the right of her.
The two figures to the right of the coach door also rhyme, the round
stomach of the one repeated in the circular hat held out for a tip by
the other; the one's round shoulders becoming the other's humpback
(or an inversion of the fat man's stomach), and these echoed again in
the wheels of the coach. In the same way the refreshment seller and
her stall seem in terms of shape made for each other. There is comic
appropriateness or decorum linking these round shapes, as there is a
comic incongruity linking them and the rectangular enclosing shapes
of the coach doors, inn doors, windows, and gate through which the
coach is departing for London.

Another contrast has to do with noise. The silent center of the
woman being helped into the coach is flanked by noise that again
recalls *The Enraged Musician*. The victualler is bawling out her wares
and ringing a bell (a shape that parallels her mouth), the horn player
is blowing, and the smoker is opening his mouth either to yell or
vomit. All of this noise at the left is balanced by the noise from the
open mouths of the election mob at the right; while on top of the
coach noise is potential in the Frenchman who, we know, will cry
out when his hat is knocked off.

These are the "incompatible excesses" that meet in comedy as Ho-
garth describes it six years later in the chapter "On Quantity" in
The Analysis of Beauty (1753). Not only designs composed of only
"straight or only round" lines are comic, "especially when the forms
of those excesses are inelegant, that is, when they are composed of
unvaried lines" (as opposed to serpentine Lines of Beauty), but in
particular those formal contrasts that also join "opposite ideas" as
when we "laugh at the owl and the ass, for under their aukward
forms, they seem to be gravely musing and meditating, as if they had
the sense of human beings" (48–49). One of Hogarth's examples of
such "an improper person," visually reproduced in Plate 1, figure
17, of *The Analysis of Beauty* is the "No Old Baby" of *The Stage
Coach*. This figure, he writes, "represents a fat grown face of a man,
with an infant's cap on, and the rest of the child's dress stuff'd, and
so well placed under his chin, as to seem to belong to that face. This
is a contrivance I have seen at Bartholomew-fair, and always occa-

sion'd a roar of laughter" (48). It fits in with the general comedy of incompatibles including the round woman who will not fit into the rectangular door of the small coach and the round victualler whose counter miraculously swells out to accommodate her belly. The incongruity of the child's shape and the old face epitomizes the whole scene, in which (according to the *Analysis*) "the ideas of youth and age [are] jumbled together, in forms without beauty."

At this moment, in this print, however, "No Old Baby" has a specific political reference. The reference, for Hogarth following upon the Forty-Five and the portrait of the Jacobite traitor Lord Lovat, is to the "Babe of Grace," also known as the "Warming Pan Babe," who was claimed by James II to be the crucial son he needed as heir to his throne and perpetuator of Catholicism in England.[8] By the Protestants the baby was scoffed at as an imposter brought into the bedchamber in a warming pan to substitute for the nonexistent heir. (Pope-burning parades in Hogarth's youth carried an effigy of the infant Pretender on a warming pan.) If with much fanfare James II's wife thus produced James III, the so-called Old Pretender, the latter's wife in 1720, with even more fanfare and documentation, gave birth to Prince Charles Edward, the Young Pretender. And so in 1747 the pretender to the throne at the moment was still the "Old Baby" of the warming-pan episode, although there was also a "young Baby" who actually conducted the invasion of 1745 in the name of his father. Fielding and the Whigs continued throughout these years to perpetuate the fiction that Charles Edward was in fact a bastard.[9]

Babies figure in some of the prints published in England during the 1747 campaign. In *Great Britain's Union or the Litchfield Races Transposed* (September 1747), for example, a child appears in a cradle under a coverlet of divided Scotland–England, immediately adjacent to a tent of Jacobites toasting the Pretender. The baby represents either the warming-pan baby or the Young Pretender. Another print, *The Cradle: or No Crazy Baby,* gives the baby what looks like the face of James III, the Old Pretender.[10] Moreover, one of the potential candidates on the Tory side for Middlesex in 1747 was a fifty-four-year-old named Samuel Child. Middlesex was one of the constituencies where the Jacobite slur operated with effect in this election.[11]

"Jacobite" at this time, as Fielding was to show a few months later with his ironic publication *The Jacobite's Journal,* was a term that was applied by the Pelham ministry to the Opposition: to those who

wanted to end the war with France, were thoroughly disillusioned with the Hanoverian royal family, and were distrustful of Pelhamite policies. But in a more particular way the term carried an allusion to the reports in May that the Prince of Wales's Opposition party (which he had made public at the beginning of the year) was basing its strategy on attracting Tories and Scottish M.P.s to its banner.[12] The emerging polarization pitted the duke of Cumberland (the victor of Culloden) and the monarch against the Prince of Wales, the Scots injured by the repression following the Forty-Five rebellion, and by implication the Jacobites themselves. Though a screen for other Scottish problems, the Jacobite issue was still present in the memory of the trials of the Scottish rebel lords in 1746, and was revived by the trial and execution of Lovat, the prototypical Scottish Jacobite, in 1747.[13] As Linda Colley has shown in her history of the Tory party, in the metropolitan contests of Middlesex, Westminster, and London the Tory defeats "owed something to their opponents' exploitation of those Jacobite trials which had been held in the capital" (253).

If *The Stage Coach* anticipates the *Analysis*'s theory of comedy and Rowlandson's comic drawings, it also anticipates Hogarth's nightmare allegory of 1762, *The Times, Plate 1,* and opens the phase of political satire resumed with *The Election* of 1754–1758. We can hardly fail to notice, for example, that the inn sign is in fact spelled "Old Angle In," a misspelling that produces a verbal pun: "Old England."[14] The signboard turns the innyard into a scene very like the city street of *The Times,* which is Europe afire in the Seven Years' War. In the present situation, the War of the Austrian Succession is reduced to a comic squabble on a coach roof between an English sailor off the Centurian man-of-war and a Frenchman (perhaps a valet) with the Englishman tipping off the Frenchman's hat. In terms of *The Times,* the scene offers a travesty of the war in a petty private skirmish; and in this context the watchdog, England's watchdog, is significantly asleep while everyone in sight is either drunk, amorous, cheating, rioting, or departing.

The presence of the electioneering itself raises particular issues that complement the formal play of container/contained. The crowd, as the ultimate human force that cannot be contained, already points toward the theme of uncontrolled mob violence in the *Election* prints, which relate the squabbles of domestic politics to the Seven Years' War. A new subject that begins to emerge here, and was not present in *The Enraged Musician,* is the voice of the plebeians who, though

themselves without a vote, may or may not influence electors by their sheer mass. In *The Times* the encroaching election crowd of *The Stage Coach* will become the inchoate forces that, led by such demagogues as William Pitt, are overrunning England.

The chief antiministerial journal (also obsessively anti-Fielding) was called *Old England; or, the Broadbottom Journal, by Argus Centoculi, Inspector General of Great Britain.* In the context of the General Election, the "Old England" of Hogarth's inn is not just ancient England but the sign of the Country party, and the central figure in his design, climbing into the stage coach, recalls the subtitle "Broadbottom Journal" with its allusion to the broad-based coalition government advocated by that party.

Perhaps the most local context of all for Hogarth's print is Fielding's proministerial pamphlet, *A Dialogue between a Gentleman of London, Agent for Two Court Candidates, and an Honest Alderman of the Country Party,* which was announced in the *General Advertiser* of 23 June, three days before Hogarth's print was advertised in the same periodical. In the *Dialogue* Fielding's spokesman is the Gentleman, "agent for two Court Candidates," and his adversarius, the Alderman, is a spokesman for the "Country Party," the Prince of Wales's Opposition to the king's ministry. We notice that, as his advertisement states, Hogarth's print is laid in a "Country Inn Yard at Election Time" (the inn sign tells us that the coach comes "From Lundun," the "country" spelling for London).[15] Concerning "Old England," we read in Fielding's *Dialogue* that the Alderman says he wishes to "consult the Good of Old England only" (8), by which he means the journal that expresses his and the Jacobites' point of view. The emphasis is on *Old* England, the England of the Stuarts and the Old Pretender as opposed to contemporary England.

And so, interpreted in the context of contemporary polemics and Fielding's *Dialogue,* the scene may be "Old England" specifically in the journal's sense, where we find the lovemaking and boozing that Fielding associates with the Jacobites (even more forcibly stated in his *Jacobite's Journal*). Fielding's Gentleman in the *Dialogue* notes that "it is well known how gloriously and openly they draw their Corks [vs. their swords] in the Pretender's Favour" (7). The tipsy men at the inn window and the "broadbottomed" woman whose flask is handed up after her are those Jacobites whose "arguments and their Weapons are indeed one and the same; Songs and Toasts, Curses and Huzzas" (23). Or they represent the more general "Reign of Drunk-

enness, Idleness, and other Enormities attending Elections," which the present shortness of time between announcement and election was intended to prevent (56).

The three election issues stressed by Fielding in his *Dialogue* were Jacobitism, the continuing war, and the supposed "corruption" of the incumbent ministry. Hogarth picks up only one aspect of the war theme, summed up in the Gentleman's remark: "At Sea we have a most powerful and victorious Fleet, under two Admirals [Anson and Warren], who have retrieved the Glory of the Navy of England, and to whom we owe the greatest Advantages gain'd in this War," which "must naturally incline the French and Spaniards to think of Peace" (45). So the sailor tilting the Frenchman's hat could also allude to Warren and the court party discomfiting the supposedly Jacobite, therefore French, "Independent Electors," the Country party, of Westminster (who indeed lost the election).

The final fact to note about the Centurian's sailor, however, is that he is lodged *atop* Old England's coach, his duffle bag tied to his arm so that it will not fly away in the wind. The "broadbottom" woman and the other bulky passengers can afford to ride comfortably inside the coach (meanwhile the French valet riding on top may mean that his French, or at least Jacobite, master rides within). If this coach with its "respectable" folk inside and its poor-but-heroic sailor outside (and indeed its pathetic little postilion to one side) recalls the famous coach encountered by Joseph Andrews on the road in Fielding's novel, it must also be taken, in the context of the comic play of container/contained, as a symbol of all elections that ask the question "Who's out and who's in?"

The third issue raised in Fielding's *Dialogue* was corruption, alluded to by the "Act" in the traveler's pocket. The "Act" finds echoes in various parliamentary bills all associated with the corruption attached by the Country Alderman to the Pelham ministry, and defended by the court Gentleman. It could be the Place-Bill or the bill for annual or triennial parliaments, but more likely it is "An act for the more effectual preventing bribery and corruption in the election of members to serve in Parliament," which required an oath of every voter if demanded by a candidate or by two electors. "The bare mention of it is enough to fill any honest Man with Horror," writes Fielding (22–23). All of these, from Fielding's point of view, are ridiculous and impractical expedients urged by the Opposition, who are proposing to combine Jacobitism with republicanism in their

"Broadbottom" ministry. Corruption is the issue the Alderman makes most of, and which Fielding's Gentleman spends most time defending. He sums up with the words: "As to the Corruption practised at Elections, it is so known and certain, that I should think no Man deserved the least Credit who denied it; but as to the Corruption of the Elected, I can lay my Hand on my Heart and Declare, I believe it to be infinitely less than it hath been represented" (28). Hogarth in his print makes the point clear: the bribery is at election time; but he leaves open the question of whether the man with the paper in his pocket is an elector, an election agent, or merely someone who is ignoring the election, turning the act against bribery into an objection to an excessive inn reckoning. On such a point the general and particular references of Hogarth's print depend. "An Act" catches the moment of corruption far from London and the Pelham ministry in a country innyard; but after the election "An Act" remains a metaphor for the failure of controls over human actions, a verbal analogue to the window and door frames.

If the "No" of "No Old Baby" is to be believed, the crowd, rejecting the "Old Baby," is anti-Jacobite. One historical fact is that in distant counties such as Lancashire and Yorkshire that had been affected by the Jacobite rebellion of 1745 (in Linda Colley's words), "some Tory candidates received the attentions of anti-Jacobite mobs" (253). These people, unlike Londoners, had felt the bite of the Jacobite troops and knew what "country" really meant. Hogarth is showing not an allegorical "Country Party" but an actual "country" innyard with a "country" crowd that is repudiating the position of the so-called country party, perhaps including Old England, the Broadbottoms, and the tipplers in the foreground.

If this is the case, then the election crowd (and the election itself) is shown to be as peripheral as the figure of the falling Icarus in Bruegel's painting, and the Old Angel (Old England) with her outstretched arms is all that attempts to draw together the election and the unconcerned people who are in the process of departing the "country" for London. Then the lovers on the balcony above the crowd show, by their juxtaposition with the double sense of "Baby," how life goes on despite elections, despite Old Pretenders. Then, though anticipating the crowd of *The Election* and *The Times, Plate 1,* the election crowd here is manifestly not dangerous or central to the concerns of the prosperous "respectable" folk (the citizens with the franchise) entering the coach either to avoid voting or to return

unfazed by their country experience to vote "country" in one of the London contests.

Then in terms of the General Election, Hogarth's comedy of containment—or of "Who's out and who's in?"—becomes merely a satire of concealment and withdrawal. Now it is partial concealment (of the hiding lovers in the doorway, the two revelers *un*concealed by their window, the dog too long for his kennel, or the woman trying to get into the coach) or rather the withdrawal of people into private concerns at a time of public crisis: private concerns that happen to be equated with the concerns of the "Country Party" as outlined in Fielding's *Dialogue*. Apathy or distraction amounts to the same theme here, summed up in the fat woman at the center, the man for whom "An Act" refers only to an inn reckoning, and the dog asleep in his kennel, off to the side like a mute chorus.

The fat woman's back is the central feature of the picture. Whether we think of her as "Broadbottom" or as backside, she embodies self-absorption and unawareness of what is going on around her as she prepares to disappear inside the coach. The composition focuses on her back, and creates another verbal pun: she is literally "turning her back" on the urgency of the election issues here in the country where it is most deeply felt because most deeply remembered. And the dog then becomes verbalized as the proverb about "letting sleeping dogs lie," which is the sentiment of the Englishmen who are ignoring the General Election, or the threats posed to England by Jacobitism (indeed the secreting of Frenchmen without and Jacobites within the coach), and the message of the parading of "No Old Baby" they are leaving behind them.

There is finally no way of avoiding the fact that the composition renders the election marginal, "in the background" so to speak, suggesting that the English are too preoccupied with their own petty day-to-day doings to take an interest in politics at a moment of actual crisis. The sleeping dog, however we may proverbialize him, is a motto for these people who are unconcerned with the election or, by implication, with their Old England.

This small, seemingly topical print that immediately precedes (or overlaps with) the monumental effort of *Industry and Idleness* in fact lays the groundwork for an understanding of the later series. The crucial words that are summed up by the images of "country," "Old England," "Broadbottom" or "back," and "sleeping dog" are all in-

terpretable in both a general and a particular way—ways that are not mutually exclusive. The superimposition of the title and the marginality of the crowd, and especially the hesitant presence/absence of "No Old Baby" (removed in a later state), not only underline a theme of overly detached English men and women at a time of crisis; they also offer the spectator a more general interpretation that ignores the General Election altogether, once it is history and once the print goes into Hogarth's folio as simply "Country Inn Yard."

The sign of the Old Angel, for example, hangs directly above the head of the old crone, on the other side of whom is the "Old Baby"; and directly above the baby, as in a genealogical chart, a pair of lovers embrace on the balcony. On the other side of the scene another pair of embracing lovers are not far from another baby being held up for a thin spinsterish old woman to view. These figures project an "Ages of Man" that juxtaposes childhood with young lovers, middle age, and old age. The angel gesturing toward the innyard door may be pointing to the final exit for all of these people. At any rate, the crone, smoking a pipe, offers the perspective of old age on life, lovers, infancy, and the milling crowd. She is lodged in the large basket kept on every coach for "excess baggage." In Dutch still-life paintings smoking pipes were symbols equivalent to skulls, a sign of near mortality: "For my days are consumed like smoke" (Ps. 102:4). In his *Tailpiece* (1764) Hogarth will show Time himself holding a broken pipe and his last breath emerging in a billow of smoke labeled "Finis."

Hogarth's coach, standing within the yard of the Old Angel Inn, in fact preparing to leave it, calls up two of the basic metaphors of eighteenth-century fiction, life as a journey and as an inn.[16] The inn projected a milieu through which a traveler passes, encountering strangers (not his family or established friends) and new configurations out of which he tries to make some order. The most obvious eighteenth-century novel informed by the principle of an inn was Fielding's *Joseph Andrews,* whose model was *Don Quixote,* the narrative par excellence in which characters and actions converge in inns. As *Joseph Andrews* shows, the inn was a nexus for the gathering of rural society mingled with city visitors, and so involved a country-city theme with both rustic humors and reverberations of the popular contemporary topos of retirement. The inn was also a place where inhibitions could be left behind or stripped away, true or

new identities revealed, and characters slip into the wrong beds—as also in the implications of Hogarth's drunken revelers, passionate lovers, and newborn babies.

Both Fielding and Hogarth were concerned with the inn less as a prevalent metaphor than as a way station on the journey of life which is a pilgrimage. An Angel Inn was on the New Road, Clerkenwell, and the Angel (taken from the Angel of the Annunciation, a derivation which may also help to explain the babies) was one of the most popular of inn signs, especially on the roads used by pilgrims.[17] Hogarth joins the ideas of inn and pilgrimage by showing the coach, with a symbolic cross section of passengers preparing to leave, projected out of the innyard into another, unindicated world. The sign of the inn, in short, suggests that in larger terms the formal comic play we have observed may embody an allegory of life. Youth and age, the fat body and the thin door, can be either juxtaposed or seen consecutively as stages in a progression leading to exits of various sorts.[18]

12.

POPULAR PRINTS (II)

Industry and Idleness, 1747

Without a subscription, Hogarth announced *Industry and Idleness* (figs. 112–125) in the *London Evening Post* of 15–17 October 1747:

> This Day is publish'd, Price 12s
> Design'd and engrav'd by Mr. Hogarth.
> TWELVE Prints, call'd INDUSTRY and IDLENESS: Shewing the Advantages attending the former, and the miserable Effects of the latter, in the different Fortunes of two APPRENTICES.
> To be had at the Golden Head in Leicester-Fields, and at the Print-Shops. N.B. There are some printed on a better Paper for the Curious, at 14s. each Set. To be had only at the Author's in Leicester-Fields. Where also may be had all his other Works.

The special paper was for his elite audience of collectors and distinguished the Golden Head from the other printshops where the series was retailed. Vertue's entry expresses one contemporary's view of Hogarth's latest project:

> as the View of his Genius seems very strong & Conversant with low life here as heretofore, he has given a fresh instance of his skill, rather to compass or gripe the whole advantage of his Inventions & to prevent the shop print sellers any benefit he has gravd them in a slight poor strong manner. to print many.—& engross that intirely to himself.—
> without being at that great expence he was, of good workmen when he publishd—his Marriage A la Mode—the cost of which works of engraving. he paid dear for—(3: 136–37)

The important point for Vertue (after his condescending remark about a talent for "low life" representation) is Hogarth's finding a

way to capture the cheap copy market as well as the deluxe, and a way to save on the cost of engraving.

Hogarth himself, when he undertook a commentary on his prints around 1760, wrote that they were

> calculated for the use & Instruction of youth wherein every thing necessary to be known was to be made as inteligible as possible. and as fine engraving was not necessary to the main design provided that which is infinitely more material viz that characters and Expressions were well preserved, the purchase of them became within the reach of those for whom they [were] cheifly intended.

Only a shilling a plate, nevertheless at 12 shillings the set was beyond journeymen and artisans whose month's wages were little more. The purchasers probably included the smaller merchants, who, however, displayed the print for the edification of their journeymen and apprentices. Hogarth also noted with satisfaction that he had heard of a sermon preached on *Industry and Idleness* and that the prints sold especially well at Christmas, when masters gave their apprentices sets as Christmas gifts.[1] After the appearance of Hogarth's prints Lillo's *London Merchant* was produced every Christmas (starting in 1749) as instructive entertainment for the apprentices. The schoolmaster John Adams of Edmonton, who had *Industry and Idleness* framed and hung up in his school room, once a month lectured his pupils on the examples of the two apprentices and "rewarded those boys who had conducted themselves well, and caned those who had behaved ill."[2]

Another segment of Hogarth's audience is uncovered by the author of *The Effects of Industry and Idleness Illustrated,* a simpleminded moral explanation of the prints, who begins his preface:

> Walking some Weeks ago from *Temple-Bar* to *'Change* in a pensive Humour, I found myself interrupted at every Print-Shop by a Croud of People of all Ranks gazing at Mr. *Hogarth's* prints of *Industry and Idleness.*

He tours the printshops and listens to the opinions of the spectators in order to see "the Influence which a Representation of this Kind might have upon the Manners of the youth of this great Metropolis." But while his head, he says, was full of the prints' moral, and he expected the same from other viewers,

I was mistaken, for the first I heard break Silence was one of the Beadles belonging to the Court-End of the Town, who upon viewing the Print of the idle 'Prentice at play in the Church-yard, breaks out with this Exclamation, addressed to a Companion he had along with him, *G—d Z—ds,* Dick, *I'll be d—n'd if that is not* Bob———, *Beadle of St.——— Parish; its as like him as one Herring is like another: see his Nose, his Chin, and the damn'd sour Look so natural to poor* Bob. *G—d suckers, who could have thought* Hogarth *could have hit him off so exactly?*

The author walks to St. Paul's churchyard, stops at another print-shop, and hears beaux identifying the old woman with the pew keys in the second plate as a bawd of St. James's Street. All of this leads the author to write down the moral for the benefit of these benighted people, but this turns out to be no more than a story to accompany the prints.

His account suggests something of the excitement and the attraction of a new set of Hogarth's prints at the moment of their publication—and something of the inframoral message read from the prints by one type of audience. The series was topical enough to lend itself to such a reading: Idle hangs out in the Blood Bowl in Hanging-Sword Alley, a disreputable haunt whose keeper, James Stansbury, had recently been tried at Sessions for breaking open and robbing a linendraper's. W. J. Pinks, in his *History of Clerkenwell,* believed that Hogarth alludes here to a group of murderers known as the Black Boy Alley gang who terrorized Clerkenwell about this time.[3] But it is also clear from *The Effects of Industry and Idleness Illustrated* that viewers read into the prints any likenesses they wished; that Hogarth aimed at not so much precise identification of his figures and locales as the viewer's active participation, if only at the gossip level of this pamphlet.

Twelve plates (perhaps not so coincidentally the number Highmore had used to illustrate *Pamela*) was the number associated with popular print series—those picture stories of harlots and rakes which to some extent had originally inspired Hogarth. Accompanying verses had played a part in the *Rake's Progress,* but Hogarth had not repeated the experiment until *Industry and Idleness,* where he places naïvely explicit titles over each design and Bible verses underneath (reminiscent of those on the cheap reprints of the *Harlot*), surrounding his scenes with frames containing symbolic cornucopias and skel-

etons, coronets with maces and whips with fetters corresponding to the fates of the two apprentices.

The ostensible audience, for the first time, coincides with the subject of the prints. The *Harlot's* and *Rake's Progress* were not addressed to harlots and rakes but to an audience that could meditate with detachment on such representative types. But *Industry and Idleness* is addressed—in both form and content—to apprentices. It was the master, however, who bought the prints and displayed them for his apprentices' enlightenment (although the master himself was, of course, an ex-apprentice). Nevertheless, as the deluxe edition indicated, the prints were intended not only to be framed and hung on the wall where apprentices could see them but to go into the collector's folio of Hogarth's prints to join the *Harlot, Rake,* and the rest as part of a larger series and an oeuvre.

It had been Hogarth's great accomplishment in the *Harlot* to capture both the "men of greater penetration" and the "ordinary reader," and it was his continuing challenge to hold both. But even in the *Spectator* essays Addison had privileged the immediately graspable image—the sort an apprentice could construe. Corroborating Shaftesbury's advice to avoid the *difficultas* of the hieroglyphic mode, he had opposed interpretations based on a learned tradition, calling them merely illustrated metaphors.[4] Whatever is difficult is probably confused; the perseverance and exertion the Renaissance critics had urged on the reader should be all the author's, with no effort wasted on interpretation.[5] Quite different from Dryden's view that "noble pictures" should be "considered at leisure, and seen by intervals,"[6] are Addison's words in *Spectator* No. 411: "The Pleasures of the Imagination have this Advantage, above those of the Understanding, that they are more obvious and more easie to be acquired. It is but opening the Eye, and the scene enters." And Addison's follower Thomas Tickell wrote:

> Unless Poetry is taken in at the first glance, it immediately loses its force and point. For Pleasure does not suffer tiresome and indefatigable labour of the mind, and delights not in following, like a nimble acrobat, the tangled thread of reasoning.[7]

Coincidentally, in the year *Industry and Idleness* was published, Joseph Spence's *Polymetis* restated the case against hieroglyphic readings and in particular multiple interpretations (three different passions sup-

posedly aroused by the same Venus, for example).[8] In France, which Hogarth had recently visited, rococo frivolity and play were being attacked in the name of seriousness and restraint. Simplicity of form was being equated with simplicity and purity of morals—with art as moral propaganda.[9] Hogarth of course shared the preference for the moral over the frivolous and erotic, as he had earlier the modern and immediate over the classical-mythological. Formally, the general impression given by rococo art is a lack of surbordination, forms denying "the eye stable focusing points round which the rest of the composition could be organized," as opposed to a "good" gestalt with its simple, stable, compact structure.[10]

In *Industry and Idleness* simple contrasts are starkly depicted, strengthened by the relatively ungraduated blacks and whites of the design. The folly, simpler than the Harlot's, is reduced to idleness; and, in the manner of a morality play, its opposite—industry—is also presented. To Hogarth, the essence of a "popular" print was apparently simpler forms and simpler choices, fewer allusions and less "reading." But "descending" to a popular (in Vertue's terms, "low") mode allows him to simplify forms, reactions, emotions, and characters into a kind of heroic opposition that is coincidentally closer to sublime history painting, where gods or saints opposed devils, than to the complex, "mixed" (Fielding's term) world of his modern histories. These prints, beginning with the story of Idle and Goodchild and ending with the death of Tom Nero (in the *Stages of Cruelty,* see vol. 3), are in fact Hogarth's most bold, original, and powerful modern equivalents of history.

In the prints of the late 1730s he had already replaced the "progress" structure of action-consequence and crime-punishment with the simple contrasts of the pious and the profane, order and disorder, "Before" and "After." These contrasts were, however, mediated by a central female figure, who urged a comic acceptance of both values. A mediator is no longer physically present: the beautiful young woman is replaced in *The Stage Coach,* a comic play of contrasting forms, by the fat woman's backside; and in *Industry and Idleness* the master's daughter, whom Goodchild marries, is marginal, balanced by the slut who betrays Idle.

And yet the ambiguity of condemnation and sympathy in *Simon Lord Lovat,* which bothered Vertue, and the political skepticism of *The Stage Coach,* now imposingly inform *Industry and Idleness.* In some form or other Hogarth always retains a rococo complexity,

even deviousness, of turns and twists that does not conform very well to the ideal of simplicity.

GOODCHILD AND IDLE

The stories of the two apprentices are ostensibly as simple as their names, Francis Goodchild and Tom Idle. In Plate 1 Goodchild directs the thread on his loom as he directs his life by *The Prentice's Guide* and the ballads of *Dick Whittington* and *The London Prentice* toward the Whittingtonian goal of mayorship. Tom Idle dozes, relinquishing control of his spindle; his *Prentice's Guide* is tattered and discarded on the floor and his diversions are the ballad of *Moll Flanders,* beer, and tobacco.

Eleven more plates are built on the same contrasts. Plates 2 to 9 are structured in pairs, with Goodchild's action followed by Idle's. Plates 2 and 3 contrast their piety: Goodchild inside the church, accompanied by his master's daughter, with light again falling on him, and Idle, outside, with bad company, gambling on the sabbath, suspended over an open grave, among skulls and bones, and with nothing over him but the threatening shape of a beadle replacing that of his master in 1.

Plate 4 shows Goodchild inside his master's countinghouse, with the master pointing to the shop, saying in effect: "The shop is all yours: I entrust you with its management." The church is followed by the countinghouse, obedience to his heavenly master by obedience to his earthly. In 5 Idle has forfeited his indentures, which are floating away in the water. He has betrayed first his heavenly and then his earthly master, and instead of being in the solid, comfortable, protective shop, he now floats precariously on a choppy sea, exposed to the elements, but accompanied by his widowed mother, a sad reminder of conscience and duty. As the master points to the shop, which is now Goodchild's, so a sailor points to Idle's immediate and eventual destinations, the ship and the gallows. As the master rests his hand on Goodchild's shoulder, so does a sailor on Idle's, but to show him the cat-o'-nine-tails and indicate the misery he will suffer on shipboard. Idle defiantly responds with the cuckold's sign directed at his tormentors, but almost equally at his poor mother.

Nooses hang at the side of the boat: they have now moved from the decorative border into Idle's world.

In 6 Goodchild has married his master's daughter and become his partner. In the morning sunshine Goodchild leans out of his window to pay the serenading musicians, while in 7 Idle is in bed with a prostitute, who examines earrings, a watch, and other objects he has stolen (apparently for her). Unlike Goodchild's solid brick house, this is a dilapidated garret with fallen plaster, gaping holes in the floor, a crumbling chimney, and broken utensils. Goodchild's door is open, a gesture of charity; Idle's is bolted shut, and as usual he is lying on a bed. The sound of music pleases Goodchild; the noise of the cat and rat terrifies Idle, reminding him of the hostile outside world (a pair of pistols lies on the floor).

In 8 Goodchild, now sheriff, is at an official banquet, and a constituent appears at the door with a petition for him ("*To the Worship¹ Frs Goodchild Es. Sher[iff of] . . . Londo[n]*"); in 9 Idle is among brawling, thieving hoodlums in a night cellar, being betrayed by the woman he was in bed with in 7, accompanied by the same character with the eye patch and striped cap with whom he gambled in 3 when he should have been in church. A constable, directed by the treacherous woman, enters to arrest him. And the hangman's noose is again materialized within the picture, dangling from the ceiling.

In 10 the two apprentices are brought together once more: Idle begging for mercy, Goodchild regretfully passing judgment on him; Idle, who until now has always been asleep or (though never relaxed) nearly recumbent, cowers before Goodchild, his bent form contrasted with the strong unbending verticals of the pillars, the wall, the desk, and Goodchild's own torso. Finally, in 11 and 12 the order of contrast is reversed, and first Idle is shown on his way to the gallows and then Goodchild on his way to the Guildhall to be inaugurated lord mayor of London: Idle outside, exposed, under a cloudy sky, with a Methodist minister exhorting him to repent; Goodchild under a clear sky, inside a coach, accompanied by dignitaries, with the sword of state (now within the picture) showing at the coach window.

All of this elaboration, however, is on the basic contrast of industry and idleness, which proliferates into wisdom and pleasure, control and negligence, piety and blasphemy, good company and bad, giving and taking, respect and contempt, wife and prostitute, loyalty

and betrayal, prosperity and poverty, social and antisocial behavior, with above all this the contrast of the reason and the unreason, the directed and the undirected, order-security and chaos-danger.[11] For the first time, Hogarth has produced a *hero,* a normative counter to oppose the foolish Harlot or Rake, his usual protagonist, who embodied qualities of both good and evil, freedom and compulsion, but for whom real evil existed in the encroaching figures of the respectable Charteris and Gonson.

The mottoes, which appear under every design, emphasize the stark pattern of contrast and causality in the prints. They are mostly from Proverbs, whose verses are verbally equivalent to the visual antitheses Hogarth has constructed: "The soul of the sluggard desireth, and hath nothing; but the soul of the diligent shall be made fat" (13:14)—a structure of *this* against *that,* or of *this* will bring about *that.* And many of the proverbs were, like this one, concerned with industry versus idleness.[12] Leviticus, the next favorite source of mottoes, carries the related structure, if you do *this,* then you will be punished (or rewarded) *thus* and *thus* and *thus,* to an extreme of rigor.

The opposition of Idle and Industrious Apprentice is further emphasized by placing Idle on the left of the picture and Goodchild on the right, whether they appear together or alone. We come to expect on the left the irregular, flattened visage of Idle and on the right the regular good looks of Goodchild, and inevitably recall, "He shall set the sheep on His right hand but the goats on the left" (Matt. 25:33). Idle is also out in open spaces or in a crumbling tenement, unprotected and unsafe, while Goodchild is shown within solid, well-built architectural structures (a traditional way of contrasting vice and virtue, as in the temples of Modern and Ancient Virtue at Stowe).

We have seen that in every case the idle apprentice is kept to the left side of the plate, the industrious to the right, as goats are separated from sheep. With this pattern of expectation established, however, we notice that in every one of the plates in which Goodchild appears alone, on the right, there is also something on the left. This is a repoussoir figure that helps to stabilize the composition but also leads the viewer's eye into it, establishing its depth: the ugly old pew opener in Plate 2, the carbuncular-nosed porter in 4, and the lascivious and drunken revelers around the grandstand in 12. Plate 4 tells us what we are to make of this pattern: the porter, intruding from the weavers' workroom, is paralleled by his equally ill-favored dog in dispute with the bristling cat who stands on the raised platform

with Goodchild and his master. In short, the other, negative apprentice is a silent presence even when the subject is his opposite. The viewer's habit of left-right association with Idle and Goodchild leads us (assisted by the related shapes) to see the left-hand figure as a generalization of Idle's gross plebeian world, which Goodchild cannot escape even in the safety of the countinghouse. What is most noticeable is that the contention between these worlds is also an aesthetic one of beauty versus ugliness, with implicit the equation (evident in the platonic aesthetics of Shaftesbury and Francis Hutcheson) of beauty and good, ugliness and evil.[13]

On the other hand, in the Idle plates there is no repoussoir figure—no one to anchor the composition down on either side, so that Idle always appears to be floating over a gulf. Because he is himself on the left the emptiness of the right side is all the more emphatic.

The final plates, however, change all this. In 8 and 9, though still toward the right and left respectively, Goodchild and Idle are moving closer to the center than in the earlier plates. And in the last two plates the order has been reversed and Idle comes first; moreover, while the two apprentices are shown proceeding in opposite directions, they have been moved to exactly the same position to the left of center, and both seem suspended now above the mass of the crowd. They are, different as their fates (and the skeletons and cornucopias in their margins), located spatially at the same spot.

The motto under this last plate is "Length of days is in her right hand and in her left hand Riches and Honour" (Prov. 3: 16), which in the light of the earlier plates draws attention to the left-right pattern while at the same time minimizing the difference. *Both* long life and riches and honor are things that Goodchild has gained and Idle lost. As it happens, since the general view (following Matthew 25: 33 and other texts) was that left equals evil and right equals good, it was just this text from Proverbs failing to distinguish between them that the preachers and exegetes fastened upon for debate.[14]

One inference is that so much emphasis on contrasting values in plate after plate ends by drawing attention to underlying parallels, as in the crowds that surround both apprentices. The contrast was initially between crowd and isolation: in Plate 6 the crowd is celebrating Goodchild; in 7 there is no crowd around poor, solitary Idle. But two musicians in Goodchild's crowd are squabbling, the dog's face is sad and downcast, and the celebration itself is for hire (and by its plebeian shapes and placement on the left is associated with Idle). In

Plates 8, 9, and 10 both apprentices are surrounded by ugly, greedy, self-interested folk, distinguished mainly by the respectability of the group having dinner with Goodchild. The crowds in Plates 11 and 12 are initially contrasted: the one watching Idle is shabby, fighting, crying (his mother), stealing, and immoral, presided over by Mother Douglas the bawd; the crowd watching Goodchild is cheering, more prosperous, presided over by Frederick, Prince of Wales. But both consist largely of drunken, celebrating, out-of-control people, including bruisers with sticks (though they are wielded only in 11). Can we say that the people at Tyburn came to condemn Idle, while the people in the City came to wish Goodchild well? We must if we carry out the contrast. Or, do we recall the old saying, "The crowd that cheers him at his coronation would cheer as lustily at his execution,"[15] and see the parallel: that the roads to Tyburn and to the Guildhall amount to the same thing? Hogarth may have reversed the order of Plates 11 and 12 and moved both apprentices to the same position on the two plates in order to suggest something about the ironic interchangeability of the fates of the two.

Another interesting fact is that there is no way to hang the twelve prints on a wall without breaking up the paired contrasts (2–3, 4–5, 6–7, 8–9). With the notable exception of Plates 11 and 12, the pairing of the pictures on a wall is at odds with, runs counter to, and perhaps undermines the formal-moral contrasts.

The perspective system is also very odd: in the first plate Idle's loom has a different vanishing point from Goodchild's, and the room itself has yet a third. The effect is to set up two alien systems of reference (though Goodchild's is related to the viewer's point of view and so includes an initial identification with him), and this connects with the fact we have noticed that Idle's scenes tend to be open while Goodchild's are closed, the one outside ordinary perspective systems altogether, the other rigidly constructed along the lines of a perspective box.

At the beginning both apprentices are entirely enclosed in a room, overshadowed and further enclosed by their looms. Goodchild in effect never leaves the closed room; visually his world is fixed within the perspective-defined and closed spaces of a box, hedged in by a labyrinth of pews, covered and safe; he never ventures out of an enclosure, but remains careful, comfortable, and protected. His final residence is so safe that a row of fire buckets hangs from the ceiling,

75. *William Cavendish, Marquess of Hartington* (later fourth duke of Devonshire);
painting; 1741; 29¼ × 24¼ in. (Paul Mellon Collection, Yale Center for British Art).

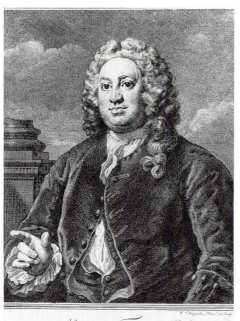

76. *Martin Folkes;* 1742; 11 × 8¹⁵⁄₁₆ in. (courtesy of the British Museum, London).

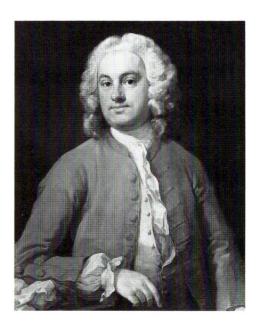

77. *A Gentleman in Red;* painting; 1741; 29¼ × 24⅝ in. (by permission of the governors of Dulwich Picture Gallery).

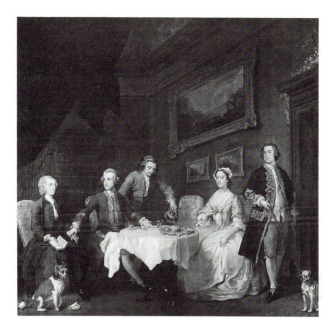

78. *The Strode Family;* painting; ca. 1738; 34½ × 36 in. (Tate Gallery, London).

79. *Lord Hervey and His Friends;* painting; ca. 1738; 40 × 50 in. (Ickworth, The Bristol Collection [The National Trust]).

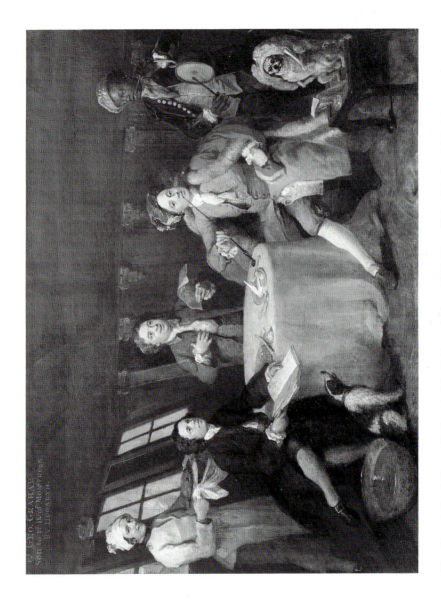

80. *Captain Lord George Graham in His Cabin*; painting; 1745; 28 × 35 in. (National Maritime Museum, Greenwich).

81. *The Graham Children*; painting; 1742; 63¼ × 61¼ in. (National Gallery, London).

82. *The Mackinen Children;* painting; ca. 1742; 72 × 56½ in. (National Gallery of Ireland, Dublin).

83. *Thomas Herring, Archbishop of York* (later of Canterbury); painting; 1744 (1747); 50 × 40 in. (Tate Gallery, London).

84. Detail of fig. 83.

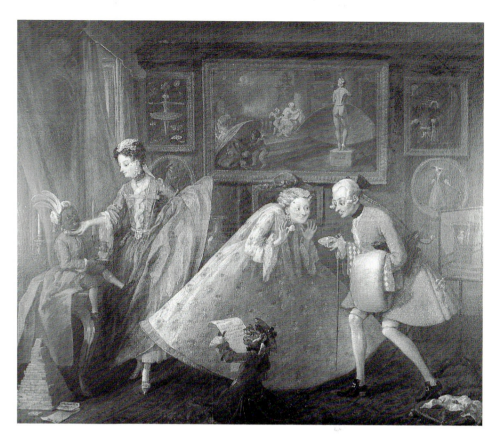

85. *Taste in High Life; or Taste à la mode;* painting; 1742; 24¼ × 29¼ in. (private collection).

86. *Gerard Anne Edwards in His Cradle;* painting; 1732; 12½ ×
15½ in. (Upton House, The Bearsted Collection [The Na-
tional Trust]).

87. *Mary Edwards;* painting; ca. 1740; 49⅜ × 37⅞ in. (The
Frick Collection, New York).

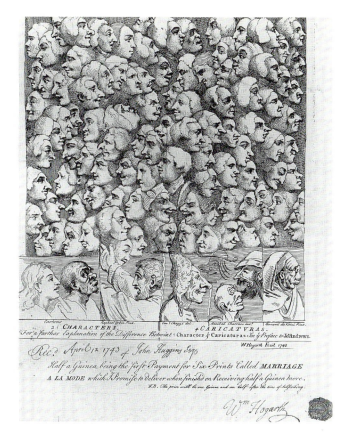

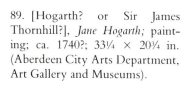

88. *Characters and Caricaturas* (first state); Apr. 1743; 7¹¹⁄₁₆ × 8⅛ in. (courtesy of the British Museum, London).

89. [Hogarth? or Sir James Thornhill?], *Jane Hogarth;* painting; ca. 1740?; 33¼ × 20¾ in. (Aberdeen City Arts Department, Art Gallery and Museums).

90. *Marriage A-la-mode*, Pl. 1; painting; 1743–1745; 27 × 35 in. (National Gallery, London).

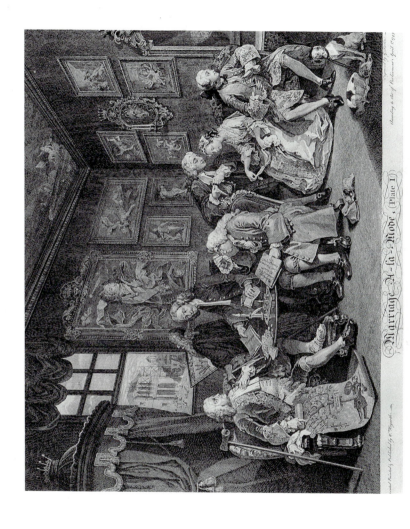

91. *Marriage A-la-mode*, Pl. 1 (engraving by G. Scotin, sixth state); 13¹⁵/₁₆ × 17½ in. (courtesy of the British Museum, London).

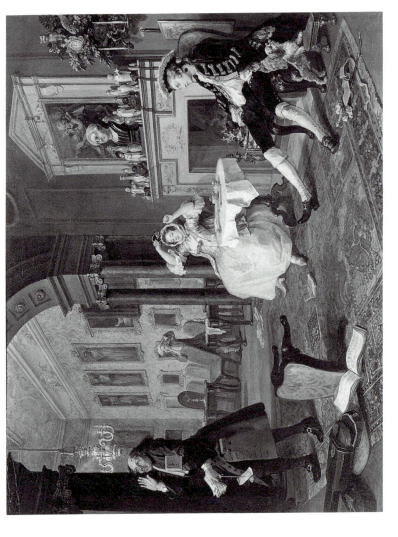

92. *Marriage A-la-mode*, Pl. 2; painting; 1743–1745; 27 × 35 in. (National Gallery, London).

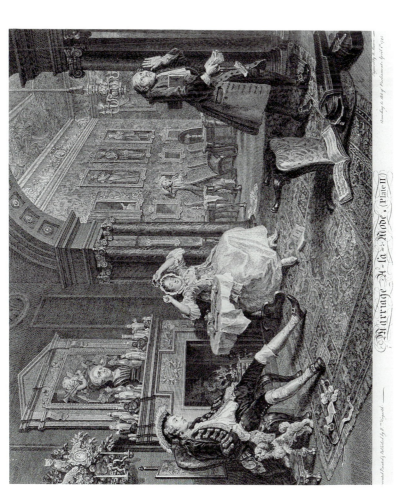

93. *Marriage A-la-mode*, Pl. 2 (engraving by B. Baron, second state); 1745; 17 × 17⅝ in. (courtesy of the British Museum, London).

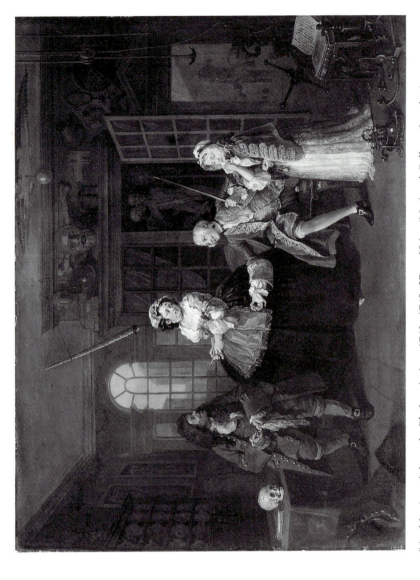

94. *Marriage A-la-mode*, Pl. 3; painting; 1743–1745; 27 × 35 in. (National Gallery, London).

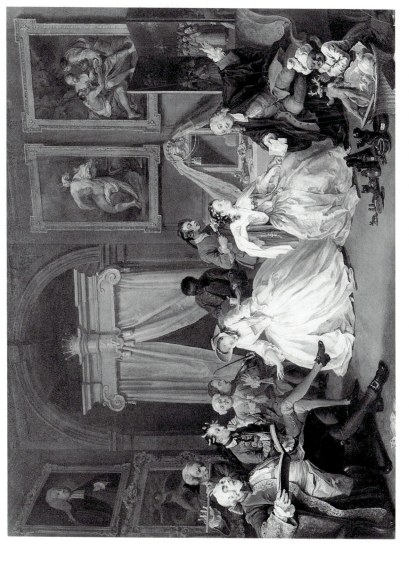

95. *Marriage A-la-mode*, Pl. 4; painting; 1743–1745; 27 × 35 in. (National Gallery, London).

96. *Marriage A-la-mode*, Pl. 5; painting; 1743–1745; 27 × 35 in. (National Gallery, London).

97. Detail of *Marriage A-la-mode*, Pl. 5 (engraving by R. [S.] F. Ravenet, third state); 1745 (courtesy of the British Museum, London).

98. *Marriage A-la-mode*, Pl. 6; painting; 1743–1745; 27 × 35 in. (National Gallery, London).

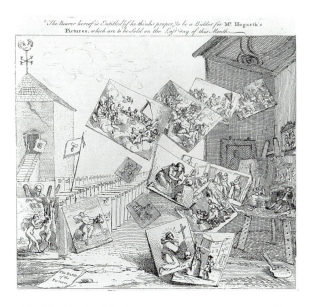

99. *The Battle of the Pictures;* Feb. 1744/45; 7 × 7⅞ in. (courtesy of the British Museum, London).

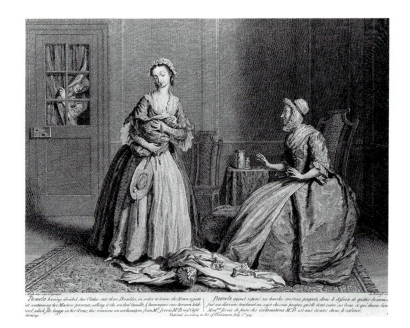

*Pamela having divided her Clothes into three Bundles, in order to leave the House, repeats
...at...nting her Master's presents, calling it the wicked bundle, & harangues over her own little
...reel, which she hangs in her Arms; this occasions an exclamation from M.rs Jervis M.r B. in ye Closet
...tening.*

*Pamela ayant separé ses hardes en trois paquets, dans le dessein de quitter la maison
fait un discours touchant au sujet du son paquet, qu'elle tient entre ses bras, ce qui donne lieu
à M.me Jervis de faire des exclamations M.r B. est aux écoutes dans le cabinet.*

100. Joseph Highmore, *Pamela Preparing to Leave the House of the Squire;* en-
graving by Antoine Benoist; 1745 (courtesy of the British Museum, London).

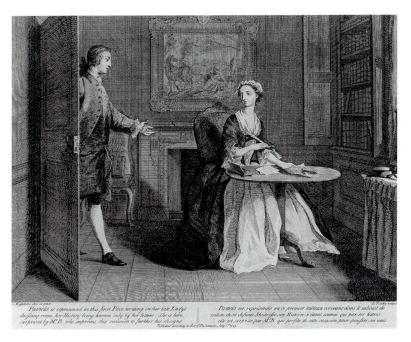

*Pamela is represented in this first Piece, writing in her late Lady's
dressing room, her History being known only by her letters; She is here
surprised by M.r B. who improves this occasion to further his designs*

*Pamela est représentée en ce premier tableau écrivant dans le cabinet de
toilette de sa défunte Maitresse, son Histoire n'étant connuë que par ses lettres,
elle est surprise par M.r B. qui profite de cette occasion pour pousser ses vuës.*

101. Joseph Highmore, *Mr. B. Finds Pamela Writing;* engraving by Louis Tru-
chy; 1745 (courtesy of the British Museum, London).

102. *The Wedding Banquet;* painting; ca. 1745; 28 × 36 in. (Royal Institution of Cornwall, Truro).

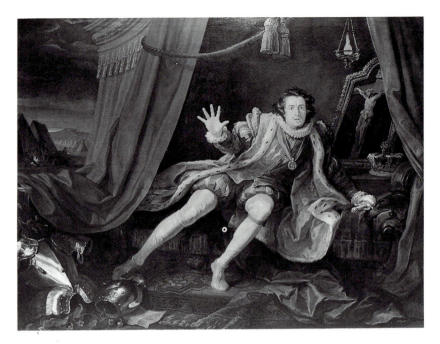

103. *David Garrick as Richard III;* painting; 1745; 75 × 98½ in. (trustees of the National Museums and Galleries on Merseyside, Walker Art Gallery, Liverpool).

104. *Mask and Palette;* 1745; 4 × 4½ in. (courtesy of the British Museum, London).

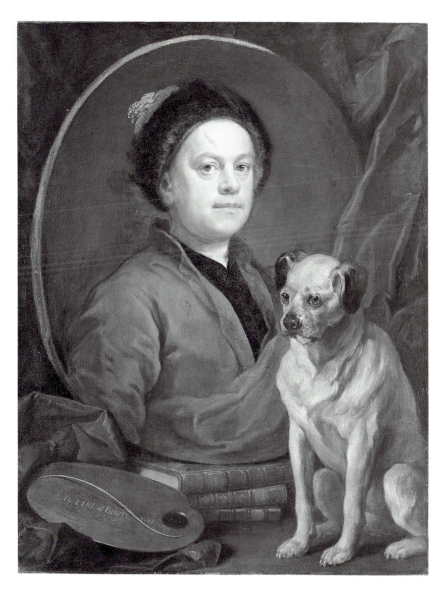

105. *Self-Portrait with Pug;* painting; 1745; 35 × 27½ in. (Tate Gallery, London).

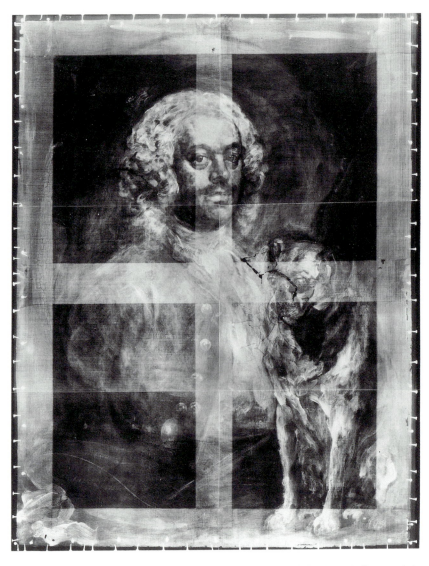

106. *Self-Portrait with Pug;* X-ray of painting (courtesy of the Tate Gallery and the Courtauld Institute).

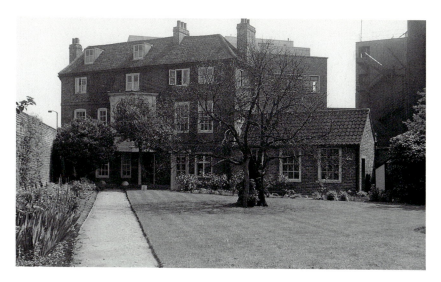

108. Hogarth's house, Chiswick; photograph by the author; 1965.

107. Jean André Rouquet (?), *Portrait of William Hogarth;* ca. 1735; 1¾ × 1⅞ in. (National Portrait Gallery, London).

109. *An Invitation to Dinner;* engraving after a lost drawing (John Nichols, *Biographical Anecdotes of William Hogarth,* London, 1785).

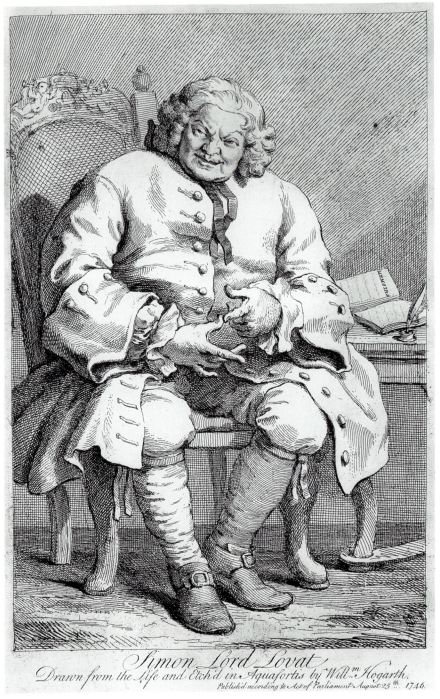

Simon Lord Lovat
Drawn from the Life and Etch'd in Aquafortis by Will.^m Hogarth.
Publish'd according to Act of Parliament August 25.th 1746.

110. *Simon Lord Lovat* (second state); Aug. 1746; 13³⁄₁₆ × 8⅞ in. (courtesy of the British Museum, London).

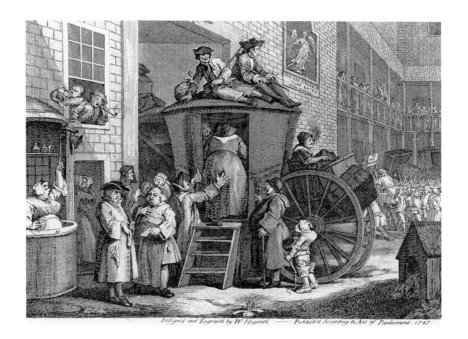

Design'd and Engrav'd by W. Hogarth ——— Publish'd According to Act of Parliament. 1747.

111. *The Stage Coach; or a Country Inn Yard at Election Time* (second state); June 1747; 8⅛ × 11⅞ in. (The Print Collection, Lewis Walpole Library, Yale University).

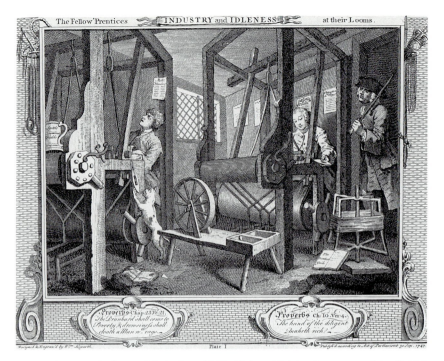

112. *Industry and Idleness,* Pl. 1; Oct. 1747; 10⅛ × 13⅜ in. (courtesy of the British Museum, London).

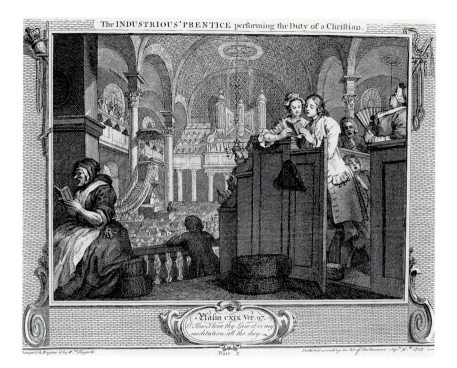

The INDUSTRIOUS 'PRENTICE performing the Duty of a Christian.

Pſalm cxix Ver: 97.
O. How I love thy Law it is my
meditation all the day.

Plate 2

113. *Industry and Idleness,* Pl. 2; Oct. 1747; 10⅛ × 13⅜ in. (courtesy of the British Museum, London).

114. *Industry and Idleness,* Pl. 3; drawing; 8½ × 11⅝ in. (courtesy of the British Museum, London).

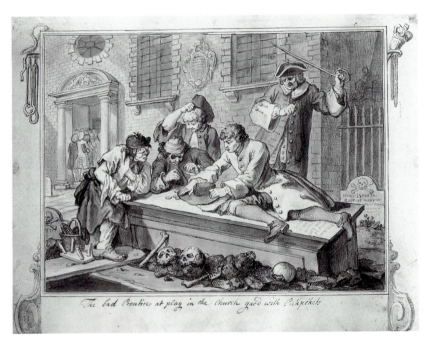

The bad Prentice at play in the Church yard with Pickpokets

115. *Industry and Idleness,* Pl. 3; drawing; 10¾ × 13⅞ in. (courtesy of the British Museum, London).

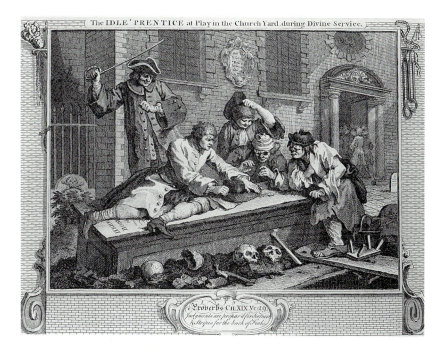

116. *Industry and Idleness,* Pl. 3; Oct. 1747; 10⅛ × 13⅜ in. (courtesy of the British Museum, London).

117. *Industry and Idleness,* Pl. 4; Oct. 1747; 10⅛ × 13⅜ in. (courtesy of the British Museum, London).

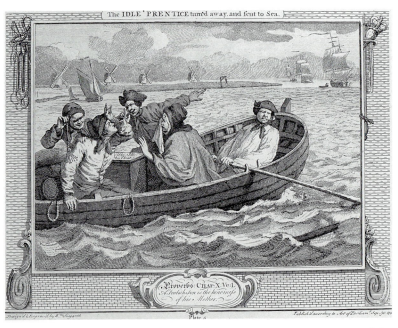

118. *Industry and Idleness,* Pl. 5; Oct. 1747; 10⅛ × 13⅜ in. (courtesy of the British Museum, London).

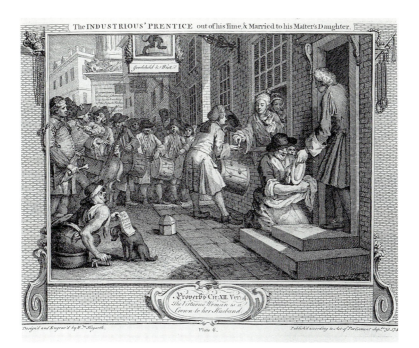

119. *Industry and Idleness*, Pl. 6 (second state); Oct. 1747; 10⅛ × 13⅜ in. (courtesy of the British Museum, London).

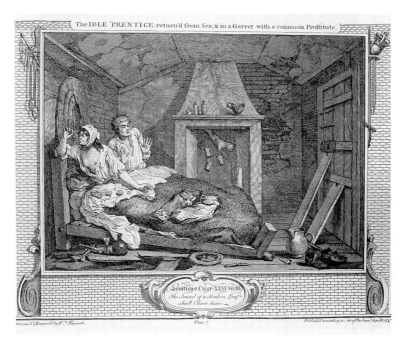

120. *Industry and Idleness*, Pl. 7; Oct. 1747; 10⅛ × 13⅜ in. (courtesy of the British Museum, London).

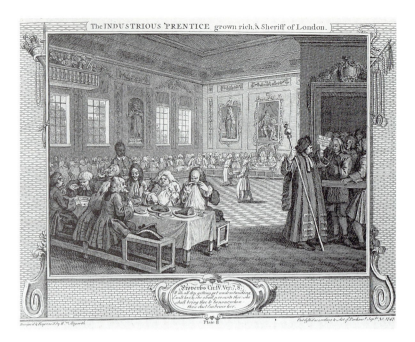

121. *Industry and Idleness*, Pl. 8; Oct. 1747; 10⅛ × 13⅜ in. (courtesy of the British Museum, London).

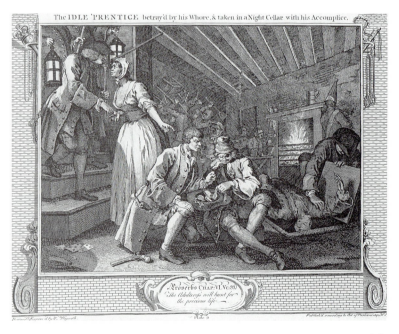

122. *Industry and Idleness*, Pl. 9; Oct. 1747; 10⅛ × 13⅜ in. (courtesy of the British Museum, London).

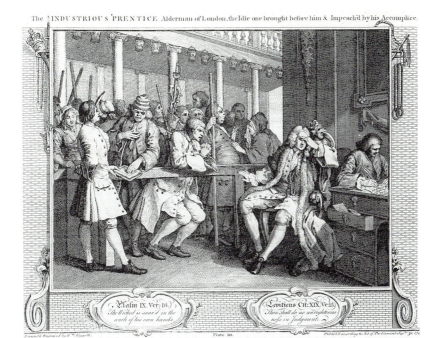

123. *Industry and Idleness,* Pl. 10; Oct. 1747; 10⅛ × 13⅜ in. (courtesy of the British Museum, London).

The IDLE 'PRENTICE Executed at Tyburn.

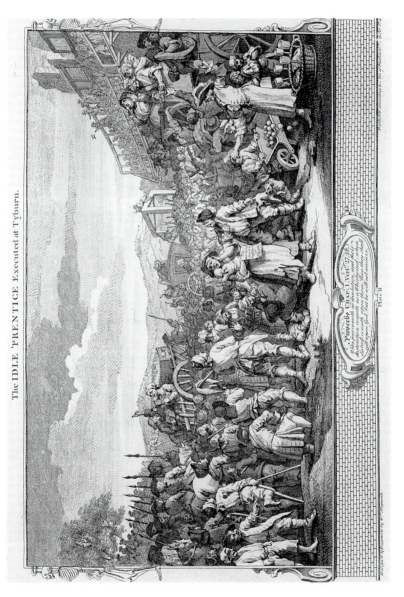

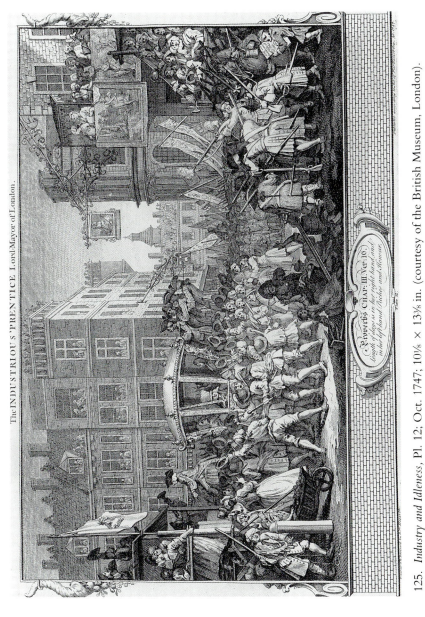

The INDUSTRIOUS PRENTICE Lord Mayor of London.

Proverbs CHAP: III Ver: 16.
length of days is in her right hand and
in her left hand Riches and Honour.

Plate 12.

125. *Industry and Idleness*, Pl. 12; Oct. 1747; 10⅛ × 13⅜ in. (courtesy of the British Museum, London).

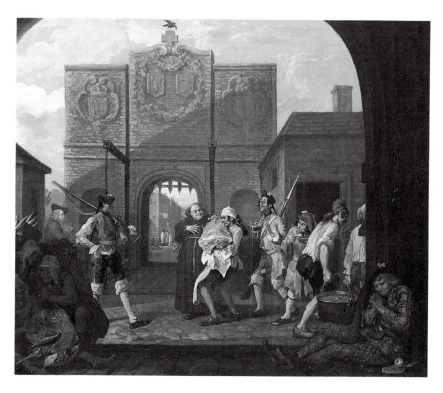

126. *The Gate of Calais, or O the Roast Beef of Old England;* painting; 1748; 31 × 37¼ in. (Tate Gallery, London).

127. Detail, Hogarth's head, *The Gate of Calais* (engraving by Charles Mosley and Hogarth, second state) (courtesy of the British Museum, London).

128. Design for the Subscription Roll of the Foundling Hospital; drawing; 1739; 4⅜ × 8¼ in. (Paul Mellon Collection, Yale Center for British Art).

129. *Moses Brought to Pharaoh's Daughter;* painting; 1746; 70 × 84 in. (from the collection of the Thomas Coram Foundation, London).

131. Detail of fig. 129.

130. Detail of fig. 129.

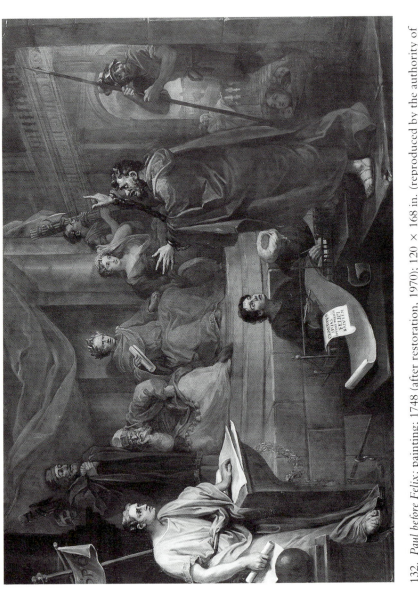

132. *Paul before Felix*; painting; 1748 (after restoration, 1970); 120 × 168 in. (reproduced by the authority of the Treasurer and Masters of the Bench of Lincoln's Inn).

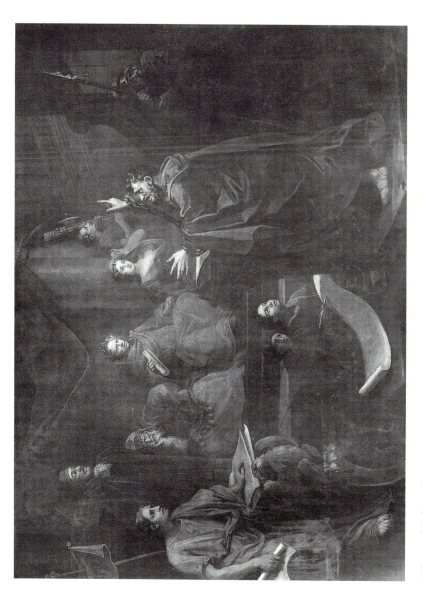

133. *Paul before Felix*; painting (revision); ca. 1751 (before restoration, 1970); (photograph courtesy of Lincoln's Inn).

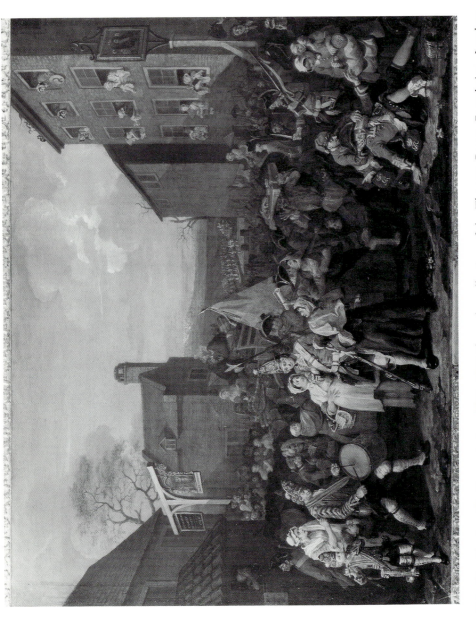

134. *The March to Finchley*; painting; 1749–1750 (from the collection of the Thomas Coram Foundation, London; photographs courtesy of the Paul Mellon Centre, London).

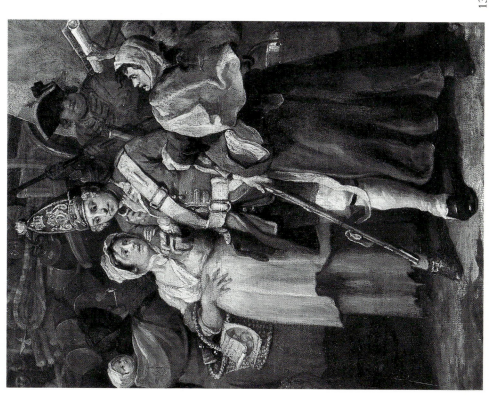

135. Detail of fig. 134.

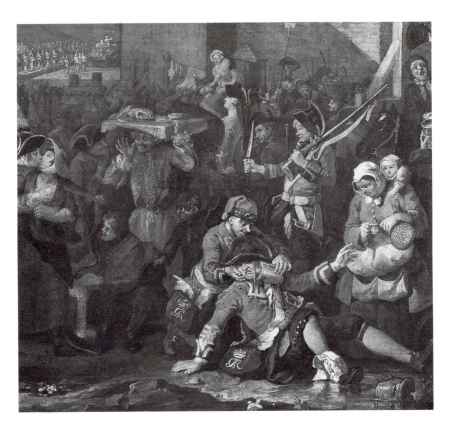

136. Detail of fig. 134.

137. Detail of fig. 134.

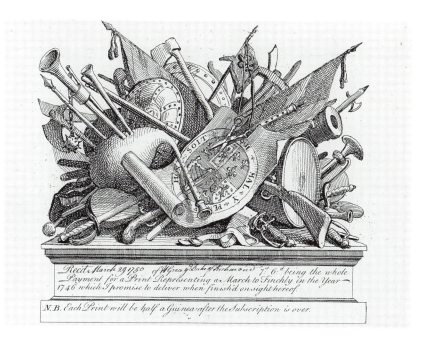

138. *A Stand of Arms;* Mar. 1749/50; 6¾ × 8 in. (courtesy of the British Museum, London).

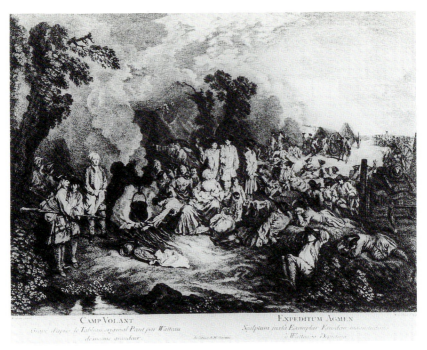

139. Antoine Watteau, *Le Camp Volant;* engraving by C.-N. Cochin; 1727 (courtesy of the British Museum, London).

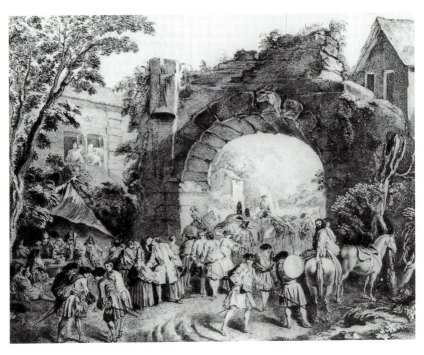

140. Watteau, *Le Départ de Garnison;* engraving by S. F. Ravenet; 1737–1738 (courtesy of the British Museum, London).

an indication that the building is insured by the Sun Fire Office. But Idle, compared to Goodchild, is unlocated, unfixed, and his world is open and exposed. Though the open door of Goodchild's house is contrasted with Idle's barricaded door (6 and 7), Goodchild himself is within his house, just protruding his head and arm through a window, while Idle, trying to close himself in, utterly fails: the gaping holes in the floor, the propped and rickety door, the collapsing bed, and the chimney through which rats and cats race show that his room is anything but closed. From the open grave to the hole in his garret floor and the trapdoor into the Thames through which corpses are dropped, Idle's is an unprotected, unregulated world of liberty but one of temptations and dangers as well, with the threat of some sort of retribution always hanging over him and a chasm yawning beneath his feet. Once the choice is made between idleness and industry, outside all is hostile and fearful; inside is religion, security, a wife, a father, status, and order.

Only in Plate 10 is Idle finally caught within the sturdy architectural world of Goodchild, which ends once again within the loomlike framework of the triple gallows of Tyburn. But meanwhile Goodchild too is receding. The expressively exaggerated perspective of the City banquet in 8 emphasizes the giant guzzlers in the foreground against the tiny figure of Goodchild, so diminished as to suggest that the office of sheriff has been gained at the expense of his own identity. In his next appearance his face is shielded behind his hand, and in the last obscured within a closed coach. The parallel is unmistakable between the Anglican clergyman, the ordinary of Newgate, in his covered coach (vs. the Methodist preacher uncovered, helping Idle in his last moments) and Goodchild in his covered, heavily protected and closed coach, guarded by the sword of state.

Seen in the sequence of Hogarth's earlier work, as Hogarth collectors at least would have seen *Industry and Idleness* mounted in their folios, these spatial relationships recall the *Harlot,* in which outdoors designated freedom and the natural self.[16] As the Harlot declined, her room, her container, shrank to a coffin, and by the 1740s the Enraged Musician had enclosed himself in his house, visible through his window (recalled by Goodchild in 6) trying to order the lively noisemakers outside in the street whose activity is disturbing him. Hogarth has begun to develop another meaning inherent in the closed room: its comfort, security, and isolation from the messiness of life.

These qualities were present in the dark, overfurnished room of the Harlot's keeper, but in *Industry and Idleness* they are associated with a protagonist who does not come to grief.

It is in fact the hero of the series, the respectable man, who spends his life in metaphoric prison cells, while the bad man remains out in the open. There *is* no prison cell in this series concerning a real criminal—it is only implied by the gap between the scenes of courtroom and gallows. So the contrast of the idle and industrious apprentices relies on the one being unprotected, out in the open, vulnerable to both criminals and the law; the other always enclosed, and with the associations from the earlier works a feeling of countermovement against the purely schematic pull of the series begins to be felt. For the world of ordered, rigid architectural shapes in *Industry and Idleness* is also the world of contrasted plates, of vice and virtue, of left and right, and this is the ordered world of Goodchild, which is increasingly impinged upon by Idle's world of undifferentiation and chaos, until nearly overwhelmed by it in the last plate.

The proverbs beneath each design also emphasize the simple pattern of contrast and causality in the prints, but for the viewers familiar with Hogarth's earlier print series they carried a particular meaning: all but one of the mottoes are from the Old Testament, of strict justice over mercy. (When the master discovers the sleeping apprentice in Plate 1, we remember the magistrate approaching the unsuspecting Harlot in Plate 3 of that series.) As it happens, the single *New* Testament motto used, for Plate 4, is from the parable of the talents (Matt. 25:14–30), which, besides being the locus for the dichotomy of sheep/goats and right/left hand, is one of the very few places in the New Testament where an "unprofitable servant" meets an Old Testament punishment, being cast "into outer darkness."

Hogarth's audience from the trading class was thoroughly familiar with Proverbs, Leviticus, Psalms, and the parables of Christ—as much so as the connoisseurs had been with the classical myths and the traditional iconography of Western art. At its simplest, as in Plate 4, the motto alludes to the "good and faithful servant," and the Hogarthian reader, familiar with his earlier prints, infers the other half of the story, the "wicked and slothful servant" who hid his one talent in the ground. "The virtuous Woman is a Crown to her Husband" in Plate 6, which shows Goodchild's bride, is completed by: "but she that maketh ashamed is as rottenness in his bones" (Prov. 12:4). The contrast of good and bad women is already implicit then in 6, and so

in Plate 7, where the other "wife" (Idle's whore) appears, Hogarth can proceed to: "the sound of a shaken leaf shall chase him" (Lev. 26:36).[17]

But in 8 the motto becomes strikingly ambiguous: "With all thy getting get understanding. Exalt her & she shall promote thee: she shall bring thee to honour when thou dost Embrace her" (Prov. 4:7–8). Most noticeably, while the feminine pronoun in the context of Proverbs, chapter 4, refers to Wisdom, Hogarth has omitted the referent (his quotation should accordingly refer to Understanding, which however he has not honored with capitalization). And so in the context of the plate and the two immediately preceding Goodchild plates, "her" and "she" apparently apply to the only familiar "she" present, the wife who sits next to Goodchild on the dais: "exalt her & she will get you her father's business; embrace her"—not the spiritual but the physical embrace (which Hogarth *does* capitalize) that has brought him to honor. The word "getting" in "with all thy *getting* get understanding" sounds, in the light of all those London politicians busily gorging themselves, like a necessary admonition.

Hogarthian irony is at work, and this interaction of motto and image draws us back to Plate 2. That motto, "O How I love thy Law it is my meditation all the day" (Ps. 119:97), raises the question, settled in Plate 8, of whether "love" and "thy Law" that is to be Goodchild's meditation all the day refer to God or to the master's daughter, who stands next to him. Then when Goodchild appears in his master's countinghouse in 4, what are we to make of the almanac emblem of Opportunity taking Time by the forelock? Plate 4 itself refers to his industry in the shop, but the daughter is so emphasized in the surrounding plates that, as we look back from 8, she is another strong contender for the role of Opportunity. In retrospect, to Goodchild's religion, security, a wife, status, and order we must add shrewd business sense and money.

The motto of 11, which sums up Idle's fear and desolation as he goes to his death, concludes: "Then they shall call upon God, but he will not answer" (Prov. 1:27, 28).[18] Hogarth has changed "me," which refers to Wisdom (the speaker in both the framing verses), to God, partly to indicate that the deity is definitely not present, at least not for Idle. The inscription tells us that the condemned man has been abandoned not only by the Church of England clergyman but by God, or at least "God" as part of the dominant ideology, who has, of course, been notably absent from other Hogarth engravings. But also partly to indicate that in this society Wisdom *is* simply God,

and vice versa. Proverbs is full of wisdom about industry and idleness, about the prudent man and the foolish, the righteous and the wicked; and Hogarth pointedly omits the last category, the moral, leaving the emphasis on the prudential and introducing the name of God as a synonym for Wisdom.

In the final motto of Plate 12 it is still Wisdom who is speaking, explaining that the "merchandise" of wisdom (Prov. 3:14) is "more precious than rubies" (v.15), making it clear that wisdom (not God) is what leads to this end. This follows all the proverbs that say if you honor the Lord, "so shall thy barns be filled with plenty, and thy presses shall burst out with new wine" (v.10), as they do here. The motto itself (v.16), "Length of days is in her right hand; and in her left hand riches and honour," is followed by "Her ways are ways of pleasantness, and all her paths are peace" (v.17), and a bit later by "Keep sound wisdom and discretion" (v.21). The reiterated "her" of course applies to Wisdom in the biblical context, but we recall those earlier "hers" in the context of Mrs. Goodchild née West. The consequences are spelled out: longevity and riches and honor; Goodchild is not being hanged, he is rich, and he is mayor of London.

Emblems are sparingly used in *Industry and Idleness*. Were we to consult Ripa's *Iconologia* on the way Idleness was represented, we would find that it is "an old Hag cloth'd in Rags" with her head bound about with a black cloth. As Ripa explains the significance of this hieroglyphic, she is "*old,* because at that Age, Strength and Activity to work, begin to fail; her Rags denote that Idleness produces Poverty; the black Cloth about her Head signifies her senseless Thoughts." It is significant historically that Hogarth does not employ the hieroglyphic—the veiled—symbol for Idleness, but rather the unlearned, the probable representation, simply a young man dozing over his loom.[19] But it is equally characteristic of him that, with his primary meaning established in this way, he also introduces the emblematic figure, with its traditional but enigmatic meaning; for the old lady, the black cloth about her head in widow's weeds, first introduced as the pew keeper in Plate 2, by the fifth plate is Idle's mother; and the idleness of old age, weakness, and helplessness is contrasted with the willful idleness of youth. This is not, of course, merely a gathering of both kinds of iconography to complicate meaning; real idleness is in the natural representation, not in the enig-

matic—the poor mother industriously follows her son step by step to the gallows, not seeking handouts but trying to help him.

Goodchild's covering his eyes in Plate 10 materializes the emblem of Blind Justice, who, not a respecter of persons, cannot recognize favors or friends.[20] But Goodchild, assuming the pose, is the one who turns himself into Blind Justice. And in its immediate context, Goodchild's covering of his eyes also prevents him from seeing the treacherous girlfriend bribing the clerk and the man with the eye patch (who lured Idle into crime) taking his oath illegally with his left hand as he swears away Idle's life. (Behind, the weapons being held up form a caduceus, emblem of Mercury the thief.)[21]

The viewer is drawn back to Plate 8 and the statue holding a dagger, whom Hogarth's City audience, from lord mayor down to apprentice, would have recognized as Sir William Walworth, the lord mayor who without warning struck down the rebel Wat Tyler—a sudden blow that saved the king, as perhaps Goodchild strikes down Idle.[22] The message is that the idle, who have sunk into crime, get what they deserve; that bribery and lying *are* justice, according to the Old Testament "an eye for an eye," for Idle has loafed, cheated, robbed, and must expect equal punishment. But implicit also is the sense that justice is cruel and that the legal system is quick, almost unthinking (like Walworth's blow), and not perfect—for one guilty man apprehended, many escape. The wicked, the temptors and corruptors, continue to flourish, and Goodchild's world is one in which he not only cannot rid himself of the Idles but must overlook bonds of friendship, the crimes of his own subordinates, and the guzzling grossness of his colleagues.

Goodchild's world of enclosed architectural spaces is plainly delimited as the City of London, of which he becomes sheriff and then mayor. The porter in Plate 4 wears the badge of the City, the almanac with Time seizing Opportunity by the forelock is a "London Almanac," Walworth was a London mayor and his dagger became part of its escutcheon, and the insignia of London's mayor appears in the margins.[23] In Plate 6 Hogarth ignores the impossible distance and the scale in order to reproduce the inscription on the London Fire Monument: "*In remembrance . . . of Burning yᵉ Protestant City by the treachery of the Papist faction In . . . year . . . of our . . . Lo[r]d 1666.*" He may be suggesting something ironic about the danger to be feared by London from a Tom Idle (cf. the fire buckets in the scene of his condemnation), but mainly he is establishing that the values represented here

are Protestant and economic (it was Defoe who in *The Complete English Tradesman* called idleness the sin against the Holy Ghost).

This inscription illustrates how the "veil of allegory" still operates in these "popular" prints. The City (from aldermen to apprentices) probably believed—and certainly preserved—the inscription; but the disinterested viewer knew by this time that it was a Protestant myth, and may have recalled Pope's lines in his "Epistle to Bathurst" (1732): "London's column pointing to the skies, / Like a tall bully, lifts the head, and lyes."[24] As Pope used the monument to place Sir Balaam in a particular economic and moral code of Protestant capitalism, so Hogarth uses it to locate not only Goodchild but the tradesman audience to whom he is directly addressing himself and its assumptions about industry and idleness.[25] But he is also allowing for the readers who knew Pope's "Bathurst" to distance themselves from the City and its values, and detect a series of ironies that tend to undercut the obvious comic-strip contrasts of the Goodchild success story.

THE CHOICE OF HERCULES

Interest in the Choice of Hercules, a topos that was part of every educated Englishman's consciousness, seems to have peaked in the 1740s.[26] To take only one example, Spence included in his *Polymetis* Robert Lowth's poem "The Choice of Hercules," preceding it with an essay on the subject.[27] There "can be no virtue without choice" is his message. Spence is a good example of a contemporary who looks back to antiquity and sees choice between *virtus* and *voluptas* as the basic pattern not only in Prodicus and Cebes but in Philostratus, Silvius Italicus, Horace, and Ovid; he adduces Ulysses' choice between Circe and Penelope, Paris's between Minerva and Venus (which Hogarth used in *Rake* 2), Aeneas's between Dido and Latium, Persius's between *avaritia* and *luxuria,* and Lucian's between Eloquence and Sculpture.

Hercules's choice, as Prodicus explained it, was essentially between industry and idleness, the difficult way and the easy or pleasurable. In *A Harlot's Progress* it was Hackabout's lackadaisical attention to her employment and her preference for pleasure that got her discharged by her keeper and apprehended by the police; the same errors led

Rakewell away from his father's business to the life of an aristocratic rake. Now in *Industry and Idleness* Tom Idle appears asleep in 1 and in the languorous supine pose of Paolo de Matteis's *Pleasure* (ill., vol. 1) on the tomb slab and on his whore's bed. Goodchild is shown standing upright singing hymns and conversing with his master more or less in the pose of Industry/Virtue. Thus the series builds on the most basic and elemental of Hogarth's earlier structures, materializing both paths of the journey, and making the original choice explicitly one of industry and idleness. And yet by Plate 6 Goodchild's industry has produced another kind of idleness—eating and drinking and sitting in state. Even the responsibilities of a magistrate take the form of a somnolent gesture. And as Goodchild's industry pays off, Idle's idleness gives way to a kind of frantic industry of stealing, vending, and hiding. Industry produces idleness, and idleness leads to industry, and both tend toward further undifferentiation, ending in the parallel processions of 11 and 12.

Hogarth had from the start, and most obviously in *Harlot* 1, appreciated the stereotypical quality of the Choice of Hercules topos as offered artists by Shaftesbury. Then it was the heroic *Hercules* he questioned; now it is the *Choice*. He expresses graphically the collapsing of binary structures demonstrated verbally a decade later by Samuel Johnson in *Rasselas* (1759) with its oxymoron "the *Choice* of *Life*"—life overwhelming all such binaries as Nekayah's "Marriage has many pains, but celibacy has no pleasures"—which leads Rasselas to conclude that "the more we enquire, the less we can resolve" (chap. 26). These formulations confirmed the general tendency of the age "to simplify morality into a decision between opposing alternatives," as E. R. Wasserman put it. A survey of eighteenth-century gardens, poetry, and prose shows that "everything is bipolar, not multiple; reality is made up of opposites"—whether structured into a choice or resolved into a *concordia discors*.[28] There seems to have been a pervasive assumption that human happiness was attainable if the right choice was made between clearly defined alternatives, especially between Virtue and Pleasure. Hogarth takes the cultural antinomies of industry and idleness and pits their ambiguous implications against the social world of London to which they only imperfectly apply, thereby demonstrating that the concept is inadequate to the world (*not* that the world as presently constituted is inadequate to certain meanings of the concept).

In this case Hogarth must remember Mandeville's central paradox,

"Private Vices, Public Vertues." Many passages in *The Grumbling Hive* (1705, 1714) could have evoked Hogarth's theme: "Envy it self, and Vanity [those ostensible "vices"], / Were Ministers of Industry" (1.25). Or, referring to "Sharpers, Parasites, Pimps, Players, / Pick-pockets, Coiners, Quacks, South-sayers":

> These were call'd knaves, but bar the Name,
> The grave Industrious were the same. (1.19)

In his preface Mandeville says he will show

> the Impossibility of enjoying all the most elegant Comforts of Life that are to be met with in an industrious, wealthy and powerful Nation, and at the same time be bless'd with all the Virtue and Innocence that can be wish'd for in a Golden Age. (1.6–7)[29]

This is the kind of realism that Hogarth also employed in his retelling of the Choice of Hercules in *A Harlot's Progress*, but Mandeville is even more specific when he contrasts industry with diligence: diligence is getting things done efficiently; industry is excess: "if he runs on errands when he has no Work, or makes but Shoe-pins, and serves as a Watchman a-nights, he deserves the Name of Industrious."[30]

Closer to hand, Fielding's *Jonathan Wild* (published in 1743), in the manner of *The Beggar's Opera* and Hogarth's *Harlot,* examines the parallel "greatness" of Wild and the respectable statesman or prime minister.[31] But *Jonathan Wild* is about a contrasted pair, Wild and Heartfree, Greatness and Goodness, with Heartfree the moral merchant, always losing out to the crafty "merchant" of crime, Wild—until the eventual happy ending. Hogarth might also have recalled the contrasting male pairs Fielding had used since his earliest stage comedies and was at the moment describing in Tom and Blifil in *Tom Jones.* He exactly reverses the roles of Fielding's schizophrenic pair, giving Heartfree-Goodchild Wild's industry and prudence and Wild-Idle Heartfree's simplicity and accident-prone folly.[32] He is pointing out that in life Wild would marry the master's daughter and become lord mayor; Heartfree would end—as Fielding does not allow him to—on the gallows. Both include a conviction by false testimony (*Wild,* 4.1), only in the latter judgment is passed by Goodchild; Wild's Machiavellian "maxims" (4.15) are echoed in the proverbs under the prints of *Industry and Idleness;* and Wild's amoral Machiavel-

lian "new man" who rises by fraud and force becomes the pious, hardworking Goodchild.

THE APPRENTICE

If the reader "of greater penetration" is still present in a reading of *Industry and Idleness,* the "ordinary" reader must also be accounted for—including *both* the apprentice and his master. The latter's voice was embodied in the apprentices' guides, a popular form that flourished in great abundance throughout the 1730s. These works, which achieve an apotheosis of a sort in Lillo's *London Merchant,* habitually contrasted the industrious and idle apprentices, the latter demonstrating "the fatal Consequence of his Neglect" of his duty to God and his master, "with regard both to his *temporal* and *eternal* Happiness." [33] The idle apprentice was assured that even reading, "or any Amusement, however laudable at *proper* Times," carried on during "the Hours of Business" "would be directly robbing" the master. Even someone who accompanies an apprentice in his delinquence "knows he contributes to a Robbery at the same time," for the master is being "defrauded of his Apprentice's Time." [34]

In his *Apprentice's Vade Mecum* (1734) Samuel Richardson virtually outlined the scenario for *Industry and Idleness* (in terms, however, available in almost any apprentice's guide): "how naturally, as it were Step by Step, Swearing, Cursing, Profaneness, Drunkenness, Whoredom, Theft, Murder, and the Gallows, succeed one another!" Indeed, he concludes with the dangerous lure of fashion for idle apprentices: "I wish, to complete the Ridicule, and shame such Foplings into Reformation, the ingenious Mr *Hogarth* would finish the Portrait" (33–35). [35] In his *Harlot* and *Rake* Hogarth had done this, and here, in a sense, he also does: for example, he illustrates in Plate 2 Richardson's admonition that by failing to attend church the apprentice "must inevitably run himself into the bad and expensive Company of habitual Sabbath-breakers, who will never leave him till he is as bad as themselves" (38), and shows one of the men who teach him to gamble on Sunday actually reappearing in the scenes of his final ruin, Plates 9 and 10, and in the latter betraying him. [36] But while Richardson's model apprentice becomes only a wealthy tradesman, with his own shop and apprentices, Hogarth's Goodchild becomes

lord mayor of London. Hogarth adds a distinct awareness of the master's vested interest, his concern with profits, concealed under the warnings to idle apprentices. And unlike Richardson (and Lillo), he does not allow his bad apprentice to proceed from theft to murder, let alone to the really heinous crime, the petit treason of murdering his master. George Barnwell, whose name Hogarth originally intended for Idle, did murder his guardian and protector, his uncle.[37]

Richardson's *Vade Mecum* is typical in that from its prohibitions we can infer the characteristics of the apprentice subculture. The *Vade Mecum* is a printed series of admonitions, couched (as befitted their author) in prudential terms, written from the point of view of the master, and summing up the patriarchal relationship at the heart of apprenticeship. Much is said about the evils of drink and fornication, but one-third of the pamphlet is devoted to the dangers of the theater (excepting *The London Merchant,* of course). The theater was condemned as a source of idleness, for both players and their audience (for this reason the vagrancy law was cited when theaters were closed and plays suppressed in the years before the Licensing Act).[38]

One context for Hogarth's reading of Richardson's *Vade Mecum* would have been Gay's *Trivia*. In Book 2 a description of the drummers who "greet the new-made Bride" (2.17–19), who crop up in *Industry and Idleness* 6, is followed two lines later by: "Now Industry awakes her busy Sons," and this connects forty lines later with the admonition, "Seek not from Prentices to learn the Way" (2.69–72). Gay's sympathy quite clearly lies with the "fabling boys" who, when asked the direction, send the pedestrian off on a labyrinthine wild-goose chase—not with the "grave tradesman" who deceives "but when he profits by't." This lad is connected with Theseus, the labyrinth, and the gulling of Ariadne, who however (as with poor Idle) in fact gulls her Theseus. In the next stanza "waggish Boys," taken from Swift's "Description of the Morning," are contrasted in their malingering activity to "The Voice of Industry [which] is always near" (2.100).

These are the boys who reappear in Book 3 (at night) as the "sly Boy" who makes off with the gentleman's "Flaxen Wig," also called in mock-heroic fashion "the curling Honours of [his] Head." This is the artful and lively boy (a "wily Fox," "this subtil Artist") who appeared in Hogarth's conversation pictures; the boy is associated with games—with pleasure rather than industry—and the mischief

is carried out as a kind of game, anticipating what Hogarth will refer to in his *Analysis of Beauty* as the "pleasure of pursuit" or "the chase." But this activity is also threatening to adults—to masters, parents, fathers—and so punishment follows, often (as in the case of Gay's pickpocket) excessively brutal (2.71–76).

Apprentices were an unruly bunch of adolescents, closely related to those youth clubs Natalie Zemon Davis has written about in medieval France, who were constantly seeking the sports (dice or cards) and plays, the mumming and dancing, the singing and drinking and lovemaking that their masters feared would lead straight to their most notorious outlet, the riot. They were famous for the jokes they aimed at the master or his wife, based on hatred of his power but focused on his wealth and bourgeois sensibility. Many drew upon the fantasy of marrying his widow or his daughter and assuming paternal control of the shop. There are accounts of the joke slipping into the verbal threat, as with the apprentice who "did threaten [his master] in an unusual manner, and often swore he would be his death, and would crush his head against the table, with many such like provoking expressions," which occasionally led to the action itself.[39] Apprentices constantly had held up to them by such writers as Richardson the polar opposites of Whittington and George Barnwell.

What distinguishes *Industry and Idleness* from Hogarth's earlier prints is that its essential reading experience is arrived at not through sophisticated inference drawn by the "men of greater penetration," who read down, but by the popular or "plebeian" audience who immediately perceived a meaning that questioned the status quo.[40] This audience consisted of neither the connoisseurs familiar with Ripa, Alciati, and the great tradition of Renaissance art, nor the merchant masters (represented by Richardson's *Vade Mecum*) who bought the sets of prints for their apprentices and hung them on the shop walls as warnings. When the apprentice—by which we mean the *idle,* not the industrious, that is, the basic ethos of the apprentice *until* he became a master—looked at Goodchild in Plate 4, joining his master in his countinghouse, emblematized by the print of Opportunity taking Time by the forelock, he saw at once a young man who in an earlier plate had courted his master's daughter and here clutches his keys and moneybag as if they were his own. Class conflict is emphasized in the contrast of the Idle-like profile of the laborer supported by the dog's parallel profile—as opposed to the classical good looks of

Goodchild, and indeed of his master (and, elsewhere, his master's daughter), separated from the lower orders by the pillar and the hissing cat.

In Plate 6, where the industrious apprentice has married his master's daughter, the shop sign of the firm reads "*Goodchild & West*": the junior partner has already usurped the senior's place (in an alternative state, it is changed to "WEST AND GOODCHILD").[41] The ballad singer is celebrating Goodchild's marriage with the ballad of "Jesse or the Happy Pair," which the apprentice-reader would have applied to Goodchild and his master as well as Goodchild and his bride. The apprentice sensibility—for whom the "*Goodchild & West*" state was presumably made—would go straight to the cynical, subversive meaning. The master's sensibility, by contrast, would read the plate "straight," as another stage in a success story.

What we notice is that the main difference between the ends reached by the "men of greater penetration" at the top and the apprentices and artisans at the bottom is the speed of transit. Both join in arriving at a reading and a set of assumptions at odds with those of the master, so overemphasized in the sets of reinforcing contrasts in every plate. But the apprentice enjoys an immediacy and intensity of response quite different from the "pleasure of pursuit," which from his point of view is a kind of mystification or muffling, defined by John Berger as "the process of explaining away what might otherwise be evident."[42]

In Plate 8 the apprentice, without need of mediation, sees the gluttonous dignitaries around the table in the light of the poor petitioners waiting vainly outside the door; he sees the empty place at the table allowed to remain empty rather than be used for one of them.[43] Neither the master nor the "men of greater penetration" would in all probability notice this aspect of the picture. The latter might remark the gross merchants and ask why Goodchild is so tiny and distant in the scene of his triumph; he might see Hogarth's subtle satire as working in both ways. But the unsophisticated audience of apprentices sees it instantaneously as about the life of sheriffs and aldermen, exploiters in whose bosom Goodchild has now lost himself. And then, when this audience looks at the emblem of Blind Justice in the form of the posturing Alderman Goodchild passing judgment on his late fellow apprentice in Plate 10, it sees straight to the judicial eyes averted from the skulduggery going on in the background with the connivance of the law itself, because this is the way it thinks. As an

alderman, Goodchild can only pass judgment according to the laws of ruling-class society—a set of laws as remote in many ways from the poor apprentices as the Ten Commandments of the Old Testament.

Looking at the first plate of *Industry and Idleness,* the apprentice might even ask such questions as: Why is Idle placed in shadow, away from the light of the window, and without a wall to support him and the inspiring proverbs that may improve his mind (only a post on which to fit his ballad of *Moll Flanders*)? Do his tattered clothes indicate his own carelessness or are they rather the consequence of his master's disapproval or disdain? Do Goodchild's neat clothes point to his own care or his master's partiality to him? Goodchild and his master (side by side on the right) have the same facial structure, idealized and aristocratic, as of father and son and in striking contrast to Idle's plebeian features. The master would of course see this scene as emblematic of the two apprentices' situations, a single cause of all that follows in the series. But a more literal-minded audience, identifying with apprentice against master, might see it as an effect of some initial deviance. If you are a poor ugly boy who lacks the favor of his master, the ability to please him, the energy of industry, and you have a dark spot for your loom, then you are doomed never to rise—indeed to descend lower.

Even Goodchild's name weighs in his favor. Is he good because his name inclines others to expect good of him and treat him well, or is he named (allegorically) to correspond to his good character? Have others been prejudiced against Idle by his name and so discouraged him that he has taken on the qualities his name assigned him? Or is the name an indication of what he essentially is, an emblem? There is a joke in *Joe Miller's Jests* (1739, no. 96) of the shoeshine boy going to church and being asked his name by the parson. He replies, "Rugged and Tough," to which the parson huffily returns, "Who gave you *that* Name?" "Why the Boys in our Alley, reply'd poor Rugged and Tough, Lord d—mn them." [44] The plebeian name has been imposed by the social milieu—in the sense of fathers, guardians, neighbors, and the rest—and Tom Idle is helpless within it. His gambling, drinking, and whoring take the form of an apprentice's escape from the specific entrapment in his "idleness."

Appropriately, the parable of the talents, the one New Testament subject cited in the biblical quotations, is the text that is invoked and questioned by *Industry and Idleness.* Plate 4, showing Goodchild being given charge of the master's countinghouse, prints the words of

the "good and faithful servant" but projects over the whole series the unstated situation of the other, the "wicked and slothful servant." What is shown, by the juxtaposition of images, is that Tom Idle is in essence the servant who is given a single talent, against the more generous allowance of five and two to the other servants. He starts at a disadvantage and does nothing more blameworthy than to return to the lord that which was lent him (his ugliness, idleness, bad name). The lord refuses to accept his attempt at mitigation and orders that the single talent of this "wicked and slothful servant" be taken away and given to the servant who now has ten talents (Goodchild): "For unto every one that hath shall be given, and he shall have abundance: but from him that hath not shall be taken away even that which he hath." And the "slothful" and "unprofitable" servant is cast "into outer darkness: there shall be weeping and gnashing of teeth." The following verses (Matt. 25:32ff.) extend the contrast to the Last Judgment's separation of sheep from goats, right hand from left, on which Hogarth builds the spatial contrasts between his apprentices.

Hogarth's allusion to the parable is a neat example of the way he problematizes a central, therefore dominant, concept or document by revealing what it represses. He refuses (in the manner of Thomas Woolston, first suggested in the *Harlot's Progress*) to take a biblical parable on its own terms, or the terms of its official commentators, as a religious truth—and so as a paradox. The message of the apprentice/criminal/whore is that of the subculture reader who, presented with the story of the Immaculate Conception, responds: Joseph was a fool to believe that story; or of the peasant who, indoctrinated in the myth of Queen Elizabeth the Virgin Queen, said, "the Queen is but a woman" (and was pilloried by the authorities). Thus the idle apprentice naturally reads the "her" in the captions to many of the prints as referring to the master's daughter. Thus it is evidently the policy of the kingdom of heaven that the rich are to get richer and the poor poorer. The servant fears his lord is "a hard man," and he is ("thou oughtest therefore to have put my money to the exchanger, and than at my coming I should have received mine own with usury"). The apprentice sees from the servant's point of view rather than (as the parable expects) from the lord's, from which the fact that one servant receives five talents, another two, and a third only one is of absolutely no importance.

THE CROWD

Apprentices were always in the eighteenth century seen as the nucleus of riots and so the prototype for that fearful double-edged symbol, the crowd, the *mobile vulgus* of the masters and the self-assertive "crowd ritual" of the apprentices.[45] For the city merchants Sir William Walworth's dagger (8), with which he struck down the rebel leader Wat Tyler (sanctified by inclusion in the arms of the City of London), maintained stability by protecting the king and putting down the rebellion of peasants. For the rioting and unruly apprentices, Walworth betrayed a truce, drew his dagger, and without warning killed the leader of the rebels, who then dispersed. In this context, the crowd waiting patiently outside the door, barred from the feast, can be seen petitioning for a meeting like the one between Walworth with the peasants.

That crowd is, from the master's point of view (the gourmandizing "insiders"), a mob—dangerous, threatening to order. From the apprentices' point of view it is a subculture ritual like the Charivari or Skimmington, which parodies, ridicules, and corrects the master's processions. The last two plates convey this double sense of the crowd. If the pictures are arranged in a row the mayor's coach seems headed like the tumbrel toward the gallows only by a different route; if they are placed one above the other, the coach and tumbrel are parallel; and if they are superimposed, the coach and tumbrel virtually coincide. "Tyburn Fair," which has been called "the ritual at the heart of London's popular culture,"[46] was carried out as a mock or parody version of a high or dominant culture ritual like the lord mayor's procession—a form taken by the subculture to create "alternative rulers" as focal points for popular grievances. Such a role could be filled by the condemned felon or the popular local politician (e.g., the "Mayor of Garret"), but the extreme national manifestation of this period would be John Wilkes (see vol. 3).[47] When the Wilkesite crowd of the 1760s drew Wilkes's carriage through the streets of London, they were drawing the "true" king of England; when they carried out a mock execution on Tower Hill with effigies of Lord Bute, the dowager princess of Wales, and Henry Fox, beheaded by a chimneysweep and burned as an act out of the populace's memory of the true duties of a just judge, they were, in effect, making Goodchild and Idle one. Recalling Hogarth's work of the 1730s,

we can say that he now has both Mr. Somebody and Mr. Nobody, at the end virtually doubles confronting the cheerful undifferentiation of the crowd.[48]

This is what E. P. Thompson has called plebeian "countertheater," in the sense that they acted out, mimicked, or even rehearsed (in the threatening sense) actions against their betters, but did not actually "live out" their actions.[49] They burned effigies, not people, much as Hogarth the artist represented but did not live out his often murderous scenarios. In the midst of Hogarth's crowd, often off-centered, is a figure surrounded or held up by the crowd as a kind of effigy. In *Hudibras and the Skimmington* it was a pair playing the henpecked, cuckolded husband with his shrewish wife, riding backward on a horse, who are the subject of the procession; in *Burning the Rumps at Temple Bar* it was the hated Puritans being burned in effigy, along with the rumps of beef standing in for the Rump Parliament; and of course in *Industry and Idleness* it is the criminal and the lord mayor. There is a festival figure of deep ambiguity: king *and* criminal, Carnival *and* Lent, savior *and* scapegoat, whose reverberations Hogarth recaptures.

Thompson defines the crowd as a group opposed to the ruling oligarchy—one consisting of people from the poor up to small gentry and professional men, and thus including Hogarth himself. He sees the common elements as "resistance to religious homily," a "picaresque flouting of the provident bourgeois virtues," "ironic attitudes toward the law," and "a ready recourse to disorder." All of these are of course manifest in *Industry and Idleness* and its second eponymous hero.[50]

But the doubleness of audience and meaning in the series can also be seen in the ambiguity of the "crowd ritual" itself as inherited by Hogarth. Either the lower orders appropriate the symbols and rituals of authority, as they execute *their* villains or chair *their* heroes or light bonfires for them (as the nation does for its king or military heroes), much as they invent their own legal forms for their extralegal activities, or the ruling class institutionalizes this plebeian license, offering the lower orders a harmless release within limits from their everyday restraints. From the official point of view, there are acceptable ways of letting off steam such as parades on certain calendar days, and unacceptable ones such as drinking, whoring and, ultimately, thieving, murdering, and rioting. The difference depends on whether the official calendar festivals are appropriated by the lower

orders and made into their tendentious expression, or are simply absorbed by the ruling class into its own theatrical designs. Hogarth exploits this ambiguity, allowing his reader (or different readers) to take it either way.

We should recall one obvious source for Hogarth's crowd—at least for the lord mayor's procession: Pope's *Dunciad,* a work Hogarth shows evidence of having known well. The level of duncical folly in shabby crowds of hacks is seen from the point of view of a masterful and successful poet (in conjunction with his equally successful friends Swift, Gay, and so forth). This view of the crowd is notably absent from *Industry and Idleness.* From the conversation pictures onward, Hogarth's point of view has reflected the subculture rituals and forms.

This historically real ritual, physically carried out in the streets, is as good a source for Hogarth's particular use of dramatic and parodic structures in his graphic works throughout his career—from *Hudibras and the Skimmington* on—as the verbally oriented high-culture tradition of *ut pictura poesis* and the parodies of seicento history painting. The popular use of substitutes and effigies is an equally satisfactory explanation for those New Testament "parodies" in the *Harlot's* and *Rake's Progress.* Both explanations, both models, both sources are present; it is only a question of which audience he addresses—the readers of Augustan satire or the participants in the subculture rituals. In Hogarth's experience, although his father must have taught him to read Dryden and Pope, I believe the subculture forms came first, as part of a London childhood, and he has gradually come to realize that this is where the future of English culture lies rather than in Rome and in the past.

WORD AND IMAGE

In *Industry and Idleness* Hogarth associates the visual language of images with the low, the subculture; the language of words—at least of written, inscribed words like those of the Ten Commandments—with the dominant or master's culture. The popular print showing Opportunity catching Time by the forelock pinpoints the actual relationship being established between apprentice and master, getting at a truth that is elided by both the pious words of the reading matter Goodchild posts on his wall next to his loom and the pious words

from Proverbs that are inscribed beneath the designs. These biblical maxims constitute the voice of authority. The popular images, depending on the way we regard them, either shine through or subvert the words of the official text (even, as in the case of Opportunity, the official, or master's, meaning of the image itself).

Goodchild, we notice in the first plate, has a well-preserved copy of *The Prentice's Guide* and a ballad of Dick Whittington; in Plate 2 a hymnal, in 4 his master's Day (or record) Book, and in 6 he is patronizing literature in the form of the ballad of "Jesse or the Happy Pair."[51] Even the shop sign of "the Happy Pair," "*Goodchild & West*," is strictly verbal, not the painterly image which Hogarth ordinarily associates with shop signs. In 10, as alderman, Goodchild has his bailiffs employ both a Bible and a letter of sentence, which amount to the same thing since it is by the standards of the Old Testament law that Goodchild sentences Idle to death for stealing a watch. It is not surprising to see that Goodchild collects and preserves texts. He respects the word, which is the law, and senses the advantages in making the most of language and books. In every plate in which he appears, he holds or is in close proximity to an open book of some sort; and he even keeps his eyes cast downward in the direction of the biblical texts beneath the designs, as if "reading" or referring to them. (His eyes are always averted from what goes on around him—from what he has to *do* to succeed.)

Idle, by contrast, is as antitextual as he is antisocial.[52] By his failure he represents the fact that utilization of language is synonymous with social success, and in particular the language of the written law. In the first plate, his copy of *The Prentice's Guide* has disintegrated through neglect (or active defacement) and he has only the ballad of *Moll Flanders,* a rogue heroine; in 3 he uses as a resting place, and covers with his body, the "text" of the gravestone which might otherwise present him with a useful moral, *ubi sunt* or *memento mori*. In 5 he lets his indenture—that most precious document of commercial London—float away on the water, and all the while he ignores the repeated warnings of the biblical passages beneath him, focusing his eyes on something in this world.[53] If Goodchild is an effective utilizer of language, and thereby rises to a societal command of it as an administrator of the law, then Idle, by cutting himself off from the word, sinks to the bottom of the heap and lower.

The ironic conclusion comes in 11, where poor Idle at last becomes, in his final moments, a reader and even a generator of texts.

We see him intently reading the Bible and listening to the pious exhortations of the Methodist preacher, while a woman in the foreground hawks "The Last Dying Speech & Confession of Tho. Idle." (In 12 another document, "A Full and True Account of ye Ghost of Tho. Idle," is being sold.) His story, by being verbalized, has been transformed and "made useful" in just the way his body is being made an exemplary punishment by the law. Both have been domesticated in the structure of official Christian society. Idle has become an anti-Whittington, to be avoided by those apprentices seeking success. The printed "Dying Speech" (whether written by him or, more likely, foisted on him by some hack writer) forces Idle into the societal role of the "Repentant Criminal."

In short, society gets its way with the most recalcitrant of deviates. But there is a final irony, which is that the visual images of Hogarth's prints were themselves destined (like the print of Opportunity) to be used as written, prescriptive words on the walls of shops like that of West and Goodchild.

One other figure in Plate 11 should be identified: the ordinary of Newgate Prison. Hogarth places the clergyman of the Established Church, cut off in a closed carriage from Idle and his Methodist comforter, on the same vertical, almost at the center of the picture, with the hawker selling the "Dying Speech."[54] They are the only two figures who look directly at the viewer, for they offer alternative versions of the story of the condemned criminal. The ordinary of Newgate, in his printed *Accounts* of the criminals who were under his spiritual charge, represented the polite view of crime. His *Accounts,* the official version of the "dying speeches" peddled by the subculture woman, sought to tame and domesticate the energy and disorder of the romantic figure of the criminal by presenting his conduct as behavior that inevitably led to the gallows. In the first part of the *Account* he would describe the basic facts of the trial, and follow this with citations of the biblical texts he preached to the condemned and synopses of his sermons. The rest would consist of a narrative of the malefactor's life and crimes: a broken apprenticeship, followed by the progression from such small sins as sleeping on the job and gambling on Sundays to greater ones—suggesting the extreme conventionality of the Idle plot—leading up to an account of the hanging itself, with conventional phrases of piety and penance.

In one graphic image Hogarth shows the two accounts juxtaposed: on the one hand, the admonitory words of society, enclosed in the

carriage—cut off from the condemned man, giving him no consolation—and in Hogarth's plates reflected in the biblical verses that would have reminded viewers of the ordinary's pious quotations; and, on the other, looming in the foreground, the wide-mouthed plebeian vendor, dwarfing the ordinary, as a raucous popular voice. Even in his literary domestication, Idle survives in two versions with different inflections, one polite and the other popular.

Whereas *A Harlot's Progress* was virtually constructed of words, puns, and verbalizations, in *Industry and Idleness* words have come to stand only for a respectable discourse, genteel and polite. Even the ballad singer represents only another version, a contrary transformation of the criminal, a heroicizing of him as opposed to the moralizing and demonizing of him by the ordinary of Newgate. The two voices, epitomized by apprentices and masters, fight for the soul of Tom Idle to retain him as a subculture hero or translate him into the "Repentent Criminal."

Hogarth expressed his own underclass "radicalism" only in images, never in words. In words, he spoke for either the aristocratic cognoscenti or the masters. When in his "Autobiographical Notes" he wrote of *Industry and Idleness,* it was only as a moral tract (AN, 225). And yet he shows how slippery the word itself can be in the inscriptions to *Industry and Idleness*—how the image and the word expose each other. But the words in the "Autobiographical Notes" are a reminder that the structure of his plates includes society's inevitable desensitizing of the visual-aural impression of subculture energy and subversion—a phenomenon that includes Hogarth himself. For it is also relevant, given the model of the apprentice, to recognize Hogarth's own dichotomy of the apprentice who grows into a master.

HOGARTH, GOODCHILD, AND IDLE

In Plate 6 the learned reader would have meditated on the balled of "Jesse or the Happy Pair." There appears to have been no such ballad, but the word Jesse in Hebrew means wealthy, and what one remembers of the biblical Jesse is his genealogy (given twice in the Old Testament) and his son David, who married Michal, his master's daughter. Out of this marriage a distinguished tree was to grow—the Tree of Jesse, the outcome of which was Jesus (Isa. 11: 1–4). This

is the meaning the master (or Goodchild, for whom the ballad is produced) would have read. But the learned reader would also recall that Goodchild and David are both apprentices; David, originally engaged in a lowly capacity as harper to King Saul, becomes his master's close companion, best friend to his son Jonathan, and lover of his daughter (in each case a "happy pair"), and finally "takes over the business" as king of Israel. The title of Hogarth's plate is a reminder that the wife, being the master's reward to his servant for faithful service (David slew double a hundred Philistines for his dowry), is a sort of "seal of approval" and will be an important factor in the servant's advancement. (The story of Saul's delays in delivering up Michal may also hint that a master uses his daughter as bait to get the apprentice to work harder in his interests: 1 Sam. 16.)

But there are yet other Saul-David implications loosed by the pursuit of "Jesse": Saul's anxiety, for example, over David's being destined to replace him as king continues to grow after the marriage, leading to attempts on David's life and to Saul's own eventual ruin.

Hogarth had alluded to this story once before, in *Harlot* 2, where (in a painting on the wall) David dances before the Ark of the Covenant and is rebuked by Michal, looking down from a window. (In *Rake* 3 he had alluded to David the harper.) The association of David, Michal, and Saul (and that other happy pair, David and Jonathan) with Hogarth, Jane, and Thornhill (and John Thornhill) is unavoidable. This was in fact the same story that Hogarth illustrated in the *Beggar's Opera* paintings, *A Scene from "The Tempest,"* and *Satan, Sin, and Death* (and yet later, *Sigismunda*).

Contemporaries—those who knew him or only his London-wide reputation—would have perceived an obvious parallel between the industrious apprentice and Hogarth himself who married the daughter of his "master" and succeeded to his business, carrying on the art academy, history painting, and the defense of Thornhill's name. But Goodchild's face—handsome, bland, sheeplike—is idealized almost to the point of caricature. One recalls the look of self-satisfaction on his face, the heartlessly academic poses he assumes, the affected manner in which he holds his cup in Plate 6 (perhaps trying to emulate the manners of the West End). It is significant that Hogarth originally called him *William* Goodchild but, thinking better of it, changed his name to Francis.[55] And it was Hogarth, after all, who insured his property with the Sun Fire Office.

It is, on the contrary, Tom Idle's face that resembles Hogarth's own

puggish, plebeian profile, which can be seen in *Characters and Cari-caturas* (fig. 88), in *The Gate of Calais* (another personally oriented work executed in 1748, figs. 126, 127), in Roubiliac's bust (frontis-piece), and in his self-portrait *Painting the Comic Muse* of 1758 and the caricatures of the 1750s (ill., vol. 3).[56] Plebeian, Idle's face makes a statement about class; Hogarthian, it makes a personal statement; grotesque, it supports Hogarth's theory of history painting. In terms of the last, Goodchild's face recalls Raphael's idealized St. Paul of *Characters and Caricaturas,* Idle's the grotesque Raphael beggar, who was there to prove that such faces were also permitted within the precincts of sublime history. A few years later Hogarth remarked in *The Analysis of Beauty* that "A middling connoisseur thinks no pro-file has beauty without a very straight nose" (8), indicating a diagram of a Goodchild face between figures 22 and 105 of Plate 1.

But if only to inject enough self-irony to make the portrayal pal-atable in his own mind, Hogarth introduced some sense of himself into his opposite: he was so unlike Idle, so like the industrious one. Yet one side of him clearly sought, as he put it, "idleness" and "plea-sure" as well as "duties" and "studies." Looking back on his time as an apprentice, both in silver engraving and in painting at Vander-bank's academy, he emphasized his idleness, saying that he required a technique "most suitable to my situation and idle disposition"; the mnemonic system he hit upon was useful because it allowed him "to make use of whatever my Idleness would suffer me to become pos-sest of."[57] Idleness is one of the key words he applied to himself in those years. It seems very much as if there is a humorous self-portrait included in Tom Idle, hinting at that aspect of Hogarth which kept him from finishing his apprenticeship, liked to go wenching, was deluded by illusions of ease and grandeur, and, perhaps, uncon-sciously associated the creative act (as opposed to the successful bus-inessman's practice) with death and mutilation: the Harlot and the Rake in him that needed to be exorcised. (We could also note disqui-eting parallels such as the tomb and bed in Plates 3 and 7.) Idle's alienation from the word also tells us something of Hogarth's own need, only a few years later, to *prove* himself a man of words as well as of images in the writing of *The Analysis of Beauty.*[58]

Though he knew Richardson personally, Hogarth never publicly acknowledged him as he did Fielding. He rejected his own alter ego, the industrious, self-employed, self-made, well-to-do printer, almost naively self-important and proud of his accomplishment, and not

afraid to show it. He chose instead as his official friend and colleague the aristocratic man of the world, the wit, playwright, political journalist, friend of Lords Chesterfield and Lyttelton, but also the spendthrift, debt-ridden, heavy-eating and drinking rake, who wrote his first reply to Richardson, *Shamela,* in a sponging house.

The *Spectator* also carried a sense of the term industry that touched Hogarth's own case as an artist; in No. 83, characterizing the different schools of painting, Addison used Industry to personify the Dutch school: "His Figures were wonderfully laboured; if he drew the Portraiture of a Man, he did not omit a single Hair in his face; if the Figure of a Ship, there was not a Rope among the Tackle that escaped him." Hogarth's detractors called him a laborious Dutch painter, and in the late 1740s he was trying to extricate himself from the shadow of Rembrandt and the Dutch school by returning more self-consciously to the simplified compositions of Raphael (see vol. 3). It is worth speculating on the extent to which the common characterization of the Dutch school was in his mind when he embodied Industry in Francis Goodchild. He may have associated with the word not only moneymaking and success, including his own, but also the Dutch school's laboriousness and mere mechanical ingenuity.

His engraving itself was the trace of his apprenticeship which remained with him, which he tried to move beyond by taking up painting; but with which he always found himself saddled. He tried repeatedly but was unable, except on one or two occasions, to find engravers who satisfied him, and so had to keep on engraving himself: and engraving for him would have represented the continuing reality of the apprentice or journeyman. In *Industry and Idleness* he gave up on the painting and returned to the engraver's practice of a careful drawing and a clear line.

Hogarth represents the ideology of the master who was an apprentice and to some degree remains one. It is well to remember, given this model, that every master was once an apprentice; that Hogarth was an apprentice who grew into a master, though many apprentices never did, retaining to a greater extent their apprentice ideology. (Hogarth was, of course, an ex-apprentice who, like Idle, did not complete his apprenticeship and so never became a "master" in the technical sense.) As part of a symbolic system, Hogarth always places himself within a master-apprentice relationship. One implication is that he was part of that group that demonstrated that class was to some extent a matter of age, and as a man passed from one age to

another he also passed from one class to another, retaining traces (sympathies, antipathies) of the earlier and younger.

He seems to have retained a psychomachia of the two levels or aspects of himself in *Industry and Idleness*. One side reflected an ideology requiring that virtue be rewarded and vice punished, that beauty correspond to virtue and deformity to evil; another reflected the ideology of the pantomimes and puppet shows, in which these things do not take place and heterogeneity is celebrated. Hogarth's career might be defined in terms of the conflict between polite and popular cultures.

But, of course, he officially simplifies the personal text by the obvious equation of Hogarth-Goodchild, as he domesticates the subculture energies of subversion (embodied in Tom Idle) by enclosing them in frames, literally solid brickwork, prisonlike with fetters and chains, and ultimately destroying them, wiping them out. In other words, while Idle's plebeian world works to undermine the assumptions of the dominant master ideology, this subversive strain is also contained—to the satisfaction of the masters at least—by the clear victory of Industry and Goodchild.

Perhaps rather than playing out a psychomachia he is exorcising that other side of him, isolating it on the left, in the bad spot, killing Idle off. In this sense, it is Hogarth, and not society, who bears the burden for having named Idle, pushed him into a dark corner, and given him (his own) plebeian features. This is, as it happens, what Fielding will do only a year or so later—and much less ambiguously than Hogarth: he will exorcise his rakehell youth when he assumes the role of Westminster magistrate, demonstrating an unrelenting Gonson-like rigor in his pursuit of criminals, urging the death penalty and the extension of capital crimes.

But we cannot close without recalling the context of the Hiram legend and the Masonic initiation ritual, which was, of course, originally the apprentice's initiation as a master. The form this took in Freemasonry was the man's symbolic "death" as an apprentice and rebirth as a master, by means of the intervention of Isis (Mrs. Goodchild, Jane Hogarth).

13.

PUBLIC PAINTINGS

The Foundling Hospital and Lincoln's Inn, 1740–1750

THE FOUNDLING HOSPITAL, 1740–1746

In the late 1730s, with the paintings for St. Bartholomew's Hospital, the central symbol of Hogarth's work changed from the prison to the hospital. Thereafter the hospital informed in some ways his choice of subject matter in both his history paintings and his popular prints—and in both his sublime and comic histories. His association with the Foundling Hospital in the 1740s coincided with a shift of attention from the harlot—or the beautiful young woman—as protagonist to the child and, perhaps the same thing, the poor and disadvantaged.

The eighteenth century was the first great period of philanthropic activity in England, and its two most notable achievements were the charity schools and the hospital movement. The former developed before Hogarth's time, but he was exactly contemporary with the hospital movement. In 1700, aside from one or two special institutions such as Bethlehem Hospital for the insane, there were only the royal hospitals of St. Bartholomew and St. Thomas. But between 1719 and 1750, the years of Hogarth's maturity, five new general hospitals were founded in London and nine in the country. St. Bartholomew's (which Hogarth had decorated in the late 1730s) and St. Thomas's were the links between the old and modern conceptions of a hospital—as a refuge for the poor and infirm and as a specialized institution for the care of the sick. Throughout this period the concern of the hospital was primarily with the sick poor.

One central fact of Hogarth's life is that he was connected in some

way with almost all the great philanthropic and humanitarian projects of his time—from the parliamentary committee on prison reform of 1729 to the Foundling Hospital, from St. Bartholomew's Hospital to the London and the Bethlehem. One cannot dissociate this obvious interest and involvement of his from the theme that runs through his engraved works and becomes stronger in the 1740s as the Foundling Hospital, his chief charitable interest, developed into what has been called "the most imposing single monument erected by eighteenth-century benevolence."[1]

Behind the philanthropic movement as a whole were motives of a very mixed sort. Puritan ideas about the use to which money should be put were important in creating the basic assumptions, and also the Latitudinarian emphasis (operative in Hogarth's St. Bartholomew paintings) on charity and the ideal of benevolence, as opposed to the mere forms of worship. Both of these contributed to the elevation of sensibility and the enjoyment of the sympathetic emotions, which came into fashion as Hogarth matured in the 1720s. The humanitarian's instinctive response to the suffering of others was charity. Bishop Isaac Maddox, in one of the numberless charity sermons of the period, asserted that "In Minds not inhumanly deprav'd, a strong and powerful Sympathy prevails; one common Sense and Feeling: Nor can Men, without doing Violence to their own Nature, be sensible and untouch'd at the Distress and Misery of the Fellow-Creatures."[2] It sometimes appeared that disaster served a valuable function, by evoking man's best feelings in response; for it was understood that benevolent urges were among the most agreeable human sensations.

The more practical aspect of the charity movement was influenced by the basic belief (deriving from the same Latitudinarian doctrines) in natural goodness and perfectability—the conviction that, given proper care and instruction, one would probably grow up to be virtuous. This, of course, corresponds to an implicit Lockean assumption underlying Hogarth's progresses, that if Hackabout and Rakewell or Squander and his countess had been allowed to develop naturally (or been properly educated), they might not have come to such bad ends. There were also the strictly utilitarian motives: too many bastards murdered by their mothers lowered the population. A foundling hospital not only preserved some of the working class populace but offered a scheme for putting those poor to work and teaching them a craft and their proper place in society. Captain

Coram saw his orphans as a source of supply for the navy, for crafts, and for the colonies—but within strict limits, for the foundling children were kept out of competition with legitimate children. They were taught to read but not to write.

In Hogarth, as in many philanthropists of the time, the humanitarian motive was supported by an awareness of the way the situation could be exploited for his own purposes, aesthetic and perhaps also commercial. St. Bartholomew's had offered him scope for a particular kind of history painting and also a dignified place for permanent public exhibition of those works.

But the hospital that seems to have permanently interested Hogarth was the Foundling: here he donated and worked and attended meetings relatively frequently for at least five years before the idea occurred to him (or the opportunity arose) to turn the hospital into an art gallery. The primary factor must have been his interest in the virtue of charity and the focus of charity on abandoned children. On the other hand, as early as 1740 he recognized the founder Captain Coram, an almost symbolic figure of charity, as the perfect opportunity for a public display of portrait painting—a way of launching out on his career as a portraitist in a line of descent from the figure of Christ in St. Bartholomew's (above, Chap. 7).

Both he and Coram were childless men and perhaps, as has been remarked of Coram, they "had some of the sensitive feeling for children not uncommon with childless men."[3] The sight of babies left by the roadside, dead and alive, and in one case of a mother in the act of deserting her child, had led Coram, the successful seaman and trader, to start agitating for a foundling hospital. These were also the scenes conflated by Hogarth on his design for the power of attorney used by the collectors of subscriptions for the hospital (fig. 128). In his own case, he would have known that a child was abandoned either because its family was too poor to support it or—the generally assumed reason—it was illegitimate, its mother a "fallen" woman like Hogarth's Harlot (who, on the contrary, *kept* her child).

Both were intransigent and single-minded men; Coram pursued his quest until, as a friend, Dr. John Brocklesby, noted, "even people of rank began to be ashamed to see a man's hair turn grey in the course of a solicitation by which he could get nothing."[4] In September 1740, a year after the incorporation proceedings, Coram noted that between £5000 and £6000 cash had been paid in, 526 annual subscriptions had been taken at a minimum of £2 each, and legacies had

been received amounting to £2300, but he was complaining to the governors that they were not moving fast enough.[5]

Coram, like Hogarth, was an originator of "a Field unbroke up in any Country or any age" (AN, 216). There was no foundling hospital in England before Coram's,[6] and none like Coram's on the Continent. All Continental foundling hospitals had been undertaken by church or state or a combination—"none derived support exclusively from private secular charity." As Ruth McClure has noted, Coram's genius

> was that he gave to this increasingly commercial and industrial world the most appropriate charitable structure possible, an adaptation of the joint stock company already in use by British entrepreneurs, whereby individuals acting together in a voluntary corporate body not only could undertake philanthropic projects of greater magnitude than any of them could support alone but also could form a legal entity capable of receiving legacies.[7]

This philanthropic project offered a model for the banding together of English artists as "a voluntary corporate body," which followed Hogarth's project in 1746 for decorating the Foundling with their paintings. It was Hogarth's particular model because he visualized an association of artists like the Foundling governors, without support from either church or state (as was the case with the French Academy). Thus the situation of foundlings served Hogarth as another example of a need not filled by English church or state, corresponding to the artists' need for an outlet for their work, and perhaps allowing for a connection in his mind between English artists and the foundlings.

Through his friendship with Coram or through his own eminence (Coram sought a cross-section of well-known Londoners), Hogarth was invited to be one of the Foundling governors. He was at the meeting for incorporation on 17 October 1739, and again at the first meeting at Somerset House, 20 November, when the Royal Charter was received; in May 1740 he presented to the hospital his monumental portrait of Coram. At the same meeting that accepted his portrait of Coram it was voted that sixty children be taken in as soon as possible, and Bishop Hoadly subscribed £5 a year. On 25 June, with Hogarth present, the earl of Abercorn subscribed £100 and

"Mr William Hogarth Subscribed One and Twenty Pounds to this Hospital." After a search for a site, the governors secured a lease in December 1740 on a house in Hatton Garden, where the hospital was temporarily located until a permanent building could be planned and built. In January 1740/41 a "Daily Committee," drawn from the governors, was set up to handle the day-to-day affairs inside the hospital. By March a staff had been engaged, and the 25th was set for the opening.

The daily committee was to be staffed by small groups of governors, taken alphabetically; but according to the procedure outlined in the minutes for the meetings in early January, the A's did not commence until 1 April. Therefore, for the opening on 25 March, the general committee (the officers) was to be augmented by "such other Gov rs as pleased to attend and discharge the Duty of the Daily Committee till April the 1st."8 Hogarth was one of the four who volunteered to be present. He also, in the last days before the opening, painted a shield with the hospital's arms, presumably similar to the one that was later engraved, and this was put over the door on the 25th.9

On Wednesday, opening day, about seven in the evening, the committee met and prepared to receive the children. Besides Hogarth, there were Martin Folkes (a vice-president) and Captain Coram, Theodore Jacobsen (who was to design the permanent hospital), the duke of Richmond, and seven others. The minute book describes the scene with great vividness. A great crowd assembled long before eight o'clock, the time of opening. The committee, "resolved to give no Preference to any person whatsoever," was "attended by the Peace officers of the Parish and Two Watchmen of theirs were ordered to assist the Watchman of the Hospital."

> At Eight o'Clock the Lights in the Entry were Extinguished, the outward Door was opened by the Porter, who was forced to attend at that Door all night to keep out the Crowd imediately the Bell rung and a Woman brought in a Child the Messenger let her into the Room on the Right hand, and carried the Child into the Stewards Room where the proper Officers together with Dr Nesbitt and some other Govrs were constantly attending to inspect the Child according to the Directions of the Plan. The Child being inspected was received Number'd, and the Billet of its Discription enter'd by three different Persons for greater Certainty. The Woman who brought the Child was then dis-

mised without being seen by any of the Gov^{rs} or asked any Questions w'soever. Imeadiately another Child was brought and so continually till 30 Children were admitted 18 of whom were Boys and 12 Girls being the Number the House is capable of containing. Two Children were refused, One being too old and the other appearing to have the Itch.

About Twelve o'Clock, the House being full the Porter was Order'd to give Notice of it to the Crowd who were without, who thereupon being a little troublesom One of the Gov^{rs} went out, and told them that as many Children were already taken in as Cou'd be made Room for in the House and that Notice should be given by a publick Advertisement as soon as any more Could possibly be admitted, And the Gov^{rs} observing Seven or Eight Women with Children at the Door and more amongst the Crowd desired them that they woud not Drop any of their Children in the Streets where they most probably must Perish but to take care of them till they could have an opportunity of putting them into the Hospital which was hoped would be very soon and that every Body would imediately leave the Hospital without making any Disturbance which was imediately complyed with with great Decency, so that in two minutes there was not any Person to be seen in the Street Except the Watch.

On this Occasion the Expressions of Grief of the Women whose Children could not be admitted were Scarcely more observable than those of some of the Women who parted with their Children. So that a more moving Scene can't well be imagined.

All the Children who where [sic] received (Except Three) were dressed very clean from whence and other Circumstances they appeared not to have been under the care of the Parish officers, nevertheless many of them appeared as if Stupifyed with some Opiate, and Some of them almost Starved, One as in the Agonies of Death thro' want of Food, too weak to Suck, or to receive Nourishment, and notwithstanding the greatest care appeared as dying when the Gov^{rs} left the Hospital which was not till they had given proper Order's and seen all necessary Care taken of the Children.[10]

Thirty were admitted that night. Hogarth did not represent this scene. Decorum required a biblical scene, but some sense of the actual chaos may have gone into his later Foundling painting, *The March to Finchley* (fig. 134). He did not attend the next day (nor did Coram) when "many Charitable Persons of Fassion visited the hospital, and whatevere Share Curiosity might have in inducing any of

them to Come, none went away without shewing most Sensible Marks of Compassion for the helpless Objects of this Charity and few (if any) without contributing something for their Relief." Hogarth was back on duty the next day, the 27th:

> We found that in the night a Child (N° 14) dyed it is imagined to have dyed of an Inflamation to the Bowells we imagine this to be one of the Children who we observed Stupify'd with Opiates and after it came to itself never left complaining. We found two other's Ill one wanting the assistance of a Surgeon from some Hurt on its arm. Mr Sainthill was sent for and Capt Coram was desir'd to ask Dr Mead to visit the Hospital this afternoon to direct what was proper for the Safety of the Sick Children.

Dr. Mead, long to be associated with the Foundling, did visit in the afternoon, and the child who appeared to be dying when taken in (No. 26) was still alive when the committee went home that evening.

Hogarth was absent on the next two days. On the 28th the chief nurse was discharged for incompetence, and the next day another, one Sarah Clarke, for "disobedience and Sawciness to the Chief Nurse." On the same day the first baptism took place, the boys being christened by the governors present and the girls by the duchess of Richmond, Lady Caroline Lennox, the countess of Pembroke, "and other Ladies of Fashion." On this occasion £35 3s was collected, and the Foundling was clearly becoming a fashionable enterprise: a fact of which Hogarth presumably took note.

In that first year, instead of the intended 60, 136 infants were admitted; of these 56 died, but the survival rate was still well above that of other poor children, and many of those left at the Foundling were already near death when delivered.

At the meeting of governors on 1 April Hogarth was present and "delivered in Mr Drummond's Receipt [i.e., to show that he had deposited in the Foundling's account the amount he had pledged the month before] for Twenty one Pounds paid the 28th of the last Month being his Benefaction to this Hospital, And was pleased to give the Corporation the Gold frame in which Mr Coram's Picture is put." Thanks were voted. The last meeting he attended for the next couple of years was the yearly meeting of 13 May when officers were elected. There was probably no connection between his absences and

the fact that once again his name did not appear on any ballot. He participated freely, giving generously of art, time, and money, but never appeared on any committee.[11]

Apparently about 1745 he designed the uniform worn by the foundlings. The color scheme was brown trimmed with red, the materials sturdy woolen cloth. The costume was described by a contemporary:

> The Boys have only one garment which is made jacket fashion, of Yorkshire serge with a slip of red cloth cross their shoulder; their shirts lapping over their Collar resembling a cape; their breeches hang loose a great way down their legs, instead of buttons is a slip of red cloth furbelowed. The Girls Petticoats are also of Yorkshire Serge; and their stays are covered with the same, of which a slip turns back over their shoulders, like that of the boys, and is of the same colour. Their buff bib and apron are linen, the shift is gathered and drawn with bobbins, in the manner of a close tucker. The Boys and Girls hats are white, and tied round with red binding.[12]

We also know that Hogarth served as an inspector appointed to select and superintend the wet nurses in Chiswick with whom some of the smaller children were boarded. As a result of the high mortality rate, the committee decided to board children up to three years old with foster mothers in the country. At five (at four after 1755) the children were readmitted to the hospital. Hogarth's post was an honorary one, frequently held by the village squire, parson, or physician. The nurses were usually paid 1*s* 6*d* weekly for each child, and in 1753 this was increased to 2*s* with the nurse supplying the baby's clothing. The governors advanced necessary funds to the inspectors for immediate payments, and for the rest—paying the nurses' wages—the inspectors rendered accounts at the end of the year.[13]

It is not certain when Hogarth began this job, but when the Book of Inspections first records Chiswick in 1756 he was the inspector; Jane was added as a separate supervisor, and Anne Hogarth signed at least one account. The survival rate of babies in the country was not much better than in the city. Out of the five children in 1756, only one lived to be returned to the hospital in 1761; the others died within one or two years. All the children taken in 1757 died, but two of the three taken in 1758 lived, being returned in 1765 after Hogarth's death.

Parenthetically, we might recall the Christ child projected in Hogarth's allusions to Nativity scenes (*Harlot* 3, *A Scene from "The Tempest," The Distressed Poet*—and, indeed, *The March to Finchley* itself [fig. 134]), and then the Hogarths' childlessness. In fact, the children who bore the name William and Jane Hogarth were in a sense miraculous children: the orphans placed in the Foundling were named after the governors, and there was always a William and Jane Hogarth in residence, as also a Thomas and Eunice Coram—and, when the governors' and their wives' names were used up, a Tom Jones and Sophia Western, and so on.[14]

The next meeting Hogarth attended was on 26 December 1744, and he was clearly there for a purpose: at this meeting Taylor White, the treasurer, proposed among other names that of Michael Rysbrack (living "near Oxford Chapel"). Hogarth may have wished to be there to support White's proposal, even perhaps to suggest it; he was absent the following meeting when Rysbrack was duly elected, however. But Rysbrack was necessary as his confederate in the scheme which must have been at this time maturing in his mind.

Behind Hogarth's plan was doubtless the idea of the new building, designed by Theodore Jacobsen (whose portrait he painted) and at this time in process of construction.[15] The land had been purchased in 1740,[16] and on 23 March 1741, just two days before the temporary hospital opened, a committee was appointed to consider plans for the proposed buildings, which were approved by the General Court of Governors, 30 June 1742. On 23 September 1742 the first stone was laid in the presence of several governors; the west wing was finished in October 1745, and the Hatton Garden premises abandoned: the first meeting in the new building was held on the 2nd. Here was a new and empty building waiting to be appropriately decorated. Hogarth was absent from all of these meetings, and exactly how negotiations took place is unknown. A reliable source, Hogarth's friend Rouquet, states that the artists volunteered to decorate the building only after "the governors refused to apply any of the charitable contributions to this use."[17] George Vertue (3: 131) indicates that by the summer of 1746 Joseph Highmore had begun his painting of *Hagar and Ishmael*, which from its size and subject was obviously intended from the first as a companion to Hogarth's *Moses Brought to Pharaoh's Daughter;* the pair would decorate the committee room in the new building.

All the sources give Hogarth credit for the initiative, which followed from his idea of donating the portrait of Coram and his earlier work for St. Bartholomew's. An exhibition was the traditional recourse for the artist who wished to circumvent hostile or prejudiced critics and connoisseurs and appeal to a wider public, as exemplified most notably by Salvator Rosa, who "was engaged in a running fight with the critics, . . . loved publicity and . . . was therefore determined that every year the public should see something new by him."[18] The English artists' motive, of course, was more general: to prove they were as good as the foreign artists in whose favor the critics and connoisseurs were prejudiced. Here they could paint and exhibit "the kind of work they would *like* to be commissioned to paint rather than turning out the usual run of what was expected of them"—portraits and chimneypiece decorations.[19] And it would be seen by a wider, less prejudiced public, and perhaps produce more commissions of the same sort.

Rysbrack was essential to Hogarth's plan. Horace Walpole's high estimate of Rysbrack reflects contemporary taste, and by bringing him into the Foundling Hogarth was allying himself with "the leading sculptor and one of the most famous artists in Britain."[20] It should be noted that Rysbrack, though a foreigner, was (unlike Kneller, Handel, and Roubiliac) able to speak and write fluent English; that, although a Burlingtonian classicist, he did not overgeneralize his portrait busts; and, as M. I. Webb points out, the personal characteristics that come through best are his steadiness and peacefulness of character. "It would seem that 'once a friend always a friend,' for of the people early associated with Rysbrack in England many of them continued in the role of fellow worker or patron until death broke the relationship."[21] When he first arrived in England Rysbrack had been part of the Oxford circle that included Gibbs and Thornhill, and he remained a friend and coadjutor of Gibbs. The earliest bust Webb identifies as his work is the earl of Sunderland, Thornhill's patron; he also did one of Gibbs.

He may have been in Vanderbank's academy, but certainly through the Thornhill connection he and Hogarth must have been acquainted from a very early time. Webb thinks that Hogarth needed Rysbrack, who was on friendly terms with most of his fellow artists, because he "was not, on the whole, popular with his fellow-artists" himself.[22] It would be more accurate to say that Hogarth was not considered as "sound" as Rysbrack, who brought with him aristocratic connec-

tions—both in patronage and in the artists of his circle—which Hogarth never acquired. If nothing else, he was needed as a sculptor to complement Hogarth the painter.

The St. Luke's Club, that "tip top Clubb of all" extoled by Vertue, had apparently disintegrated in the 1730s, partly at least because all the artistic vigor was focused in the opposing group of artists and art lovers at Slaughter's. No stewards appear on the surviving list after 1735, when Rysbrack held the post, and the last announcement is for 1743. It states that William Kent and Thomas Bryan were elected (Vertue remarks that Kent had been anxious to receive this honor for some time). Webb believes that this club "was superseded by the meetings of artists at the Foundling Hospital which began in 1746." [23] There is at any rate the coincidence that the St. Luke's Club was noted for its annual dinner (served by the stewards mentioned above) on St. Luke's Day, that the annual dinner of the Foundling artists was on that day, and that Rysbrack, a known ex-steward of the St. Luke's Club, was one of the leading Foundling artists. The club had lapsed after Van Dyck's death, and was revived by Lely after the Restoration; perhaps it was revived again in 1746. If so, one must conclude, considering the Hogarth–Rysbrack alliance, that by then Hogarth was a member and thus wished to extend or propagate the club; or, much more likely, he was not a member, and brought Rysbrack into the Foundling at least partly to establish continuity between the two clubs, St. Luke's and Slaughter's. Certainly, whether they are termed clubs or merely groups of artists, this was one purpose of the alliance between the painter and sculptor.

Although records show that a relief by Rysbrack to go over the fireplace in the new Court Room was received in 1745, this was probably only the design, and the relief itself may not have been in position until 1746. Vertue saw it in October 1746, implying that it was only just finished—probably in Rysbrack's shop since he saw the clay model at the same time. [24] The offer of a marble relief to go over the fireplace would have served to broach the subject, and Hogarth must have suggested at the same time, or shortly after (though no record of it appears in the minute books) that contemporary English painters decorate the rest of the room. Highmore was already at work on his contribution, and no doubt Hogarth was too.

The official announcement of the donations was not made until the quarterly meeting of governors of 31 December 1746 (by which time most of the works were nearly finished):

The Treasurer also acquainted this General Meeting, That the following Gentlemen Artists had severally presented and agreed to present Performances in their different Professions for Ornamenting this Hospital vizt Mr Francis Hayman, Mr James Wills, Mr Joseph Highmore, Mr Thomas Hudson, Mr Allen Ramsay, Mr George Lambert, Mr Samuel Scott, Mr Peter Monamy, Mr Richard Wilson, Mr Samuel Whale, Mr Edward Hately, Mr Thomas Carter, Mr George Moser, Mr Robert Taylor and Mr John Pine. Whereupon this General Meeting elected by Ballot the said Mr Francis Hayman, . . . [etc.] Governors & Guardians of this Hospital.

Resolved

That the said Artists and Mr Hogarth, Mr Zinke, Mr Rysbrach and Mr Jacobsen or any three or more of them be a Committee to meet Annually on the 5th of November to consider of what further Ornaments may be added to this Hospital without any expence to the Charity.

Brownlow, the first historian of the Foundling Hospital, thinks that Hogarth's plan originated in a "conjoint agreement, between Hayman, Highmore, Wills, and himself, that they should each fill up one wall of the Court Room with pictures uniform in size, and of suitable subjects taken from Scripture."[25]

MOSES BROUGHT TO PHARAOH'S DAUGHTER

The subject was an obvious one.[26] At the very first meeting of the General Committee, held on 29 November 1739, Coram presented the first seal of the corporation from a design of his own; this was presented to the governors at the 26 December meeting. The idea came to him, he explained, from "the affair Mentioned in the 2d of Exodus of Pharaoh's daughter and her Maids finding Moses in the ark of Bulrushes which I thought would be very appropo for an hospital for foundlings, Moses being the first Foundling we read of."[27] But while Hayman, the Vauxhall artist, chose this subject for his painting, Hogarth characteristically portrayed the moment in the story when the child Moses was poised between his nurse (his real mother, whose skirt he holds onto) and Pharaoh's daughter, producing another "choice" picture (figs. 129–131). Seen in relation to the social setting of the hospital, Moses is choosing between Virtue,

a hard but honest life with his true mother, and the languid reclining Pleasure, the easy life of the court. A blunt statement about the social function of the Foundling Hospital and an admonition to its charges, Hogarth's *Moses Brought to Pharaoh's Daughter* could be taken as a preface to the story of an industrious and an idle apprentice, which Hogarth was beginning at about the same time.

As a painting, however, *Moses* followed close on the heels of *Garrick as Richard III*. Hogarth had finished that heroic portrait by autumn 1745, and he probably began *Moses* not long after. He may have started work on it later, however, in 1746, under the influence of Rysbrack's mantle frieze in the Court Room. Though he employs six figures, he orders them with extreme classical restraint in a composition that anticipates Joseph Vien's celebrated *Marchand d'amour* (1763, Fontainebleau).[28] Hogarth's forms, however, are soft, almost fuzzy, and rely for much of their effect on texture, while Vien's already have the smooth, hard-edged quality associated with neoclassical art.

Since the story was well known, it did not call for a complex composition. Nevertheless, Hogarth tells the story in a distinctive way (and against such emphatic form a psychological touch, the black woman whispering the secret of Moses's parentage to an astonished friend, seems intrusive). Not Moses but Pharaoh's daughter, whose body makes a languid Line of Beauty rather like Garrick's (emphasized in the engraving by the Line of Beauty inscribed next to her on the plinth of the pillar [ill., vol. 3]), dominates the picture. She personifies the mission of the Foundling Hospital in a figure of Charity, once again the beautiful woman as mediator, supplemented here by the steward who is paying the wet nurse: schematically, these are two aspects of charity, one involving love (adoption), the other hard cash and donations. But Hogarth has complicated the matter of love: the wet nurse being paid is in fact Moses's real mother (of course, the one dressed in blue), and the poignance of the scene depends on the child's clinging to his real mother while warily eying his adoptive and ostensible mother. And, in the aesthetic terms set out by Hogarth in his recent prints, the real mother represents "character" (as in *Characters and Caricaturas*) or the Uncommon (Addison's term, later the Picturesque), while the adoptive mother represents the Beautiful (as in *Gulielmus Hogarth,* or the painting *Self-Portrait with Pug*). In these terms, the painting calls attention to itself as another Hogarthian painting about the artist.

There were many precedents for paintings of the baby Moses, but they were most if not all the Finding of Moses in the Bulrushes, of which Veronese produced no less than ten and Poussin several.[29] Hogarth's composition recalls his own early conversation pictures constructed with an empty inverted triangle separating the two groups of figures, with clear stages of depth managed in *Moses* by the staggered levels of recession made by the Egyptian buildings. Its conception is not so much heroic as (appropriately, considering its place in the Foundling Hospital) domestic. As in the conversations—but also as in such classical models as Veronese's scenes of audiences with potentates or the Venetian *sacra conversatione*, high-art relatives of the conversation picture—the emphasis is on the outstretched hand of Pharaoh's daughter, her gesture of union with Moses, and yet also— the mark of Hogarth—on the great V-shaped gap between them: Lord Castlemaine or Mr. Wollaston trying to unite two groups of guests or Polly Peachum trying to keep father and husband from each other's throats.

If Moses is ostensibly placed in a situation of choice between his true and his adoptive mother, this is *not,* however, a Choice of Hercules but another Judgment of Solomon, with the confused child caught between his two mothers and the harsh Old Testament God, or rather the murderous Pharaoh. Moses is not presiding in the place of the wise Solomon but waiting to be halved. The biblical context implies the absent figure of Pharaoh, who in the first chapter of Exodus has been trying to kill off the Israelite male children. The background architectural shapes, the pyramid rising from the top of a building directly above the head of Moses's mother, the huge pillar rising just behind the daughter, embody the patriarchal power, authority, and presence of Pharaoh.

The child is not choosing between two women—choice takes place only in the most profoundly ironic sense; rather two women are contesting for him, pulling him apart in a psychological sense which is reflected in his puzzled, anxious expression. The connection here (as the sublime history of the Good Samaritan had followed from the "comic history" of the Rake Hogarth had just completed) is with *Marriage A-la-mode,* especially its fifth plate, and with the theme of children destroyed by their parents.

As in the parable of the talents Hogarth takes the point of view not of the master but of the servant, so in the Judgment of Solomon it is

not Solomon the judge but the child who is central—who is allowed to be cut in half by his callous elders. For in Hogarth's sobering version the true mother never steps forward to save her child's life at the expense of her possession. In *his* version of myth, history, or Bible, this is always what happens. Only the marginal black woman is whispering the secret of the relationship of Moses to his two "mothers."

Hogarth's *Moses* is a striking and characteristic painting given its juxtaposition in the Court Room of the Foundling Hospital with Hayman's quite unproblematic, happy group of Moses in the bulrushes. Both Pharaoh's daughter and Moses's real mother, in Hayman's painting, are happy looking, as is the baby Moses. Hogarth, on the other hand, has chosen the moment when the child, being brought up by his real mother, is turned over to his adoptive mother, Pharaoh's daughter, as money is passed to his mother and servants gossip behind the princess's back. The gap between Moses and Pharaoh's daughter is an insurmountable and formally significant cleavage (as contrasted with the meaningless gap of vague wilderness between Hagar and the angel and Ishmael in Highmore's contribution). Hogarth's picture poses problems and vexes the viewer.

As the whispering black woman indicates, there is a "secret," ostensibly concerning Moses's parentage. But behind Pharaoh's daughter is a plinth on which Hogarth has inscribed his "hieroglyphic," the Line of Beauty, and resting on the plinth is a cluster of Masonic pillars (the medium by which the secret knowledge of the Masons was preserved from destruction by fire and water). Moses was a central figure in the Masonic legends. As Anderson put it in his *Constitutions,* "the Israelites, at their leaving *Egypt,* were a whole Kingdom of *Masons,* well instructed, under the Conduct of their Grand Master Moses, who after marshall'd them into a regular and *general Lodge,* while in the Wilderness, and gave them wise *Charges, Orders, &c.* had they been well observ'd!"[30] The founder of Masonic symbolism, Moses had become a priest of the Egyptian polytheism before his exodus with his followers for the Promised Land, where he purged the Egyptian pantheon to a monotheist god, secured the Law, and carried it in the Ark (or Shrine). The Masons discussed the way Moses's *new* religion gave "a holy use to the symbols whose meanings he had learned in his ecclesiastical education on the banks of the Nile."[31] Hogarth's painting dramatizes the conflicts in the child Moses be-

tween his real Jewish mother and his adoptive Egyptian mother, from whom he learned Egyptian hieroglyphics and the myth of Isis-Osiris.

Moses Brought to Pharaoh's Daughter is Hogarth's first and only Old Testament history painting. The story of a foundling was called for, but Moses's Masonic significance may have secularized the OT story for him and given it an esoteric side that would also have pleased him. Hogarth, in short, is making not only a Foundling Hospital statement about foundlings and charity but a Masonic statement about the transmission of their secrets and—more specifically with the Line of Beauty—a personal one about the transmission of his own "secrets of the craft."

The four history paintings hang now where they did then, Hogarth's facing Highmore's across the length of the room: Hogarth's is the one first seen as you enter. The pictures by Hayman and Wills, flanking the fireplace, are on the wall facing the windows. They are all in identical frames. Highmore's *Hagar and Ishmael* is the simplest, with only three figures, a very competent picture (although the angel appears to be perched on a rock instead of a cloud). Hayman's seven figures, Pharaoh's daughter with her maids and the babe in the bulrushes, are elegantly arranged, but they have the bulging eyes and bottle noses that are sometimes charming in Hayman's Vauxhall paintings of English rustics but incongruous in a religious subject. Hayman had just painted the Shakespeare scenes for the Prince's Pavilion at Vauxhall and was painting rustic festivals and games, simple, direct compositions such as *The Maypole* and *Falstaff's Cowardice Detected*. The fourth painting, Wills's *Suffer the Little Children*, is a soft, sentimental, and incompetent composition in the Pellegrini tradition with seemingly innumerable figures.

None of the pictures except Hogarth's reflects an awareness of the grim realities of the place in which they hang; and in Hogarth's painting it is a strangely muted awareness, compromised by the elegant forms and cheerful colors in which it is expressed. The predominance of Pharaoh's daughter, with her intrusive "Lines of Beauty," is reduced by the color scheme. She wears a salmon pink skirt-robe, covering her legs, with the upper part a yellowish white; Moses, with golden hair, is in an olive greenish tunic, and his mother's dress

is blue. The painting is defined by the large area of salmon pink as it relates to the blue of Moses's mother (once again the Virgin's color, as in *The Distressed Poet*), which is caught by both the daughter's blue hair ribbon and the deep blue evening sky (glimpsed also to the right of the pillar). All of these emerge—as has been Hogarth's custom in most of his paintings—from the large neutral areas of architecture and shadow, essentially the painter's ground. The scattering of the color blue gives Moses's mother a dominance that to some extent balances the larger salmon pink of his adoptive mother. Little Moses, whose green relates him more closely to his mother than to Pharaoh's daughter, nevertheless is isolated formally as well as by color. He shares the spatial isolation of Tom Idle, though Hogarth was careful to keep Idle from being a foundling, showing his mother—far from abandoning him—caring for him right up to the end.

The paintings by Highmore, Hogarth, and Wills were finished and hung by February 1746/47, as were evidently some of the landscapes. According to Vertue, Hayman's was "not yet quite finisht"(3: 134). Ramsay's portrait of Dr. Mead (fig. 66) and Hudson's of Theodore Jacobsen, the architect of the Foundling, also went up around this time. At last, on April Fool's Day, the whole was unveiled. The meeting was at 12 noon, the dinner at 1 P.M.; 100 tickets were printed for friends. Vertue reported the scene, with 170 present: "at the same time was seen the four paintings newly put up, done Gratis by four eminent painters," whom he names and adds:

> & by most people generally approvd & commended. as works in his-
> tory painting in a higher degree of merit than has heretofore been done
> by English Painters. . . . its Generally said and allowed that Hogarths
> peece gives most strikeing satisfaction—& approbation.

And he wrote in the table of contents to his notes, "Hogarths thout best. done" (3: 135, 90).

Hogarth had once again created for himself and his fellow artists an occasion for history painting and a place to demonstrate their abilities. Within ten years the collection, by this time including work by Reynolds, Gainsborough, Richard Wilson, and almost every noted English artist of the time, drew crowds of spectators and "a visit to the Foundling became the most fashionable morning lounge of the reign of George II." As Hogarth's own spokesman, Rouquet,

put it in 1755: "This exhibition of skill, equally commendable and new, has afforded the public an opportunity of judging whether the English are such indifferent artists, as foreigners, and even the English themselves pretend."[32]

It is quite clear, however, that Hogarth's thoughts never remained on the paintings alone. At the annual meeting on Wednesday 13 May 1747 he was present (though none of the other artists were) and brought about the following resolution:

> That the several Persons who have made Presents to this Hospital, of Pictures or any other Ornamental Works shall respectively have Liberty to appoint such Person or Persons to Copy Engrave and Print their several and respective Works as they shall think fit; And, that no other Person have power to Copy, Engrave or Print the same except this Corporation, who reserve for themselves the Power to direct the Copying, Engraving and Printing the same to be published together but not separately.

The rough draft for this passage begins with a sentence that has been crossed out: "That no Person shall have leave to take any Drawing or any Design of Pictures or other Ornament in the Hospital but with the Consent of the Artists." The rewording may suggest that Hogarth originally omitted the Foundling Hospital's prerogative of taking prints so long as they were published as a group. Hogarth was perhaps already anticipating the engraving of *Moses* which was published five years later.

At the meeting of 1 April 1747 John Pine presented the arms of the hospital, designed by Hogarth, and the minutes of the General Committee for 6 May state that Hogarth "acquainted the Committee That Mr Yeo the Engraver had offered to make a Present to this Corporation of a Seal of their Arms which were lately granted them from the Herald's Office."

After that first exhibition in the spring of 1747, the Foundling artists, consisting mostly but not altogether of the St. Martin's Lane Academy group, met on 5 November "to consider what further ornaments may be added to the building without expense to the charity." Every year thereafter they dined in the hospital at their own expense, on the day commemorating the landing of William III, toasting liberty as the parent of the fine arts out of a blue and white china

punch bowl that was preserved into the nineteenth century.[33] The 5th was also, of course, Guy Fawkes Day, which allowed a political conflation of celebrations both commemorating anti-Catholic events and reflecting anti-Gallican sentiments.

The artists' committee expanded over the years to include most of the artists of the day as well as their patrons, and the Foundling served as the first permanent art gallery for wholly English art. It still offers an illuminating cross-section of all the developing styles of the 1740s and 1750s. In addition, it laid the groundwork for the organization of the artists and the annual exhibitions which began a decade later, with many of the same artists involved. This corporate sense that Hogarth imparted to the group, however, was to prove the starting point of his own alienation from the artistic society of his time: the almost immediate consequence of the organization of the artists was the first proposals for precisely the sort of national academy of art he opposed (see vol. 3).

Another extension of Hogarth's reputation as a history painter and decorator of public buildings took place on 27 February 1750/51 when Dr. John Monro, of Bethlehem Hospital, a watercolorist in his own right, and Moses Mendez, who had just been elected a governor, were desired by the court of governors "to Ask Mr Hogarth what Painting he thinks wou'd be proper for the Altar in the Chappel of this Hospital and to Report to the next court."[34] Nothing is mentioned in the next or subsequent meetings. Presumably Hogarth visited the hospital and gave his opinion on the question of a new painting (not one already in the hospital); perhaps the governors were considering one by Hogarth himself. It would appear, however, that he did do something, for at the meeting of 26 February 1752 he was elected a governor and it was ordered "that a Staff be forthwith sent to him Notwithstanding the Order of court the 29th of April 1745," which said that there were already too many governors and no more should be nominated until 1755 (other exceptions had also been made). The announcement also appeared in the *London Evening Post,* 25–27 February. The only meeting he attended was of 8 April 1752; he appears on no committees and apparently attended no further meetings. Ordinarily qualification for governorship was a benefaction to the hospital of at least £50.[35]

LINCOLN'S INN, 1748–1750:
PAUL BEFORE FELIX

A few commissions followed the Foundling donations. Hayman was employed by the architect James Paine (one of the St. Martin's Lane people), probably on the strength of the Foundling picture, to paint an Ascension for the chapel ceiling and a Good Samaritan for the altarpiece at Cusworth Hall, Yorkshire; for which he was paid, however, only £26 5s "in full" on 29 March 1752.[36] His Foundling painting is perhaps the first sign of a transition to the more elegant, less Hogarthian decorations of the last supper boxes in the 1750s, leading up to his contemporary history paintings of the Seven Years' War in the 1760s.

Following the unveiling of the Court Room of the Foundling Hospital and its paintings, Hogarth himself received a commission for an amount as large as he had received for *Garrick as Richard III,* once again from a public institution. As Vertue, a good weathercock, had observed of the Foundling paintings, it was generally agreed that Hogarth's work gave "most striking satisfaction." Not long after, Hogarth was approached by representatives of the Society of Lincoln's Inn and asked to submit a design for a history painting to go at the west end of the chapel.

On 24 November 1745 Thomas, Baron Wyndham of Finglass, for many years lord chancellor of Ireland, had died at his lodgings in Golden Square, leaving £200 to Lincoln's Inn "for adorning the Chapel or Hall or both, as the Benchers shall think fit." The council was informed of the bequest at a meeting held on 26 February 1745/46, and again on 16 April, and the money was received on 4 November from Sir Wyndham Knatchbull Wyndham, one of the executors.[37] It appears that William Murray (later Lord Mansfield), a friend of Garrick, was the instigator. Although there is no mention of him in this connection in the records, the author of *The Student's Guide through Lincoln's Inn* states that "Lord Mansfield, who had an intimate acquaintance with, and personal esteem for Hogarth, proposed that the 200 *l.* should be applied in the purchase of a Painting by this celebrated Artist, that they might at once perform the intention of the Testator, and encourage the Fine Arts."[38] Murray, a cultivated man with literary connections, seems a likely sponsor of Hogarth.

By 12 December 1747 (with eleven benchers present) the matter had been settled:

> Ordered that the legacy given by the late Lord Windham be laid out in a picture to be drawn by M[r] Hogarth, to be placed against the wall at the west end of the Chappel, according to the subject proposed by M[r] Hogarth.[39]

Measuring 14 feet wide by 10 feet 7 inches high, the painting (fig. 132) is on a scale that dwarfs the Foundling Hospital painting and constitutes a return to the monumentality of the St. Bartholomew's staircase paintings.

The selection of the subject of St. Paul's plea before Felix was based equally on its appropriateness to the Inns of Court and the opportunity it provided to create a work directly comparable to Raphael's St. Paul Cartoons.[40] St. Paul was also, of course, the patron saint of London, the namesake of its cathedral, which was decorated with Raphaelesque paintings of his life by Thornhill. Hogarth's colors are mainly gray, pink, gold, and smoky blue: Raphael colors transmitted through the medium of late baroque painting. (The general tonality is rather pale, far paler than that of the *Moses*.) Raphael was the strongest basic influence, but the overexpressiveness of the faces and gestures shows that Hogarth has not left far behind the vigorous individuality of the St. Bartholomew's Hospital paintings. The paint is applied very thinly except in the two main figures in the foreground, Paul and Tertullus, who—especially in the painting of their heads—make up the most forceful part of the composition.

Nevertheless, Vertue wrote in May 1748 about *Paul before Felix:* "Some new grand designs of Mr Hogarth—painting. much bigger than life. the story of St Paul at Ephesus.—the greatness of his *Spirit* <tho' a little> man to out vye. all other painters" (3: 141). Once again, this "little man." Evidently in June, having finished the painting in his studio, Hogarth moved it to Lincoln's Inn, where it became apparent that it was too large to fit in the chapel. It was at any rate placed on display for the benchers. Hogarth, "solicitous to learn if it met the approbation of the Benchers, waited on them for that purpose, when he was invited to dine with them,—a favour seldom conferred but on legal or ecclesiastical characters, and generally members of the Society."[41] On 28 June he wrote to John Wood, at

this time treasurer, and included a sketch of the frame he proposed for his picture:

Sr

According to your order, I have consider'd of a place for the Picture, and cannot think of any better than that over the sound board, in the hall, all the advantage to be gain'd for Light, can only be by setting the bottom near the wall, and Inclining the Top forward as much as possible, it being thus Inclin'd will make ornaments on the sides improper, so that a Frame only is necessary. I have inquired of Mr. Gosset, a Frame maker in Berwick Street about the price of one somewhat in the manner of the Sketch below, he believes it may come to about 30 pounds Guilt, to about half as much unguilt and about five pounds less if my Lord Windham's armes are omitted. Frames may be carried up to a great expense, but he thinks one cannot be made in proportion to the picture for less. I am Sr your

 most obedt. Humble
 Sert. to comd.
 Wm. Hogarth.

I have removed the picture home again in hopes of making some improvements whilst the Frame is making.[42]

The council met the next day, 29 June, and "Ordered that the £200 left by my Lord Wyndham be paid to Mr Hogarth," and the money was in Hogarth's hands by 8 July.[43]

The subject was an extension beyond the last episode of the sequence of Raphael's Cartoons. To carry out his challenge, Hogarth based his composition on *Paul and Elymas* (ill., vol. 1), about the conversion of the Roman governor who was to judge between Paul and Elymas the magician. Paul proved himself by the "miracle" of blinding Elymas, thereby converting both Elymas and the proconsul. *Paul and Elymas* also depicts an accused person with his own spiritual authority facing a person of official, conventional authority—and turning the tables on him.

At the same time, we should recall that when Poussin adapted Raphael's *Paul and Elymas* it was in order to paint *The Judgment of Solomon* (Louvre), with the two children, the one alive and the other dead, flanking Solomon as (in Hogarth's version) Tertullus and Paul flank Felix. Hogarth's painting, following as it does directly upon *Moses Brought to Pharaoh's Daughter,* is (as Tobias Smollett at once recognized)[44] a parody Judgment of Solomon; it is another judgment

that should show a wise Solomon but has a corrupt magistrate instead. The figure of Paul himself, rebuking Solomon, is taken from Raphael's *Paul Preaching at Athens* (ill., vol. 1).

The story in Acts begins when Paul is mobbed by the Jews for ignoring their laws and saved by the Roman soldiers who, learning that he is a Roman citizen, send him to Caesarea to be judged by the governor Felix. There he is prosecuted by "an advocate named Tertullus," representing the high priest and the Jewish elders, who says, "For we have found this man a pestilent fellow, and a mover of sedition among all the Jews throughout the world, and a ringleader of the sect of the Nazarenes: Who also hath gone about to profane the temple: whom we took, and would have judged according to our law" (24:5–6). Paul responds with a brief of his own, sober and reasonable, and Felix puts off a decision until the commanding officer from Jerusalem can report to him.

At this point we arrive at the scene Hogarth has illustrated, which he cites in the epigraph to the engraving he published a few years later (the passage quoted by Hogarth is italicized):

And after certain days, when Felix came with his wife Drusilla, which was a Jewess, he sent for Paul, and heard him concerning the faith in Christ. *And as he reasoned of righteousness, temperance, and judgment to come, Felix trembled,* and answered, Go thy way for this time; when I have a convenient season, I will call for thee. (24:24–25)

The first liberty that Hogarth has taken with his text is to introduce into this private meeting of Paul, Felix, and Drusilla the figure of Tertullus and the trappings of the courtroom. In this way he makes a picture that, rather than illustrating the biblical text, is about a bad lawyer, Tertullus, and a bad judge, Felix, who can only be moved— terrified, made to "tremble"—by an extralegal force, by Paul's reasoning (he makes no mention of his god).

Steele had singled out St. Paul in his *Christian Hero* and told the story of Paul and Felix, and the story was regarded as a defense against unjust judges. In the biblical commentaries, Tertullus was a figure of the bad lawyer: "*Observe further,*" writes William Burkitt, "How *Tertullus* seeks to gain the Judge's Favour by Flattery and Falsehood: To win Judges by Flattery, hath ever by false Accusers been taken for the surest Way of Success."[45] Bishop Hoadly's sermon, "St. Paul's Discourse to Felix, preached before the King, Feb-

ruary 15, 1729/30," was about a law that is beyond the law: this scene "gives a very uncommon Appearance; the *Prisoner,* undaunted and unconcerned at his own Danger; the *Governour,* terrified and *trembling,* as if his *Prisoner* had been his *Judge;* and were now pronouncing a Sentence of Condemnation upon him."[46]

Though Hoadly and Hogarth were good friends, it is not necessary that Hogarth recalled this sermon, for in 1741 Samuel Richardson published his sequel to *Pamela* called *Pamela in High Life,* in which he introduced a scene modeled on the same interpretation of Paul's encounter with Felix. Pamela learns that Mr. B., now her husband, has begun to show interest in a countess, with whom he has taken to talking about the virtues of polygamy. Her suspicions thoroughly aroused, she invites him into her closet, where she has arranged chairs as in a courtroom, and places herself in the position of the accused and him in the position of the judge and accuser, saying:

> methinks I stand here as Paul did before Felix; and, like that poor prisoner, if I, sir, reason of *righteousness, temperance,* and *judgment to come,* even to make you, as the great Felix did, tremble, don't put me off to *another day,* to *a more convenient season,* as that governor did Paul; for you must bear patiently with all I have to say.[47]

Pamela's innocence and Mr. B's guilt turn the tables between judge and accused in precisely the way Hoadly interpreted the text. This turning of the tables, the delay in judgment by Felix, and the general theme of judgement, magistrate's court, and corrupt lawyers were embodied in Hogarth's version of the story—a resonant story that for him goes back to his *Committee of the House of Commons* painting of 1729 (ill., vol. 1).

Richardson too was obsessed with the situation of a guilty judge and innocent malefactors. In Letter 16 of the original *Pamela* Pamela addresses herself:

> Thou hast done no harm! what, if thou fearest an unjust Judge, when thou are innocent, wouldst thou do before a just one, if thou were guilty? Have courage, *Pamela,* thou knowest the worst! and how easy a Choice Poverty and Honesty is, rather than Plenty and Wickedness?

And she continues: "O how can wicked Men look so steddy and untouch'd, with such black Hearts, while poor Innocents look like

Malefactors before them!"[48] More significantly, later she misre-members the fable of "A Dog, a Sheep, and a Wolf," in which a dog accuses a sheep, with a kite, wolf, and vulture as witnesses. In Pa-mela's version, "The poor Sheep, in the Fable, had such an one ["a Strange Tribunal to plead before"]; when it was try'd before the Vul-tur, on the Accusation of the Wolf!" (162). Above all, there is the great "trial" scene set up by Lovelace in *Clarissa*.

All of Richardson's courtroom metaphors make the woman the accused/judge, while Hogarth makes it the man. In *Paul before Felix* the woman is Drusilla, a bad advisor. This would not be strange but for the fact that Hogarth's contribution to the dialogue with Richard-son had been the Harlot, a woman in the midst of modern London, followed between 1730 and 1741 by Sarah Young, the Poet's wife, Miranda, Sin, and the milkmaid of *The Enraged Musician:* all women mediating between opposing men. One wonders if this change from a woman to a man in *Paul before Felix* is Hogarth's comment on Pamela by way of Joseph Andrews (and Parson Adams), Fielding's male answer to Pamela and Mr. B.

The context for Richardson's scene—Mr. B.'s adultery—and the larger context of Pamela and Mr. B. (whom she has turned, in Field-ing's parody, into her sexual pawn), was the verse preceding Ho-garth's epigraph, concerning Felix's "wife Drusilla, who was a Jewess." As James Foster commented in a sermon of 1733:

Felix, by the confession of *Tacitus* . . . governed the *Jews* in a very arbitrary manner, and committed the grossest acts of *oppression* and *tyranny.* And *Drusilla* his wife, without a good reason to justify a di-vorce, had left her former husband, and given herself to him; and con-sequently was an *adulteress.* When St. *Paul,* therefore, was sent for to explain to them the nature of the Christian Religion . . . and the im-mutable obligations of temperance and chastity; the conscience of the governour was alarmed and terrified, and a sense of his crime . . . filled him with the utmost confusion. *Drusilla* indeed does not appear to have discovered any remorse; perhaps she was, naturally, of a more hard, insensible, unrelenting temper; or confided in her *Jewish* privi-leges, and expected to be saved, as a daughter of *Abraham,* notwith-standing the immorality and wickedness of her life.

The biblical commentaries made the same point, Burkitt for ex-ample: "*Drusilla* was guilty of Incontinency and Adultery, to her [Paul] preaches of Temperance; and to both of a Judgment to come."[49]

When in this light we read the verse Hogarth quotes, we see that it is not Paul's invocation of the deity but specifically his turning "to questions of morals, self-control, and the coming judgment" that causes Felix to become alarmed and exclaim, "That will do for the present; when I find it convenient I will send for you again." In other words, Paul is accusing the judge himself, turning the tables on him in precisely the way Pamela does with Mr. B., by saying in effect: Who are *you* an adulterer to accuse me? (But it also signifies that Drusilla the Jewess, like Pamela the poor servant, has used her sexual wiles to rise in the world.)

Attention was drawn in the late eighteenth century by John Ireland to one other fact. Ireland claimed that the reason Hogarth dropped Drusilla from the final engraved version of the painting (by Luke Sullivan, 1752, ill., vol. 3) was that it was "thought that *St. Paul's* hand was rather improperly placed" in relation to Drusilla's body.[50] Of course, Hogarth did this—and retained it in the painting—quite on purpose, letting Paul indicate by his hand (and a characteristically Hogarthian trick of perspective) where the source of Felix's sin in fact lay.

Paul's hand is placed so as to suggest that his challenge is involved in Felix's judgment of him, but also to indicate the falsity of this woman who should be the mediator between Paul and his judge but is in fact the latter's mistress. What she tells us about Hogarth's attitude toward the Charity figure he celebrated earlier (in Sarah Young, the Good Samaritan, and Christ) is that she has now become (with Pharaoh's daughter) merely a part of an upwardly mobile ruling-class ideology—a buffer between rich and poor, magistrate and accused, Felix and Paul, that only serves the former.

It seems clear that Hogarth made the painting so large that it would not fit in the chapel, where the benchers intended to hang it, and so it would have to go in the Old Hall. The minutes of 12 December 1747 show that the benchers resolved that the painting would "be placed against the wall at the west end of the Chapel, according to the subject proposed by Mr. Hogarth." But when it was finished a year later Vertue noted that "this large peece was done for to be placed in Lincolnns Inn chapel but there being no propper room for it is placed in Lincolnns Inn hall over the Seat where the Lord chancellor sitts" (3: 155). Hogarth, we can conclude, made sure that his painting did not hang in a Church of England chapel (and he chose a scene in which Paul's reasoning, not the presence of God, caused his

judge to tremble); but that it did hang where it carried the maximum ironic impact, noticed at least by the observant Vertue if not by the lawyers and the lord chancellor himself.

The Old Hall, completed the year before Columbus discovered America, was the oldest by half a century of the surviving halls of the Inns of Court and Chancery. The dais at the end was originally high table, and the hall was a dining room. From 1737 on, however, it was used more or less continually for sittings of the Court of Chancery, and so the lord chancellor sat on the dais under Hogarth's picture. The hall was also used for dinner by the benchers and students. The lord chancellor was protected from seeing the painting himself by an awninglike projection over his head; but it was plainly visible to the audience of counsels and by the dining barristers.[51]

There was, of course, also a graphic context to support the literary (or biblical) allusion. As Alexander Gourlay has shown, a northern tradition of justice pictures, hung in halls of judgment, dealt with the issue of the corrupt judge.[52] Perhaps of easiest access to Hogarth and his audience was Rubens's *Judgment of Cambyses* (engraved by Robert Eynhoudts), illustrating Herodotus's story of the Persian tyrant Cambyses's punishment of his judge Sisamnes, who was caught taking a bribe. He had the judge's throat cut, his dead body flayed, and the "man-skin" used as upholstering for the judicial bench. Then he installed Sisamnes's son Otanes in his father's place, telling him to remember where he sat as he rendered decisions. In the Rubens-Eynhoudts etching Cambyses emphatically points his scepter at the seated Otanes, with his other hand on his sword.

The composition is not unlike Hogarth's, but Rubens has produced a closer knit, more baroque composition by drawing together the accuser and the questionable judge: Cambyses's hand and scepter overlap Otanes's figure; Paul's reaches only as far as Drusilla in a more open Raphaelesque composition. The difference lies in the fact that Rubens places power on the side of the ruling elite; Hogarth gives it to the accused "criminal," whose power is only spiritual. A growling, crouching dog, whose expression parallels Cambyses's, will reappear—not in Hogarth's painting or engraving but as a "northern" touch in the burlesque version of the scene he added as subscription ticket in 1752.

Although the official explanation might have been that the picture placed the magistrate in a divine perspective, showing his subservience to a greater power of judgment, this is to see the picture from

the point of view of Felix, or of the judges and lawyers, the benchers of Lincoln's Inn, the patrons who commissioned it. This was presumably the selective vision employed by the legal profession. In general this is the way commissioned history paintings functioned. Rubens painted his ceiling of the Whitehall Banqueting House from the point of view of the king who sat at the head of the hall, and of the king his father who figures above him in gestures of *fiat lux* and apotheosis. Every detail indicates the wise scholar king as Solomon, and when James is shown as Solomon offering his ironic judgment on the two women who both claim the same child, Rubens gives it straight: the audience of courtiers dutifully suppresses the detail that the two women (allegorically England and Scotland) were in the story prostitutes.

Hogarth has painted his *Paul before Felix* from the point of view of the accused. We read the painting as Paul's story, with Felix in the Raphaelesque position of the converted proconsul and Tertullus of the defeated alternative Elymas. How did he get away with this strategy? Probably by invoking, as he did, the authority of the Raphael Cartoon, which absorbed any subversive trace that might have been detected. Moreover, the composition of the Raphael Cartoon-tapestry-engraving, with its reversals and backward-forward readings, conferred sufficient ambiguity on Hogarth's design that a viewer could have it either way, as about Paul or about Felix, as about a prisoner or about a judge. It could also be argued that *Paul before Felix* is only a *memento mori,* an admonitory image for the judges in order to remind them that they are fallible humans.

The model, however, is neither the medieval tradition of *vanitas* (compromised, for example, by the detail of Drusilla's hand), nor Shakespearean generosity, the inclusion of both contrasting points of view, but Swiftean irony. At just the time he was carrying out this painting, Hogarth was also engraving *Industry and Idleness* and gestating the six popular prints of 1751, which go much further in the bifurcation of viewpoints (ill., vol. 3). *Paul before Felix,* the high-art equivalent of *Industry and Idleness,* is ostensibly addressed to the legal profession who commissioned it, but its true meaning addresses itself to defendants. While in situ the painting was seen only as *Veluti in speculum* by the lawyers themselves, in the engraving of 1752 it would reach a broader audience that could more readily separate the judge and lawyer from the prisoner and see from the latter's point of view. The manipulation of the patron in the painting is exactly analo-

gous to the manipulation of the purchaser—the master who buys it for his apprentices—in *Industry and Idleness.*

Although Hogarth was not ashamed of cultivating patrons, and his claims against them were to some extent sour grapes, his most publicized gesture was to seek and find public places of exhibition for his paintings. Where there was a patron—a public organization, such as the benchers of Lincoln's Inn—he still supposed a more general and extensive print audience of consumers: perhaps *because* he had a message which he felt would be lost on the benchers. For the patron in this case is alienated if not eliminated, and once again absorbed into the scene as a villain while the print audience associates itself with the accused criminal, the object of the patron's aggression.

As to the significance of St. Paul, it must be remembered that if Hogarth had associated himself with Raphael and Thornhill, who painted Paul, he also showed signs of associating himself with the patron saint of London. The story of Paul at Ephesus was part of the subtext of *Boys Peeping at Nature*. *Paul before Felix* initiates a series of works in which Hogarth himself becomes a hortatory, while at the same time beleaguered, Pauline figure. This figure, corresponding to the frontispiece *Gulielmus Hogarth,* makes him an exemplary English artist, a public version of the private alter egos (Ferdinand, David, Goodchild–Idle) we have seen him trying on as if he were Bunyan with the roles of Peter, Esau, Francis Spiro, and Christ.

St. Paul was also a figure around whom to build a history painting at a time when the Sublime was being increasingly valorized by critics. The Old Testament had been traditionally seen as the locus of sublime poetry (of simplicity and originality), but in Hogarth's time there had been much effort to prove the New Testament as or more sublime. Those who argued for the New Testament cited as an authority Longinus himself, who had ranked St. Paul one of mankind's sublime orators; and William Smith in the notes to his edition of *Peri Hupsous* (1739) praised St. Paul "some eight times as one of the sublimest rhetoricians of antiquity."[53] Hogarth is plainly drawing on this idea of Paul as the sublime orator, placing him in what he regards as a sublime (elevated, simplified, powerful) composition.

Both Moses and Paul appear in Judgment of Solomon scenes. But Moses was a passive victim, while Paul, despite his imprisonment, is an active, powerful agent. If Hogarth's subject has become, especially in light of the Foundling experience, types of the child Moses, he himself, painting these, has been a St. Paul, eloquent and successful

but put upon by the Jewish merchants and priests. Moses and Paul amount to another version of the schizoid figures of Idle and Good-child in *Industry and Idleness*.

If between 1746 and 1748 Hogarth produced a series of cheap, popular prints, during these same years he also painted two large, ambitious history paintings, which seemed another attempt to storm the heights of the art establishment. What these two apparently an-tithetical enterprises had in common was the extension of his audi-ence—from subscribers to an unlimited general public for his prints, and from private patrons and homes to the public exhibition of his paintings.

Moreover, his history paintings (beginning with the *Good Samari-tan* and *Pool of Bethesda*) were intended for London hospitals, chari-table foundations, and a law court. And their subjects concerned social issues that corresponded very closely, though on what was regarded as a higher level of representation, to those of the popular prints. Hogarth's work of the later 1740's—some of his most inter-esting—presented itself as a two-pronged attack on the art establish-ment: one extended the subject of art—as both production and commodity—to large issues of social injustice, and the other to the issue of art's role in society.

THE ROAST BEEF OF OLD ENGLAND

We may suppose that Hogarth turned from the completion of *Moses* in 1746/47 to the completion of *Industry and Idleness*. After the un-veiling of the Foundling paintings in April, he was approached by Murray to make a painting for Lincoln's Inn. Probably, as soon as he published *Industry and Idleness* he turned his attention to this painting; thus, when he finished *Paul before Felix* in July 1748 he decided that he needed a rest. The outing he planned sounds rather like a more prosperous version of the "peregrination" of fifteen years earlier. The signal could have been the end of the War of the Austrian Succession: the armistice was declared in May (the peace of Aix-la-Chapelle was at length concluded on 18 October). He had been to Paris in 1743, just before the outbreak of hostilities, and he apparently had enjoyed himself, coming back with some feeling for the kind of painting be-ing done there and some sense of the popularity his engravings en-

joyed. Then the war prevented both a return visit (he may have intended to carry the *Marriage A-la-mode* paintings over himself) and the employment of some of the engravers he had hired. Though his first trip, perhaps encouraged by his friendships with Gravelot and Roubiliac, left him with good memories of France, he remained Francophobe, resenting some of the French émigré artists in England (notably Vanloo) and certain aspects of the French style.

Once the preliminaries for the peace negotiations had been agreed upon and the passage from Dover to Calais was free, Hogarth joined some of the artists who had previously shared in the Foundling project (they were also St. Martin's Lane Academy people): Hayman, the sculptor Henry Cheere, Hudson, and the drapery painter (at that time shared by Hudson and Ramsay) van Aken. In the words of Vertue, who chronicles the episode, they "resolved and agreed to go to Paris" (3: 141–42). From Paris the majority traveled north to Flanders and Holland; Hogarth and Hayman either went along and then returned together to Calais or returned directly from Paris to Calais.[54]

There Hogarth took out his sketchbook and drew some views of the drawbridge to Calais Gate—the old English tower fortifications. "I was santering about and observing [the people] & the gate which it seem[s] was built by the English when the place was in our possession (there is a fair appearance still of the arms of England upon it)" (AN, 228). Walpole's account, written the following December, which sounds as though it was had from Hogarth himself, says he was taking a sketch of the drawbridge. Vertue's account has both Hogarth and Hayman drawing. Hogarth, according to his own and Walpole's accounts, "was seized and carried to the Governor"—as a spy. "I conceild none of the memorandum I had privately taken and they being found to be only those of a painter for [my] own use it was Judged necessary only to confine me to my lodging till the wind changed for our coming away to England." In Walpole's account "he was forced to prove his vocation by producing several caricatures of the French; particularly a scene of the shore with an immense piece of beef landing for the Lion d'Argent, the English inn at Calais, and several hungry friars following it. They were much diverted with his drawing, and dismissed him."[55] Nichols got his version from Dr. Ducarel, who had it from the Reverend William Gostling of Canterbury, with whom Hogarth stayed the night after his return to England, and whom he regaled with the story. After being carried

before the governor as a spy, and "after a very strict examination," he was "committed a prisoner to Grandsire, his landlord, on his promising that Hogarth should not go out of his house till it was to embark for England." Then Nichols adds: "The same incident, however, has been more circumstantially related by an eminent English Engraver, who was abroad when it happened." This may have been Robert Strange, who was in France between 1748 and 1750, or Thomas Major, who was there between 1745 and 1748. If it was Major, the story becomes more poignant, for he had himself been seized one night in October 1746 and taken to the Bastille, in reprisal for the French and Irish prisoners taken after Culloden, and was released only after the strenuous intercession of Le Bas and Gravelot with the marquis d'Argenson.[56] This engraver's account, written down (and demonstrably embroidered) by Steevens, comes out as follows:

> While Hogarth was in France, wherever he went, he was sure to be dissatisfied with all he saw. If an elegant circumstance, either in furniture, or the ornaments of a room, was pointed out as deserving approbation, his narrow and constant reply was, 'What then? but it is French! Their houses are all gilt and b—t.' In the streets he was often clamorously rude. A tattered bag, or a pair of silk stockings, with holes in them, drew a torrent of imprudent language from him. In vain did my informant (who knew that many Scotch and Irish were often within hearing of these reproaches, and would rejoice at least in an opportunity of getting our Painter mobbed) advise him to be more cautious in his public remarks. He laughed at all such admonition, and treated the offerer of it as a pusillanimous wretch, unworthy of a residence in a free country, making him the butt of his ridicule for several evenings afterwards. This unreasonable pleasantry was at length completely extinguished by what happened while he was drawing the Gate at Calais; for, though the innocence of his design was rendered perfectly apparent on the testimony of other sketches he had about him, which were by no means such as could serve the purpose of an Engineer, he was told by the Commandant, 'that, had not the Peace been actually signed, he should have been obliged to have hung him up immediately on the ramparts.' Two guards were then provided, to convey him on shipboard; nor did they quit him till he was three miles from the shore. They then spun him round like a top, on the deck; and told him he was at liberty to proceed on his voyage without farther attendance or molestation. With the slightest allusion to the ludicrous particulars of this affair, poor Hogarth was by no means pleased. The leading circumstance in it his own pencil has perpetuated.

This anecdote, which if true Hogarth may have wished to forget, sounds like a germ of the truth expanded—more probably by Steevens than by Major or Strange.[57]

Hogarth's own account was intended to explain his engraving of the experience:

> The first time any one goes from hence to france by way of Calais he cannot avoid being struck with the Extreem different face things appear with at so little distance as from Dover[:] a farcical pomp of war, parade of riligion, and Bustle with little with very little bussiness in short poverty slavery and Insolence ⟨with an affectation of politeness⟩ give you even here the first specimen of the whole country nor are the figure less opposed to those of dover than the two shores. fish wemen have faces of [*word illegible*] leather and soldiers raged and lean (AN, 227–28).

As soon as he arrived back in England he "set about the Picture"—it is not clear whether he means the one he was sketching when interrupted, although this is Walpole's interpretation. To this "I introduced a poor highlander fled thither on account of the Rebelion year before brozing on scanty french fair; in sight a Surloin of Beef a present from England which is opposed the Kettle of soup meager[;] my own figure in the corner with the soldier['s] hand upon my sholder is said to be tolerably like."

The painting (fig. 126) was done with speed but is a meticulous performance, as careful and finished as *Marriage A-la-mode*. When it was cleaned in 1966, the warm colors disappeared and cool grays and blues and off-reds emerged: though as detailed as a miniature, its style begins to suggest the broad almost posterlike handling of the *Election* series of a few years later. The engraving, partly done by Charles Mosley, was published in early March 1748/49:

> *This Day is publish'd, Price 5s.*
> A Print design'd and engrav'd by Mr. HOGARTH, representing a PRODIGY which lately appear'd before the Gate of CALAIS.
> O the Roast-Beef of Old England, &c.
> To be had at the Golden Head in Leicester-Square, and at the Print Shops.[58]

Vertue, noting the appearance of the print, observes that the title is "a prodigious Blunder of his—for he has represented a Man carrying a peice of (Raw beef) instead of Roasted—as it appears colour'd only

red & yellow in the Middle of the print" (6: 200).[59] Vertue must be thinking of the painting, which no doubt was displayed next to the print in Hogarth's house. He adds that the "print of him and his dog" (*Gulielmus Hogarth*) was out, selling for 3s 6d.

Vertue's comments also indicate that with these two prints Hogarth was further publicizing himself or making himself his own protagonist; anyone who had not heard the story of his adventure in Calais by word of mouth would "read" it in his print. If there is any doubt that Hogarth saw himself dispassionately in this episode, it is dispelled by the blatantly stagelike structure of *The Gate of Calais*—perhaps more obvious than in any picture since *The Beggar's Opera*. Hogarth's self-comment is that this was a small comedy played out with a motley cast of characters. But the protagonist is another accused criminal, in this case a spy.

Hogarth's original self-image, summed up in the *Harlot* and *Rake*, involved a prison (real or metaphorical) in which there is a prisoner (father), a warder, with a mediating woman (mother), and a child—Hackabout's or Rakewell's. In the mid-1730s we have seen the prison replaced (in a sort of wish-fulfilment fantasy) by a hospital in which the foundling-child is being cared for by a more charitable version of the warder—but (as in the case of Moses) in fact he is being torn apart by figures who join the functions of mother and warder. Simultaneously Hogarth was exploring in *Industry and Idleness* a fantasy apprenticeship in which both the greatest hopes and fears of the apprentice are materialized; and in *Paul before Felix* a fantasy courtroom in which the innocent accused turns the tables on the unjust magistrate. At this point in time Hogarth found himself falsely accused and threatened with a real prison, and he represented the moment of his arrest.

The detail of his profile was extracted from the context of the arrest (the officer's hand on his shoulder removed) and widely copied. A print for Robert Sayer was dated as early as 29 September 1749, followed by many others, some adapting the Hogarth's Head as a shop card or sign for professions ranging from printseller to tailor.[60]

14.

THE MARCH TO FINCHLEY, 1749–1750

The Foundling Hospital experience had stimulated a new kind of portrait—of a simple ship's captain as a symbol of charity—then a new kind of history based on a child cut off from its mother. The Foundling Hospital may have led Hogarth into the popular mode of *Industry and Idleness*. But between the establishment of the Foundling and the story of the poor boy who fails through idleness and the other who succeeds through industry, Hogarth had turned his attention to the metaphorical foundlings of *Marriage A-la-mode*. Though their parents are, respectively, idle-aristocratic and industrious-prosperous, the younger generation ends in undifferentiated disaster. With *Paul before Felix,* painted for the nearby Lincoln's Inn, Hogarth added to the foundling a defendant before the English law. The difference between the Foundling Hospital and Lincoln's Inn, as between the pictures Hogarth painted for both, was simply the difference between magistrates and their prisoners and governors and their "charges."

Hogarth's next project was the most ambitious of his contemporary history paintings, a "modern moral subject" about "children" and the consequences of uncaring parents. It was literally a "history" painting of a recent event, the invasion of the Stuart Pretender in 1745, but from the start Hogarth intended for it to hang in the Foundling Hospital. The meaning of *The March to Finchley* (figs. 134–137) is embodied in an animal emblem in the lower right corner: as the manacled dogs epitomized the children of *Marriage A-la-mode,* the baby chicks separated from their mother (whose wing protrudes from a grenadier's haversack) epitomize the fragmentation of both war and the life from which the Foundling Hospital is a refuge.

The first announcement of the subscription on 16 March 1749/50

(*General Advertiser*) mentioned that a lottery would be used to dispose of the painting. The *General Advertiser* for 23 April added further information:

> In the Subscription-Book are the Particulars of a Proposal whereby each Subscriber of 3*s*. over and above the said 7*s*. 6*d*. for the Print, will, in consideration thereof, be entitled to a Chance of having the original Picture, which shall be deliver'd to the winning Subscriber as soon as the Engraving is finish'd.

A few days later Hogarth announced that on Monday, 30 April, at 2 P.M. the box would be opened and the drawing made. The *London Evening Post* for 28 April to 1 May reported:

> Yesterday Mr. Hogarth's Subscription was closed, 1843 Chances being subscribed for. The remaining Numbers from 1843 to 2000 were given by Mr. Hogarth to the Hospital for the Maintenance and Education of exposed and deserted young Children. At Two o'Clock the Box was open'd, in the Presence of a great Number of Persons of Distinction, and the fortunate Chance was drawn, No. 1941, which belongs to the said Hospital; and the same Night Mr. Hogarth deliver'd the Picture to the Governors. His Grace the Duke of Ancaster offer'd them 200*l*. for it before it was taken away, but it was refus'd.

It is clear from the various stories surrounding the auction that Hogarth wanted the painting to hang in the Foundling Hospital.[1] He explained later that the painting was "disposed of by lot (the only way a living Painter has any probability of being tolerably paid for his time)," remembering the amount it brought him as £300. The whole subscription must have earned him £920 and, counting only the 3*s* addendum for the lottery, the painting alone brought £276.[2]

Vertue's comments on the subscription and disposal of the painting were such as we have become accustomed to. After explaining the terms of the auction, he notes that faced with the choice everyone naturally

> rather subscribed half a guinea than 3 half Crowns; by which means he gathered about 1800 for Tickets subscription before hand—thus cunning & skill joynd to gether. changes the proverb. (say well is good, do well is better.)—for here in this case he valud the painting at 200 pounds its said—a great unbounded price, however, by this means. he

raised 900 hundred pounds. and still has the Engraved plate to dispose of prints at half guineas more—(therefore, it may well be said. do well is good, but say well is better) such fortunate successes are the effect of cunning artfull contrivance. which men of much greater merritt, coud never Get or expect—(3: 153)

At the annual Court of Governors of the Foundling Hospital on 9 May, with Hogarth (and, of the artists, Pine and Zincke) present:

> The Treasurer acquainted the General Court, that Mr Hogarth had presented the Hospital with the remainder of the Tickets Mr Hogarth had left, for the Chance of the Picture he had painted, of the March to Finchley in the time of the late Rebellion; and that the fortunate Number for the said Picture being among those Tickets, the Hospital had received the said Picture.
> Resolved.
> That the thanks of this General Court be given to Mr Hogarth, for the said Benefacation; which the Vice-President accordingly did.

This was the first meeting he had attended since he put through the resolution about engraved copies of the history paintings donated to the hospital. He did not attend another until October 1754. But it must have been with some satisfaction that he attended this meeting. He had now placed on public display one work "in each of the styles of painting which he had attempted" and which he could claim as his own.[3]

This comic history painting had not been commissioned by the governors of the Foundling Hospital—a patron who asks to see the painting from his point of view. It could be seen by anyone who came to visit the hospital on open days—Sundays—including of course the foundlings themselves, for whom *Finchley* would have been a story of castaways, children without parents, or the poor without powerful friends. Though *Moses* hung in the Court Room, *The March to Finchley* hung in one of the public rooms.

In the summer or autumn of 1750 Rouquet wrote his account of *The March to Finchley* as an addendum to his *Lettres de Monsieur**.* This seven-page pamphlet, which was bound in with the *Lettres,* can be dated only roughly: it obviously postdates February 1749 when *Tom Jones* was published, because it makes reference to that novel, and antedates January 1750/51, because Rouquet apologizes for describing the painting before the print was made, using his correspon-

dent's impatience as his excuse. More probably, he had to leave for France himself.

Hogarth employed Luke Sullivan, a young engraver who may have worked his way up in Hogarth's shop, to make a detailed drawing—and I think it likely that a separate set of carefully drawn heads is by Hogarth himself.[4] Sullivan gets full credit for the engraving in the publication line of the finished (unreversed) print. Finally, in the *London Evening Post* (which throughout advertised and reported Hogarth's progresses, although it appears within *Finchley* as a Jacobite periodical) of 29 December–1 January 1750/51 the print was announced as ready for subscribers on 3 January. Its appearance was closely followed, on 17–19 January, by a translation (without acknowledgment) of Rouquet's commentary in *The Midwife; or, The Old Woman's Magazine*. And on 7–9 March an original explication by Bonnell Thornton or one of his colleagues appeared in *The Student; or, Oxford and Cambridge Miscellany*.[5]

FINCHLEY AND TOM JONES

Fielding refers to "my friend Hogarth" in *Tom Jones,* and the Reverend James Townley wrote Hogarth on 28 February 1749/50: "I wish I were as intimate with you . . . as your Friend Fielding."[6] Their symbiant relationship continued. *Industry and Idleness* appeared in October 1747, and on 28 March 1748 Fielding opened a puppet theater in Panton Street, just a block from Leicester Fields, which operated with great popular success until he closed it in June.[7] Fielding had expressed in *The True Patriot* of 11–18 February 1746 his desire for a return from sophisticated modern plays to the vigor of the ancient Punch and Judy (or Joan) show (specifically, he adds, as a vehicle for satire). With the success of Hogarth's "George Barnwell" morality play before him, he opened his theater, which to evade the Licensing Act he passed off as entertainment accompanying "breakfast." His fare consisted of the old puppet plays seen by generations of Londoners at the fairs: *Bateman, Fair Rosamond,* and *Whittington and His Cat*—plus a revival of his own *Covent Garden Tragedy.* The whole subject came up again in Book 12, Chapter 5, of *Tom Jones,* where Tom argues for the truth and vigor of Punch and Judy shows as against the sentimental gentility of *The Provok'd Husband.* Ho-

garth may have had these matters in mind a few years later when he introduced a Punch and Judy show on the signboard in the second painting of *The Election* (ill., vol. 3).

In 1745, perhaps early in the year, Fielding began writing *Tom Jones*.[8] The rebellion known as the Forty-Five broke out in the summer, and in November he began to produce *The True Patriot,* an alarmist propaganda organ for the government, and at the same time wrote *A History of the Present Rebellion in Scotland* (pub. 1745). Fielding ends his *History* with the rout of Colonel James Gardiner's dragoons prior to the Jacobite victory at Preston Pans. This is in fact the focal encounter of his *History,* and he even includes a list of casualties. This event, which produced the scare that led to the dispatch of reinforcements to Finchley, is also the one designated by Hogarth in the signboard of "Giles Gardiner" (the "Adam and Eve" nursery) in *The March to Finchley*.[9]

Three years later, with the Forty-Five quite dead but the unpopularity of the Hanoverians undiminished, Fielding was confronted with the need to defend the Pelham ministry against opponents from the right and left, all labeled Jacobites. The journal he published for this purpose was called *The Jacobite's Journal,* for which Hogarth probably designed the headpiece.[10] In the winter of 1748–1749, as reward for his proministerial efforts, Fielding was appointed a Westminster magistrate, indeed in the place once occupied by Justice De Veil.

Tom Jones, which he was still writing as he took up his puppet theater and his police duties, was published in the same winter, at the turn of the year, with its quota of Hogarth references. Fielding describes Bridget Allworthy by referring the reader (with an "only the pen of Hogarth" sort of phrase) to the prude in *Morning* (1.11), Mrs. Partridge to the bunter in *Harlot* 2 (2.3), and Square to the warder in *Harlot* 4 (3.6). But there are many others: Jenny Jones's neighbors think of her "beating hemp in a silk gown," and Molly Seagrim wears Sophia's finery and is attacked for this by the women in the churchyard; both instances (1.9) recall *Harlot* 4.[11]

Hogarth had chosen in *Moses Brought to Pharaoh's Daughter* a comic moment in which Moses's mother is confused—at least by the puzzled looking young Moses—with his nurse and his adoptive mother with his real mother. Then in *The History of Tom Jones: A Foundling* (invariably referred to before publication as simply "The History of the Foundling"), Fielding introduces an equivalent of the scene in the bulrushes with the confusion over whether this found-

ling's mother is Jenny Jones or Bridget Allworthy, a situation in which Tom, as he grows up, is as helpless and torn as Hogarth's young Moses.

But while Fielding may have started with a foundling and the context of Coram's charitable hospital, by 1745 the subject of questionable parentage was in the air at the highest level: while in the Restoration the subject (of plays and poems) had been the succession, questioned patrimony, and royal potency (infertility with the queen, fecundity with mistresses), in the 1730s the literary imagination had been turned (by Jacobite-inclined, or rather antiministerial artists) to the upstart prime minister, Walpole, and so to upwardly mobile characters such as the Harlot and Rake, Pamela and anti-Pamelas. In the 1740s the master fiction takes as its central question the legitimacy of the royal line, and in 1745 the invasion of the charming young prince Charles Edward highlighted the absence of a clearly legitimate, traditionally accepted (a Stuart) monarch. In the historical context of the Forty-Five in Fielding's genuinely "historical" work, England has to decide between an unkingly Blifil with apparent legitimacy or an admirable Tom Jones with a bend sinister.[12]

The great religious issue of Catholic versus Protestant, indeed English versus French (the Pretender had lived in France since 1688), which underlay the problem of legitimacy and succession, played into Hogarth's hands as well: it was already at issue in the subject of art, and as well, patronage. In *Marriage A-la-mode* he made a great deal out of the patriarchal oppressiveness of baroque, Counterreformation, Roman Catholic painting. But after 1745 he painted a series of sublime histories that emphasized the English Protestant tradition of Thornhill and the "English" patrimony of the Raphael Cartoons. And for subject he chose the foundling Moses between his real and adoptive mothers—let us say, Tom Jones between Bridget Allworthy, who cannot acknowledge her son, and Jenny Jones—and the falsely accused St. Paul, a Tom Jones facing instead of Square, Molly, and Blifil, the hypocritical Felix, Drusilla, and Tertullus. Fielding and Hogarth are at the very least sharing plots, still grounded in the structure of *A Harlot's Progress* with Moll Hackabout, who like Tom has a poor "character," pitted against the respectable Charterises and Gonsons, the clergymen and prison wardens—the Blifils and Prince Charles Edwards.

In 1747 Hogarth published *Industry and Idleness,* his own psychomachia in which he split his hero between Wisdom and Pleasure,

reminiscent of the Rake's choice between Minerva and Venus: which anticipates Tom Jones's inability not to have *both* Sophia (Wisdom) and Molly Seagrim or Jenny Waters (Pleasure). Fielding places at the center of *Tom Jones* a Choice of Hercules: in Book 8 the Old Man of the Hill recalls how as a youth he chose the path of Pleasure, which he thoroughly exhausted before turning to the path of Virtue— which however led him to the sort of pleasureful virtue that wipes out the distinction. He ends so detached that he can stand by, though armed with a firearm, while Jenny Waters is being strangled by Ensign Northerton.[13] In Book 9 Tom, who rescues Jenny, is attracted by her bare breasts and eventually succumbs (first having totally satisfied his gustatory appetite) to her ogles and innuendoes. Here is Tom's choice, at the centerpoint of the novel, between Sophia and Jenny Waters (the usual languid, underdressed, gourmandizing Pleasure figure). In Book 10 Sophia arrives on the scene, too late. This sequence seems to be Fielding's attempt to place *Tom Jones* within the history-painting tradition of the Shaftesbury-Hogarth narrative of choice. But this was a "choice" between Stuart and Hanover, between Roman Catholicism and Protestantism, and between absolute monarchy and parliamentary government, as well as (in the anti-Jacobite demonology) home and brothel, water and spirits, and peace and war.

Fielding also dramatizes in *Tom Jones* a gravitation away from a hero to a group, first the family, then (by way of the rootless foundling) the army and the crowd. This is by way of a "family," but we could detect another sequence that begins with the Richardsonian paragon (Pamela or Clarissa) and proceeds, by reaction, to the mixed, the increasingly ambiguous hero (Goodchild or, in *Amelia,* Billy Booth), partly because (as in *Marriage A-la-mode* and *Clarissa*) he or she is subordinated to a family and then—as the family gets more and more out of control—to a mere crowd in what Thackeray would call a "novel without a hero."[14] A realization that informs Fielding's satiric writing after 1742—and reaches Hogarth in the 1750s—is that the system of political patronage developed by Walpole was not simply a case of personal corruption but a public and ongoing system. By the end of the 1740s both Fielding and Hogarth are representing the individual submerged in the structures of larger groups, interests, and forces.

When, later in the same year in which *Tom Jones* was published, Hogarth painted *The March to Finchley,* he expressed his homage and

response to *Tom Jones*—the equivalent of the gestures Fielding had made to him in that novel. Rouquet takes time off in his essay on *The March to Finchley* (which must have been more or less dictated by Hogarth) to devote a paragraph to *Tom Jones,* which he praises in the same terms he uses for Hogarth's work.

The central sections of *Tom Jones,* including the historical event of the Forty-Five, and Hogarth's *March to Finchley,* are both concerned with unmanageable groups of people, but standing out from the confusion around him is the figure of Tom Jones. Tom, had he been in his regiment long enough to wear a uniform, might have looked like the grenadier at the center of *Finchley.* And if Fielding nods to Hogarth when he introduces the Choice of Hercules in Tom's choice between Sophia and Jenny Jones-Waters, Hogarth re-creates this trio in his central group: if the young woman is a conflation of the young pregnant Molly Seagrim and the Ideal Sophia, the older woman, pulling him toward the brothel, invokes Tom's aging admirers, Jenny, Lady Bellaston, and even (what Jenny comes to represent in the incest plot) his mother Bridget Allworthy. Pleasure, according to *Tatler* No. 98, which retells the story of the Choice of Hercules, is a whore who will lead Hercules to a place where "the affairs of war and peace shall have no power to disturb" him.[15]

The parody of a Good Samaritan group in the right foreground refers back to Fielding's quotation of Hogarth's St. Bartholomew's painting in *Joseph Andrews.* What the biblical parable of the Good Samaritan had meant to that novel the historical rebellion of Forty-Five meant to *Tom Jones.* This fact indicates a fundamental difference between the narrative modes of the two novels, one based on a literary and the other on a historical, or more precisely political, nexus. *Tom Jones* calls itself a "history," its author an "historian."[16] For both Fielding and Hogarth the Forty-Five is a metaphor for a clash between ideals of order and stability in the Jacobite's absolute monarchy and the disorderly but very English parliamentary system of government staggering along under the Hanoverians. Absolute and limited (constitutional) monarchies represent the same oppositions that appear on the level of character in the contrasts between a theoretical paragon (like Blifil) and Tom Jones, between Sophia and the Mollies and Jennies, or, in the judgment of character, between law and mercy. These are the same poles upon which Hogarth constructs his *March to Finchley,* and they take the form of the same historical struggle that sundered families, confused loyalties, and led to egregious

misunderstandings. The amorous "choice" corresponds to the political: the young woman carries in her basket broadsides with a picture of the duke of Cumberland and the ballad "*God save our Noble King*"; the older woman wears a cross and carries "THE JACOBITE JOURNAL," "[The] LONDON EVENING POST," and "THE REMEMBRANCER," indicating her position among the Hanoverian opposition.[17]

Hogarth virtually constructs *The March to Finchley* on Fielding's principle of "contrast" discussed in *Tom Jones* (5.1), another case of taking back with the authority of Fielding's words a practice he had himself developed to a fine art in the 1730s. Fielding introduces contrast as a principle to explain his digressive essays—a reminder that in Hogarth's case contrast also depends largely on the "digressive" detail. He places a leafy tree on the left, a bare dead tree on the right; the "Tottenham Court Nursery" of "Giles Gardiner" on the left, with the sign of Adam and Eve (with puns on "gardener," the Garden of Eden, and the nursery where trees are raised—the Tree of Knowledge perhaps, but also where children are raised), and a brothel on the right with the sign of the King's Head, Charles II, the merry monarch, and fallen sexuality.

But Charles II, the whoremaster, was also the brother of the Catholic James II whose exile began the political unrest that ultimately led to this scene in 1745. Charles II was restored to the throne after an exile in France, a pattern which his namesake Prince Charles Edward was trying to repeat. The head of Charles II is marked "CR," as a contrast and a link to the "GR"'s for George II on the soldiers' haversacks. The spectator's eye moves down from the Adam and Eve to the Cain and Abel fighting beneath and to the result of the Fall, promiscuity and disorder, fanning out until it reaches the brothel on the opposite side.

The soldiers are torn between the choices of duty to king–country–parents and a free and easy life of the loose attachments symbolized by Charles and the brothel. The subject of the picture is homelessness, every soldier a lost foundling, starting with the baby chicks who have lost their hen and the parody of a Good Samaritan group. The principle of contrast serves only as an armature for the shapeless crowd, which is the picture's representational subject.

The stage-set buildings direct the eye back and inward to the focal point of the neat marching ranks in the far distance. The eponymous story goes on in the distant background, the troops marching toward

Finchley, but the foreground is all confused soldiers *not* marching to Finchley, indeed appearing to surge in the direction of the viewer. The fifer and drummer at the left and the pioneer at the right, whose duty it was to be at the head of a regiment, are in fact at its rear. So if we look for a narrative, we find that our expectations are disappointed, that this is not a narrative but rather a huge conversation picture showing a configuration of relationships based on connection and lack of connection, on platoons or families united or fragmented, on men with wives or mistresses or casual whores.

The pervasive contrast, however, is the old mock-heroic one, between the chaotic present and the ideal in the past. What this amounts to is the heroic view versus the reality of war. Even the subscription ticket for the engraving, *A Stand of Arms* (fig.138), reflects in its contrast between the Scots' outmoded weapons and the modern English ones an antiheroic view of war. (The Scottish weapons may have been sketched by Hogarth from the arms captured at Carlisle and displayed, early in 1746, in the Tower.)

But in this case the contrast is between the "March to Finchley" and heroic battle scenes such as Le Brun's grandiloquent *Battles of Alexander the Great,* which allegorically celebrated the victories of Louis XIV, and the tapestries of Louis's own battles, in their way equally allegorical. These (seen by Hogarth in France) were the official paintings that showed the military commanders in the foreground giving orders, which are being wonderfully carried out on the field by the neat lines of their troops like those distant ranks in Hogarth's painting. The antibattle scene, of the sort Hogarth is painting, also asks to be seen in the context of the *Battles of Marlborough,* the engraved series of great English victories over the French, with a precisely ordered unity of commanders and troops.[18]

A precedent, which Hogarth would have known, existed in Watteau's scenes, painted during the same War of the Spanish Succession in which Marlborough's victories took place, of the unheroic time before or between battles. *Le Camp Volant* (fig. 139) is a typical example, available in Charles-Nicolas Cochin's engraving of 1727. The closest parallel is *Le Départ de Garnison* (fig. 140), which shows troops moving out and includes departing lovers, and was available in an engraving of 1737–1738 (by Ravenet, who later worked for Hogarth on the engravings of *Marriage A-la-mode*).

In his own work the composition is anticipated by the mock-heroic *Hudibras and the Skimmington* (ill., vol. 1), the unheroic crowd-

ritual version of a Carracci processional painting, now inhabited by rustics. Dominating *Finchley* is the popular crowd that designates Saturnalia, in contrast to the thin line of soldiers marching off to war in the distance. But spiritually (if not in provable fact) Hogarth is painting in the tradition of Rembrandt's great "militia piece," *The Night Watch*, which Samuel van Hoogstraten commended for its avoidance of the dominolike rows of figures usual in such large military compositions. *The March to Finchley* evokes the original, uncut composition of *The Night Watch* in the use of lighting, which on the face of it is rather odd in the broad daylight of the Tottenham Court road. There is the interrelation of the three lighted groups at right, left, and center. A heavy shadow is cast across most of the crowd in the middle distance and slants across the buildings at the right: the sun is going down in the west. Picked out by the sunlight are the tiny lines of troops marching away in the distance and the hilltop (the town of Finchley itself), the windows of the brothel (all but one of the whores is bathed in sunlight), the three main groups in the foreground, and a few individual faces in the middle distance. Finally, Hogarth uses the same unfurled flag rising near the center background, and, above all, the S-shaped movement, forward and back, of the various groups of figures.[19]

A final graphic context is a painting such as Bruegel's *Christ Carrying the Cross* (Kunsthistorisches Museum, Vienna): the tiny figure of Christ is barely visible in the distance, and the foreground is filled with crowds of Flemish pleasure seekers (but visible among them are also the two Marys and St. John). In *Finchley,* if the column of an ideal army is glimpsed in the distance, a Madonna and Child appear on a wagon of sutlers just to the right of the Adam and Eve sign. This group may be construed as a Flight into Egypt—that is a flight *from* the Massacre of the Innocents, another Foundling reference— but the Madonna, a more idealized version of the pregnant woman at front center, of course derives from the pretty young women Hogarth has been using as normative figures. As such the Mother-Child is a small hint of the ideal between Adam and Eve and the chaos of fragmentation leading toward the brothel, between the living and dead trees—an alternative preferable to the column of soldiers in the far distance. The particular reference of the Forty-Five is thus set in the larger context of the symbolism of fertility and sterility, and once again Hogarth evokes the biblical story: The Tree of Knowledge withered after Adam and Eve ate the forbidden fruit; it was from

the wood of this tree that the cross was made—life restored only through the crucifixion of Christ, alluded to in the Madonna-Child group halfway between the two trees. The army is marching toward the dead tree, which therefore connotes war and death as well as fallen sexuality. It is important to notice how normative the Nativity story has become for Hogarth—or perhaps for the Foundling children who will be poring over this picture—now that the issue of anticlericalism has faded into the background.

ORDER OR DISORDER

Like Fielding's, Hogarth's context is not the patriotism of 1745–1746 but the perspective of current discontent in an unhappy England ruled by an unpopular foreign family and swarming with dissident elements; and, more immediately for Hogarth, the attempt by the victor of Culloden to bring the British army up to a German standard of order and precision. An English "liberty" and disorder are juxtaposed with the imposed order of the Mutiny Bill.

When the print of *The March to Finchley* appeared it bore the inscription: "To his Majesty the King of Prussia and Encourager of the Arts and Sciences! This Plate is most humbly Dedicated." One story has it that Hogarth offered the dedication to George II, who, offended by the treatment of his grenadiers, refused. He then dedicated it to Frederick II of Prussia. The spectator could as well take the dedication as a backhanded reference to the Hanoverian king's notorious indifference to the arts,[20] as opposed to Frederick's great collection, which included Watteau's most important paintings. The reference could, in fact, indicate Hogarth's debt in *Finchley* to Watteau's bivouac paintings.

But a contemporary would have taken this dedication to the king of Prussia in conjunction with the moiling confused troops as a commentary on the Mutiny Bill which was being violently and spectacularly debated in Commons in 1749–1750 and continuing into 1751. The supporters of the duke of Cumberland, on the side of the bill, might have seen the print as depicting the current chaos of English martial discipline, as opposed to the Prussian standard of order and precision advocated by Cumberland as chief of the armed forces. That there is clearly a reference to the duke of Cumberland can be

educed from his picture on the ballad sold by the young woman in the center, and perhaps also from the presence of the young fifer: Cumberland had introduced fifers into English regiments (a detail pointed out by Rouquet). Indeed, in Hogarth's own mind the central grenadier may have recalled the child Cumberland painted in his grenadier's uniform thirteen years before he commanded the forces at Culloden (fig. 3).

The duke and his supporters could read the chaos in the foreground as the satiric object of the print, with the tiny detail of the troops in the distance as the conventional ideal against which this chaos is judged. But then again, Hogarth allows opponents of the Mutiny Bill to read his print as a comment on the frequently heard assertation that the duke, the incarnation of "Prussianism," treated his soldiers "rather like Germans than Englishmen."[21] The Prince of Wales, the duke's political enemy (and sponsor of *The Remembrancer*), might have read the dedication as a reference to his brother, who was also known as the "Butcher" after the repressive massacres that followed the victory of Culloden.[22]

No brothels figured in the story of the Mutiny Act, but in another event of current interest there was a conjunction of the British armed forces, a riot, and a brothel; moreover, Fielding played a central and controversial role. The story was of some sailors of the H.M.S. *Grafton* who, on 1 July 1749, felt they had been cheated in a brothel and started to riot; joined by their comrades and many nonsailors, they destroyed three brothels and much adjacent property before the vigorous intervention of Fielding, as Bow Street Magistrate, brought the trouble to an end. Fielding also vigorously prosecuted a few of the rioters, including the riot's eponymous hero/scapegoat Bosavern Penlez. The anti-Fielding journal *Old England* represented the mob as "honest tars who, having served their country gallantly on the high seas, wanted now, in an access of patriotic zeal, to rid the capital of vice."[23] Fielding was represented as protecting the brothels (probably taking bribes) against the armed forces. He replied that they were "a licentious, outrageous Mob, who in open Defiance of Laws, Justice or Mercy, committed the most notorious Offences against the Persons and Properties of their Fellow-Subjects":

> The Clamour against Bawdy-Houses was in them a bare Pretence only. Wantonness and cruelty were the Motives of most, and some, as it plainly appeared, converted the inhuman Disposition of the Mob to

the very worst of Purposes, and became Thieves under the Pretense of Reformation.

But as to the brothels: "The Law clearly considers them as a Nuisance, and hath appointed a remedy against them; and this Remedy it is in the Power of every Man, who desires it, to apply."[24]

It is not so easy to see the relative positions of Hogarth and Fielding on this issue as it was on the those of *Tom Jones*. For example, while Fielding was not defending the brothels as property, in his *Charge to the Grand Jury,* delivered just before the riots on 29 June (published shortly after), he spoke out strongly against them as tending "directly to the Overthrow of Men's Bodies, to the wasting of their Livelihoods, and to the indangering of their Souls."[25] Hogarth, the author of *A Harlot's Progress,* would have been bemused by such effusions (as would the Fielding of *Covent Garden Tragedy*).

One consequence of Fielding's position was the trial and capital conviction of the supposed inciters of the riot. The villain of the affair, in the public view, was the judge, Lord Chief Justice Sir John Willes, who rejected the jury's plea for mercy and thrice refused to advise the king to grant a pardon (based on public petitions to the duke of Newcastle) on the grounds that the condemned men must be made an example.[26] Bosavern Penlez and fourteen others were hanged for the crime (on 18 Oct.), the antiministerial reaction was strong, and Fielding (who agreed with Willes's principle of the example) came in for his share of opprobrium. Fielding responded with a defense of his part in *A True State of the Case of Bosavern Penlez* (18 Nov.) and in a proposed bill for more stringent laws against crimes and a more efficient police force (parallel in its stringency to the Mutiny Bill). The bill extended the range of criminals to include "anyone of low birth found in the streets armed, or in a public house with a concealed weapon; any gamester; anyone guilty of open acts of lewdness, or of profane cursing and swearing; brawlers and drunkards and street-walkers; ballad singers and street musicians; indeed, anyone found abroad or in a public house after ten o'clock who could give no good account of himself."[27]

We can only speculate on where Hogarth stood on these issues. But we do know that he included the grim visage of Chief Justice Willes among the judges of *The Bench* (1758, ill., vol. 3), where judgment without mercy is at issue. From the evidence of *Industry and Idleness,* he would have agreed with the ironic "Monumental In-

scription intended for PENLEZ" that was published in late October in the *Gentleman's Magazine* and ends:

> And think thyself happy under that Government
> 'That doth *truly* and *indifferently* administer Justice,
> 'To the Punishment of Wickedness and Vice,
> 'And to the Maintenance of God's True Religion and Virtue.'[28]

We know that Hogarth was himself in London in June from the letter he wrote to Jane in Chiswick on the 6th, and so he experienced the riots at first hand. It is also evident that the category of criminals in Fielding's bill included precisely those figures Hogarth portrayed in *The Enraged Musician*. Even the story of *Paul before Felix* began significantly with a riot and the charge that Paul, "a mover of sedition among all the Jews throughout the world," had incited it.

The Penlez Riots were also conflated in the public consciousness with the unruly Westminster election of November–December, one of the longest and most riotous, bitterly fought Westminster elections on record, and one in which Fielding was again castigated by the Opposition: this time as a magistrate who used his power to support the candidacy of the ministry's candidate, Granville Leveson-Gower, Lord Trentham.[29] Trentham was opposed by Sir George Vandeput, second baronet of Twickenham. The election race was made more bitter by the support the duke of Cumberland gave Trentham and the Prince of Wales gave Vandeput. The mobs were appropriately (given the reputation of Cumberland at this time) against Trentham. The chief accusations leveled at Trentham were that he had been responsible for the king's ignoring the public desire that Penlez be pardoned and that he sponsored "the French Strollers," who performed at the Little Theatre in the Haymarket, at a time when the anti-French feeling ran especially high in England in the wake of the war that had just come to an unsatisfactory end. The attempt to prevent the French players from performing led to a riot in the theater on 14 November.

We are familiar with Hogarth's Francophobia. His attitude toward the crowd in *The March to Finchley* is at the least ambivalent. Reading Fielding's long account of riots, the law, and the Riot Act, which takes up almost the whole text of *A True Case of Bosavern Penlez*, he would have noted with interest that a "public" riot is "High-Treason within the Words Levying War against the King," and (Fielding

quotes Coke) "is levying War within the Purview of the above Statute" (37). In the accompanying note Fielding adds that such a group is "called an Army" by Coke. In *Finchley* Hogarth simply equates *riot* and *army*. From his experience in the 1730s the Riot Act was a repressive Hanoverian weapon used against the liberties of a free people. Given the evolution during these years of his aesthetic theory, it is also possible to see the crowd, moving as it does within the geometrical forms of the nursery and brothel, as embodying the formal principle of variety—the utmost variety possible—within unity, which he was to enunciate in *The Analysis of Beauty* three years later.

The rows of whores' heads tells us something about the meaning unity or order had for Hogarth: the only other ranked people in the picture besides the soldiers marching to Finchley are the whores in their rows of windows (fig. 137).[30] All try to lean out and assert their independence, but they are enclosed within a system as lacking in individuality as the ranks of soldiers. (Rouquet thinks their placement shows their ranking in a hierarchy of whores.) At any rate, all of the groupings, from Adam and Eve to the ordered geometry of the brothel, from the two pugilists fighting to the cycle of thievery and drunkenness, from child to mother to grown man, are structures of order, within which variety plays out its oppositional game.

There is a final historical context, which may bear on Cumberland's military discipline. On the night of 8 February 1749/50 London suffered an earth tremor, and a second more violent one followed exactly one month later. Charles Wesley and the bishop of London issued a sermon and a pastoral letter respectively admonishing the nation to repentance, which alone could avert the just chastisement of God. A lifeguardsman ran around London prophesying a third earthquake that would swallow the city on 4 April, one lunar month from the second earthquake. Panic set in, and in three days 730 coaches were counted passing Hyde Park Corner "with whole parties removing to the country"—in effect, another "march to Finchley." As Horace Walpole vividly describes it, great mobs of people left their houses and gathered on the commons in carriages to await the end.[31] *The General Advertiser* of 13 April viewed the affair, logically enough, in terms of a satire by Hogarth:

Not a Fribble, Bully, Wicked, or Damn'd-Clever Fellow was left in Town on Wednesday last Week.—The First Class own'd their Fright,

and pleaded their Nerves. The second sneak'd out. The Third and the Last swore furiously, on their Return, that they never flinch'd an Inch.—We hear that a True List of these Demi-men will be soon published.—If Mr. Hogarth were to oblige the Town with a Print of these woeful Wretches in their Fright and Flight, it could not be disagreeable.

Hogarth would also have been amused by *Old England*'s accustomed attack on Fielding, which on 7 April attributed the earthquakes to God's wrath at the favorable reception the public had accorded *Tom Jones*.

But already on 16 March, in the same paper, Hogarth had published an advertisement announcing such a project in *The March to Finchley*. The painting must have been finished by this time. The portrayal of chaos and inglorious mismanagement in time of crisis, to be seen at the Golden Head, may have reminded people of their own "fright and flight."[32]

But if the picture appears to be constructed on contrasts, it is also evident that the figures on the left are so determinedly stepping off, marching out toward the right, that something of the usual left-to-right movement of the *Harlot's* or *Rake's Progress* is also present: our eyes do initially move in that direction. We find that all the examples scattered across the foreground and middle distance make a kind of progression from left to right. It is not just that fertility and family are being contrasted with sterility and promiscuity. A battle scene has been transposed, beginning on the far left, into a fisticuffs match, a family dispute, a "battle of the sexes," the pain of venereal infection (we know because he is grimacing at a sign advertising "Dr. Rock," whose pill was supposed to cure, among other things, venereal disease), with the main foreground group a wife and child chiding the husband and elder son for leaving them to go off to war. Then as we move right, this becomes the central group, the grenadier and his two women, the one on the left beckoning toward the Adam and Eve side of the picture and the weeping wife of the drummer, while the old woman (who sells the *Jacobite's Journal*) pulls him off, with a violent gesture that almost detaches herself from him, toward the pillaging on the right and the houseful of whores. Her gesture leads the eye into the soldier kissing the milkmaid, who should be

delivering her milk; her spilt milk is being gathered by a soldier in his hat (a chimney sweep waits next in line), and this is witnessed by a pieman who gestures his ridicule while another soldier steals one of his pies; and behind him a keg has been punctured for a drink by yet another soldier: and so on, the links leading down to the main group on the right, the prone soldier whose comrade tries to administer a drink from his canteen, which he shuns, reaching for a glass of gin poured by a suttler whose baby greedily disputes it with him.

Families are at the left, beginning with the Adam and Eve sign and the Madonna and Child figures, and as the groups progress to the right they fragment into separations, love affairs, and one-night stands. Dryness on the left (the poor soldier who, as a result of lovemaking, cannot urinate) progresses to the pouring of liquids and a large puddle on the right. Everything toward the right is about taking something from someone else and about pouring out. Recalling the movement of liquids in *The Four Times of the Day,* the milk and wine, water and gin all seem to drain down into the puddle in which the soldier lies.[33]

The March to Finchley is, among other things, a sublimation or displacement of war as seen in conventional battle scenes. On the left we see not soldiers fighting but Adam and Eve, then the "battle of the sexes," a family dispute, fisticuffs, and the pain of venereal disease; on the right, beginning with a divisive romantic triangle, not couples but confused knots and masses of people, not killing but taking something from someone else, and, above all, not bloodletting but the flowing of intoxicating and other beverages (see below, note, 450).

HOGARTH'S AUDIENCES AND FIELDING'S

The March to Finchley was one Hogarth work that immediately elicited comments, first in the story of George II's reaction to it, and then in printed explanations, one in French and two in English. George II, with his cry "Does the fellow mean to laugh at my guards?," recognized this fact at once. Like an apprentice scrutinizing *Industry and Idleness,* he saw straight to the point of the print.[34]

Rouquet, writing for the readers "of greater penetration," in particular those in Paris, took notice of the contrast between the orderly

column of soldiers in the distance and the foreground, where (he says) "discipline is less observed." But, he goes on, reflecting both his French audience and the ambivalence of the painting itself: "if you wish to choose between the two, it is well said that order and subordination apply only to slaves, and that the quality which we (in France) call license in England is given the august name of liberty." He also goes on to say that

> what makes the painting so remarkable is Hogarth's ability to seize upon innumerable tiny details [mille petites circonstances] which escape the majority of viewers; it is a collection of these details out of which he has constructed, enriched, and diversified his work.[35]

George II and Rouquet offer a documented example of the different readings elicited and invited by Hogarth's graphic work. Rouquet fills in Hogarth's own view, beginning with an ironic apology for the painting's faults: it is too totally *new* and bears too great a resemblance to the objects it represents. It is too close to nature for comfort (one recalls Fielding's account in *Tom Jones* of Garrick's natural acting style); it lacks the signatures of smoke, varnish, and dirt that endear paintings to connoisseurs. Implicitly Rouquet contrasts this scene of the real muddle of war with the sublime representations of heroic battles in which all is order, victory, and heroism.

Fielding had elaborated on the theatrical model Hogarth had proposed in *The Laughing Audience* of 1733 (fig. 12) in *Tom Jones* (7.1).[36] After mentioning the various analogies between men and players, Fielding says that no one yet has considered "the audience at this great Drama": as of course he had done himself in his rehearsal plays. Given the importance of understanding Tom and his "character" in *Tom Jones,* the audience has become, by this time, Fielding's central concern. Based implicitly on class and wealth, but divided as to boxes, pit, and galleries, there are four symbolic groups: in the boxes, the aristocrats and nouveaux riches, to see and be seen; in the pit, the professional writers, law students, and coffeehouse critics, the "critical" element of the audience, the "men of greater penetration"; in the middle gallery the tradesmen, citizens, and their wives, who represented conventional morality and respectability; finally, in the upper gallery the footmen and apprentices, the riotous rabble who had free access if accompanying their masters and ex-

pressed their elemental opinions with shouts and rotten fruit and vegetables—which probably corresponded to the reaction of Hogarth's apprentices on the one hand and George II on the other.

Fielding characteristically includes a final segment of audience that Hogarth does not—an elite who are admitted *behind* the scenes: another idea he had developed in his rehearsal plays, which had been memorably illustrated in Hogarth's *Strolling Actresses* (fig. 53). Apparently only these spectators "can censure the Action, without conceiving any absolute detestation of the Person, whom perhaps Nature may not have designated to act in all her Dramas." The notions of a single omniscient audience and of a Tom Jones "cast" as a hero today, a villain tomorrow (used by Fielding as a kind of self-serving vindication of Tom's sexual peccadilloes) may not at this point have appealed to Hogarth. In Idle and Goodchild his emphasis is on the differing viewpoints from which they are seen rather than the "mixed" quality or complexity of each character.

For Fielding, the "critic" is the enemy. The "slanderers" of Tom and the critics of the book *Tom Jones* equally dismiss both because of a few flaws in conduct or construction—because of the inclusion of Punch and other "low" elements in a character or a plot that should have the unity of a paragon. Hogarth too, and increasingly in the 1750s, focuses on the critic. He agrees with Fielding's distinction between the negative and positive senses of critic as between a single carper and "every Reader in the World" (8.1). Both radically democratize the term, dismissing the traditional discrimination between critic or man of taste, with special skill and training, and the common reader. The difficulty is that Fielding admits in practice the virtual impossibility of communicating with such a diverse (and perverse) audience—which, as he proceeds, he turns from the hierarchical audience at a play into the judge and jury of a courtroom. This is also, of course, what Hogarth is doing—indirectly in *Moses,* directly in *Paul,* which is laid in a courtroom and supposes the audience at a trial.[37] But Hogarth subverts the court.

Paul, interestingly, predates by six months Fielding's appointment as a magistrate. It establishes Hogarth's position on the subject as essentially the same as Fielding's metaphor of a court in *Tom Jones.* But becoming a magistrate, particularly in a criminal court, changed Fielding's position: in *Tom Jones* the elements were evidence, a jury, and—the author's position—an attorney for the defense; in his sub-

sequent works, Fielding projects a court in which the author is the just but severe magistrate, a role Hogarth distrusted per se.

The experience of unruly servants at the theater in the late 1730s may have influenced Fielding's response in the 1740s to that wily servant Pamela and Mrs. Slipslop in *Joseph Andrews*. There was the stable audience in the pits and boxes, the masters; and in the galleries their servants: noisy and inattentive at the best of times, they were often riotous, sometimes locked out and battering at the doors. This was the experience (besides the Licensing Act) that Fielding carried away from his last season of 1737, from both Drury Lane and the Little Theatre in the Haymarket, in particular from his disastrous reception on the opening night of *Eurydice*. These servants who did not know their place, these illiterates who were criticizing his plays, had no business being at a play, and their rioting was also a contributing force to the passage of the Licensing Act itself. Even Joseph Andrews, when he arrives in London, becomes fashionable and, in particular, "a little too forward in Riots in the Play-Houses and Assemblies."

Fielding, a man of birth and a graduate of Eton who never let his audience forget it, while requiring educated readers as urgently as Hogarth, within his novels thematizes literacy as a distinction of superior individuals, focusing his ridicule on the affectation of literacy—inheriting this, of course, from the literary satire of Dryden, Swift, and Pope, and in particular *The Dunciad*. His precarious financial situation during the decade preceding the reward of the Westminster magistracy had made him acutely aware of his vulnerability and defensive about the poor who lacked his education and breeding, if not his blood, but were at that moment indistinguishable from him.

The principle of production and consumption was basically different for Hogarth and for Fielding. Hogarth's prints, like a theatrical performance, were seen as well as read and seen by many more than purchased or owned them—constituting a genuinely social occasion; whereas the novels of Fielding had to be read in private, and each book enjoyed a much more limited circulation. Hogarth's prints could presuppose both a mass and an elite audience in a way that was impossible for Fielding, whose "readers" could not by definition include the illiterate (though he spends a great deal of space instructing his readers in how to read his text). It is the peculiar quality of Ho-

garth's prints to play back and forth between the written and legible parts of an image—between the textual and the visual or graphic, of which (as Addison says) "it is but opening the Eye, and the Scene enters." But in the later 1740s, after the climactic "comic history-paintings" of *Marriage A-la-mode,* in *Industry and Idleness* and the prints that followed Hogarth begins to privilege the purely visual, and this is just as he coincidentally turns his attention to the plight of the poor and the illiterate. He launches into prints that distinguish—or at least open up a space for—the uneducated plebeian spectators of the theatre galleries who bring a totally different mode of understanding to his prints. For one thing, they are specifically the nonpurchasers of the prints, the apprentices who look at the prints purchased by the master and hung on their walls for their edification, but from which they draw their own meanings. At this point understanding radically breaks with education as well as property and status.

Hogarth produces a scenario that does not, of course, cancel the educated reader, but it now privileges the naive immediacy of the apprentice's apprehension, suggesting that there is a strength in this unmediated reading which the elite reader should try to appreciate—as in the contemporary poems of William Collins and the ballad collections of Thomas Percy, they were being turned from the mode of Pope ("Pope Alexander") to one that draws upon the superstitions of the Scottish highlands and other ostensibly preliterate, unmediated sources. The part of Hogarth's audience closest to himself would have been not the readers of Dryden, Pope, Swift, Gay, and Fielding, either those who *were* consumers of high art or those who were irresistibly drawn to emulative consumption (and shamed by his satire); but rather the consumer who appreciates his belatedness, cannot himself afford to buy original Old Master paintings, and so is on a par with the artist who wishes to circumvent the influence and reputation of those paintings—who cannot, for a variety of reasons as stringent as those that limited poor Tom Idle, paint them any more than his audience can purchase them.

But the reader of greater penetration—the collector who bought and kept up Hogarth's folios—is urged to enjoy the apprentice's stronger point of view, as Collins urged his readers to appreciate the vigor of the primitive Scottish superstitions. It does not occur to the penetrative reader, for example, to take sides. He is in fact being

moved toward the position of Shaftesbury's distinterested aesthetic observer.

Hogarth was never a subversive artist. Overturning never occurred to him. But we can safely say that his works, in virtually every case, show a dissident awareness and awaken such an awareness in his audience. In the reading of his prints he invites a participation that is egalitarian, inclusive, and in many ways transgressive. The prints (and many of the paintings as well) habitually expose and disrupt hierarchical relations, question and undermine accepted (and unexamined) ways of reading, thinking, and doing things. Incoherence or the heterogeneous often seem to have a positive value for Hogarth. The family, for example, was problematized in his conversation pictures by the insurgency of children and pets, and the character's "identity" itself by the increasing domination of the works of art he or she collects. In the *Harlot's* and *Rake's Progress,* the notion of a character's "life" or "spiritual biography" was put in question by the fragmenting of "character" into aspiration and imitation, the mediated fantasies of the pictures on his or her walls and the unmediated instincts of the animals at his or her feet.

With both of these categories, "family" and "character," if we search for a counterform we come up with theater, the mode that Hogarth adopted from *The Beggar's Opera* and later used to describe his "modern moral subjects"—a "sort of dumb shew" (AN, 209). As the whole antitheatrical tradition in England attests, theater permits one to experiment with other selves, including the sublime and grotesque—to fragment or dissolve the "true" or best self, which means the integrity of the self, self-knowledge ("Know Thyself"), and regularity of conduct. Hogarth fairly consistently presents his imaginary world as a theater; moreover, he theatrically fragments his own character as well as those of his Harlot and Rake. He clearly disapproves of their homemade identities, assuming the presence of an original true identity, but he is intrigued and obsessed with the possibilities of such alternatives for himself, giving us Ferdinand *and* Caliban and, at last, Goodchild *and* Idle.

But by killing off Idle he ultimately contains these disruptive and heterogeneous energies. He knows that his patrons, the purchasers of his folios and collectors of his prints, both fear being locked in by convention and love their conventions. In practice, his reading structure, with its dialectic of interpretation, its existence as a social event

of two or more spectators discussing it, presupposes spectators who probe into its recesses and are aroused to consciousness if not to action; and at the same time it provides possibilities for the complacency of sheer playfulness, as one gestalt shifts into another (first you see it this way, then that way). This playfulness based on double gestalts, probably the real origin of the Hogarthian reading structure which by the 1730s and 1740s has become politicized, will be the aspect of his "modern moral subject" that he aestheticizes in his writings and engravings of the 1750s.

Vertue's denigration of Hogarth's "low" materials draws attention to a socio-historical phenomenon corresponding to the schizophrenia of *Industry and Idleness.* In the 1730s the announcement of a "low" subject (as in the *Harlot)* could be taken as a broadly-based anti-aristocratic, and so bourgeois, manifesto. The "low" was worn proudly among other antiaristocratic attributes by the rising bourgeoisie. But in the 1740s an urge toward respectability was driving out the "low," as can be seen in Richardson's polite revisions of *Pamela* and in the critical comments by Richardson and others on Fielding's novels. The Richardsons were now demonizing the low, detaching it from themselves and associating it with plebeians, while defining themselves in terms of polite and sentimental gentility.

But in a significant way the "low" was cherished by both high and low audiences. However far apart in other ways, they shared an ethos of personal liberty (especially loose living, sexual excess, drinking, and swearing) which defined itself in reaction to the respectable middle class. Aristocrats had their models in Restoration rakes and libertine philosophers and regarded the ability to undermine both sides of an issue as an escape valve from the responsibilities of a ruling elite. The apprentices' "libertine" acts of subversion (up through rioting) were equally escapist, but from the oppressive weight of the society in whose functioning they had no part whatever. Hogarth's career witnessed and exploited the convergence of underclass skepticism and aristocratic Deism or philosophical atheism.

If the aristocratic rake and the apprentice (and the many more who projectively imitated one or the other) were Hogarth's model audience, it is only because they were equally dissident. As *Marriage-A-la-mode* shows, he had no time for aristocrats per se. While he understood the value of the comedy of dissidence, his great discovery—increasingly emphasized in the 1740s—was the energies of the

subculture. He in effect dramatizes the situation of the subculture, incidentally addressing it as one apprentice to another. His prints are in fact more about the absorption of the vital subculture energy into the fabric of society, and the ironies engendered thereby, than anything remotely resembling a call to arms of the masses. Hogarth's prints are of course, in this sense, about himself and his own psychomachia.

NOTES

ABBREVIATIONS AND SHORT TITLES

Analysis	William Hogarth, *The Analysis of Beauty* (1753), ed. Joseph Burke (Oxford, 1955).
Antal	Frederick Antal, *Hogarth and His Place in European Art* (London, 1962).
Apology for Painters	Hogarth's "*Apology for Painters,*" ed. Michael Kitson, Walpole Society, 41 (Oxford, 1968): 46–111.
AN	William Hogarth, "Autobiographical Notes," in *The Analysis of Beauty,* ed. Joseph Burke (Oxford, 1955).
Battestin, *Fielding*	Martin C. and Ruthe R. Battestin, *Henry Fielding: A Life* (London, 1989).
Beckett	R. B. Beckett, *Hogarth* (London, 1949).
Biog. Anecd.	John Nichols, George Steevens, Isaac Reed, et al., *Biographical Anecdotes of William Hogarth* (London, 1781, 1782, 1785).
BL	British Library
BM	British Museum
BM Sat.	*British Museum Catalogue of . . . Political and Personal Satires* (London, 1873–1883).
Cobbett	Pitt Cobbett, *Parliamentary History* (London, 1810 ff.).
Coley	*Hogarth on High Life: Lichtenberg's Commentaries,* trans. and ed. A. S. Wensinger and W. B. Coley (Middletown, 1970).
Commons	*Dictionary of the House of Commons: 1709–1754,* ed. Romney Sedgwick (London, 1970); *1754–1790,* ed. Sir Lewis Namier and John Brooks (London, 1964).
Cowley	Robert L. S. Cowley, *Hogarth's "Marriage-A-la-mode"* (Ithaca, 1983).
Croft-Murray	Edward Croft-Murray, *Decorative Painting in England, 1537–1837, 2: Eighteenth and Early Nineteenth Centuries* (London, 1970).
Dabydeen	David Dabydeen, *Hogarth, Walpole and Commercial Britain* (London, 1987).

Davies	Martin Davies, *National Gallery Catalogues: The British School* (London, 1959).
DNB	*Dictionary of National Biography*, ed. Leslie Stephen and Sidney Lee, 66 vols. (London, 1885–1901).
Dobson	Austin Dobson, *William Hogarth* (London, 1907 ed.).
De Voogd	P. J. De Voogd, *Henry Fielding and William Hogarth: The Correspondences of the Arts* (Amsterdam, 1981).
ECS	*Eighteenth-Century Studies*
Edwards, *Anecdotes*	Edward Edwards, *Anecdotes of Painters who have resided or been born in England . . . Intended as a Continuation to the Anecdotes of Painting of the Late Horace Earl of Orford* (London, 1868).
Garrick Letters	*The Letters of David Garrick*, ed. D. M. Little and G. M. Kahrl, 3 vols. (Cambridge, Mass., 1963).
Gen. Works	John Nichols and George Steevens, *The Genuine Works of William Hogarth*, 3 vols. (London, 1808–1817).
George	M. Dorothy George. *English Political Caricature to 1792* (Oxford, 1959).
GM	*The Gentleman's Magazine*
HGW	Ronald Paulson, *Hogarth's Graphic Works: First Complete Edition* (New Haven, 1965; revised eds., 1970; London, 1989).
HLAT	Paulson, *Hogarth: His Life, Art, and Times.* 2 vols. (New Haven, 1971).
HMC	*Historical Manuscripts Commission*
J. Ireland	John Ireland, *Hogarth Illustrated*, 3 vols. (London, 1791–1798; 1805 ed.)
S. Ireland	Samuel Ireland, *Graphic Illustrations of Hogarth*, 2 vols. (London, 1794–1799).
Jacob	Margaret C. Jacob, *The Radical Enlightenment: Pantheists, Freemasons and Republicans* (London, 1981).
Jarrett	Derek Jarrett, *The Ingenious Mr. Hogarth* (London, 1976).
Lichtenberg	Georg Christoph Lichtenberg, *The World of Hogarth: Lichtenberg's Commentaries on Hogarth's Engravings,* trans. of the *Ausführliche Erklärung* by Innes and Gustav Herdan (Boston, 1966).
Lindsay	Jack Lindsay, *Hogarth: His Art and His World* (London, 1977).
Lippincott	Louise Lippincott, *Selling Art in Georgian London: The Rise of Arthur Pond* (New Haven, 1983).
LM	*The London Magazine*

LS	*The London Stage,* pt. 2: 1700–1729, ed. Emmett L. Avery, 2 vols; pt. 3: 1729–1747, ed. Arthur H. Scouten; pt. 4: 1747–1776, ed. George Winchester Stone, 3 vols. (Carbondale, Ill. 1960–1962).
Mackey	Albert G. Mackey, *Encyclopedia of Freemasonry* (Chicago-New York-London ed., 1921), 2 vols.
Mellon, Yale	Paul Mellon Collection, Yale Center for British Art
Mitchell	Charles Mitchell, ed., *Hogarth's Peregrination* (Oxford, 1952).
Moore	Robert E. Moore, *Hogarth's Literary Relationships* (Minneapolis, 1948).
NPG	John Kerslake, *National Portrait Gallery: Early Georgian Portraits,* 2 vols. (London, 1977).
J. B. Nichols	J. B. Nichols, *Anecdotes of William Hogarth* (London, 1833).
Nichols, *Literary Anecdotes*	John Nichols, *Literary Anecdotes of the Eighteenth Century,* 9 vols. (London, 1812–1815).
Oppé	A. P. Oppé, *The Drawings of William Hogarth* (London, 1948).
Paulson 1975	Ronald Paulson, *The Art of Hogarth* (London, 1975).
Paulson 1979	Paulson, *Popular and Polite Art in the Age of Hogarth and Fielding* (South Bend, 1979).
Paulson 1982	Paulson, *Book and Painting: Shakespeare, Milton, and the Bible* (Knoxville, 1982).
Paulson, *E and E*	Paulson, *Emblem and Expression: Meaning in English Art of the Eighteenth Century* (London and Cambridge, Mass., 1975).
Phillips	Hugh Phillips, *Mid-Georgian London* (London, 1964).
Plomer	Henry R. Plomer, *Dictionary of the Printers and Booksellers who were at Work in . . . England from 1668 to 1725 and . . . from 1726 to 1775,* 2 vols. (Oxford, 1922–1932).
Pye	John Pye, *Patronage of British Art* (London, 1845).
Quennell	Peter Quennell, *Hogarth's Progress* (New York, 1955).
Roberts	J. M. Roberts, *The Mythology of the Secret Societies* (New York, 1972).
Rouquet	Jean André Rouquet, *Lettres de Monsieur ** à un de ses Amis à Paris* (London, 1746).
Shesgreen	Sean Shesgreen, *Hogarth and the Times of the Day Tradition* (Ithaca, 1983).
J. T. Smith	J. T. Smith, *Nollekens and His Times* (1828), ed. Wilfred Whitten, 2 vols. (London, 1917).

Spectator	*The Spectator,* ed. Donald F. Bond, 5 vols. (Oxford, 1965).
Survey of London	*London County Council Survey of London,* ed. J. R. Howard Roberts and Walter H. Godfrey (London, 1900–).
Tate	Elizabeth Einberg and Judy Egerton, *Tate Gallery Collections, II: The Age of Hogarth, British Painters Born 1675–1709* (London, 1988).
Trusler	John Trusler, *Hogarth Moralized* (1768), ed. John Major (London, 1831).
V & A	Victoria and Albert Museum, London
Vertue	George Vertue, *Notebooks,* 6 vols. (Oxford: Walpole Society, 1934–1955).
Walpole, *Anecdotes*	Horace Walpole, *Anecdotes of Painting in England,* 4 (1771, released 1780), ed. James Dallaway (London, 1828).
Walpole, *Corr.*	*The Yale Edition of Horace Walpole's Correspondence,* ed. W. S. Lewis (New Haven, 1937–1983).
Waterhouse	Ellis Waterhouse, *Painting in England, 1530 to 1790* (London, 1953).
Whitley	W. T. Whitley, *Artists and Their Friends in England, 1700–1799,* 2 vols. (London, 1928).

PREFACE

1. See J. H. Plumb, *The Commercialization of Leisure in Eighteenth-Century England* (Reading, 1974); Neil McKendrick, John Brewer, and Plumb, *The Birth of a Consumer Society* (Bloomington, 1982); and in particular Brewer, "'The Most Polite Age and the Most Vicious': Attitudes towards Culture as a Commodity, 1660–1800," in *The Consumption of Culture: Word, Image, and Object in the 17th and 18th Centuries,* ed. Ann Bermingham and Brewer (Los Angeles, 1992). The following paragraphs draw upon my essay "Emulative Consumption: The Harlot, Moll Flanders, and Mrs. Slipslop," in the same volume.

2. See Harold Perkins, *The Origins of Modern English Society, 1780–1880* (London, 1969), 23.

3. Fry, *Reflections on British Painting* (London, 1934), 35–37.

4. Robert E. Moore made an implicit claim for Hogarth in this regard, but in a book on Hogarth, not on the English novel (see Moore).

5. In Antal's naïve Marxist interpretation, Hogarth was simply an exemplar of the rising bourgeoisie and a "reformer" who tried to save the lower classes by attacking gin drinking. In the more sophisticated and anti-essentialist criticism of today he is ineluctably determined by the con-

straints of his ruling class ideology. I have found more useful the essays of
E. P. Thompson and his followers, which focus on subculture transgression
in terms of particular historical issues (this was the stimulus of my *Popular
and Polite Art,* Paulson 1979). I have found Foucault and his followers end-
lessly stimulating, more in the terminology of discourse than of imprison-
ment, but in need of subordination to relentlessly historical facts of both
chronology and textuality.

6. Cited, Terry Eagleton, *Marxism and Literary Criticism* (Berkeley and
Los Angeles, 1976), 18.

1. PATRON AND PUBLIC (I)

1. Jonathan Swift, *Correspondence,* ed. Harold Williams (Oxford, 1963–
1965), 4: 391–92; Alexander Pope, *Correspondence,* ed. George Sherburn
(Oxford, 1956), 3: 436.

2. Boydell's print of Hogarth's *Scene from "The Indian Emperor"* (1791)
says the performance was held in Conduitt's house in 1731 (presumably
1731/32), before the younger members of the royal family. The original
contents of the room, including the bust of Newton were sold on 27 De-
cember 1750, by John Heath at the Exeter 'Change (*Daily Advertiser;* cited
by Phillips, 244).

3. *London Evening Post,* 27–29 Apr. 1732, tracing the duke of Cumber-
land's week (eleven years old at this time); letter of Dr. Alured Clarke to
Mrs. Clayton, 22 Apr. 1732, in National Library of Scotland, MS. 826,
f. 45*v;* reprinted in Katherine Thomson, ed., *Memoirs of Viscountess Sundon*
(1847), 2: 112.

4. Letter from Thomas Hill to John Conduitt, London, 20 June 1732,
in Earl of Portsmouth MSS., *HMC,* 8th Report, app., pt. 1 (1881), 62b.
Hill later commented, in an undated letter to Conduitt: "Lady Caroline has
complied with your request, and I hope Hogarth has done you justice and
her too" (63b). While the picture was commissioned by the Conduitts, it is
first heard of in 1778 in the second Lady Holland's collection. Beckett, un-
aware of the letters connecting Conduitt with the picture, inferred that it
had been commissioned by the duke of Richmond (42). Evidently it passed
to Kitty Conduitt in 1740 when she married Viscount Lymington (John
Conduitt died in 1737 and was buried in Westminster Abbey at Sir Isaac
Newton's right hand), and she gave or willed it to her friend Lady Caroline
Lennox, who appears in the picture and who in 1743 married Henry Fox
and in 1762 became first Lady Holland.

5. Vertue 3: 68, dated 1733. It does not seem to have been painted for a
member of the royal family.

6. The identifications made years later in Boydell's engraving seem ar-
bitrary since they refer to averted heads. But see *Gen. Works,* 2: 279, and

Elizabeth Einberg, *Manners & Morals: Hogarth and British Painting, 1700–1760* (London, Tate Gallery, 1987), no. 68; for an account of the picture as it hung in Holland House and identification of the sitters, Katherine Thomson, ed., *Recollections of Literary Characters and Celebrated Places* (1854), 1: 112.

7. Hogarth had a cast of the Newton in his house (Jane Hogarth's sale catalogue, 1790, no. 56).

8. Actually the luckless Huggins did not enjoy a successful reception of his opera on its first night. On Huggins's oratorios and his and Hogarth's common interest in music, see below, Chap. 3.

9. Salt glazeware mugs with *The Midnight Modern Conversation* on them, one dated 1732 (i.e., 1732/33, with R M to the sides and a B over the design), are in the Williamsburg (Va.) Museum.

10. *Daily Courant,* 5, 8 Feb. 1732/33; *Daily Journal,* 8, 10 Feb.; *Daily Post,* 16 Feb. As Margaret Anne Doody suggests, she admitted theft and denied murder, knowing that while both were capital offenses, the former was frequently pardoned. See Doody, "The Law, the Page, and the Body of Woman: Murder and Murderesses in the Age of Johnson," *The Age of Johnson,* ed. Paul Korshin, 1 (1987): 130.

11. *Old Bailey Sessions Papers 1733,* no. 3, pt. 2 (Feb.), 91–92.

12. *Daily Journal,* 21, 26 Feb.; *Daily Courant,* 22, 23 Feb.

13. *Daily Journal,* 27 Feb.; *Daily Courant,* 4 Mar.

14. On the ordinary's narrative, see *Industry and Idleness,* below, Chap. 12.

15. *Craftsman,* 10 Mar.: "Monday Sarah Malcolm sate for her Picture in Newgate, which was taken by the ingenious Mr. Hogarth; Sir James Thornhill was likewise present"; *Daily Advertiser,* 7 Mar.

16. See Doody, "The Law," 131.

17. *GM,* 55 (1785): 345.

18. *Daily Post, Daily Courant,* and *Daily Journal,* all 8 Mar.

19. See Nicholas Rogers, *Whigs and Cities: Popular Politics in the Age of Walpole and Pitt* (Oxford, 1989), 374, 376–77; Paul Langford, *The Excise Crisis: Society and Politics in the Age of Walpole* (Oxford, 1975).

20. Vertue, 3: 68; see also Oliver Millar, *Pictures in the Royal Collection: Tudor, Stuart, and Early Georgian Pictures* (London, 1963), nos. 184, 559.

21. This large work was finished by 15 August 1734 when the bill ("for the Hunting Piece for the Earl of Cholmondeley") was drawn up. On 31 August a payment of £246 15s was made, of which £31 10s "To Mr Hogarth for Painting six Faces in the Picture at 5 Guineas Each Face" (Duke of Cornwall MSS., 4: f. 216, in Millar, *Early Georgian Pictures,* 183 (repro., pl. 205). See Vertue 3: 61–62; R. W. Symonds, "Hogarth a Ghost for Wootton," *Burlington Magazine,* 81 (1942): 176–79; Oliver Millar, "John Wootton, William Hogarth and Frederick, Prince of Wales," *Burlington Magazine,* 103 (1961): 383–84.

22. *Lord Hervey's Memoirs,* ed. Romney Sedgewick (London, 1952), 58, 77.

23. Tobias Smollett, "Advice" (1746), ll. 17–18. Kent himself was paid for "making designs to adorn the Royal Chapel at St. James's for the marriage of the Princess Royal" (1734, P.R.O., L.C. 5/150).

24. Moreover, if Kent had forgotten about Hogarth, he was reminded at the very beginning of the year when the *Daily Journal,* in which Hogarth was advertising his subscription for *A Midnight Modern Conversation,* announced on 3 January: "A Print representing an Epistle on Taste. Written by M. P–pe. Which may serve for its Frontispiece. . . . Price 1 *s.*" While this print does not remotely resemble Hogarth's style, it is evident that many contemporaries attributed the anti-Pope, anti-Burlington, anti-Kent satire to him on the basis of the Burlington Gate the print appropriates from Hogarth's *Masquerades and Operas,* with Kent still astride its top. (It is of course possible that Hogarth furnished a sketch which someone else etched.) Even if Kent did not believe Hogarth made this print, he would have been reminded of the earlier one. The pamphlet *The Man of Taste,* which used a copy as frontispiece, also kept the print in the public eye. See *HGW* 1965, 1970, cat. no. 277, pl. 321.

25. *Daily Post,* 17 Oct.

26. *Daily Journal,* 25 Oct. 1733; *Daily Post,* 27 Oct.; *Daily Post,* 30 Oct.

27. *Daily Journal,* 6 Nov. The final blow came a year later when on 24 October 1734 the *Daily Advertiser* announced: "*This Day is publish'd,* A Print of the ceremony of the Marriage of her Royal Highness the Princess Royal with his Serene Highness the Prince of Orange in the Chapel at St. James's, from Mr. Kent's Design. Engrav'd by Mons. Rigaud. To be had at several Print-shops."

2. PATRON AND PUBLIC (II)

1. *London Journal,* 22 Dec., 1 Jan. The first announcement of the subscription, however, was on 9 October 1733 in the *Daily Advertiser;* repeated 10 Oct. and 7 Dec. On the 8th the date was changed to "on the 1st," and from the 10th it ran in every issue through the 23rd, and again from 17 to 29 December. The painting (Cincinnati Art Museum) itself is a remarkable accomplishment but seriously damaged. Still beautiful at a distance, all the highlights have been retouched by an unskilled hand (in the 1960s) and the detail of the painting can no longer be attributed to Hogarth.

2. *Daily Post,* 29 May 1733; see *An Apology for the Life of Mr. T*[heophilus] *C*[ibber], *Comedian* (1740), 16, 85–89; Benjamin Victor, *The History of the Theatres of London and Dublin, from the Year 1730 to the Present Times* (London, 1761), 1: 4.

3. *Daily Advertiser,* 4, 27, 31 July (for Saturday, 4 Aug.) 1733, *General Advertiser,* 29 Mar. 1748.

4. *Daily Post,* 13 Nov. 1733; *Daily Post,* 13, 14, 16 Nov.; *Grub-street Journal,* 6 Dec.; *Daily Journal,* 1 Feb. 1733/34; *GM,* Nov. 1733 and Mar. 1734. The announcement of *Southwark Fair* was in the *Daily Journal,* 22 Dec. 1733, and again on 19 and 26 Jan. 1733/34.

5. On 25 August was published "A Curious Print of BARTHOLO-MEW FAIR, printed on a large Elephant Sheet of Paper, representing its various Diversions and Humours; to which is added, an Historical account of it from its Original in King Henry IId's time" (*Daily Advertiser,* 25 Aug. 1733). The appearance of this print suggests that word of Hogarth's had leaked out, not that he took his idea from it; but he may have felt he should therefore turn to the other fair.

6. *LS,* pt. 3, 1: 312–14. In September, the *Harlot's Progress with the Diverting Humours of the Yorkshire Waggoner* was playing in Yeates's Booth; another version, with *Jephtha's Rash Vow,* was playing at the Lee-Harper Booth. The same had appeared earlier in the summer at Bartholomew Fair, except that *The Fall of Bajazet* was also playing there, at the Cibber–Griffin–Bullock–Hallam Booth, and apparently did not continue at Southwark Fair.

7. See S. Ireland, 1: 110; Beckett, pl. 62. The oil sketch is in a private collection.

8. *Gen. Works,* 1: 46.

9. Hogarth also claims that his "scenes" would be made "intelligible" by the "actor figures" (AN, 203); and: "I have endeavourd to weaken some of the prejudices belonging to the judging of subjects for pictures, by comparing these with stage compositions the actors in one sugesting whats to the spectator" (211). Hogarth probably recalled Jonathan Richardson's many analogies between history painting and the stage, and in particular the one in which he refers to a painting as a "dumb-shew" (*Essay on the Theory of Painting* [1715], in *Works* [London, 1774], 172).

10. Reprinted, *The Prompter: A Theatrical Paper 1734–36 by Aaron Hill and William Popple,* sel. and ed., W. W. Appleton and K. A. Burnim (New York, 1966), 160.

11. *The Progress of a Rake: Or, The Templer's Exit* (1732).

12. *The Accomplish'd Rake,* in *Four before Richardson,* ed. W. H. McBurney (Lincoln, Neb., 1962), 277, 301. Hogarth may also have been intrigued by the scene at the Covent Garden masquerade, which leads to a bagnio (cf. *Marriage A-la-mode* 5).

13. See Hilda Kurz, "Italian Models of Hogarth's Picture Stories," *Journal of the Warburg and Courtauld Institutes,* 15 (1952): 155, pls. 35, 36.

14. In a later state Hogarth augmented Nero, replacing another of the

decollated Roman emperors with the face of the chef Pontac, I presume to suggest that Rakewell also aspired to gluttony as well as cruelty, lechery, and the like.

15. For annotation and more detail, see Paulson, "Life as Journey and as Theater: Two Eighteenth-Century Narrative Structures," *New Literary History*, 8 (1974): 291–320.

16. See Felicity Nussbaum, "'By These Words I Was Sustained': Bunyan's *Grace Abounding*," *ELH*, 49 (1982): 18–34.

17. Shaftesbury's *Characteristics* (1709), his *Notion of the Historical Draught or the Tablature of the Judgment of Hercules* (1713), and Richardson's *Science of the Connoisseur* (1719).

18. For the references to Richardson and Mandeville, see vol. 1, 334ff.

19. For a more elaborate series of parallels, see Werner Busch, *Nachahmung als bürgerliches Kunstprinzip: Ikonographische Zitate bei Hogarth und in seiner Nachfolge* (Hildesheim, 1977).

20. Hogarth may have had in mind Maria in Lillo's *London Merchant*, who loves Barnwell, helps Trueman try to cover up Barnwell's embezzlement, and is reunited with Barnwell in the prison cell where he is confined awaiting execution. Or he could have recalled the old song, modernized in John Oldmixon's "The Nut-brown Maid" (1707) and Prior's "Henry and Emma" (1709), about the Griselda who does anything to stay near her beloved, even when he is unfaithful.

21. Marlowe, *Doctor Faustus*, V.i.58–61; or Portia's speech in Shakespeare's *Merchant of Venice*, IV.i.184–86.

22. Frank and Dorothy Getlein, *The Bite of the Print* (New York, 1963), 152. See Edward G. O'Donoghue, *The Story of Bethlehem Hospital from Its Foundation in 1747* (London, 1913), 244, who believes that *Rake* 8 "looks as though it were also an endorsement of a subscription-book at that time being circulated through the city" to pay off the debt for the new wing built for female incurables.

23. It is clearly not, as has been argued, a first thought for the first scene (Kunzle, "Plagiaries-by-Memory of the Rake's Progress," *Journal of the Warburg and Courtauld Institutes*, 29 [1966]: 322). If the young man came into his money by marrying a wealthy old woman before the viewer knew anything else about him, the typical Hogarth story line, already presented in the *Harlot*, would be lost. The elaborate double-dealing shown here is not characteristic of the Tom Rakewell who (though his eye may wander from his old wife to a young bridesmaid) is determined to emulate the stereotype of a rake. If the sketch represented a first scene, it would have been for another series, perhaps *Marriage A-la-mode*.

Another oil sketch, somewhat larger (25 x 39 inches, as opposed to 19 x 25), in the Atkins Museum, Kansas City, is probably not by Hogarth

(but see Ross E. Taggart, "A Tavern scene: An Evening at the rose [Study for Scene III of 'The Rake's Progress']," *Art Quarterly,* 19 [1956]: 321–23). The most likely conclusion is that the painting is by someone who copied Hogarth's picture and then made a few changes to make it appear a preliminary sketch.

24. For a later use of the Madonna and the Holy Family by a Hogarthian follower, John Zoffany, see Paulson, *E and E,* chap. 9.

25. Dabydeen (132–35) sees an analogy between Rakewell and Walpole's association with Oxford, his profligate sex life, his rise from middling to aristocratic rank, his collecting of Old Master paintings and support of the opera, his luxury and decadence, his self-association with Roman leaders (and by his enemies with the emperors), and his courting of Queen Caroline. I suspect that a faint trace of Walpole is present in the first four plates, but that it is less a political statement than a reflection of Walpole's as the typical liberal-progressive career of the time, later embodied as well in Richardson's *Pamela* and in Fielding's responses to *Pamela* (see below, Chap. 8).

26. See Suetonius, *Nero,* 38.2; Tacitus, *Annals,* 15.38–39. For these parallels I am indebted to R. L. S. Cowley's interesting master's thesis, "An Examination and Interpretation of Narrative Features in 'A Rake's Progress,'" (Birmingham Univ., 1972).

27. Discussed in vol. 1, 28–32.

28. "But it is granted that colouring was not Mr. Hogarth's *forte,*" said his close friend and admirer Thomas Morell (Letter to John Nichols, *Gen. Works,* 1: 318). Hogarth's obituarist in the *Public Advertiser* (8 Dec. 1764, perhaps Morell) felt that he "must observe in general of this excellent Painter, that his colouring is dry and displeasing, and that he could never get rid of the appellation of a *mannerist,* which was given him early in life."

29. Studies of visual perception show that in "reading" a picture the eye moves from the lower left up and into the depth of the picture and toward the right. See Mercedes Gaffron, "Right and Left in Pictures," *Art Quarterly,* 13 (1950): 312–31; also Heinrich Wölfflin, "Ueber das Rechts und Links im Bilde," in *Gedanken zur Kunstgeschichte* (Basel, 1941), 82–96; Rudolph Arnheim, *Art and Visual Perception* (Berkeley and Los Angeles, 1966), 22–24. The same holds true on a stage: when a curtain rises the audience looks to the left; actors consider the left the strong side of the stage, and the actor furthest to the left dominates a group (Alexander Dean, *Fundamentals of Play Directing* [New York, 1946], 132); also Paulson, *E and E,* 44–45.

30. Only the second plate is unreversed, and the painting was clearly painted without reversal in mind. Here as in *Southwark Fair,* however, Hogarth tends to make the picture come down at left and right, so that the viewer can enter from either direction.

31. Hogarth's use of reversal should be related to the model of Raphael's

reversal in the Cartoons, which were made as modelli for transfer into tapestries, as Hogarth's were made for transfer into engravings. They have therefore a peculiarly ambiguous reading structure (for further discussion, see Paulson 1982, 64–65).

32. Getlein, *Bite of the Print,* 41.

33. John Elsum, *Art of Painting,* 63–64. See also Jonathan Richardson, *Essay on the Theory of Painting,* in *Works,* 84.

34. Dryden, "A Parallel of Painting and Poetry," in *Works,* 20 (Los Angeles and Berkeley, 1989): 71–72.

35. See Richardson, *Works,* 82–83, 233–35, where he goes into detail on the differences between painting and print in terms of both color/monochrome and original/copy. It is difficult to imagine Hogarth not knowing these passages.

36. Marjorie Hope Nicolson, *Newton Demands the Muse* (Princeton, 1946), 150 (referring to Young's *Night Thoughts*).

37. See Dean Tolle Mace, "Ut Pictura Poesis: Dryden, Poussin and the Parallel of Poetry and Painting in the Seventeenth Century," in *Encounters,* ed. John Dixon Hunt (London, 1971), 62–63.

38. John Hoadly to Robert Dodsley, 1 Nov. 1757, in Hyde Collection (Houghton Library, Harvard). The verses were reprinted in Dodsley's fifth *Miscellany* of 1758. Hoadly wanted his verses printed entire and continuously, as they were only "printed piecemeal under the Prints." They "are well known to be mine."

39. For Overton's 1733 catalogue, see *HMC,* 15th Report, app., pt. 7 (1898), 233.

40. *Gen. Works,* 1: 76, as told by Hogarth to Sir John Hawkins. Michael Lort wrote on his copy of *The Case of Designers, Engravers, Etchers, &c. Stated in a Letter to a Member of Parliament* (1735): "Hogarth got this drawn up & an act of Parliament passed to preserve the copy right to Engravers in Consequence of his Harlots Progress having been so often & so [?] Copied" (V & A, 233.1g22/E388).

41. For elaboration, see Paulson, "Emulative Consumption and the Rise of the Novel," in Bermingham and Brewer, eds., *Consumption of Culture.*

42. See Locke, *Second Treatise on Government* (pub. 1704), chap. 5; Paulson, *Breaking and Remaking* (New Brunswick, 1989), 246–59.

43. See Marjorie Plant, *The English Book Trade,* 2d ed. (London, 1965), 118; Harry Ransom, *The First Copyright Statute: An Essay on an Act for the Encouragement of Learning* (Austin, 1950), 64, 77.

44. *Journals of the House of Commons,* 22: 364. The text of the act itself is reproduced in *HLAT,* Appendix E.

45. *Journals of the House of Commons,* 22: 380–81, 401, 414, 442, 457.

46. *Journals of the House of Lords,* 24: 516, 530; *Journals of the House of Commons,* 22: 476.

47. See above, n. 25. One wonders whether the Walpole issue led Hogarth to change "Julius Caesar" to "Pontac" in a later state of Plate 3.

48. Sir John Hawkins, *The Life of Samuel Johnson, LL.D.* (1787), 500n; cf. my misstatement in *HLAT,* 1: 290.

49. See Dabydeen, 140, who also notes that Thornhill consistently voted with Walpole in the House of Commons, including the Excise Bill vote of 1733. See *The Ever Memorable List of Those Who Voted for and against the Excise* (1734) and Cobbett, 8, 1722–1733 (1811): 703–34, 1311.

50. *Daily Advertiser,* 3 May 1735; repeated 5, 7–9 May.

51. See Kunzle, "Plagiaries-by-Memory."

52. *Journals of the House of Commons,* 22: 493.

53. For an ambiguity Vertue detected in the act, see 6: 200.

54. *7 George III,* Cap. 38, passed in 1767; for the commemorative print, the subscription ticket for the *Election,* see *HGW,* no. 197, and vol. 3.

55. Quoted, Edward Hughes, *North Country Life in the Eighteenth Century. I: The North-East* (London, 1952), 387–88; *Grub-street Journal,* 22 Jan. 1735/36.

56. *LM,* July 1737.

57. Faulkner to Hogarth, 15 Nov. 1740, BM. Add MS. 27995, 4; transcribed in J. Ireland, 3: 59. Faulkner remarks that he had retailed fifty sets of the *Times of the Day* in Dublin.

3. PUBLIC AND PRIVATE LIFE IN THE 1730S

1. Charles Macklin's *Diary,* 1733 (Folger Library), f. 117; William Cooke, *Memoirs of Charles Macklin* (London, 1804), 72.

2. *Biogr. Anecd.,* 1781 ed., 14; *Gen. Works,* 1: 26.

3. St. Martin-in-the-Fields Collection Book for the Poor Rate, 1733 (Westminster Public Library, F486), shows only that Hogarth's name has been added over Lady Howard's, which has been boxed; when the insertion was made cannot be determined. The first collection was on 6 April, the second on 12 October; so he was definitely in residence by 12 October. The date can be narrowed down by a look at the Scavenger Rate Book for 1733 (New Street Ward, F5677): the collection took place on 12 April 1733 and Lady Howard (though dead) was still listed as householder (£50, rated at 16*s* 8*d*). Thus one can safely conclude that Hogarth was not installed by 12 April; he must have moved in between then and 12 October. The Tyers letter—probably, though not certainly, genuine—was in the Forman Collection; published in *Catalogue of the Works of Antiquity and Art Collected by the Late William Henry Forman, Esq. . . . by Major A. H. Browne* (privately printed, 1892), 24; also published in the Dorking *Inventory* (1869), 157.

4. Hoadly, BM Add. MS. 27995, f. 23J. J. Macky, writing in the 1720s, remarked that it "was till within these Fourteen Years always call'd Leicester-

Fields, but now Leicester Square" (Macky, *A Journey through England*, 4th ed. [1724], 1: 178).

5. See *Survey of London: The Parish of St. Anne, Soho*, 34 (London, 1966): 447–48. For Hogarth's residence, see 501–2.

6. Macky, *Journey through England*, 1732 ed., 1: 205.

7. *London Evening Post*, 9–12 Apr. 1737.

8. Derek Hudson, *Sir Joshua Reynolds, A Personal Study* (London, 1958), 72.

9. Westminster Public Library, Deed 67/4; Middlesex Land Register, 1723/1/124.

10. *Craftsman*, 10 Dec. 1732; *GM*, 2 (1732): 1125.

11. *Gen. Works*, 1: 398. He is also supposed to have modeled a head of Van Dyck in clay.

12. Lippincott, 33. "Shop signs were becoming controversial in London at this time, and especially so in the art world as it bridged the distance between the old view of art as a mechanical trade and new aspirations to acceptance as one of the learned and gentlemanly professions."

13. Lippincott, 33.

14. Tom Taylor, *Leicester Square* (London, 1874), 281.

15. *The Chiswick Times,* cited by Warwick Draper, *Chiswick* (London, 1923), 106.

16. See also *European Magazine* (June 1802), 442; and *Survey of London,* 34 (London, 1966): 501–02, 505.

17. "Hunter Album," Royal College of Surgeons, 38–39, 163, including on 39: William Clift, "Ground Plan of 28 Leicester Square as it appeared in 1792, drawn in 1832."

18. *GM*, 4 (May 1734): 274–75; Mitchell, 14n. For the text, see *HLAT*, Appendix F.

19. *General Evening Post*, 12–14 June; also in *Read's Weekly Journal, or British-Gazetteer*, and *Weekly Register,* 17 June, same wording; in *Daily Advertiser,* 19 June; *GM,* 5 (1735): 333.

20. *Daily Courant*, 11 June; *Daily Journal,* 13 June; *General Evening Post,* 12–14 June; and Burial Register of St. Anne's Parish, Soho (Westminster Public Library).

21. See Michael R. Grauer and David W. Spangler, "Where Is the Portrait of Hogarth's Mother?" (forthcoming). In restoration, a "second inscription was also revealed to the right of the sitter and above the marble seat and red velvet pillow on which she is seated": "H [illegible] 1730," which may suggest that Hogarth had begun the portrait in 1730 and retouched it when his mother died in 1735. I am grateful for this information to Mr. Grauer of the Panhandle Historical Museum, and for his attempt to set out a provenance for the painting, first listed by Dobson and later by Beckett (nos. 37, 77–80).

The authenticity of the painting is not certain. Beckett had not seen the original; he says it was in Jane Hogarth's collection until 1789, but does not say on what authority. It was not in her sale catalogue (no. 48, which, in the same lot with a portrait of Lady Thornhill, is more probably a portrait of Jane Hogarth). Dobson is the first scholar to list it, tracing it back to Capt. P. Cosens, who purchased it from Mary Lewis. This suggests why it was not in Jane Hogarth's sale and why Beckett gave 1789 as the date of its departure from her collection: the date of her death (she seems also to have left at least one of Hogarth's portraits of herself to Mary). The only description of the painting, before it disappeared, was Max Roldit, "The Family of Hogarth," *Connoisseur,* 1 (1902): 145–46, repro. opp. 143.

22. Lindsay, 95.

23. In the registers of policies taken out with the Sun Fire Office from 1710, vol. 44, policy no. 70649, 17 June 1736: "William Hogarth of the parish of Saint Martin in the fields Painter On his household Goods and Goods in Trade and Copper plates Pictures excepted in a brick house being his now Dwelling house and situate at the Golden Head on the East Side of Leicester Fields in the parish aforesaid not Exceeding five hundred pounds £500."

His sisters' policy, though dated later (24 June), precedes Hogarth's in sequence in the register, which presumably means that they were sent in together by the agent and entered in the register in the wrong order. (The discovery of these entries, which I passed on to the archivist of the Sun Insurance Company, was recorded [mentioning only Hogarth's policy] without acknowledgment in the *Sun Alliance Group Gazette,* 1, no. 13 [Autumn, 1965]: 10–12.) These records are now in the Guildhall Library.

24. See vol. 1, 114; and "Minutes of the Grand Lodge of Freemasons of England 1723–1739," intro. and notes by W. J. Songhurst, in *Quatuor Coronatorum Antigrapha,* 10 (London, 1913): 43. See Eric Ward, "William Hogarth and His Fraternity," *Ars Quatuor Coronatorum, Transactions of Quatuor Coronati Lodge No. 2076,* 77 (London, 1964): 1–18. On the variety of club life in London, see Robert Allen, *The Clubs of Augustan London* (Cambridge, 1933).

25. "Minutes," 239–40, 254; James Anderson, *Constitutions of the Free Masons Containing the History, Charges, Regulations, &c. of that Ancient and Right Worshipful Fraternity* (1738 ed.), 134n. (I cite the facsimile edition of both 1723 and 1738 editions by Eric Ward [London, 1976]. The frontispiece of the 1738 edition, engraved by John Pine, was after a design of Thornhill's—"Frater Jˢ Thornhill Eq.") One of the stewards chosen for the next year was the young Isaac Schomberg, son of Dr. Meyer Schomberg, and Hogarth's friend and physician in later years (135n). Vols. 11 and 12 contain minutes for the years following, but there is no further mention of Hogarth.

26. Henry Wilson Coil, *Freemasonry through Six Centuries* (Richmond,

1967), 1: 226. For the Grand Jewel, see Robin Simon, "Panels and Pugs," *Apollo,* June 1991, 372. (The Grand Lodge, by contrast, consisted of the present and past grand officers, the masters and wardens of all constituted lodges and the master and wardens of the Steward's Lodge.)

27. Quoted, D. Knoop, G. P. Jones, and D. Hamer, *Early Masonic Pamphlets* (Manchester, 1945), 76.

28. More doubtfully, Desaguliers has been identified as the prompter standing in the wings (the face is hardly visible). But Montagu, standing directly under the portrait of Mrs. Conduitt, is unmistakable. See Einberg, *Manners & Morals,* no. 68; *Gen. Works,* 2: 279. Other prominent Freemasons whose portraits were painted by Hogarth include Martin Folkes, Thomas Pellett, James Quin, Stephen Beckingham, Lord George Graham, and Sir Andrew Fountaine.

29. Toland's connections with Freemasonry have been discussed by Jacob (111, 118–19, 153, 155). On the other hand, the Roman Catholic duke of Norfolk became grand master in 1730.

30. Jacob, 109.

31. Lipson writes: "The similarity between deism and Freemasonry is so pervasive that it is difficult to distinguish them. Deism had grown out of the assumption that, in the language of the accommodation to science that eventually found its way into so many religions, God was 'a first cause, a great mathematician architect who created the world and had given it its basic constitution.' . . . Deists believed that since rationality was a universal attribute, the perception of monotheism must have once been the essence of all religion. The growth of particular theologies had corrupted universal religion, but the knowledge of its existence may have been preserved by secret religious elites and might be restored. The myths of origin, the organization, and the tenets of Masonry fit neatly into the deistic pattern of belief" (*Freemasonry in Federalist Connecticut* [Princeton, 1977], 123–24).

32. Wellins Calcott, *A Candid Disquisition of the Principles and Practices of the Most Ancient and Honourable Society of Free and Accepted Masons* (London and Boston, 1769), 37, 4.

33. Details of Hiram and the third-degree ritual along with other rituals that until then had been passed on by word of mouth among Masons (printed rituals were not allowed until the 1840s) were revealed for the first time in Samuel Prichard's *Masonry Dissected* (three editions and a reprint between October and the end of 1730). The revelation of Hiram was so embarrassing to the Grand Lodge that it transposed the secret words of the first and second degrees, and this led to quarrels between Masonic factions. See James Dewar, *The Unlocked Secret: Freemasonry Examined* (London, 1966), 36; also Roberts, 20.

34. The details of the publication and reception of Anderson's *Constitutions* are not clear, except that the reception was mixed and the situa-

tion—given the apostasy of the Jacobite Grand Master Wharton—was volatile. The *Constitutions* were published by the author himself, not by the Grand Lodge, and written out of Anderson's association with Scottish Masonry and all that involved: which included on the one hand a confusion of operative and speculative aims of Masonry (cf. Charges IV and V) and on the other a suspicion of Jacobitism. Besides, Anderson produced a fantastic genealogy of Masonry back to Adam and focused on Egypt and Moses, as well as on Pythagoras and many others. Anderson's "fertile imagination" and "learned credulity" in the Masonic genealogy he contributed to the *Constitutions,* which does not inspire "confidence either in his scholarship or his judgment," may have amused Hogarth as much as it has later Masonic commentators. The references in his satire are, however, to ritual rather than "history." It remains an ambiguous, probably coded print. (See *Grand Lodge, 1717–1967* [London, 1967], 47; R. F. Gould, *The Genesis of Free-masonry,* ed. Dudley Wright [London, (1932)], 1: 63; and Roberts, 22; on the *Constitutions,* see Ward, ed., v–vi; also below, 407n31.)

35. For the Christological interpretation of Freemasonry, see Thomas de Quincey, "Rosicrucians and Free-Masons" (1824), in *Collected Writings of Thomas de Quincey,* ed. David Masson (London, 1897), 13: 424, 426. Another important Hogarthian element may have had Masonic sources. Mnemonic systems of the sort he employed in order to avoid copying (and discussed in his "Autobiographical Notes"; see vol. 1, 42–47) were based on an architectural structure, for example, a stage. The Masonic lodge was constructed as a symbolic mnemonic of the Temple of Jerusalem. The Masonic initiation involved walking through a sequence of spaces in which architectural features would be memorized and dialogues carried out. For each of the stages, colloquies, and interrogations, memory played a crucial part: "proficiency in mnemonic technique was regarded as an essential part of the Freemason's skills," as James Stevens Curl has noted (*The Art and Architecture of Freemasonry* [London, 1991], 44; also 45).

36. Edwards, *Anecdotes,* 19–20. Other accounts credit Rich (see J. T. Smith, 2: 157; Walter Arnold, *The Life and Death of the Sublime Society of Beef Steaks* [London, 1971], 2); and one story gives partial credit to the earl of Peterborough (F. S. Russell, *The Earl of Peterborough* [1887], 2: 261; also *The National Review,* 4 [1857]: 313–14). The standard work on the Beef-steaks is Arnold's, but new research has been done by Peter Cameron, who is preparing a book. The date of inception for the society and the dates of the various memberships come from two eighteenth-century MS. lists (one in the BL and one in the possession of the present Beefsteak Club) which, although dating from the fourth quarter of the century, appear to be accurate. Arnold heads the list of Rules "January 11th, 1735," which is probably 1735/36. It would seem likely that the society was instituted 6/12/1735 and

formalized at the meeting of 11/1/1735/36 when any provisional rules made the month before were amended and restated. My thanks to Cameron.

37. Arnold lists them as Rich, Lambert, and Hogarth.

38. Beefsteak rings were turned out for memorial reasons: Peter Cameron has two gold rings bearing the motto "Beef and Liberty" against a background of blue and white enamel, inscribed in memory of John Thornhill (this would have dated from 1757).

39. Those members who were actors at Covent Garden appear to have given up membership if they moved to Drury Lane. They are not listed as rejoining. Indeed, to return after resignation from the society was not a common occurrence although Hogarth was not unique in doing so. John Ellys was a member from 23/9/38 to 16/2/39/40 and again from 6/10/50 to 29/12/50; John Winde, the wine merchant, resigned and was reelected; John George Cox, the dancing master, did the same. In contrast to those like Henry Kelsall, the civil servant, who were members for very short periods, Lambert, Rich, John Thornhill (whose illegitimate son would seem to have been an honorary member), Henry Smart (the lace man) and Ebenezer Forrest were loyal members for the remainder of their lives.

40. For the Masonic-sounding rules, see Arnold, *Life and Death*, xiii–xvi. See also *Connoisseur* No. 19, letter about the Beefsteaks; and, to date some of the formalities, Eugene R. Page, *George Colman the Elder* (London, 1935), 187.

41. *Gen. Works*, 1: 129, 420–21.

42. The official song, "O joyful theme of Britons free, / Happy in Beef and Liberty," was written—presumably after 1763 when he became a member—by Theodosius Forrest, the son of Ebenezer.

43. Sadly, the list ends at this point; but the evidence indicates that both Hogarth and Huggins participated. The history of this body has been somewhat confused: the "Academy of Vocal Music" which met in the Crown and Anchor can be seen to be one and the same as the "Academy of Ancient Music" (see Robert Elkin, *The Old Concert Rooms of London* [1955] and Henry Davey, *History of English Music* [1895]). The "Academy of Vocal Music" became the "Academy of Ancient Music" in 1733. The subscription lists date from a first meeting on 7 January 1726 (BL. Add. MS. 11732). The first note of Hogarth's membership is in 1729, but he was probably admitted the previous year.

44. See *HGW*, nos. 127, 224.

45. The term "academy" probably derived from the Royal Academy of Music, the name of the London opera between 1719 and 1728 (itself derived from the Paris Opéra, the Académie Royale de Musique). I am indebted for this information to William Weber, *The Rise of Musical Classics in Eighteenth-Century England: A Study in Canon, Ritual & Ideology* (forthcoming). Weber

points out that the membership was heavily High Church and independent Tory.

46. *Gen. Works,* 1: 237. Cheselden had been a member of Vanderbank's academy with Hogarth back in the 1720s; see vol. 1, chap. 4.

47. Correspondence with William Weber.

48. *Letters of Baron Bielfield* (1741), quoted, Phillips, 107. Contemporaries do not seem to have regarded Slaughter's as simply a hangout for artists. The *Westminster Journal,* 27 Feb. 1741/42, says it is inhabited by "the neighbouring Tradesmen who meet there early for their Dish of Chocolate and Dish of Politics," and Goldsmith refers to it as a place where "old orators" collect to "damn the nation because it keeps [them] from starving" (*Busy Body,* 13 Oct. 1759; see also the issue of 20 Oct. 1759; in *Goldsmith's Collected Works,* ed. Arthur Friedman [Oxford, 1966], 3: 6, 20).

49. "Young" or "New" Slaughter's, a competitor, was founded in 1742 a few doors south. See Bryant Lillywhite, *London Coffee-Houses* (London, 1963), no. 937; Phillips, 107–8. This Thomas Slaughter was *not* the same as the Thomas Slaughter, a lace maker, who was a Masonic grand steward the year Hogarth was named a steward (cf. *HLAT,* 1: 343).

50. Fielding's and Garrick's names are also often mentioned. Most of the names come from much later lists, often manufactured, one suspects, on the basis of the artists and writers, physicians and "characters" known to have lived nearby. See, e.g., J. T. Smith (1: 144–51), who seems to be doing little more than listing the artists who lived nearby. Ephraim Hardcastle, Citizen and Dry-Salter (William Henry Pyne), has much material on the Slaughter's group in *Wine and Walnuts; or, After Dinner Chit-Chat,* 2 vols. (London, 1823–1824), 1: 104–21. Mark Girouard also speculates on the Slaughter's group—sometimes with an overly credulous inclusiveness—in a series of influential articles called "English Art and the Rococo," in *Country Life,* 1: 13 Jan. 1966, 58–61; 2: 27 Jan. 1966, 188–90; 3: 3 Feb. 1966, 224–27.

51. *The Diary of Joseph Farington,* ed. Kathryn Cave, 8 (New Haven, 1982): 2800–2801.

52. Jean André Rouquet, *State of the Arts in England* (London, 1755), 104. It is possible, however, that Hogarth was promulgating a myth about a friend and close colleague. H. A. Hammelmann ("Early English Book Illustration," *TLS,* 20 June 1968, 652–53) traces the origin of rococo to Vanderbank's *Don Quixote* illustrations in the late 1720s, to the Coypel *Don Quixote* illustrations, and to work of the foreign illustrators introduced to England by Jacob Tonson in his editions of the classics and the English dramatists. This is a plausible view, and Gravelot's position in the Slaughter's circle may have been more a symbolic than a practical stimulus.

53. See Girouard, "English Art," 1: 59–60; 3: 224.

54. *Monthly Magazine,* 27 (June and July 1809): 440; cited, Hammel-

mann, "First Engraver at the Royal Academy," *Country Life,* 14 Sept. 1967, 616–18.

55. *European Magazine,* 55 (1809): 443. For the fullest account of Hayman, see Brian Allen, *Francis Hayman* (New Haven, 1987).

56. J. T. Smith, 2: 271. See also Hayman's obituary in *The Public Advertiser,* 3 Feb. 1776; *Morning Post,* 5 Feb.

57. Vertue, 3: 6. Lambert's connection with Rich may have led to Hogarth's. Records of accounts show a payment of £50 to Lambert on 28 Dec. 1726 and one of £48 on 14 Mar. 1727 (account books of Lincoln's Inn Fields Theatre, BM MSS. Egerton 2265, 2266). For Lambert's life records, possible marriage, etc., see Elizabeth Einberg, *George Lambert* (Kenwood, Greater London Council, 1970), 5–10.

58. Einberg, *Lambert,* cat. no. 55; Vertue, 3: 24, 47; for the reference to Lambert's library, see S. Ireland, 1: 155; for the genealogy, etc., see *HGW,* no. 118.

59. *London Journal,* 26 Aug. 1727.

60. There is a wash drawing in the BM of a laborer with a scythe, inscribed in an old hand, "This & the following 6 Sketches were made from Nature by Hogarth for his friend George Lambert ye Landskape Painter" (S. Ireland's sale, Christie's 6 May 1797, lot 131; see *Tate,* cat. no. 127). If such drawings are authentic, it would seem that Hogarth had supplied Lambert with sketches for *him* to paint. But of the drawing and the painting, I see more evidence of Hogarth in the latter. Two paintings in Lambert's sale catalogue are listed as with figures by Hogarth (Langford, 18 Dec. 1765, nos. 78, 82). See also J. B. Nichols, 366; Sidney, sixteenth earl of Pembroke, *A Catalogue of the Paintings & Drawings in the Collection at Wilton House* (London, 1968), cat. nos. 34–37; Einberg, *Lambert,* cat. nos. 9 and 14–15.

61. See Dobson, 25n, citing a *View of Bloomsbury Square and Bedford House.*

62. For the Scott–Lambert collaboration, see the records of the East India Company; prints were published by Kirkall in 1735 and by Vandergucht in 1736. The two also worked together on a set of views of Mount Edgcumbe and Plymouth Harbor of which only engravings have survived (Einberg, *Lambert,* cat. nos. 43, 44).

63. Vertue, 3: 47; Whitley, 1: 27.

64. Vertue, 6: 31, 35, 351; Whitley, 1: 68.

65. Victor, *History of the Theatres of London and Dublin,* 1: 6, 66. It has been suggested that Ellys collaborated with Hogarth on the cartoon "Rich's Glory or His Triumphant Entry into Covent Garden" (*HGW* 1965, 1: 300–301); the theory is based on the inscription 'WHIESULP," which might stand for "William Hogarth and John Ellys sculp" (no. 104 in "Theatre and Drama during the Restoration and Eighteenth Century," catalogue of an exhibit held at the Humanities Research Center, Univ. of Texas, Autumn,

1964). Certainly the engraving is not etched by Hogarth, and this theory might explain why so unlikely a print was associated with his name. It still, however, seems to me likely that "WHIESULP," added by a later hand, means "William Hogarth invenit et sculpsit" (a small superscript can be detected above the E, to suggest Et).

66. See Lippincott, 18, 113.

67. Lippincott, 19; see 19–26. For Richardson, see vol. 1.

68. See vol. 1, 335–37, and above, 22–23; and further in vol. 3 with Hogarth's *Analysis of Beauty.*

69. Lippincott makes Pond out to have been, in these terms, a direct rival of Hogarth's. She argues "that Pond and Hogarth employed the same formula for selling reproductive fine arts prints to the English public. Both produced sets containing four to eight prints unified by theme and composition, relevant to contemporary interests, large and rich enough to decorate the walls of a Georgian-scale room, after known original paintings by name artists" (144).

70. *Explanatory Notes and Remarks on Milton's 'Paradise Lost'* (1734), cxli. For the story, attributed to Joseph Highmore, see S. Ireland, 1: 117–20. For Richardson's friendship with Thornhill, see *Works,* 192.

71. *HGW,* 1: 314, for the attributed etcher, Joseph Sympson, Jr., and a tentative ascription to William Henry Ireland; see Walpole's *Book of Materials* for 1759 (1: 6), in the Lewis Walpole Collection, Yale University.

72. From the Forman Collection; see above, n. 3. The medal, now in the BM, was copied by James Stow in an engraving (pub. 1825 by Robert Wilkinson).

73. *Gen. Works,* 1: 47; Dobson, 24; *HGW* 1965, 1: 137; Thomas Faulkner, *The History and Antiquities of Brentford, Ealing, & Chiswick* (London, 1845), 442n.

74. Lockman, *Sketch,* 2. An advertisement for the *Sketch's* publication, dated 7 May 1752, is reprinted in *The Vauxhall Papers,* 16 (23 Aug. 1841). The same collection (12 [13 Aug. 1841]) reprinted another description by Lockman in the style of the *Sketch* and identical in many parts. The basic work on the Vauxhall decorations is Lawrence Gowing, "Hogarth, Hayman, and the Vauxhall Decorations," *Burlington Magazine,* 95 (1953): 4–19. See also James G. Southworth, *Vauxhall Gardens: A Chapter in the Social History of England* (New York, 1941).

75. *A Brief Historical and Descriptive Account of the Royal Gardens, Vauxhall* (London, 1822), 7, 33; *A Description of Vauxhall Gardens. Being a Proper Companion and Guide for all who visit that place* (London, 1762), 28. See also Allen, *Francis Hayman,* 62–73, 107–9.

Hogarth must also have visited Tyers's private garden at Denbies, near Dorking, a retreat from his business affairs at Vauxhall. There Tyers constructed a Temple of Death and a clock that chimed on the minute (in the

grove of Il Penseroso). He also had a Valley of Death, with one gateway made of two vertical coffins, crowned by the skulls (reputedly) of a hanged highwayman and a notorious courtesan; another showing in contrasting alcoves the happy death of a good Christian and the terrible death of a libertine (a subject later treated by Hayman). See David Jacques, *Georgian Gardens: The Reign of Nature* (London, 1983), 17.

76. Walpole to John Nichols, 31 Oct. 1781, *Corr.*, 41: 451. Lawrence Gowing has argued in favor of a large canvas, *Fairies Dancing on the Green by Moonlight*, which (according to the guides) hung in a supper box on the south side of the Grove (Gowing, "Vauxhall Decorations," 4–6). This painting, in the Callaly Castle Collection, may be Hogarth's work, but its condition does not make for easy authentication. It was cut in two after 1860, leaving the watchman in one section and the dancing fairies in the other.

77. *GM*, 25 (1755): 206: "At Vauxhall . . . they have touched up all the pictures, which were damaged last season by the fingering of those curious Connoisseurs, who could not be satisfied without *feeling* whether the figures were alive."

78. J. T. Smith, 2: 31.

79. The following passages are from Hogarth's *Apology for Painters*, 95. My text replaces some strike-throughs in the manuscript and is slightly regularized.

80. Ibid., Kitson's introduction, 52n76; Phillips, 278. Phillips thinks it was in the basement of one of the largest houses in the lane, probably in the upper half and on the west side, where the most heavily assessed houses appear. The painting called *The Life School* (repro. *HLAT*, fig. 139) is no longer thought to be the St. Martin's Lane Academy; see Martin Postle, "The St. Martin's Lane Academy: True and False Records," *Apollo*, 134 (1991): 33–38. Postle has discovered a small unfinished painting showing a life class conducted in a paneled room (corresponding more closely to the interior of a meeting house) which he believes may be the St. Martin's Lane Academy in the early 1760s (Royal Academy).

81. 6: 170. See also *The Conduct of the Royal Academicians, &c.* (London, 1771), a pamphlet of the Incorporated Society of Artists. Ellys took over, at Vanderbank's death (1739), both his atelier and practice, and may have inherited the paraphernalia of the old Vanderbank academy as well, and added it to the new academy.

82. *Apology for Painters,* intro., 70.

83. See Nikolaus Pevsner, *Academies of Art Past and Present* (London, 1940), esp. chap. 1. I am also grateful to David S. Shields, "The Club as an Institution of British American Heterodoxy," a paper delivered at the eleventh annual Le Moyne Form on Religion and Literature (1991), where my own materials on Deism and Freemasonry were also first delivered. For

general assumptions about this area of English social life, see Jurgen Habermas, *The Structural Transformation of the Public Sphere; An Inquiry into a Category of Bourgeois Society,* trans. Thomas Burger and Frederick Lawrence (Cambridge, 1989), first published in German in 1962.

4. ST. BARTHOLOMEW'S HOSPITAL

1. See Vertue, 3: 78 (written Apr. 1736). John B. Shipley's inference that Amigoni tried to supplant Hogarth is based on a false chronology of events: "Ralph, Ellys, Hogarth, and Fielding: The Cabal against Jacopo Amigoni," *ECS,* 1 (1968): 322–23.

2. See Arthur W. Crawley-Boevey, *The 'Perverse Widow': Being Passages from the Life of Catharine, Wife of William Boevey, Esq. of Flaxley Abbey, in the County of Gloucester* (London, 1898), 249n.

3. Ralph's entry is under the date "Wednesday, *Feb. 20.*" Cf. Robert Seymour (i.e., John Mottley), *A Survey of the Cities of London and Westminster* (1734), 2: 883: "Among the Governors of St. Bartholomew's Hospital was lately chosen Mr. William Hogarth, the celebrated Painter; who, we are told, designs to paint the staircase of the said Hospital, and thereby become a benefactor to it, by giving his labour *gratis.*"

4. See Shipley, "Ralph," 313–31.

5. "Essay on Taste," *Weekly Register* No. 43, 6 Feb. 1730/31; on Hogarth, No. 112, 3 June 1732; rpt., No. 222, 8 June 1734, in the series on painting.

6. Richardson, *Works,* 68.

7. Journal of the Meetings of the Governors of St. Bartholomew's Hospital (archives of the hospital, Hal/10). Reprinted by permission of the governors of the Royal Hospital of St. Bartholomew.

8. Norman Moore, *The History of St. Bartholomew's Hospital* (London, 1918), 2: 280.

9. The usual motive was access to the hospital's beds. The precipitate growth of population in the seventeen century had left the few hundred beds of the two ancient London hospitals—St. Bartholomew's and the London—hardly adequate for the city's needs. To be a governor of a hospital enabled one to get his own charges in, since a ticket signed by a governor was usually required for admission in the crowded wards—or to have the status that went with such power.

10. As to public buildings as decorative possibilities, Scott and Lambert had been contracted, ca. 1732, to paint six pictures to decorate the Court Room of East India House in Leadenhall Street. These were views of the more important settlements belonging to the company. Finished and in place by the autumn of 1732 (on 1 Nov. Lambert received payment of £94 10*s.*;

prints followed by Kirkall in 1735 and Vandergucht in 1736), they may well have influenced Hogarth's thinking on the subject of public exhibition space.

Another possibility was the great nobleman's house. Hogarth later noted the incongruity of some biblical subjects painted in a dwelling (on a ceiling or along a staircase), and showed it in the first scene of *Marriage A-la-mode*. There is the single anecdote (perhaps based on the ceiling of Earl Squander's chamber): "A certain old Nobleman, not remarkably generous, having sent for Hogarth, desired he would represent, in one of the compartments on a staircase, Pharaoh and his Host drowned in the Red Sea; but at the same time gave our artist to understand, that no great price would be given for his performance. Hogarth agreed. Soon after, he waited on his employer for payment, who seeing that the space allotted for the picture had only been daubed over with red, declared he had no idea of paying a painter when he had proceeded no further than to lay on his *ground*. 'Ground! said Hogarth, there is no *ground* in the case, my lord. The red you perceive is the *Red Sea*. Pharaoh and his Host are drowned as you desired, and cannot be made objects of sight, for the ocean covers them all'" (Letter from "A Microloger," *GM,* 53, pt. 1 [1783]: 316; repeated in L. M. Hawkins, *Anecdotes, Biographical Sketches, and Memoirs* [1824], 47n).

11. Ralph, in another of his history painting essays (No. 215, 20 Apr.), distinguishes between "that which copies real Events, and that which feigns both Character, and Fable." The latter is either based on a text or, most difficult of all (and he is plainly thinking of Hogarth's recent "progresses"), invented by the painter: "Unless, therefore, the Painter has Genius, and Knowledge enough to form a compleat Tale, on the most delicate Principles of Nature, to support it with just and masterly Characters, to give those Characters a proper share of the Business, and spirit the Whole with noble Attitudes, and bold Expression; unless, I say, he is perfect in all these Secrets of picturesque Narration, I would advise him not to trust his Imagination too far, but content himself with an Imitation of known Facts, or a Transcript of the celebrated Imaginations of others."

12. *Daily Advertiser,* 18 Nov. 1735.

13. The graphic sources for *The Pool of Bethesda* include versions by Bartolomé Esteban Murillo (National Gallery, London), Sebastiano Ricci (Ministry of Public Buildings), and Louis Laguerre (Chatsworth). Ricci's *Baptism of Christ* could have been a direct influence: The painting was in the chapel at Bulstrode (for the duke of Portland, described by Vertue in 1733 and destroyed in the nineteenth century); the oil sketch may have remained in England (now in the Metropolitan Museum, New York). See Einberg, *Manners & Morals,* cat. no. 11.

14. *Gen. Works,* 2: 263; Lane to Nichols, *Gen. Works,* 1: 189; see also Moore, *St. Bartholomew's Hospital,* 851.

15. Hoadly, Sermon 2, "Of the Divisions, and cruelties, falsely Imputed to Christianity," in *Sixteen Sermons Formerly Printed . . . To which are added Six Sermons upon Public Occasions* (London, 1758), 33.

16. Hogarth's source may have been his friend Dr. Freke, who wrote a chapter on rickets. See Moore, *St. Bartholomew's Hospital*, 850.

17. *Gen. Works*, 2: 190.

18. For the proof state, see *Biogr. Anecd.* (1781), 90; *Gen. Works*, 2: 101; and *HGW*, no. 122. In volume 1 (292) I suggested some reasons for Hogarth's cancelling the portrait of Woolston, but another is that all framed pictures in Hogarth's works are authoritarian and oppressive; whereas Woolston represents a persecuted man and a hermeneutics that undercuts authority. His portrait would therefore have been out of place on the wall with the Old Testament scenes unless intended as a parallel to them.

19. *Mr. Woolston's Defence of His Discourses*, 20; cf. Anthony Collins, *Discourse concerning Ridicule and Irony in Writing* (1729).

20. Roland N. Stromberg, *Religious Liberalism in Eighteenth-Century England* (Oxford, 1954), 58.

21. Hoadly, Sermon 16 in *Twenty Sermons* (London, 1755), 332; noticed by Martin C. Battestin, *The Moral Basis of Fielding's Art* (Middletown, 1959), 22. One cannot help recalling Parson Adams's words in *Joseph Andrews* (2.17): "a virtuous and good Turk, or Heathen, are more acceptable in the sight of their Creator than a vicious and wicked Christian, though his Faith was as perfectly Orthodox as St. Paul himself."

22. To Ann Granville, 22 Apr. 1740; *The Autobiography and Correspondence of Mary Granville, Mrs. Delany,* ed. Lady Llanover (London, 1861), 2: 82–83.

23. The print was based on a small, beautifully painted oil sketch of a few years earlier (Minneapolis Institute of Arts; ill., vol. 1). In the painting, however, the clerk's eye is not open and focused on the young woman's bosom.

24. Or to the family, as in the escutcheon attached to a pillar (showing a chevron sable between three owls, creatures of the night and dullness).

25. This addition is datable between 1747, when Rouquet described the print in its second state, and 1753, the date of the Greenberg folio, which has the third state (see *HGW*, no. 20). Thus the lightning bolt was not connected with the labeling of Bedlam as England in Plate 8 (datable in 1763). But there is a very similar bolt of lightning striking the Temple of Jerusalem in Hogarth's Bristol altarpiece of the Resurrection (1756, vol. 3).

26. See Jean Calvin, *Institutes of the Christian Religion,* 1.11.12 (ed. Henry Beveridge [London, 1953], 1: 100); and Paulson, *Breaking and Remaking,* chap. 4, whose discussion of Hogarth the iconoclast I would now revise in the light of the evidence of Deist and Masonic influences.

27. As in interlocking triangles in which one is black and the other white, down and up signify "the mingling of the two apparent powers in nature, darkness and light, error and truth, ignorance and wisdom, evil and good, throughout human life" (Mackey, 801). In *The Analysis of Beauty,* discussing the reversed proportions of the Apollo Belvedere, Hogarth refers to "a pyramid, which being inverted, is, for a single figure, rather more natural and genteel than one upon its basis" (90–91).

28. Approaching from the direction of "eroticism" in Hogarth's art, Peter Wagner (who drew my attention to the lion's sexual organs) would interpret *The Sleeping Congregation* as "a comic and essentially moral juxtaposition of the absence of God and the presence of lust." But the Puritan moral emphasis attributed by Wagner does not correspond to the centrality Hogarth gives the young Mary-substitute who functions as mediator. A more accurate formulation, as far as it goes (also Wagner's), is: "When God is absent, the print seems to suggest, Eros creeps in in the form of new and preferably female idols" (Wagner, "Eroticism in Graphic Art: The Case of Hogarth" [forthcoming], in which he responds to my analysis of the print as "iconoclastic" in *Breaking and Remaking*). In addition, see Berthold Hinz and Hartmut Krug, eds., *William Hogarth. Das vollständige graphische werk* (Giessen, 2d ed., 1986), 107–8, and Herwig Guratzsch, *William Hogarth. Der Kupferstich als moralische Schaubühne* (Stuttgart, 1987), 86–87.

29. The portrait, by Hans Hysing, was engraved by P. Pelham (repro., Mackey, opp. 206). Desaguliers (who appears with the same magnifying glass in *Scene from "The Conquest of Mexico"*) was identified by Nichols (*Biog. Anecd.,* 1782, 195) and the Freemasons themselves have accepted the identification; the Quatuor Coronati Lodge bought the copperplate of *The Sleeping Congregation,* along with other Hogarth plates in which Freemasons are represented. For Desaguliers, see Jacob, 122–24.

30. On the origins of Freemasonry in Egypt, see Anderson, *Constitutions* (1723), 8; Samuel Prichard, *Masonry Dissected* (1730), in *The Early Masonic Catechisms,* ed. Douglas Knoop, G. P. Jones, and Douglas Hamer (Manchester, 1943), 108–9; *The Perjur'd Free Mason Detected* (1730), in ibid., 138; and *A Defence of Masonry* (1731), in ibid., 166–67.

31. There have been various explanations proposed for the Gormogans, most centering around Jacobitism, but one is that "it was the outgrowth of discontent on the part of the Old [i.e., operative] Masons with the innovations brought along by the Grand Lodge and was the basis for the 'Schism' of 1751." See Coil, *Freemasonry through Six Centuries,* 1: 200; also 198–201. Certainly mock-Masonic processions of the sort Hogarth represents were used in the 1740s (and by Hogarth's associates) to satirize the Freemasons (or one faction). See *HGW,* 54 (No. 55 [43]); vol. 1, 115; and, on the schism that began in the late 1730s and split the London Freemasons into opposing

grand lodges in 1751, see Bernard E. Jones, *Freemasons' Guide and Compendium* (London, 1950), 194 (and chap. 12).

The Gormogans annually announced meetings between 1725 and 1735: *Daily Post,* 30 Oct. 1725; *Daily Journal,* 26 Apr. 1727; 27 Apr. 1728; 30 Oct. 1728; 28 Oct. 1730 (announcing for the 30th); 28 Oct. 1731 (for 1 Nov.); 29 Apr. 1732 (for 1 May); 27 Oct. 1732 (for 31 Oct.); and *The London Daily Post and General Advertiser,* 6 Dec. 1735 (for 10 Dec.). (Prichard discussed them in *Masonry Dissected,* reprinted in *Early Masonic Catechisms,* 109.)

32. See, e.g., William Warburton, *The Divine Legation of Moses,* 1 (1738): 195: "it was the Custom . . . to have what was wanted in those Rites, carried on asses."

33. See Mackey, "Egyptian Mysteries," 232–33; and for the Mary-Isis analogy, Hippolytus Marraccius, *Polyanthea Mariana, in qua liberis octodecim* (Cologne, 1710). One source of the All-Seeing Eye also came from the Isiac mysteries (the god Ptah).

34. See Curl, *Art and Architecture of Freemasonry,* chap. 6; Mackey, 2: 776–77. The many-breasted Isis and Artemis-Diana are distinguished only by their headdress: the Egyptian wears a lotus, the Greek-Roman wears a tower. Hogarth's Isis in *Boys Peeping* characteristically wears something resembling the headdress of the Harlot and the monkey in *Harlot* 2.

35. It is stipulated in Anderson's *Constitutions* that "the Persons admitted members of a Lodge must be good and true *Men,* . . . no Bondmen, no *Women,"* etc. (emphasis added; 1723, 51).

36. On the Eleusinian Mysteries, see, e.g., Warburton, *Divine Legation,* 1 (1738), 2, 4; and J. N. Casavis, *The Greek Origin of Freemasonry* (New York, 1956), 82.

5. THE MEDIATING WOMAN

1. Walpole, *Anecdotes,* 4: 140.

2. She could have been related to Fielding's Shamela, the reality under the pseudonymn "Pamela." See below, Chap. 8. The painting has not been traced.

3. James Parsons, *Human Physiognomy Explain'd: In the Crounian Lectures on Muscular Motion for the Year 1746* (1746), 57–58; published as a supplement to the *Philosophical Transactions of the Royal Society,* 44 (1746).

4. See Robin Simon, "Hogarth's Shakespeare," *Apollo,* 109 (Mar. 1979): 216–19. He believes the lines illustrated are I.ii.422–24, Ferdinand's "Most sure the goddess / On whom these aire attended: Vouchsafe my prayer / May know if you remain upon this island." The original version was only revived in 1757 by Garrick: see George Winchester Stone, Jr., "Shakespeare's 'Tempest' at Drury Lane during Garrick's Management," *Shakespeare Quarterly,* 7 (1956): 1–7. As Simon points out, the *Tempest* painting

recorded as hanging as a Vauxhall Garden decoration was based on the opera and was obviously not by Hogarth (220n).

5. *De Arte Poetica,* ll. 3–4 (trans. Smith Palmer Bovie, *Satires and Epistles of Horace* [Chicago, 1959]). Recall that Hogarth took one of his epigraphs for *Boys Peeping at Nature,* in which he laid out the poetics of *A Harlot's Progress,* from ll. 48–51.

6. Simon notes the resemblance to "religious subjects such as the Adoration of the Magi or annunciation: at least, the virginal associations of Miranda seem clear, in keeping with their recurrence in the text" ("Hogarth's Shakespeare," 218).

7. Cf. the doves at Venus's feet in *The Analysis of Beauty* 1, and indeed the manacled dogs of *Marriage A-la-mode* 1 and the two courting dogs of *Rake* 5.

8. Richardson, *Explanatory Notes,* 71–72. For the problem of dating Hogarth's *Satan, Sin, and Death,* see Beckett, 72; Antal, 155–56; my note in *Studies in Burke and His Time,* 9 (1967): 815–20; and David Bindman, "Hogarth's 'Satan, Sin and Death' and Its Influence," *Burlington Magazine,* 92 (1970): 153–59. Aside from other considerations, the canvas is 25 × 30 inches, the size Hogarth used for subject pictures in the 1730s; after 1742 only for portraits.

9. Peter M. Briggs, "The Jonathan Richardsons as Milton Critics," *SECC,* 9 (1979): 115.

10. And, above all, Edmund Burke; see vol. 3 on Burke's adaptation and response.

11. Addison treated the scene as an allegory of genealogy: "*Sin* is the Daughter of *Satan,* and *Death* the Offspring of *Sin*" (*Spectator* No. 309). And this led him to draw attention to the "Sublime Ideas" evoked by the confrontation of Satan and Death: "The Figure of death, the Regal crown upon his Head, his Menace of Satan, his advancing to the Combat . . . are Circumstances too noble to be past over in Silence, and extreamly suitable to this *King of Terrors.*" If the second of these insights was to serve Edmund Burke, the first was picked up by Richardson in his *Explanatory Notes.* The genealogical allegory is the epitome of the whole argument: "a kind of paraphrase on those words of St. James I.15. Then when Lust hath conceived it bringeth forth Sin, and Sin when it is finished bringeth forth death" (71–72). See also John Hughes, *On Allegorical Poetry* (1715), whose first example of allegorical writing is Milton's Satan, Sin, and Death (in *Critical Essays of the Eighteenth Century,* ed. W. H. Durham [New Haven, 1915], 88).

12. I am indebted for this interpretation to Leslie Moore's analysis of Richardson in the fourth chapter of her *Beautiful Sublime: The Making of "Paradise Lost" 1701–1734* (Palo Alto, 1990).

13. See, e.g., Styan Thirlby, *A Defence of the Answer to Mr Whiston's Suspicions, and an Answer to His Charge of Forgery against Athanasius* (1713). Sam-

uel Clarke (in the Giles King version of *Harlot* 2) was also known for his unorthodox arguments in the controversy.

14. Such mental play around the doctrine of the Trinity will be very evident fifteen years later in Hogarth's aesthetic treatise *The Analysis of Beauty* (1753), beginning with the triangle on its title page, inscribed with Eve's serpent: see vol. 3.

15. *Explanatory Notes and Remarks on Milton's 'Paradise Lost,'* clxxviii.

16. See M. F. Feuillet de Couches, "William Hogarth," *Gazette des Beaux Arts,* 25 (1868): 209.

17. A single impression survives: see Paulson, *Burlington Magazine,* 115 (1973): 805; *HGW,* no. 152.

18. See Seymour Slive, *Frans Hals* (London, 1970), pl. 116; a copy, fig. 142; see also figs. 143–45. Jacob Cats makes the liberty/seashore, servitude/city contrast in a poem, "On the Image of a Fisher Girl from Schevengingen Carrying a Basket with Fish on her Head" (see Julius Held and Donald Posner, *Seventeenth and Eighteenth-Century Art* [New York, 1972], 227). For the following citations, see Slive, *Frans Hals,* 1: 144.

19. In economics, as J. G. A. Pocock has written, "every theory of corruption . . . is a theory of how intermediaries substitute their own good and profit for that of their supposed principles" ("The Mobility of Property and the Rise of Eighteenth-Century Sociology," in *Theories of Property: Aristotle to the Present,* ed. Anthony Parel and Thomas Flanagan [Waterloo, Ont., 1979], 162). Hogarth's middle figure has one locus—an economic locus—in Addison's female figure of Credit, who (as Pocock has pointed out) has the attributes of Fortuna and confuses the simple relationship of exchange.

20. As in what René Girard calls "mediated desire" (*Deceit, Desire, and the Novel,* trans. Yvonne Freccero [Baltimore, 1967]).

21. There was also a description of a poet in his garret in the *Grub-street Journal,* 2 May 1734, which predicts in many details Hogarth's design (except that the bawling milkmaid is at "the foot of the stairs").

22. Samuel Johnson's words: his account of the affair, which drew on living sources and was unfavorable to Pope, would probably have been close to Hogarth's (*Prefaces, Biographical and Critical, to the Works of the English Poets,* 1781; *Lives of the Poets,* ed. London, n.d., "Chandos Classics," 400). See also *HGW,* no. 145.

23. See Stephens, *BM Sat.* 2309. The detail of the Poet was later copied and issued as Theobald's portrait accompanying a pamphlet on him: "Pub^d Jan^y 20^th 1794 by W^m Richardson Castle St Leicester Fields." See also Peter Seary, *Lewis Theobald and the Editing of Shakespeare* (Oxford, 1990).

24. Rosemary dePaolo ("A New Source for Hogarth's *Distressed Poet,*" *Studies in Eighteenth-Century Culture,* ed. Leslie Ellen Brown and Patricia Craddock [East Lansing, 1990], 93–114) believes that the engraving, as op-

posed to the painting, shows Hogarth's reconciliation with Pope. But she is referring to the Pope–Curll print.

25. Cf. vol. 1, 261, where it is suggested that the Harlot's name, *Hack-about* may include hackney writers as well as whores in its designation, and serve for Hogarth as a memory of his father's struggles with the booksellers.

26. See W. K. Wimsatt, *Pope Portraits* (New Haven, 1965).

27. *Dunciad,* ed. James Sutherland (London, 2d ed., 1953), 17.

28. Swift repeated Pope's formulation in his "Verses on the Death of Dr. Swift" (pub. 1739), again in terms of deformity: he never satirized deformity unless a humpback tried to pass for a beau. But Hogarth would have recalled another text, Juvenal's third *Satire,* ll. 147–53 (Dryden trans., ll. 248–57), which discusses jests, wit, and humor at the expense of the poor.

29. See Douglas Brooks-Davies, *Pope's "Dunciad" and the Queen of Night* (Manchester, 1985). The Poet's wife, immured in the Poet's chamber, could also refer to Theobald's *Rape of Proserpina* (1717), in which case the milk-maid in the doorway would be a Ceres from the upper world. See *Dunciad* 1.209, 3.308–10.

30. *Daily Gazetteer,* 5 Mar., repeated 7 Mar. and in the *Craftsman* 12 Mar.

31. Later, in *Analysis,* Pl. 1, he reproduced part of Ghezzi's *The Bearleader* to illustrate his attack on "those who have already had a more fashionable introduction into the mysteries of the arts of painting" (22). A complete set is in the V & A, Dept. of Prints and Drawings (E4961–1902 to E4981–1902 and E2366–1938). See Lippincott, 132–35.

32. 10 May 1751, *The Letters of the Earl of Chesterfield to His Son,* ed. Charles Strachey (London, 1901), 2: 150.

33. See James Sherry, "Four Modes of Caricature: Reflections upon a Genre," *Bulletin of Research in the Humanities,* 87 (1986–87): 29–62.

34. *Grub-street Journal,* 25 Nov. 1736.

35. On 28 November 1734 "Misoquackus" recounted cases of paralysis following from the use of Ward's "Pill and Drop." See J. T. Hillhouse, *The Grub-street Journal* (Durham, 1928), 271–89.

36. *General Evening Post,* 4 Sept. 1735; *London Daily Post and General Advertiser,* 11 Oct. 1735; *London Evening Post,* 22–25 May, 12–14 Aug., 17–19 Aug. 1736.

37. *London Evening Post,* 20 Dec. 1744–1 Jan. 1744/45; see *HGW,* no. 77.

6. URBAN PASTORAL

1. Copies of *The Four Times of the Day* appear in the Vauxhall cata-logues under various designations: "3. New-river-head, at Islington with a family going awalking, a cow milking, and the horn archly fixed over the husband's head," or "A bonfire at Charing-Cross, and other rejoicings; the

Salisburystage overturned, etc." (See *The Ambulator; or, the Stranger's Companion in a Tour Round London . . . comprehending Catalogues of the Pictures by Eminent Artists* [London, 1774].) Nichols records that Hayman made copies of the *Four Times of the Day* for Vauxhall, and that *Evening* and *Night* were still there in 1808 (*Gen. Works,* 2: 150). A copy of *Evening* was at the Lowther Castle sale, 19 April 1747, lot 1855, 54 × 50 in. Lawrence Gowing remarks: "If, as is possible, it is a Vauxhall picture, the vertical measurement was approximately that of the decorations in the other boxes; the series would thus have retained some uniformity in spite of the upright shape of the *Times of Day*" (Gowing, "Vauxhall Decorations," 11).

2. *London Evening Post and General Advertiser,* 23 Jan. 1737/38. The subsequent ads were in the *Daily Post,* 25 Apr.; *Gazetteer,* 29 Apr.; *London Evening Post and General Advertiser,* 3 May.

3. *St. James's Evening Post,* 10–12 May 1737; repeated in the six subsequent issues, the last 21–23 June.

4. *Spectator* No. 237.

5. Hogarth refers to the tradition (followed by Masonic ritual) that portrayed Isis as not just the virginal moon goddess but as the mother goddess—*Alma Mater*—with many breasts (see, e.g., Athanasius Kircher, *Oedipus Aegyptiacus* [Rome, 1652–54], 1: 190, "Statui Isidis Multimammae").

6. *Essay towards Fixing the true Standards of Wit, Humour, Raillery, Satire, and Ridicule . . .* (1744), x.

7. For the identification, see *Biogr. Anecd.* (1782), 211 (where Hawkins is cited as denying a resemblance); J. Ireland, 1: 149–50.

8. *London Evening Post* 16–18 Aug. 1737.

9. Ibid., 21–24 Jan. 1737/38.

10. Ibid., 9–11 Mar. 1737/38.

11. See E. P. Thompson, "Patrician Society, Plebeian Culture," *Journal of Social History,* 7 (1974): 396–404.

12. See Nichols Rogers, *Whigs and Critics,* chap. 10.

13. For a general account of the background of the act, see Vincent J. Liesenfeld, *The Licensing Act of 1737* (Madison, 1984).

14. *LM,* Feb. 1736/37, 107.

15. *Common Sense,* 12 Mar. 1736/37; *LM,* Mar. 1736/37, 163; *Daily Advertiser,* 7 and 8 Mar. 1736/37.

16. See Liesenfeld, *Licensing Act,* 60–70. The three versions of *The Golden Rump*—one called "The Vision of the Golden Rump" in *Common Sense,* one a print (*The Festival of the Golden Rump*), and one the play text read to the House of Commons by Walpole—could well have owed their original conception to Hogarth's antiministerial satire of 1726, *The Punishment of Lemuel Gulliver* (ill., vol. 1).

17. See Shesgreen for a thorough discussion of the tradition.

18. See J. Richard Judson, *Dirck Barendsz 1534–1592* (Amsterdam, 1970), pls. 49–52 (*Times of the Day*), 53–56 (*Seasons*), and 57–60 (*Saints*). See also Egbert van Panderen's engravings after Boias Verhaecht (F. W. H. Hollstein, *Dutch and Flemish Etchings, Engravings, and Woodcuts ca. 1450–1700* [Amsterdam, 1949–60], 1: 102, 15: 101). The work of Crispijn de Passe de Oude (e.g., his *Times of the Day* after Gerard van der Horst; Hollstein, 9: 147) was probably known to Hogarth and English artists, since Oude's sons and daughters all worked in England.

19. See Appendix F in *HLAT* for the full text.

20. *Weekly Register* No. 112, 3 June 1732.

21. My text for *Trivia* is *John Gay: Poetry and Prose,* ed. Vinton A. Dearing, 2 vols. (Oxford, 1974). For Hogarth and Oldham, see vol. 1, 343n40.

22. The tyler was identified as a portrait of a Grand Lodge officer, Andrew Montgomerie. For identifications, see *Gen. Works,* 2: 150; J. Ireland, 1: 149–50; W. G. Speth, *Transactions of the Lodge Quatuor Coronati,* 1 (1889): 116; and James Dewar, *The Unlocked Secret: Freemasonry Examined* (London, 1966), 116. Dewar also identifies the utensil at the far right as a mop and the figure holding it as another member of the lodge. A diagram of the "lodge" was chalked on the floor of the tavern by the tyler, and after a candidate had been admitted he was given a mop and pail to wash out the drawing.

23. As set forth in handbooks such as Andrew Tooke's *Pantheon,* Diana (or Isis) "is called *Triformis* and *Tergemina,* I. Because, though she is One, yet she has a threefold Office; for she is *Luna* in the Heavens, *Diana* upon earth, and *Hecate* in Hell" (*The Pantheon* [1713], 241).

24. But the taint of French Freemasonry may be implicated in the signs of Restoration Day. French Freemasonry was considered from the outset to have had close connections with the Jacobite exiles and a London-dependent lodge had been founded in Paris in 1732 to counterbalance it (although the grand master installed in 1736 was accepted by both). A Papal Bull published in 1738 condemning Freemasonry had played into the hands of the former, prompting them to put an even greater emphasis on the Catholic and legitimist aspect of their Masonry. The Jacobite imagery of Restoration in *Night* may also connect with the foppish Frenchman in *Noon,* as the pair of males in the one does with the arm-in-arm pair in the other. The Freemasons themselves were being harassed by Cardinal Fleury's agents in Paris in 1737 much as De Veil is in *Night.* Moreover, English Freemasons had been accused of sodomy, but in Paris, in the Masonic circles of the prince de Conti and the duc de Richelieu, the accusation was more seriously meant. (See *Free Masons; an Hudibrastick Poem* [2d ed., 1723] and *The Free-Masons Accusation and Defence* [1726]; Roberts, 63, 33–34.)

25. Prints were, of course, colored at this time, though never Hogarth's (unless by a dealer or subsequent owner of them). In 1716 *Trivia* referred to "The colour'd Prints of *Overton*" (2.488).

26. Lindsay, 110. The early conversation pictures were various in size, with an occasional larger canvas (*The Beckingham-Cox Wedding*, 50 1/2 × 40 1/2; *The Wollaston Family*, 39 × 49). Interestingly, the 25 × 30 inch canvas of the 1730s "modern moral subjects" begins with the most monumental and crowded of the conversations, *An Assembly at Wanstead House*, and continues with the *Ashley and Popple* and *Wesley* families. But the continuity with the "modern moral subjects" is most firmly established in the pair of children's conversations (*Children's Tea Party* and *House of Cards*). (The comic *Denunciation* and *Christening* are only 19 1/2 × 24 3/4 and 26, respectively: all ill., vol. 1.)

27. Quoted, Thomas Puttfarken, *Roger De Piles's Theory of Art* (New Haven, 1985), 22, and 23ff.

7. PORTRAIT PAINTING

1. Rouquet, *State of the Arts*, 37–38.

2. *London Evening Post*, 2–4, 4–7 Mar.; Vertue noted this visit, probably from the newspaper account (3: 82).

3. Another foreigner, the Florentine Andrea Soldi, who had been in England for two years without notable success, now adopted Vanloo's mannerisms and also was soon in great demand, from April to August undertaking over thirty portraits large and small.

4. *LM*, 7 (1738): 552.

5. Piper, *The English Face* (London, 1957), 163. The Abbé Le Blanc, an observant Frenchman who lived in England from 1737 to about 1744, remarked of this phenomenon: "At present in London the portrait painters are more numerous and more unskilful than ever they were. Since Mr. Vanloo came hither, they strive in vain to run him down; for no body is painted but by him. I have been to see the most noted of them; at some distance one might easily mistake a dozen of their portraits for twelve copies of the same original. Some have their heads turned to the left, others to the right; and this is the most sensible difference to be observed between them. Excepting the single countenance or likeness they have all the same neck, the same arms, the same colouring, and the same attitude. In short these pretended portraits are as void of life and action as of design in the painter" (*Letters on the English and French Nations* [Dublin, 1747], 1: 160).

6. Waterhouse, 138.

7. The earl of March, *The Duke and His Friends* (Oxford, 1911), 308.

8. See Elizabeth Johnston, introduction, *Paintings by Joseph Highmore 1692–1780* (London, Kenwood House, 1963).

9. *Shaftesbury's Second Characters,* ed. Benjamin Rand (1914), 134–35.

10. *Essay on the Theory of Painting,* in *Works,* 78–79.

11. Horace Walpole tells how one of these representations, this time with the duchess as a Madonna holding one of her royal bastards, was sent by her to another of her children in a French convent and was hung over the altar until its true subject was discovered (*Aedes Walpolianae* [1742 ed.], xvi).

12. Vertue, 3: 45, 56–57; Margaret Whinney, *Sculpture in Britain* (Harmondsworth, 1964), 72–73. By 1747, when Hogarth had given up his serious career as a portraitist, the *London Tradesman* noted: "The taste for busts and figures in these materials [i.e., clay, wax, and plaster of Paris] prevails much of late years, and in some measure interferes with portrait painting. The Nobility now affect to have their apartments adorned with bronzes and figures in plaster and wax" (cited Whinney, 112).

13. Whinney, *Sculpture,* 103.

14. These were subsequently engraved in mezzotint and published in, respectively, 1736 and 1747. The latter is Beckett's dating, but it might have been published in 1737 when Boyne became a commissioner of revenue. They were presumably made for the sitter's family and friends and had no connection with Hogarth.

15. *GM,* May 1732; cited Jarrett, 83.

16. *The Bee,* 5 (18–25 May 1734): 551–52; reprinted in *GM,* 4 (1734): 269.

17. The earliest head-and-shoulder portraits would appear to be Sir James Thornhill (which at present survives only in Ireland's etching), painted sometime before Thornhill's death in 1734, and the self-portrait in a wig (ill., vol. 1). As with the full-length of his mother, it is likely that Hogarth began with himself and his immediate family as sitters. Only these two relatively private, experimental portraits focus on the face, limiting the body to head and shoulders. As with his full-length works, Hogarth's first three-quarters-length portraits were of his family, with Jane Hogarth holding an oval portrait of her recently dead father (vol. 1, fig. 69).

18. R. H. Nichols and F. A. Wray, *The History of the Foundling Hospital* (London, 1935), 14.

19. AN, 216–17 (I have regularized this and the subsequent passages); Vertue, 3: 97–98; Vanderbank's will, 13 Dec. 1739 (P.C.C. 1740 Browne 188), shows that he was childless and left what property remained to his wife Anne. Vertue adds: "For his Friends I can't say he had made the best use of them, many he had had, very extraordinary, but did not acquit himself in the best manner.—many stories related of his carelessness or ingratitude on that account, are better forgot than to be rememberd.—as I was early of his acquaintance in his youth, so I sometimes shar'd his company and affections. but never to any degree, extraordinary—"

20. *Philosophical Transactions of the Royal Society,* 41: 484; Vertue, 3: 96;

National Library of Scotland, MS. 3134, f. 22; Lord Killanin, *Sir Godfrey Kneller and His Times, 1646–1723* (London, 1948), 26.

21. Alastair Smart, *The Life and Art of Allan Ramsay* (London, 1952), 1.

22. MS. *Life of Allan Ramsay* [*the Elder*] *(by his son)*, Laing MSS., Edinburgh University Library; quoted, Smart, 1.

23. See Smart, *Life of Ramsay*, 1; and *GM*, 199 (1853): 370, which quotes a letter from his father addressed to "Mr. Allan Ramsay, at Mistress Ross's, In Orange Court, Near the Meuse, London." Asserting that his earliest portraits show awareness of Hogarth's portraits, Smart puts it this way: Ramsay began "to come to terms with the new informal portraiture of Hogarth" (13). John Hayes says much the same, though not placing it specifically before Ramsay's trip to Italy (and so before Hogarth began to produce this sort of portrait): "Ramsay's inclination towards the unaffectedly natural in portraiture meant that his sympathies lay entirely with the new school of portraitists headed by Hogarth and Highmore. . . . The genial head of Sir John Hynde Cotton . . . , painted in 1740, is in sympathy with Hogarths of the later 1730's, though, stylistically, the conception of this portrait is perhaps closer to Van Loo . . ." ("Allan Ramsay at the Royal Academy," *Burlington Magazine*, 106 [1964]: 190–93).

24. Vertue, 3: 96.

25. Ramsay to Cunyngham, 10 Apr. 1740, in *Curiosities of a Scots Charta Chest*, ed. Hon. Mrs. Atholl Forbes (1897), 142.

26. See Piper, *English Face*, 161–62.

27. Vertue, 3: 96, 125; Smart, *Life of Ramsay*, 40–41; John Steegman, "A Drapery Painter of the Eighteenth Century," *Connoisseur*, 97 (June 1936): 309ff.

28. Vertue, 3: 93–94, 96. Scottish connections do not seem to have helped Hogarth in his portrait commissions.

29. James Northcote, *The Life of Sir Joshua Reynolds* (London, 1819), 1: 17–18; Hogarth, *Apology for Painters*, 101. Many years later Reynolds told Northcote: "A party of painters of whom Hogarth was one, were looking at a picture by Allan Ramsay, but were not able to ascertain who was the artist, being all in doubt, with the exception of Hogarth, who soon set them right, by saying, 'Don't you see clearly in the picture the Ram's eye?'" (Northcote, 1: 17–18).

30. The *Journal of the Minutes of the General Court and General Committee* is in the Thomas Coram Foundation for Children, Brunswick Square; reprinted and regularized in John Brownlow, *Memoranda; or, Chronicles of the Foundling Hospital* (London, 1847), 7–8.

31. Waterhouse, *Three Decades of British Art, 1740–1770* (Philadelphia, 1965), 15; see 14–17. Hudson's portrait of Theodore Jacobsen, the hospital's architect, should also be compared with Hogarth's. Hudson shows him full length in the pose of Scheemakers's well-known statue of Shakespeare, lean-

ing on a plinth; Shakespeare's poem is transformed into the architectural plans for the Foundling. Jacobsen, a rich London steelyard owner who had retired to become an architect, presumably wished to see himself poeticized in this way. Hogarth's portrait of a few years earlier is a straightforward half-length in which Jacobsen simply holds up his plans (Beckett, pl. 135).

32. *Gen. Works,* 1: 23.

33. Lady Elizabeth Cust, *Records of the Cust Family, Second Series* (London, 1909), 250, 260, 261.

34. There is a full-length portrait of a boy that has been traditionally identified as Horace Walpole; but internal evidence makes him ten years old at the time, and this would mean that the portrait was painted in 1727—a very early date for Hogarth (see Einberg, *Manners & Morals,* cat. no. 54).

35. BM. Add MS. 27995, f. 23. See "Memoirs of the Life of the late Rev. John Hoadly," *Annual Register,* 19 (1776): 38–43; Pyle, *Memoirs of a Royal Chaplain* (London, 1905), 268–69.

36. No. 56 in Jane Hogarth's sale catalogue (1789).

37. *London Journal,* 9 Mar. 1734.

38. The £17,000 he left in his will should be compared to the £40,000 left by Bishop Sherlock and the £50,000 by Bishop Hutton.

39. Pyle, *Memoirs of a Royal Chaplain,* 178.

40. *Joseph Andrews,* 1.17; *Tom Jones,* 11.7.

41. The Hoadly brothers' play *The Contrast,* performed at Lincoln's Inn Fields on 30 April 1731 and the three subsequent nights, though aimed primarily at Thomson (whom Fielding had also burlesqued), includes an allusion to Fielding. Whether Fielding would have taken it as an attack is questionable, but it was printed as such in the *Grub-street Journal,* 27 May 1731: "By G—," says one of the characters, "I hate all ghosts, from the bloody ghosts in Richard the Third to that in 'Tom Thumb.'" The play was never published because it was suppressed by Bishop Hoadly.

42. For the question of *which* Mrs. Hoadly and its dating, see *Tate,* cat. no. 99. The style, especially of Mrs. Hoadly, could be as late as the mid-1740s. Mary Webster has argued for the later date for both *Bishop* and *Mrs. Hoadly* (*Hogarth* [London, 1979], 94–95).

43. Recent cleaning has revealed the date 1741, which establishes its priority over the engraving by Baron (cf. Robert Wark, "Two Portraits by Hogarth," *Burlington Magazine,* 99 [1957], 344–47; *Tate,* cat. no. 99).

44. See *HGW,* no. 226. On the question of the positioning of the garter badge and other controversial details of the engraving, see J. L. Nevinson, "Portrait of Bishop Hoadly," *Burlington Magazine,* 100 (1958): 344–47; *Tate,* 103.

45. G. R. Cragg, "The Churchman," *Man versus Society in 18th-Century Britain,* ed. J. L. Clifford (Cambridge, 1968), 59.

46. It is perhaps more likely that, given his admiration for Hoadly, Ho-

garth is illustrating one of the great Pauline texts on the spirit and the flesh (e.g., Rom. 7: 5, 18, 25; Gal. 5: 17, 24).

47. See Beckett, 53, pls. 130, 149.

48. One story has it that both Arnold and his daughter were "painted by *Hogarth* whilst [he was] on a visit here," at Ashby Lodge, Northampton-shire. Arnold was a retired merchant, who built Ashby Lodge in 1722 and collected pictures by the Old Masters, among them paintings attributed to Rubens, Veronese, and Teniers the elder. See George Baker, *The History and Antiquities of the County of Northampton* (London, 1822–30), 1: 248.

49. Hyde Collection (Houghton Library, Harvard University); see *HLAT,* figs. 272–73, for reproductions.

50. Piper, *English Face,* 184.

51. For the Masonic sense, see Dewar, *Unlocked Secret,* 53; but cf. Mackey, 1: 120, under "Broken Column," who says enigmatically "the broken column is, as Master Masons well know, the emblem of the fall of one of the chief supporters of the Craft."

52. Pyle, 22 Nov. 1760, *Memoirs,* 330.

53. He avoids the worst excesses of the school. Both Lely and Kneller—and to an outrageous extent Richardson—habitually emphasized the light on garments with violently obvious brushstrokes, often at odds with the execution of hands and face. Another of Kneller's mannerisms bypassed by Hogarth (carried on by Highmore and Ellys) was allowing the grayish un-derpainting to show through as shadows.

54. It may have been painted to commemorate the autumn of 1738 when Hervey and his friends hunted and caroused together at the Foxes' house at Maddington. See earl of Ilchester, *Henry Fox, First Lord Holland, His Family and Relations* (London, 1920), 1: 51; Beckett, 44.

55. Pulteney, as "Caleb D'Anvers," *A Proper Reply to a Late Scurrilous Libel* (London, 1731), 3–6 and 27–28. I am indebted for this reference and other valuable suggestions to Jill Campbell's essay, "Politics and Sexuality in Portraits of John, Lord Hervey," *Word & Image,* 6 (1990): 281–97. See also Robert Halsband, *Lord Hervey: Eighteenth-Century Courtier* (London, 1973), 108–12. Martin Battestin has suggested that Hogarth has Hervey stand in order to minimize his short stature ("Lord Hervey's Role in *Joseph Andrews,*" *Philological Quarterly,* 42 [1963]: 229n5).

56. Jill Campbell detects directed at the viewer "the sly and oblique, but intensely aware gazes of both Hervey and the mischief-making Stephen Fox," which suggest the in-joke or the in-group. This conversation, painted *for* the in-group, should be compared with similar group portraits painted by John Zoffany in the next generation—in particular *Charles Townley and His Friends* (see Paulson, *E and E,* 138–58).

57. See Halsband, *Lord Hervey,* 86–104, 190–91, and Ilchester, *Henry Fox,* 38–47. Both Henry Fox and Thomas Winnington were also linked to

Hervey at various times as erotic objects (Halsband, 62–63, 91).

58. Graham (a friend and encourager of another Scotsman, Tobias Smollett, whose ill-fated play *The Regicide* he read around 1745) died in January 1747. See his obituary, *LM*, 16 (1747): 53; Lewis Knapp, *Tobias Smollett, Doctor of Men and Manners* (London, 1949), 50n.

59. See C.G.T. Dean, *The Royal Hospital Chelsea* (London, 1950), 221; *GM*, 85 (1816), pt. 1: 633. Mary Webster ("An Eighteenth-Century Family: Hogarth's Portrait of the Graham Children," *Apollo*, Sept. 1989, 171–73) has filled in further information on the Graham family, but surprisingly implies that Daniel Graham is her discovery, failing to cite either Dean or *HLAT*. The children are, from left to right, Henrietta Catherine (1733–1800), Anna Maria (1738–1788), and Richard Robert (1734/35–1816), and the baby is Thomas (1740, buried 4 Feb. 1741/42): thus, given the date on the painting, the baby must by then have been dead.

60. See Oliver Vere Langford, *The History of the Island Antigua* (London, 1890), 2: 220–30, 259; also Alexander Mackenzie, *History of the Frasers of Lovat* (Inverness, 1896); Mary Webster, "From an Exotic Home: Hogarth's Portrait of the Mackinen Children," *Country Life*, 28 Sept. 1989, 151.

61. Wendorf, *The Elements of Life: Biography and Portrait-Painting in Stuart and Georgian England* (Oxford, 1990), 182.

62. Vertue, 3: 107, 110.

63. For example, the *London Evening Post* of 11–14 Nov. 1738 reported: "Last Week a fine *Venus* was finish'd at a sculptor's in St. Martin's Lane for a Person of Quality; eight of the most celebrated Painters assisted at the Performance, and the Lady who sat nine Hours at different Times for the same, had three Half Crowns each Hour for her Complaisance and Trouble." The same paper for 14–16 Nov. clarified the report. "Mr. Roubillack, the Statuary, is carving a curious Figure of a Lady for Sir Andrew Fountaine, Knt. which, we hear, will cost 300*l.*"

64. Quoted, *Gen. Works*, 3: 350. For the portrait of John Herring, see Beckett, 51, pl. 120; for the story that Elizabeth Salter, another portrait subject, was Herring's niece, see *Tate*, cat. no. 101 (which doubts the connection). For *Archbishop Herring*, see John Ingamells, "Hogarth's 'Red' Herrings: A Study in Iconography," *Connoisseur*, 179 (1972), 21–26, and *The English Episcopal Portrait 1559–1835* (York, 1981), 217–19; *Tate*, cat. no. 106.

65. *Gen. Works*, 1: 193.

66. Philip Yorke–Daniel Wray correspondence, quoted by Whitley, 1: 31. For Ramsay, see 2: 458n70. There is a puzzling reference following Vertue's list of portraitists in 1743 (3: 118): "also crayon painters of portraits especially—Knapton—Hogarth Pond & hore—some Landskips also well done." Hogarth's painting may also owe something, if only in a negative way, to the fashion of pastel imported from France and popularized by Pond

in the 1730s and early 1740s (though on a small scale, faces only); a fad commented on acerbically by Vertue (3: 109; see also Lippincott, 85).

67. It was owned by the family, in which it has remained to the present, but Hogarth may have seen it or one very like it in La Tour's studio (George Wildenstein, *La Tour* [Paris, 1928], pl. 35). La Tour had practiced in England as a young man in the 1720s (a London newspaper published shortly after La Tour's death, quoted by Whitley, 1: 30).

68. *Letters from the Late Most Reverend Dr. Thomas Herring, Lord Archbishop of Canterbury, to William Duncombe, Esq; deceased* (London, 1777), 88–89.

69. *Tate,* 125.

70. John Duncombe, annotations to the *Letters,* 89.

71. See *Tate,* 125.

8. "COMIC HISTORY-PAINTING"

1. For an illuminating discussion of this subject in relation to Richardson and Fielding, see William B. Warner, "The Elevation of the Novel in England: Hegemony and Literary History," *ELH,* forthcoming.

2. See T. C. Duncan Eaves and Ben D. Kimpel, *Samuel Richardson: A Biography* (Oxford, 1971).

3. Preface, *Pamela,* 2d ed. (1741), 1: xxxvi–xxxvii. See Eaves, "Graphic Illustration of the Novels of Samuel Richardson, 1740–1810," *Huntington Library Quarterly,* 14 (1951): 350–51.

4. *Correspondence of Samuel Richardson,* ed. Anna Laetitia Barbauld (London, 1804), 1: 56; Aaron Hill, *Works* (1753), 2: 300–302. Not until the sixth edition, in 1742, did illustrations appear, engraved after designs of Gravelot and Hayman.

5. *Pamela,* ed. Eaves and Kimpel (Boston, 1971), 60.

6. I am referring to the characteristics Ian Watt attributes to his term "formal realism" or "realism of presentation" in his chapter on *Pamela* (chap. 5) in *The Rise of the Novel* (Los Angeles, 1957).

7. *The Complete Works of Henry Fielding, Esq.,* ed. W. E. Henley (London, 1903), 8: 275.

8. He would have remembered Pope's Vice riding triumphantly in Virtue's place in the "Epilogue to the Satires" (1737), itself an allusion to Walpole's marrying his longtime mistress Maria Skerrett, making her Lady Walpole following the death of his wife.

9. Armstrong, *Desire and Domestic Fiction: A Political History of the Novel* (New York, 1987), 39; also 38.

10. My text of *Joseph Andrews* is Martin Battestin's (Oxford, 1967).

11. Somerville, dedication to Hogarth of *Hobbinol, or the Rural Games* (1740): Hogarth's province, Somerville writes, is the town, while his own

will be the country, but they will agree "to make Vice and Folly the Object of our Ridicule; and we cannot fail to be of some service to Mankind."

12. This passage has puzzled commentators, e.g. W. B. Coley, "Fielding, Hogarth, and the Three Italian Masters," *Modern Language Quarterly*, 24 (1963): 386–91.

13. J. Paul Hunter's argument that Fielding is refuting Morgan is unconvincing; following Battestin, he must see the Joseph and Abraham analogies as normative (*Occasional Form: Henry Fielding and the Chains of Circumstance* [Baltimore, 1975], 101–05; Battestin, *The Moral Basis of Fielding's Art* [Middletown, Conn., 1959], 30–43). It is much simpler to accept the possibility (unacceptable to Battestin and Hunter) that Fielding may have shared some assumptions with the Deists and still have been a decent man.

14. For a further development of the relationship, see Paulson 1979, 164–67.

15. Burlesque too, though "the Exhibition of what is monstrous and unnatural," arises from "appropriating the Manners of the highest to the lowest, or *e converso*"—though the *e converso* is pro forma; he means in fact only the appropriation by the lowest (Battestin ed., 4).

16. I am indebted to Judith Frank for putting me onto this line of thought. See her forthcoming essay, "The Comic Novel and the Poor: Fielding's Preface to *Joseph Andrews*."

9. *MARRIAGE-A-LA-MODE*

1. *Gen. Works*, 2: 158; W.F.N. Noel, "Edwards of Welham," *The Rutland Magazine and County Historical Record*, 4 (1909–1910): 211. On Portmore, see *GM* 1 (1731): 121.

2. *The Scots Peerage*, ed. Sir James Balfour Paul, 4: 385. For the information on Mary Edwards I follow W.F.N. Noel, "Edwards of Welham," 209–12, 243–44. Much abbreviated, this material was reprinted in Emilia F. Noel, *Some Letters and Records of the Noel Family* (London, 1910), 30–31.

3. *Grub-street Journal* of Feb. 1731/32 (quoting the *Daily Post*): "Miss Edwards of Kensington, the rich heiress, is coming out with one of the finest equipages that has been seen"; to which the *Grub-street Journal* adds: "Most of my brethren were concerned in marrying this Lady to a Lord, three months ago." For the marriage, see *GM*, 1 (1731): 311.

4. For the birth of Gerard Anne, see *GM*, 3 (1733): 156. Francis Edwards, Mary's father, is said to have possessed paintings by Hogarth, but there seems to be a confusion with a later S. Edwards who owned Hogarth's portrait of Sir George Hay, *The Savoyard*, *The Bench*, and other paintings from his last years (Noel, "Edwards of Welham," 210).

5. Vertue, 4: 68. I am very dubious of the other picture Noel lists (211), "by Hogarth, of the interior of a barber-surgeon's shop, in which monkeys

are shaving and bleeding cats," which was retained by the family. This may have been the *Barber Shop of Monkeys,* attributed to Teniers in Mary Edward's sale catalogue (Cock's, lot 38, 29 May 1746). She owned four Heemskirks, but also paintings by Rubens, Guido, Andrea del Sarto, Raphael, Van Dyck, and Kneller. She bought Rubens's *Nature Adorned,* with its connection with Hogarth's *Boys Peeping at Nature,* at Thornhill's sale (6 Mar. 1734/35, for 215 guineas).

6. See Sir Charles Holmes, *Catalogue of the Frick Collection,* 1 (New York, 1949): 30–33.

7. Noel, "Edwards of Welham," 211.

8. Without his permission, a print was brought out in 1746 after Mary Edwards's death and the publication of *Marriage A-la-mode,* with the title "Taste in High Life" attached (repro. *HGW* 1965–70, opp. 25).

9. Martin Battestin first noticed these faces and presented his case (to me utterly convincing) in "Pictures of Fielding," *ECS,* 17 (1983): 9–13.

10. Annibale Carracci produced sheets covered with faces—caricatures and otherwise—very like Hogarth's *Characters and Caricaturas,* and Hogarth may well have seen one of these (one is in the Oppé collection).

11. This is a problematic portrait. It may be by Hogarth; it may be by his father-in-law, Thornhill. The other portrait is reproduced in vol. 1, fig. 69.

12. Vertue, 3: 137; *Gen. Works,* 1:121; *HGW,* 15. Figures of Janus appeared in the headpieces introducing the first chapters in volumes 2 and 3 of Shaftesbury's *Characteristics* (a work Hogarth knew well; see above, 103; my edition is that of 1714). The former was juxtaposed with a *Diana multimammia,* to which a satyr points.

13. Finally, in the issue for 22 November, a further advertisement was published, addressed to Henley: "*To the aldgate* GAME-COCK *in* Tom o'Lincoln's *Pens.* / We should be very glad to strengthen our Side of the Aldgate Match, by lending you our invincible little Favourite; but though the Shake-Bags of St. Martin's are *told out,* yet there is a Wright Stag or two that must be *pounded* before he is disengaged; besides, we have promised the next time we put on his Weapons, he shall fight Battle Royal in St. Margaret's Pit, against the old Pastry-Cook's Custard-fed Smock-Cocks. from / *The Covent-Garden true-Cocks.* / Note, I suppose you know our Colour's Coal-Black." The terms are from cock-fighting: the "Wright Stag" (i.e., male artificer) is only an allusion to those French engravers in Hogarth's advertisement; the last part is a way of saying that the authors wish Hogarth would turn his attention to the political cockpit (see vol. 3, Hogarth's *Cockpit*).

14. Northcote, *Life of Reynolds,* 1: 138.

15. The case is even plainer in 4, where the eye is drawn to the gesturing

woman in white, framed by the large pink tester, and not to the countess, who in terms of the readable structure is the center of interest.

16. Robert Wark, "Hogarth's Narrative Method in Practice and Theory," in *England in the Restoration and Early Eighteenth Century,* ed. H. T. Swedenberg, Jr. (Los Angeles, 1972), 163.

17. *London Evening Post and General Advertiser,* 20 Oct. 1735. Cibber's version, premiered in 1707, was performed on and off until 1715, and then not revived until 1746, when Kitty Clive chose it for a spring benefit, probably to capitalize on the popularity of Hogarth's prints (see *LS,* pt. 2, 1: 330; pt 3, 2: 1223ff.). But Hogarth could have read Cibber's play in the London editions of 1707 or 1736.

18. Cibber's VI.i may recall Hogarth's Pl. 4; cf. also Florimel's speech to her lover Celadon, III.i: "What would you say if I should make you an assignation at the masquerade tonight?" (*The Dramatic Works of Colley Cibber, Esq.,* 3 [London, 1777]: 231, 277). The calling and invitation cards in Plate 4 may have come from Vanbrugh's *The Provok'd Husband* (1717–1728), which has a Basset, a Lady Townly, and (a walk-on) a Lady Squander (though Lady Townly also appears in Etherege's *Man of Mode*).

19. Out of 241 comedies studied, Gilbert Alleman found that more than one-third, or 91, introduced clandestine marriage to unite the major characters; while in 37 the hero or heroine was "clearly threatened with an immediate forced marriage" (*Matrimonial Law and the Materials of Restoration Comedy* [Wallingford, Pa., 1942], 80). Hogarth may also be nodding to another play, David Garrick's *Lethe* (1740), in which Lord Chalkstone comments on marriages of convenience: "I married for a Fortune; she for a Title. When we both had got what we wanted, the sooner we parted the better—" (Garrick later built his *Clandestine Marriage* on this proposition, acknowledging *Marriage A-la-mode* as his source).

20. There were also, of course, Steele's *Spectator* essays attacking dueling.

21. *Pamela,* 370.

22. Morgann, *An Essay on the Dramatic Character of Sir John Falstaff* (1777).

23. Robert Cowley has given a highly detailed explanation of this—to which I am indebted.

24. Cf. the decorations represented by Hogarth in *An Assembly at Wanstead House,* ill., vol. 1.

25. See Cowley, but also the entries in *HGW* (I do not accept all of Cowley's inferences and disagree with some of his interpretations).

26. Cowley makes this interesting point, 42–43.

27. For identifications, see *HGW* 1965, 1: 269–70, 327. Most were originally identified by Georg Christoph Lichtenberg (Coley, 30) and corrected by Davies, 49–50.

28. Or, at its most literary, it is a reference to Tityus, whose liver, the seat of carnal passion, was gnawed by vultures.

29. Cf. the gridiron behind the Rake in Plate 7 and the picture of St. Lawrence himself in Plate 8 of the *Rake's Progress.*

30. The pictures on the walls of the countess's boudoir may have been suggested by those in the parlor of the whore, Sarah Millwood, the seducer of the apprentice George Barnwell, described in *The Prentice's Tragedy; or the History of George Barnwell: Being a fair Warning to Young Men to avoid the company of Lewd Women* (ca. 1700) as "suitable to the grade of the owner, for on one hand he espied Venus and Mars naked, embracing each other in Vulcan's Net, which he laid to catch them when they were at the height of their stolen pleasures; on the other hand a Satyr ravishing a Nymph; and again Jupiter transformed into a Bull, running away with Europa to deflower her, and other such fancies, to incite and stir up amorous delights" (6; cited Kurz, "Italian Models of Hogarth's Picture Stories," 151–52; the last sentence, Kurz says, has been lifted from Garzoni's *Discorso,* which singles out *The Judgment of Paris* used in *Rake* 2 as especially wicked). Some of these pictures may have been in Lillo's stage version, *The London Merchant* (1731), which Hogarth certainly saw. For the *Ganymede* painting, see Richardson, *Essay on the Theory of Painting,* in *Works,* 65.

31. But as Cowley notes (46), the face actually derives not from Caravaggio's *Medusa* but from the face illustrating Le Brun's "passion" of "Fright," in his *Méthode pour apprendre à dessiner les passions* (1696, fig. 13, opp. 31), which suggests *her* terror at what she sees in the earl's chamber.

32. I do not want to underestimate the theatricality of the scenes, especially as an anticipation and support of the primary metaphor of life-as-theater which permeates Fielding's *Tom Jones* three years later. The fifth scene is the most clearly theatrical, the flattest and most stagelike, and brings together the three protagonists in a climactic conflict.

33. Though I have not located a specific source, it does appear to be a Flemish, and not an Italian, paradigm. The school of Petrus Christus *Deposition* and the School of Coter *Trinity,* both in the Louvre, have the essential features; the former also has the Magdalen wringing her hands. One wonders whether Hogarth was recalling Jonathan Richardson's passage on artists' errors in painting *The Descent from the Cross* in his *Treatise on Painting* (*Works,* 30–31).

34. The general slouch and position of the falling sword may, on the other hand, derive from a mythological subject, the figure of Ajax in Poussin's *Realm of Flora.* Hogarth has drawn upon a vague memory of that figure, altering it in almost every detail. I doubt whether it served as an allusion, but it did bring to Hogarth's mind, if not to ours, the mad Ajax who threw himself on his sword, killing himself as in a sense the earl has brought about his own death.

35. See Helen M. Garth, "Saint Mary Magdalene in Medieval Literature," *Johns Hopkins University Studies in Historical and Political Science,* 67 (Baltimore, 1950), pt. 3: esp. 31–36; "stood near" was Honorius of Autun's description (cited, 36).

36. The tapestry is generally reminiscent of Simon Vouet's *Judgment of Solomon* tapestry in the Louvre (engraved by François Tortebat, 1665). But Hogarth would also have remembered Millamant's remark to Mirabell about the Solomon story in an old tapestry in Congreve's *Way of the World* (1700), ed. Kathleen M. Lynch (Lincoln, 1965), 49.

37. Rubens's version offers, among other things, an authority for omitting the body of the other, the dead child, who was materialized in Poussin's and Raphael's versions.

38. Cf. vol. 1, 126: Falstaff was the first of the false judges (vol. 1, 163–64).

39. Recall the detail supplied by Rouquet that the clergyman is the girl's father; but the churchman, in any case, fills his function (see vol. 1, 328).

40. David Dabydeen makes the point about savagery, civilization, and the castrato (*Hogarth's Blacks* [Kingston-on-Thames, 1985], 74–81). My discussion of Hogarth's blacks first appeared in Paulson 1982, 80–82.

41. BL Dodd MSS. IX/62 (Add. MSS. 33402).

42. Dated 11 Feb.; Walpole's copy, in the Lewis Walpole Library, Yale University.

43. Thornhill sale catalogue: first day, no. 85; second day, nos. 28, 35, 36, 41.

44. *Lot* was second day, no. 24; *Apollo,* first day, no. 11; *Bacchus,* second day, no. 93; *Assembly,* first day, no. 62.

45. Walpole to Mann, 25 July 1750, Walpole, *Corr.,* 20: 164, remarking that King Theodore is in the King's Bench Prison for debt: "I have desired Hogarth, to go and steal his picture for me; though I suppose one might easily buy a sitting of him." The editors add that "this portrait does not seem to have been executed." For the room in Plate 2 of *Marriage A-la-mode,* see Sir Wemyss Reid, *Life, Letters, and Friendships of Richard Monckton Milnes, First Lord Houghton* (1890), 2: 364; Dobson, 74. For the story of Hogarth and Gray, see *Gen. Works,* 1: 393.

46. Walpole to Ossory, 3 Apr. 1773, Walpole, *Corr.,* 32: 114; Walpole, MS. *Commonplace Book,* 44 (Lewis Walpole Library, Yale University). Concerning *Strolling Actresses,* sold to Francis Beckford and then to Wood, see J. Ireland, 3: 232. In the 1780s it was in the possession of Wood's brother Thomas (1708–1799), and it remained in the family till destroyed by fire at Littleton in 1874.

47. A receipt in Hogarth's hand, dated 2 Mar. 1745, is in the Houghton Library, Harvard University, Murdock MS. 21.

48. Roubiliac supplied the monument of the second duke of Ancaster

(d. 1742); the third duke, who bought Hogarth's paintings, had his wife painted by Hudson, and in the 1750s filled his rococo rooms with chimneypieces by Cheere.

49. Mary Edwards's sale, Cock's, 28, 29 May 1746; *Gen. Works,* 2: iv. *The Distressed Poet* was also missing; it was presented by Hogarth to Mrs. Draper, Queen Caroline's midwife (J. Ireland, 1: 117).

50. *London Evening Post,* 27–30 Apr. 1745; *Daily Advertiser,* 29 Apr.; *London Evening Post,* 6–8, 13–14 June, and in many subsequent issues as late as mid-September, reminding that the subscribers' edition could be picked up and others bought.

51. *London Evening Post,* 16–18 July 1745. The paintings (done between 1742 and 1744) are now divided in fours, among the Tate, the Fitzwilliam, and the National Gallery of Victoria, Melbourne (all repro., Einberg, *Manners & Morals,* nos. 134–45).

52. Written in the 1750s, published in *GM,* 36 (1766): 354–55.

53. That Highmore succeeded was proved by the anonymous broadsheet of 1750 that shows James Maclean, the highwayman known for his gentlemanly manners, "being visited in his cell by 'the quality,' and the elegant crowd is made up of groups and figures taken entirely from various plates of the 'Pamela' series, including Maclean himself, who is based on the bridegroom in plate IX, with chains added to his legs" (Einberg, in *Tate,* 51).

54. He pursued Benjamin Wilson with questions about Hogarth and about this picture in particular. Wilson told him that the ornaments of the chimneypiece were from some old carvings in a room in the Charterhouse, shown Hogarth by Wilson when he was still clerk there, and that the head of the bride had been painted only ten or twelve years earlier (by implication, shortly before Hogarth's death, and in time for it to be modeled on Queen Charlotte). See *Gen. Works,* 1: 124–28; Wilson's autobiographical notes, in H. Randolph, *Life of General Sir Robert Wilson* (London, 1862), 1:32.

55. This was known as the Kit Cat or Kit-kat, "the smallest of a series of standard formats intended for portrait painting by the early part of the eighteenth century" (Ashok Roy, "Hogarth's 'Marriage à la Mode' and Contemporary Painting Practice," *National Gallery Technical Bulletin,* 6 [1982]: 59).

56. The paintings were first discussed and copied by S. Ireland, 2: 127–34. For the paintings, see Beckett, 67–68, pls. 163–68; and, for an argument against the series, Arthur S. Marks, "William Hogarth's *The Happy Marriage,*" *Art Quarterly,* 35 (1972): 143–57. The idea that there was a projected series depends partly on Ireland's word, which is admittedly not too reliable. But the fact remains that Ireland did know Jane Hogarth and that in most cases the paintings he described or copied have proved to be genuine. The only positive evidence for Marks's case is Benjamin Wilson's word that there was only one such painting. But Wilson's notes were casu-

ally written, recalling events long after; he may not have been thinking in terms of a series, may not have had contact with the other pictures in it, or with Hogarth (on this particular point) until after the series had been discontinued; or he may have forgotten. Marks shows Wilson's inaccuracy in other matters, and he does not explain why he accepts his word in this case. (See Wilson's autobiographical notes, themselves recast in the third person, in H. Randolph, *Life of Wisdom,* 1: 32.)

57. See Kurz, "Italian Models of Hogarth's Picture Stories," 159.

58. *Tate*, 117.

59. As Cowley points out, *Marriage A-la-mode* was built on a structure of ABCCBA: parents and children in 1 and 6; husband and wife in 2 and 5; husband/wife and lover in 3 and 4.

10. GARRICK AND THE THEATER

1. *Marriage A-la-Mode: An Humourous Tale, in Six Cantos, in Hudibrastic Verse; being an explanation of the six Prints lately Published by the Ingenious Mr. Hogarth* (1746), iii–iv (advertised as published, *London Evening Post,* 6–8 Feb. 1745/46).

2. *Tom Jones,* 16.5. Partridge also refers to Hamlet as the "little man" on the stage, an allusion to Garrick's small stature—another characteristic he shared with Hogarth.

3. *Memoirs of Richard Cumberland* (London, 1807), 1: 80. I am indebted throughout this discussion to Alan S. Downer, "Nature to Advantage Dressed: Eighteenth-Century Acting," *PMLA,* 58 (1743): 1002–37; reprinted in John Loftis, ed., *Restoration Drama, Modern Essays in Criticism* (New York, 1966), 328–71.

4. The words are from *Spectator* No. 40 (16 Apr. 1711).

5. *The Dramatic Censor,* quoted, E. A. Parry, *Charles Macklin* (London, 1891), 67; "Sir" John Hill, quoted by William Cooke, *Memoirs of Samuel Foote* London, 1805), 1: 38–39.

6. The story of the St. John's Gate performance was originally told by John Nichols, and is dated 1740, possibly through the identification of the special epilogue Garrick wrote for it, published in September 1740, signed "G" (reported, Sir John Hawkins, *Johnson* [1787], 45; see J. L. Clifford, *Young Samuel Johnson* [London, 1955], 235 and n).

7. William Cooke, *Memoirs of Charles Macklin, Comedian, with the Dramatic Characters, Manners, Anecdotes, etc. of the Age in which He Lived* (London, 1804), 98–99; see also "Character of Mr. Garrick," *GM,* 12 (1949): 527.

8. *The Actor: A Treatise on the Art of Playing* (London, 1750), 171–72; see also Cooke, *Macklin,* 114.

9. Cooke, *Macklin,* 114.

10. Downer, "Nature," in Loftis, *Restoration Drama,* 340, 343.

11. John Genest, *Some Account of the English Stage* (London, 1832), 4: 14.

12. J. Ireland, 3: 337.

13. Genest, *Some Account,* 4: 162; Cooke, *Macklin,* 19.

14. See Lance Bertelsen, "David Garrick and English Painting," *ECS,* 11 (1978): 308–24.

15. Letter to John Hoadly, 22 May 1745, *Garrick Letters,* 1: 47–48; to Somerset Draper, 10 Oct., 1: 50; to Hayman, 10 Oct., 1: 54 and 55n.

16. *Garrick Letters,* 1: 56. For information on Windham (1717–1761), see R. W. Ketton-Cremer, *Early Life and Diaries of William Windham* (London, 1930), and *The Windham Papers* (London, 1913).

17. Letter to Draper, 23 Oct. and 1 Dec., *Garrick Letters,* 1: 65, 70.

18. See, e.g., *Garrick Letters,* 1: xxxiv, 66n.

19. Hogarth liked to think that it did resemble Garrick, as the letter quoted below (21 Oct. 1746) shows, but in fact his point probably was to make it as generalized as possible without losing the resemblance.

20. Charles Mitchell has made this point in "Benjamin West's 'Death of General Wolfe' and the Popular History Piece," *Journal of the Warburg and Courtauld Institutes,* 7 (1944): 28.

21. *An Epistle: Addrest to Sir Thomas Hanmer, On His Edition of Shakespear's Works* (1743).

22. For other connections, see E. R. Wasserman, "The Sympathetic Imagination in Eighteenth-Century Theories of Acting," *Journal of English and German Philosophy,* 46 (1947): 264–72.

23. An engraving of the letter was published by Laurie and Whittle, 12 May 1797; the original is now in the Royal Library (Oppé, cat. no. 39, pl. 37).

24. The first letter from Garrick to Hoadly is dated 29 Dec. 1744 (1: 45–46), so they may originally have been acquainted through Hogarth.

25. "Memoirs of the Life of the Late Dr. John Hoadly," *Annual Register,* 19 (1776): 39–40.

26. Garrick to Hoadly, July 1746, *Garrick Letters,* 1: 78–79. Funnidos: the witty, sober courtier in Carey's *Chrononhotonlogos;* quote from *Merry Wives of Windsor,* III.i.104–7.

27. For more on Monsey (1693–1788), see Ketton-Cremer, *Norfolk Portraits* (London, 1944), 87–88 (also 85–95); John Taylor, *Records of My Life* (1832); anon., *A Sketch of the Life and Character of the Late Dr. Monsey* (1789), 415–19.

28. See Ketton-Cremer, *William Windham,* 43; Ketton-Cremer, *Felbrigg, the Story of a House* (London, 1962), 124.

29. The quotation is from *Gen. Works,* 1: 215–16, but the passage, written by Steevens, had appeared in the 1782 and 1785 editions of *Biogr. Anecd.* as well. The earliest appearance of the story, still by Steevens, was probably

in the account of Garrick in *Biographia Dramatica* (1782), 1: 238, where the detail of the scene painting has not yet been added. See *DNB;* Dougald MacMillan, "George Steevens's Contributions to *Biographia Dramatica,"* in *Restoration and Eighteenth-Century Literature,* ed. C. Camden (Chicago, 1963), 265–74. Marked by J. P. Collier, in Hoe copy, Huntington Lib. Another version, that Hogarth chalked the lines over a door, was told by S. Ireland (Bodleian MS. Eng. c.408, ff. 28, 29).

30. This scene from the MS. in his possession was kindly transcribed for me by the late R. W. Ketton-Cremer, who also gave permission for its publication.

31. *Gen. Works,* 1: 216.

32. Letter to Peter Garrick, 9 Aug., *Garrick Letters,* 1: 80; to Hoadly, from Cheltenham, 19 Aug. 1746, 1: 84–85; to Hoadly, 14 Sept., 1: 86.

33. See *Tate,* cat. no. 103.

34. See *Tate,* 112; another version is with Edwin Bucher of Trogen, Switzerland. Neither is signed or dated, but the Bucher version is in a contemporary silver-gilt case which is engraved on the back, "Wm Hogarth / Painted by Zincke / 1735."

35. Richardson in his *Treatise on Connoisseurship* draws attention to Lomazzo's use of animal characterization of the Old Masters (*Works,* 210). Pyne tells the story, probably spurious, of the apprentice (one Kit Sugar) whom Hogarth caricatured on the wall and who in return caricatured Hogarth and his pug as look-alikes. Hogarth enjoyed the joke and insisted that the drawing not be erased. Pyne, however, has the chronology wrong: the episode is made contemporary with *Industry and Idleness* and Scott's painting of *London Bridge* (*Wine and Walnuts* 1 [1823]: 64–68).

36. Nichols reports that according to William Strode, son of the Strodes in the portrait, the dog on the left belonged to Mr. William Strode and the pug to Colonel (or Mr. Samuel) Strode (*Biogr. Anecd.,* 1782, 362; cf. *Gen. Works,* 1: 424–25). But even if Strode Jr.'s memory over forty years is accurate, the fact remains that Hogarth essentially duplicates the image of this hungry dog with the pug that reappears in the self-portrait.

37. Wendorf, *Elements of Life,* 184.

38. For the Masonic dog, see Mackey, 192. For the Masonic pug of the German *Mopses* (*mops,* pug) lodge, see Mackey, 491; James Stevens Curl, *The Art and Architecture of Freemasonry* (London, 1991), 76–77; and Robin Simon, "Panels and Pugs," *Apollo,* June 1991, 372–73. Simon cites a Meissen snuffbox whose lid shows a landscape but when opened the underside reveals a pair of pugs and a Masonic triangle. Mackey argues that these secret lodges were founded in the Catholic states of Germany as "an imitation of Freemasonry under a less offensive appellation" following the Papal Bull *In Eminenti* of 1738 excommunicating all Freemasons. But the "secret" of *Le Secret de la Société des Mopses* (Amsterdam, 1740) may have

been less that the *Mopses* lodge required secrecy in the aftermath of the Papal Bull (there was no enforcement of it except in the papal states) than that it admitted women. In any case, the *Mopses* were not regarded as true Masonic lodges.

For the Jacobite inclusion of pugs in some of their portraits I am indebted to the researches of Jane Clark. The Jacobite pug raises the possibility of a connection between Hogarth and Jacobitism (and the Jacobite faction of Freemasons led by the duke of Wharton), for which, however, there is no supporting evidence. Nevertheless, it is worth speculating: the Gormogans traced their origins back to the Chinese; the Gormogans were apparently a cover for the Jacobites; if the Jacobites used the pug as *their* Masonic dog it could be because of the pug's Chinese origins. Hogarth's pug, of course, could have been disputing the Jacobite use of the pug.

The pug who appears in the contemporaneous portrait group of Lord George Graham (fig. 80) could have a Masonic reference: Graham was a prominent Freemason, a grand warden and a grand steward. It is on Graham's (the right) side of the picture, balanced by an ordinary dog on the left, which seems to represent the shipmates. But, with Hogarth also a Freemason, the pug could in this instance indicate fraternal fidelity and courage, shared by artist and sitter. The pugs who appeared in Hogarth's conversation pictures (to designate, I have argued, Hogarth himself) could have served the same function. This could have been the case in the Fountaine conversation (Sir Andrew was a Mason), but it would have to be proved that the Wollaston and Strode families included Freemasons.

39. See *Essay on the Theory of Painting,* in *Works,* 129–34. Richardson's examples of the sublime in painting are Rembrandt and Zuccaro.

40. See J.V.G. Mallet, "Hogarth's Pug in Porcelain," *Victoria and Albert Museum Bulletin,* 3 (1967): 45–54.

41. Lippincott, 146–48.

42. Graham Reynolds, *English Portrait Miniatures* (London, 1952), 116–18; *Description of Vauxhall* (1762), 6. Pyne has several dubious anecdotes about Rouquet, e.g., *Wine and Walnuts,* 2 (1824): 7.

43. *GM,* 15 (1745): 319; *London Evening Post,* 16–19, 21–23 Feb. 1744/45; 2–5, 5–7, 23–26 Mar.; 27–30 Apr.; 8 July.

44. AN, 229–30; *GM,* 16 (1746): 224. Nichols adds that Rouquet "was liberally paid by Hogarth, for having cloathed his sentiments and illustrations in a foreign dress" (*Biogr. Anecd.* [1782], 93).

45. Rouquet, 4.

46. John Bowack, *Antiquities of Middlesex,* pt. 2 (1706), 43.

47. Warwick Draper, *Chiswick* (London, 1923), 10; J.E.B. Gover, *Place Names of Middlesex* (London, 1922), 15; Thomas Faulkner, *History of Brentford, Ealing and Chiswick* (London, 1845), 175.

48. See the Court Roll of the Prebendal Manor of Chiswick, Archives of

the Church Commissioners, London, 205.418, vol. A, 2 May 1737–25 Oct. 1763, ff. 143–45. In 1701 one Richard Downs was admitted a copyhold tenant of a piece of "Chiswick Field," bounded on the north by the lane leading to the parish church of Chiswick, which had been owned since 1671 by his forbears. Between 1713 and 1718 a brick house was built and a garden and orchard planted. In 1721 James Downs sold the estate to George Andrew Ruperti (or Ruperty), a clerk in holy orders, evidently (based on talk of a mortgage) for £150. On 9 July 1735 George Ruperti, aged fourteen, the elder Ruperti's only son and heir, was admitted to two-thirds of that "brick Messuage or Tenement together with a Garden or Orchard to the Same belonging situate in Chiswick containing by Estimation Sixty Rods" and Anne Elizabeth Ruperti, widow and relict, was admitted to a third part. In 7 June 1748 George Ruperti came of age and was admitted to his part of the property. It may have been this that brought the house on the market; it is quite possible (since the rate books do not survive beyond 1753) that the Hogarths had rented the house for many years.

On Wednesday 13 September 1749, at a court of the manor held in Robert Briggs's house "called the Bowling Green House," Anne Elizabeth Ruperti surrendered her third to George. Thus the entire property came to George, who then announced that he had sold it to William Hogarth: "To the Use and Behoof of William Hogarth of Leicester Fields in the Parish of Saint Martin in the fields in the County of Middlesex Gent^ln—his heirs and Assigns for Ever." Hogarth was present at the court, paid the Lady of the Manor (Susannah Sharp) sixpence, and was admitted copyhold tenant. This meant that the property was in his family as long as the family and its assignees lasted; when it died out, the land reverted to the freeholder (presumably the Sharps). For the rating of the property, see the Poor Rate Books, 1753–77, in St. Nicolas Church, Chiswick. The first page is missing, and the record begins with 1753, "rent" £10 and rated 5s (5); the "rent" continues the same with the rate sometimes up to 6s 8d. Dr. John Ranby, who lived in Corney House on what is now Corney Road, paid 6s on a £12 property; the earl of Burlington, £180 at £4.10.0 for Chiswick House. James Ralph's name appears in the rate book too, sometimes in one house, sometimes in another.

49. Henry T. Riley, "Hogarthiana," *Notes & Queries,* 14 (1856): 406.

50. J. Ireland, 1: cvi. The marker was still there in 1856 when Riley visited the house, and another inscribed "Life to the last enjoy'd, here Pompey lies, 1790."

51. See *Garrick Letters,* 1: 96. For Hogarth's portraits of Ranby and his natural son and daughter, George (later John) and Hannah, see Einberg, *Manners & Morals,* nos. 191, 192; for the portrait of Pine, see Nichols, *Biogr. Anecd.* (1781), 68* (double numbers), 141. For more on Ranby, and his relations with Fielding, see Battestin, *Fielding,* 395–96.

52. S. Ireland, MS. Eng. Misc. c. 408, f. 68 (Bodleian); *Gen. Works*, 1: 216–17.

53. Wilson's autobiographical notes, in Randolph, *Life of Wilson*, 1: 32.

54. J. B. Nichols, ed. note to J. T. Smith, *Cries of London* (London, 1839), 98; J. T. Smith, 2: 270; *The Mirror of Literature, Amusements, and Instructions*, 26 Sept. 1823. He presumably no longer affected the sword of his younger days, which might in some way connect him with his Distressed Poet (see *Biogr. Anecd.*, 1782, 8; J. Ireland, 1: cxx). According to J. T. Smith (1: 379), in his early years Hogarth, like Thornhill and Jonathan Richardson, wore a flowing wig, later a bushy wig, and (while painting) a velvet cap.

55. *Gen. Works*, 1: 138–39 (told by Dr. Ducarel).

56. *Gen. Works*, 1: 393.

57. *Tom Jones*, 2.3; J. Ireland, 3: lxxxiii.

58. Burial Register, St. Anne, Soho, in the London County Council Record Office. By mistake she is called Anne.

59. See *HLAT*, Appendix J.

60. Houghton Library, Harvard University: published as *Hogarth to His Wife* (Houghton Library Brochures, No. 5 [Cambridge, Mass.], 1946), it was apparently preserved by Jane. Reproduced by permission of the Harvard College Library.

61. *Gen. Works*, 1: 127n.

11. POPULAR PRINTS (I)

1. Duke of Cumberland papers, quoted, Evan Charteris, *William Augustus, Duke of Cumberland, His Early Life and Times* (London, 1913), 244. The date of 12 August is a guess; Lovat arrived in London on the 15th (*GM*, 16 [1746]: 438). Dobson says Hogarth sketched Lovat on the 14th, giving no authority (95). The account of Dr. Webster is from *Gen. Works*, 1: 131, taken from S. Ireland, 1: 146–47.

2. *Malmesbury Letters* (London, 1870), 1:45.

3. S. Ireland, 1: 146–47; Peter Pindar, letter to *GM*, 55, pt. 1 (1785): 347, making some corrections in the 1782 ed. of *Biogr. Anecd.* (228n), which were taken over word for word by Nichols in the 1785 ed. (282–83). Ireland then added the details of Dr. Webster, which Nichols incorporated in later editions. See also *Gen. Works*, 1: 131–32; J. Ireland, 3: 385–91. The story of the suds may be true or only a memory of the scene in Smollett's *Roderick Random* (1747), chap. 8, where Strap greets Roderick in this way.

4. The print, dated 25 Aug., was announced for that date in the *London Evening Post*, 23–26 Aug.

5. Joseph Spence to Burrell Massingberd, 23 Mar. 1746/47; quoted Austin Wright, *Joseph Spence, a Critical Biography* (Chicago, 1950), 221.

6. *Daily Advertiser* and *General Advertiser*, 16 June 1747.

7. The plate size is too small for the *Industry and Idleness* series, but Hogarth could have cut it down.

8. For more detail, see *HGW,* no. 167, and Paulson, "Hogarth's *Country Inn Yard at Election Time:* A Problem in Interpretation," in *The Yearbook of English Studies,* ed. C. J. Rawson (London, 1984), 196–208.

9. See Hugh Amory, "Law and the Structure of Fielding's Novels" (Ph.D. diss., Columbia Univ., 1964), 299.

10. *BM Sat.* 2864. *The Cradle: or No Crazy Baby* is in the Lewis Walpole Library, Yale University.

11. See Nicholas Rogers, "Resistance to Oligarchy: The City Opposition to Walpole and his Successors, 1725–47," in *London in the Age of Reform,* ed. John Stevenson (Oxford, 1977), 21–23; and Romney Sedgewick, *The History of Parliament: The House of Commons 1715–1754* (London, 1971), 1: 550.

12. See Linda Colley, *In Defence of Oligarchy: The Tory Party, 1714–60* (Cambridge, 1982), 254: "On 4 June 1747, fourteen days before Parliament was dissolved, Frederick [Prince of Wales] sanctioned the Carlton House declaration. This document [which rapidly passed into the hands of prominent Whigs] promised the Tories moderate constitutional reform: Place and Militia Bills, restrictions on the Civil List, and a £300 *per annum* landed qualification for J.P.s. It also urged them to 'coalise and unite' with the Prince, and made clear their incentive: 'His R.H. promises . . . totally to abolish for the future all Distinctions of Party . . . to take away all Proscription from any set of men whatever, who are Friends to the Constitution.'"

13. See W. B. Coley, intro. to Henry Fielding, *The Jacobite's Journal and Related Writings* (Oxford, 1974), xxv–xxvii. I use Coley's text for my quotations from Fielding, *A Dialogue between a Country Gentleman . . . and an Honest Alderman.*

14. A reader would have recalled lines like the ones spoken by Morocco in *The Merchant of Venice:* "They have in England / A coin that bears the figure of an angel stamped in gold" (II.vii.55).

15. *Country* party in fact meant champion of the best interests of the country as a whole, versus the selfish interests of the *Court* party.

16. See *Spectator* No. 219; and Paulson 1979, 115–33.

17. W. J. Pinks, *History of Clerkenwell* (London, 1881), 550; Bryant Lillywhite, *London Signs: A Reference Book of London Signs from Earliest Times to about the Mid-Nineteenth Century* (London, 1972), 8–13 (and addenda, 670).

18. Of course, it is possible that this print either illustrates or recalls a production of George Farquhar's popular before or afterpiece *The Stage-Coach,* which had been produced as a ballad opera at Goodman's Fields in February 1731; the play itself had appeared at Drury Lane in 1745 (advertised as "Not Acted 10 years"). The common elements are an Angel Inn on the road to London, a character with a bag of money offering a bribe (to

a coach driver to get him to London quickly), a love affair and lovers united and escaping enforced marriage (and the uncle who is imposing the marriage), mention of an election, and probably the general visual setting outside the inn with the coach present. But also present in Hogarth's memory would have been the election in Fielding's "Country Election" segment of *Pasquin* (1736).

12. POPULAR PRINTS (II)

1. AN, 225; *Apology for Painters,* 81. Earlier versions of parts of this chapter originally appeared in Paulson, *E and E,* chap. 5, and Paulson 1979, 9–31.

2. See the appropriate years in *LS;* Colley Cibber, *Lives of the Poets,* 5: 340; and J. T. Smith, 5: 165.

3. *London Evening Post,* 21–23 Feb. 1744/45; Pinks, *Clerkenwell,* 698.

4. *Dialogue on the Usefulness of Ancient Medals* (1726), 30–31; cf. Shaftesbury, *Second Characters,* 36.

5. See, e.g., Fénelon's "Letter to the French Academy," in *Dialogues concerning Eloquence in General,* trans. William Stevenson (1722), 252. For a more detailed discussion with full annotation, see Paulson, *E and E,* chap. 4.

6. Dryden, "A Parallel of Painting and Poetry," *Works,* 20: 54–55.

7. "De Poesi Didactica," a lecture delivered in Oxford "Term Pasch. 1711," in Richard Eustace Tickell, *Thomas Tickell and the Eighteenth Century Poets* (London, 1931), 203.

8. Joseph Spence, *Polymetis* (1747), 68. For a fuller discussion of this work in relation to Hogarth's *Analysis of Beauty,* see vol. 3.

9. The basic texts are La Font de Saint-Yenne, *Réflexions sur quelque causes de l'état présent de la peinture en France* (The Hague, 1747), Abbé Jean-Bernard Leblanc, *Lettre sur l'exposition des ouvrages de peinture, sculpture, etc., de l'année 1747* (Paris, 1747), and François-Cyprien-Antoine Lieude de Sepmanville, *Réflexions d'un amateur des beaux-arts* (Paris, 1747). For arguments for clarity in the allegories of history painting, see Jean-Baptiste Dubos, *Réflexions critiques sur la poésie et sur la peinture* (Paris, 1719), 1: 24; and Abbé Pluche, *Histoire du ciel* (Paris, 1748), 2: 427; for general background, James A. Leith, *The Idea of Art as Propaganda in France, 1750–1799* (Toronto, 1965), 8–14.

10. Anton Ehrenzweig, *The Hidden Order of Art* (Berkeley and Los Angeles, 1967), 67. It may be significant that Hogarth turns away from the rococo to a simpler more native style shortly after Gravelot—the chief rococo proponent in Hogarth's circle—returned to France (in 1745).

11. Patience and Passion in *Pilgrim's Progress* is one pair that lies behind Goodchild and Idle. "These two Lads are Figures," Bunyan writes; "*Passion,* of the Men of *this* World; and Patience, of the Men of *that* which is to

come: For as here thou seest, *Passion will have all now,* this year; that is to say, in *this* World; *So* are the Men of this World: they must have all their good things now, they cannot stay will next *year;* that is, until the *next* World, for their Portion of Good" (*Pilgrim's Progress,* ed. J. B. Wharey [Oxford, 2d ed., 1960], 31). But the difference is important: Hogarth shows Patience's reward in *this* world, and Patience becomes Prudence, or Foresight, or some more economically oriented value.

12. See also Proverbs 12:24, 27; 19:24; 20:4. The scriptural passages were said to have been chosen for Hogarth by his friend the Reverend Arnold King (*Gen. Works,* 1: 109, 128), which I take to mean that King helped Hogarth to the *kind* of passage he wanted. There is, however, no reason to think that Hogarth was not thoroughly familiar with the Bible himself.

13. See the discussion of Shaftesbury's and Hutcheson's aesthetics and Hogarth's response in his *Analysis of Beauty* in vol. 3.

14. See, e.g., Eccles. 10:2, Isa. 9:20; Jon. 4:11 suggests undifferentiation. For the debate, see Cornelius à Lapide and the *Biblia Critica.* The old prejudice against the left side had begun to break down in the sixteenth and seventeenth centuries, especially with the location of the heart (and presumably the Sacred Heart). See Vladimir Gurewich, "Observations on the Iconography of the Wound in Christ's Side, with Special Reference to Its Position," *Journal of the Warburg and Courtauld Institutes,* 20 (1957): 358–62; and "Rubens and the Wound in Christ's Side," *Journal of the Warburg and Courtauld Institutes,* 26 (1963): 358. In the Christian tradition right and left were established relative to a gaze located on the inside of the image looking out, whereas Hogarth identifies it with the gaze of the viewer outside the image looking in.

15. Or the comment by a contemporary on a Tyburn execution: "no solemn procession, it was just the contrary; it was a low-lived blackguard merrymaking" (quoted, Peter Linebaugh, "The Tyburn Riot against the Surgeons," in Douglas Hay, Peter Linebaugh, John G. Rule, E. P. Thompson, and Cal Winslow, eds., *Albion's Fatal Tree: Crime and Society in Eighteenth-Century England* [New York, 1975], 68). Fielding makes the same comment a few years later in his *Enquiry into the Late Increase of Robbers* (1750/51, in *An Enquiry into the Causes of the Late Increase of Robbers and Related Writings,* ed. Zirker, 167).

16. Sanctioned by the *Spectator* (No. 412), the view was confirmed by William Gilpin in his *Dialogue upon the Gardens at Stowe* (1748): "There is nothing so distasteful to the Eye as a confined Prospect. . . . The Eye naturally loves Liberty, and when it is in quest of Prospects, will not rest content with the most beautiful Dispositions of Art, confined within a narrow compass" (54).

17. The chapter of Leviticus from which "the sound of a shaken leaf shall chase him" is taken, a chapter about the perils of sloth, is a horrible se-

quence of action-consequence structures with consequence heaped upon consequence: "And if ye walk contrary unto me, and will not hearken unto me; I will bring seven times more plagues upon you according to your sins." Often the surrounding verses or the whole chapter from which the motto is taken provides it with a supporting context. Plate 2 uses Psalm 119:97, but verses 97–104 all apply to the Industrious Apprentice and fill in the story. So too in Plate 3 the "judgment" referred to in Proverbs 10:29 is in fact for sloth.

18. In the previous verse Wisdom is responding to the fool who did not heed her words: "I also will laugh at your calamity; I will mock when your fear cometh"; and the chapter ends, "But whoso hearkeneth unto me shall dwell safely, and shall be quiet from fear of evil."

19. In the popular tradition there are many instances of the sin of idleness being graphically represented by a sleeping man.

20. See Cesare Ripa, *Iconologia* (1709 ed.), no. 118; Justice's blindfold appears as early as Sebastian Brant's *Ship of Fools* (1594), and by the early sixteenth century it was a standard emblem of justice's impartiality (Andrew Simmonds, "The Blindfold of Justice," *ABA Journal* [1977], 1164).

21. The motto under Goodchild, Lev. 19:15, deals with blind justice ("Thou shall do no unrighteousness in Judgment"), but the verses preceding are about stealing and lying with an admonition "Thou shall not swear by my name falsely" as the one-eyed man is doing. The verse following the motto is about talebearers and those who "stand against the blood of thy neighbour," and the next two admonish one not to "rebuke thy neighbour": "Thou shalt not avenge . . . but thou shalt love thy neighbour as thyself."

22. The statue was by Edward Pierce (1684), in Fishmongers' Hall. The dagger is also an attribute of Severity (see Ripa, added in 1645 ed., Venice, 568).

23. The ballad of Dick Whittington, lord mayor of London, in Plate 1 is one of these references. The Whittington ballad activates the cat who appears, most noticeably again in 4, representing the countinghouse and the master and Goodchild against the intrusion of those types of the outside world associated with Idle. Note that his cat, and not Whittington himself, was the hero of the story: the cat acted, and Whittington's virtue was his ability to take Opportunity by the forelock on these occasions. In Plate 7 the cat by his rush down the chimney after the mouse is a terror to Idle and perhaps a reminder of the feat of Whittington's cat, who brought him prosperity precisely by devouring the rats that destroyed the cargo of his master's ship. To judge by these scenes, the cat back in Plate 1 is a Whittingtonian cat too, trying in vain to awaken the sleeping apprentice and make him into as much a Whittington as Goodchild. Perhaps we can say that the memory of Whittington remains in Idle's shabby ambience as only a scrawny cat (Pl. 9).

24. "Epistle to Bathurst" (1732), ll. 339–40. The inscription was erased in James II's reign, restored in William III's, and not finally removed until 1831; recall its centrality to *The South Sea Scheme*.

25. Cf. *Royalty, Episcopacy, and Law* (1724, ill., vol. 1), where the judge carried the sword carried in lord mayors' processions, and just behind him was the hat worn by the marshall of the city in the procession supported on the dagger taken from the coat of arms of London.

26. For example, William Shenstone, *The Judgment of Hercules* (in verse, 1741); John Baillie, *An Essay on the Sublime* (1747), 15, in which he says Prodicus's parable is "universally allow'd noble and sublime"; John Gilbert Cooper, in *Dodsley's Museum* (1746), 2: 48–49; Peter Layng, *The Judgment of Hercules, Imitated . . . from Prodicus* (Eton, 1748); [Thomas Cooke of Braintree], *The Tryal of Hercules, an Ode on Glory, Virtue, and Pleasure* (1752); and translations by William Duncombe (1745) and Spence, in *Moralities: or, Essays, Letters, Fables, and Translations* (1753), by "Sir Harry Beaumont." Maurice Greene (whom Hogarth discusses in a well-known anecdote, above, 63) set a *Judgment of Hercules* to music (*Apollo Society Collection* of 1740), and John Stanley also produced a musical setting in the 1740s. For references to the general prevalence of the Choice of Hercules, see vol. 1, 269–72.

Incidentally, the Greek γ, the sign of the crossroads associated with the Hercules topos, was also connected with right-left symbolism: the *right* arm leads to success, the *left* to failure (see Casavis, *Greek Origin of Freemasonry*, 124).

27. Lowth's "The Choice of Hercules" appeared anonymously in *Polymetis* in 1747 and was reprinted in Dodsley's *Collection of Poems* in 1748 and in the same year in the *Preceptor: Containing a General Course of Education . . . for . . . Advancing the Instruction of Youth*. Handel put Lowth's verses, adapted by Morrell, to music in 1750 as *The Choice of Hercules* (pub. 1751).

28. E. R. Wasserman, "Johnson's *Rasselas*: Implicit Contexts," *Journal of English and Germanic Philology*, 74 (1975): 1–25.

29. Hogarth's figure of Justice in *Industry and Idleness* may also derive from Mandeville's: "Yet, it was thought, the Sword she bore / Check'd but the Desp'rate and the Poor; / That, urg'd by meer Necessity, / Were ty'd up to the wretched Tree / For Crimes, which not deserv'd that fate, / But to secure the Rich and Great" (*Fable of the Bees*, ed. F. B. Kaye [Oxford, 1924], 1: 23–24). The same passage may have informed the image in *Harlot* 4. (Mandeville refers to criminals who "were hang'd in Hemp of their own beating.")

30. *Fable of the Bees*, 1: 244, also 245; on laziness, see 1: 238–45. There are other connections: the marginal decorations of chains of office, halters, and so forth are mentioned ironically by Mandeville as serving to animate apprentices and to deter "Men of abandon'd Principles" (*Fable*, 1: 164).

31. Chapter 5 of Book 1 in particular is a discursive analysis of the meanings implicit in *The Beggar's Opera* but also in *A Harlot's Progress*. One could say that *Industry and Idleness* simply gives us both Macheaths, the condemned and the reprieved: the unromanticized and the romanticized criminal.

32. Behind Fielding's satire there were of course others, such as Charles Davenant, *The True Picture of a Modern Whig, Set Forth in a Dialogue between Mr. Whiglove and Mr. Double* (6th ed., 1701), in which a bad apprentice flourishes on his industry, as up to a point Wild does.

33. Part of the title of *The Apprentice's Faithful Monitor,* advertised in the *LM,* 2 (Oct. 1733): 534.

34. Samuel Richardson, *The Apprentice's Vade Mecum* (1734), 27, 8–9.

35. Richardson, *Vade Mecum,* 33–35. Richardson is connecting delinquent apprentices with Hogarth's theme (expressed in the 1730s in the Harlot and Rake) of the young man or woman who apes fashion and comes to grief. Fashionable dress and other luxuries such as gambling lift "up the young Man's Mind far above his Condition as an Apprentice." After a long description of apprentices emulating the fashion, Richardson concludes with his charge to Hogarth. And Hogarth does begin with both apprentices and their models—Whittington and Moll Flanders—and ends with the logical consequences of such emulation.

36. On apprentices' gambling, cf. Sir John Gonson's Charge to the Quarter Sessions, 1 Jan. 1730/31, as Hogarth was preparing his subscription for *A Harlot's Progress:* "Apprentice Boys, School Boys, &c. are taught to play at dice; and when once they have contracted a habit of this low gaming, and lose their money, they too often rob or pilfer from their masters or parents" (*Daily Post,* 1 Jan.).

37. Idle's pair of pistols indicates that he has become a highwayman; he seems to be either dividing his loot with the one-eyed man or using him as his fence. The corpse being dropped through a hole in the floor must have been the result of the brawl going on in the tavern. Tom Idle's career may, in fact, be a memory of Jack Sheppard, whose life had close parallels to Idle's—and whose portrait Thornhill had taken at the time of his final imprisonment (see vol. 1, 120–21). See also, on the "revolted apprentice," John Richetti, *Popular Fiction before Richardson* (New York, 1968), 31, 53, 56; and cf. L. B. Faller, *Turned to Account: The Forms and Functions of Criminal Biography* (Cambridge, 1987), 45.

38. When Barnard spoke in the House of Commons for his (unsuccessful) Licensing Act of 1733, he complained of "the Mischief done to the City of London by the Play-Houses, in corrupting the Youth, encouraging Vice and Debauchery, and being prejudicial to Trade and Industry." According to Liesenfeld, "it was this threat to industry more than any other single factor that provoked attacks on the theaters in 1735" (*Licensing Act,* 24–26).

39. Davis, "The Reasons of Misrule: Youth Groups and Charivaris in Sixteenth-Century France," *Past and Present,* no. 50 (Feb. 1971), 74; Merchant Adventurers, Minutes, 13 Dec. 1704, quoted in O. J. Dunlop, *English Apprenticeship and Child Labour* (London, 1912), 184. For further information on apprentices as adolescents and disruptive, see Steven R. Smith, "The London Apprentices as Seventeenth-Century Adolescents," in Paul Slack ed., *Rebellion, Popular Protest and the Social Order* (Cambridge, 1984), 219–31.

40. Sean Shesgreen's explanation for the "ambiguity" of *Industry and Idleness* described in *HLAT* is that the historical particulars of Hogarth the accurate reporter threaten to subvert the universal moral exemplum Hogarth the moralist wishes to convey ("Hogarth's *Industry and Idleness:* A Reading," *ECS,* 9 [1976]: 569–98).

41. I see no reason why the two states, "*Goodchild & West*" and "West and Goodchild," could not have been distributed to different buyers, as Hogarth did later with the subscription ticket for *An Election Entertainment,* and indeed with the different versions of *Paul before Felix.*

42. Berger, *Ways of Seeing* (London, 1973), 15–16.

43. The feasts on the Lord Mayor's Day were proverbial for the gluttony of the aldermen: a situation noted by Pope, *Dunciad,* 1.90 (vs. the starving poet in his garret); and anon., *Bath* (1748), 18. On the purchasers of criminal accounts of apprentices, Faller comments: "tradesmen, artisans, merchants, lower-ranking professionals (to say nothing of people of higher means). . . . Such an audience would not seem likely to have identified, even unconsciously, with the crimes of 'revolted apprentices'" (*Turned to Account,* 47).

44. For a discussion of *Joe Miller's Jests* as a subculture text, see Paulson 1979, chap. 6.

45. Hogarth problematized his case from the start by choosing the profession of weaving as his illustration. Contemporary sources on the weavers all emphasize that it was the poorest paying of London trades, with supply usually exceeding demand, and Englishmen being discharged for the cheaper labor of women, children, and Irishmen. There were bloody riots in 1736 against the Irish interlopers, and the trade was known for its violence. Only the masters prospered, and the pamphlets emphasize the frequency with which the master weaver's children (sons as well as daughters) married other weavers in order to perpetuate the family business. See M. Dorothy George, *London in the Eighteenth Century* (London, 1966), 181–87.

46. See Linebaugh, "Tyburn Riot"; E. P. Thompson, "The Moral Economy of the English Crowd in the Eighteenth Century," *Past and Present,* no. 50 (Feb. 1971), 109ff.

47. See John Brewer, *Party Ideology and Popular Politics at the Accession of George III* (Cambridge, 1976), chap. 9, 163–200.

48. I refer to the figures Hogarth used to decorate the opening and closing of the "peregrination" MS. of June 1732.

49. Thompson, "Patrician Society, Plebian Culture," *Journal of Social History*, 7 (1974): 396.

50. See Thompson, "Eighteenth-Century English Society: Class Struggle without Class?" *Social History*, 3 (1978): 144, 151; "Patrician Society, Plebian Culture," 382–405.

51. Cf. the slogans about "industry" in *Harlot* 4, "Better to Work than Stand thus" and "The Wages of Idleness" inscribed on the whipping post and stocks.

52. It is not a question of Idle's or the apprentice's ability to read: both Goodchild and Idle are provided with copies of *The Prentice's Guide*, as the bootback was shown reading "The Farthing Post" in *Rake* 4 and various plebeians enjoy the king's speech and "A New Ballad on the Herring Fishery" in *Beer Street* (ill., vol. 3). Indeed, it was often the case that the more "popular" the print the longer the printed text accompanying it. It is quite possible that the images in popular prints, which were often interchangeable, mattered less than the words. Hogarth's point is that the words are used to police the images; the inscriptions and biblical quotations he reproduces are clearly a means of social control.

53. "The Sea," Richardson tells us in the *Vade Mecum*, is "the best Choice for such as cannot comport to orderly Rules; and better at first than at last" (51).

54. See Peter Linebaugh, "The Ordinary of Newgate and His Account," in J. S. Cockburn, ed., *Crime in England, 1550–1800* (London, 1977), 246–69, 348–52. The ordinary's pamphlets were titled *The Ordinary of Newgate: His Account of the Behaviour, Confession, and Dying Words of the Malefactors Who Were Executed at Tyburn*. If Hogarth's ordinary is a portrait, it would have to be Thomas Purney (who was ordinary until 1746) or possibly Samuel Rossell or John Taylor (who followed Purney within the year).

55. This appears in Hogarth's list of the plates on the back of a first sketch for Plate 10 in the BM. Among these jottings is also an explicit reference to *The London Merchant;* Idle's name was to have been Barnwell. Barnwell, of course, in the last act, with his punishment about to be carried out, is forgiven by all the other characters, including the master he has betrayed. It is worth noting that Hogarth knew a City merchant named Goodchild, who was with him a governor of St. Bartholomew's Hospital in the 1730s and 1740s.

56. Moreover, Idle's profile is very close to the profile of the Freemason whose neck is through the ladder in *The Mystery of Masonry* (ill., vol. 1), which could be another self-portrait.

57. See AN, e.g., 208, discussed above, vol. 1, 43–45. One further speculation: the strange muffled shape of Idle's mother in Plate 5 (repeated

in 10 and 11) bears a disconcerting resemblance—hooded and in mourning attire (designating a widow)—to Hogarth's portrait of his own mother, which hung in his house (fig. 29).

58. Indeed, the first trial run for the story of an idle and industrious apprentice came only six years after he broke his own apprenticeship: in the large *Hudibras and the Lawyer* (1726)—with nearby, as supporters, a somnolent and an alert dog. The two boys are scriveners.

13. PUBLIC PAINTINGS

1. David Owen, *English Philanthropy, 1660–1960* (Cambridge, Mass., 1965), 53. I am indebted in the following paragraphs to Owen, 13–15, 38–39.

2. Isaac Maddox, bishop of Worchester, *A Sermon Preached before the Trustees of the Public Infirmary in James Street, Westminster* (Westminster Hospital; London, 1729), 9.

3. Owen, *English Philanthropy*, 53. In fact, most active governors of the Foundling were childless men. See Ruth K. McClure, *Coram's Children: The London Foundling Hospital in the Eighteenth Century* (New Haven, 1981).

4. Nichols and Wray, *Foundling Hospital*, 15. See also John Brownlow, *Memoranda; or, Chronicles of the Foundling Hospital, including Memoirs of Captain Coram, &c. &c.* (London, 1847). Brownlow's *The History and Design of the Foundling Hospital with a Memoir of the Founder* (London, 1858) is a revised edition, with the section on art abridged, illustrations omitted, and more history of the hospital added. The manuscripts are in The Thomas Coram Foundation for Children, both at its offices in Brunswick Square and, on deposit, in the London Country Record Office at County Hall. The minute books of the General Court and General Committee are in Brunswick Square.

5. Nichols and Wray, *Foundling Hospital*, 21.

6. Addison had written as early as 1713: "Since I am upon this Subject, I shall mention a Piece of charity which has not been yet exerted among us, and which deserves our Attention the more, because it is practiced by most of the Nations about us. I mean a Provision for foundlings, or for those Children who for want of such a Provision are exposed to the Barbarity of cruel and unnatural Parents."

7. Ruth McClure, *Coram's Children*, vii.

8. Minute book of the Daily Committee, Foundling Hospital, 10 and 31 Jan., 18 Feb., and 4 Mar. 1740/41, lays out the procedure for staffing the committee. (Nichols and Wray omit the facts about the alphabetization to begin 1 April.)

9. Minutes of the "Committee for Transacting the Affairs of the Hospital," 25 Mar. 1741: "Mr Taylor White acquainted the Committee that Mr

Hogarth had Painted a Shield which was put up over the Door of this Hospital." See also Nichols and Wray, *Foundling Hospital,* 36; the shield was not preserved. See also *HGW,* no. 225.

10. Daily Committee's minutes, 6–7, GLRO.

11. The two references to Hogarth's pledge refer to the same amount of money, not two payments (cf. Benedict Nicolson, *The Treasures of the Foundling Hospital* [Oxford, 1972], 4). There is no record of further money subscribed by Hogarth. The meetings, it should be noted, were deadly dull, and very few of the governors attended them. In 1742 Hogarth missed even the annual meeting, which was well attended; he attended the annual meeting in 1743, but missed it again in 1744.

12. 1 May 1747, Foundling Hospital Library, vol. 39; General Committee 2: 91; *GM,* 17 June 1747, 284; quoted, McClure, *Coram's Children,* 193.

13. Brownlow, *History,* 47; Nicholas and Wray, *Foundling Hospital,* 101–02; *Book of Inspections,* records of the Foundling Hospital.

14. A boy and girl from the first admittance were baptized Thomas and Eunice Coram, and subsequently there were always children in the hospital commemorating the founder and his wife. On 3 April the first Thomas Coram, No. 18, died, but another (No. 38) was promptly named. The presence of a William and a Jane Hogarth down the years has caused some uninformed people to claim descent from the childless artist. There were also Bedfords, Montagues, Newcastles, and Vernons; and when these names were exhausted, the eminent of the past were drawn upon: Wyckliffe, Huss, Ridley, Latimer, Sancroft from the clergy, Geoffrey Chaucer, William Shakespeare, and John Milton from writers; even (by the end of the decade) Tom Jones, Sophia Western, and Clarissa Harlowe were represented (Brownlow, *History,* 208–09).

15. Hogarth had painted Jacobsen in 1742 (Oberlin College) for Sir Jacob Bouverie, vice-president of the hospital, for whom Jacobsen had rebuilt a country seat. Jacobsen was brother of Sir Jacob Jacobsen, both of whom inherited the Steelyard in Upper Thames Street, now the site of the Cannon Street Station. Theodore carried on business at the steelyard in his youth, but later retired and lived in Basinghall Street practising architecture (Philip Norman, *Archaeologia,* 13 May 1909). Besides the Foundling, Jacobsen also designed the Haslar Royal Hospital for sick soldiers at Gosport. He was a fellow of the Royal Society, an original fellow of the Society of Antiquaries, and of the Society of Arts (d. 1772).

16. On 17 October 1740 it was recommended to the committee that it purchase two fields belonging to the earl of Salisbury, covering 34 acres near Lamb's Conduit Street. The earl then said he would sell no less than four fields, comprising 56 acres. The committee offered £6,500; the earl wanted £7,000, but he made a donation of £500 and the deal was settled.

17. Rouquet, *State of the Arts,* 24.

18. Francis Haskell, *Patrons and Painters, A Study in the Relations between Italian Art and Society in the Age of the Baroque* (London, 1963), 125–31.

19. Waterhouse, *Three Decades,* 18.

20. M. I. Webb, *Michael Rysbrack, Sculptor* (London, 1954), 48.

21. Webb, *Rysback,* 50.

22. Webb, *Rysback,* 57, 131. Rysbrack's being a print collector might also have drawn him and Hogarth together. His large library of "Prints, Drawings and Books of Prints" took ten evenings to sell in 1764 (Webb, 47). It may, of course, be significant that White and not Hogarth proposed Rysbrack as a governor: possibly an indication that their gifts and entrances as governors were independent. But once in, it was clear that Hogarth represented the Hayman–Highmore–Wills group, and that Rysbrack brought along other artists.

23. BM. Add. MS. 30167; Webb, *Rysback,* 61.

24. Webb, *Rysback,* 141. Rysbrack, Vertue writes in October 1746, "has finisht his bass relief for the foundling hospital representing charity a woman embraceing of children—several other the boys coyling a cord or ship and anchor & the Girls. huswifery and rural imployments milking the Cows &c. the whole block of marble about 5 or 6 foot long—and the sculpture finely finisht and executed is for a present his own donation to the Hospital—" (3: 132).

25. Brownlow, *History,* 15.

26. Another painting, *The Angel of Mercy* (Mellon, Yale), reproduced in *HLAT,* pl. 201, is not by Hogarth; it may be an oil sketch by Highmore.

27. Not in the minute books, but quoted, Nichols and Wray, *Foundling Hospital,* 20–21.

28. The matron in the Vien painting sits facing left with vertical pillars slightly ahead of her, a female attendant behind her, and a kneeling woman at the other side of the picture offering a Cupid. (See Antal, 200–201; cf. Robert Rosenblum, *Transformations in Late Eighteenth Century Art* [Princeton, 1967], 1–7.)

29. The primary Old Master source is Veronese, a favorite painter of English collectors. There is a close resemblance to the Prado *Youth between Vice and Virtue,* but more generally it is to the narrow pictorial space, the stagelike setting, bounded by outscale architecture, in which Veronese shows a scene of a prominent figure receiving visitors—for example, *Alexander Receiving the Family of Darius* (National Gallery, London).

30. *Constitutions,* 1723 ed., 8; 1738 ed., 6–7.

31. The biblical source was Acts 7:22: Moses was "instructed in all the wisdom of the Egyptians"; see D. C. Allen, *Mysteriously Meant* (Baltimore, 1970), 108–9. The Masons quoted Philo-Judaeus to the effect that "Moses was instructed by the Egyptian priests in the philosophy of symbols and hieroglyphics as well as in the mysteries of the sacred animals" and was

educated at Heliopolis as a priest (Mackey, 2: 494). For a contemporary source, see Robert Samber, *Long Livers: A Curious History of Such Persons of both sexes who have liv'd several Ages, and grown Young Again* (1722), quoted Jacob, 294–95.

32. Nichols and Wray, *Foundling Hospital*, 252; Rouquet, *State of the Arts*, 27.

33. General Court, 31 Dec. 1746; cf. *The Conduct of the Royal Academicians* (1771), 7–8.

34. Minute book of the Court of Governors of Bridewell and Bethlehem Hospitals, MS. at Bridewell Royal Hospital, now King Edward's School, Witley, Surrey.

35. Edward G. O'Donoghue, *The Story of Bethlehem Hospital*, 371. The roll call of hospitals with which Hogarth was in some way connected should also include the London, for which he designed a headpiece for subscriptions around 1740. See *HGW*, no. 227.

36. See Geoffrey Beard, *Georgian Craftsmen and Their Work* (London, 1966), 61, pl. 76.

37. For Lord Wyndham's obituary, see Fielding's *True Patriot*, 3 Dec. 1745, 3, which, with its details and references to Salisbury, makes one suspect that it was written by Fielding himself. For the records of the society, see *The Records of the Honorable Society of Lincoln's Inn, The Black Book, 3: From A.D. 1660 to A.D. 1775* (London, 1900), bk. 12.373, 375 [337].

38. Thomas Lane (steward), *The Student's Guide through Lincoln's Inn*, 2d ed. (1805), 27; also supported by William H. Spilsbury, *Lincoln's Inn: Its Ancient Buildings with an Account of the Library* (London, 1873), 55n, though he probably draws on Lane. For Warburton, see J. S. Watson, *The Life of William Warburton* (London, 1863), 278.

39. *Records*, bk. 13.28 [339].

40. There is no sign of Masonic symbolism here. The Masons utilized the story of Peter and Ananias (a case of lying) but no stories of Paul. These remarks on *Paul before Felix* were developed in Paulson 1975, 50–53; my discussion of the order of the various versions of *Paul before Felix* in *Burlington Magazine*, 114 (1972), 233–37; my discussion of Bishop Hoadly and Paul/Felix in *Art Bulletin*, 57 (March 1975), 293–94; and Paulson 1982, 87–98.

41. Lane, *Student's Guide*, 27.

42. Archives of the Society of Lincoln's Inn (*Records*, 472); quoted, Dobson, 106–7n, and facsimile reproduced.

43. *Records*, bk. 13.49 [343]. The painting, however, did not come back for some time. See vol. 3.

44. Smollett, *Peregrine Pickle* (1751), chap. 46.

45. William Burkitt, *Expository Notes with Practical Observations on the New Testament* (7th ed., London, 1719), s.v. Acts 24: 24–25.

46. Hoadly's sermon, "St. Paul's Discourse," was not published before it appeared on Hoadly's *Works* of 1773 (3: 735–42). There is an extensive discussion of Paul's trial in Matthew Henry's commentary on the Bible (1708–1712 and often reprinted), probably the most easily accessible theological and historical resource on the episode: see *Matthew Henry's Commentary on the Whole Bible* (McLean, Va., n.d.), 6: 305–17. A few years after Hogarth's version, Orator Henley was applying it in the same way in *Second St. Paul, in Equity-Hall, to Felix, Caesar and all, etc.* (1755).

47. *Novels of Samuel Richardson* (1902), 4: 121–22.

48. *Pamela,* ed. T. C. Duncan Eaves and Ben D. Kimpel (Boston, 1971), 43.

49. James Foster, *Sermons* (2d ed., 1733), 2–3 (sermon 1); cited by L.V.D.H. Hammond, *Laurence Sterne's Sermons of Mr. Yorick* (New Haven, 1948), 123 (citing the 3d ed. of 1736). See also Burkitt, *Expository Notes,* and Henry Hammond, *A Paraphrase and Annotations upon All the Books of the New Testament* (2d ed., 1659), s.v. Acts 24: 25. I am grateful to Melvyn New for these references, which will appear in his edition of *The Sermons of Mr. Yorick* (Gainesville, Fla., 1991). Laurence Sterne's sermon "Felix's Behaviour towards Paul Examined" (published in 1766) develops these traditional points ("Sermon IV. Felix's Behaviour towards Paul Examined," in *The Sermons of Mr. Yorick,* 3 [London, 1766]: 104; in later collected editions the numbering is continuous from the first two volumes, and so this sermon becomes no. XIX).

50. J. Ireland, 2: 92.

51. According to the view by Pugin and Rowlandson (published by Ackerman, 1808–1810), the hall was divided in half with fixed tables for counsel in the upper half of the hall: Hogarth's painting can be glimpsed above the dais and the heads of the presiding magistrates.

52. Gourlay, "Hogarth, Rubens, and the 'Justice Picture' Tradition," *Eighteenth Century Life,* 14 (1990): 35–46. The reference to Herodotus is to 5.25.

53. See David Morris, *The Religious Sublime: Christian Poetry and Critical Tradition in 18th-Century England* (Lexington, 1972), 90–91. He points out that the Longinus passage was cited as early as *Spectator* No. 633. Smith, of course, ranks Jesus as a yet more sublime rhetorician than St. Paul (*Dionysius Longinus on the Sublime,* 1739, 42). The negative valuation of the Old Testament held by many Englishmen (including Hogarth) would have been based upon the Pauline Epistle to the Romans, chaps. 4 and 7.

54. The chief evidence for Hogarth's northern trip is inferred from Smollett's possibly imaginary account of Hogarth/Pallet's northern trip in *Peregrine Pickle.*

55. Vertue, 3: 141–42; Walpole, letter to Horace Mann, 15 Dec. 1748, in *Corr.,* 20: 13. Coincidentally, nearly sixty years earlier in 1690, Sir John

Vanbrugh had been arrested in Calais, one story having it that he was caught studying the fortifications. But his fate was more serious than Hogarth's: eighteen months in French prisons, including the Bastille (Laurence Whistler, *Sir John Vanbrugh, Architect & Dramatist* [London, 1938], 22–23).

56. *Gen. Works,* 1: 142–44. For Strange, see James Dennistoun, *Memoirs of Sir Robert Strange, Knt.* (London, 1855). For Major, see his "Account of Thomas Major's Confinement in the Castle of the Bastile, in the Year 1746," *Monthly Magazine,* 27 (June, July 1809): 429–35, 540–52; and preface, *The Ruins of Paestum* (1767). See also H. A. Hammelmann, "First Engraver at the Royal Academy," *Country Life,* 14 Sept. 1967, 616–17.

57. *Gen. Works,* 1: 143–44.

58. *London Evening Post,* 7–9 Mar. 1748/49.

59. Perhaps it is meant only to be underdone. Hogarth probably did not know La Mettrie's *L'Homme-machine,* published in the same year as *The Gate of Calais,* which argues that the pride of the English, their contempt for other nations, and their ferocity as fighting animals derives from their love of underdone steaks. Theodosius Forrest's cantata *The Roast Beef of Old England,* with a small copy of Hogarth's print at the top, was published by Robert Sayer at the Golden Buck in Fleet Street, and so can be dated sometime before 1752 (when Sayer's shop was at 53 Fleet Street). The text is reprinted, *Gen. Works,* 1: 148–53.

60. See *HGW,* no. 180.

14. *THE MARCH TO FINCHLEY*

1. The *General Advertiser's* account of 1 May was essentially the same, though without the reference to the duke of Ancaster. According to an anonymous writer in the *GM,* "a lady was the possessor of the fortunate number, and intended to present it to the Foundling Hospital. But that some person having suggested what a door would be open to scandal, were any of her sex to make such a present, it was given to Hogarth, on the express condition that it should be presented in his own name." Cf. the reports published by Nichols and his collaborator, who elaborate on the story, adding that "soon after the Lottery, our Artist waited on the Treasurer to the Foundling Hospital acquainting him that the Trustees were at liberty to dispose of the Picture by auction. Scarce, however, was the message delivered, before he changed his mind, and never afterwards would consent to the measure he had originally proposed. The late Duke of Ancaster offered the Hospital 300*l.* for it" (*Gen. Works,* 1: 156–57).

2. AN, 227.

3. Nichols and Wray, *Foundling Hospital,* 260.

4. These are in the BM Department of Prints and Drawings.

5. *Old Woman's Magazine* (1751), 1: 182; *Student,* 20 Jan. 1750/51 (Ox-

ford, 1751), 2: 162–68. Lance Bertelsen points out that "By the time of the Hogarth piece—in a letter dated 20 January 1750 (OS)—Thornton was no longer deeply involved with *The Student,* though he may still have been a contributor. On the other hand, the very fact that the letter is dated Old Style (something Thornton never does), and that it contains none of his more obvious stylistic quirks, would seem to argue against his authorship" (*The Nonsense Club,* [Oxford, 1986] 279n28, and in correspondence). According to Saunders Welch's daughter, Welch was the author (S. Ireland, 1: 156).

6. *Tom Jones,* 2.3; J. Ireland, 3: lxxxiii.

7. Fielding's advertisement ran in *The General Advertiser* from 7 March off and on until 2 June; for a full account, see Martin Battestin, "Fielding and 'Master Punch' in Panton Street," *Philological Quarterly,* 45 (1966): 191–208.

8. See Battestin's arguments, *Tom Jones* (Wesleyan ed., Oxford, 1974), introduction, xxv–xxxix. This section appeared in a somewhat different form as "Fielding in *Tom Jones:* The Historian, the Poet, and the Mythologist," in *Augustan Worlds, Essays in Honour of A. R. Humphreys* (Leicester, 1978), 175–87, and in Paulson 1979, 190–207.

9. Philip Doddridge's very popular life of Colonel Gardiner, a moral story of a Christian soldier, was published in time for Hogarth to have known of it before introducing the name into *Finchley.*

10. W. B. Coley ("Hogarth, Fielding, and the Dating of the March to Finchley," *Journal of the Warburg and Courtauld Institutes,* 30 [1967]: 317–26) makes a case against the authenticity of this drawing (in the Royal Collection, Oppé, cat. no. 67); for a counterargument, see my review of Coley's edition of *The Jacobite's Journal* in *Modern Language Review,* 71 (1976), 889–93.

11. See also 14.1 and 8. For Fielding's formulation of the theatrical metaphor of Hogarth's *Laughing Audience,* see below, 375–76.

12. Fielding made "foundling" also apply as a metaphor to the new genre of *Tom Jones:* both Tom and the novel in which he appears are apparent, literal bastards but with good blood lines. See Homer Obed Brown, "*Tom Jones:* The 'Bastard' of History," *Boundary,* 7 (1979): 201–33; Claude Rawson, *Henry Fielding and the Augustan Ideal under Stress* (London, 1973), 7.

13. See Maren-Sofie Røstvig, "*Tom Jones* and the Choice of Hercules," in *Fair Forms: Essays in English Literature from Spenser to Jane Austen,* ed. Røstvig (Cambridge, 1975), 147–77.

14. As I have shown elsewhere, the novel of the late 1740s and 1750s (by Smollett as well as Richardson and Fielding) moves its interest from the protagonist to the family, which tends to disintegrate into a crowd, with special interest in the vague line separating them (Paulson, "The Pilgrimage and the Family: Structures in the Novels of Fielding and Smollett," in *To-*

bias Smollett: Bicentennial Essays Presented to Lewis M. Knapp, ed. G. S. Rousseau and P.-G. Bouce [New York, 1971], 57–78; revised in Paulson 1979, 134–56).

15. We know the ballad seller is a Hanoverian because of her wares, referring to Culloden and the duke of Cumberland; and we know the news vendor is a Jacobite because of the cross around her neck and her newspapers, which indicate antigovernment sentiment.

16. As opposed to the "comic epic-poem in prose" of *Joseph Andrews,* though Fielding had included the word "history" in its title. Battestin first drew attention to the parallels between *Tom Jones* and the situation of the Forty-Five in "Tom Jones and 'His Egyptian Majesty': Fielding's Parable of Government," *PMLA,* 72 (1967): 68–77.

17. *The Jacobite's Journal,* which was not in fact published until 1747, merely indicates her political persuasion, as the *Grub-street Journal* in *The Distressed Poet* indicated that the Poet subscribes because its title signifies a journal of Grub Street; not because it is an attack on Grub Street writers such as himself by Pope.

18. One scene from the *Battles of Marlborough,* however, *The Battle of Tanières,* is a close-up of warfare: the English have overrun the French position, are taking their cannon and removing their fortifications. Two figures are fighting to the death in the left foreground, two more in the right, and in the middle several soldiers are trying to move some logs that create powerful diagonals recalled by the flag in *The March to Finchley.* Here is all the chaos of *Finchley* but in an actual battle scene, not before or after. Perhaps the irony of Hogarth's painting is in showing the same pitched flags and the same structure of the three forward actions but beforehand, in the peaceful bivouac. Gin, for example, *would* have been administered during a battle in the way it is at the lower right corner of *Finchley.*

19. *The Night Watch* had hung prominently in the Amsterdam City Hall since 1715, and Hogarth may have traveled that far north in 1748. There were also copies, including at least one of the uncropped state, which is closer to Hogarth's composition. The painting's fame had been transmitted through Samuel van Hoogstraten's *Inleyding tot de Hooge Schoole de Schilder-Konst* (1678), 176, and Filippo Baldinucci's *Cominciamento e progresso dell'arte dell'intagliare in rame* (1682), 78; see Seymour Slive, *Rembrandt and His Critics, 1630–1730* (The Hague, 1953), 6–7, 97–98. For the copies, see Neil MacLaren, *National Gallery Catalogues, The Dutch School* (London, 1960), 343–40.

20. Cf. Pope's fable of George as Midas, gaining his asses' ears by choosing Marsyas over Apollo, in his "Epistle to Dr. Arbuthnot."

21. Horace Walpole remarked of the proposed bill: "The penalty of death came over as often as the curses in the Commination on Ash-Wednesday. Oaths of secrecy were imposed on Courts Martial; and even officers on half-

pay were for the future to be subject to all the jurisdiction of military law" (Walpole, *Memoirs of the Reign of King George the Second*, ed. Lord Holland [1847], 1: 38). According to John Brooke, Cumberland's unpopularity did not result from the slaughter of the Jacobite troops so much as from his attempt to reform the army, especially after the peace of 1748 (*King George III* [London, 1972], 31).

22. There may even be a reference in the pugilistic match under the sign of Adam and Eve to the famous Broughton-Slack match of April 1750, in which Broughton was temporarily blinded and lost, to be angrily disowned by his patron Cumberland, who had bet a sizable amount of money on him. If this allusion is present, it is not necessarily a flattering one.

23. Battestin, *Fielding*, 475.

24. *Penlez*, in Fielding, *An Enquiry into the Causes of the Late Increase of Robbers and Related Writings*, ed. Malvin R. Zirker (Middletown, 1988), 58–59.

25. *Charge to the Grand Jury*, in Fielding, *Enquiry*, 23. In these legal pamphlets, as well as in *The Covent-Garden Journal*, Fielding sounds, in his attacks on prostitutes, like Justice Gonson; but he invariably singles out as the exception the sixteen-year-old girl who has been suborned into a life of prostitution (the age is invariable).

26. See *The Newgate Calendar*, ed. Andrew Knapp and William Baldwin (London, 1824), 2: 61.

27. Battestin, *Fielding*, 479.

28. *GM*, Oct. 1749, 465.

29. His most virulent attacker in this case was Paul Whitehead, a Tory apologist, and a known friend of Hogarth's. See M. C. and R. R. Battestin, "Fielding, Bedford, and the Westminster Election of 1749," *ECS*, 11 (1977–1978): 143–85.

30. For the rows of windows Hogarth may have been inspired by a print of the riot called *The Sailors Revenge or the Strandian Uproar* (reproduced, Fielding, *Enquiry*, pl. 2).

31. Dated 2 Apr.: Walpole, *Corr.*, 20: 137; also 119–20, 130–31. See also *GM*, 20 (1750): 137ff.; *LM*, 19: 91 and ff.; *Universal Magazine*, 6: 187. Many admonitory sermons and pamphlets followed, as well as satiric ones. Walpole's friend, Richard Bentley, Jr., published *A Full and True Account of the Dreadful and Melancholly Earthquake, which happened between Twelve and One o'Clock in the Morning, on Thursday the Fifth of April. With an Exact List of such Persons as have hitherto been found in the Rubbish. In a Letter from a Gentleman in Town, to his Friend in the Country*, a six-page pamphlet which went through seven editions and was popular enough for another, unidentified writer to publish a sequel, *A Second Letter from a Gentleman in Town*, a month later. Bentley ridiculed the notion of the prophesied earthquake.

32. The advertisement specifies that during the time of subscription tak-

ing, until 30 April, "the Picture [i.e., the painting] may be seen and not longer, to the End that the Engraving may not be retarded." The print was priced at 7s 6d until the subscription was over, then half a guinea.

33. Cf. the example of *Trivia,* above, 145.

34. J. Ireland, 2: 141–42.

35. Rouquet, *Tableau,* 2.

36. Fielding formulated it first in *The Tricks of the Town Laid Open: or, A Companion for the Country Gentleman* (1747) and then, definitively, in *Tom Jones.* See Bertelson, *Nonsense Club,* 70.

37. And Hogarth carries the theme of judgment over into his next large project, *The Analysis of Beauty,* and beyond into *The Bench.*

Note to page 98: Sir John Gonson's charges to the Grand Jury had placed a great deal of emphasis on divine intervention: Human societies cannot, he declaimed to the gathered magistrates, "subsist without acknowledging some invisible power, that concerns himself with human affairs, and will punish the immoral and vicious, and reward the good and virtuous in another life. . . . [T]he awe and reverence of this divine being makes men more effectually observe their duties, in which their mutual happiness consists, than all the punishments of the magistrate" (*Five Charges to Several Grand Juries* [1730], 55–56).

Such speeches may explain why Hogarth introduced Gonson into *Harlot* 3 as a parody of the Angel of the Annunciation: Justice Gonson, the scourge of prostitutes, represents the *only* kind of intervention there is going to be in Hackabout's life—certainly not the God who saved Isaac from Abraham's knife (in the print on her wall). Gonson can be regarded as another example, with the bishop of Plate 2, of the human replacing the divine in this society (see vol. 1, 245–46, 273).

Note to page 374: The unravelling movement Hogarth traces from Adam and Eve to the brothel is the reverse of the progression in *Tom Jones* (in Jill Campbell's words): "Tom's progression towards battle with the rebels [impeded by insubordination in the inchoate and divided company he joins— its cynicism about the Protestant cause and Ensign Northerton's abuse of Sophia] is gradually transformed into a pursuit of Sophia—that is, of female virtue, of heterosexual union, and of personal happiness" (*Natural Masques: Gender and Identity in Fielding's Plays and Novels* [Stanford, forthcoming]).

General Index

Index of Hogarth's Works

I. PAINTINGS, ENGRAVINGS, DRAWINGS (GENERAL)

II. PAINTINGS, ENGRAVINGS, DRAWINGS
(INDIVIDUAL WORKS)

III. WRITINGS